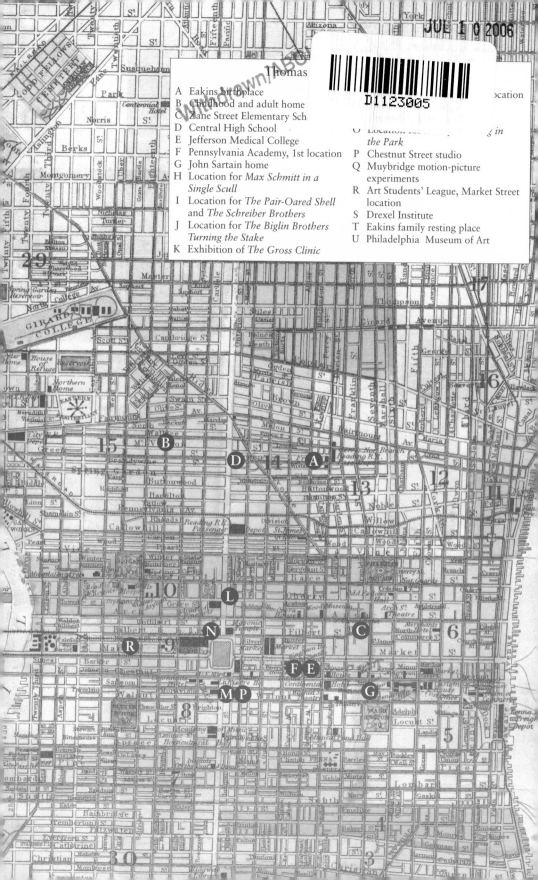

JUL 1 0 2006

D1123005

Thomas

A Eakins birthplace
B Childhood and adult home
C Zane Street Elementary School
D Central High School
E Jefferson Medical College
F Pennsylvania Academy, 1st location
G John Sartain home
H Location for *Max Schmitt in a Single Scull*
I Location for *The Pair-Oared Shell* and *The Schreiber Brothers*
J Location for *The Biglin Brothers Turning the Stake*
K Exhibition of *The Gross Clinic*

O Location for *Swimming in the Park*
P Chestnut Street studio
Q Muybridge motion-picture experiments
R Art Students' League, Market Street location
S Drexel Institute
T Eakins family resting place
U Philadelphia Museum of Art

The Revenge of

THOMAS
EAKINS

The Revenge of
THOMAS
EAKINS

SIDNEY D. KIRKPATRICK

Yale University Press *New Haven & London*

Henry McBride Series in Modernism and Modernity

This book has been published with assistance from the fund
established for the series by Maximilian Miltzlaff.

Designed by Sonia Shannon.
Set in Monotype Bulmer type by Duke & Company,
Devon, Pennsylvania.
Printed in the United States of America by Vail-Ballou Press,
Binghamton, New York.

Library of Congress Cataloging-in-Publication Data
Kirkpatrick, Sidney D.
The revenge of Thomas Eakins / Sidney D. Kirkpatrick.
p. cm.
Includes bibliographical references and index.
ISBN-13: 978-0-300-10855-2 (alk. paper)
ISBN-10: 0-300-10855-9 (alk. paper)
1. Eakins, Thomas, 1844–1916. 2. Painters—United States—
Biography. I. Title.
ND237.E15K55 2006
759.13—dc22 2005027935

A catalogue record for this book is available from the
British Library.

The paper in this book meets the guidelines for permanence
and durability of the Committee on Production Guidelines
for Book Longevity of the Council on Library Resources.

10 9 8 7 6 5 4 3 2 1

To agent Richard Morris
and artist Mercedes Thurlbeck

I see no impropriety in looking at the most beautiful
of Nature's works, the naked figure.

Thomas Eakins

Contents

Part III EXPOSED AND EXPELLED

Color plates appear following pages 182 and 374

introduction

In Light and Shadow

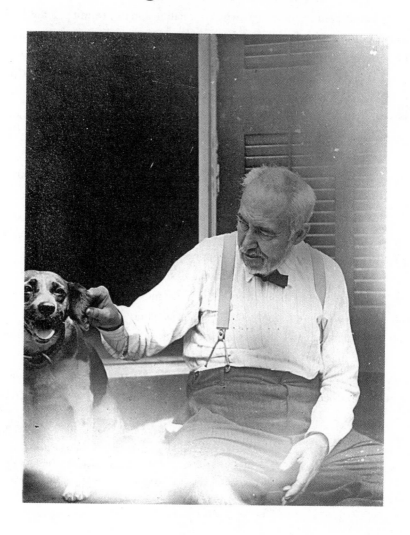

Thomas Eakins was an enigma who shocked art lovers and critics alike in his time. Today he is considered the finest portrait painter our nation has ever produced. Through sheer will, clarity of vision, depth and incisiveness of technique, he captured images of such realism and narrative fascination that viewers are pulled into them the way a theater audience is drawn into a scene from a motion picture: looking at his paintings, one experiences a feeling of being there, in the moment, with the champion boxer in a crowded, smoke-filled arena, the pianist resting her head in her hands, the physicist at work in his laboratory, or the baseball batter waiting for a pitcher to let loose. That Eakins created these inspired, fully articulated, and profoundly "modern" images more than a century ago, when our nation and its portrait painters had just begun searching for a uniquely American identity, makes his achievement the more remarkable.

Eakins' own generation missed the point of his art altogether. For his professional debut in 1871, the twenty-seven-year-old Eakins chose the first in a series of portraits that were unlike anything done before in American art: professional oarsmen poised in racing sculls on the reflective waters of Phila-delphia's Schuylkill River. His scenes were recorded with absolute fidelity to the time of day, the precise dimensions and plane of the scull cutting through the calm water, and, in his keen attention, the rowers' biceps.

"Men with their beautifully-ugly muscles," the critic for the *New York Tri-bune* sniped. "A shock to artistic conventionalities," declared the *Philadelphia Evening Telegraph*. "Peculiar," another reviewer remarked. Most brutal was a critic from the *American Art Review* who described Eakins' work as a "scien-tific statement" rather than "an embodiment of movement and color." Review-ers of his work were more receptive in Paris, where Eakins had completed advanced art studies a few years earlier. Still, they found his rowing paintings little more than "photographic proofs," lacking "poetic imagination."

Eakins was bewildered by the response. Real beauty, he believed, was not a quality that had to be imagined or hidden. It existed everywhere. "I love sun-

light and children and beautiful women and men, their heads and hands and almost everything I see," Eakins had once written in a letter to his father.

Though technically brilliant in its precise observation of subjects, Eakins' art was judged provincial by the French and yet too avant-garde by Victorian America. Rather than adapt his course in such an environment, Eakins forged stubbornly ahead, obsessively pursuing themes and honing a technique that continued to be largely ignored by the French and deemed offensive at home. No one disputed his technical mastery of anatomy and perspective; critics and patrons simply couldn't come to terms with how he chose to apply his talent. "If he had been a French painter, or even an English one, every European museum would covet his work," one critic has observed. "He would be as familiar to collectors, dealers and art students as Manet and Degas. But although French-trained, Thomas Eakins was . . . thoroughly American."

During Eakins' tumultuous four-decade career he had only a single one-man showing of his work. At the Exposition Universelle, held in Paris in 1889, when American painters emerged as a sophisticated and competitive presence in the community of world art, receiving an astonishing fifty-seven awards and twenty-four honorable mentions, Eakins' two submissions went unnoticed by the judges. The most significant honor he received in his later years was a gold medal presented by the Pennsylvania Academy of the Fine Arts; by then, out of spite, after years of meticulous work being met with misunderstanding, he melted the medallion down and redeemed it for cash. A full century passed before Eakins' post-mortem revenge began.

Like his art, Eakins himself included deep and vexing contrasts: a complex mix of conservatism and daring, loyalty and rebellion, classical technique and cutting-edge science. Handsome and charismatic in his youth, he nonetheless dressed in a slovenly manner and offended visitors to his studio with crude remarks. He studied logarithms and etymology for fun, built his own cameras, and designed elaborate gymnastic devices to demonstrate the muscular actions of the human body. He was fluent in seven languages and could dissect cadavers with the skill of a trained surgeon. Yet he detested popular culture, politics, literature, and anything that smacked of delicacy, refinement, or religious dogma. And although he had once distinguished himself as an art

student in Paris and traveled widely throughout Europe, he lived and worked virtually his entire career in the accommodating but modest Philadelphia row-house where he grew up. He married late in life, had no children, and spent his nonworking hours with friends and admirers, many of them students and fellow sportsmen. Had it not been for financial support from his doting father, he might well have given up painting altogether to pursue a career in medical science, a field that interested him nearly as much as art.

The reason most often cited for Eakins' lack of commercial success was his failure to abide by the artistic trends that defined his times. At the height of the great Gilded Age "cover-up," when everything from clothing to office buildings to piano legs was disguised by pretentious overdecoration, and when portraiture both at home and abroad was an exercise in social flattery, Eakins' art was blunt and direct. He stripped his images of glamour and artificiality. It may not, in fact, have occurred to him to paint any other way. The romantic imagery and majestic panoramas of his American contemporaries Frederic Church and Eastman Johnson held no more interest for him than the light-hearted spontaneity of the French impressionists. His goal was to depict his current world exactly as he saw it, even if that meant reaching back into an-tiquity to reinvent the academic realist tradition. His hero was Phidias, the legendary Greek sculptor of the Parthenon. His inspiration was the work of Diego Velázquez, whom he considered the greatest of all the Spanish masters. Into the remnant shell of academic realism Eakins injected modern science, technology, and his own remarkable talents, generating likenesses of extraordi-nary and compelling intensity. His work was as truly American as the ten-ton Baldwin steam engines and locomotives that were produced in a Philadelphia factory several blocks from his home.

Eakins' paintings poised on a balance between carefully composed im-agery—featuring subjects often admired for aesthetics or sentiment—and an insistence on realistic honesty that both onlookers and experts found hard to understand. In what many critics now consider our nation's finest painting, Eakins depicted Dr. Samuel Gross and a team of surgeons removing diseased bone from a patient's leg. Eakins' contemporaries found the scene's theme objectionable, as they did the artist's unblinking attention to "horrible and disgusting detail." As one Philadelphia reviewer complained in 1880, "The

more we study it, the more our wonder grows that it was ever painted in the first place, and that it was ever exhibited in the second." The *New York Tribune*'s critic agreed, though he, like so many others who stood in judgment over Eakins' work, acknowledged the strange impact the painting had on viewers. "Powerful, horrible, and yet fascinating. . . . The more we praise it, the more we must condemn its admission to a gallery where men and women . . . must be compelled to look at it." Other acknowledged Eakins masterpieces, such as his portrait of Dr. Hayes Agnew performing a mastectomy, were considered too graphic and finely detailed for public display. A painting that is today considered one of his finest, a classically themed, nearly mythic depiction of nude men swimming and sunbathing at Dove Lake, near Bryn Mawr, Pennsylvania, hastened his transition from avant-garde artist and teacher to Philadelphia outlaw.

Eakins' philosophy of art without artifice upset many of the people who sat for his portraits as well. They wanted paintings that would enhance their self-image, not catalogue what might be deemed their "physical deficiencies." Eakins sometimes asked his portrait subjects to wear old, rumpled clothing and worn-out shoes; he instructed more than one sitter not to shave for twenty-four hours before posing. The artist did not banter charmingly with his sitters in order to coax lively expressions from them; instead, he painted in stony silence, searching for truths that could not be pried loose with lighthearted conversation. "His gift," scholar James Thomas Flexner wrote, "was to catch people at the moment when they lapsed into themselves."

Eakins' steadfast refusal to remove a mole or smooth wrinkles from a subject's face is perhaps why he has the unique distinction of having had more of his paintings destroyed than any other great artist of modern times. Eight of his portraits were burned or shredded by the people who appeared in them; another fifteen simply disappeared under questionable circumstances. A portrait of the revered mother superior at a local convent was either destroyed or conveniently lost after her death by nuns seeking to do Christian service to her memory. The daughter of the subject of another Eakins portrait merely refused to let her family hang it on the wall. To visitors who asked to see it, she said apologetically, "Mother was sick when this was painted . . ."

In addition to the offended sensibilities of his sitters, viewers found even

greater objections at the core of Eakins' work. Philadelphia art patrons had considerable difficulty accepting Eakins' passionate belief that the nude human body was the most beautiful thing on earth. He studied it artistically as he did scientifically, not overtly as an object of desire, but as a miracle of muscle, bone, and blood. At a time when unclothed female models were often required to wear masks to hide their identities, and male models wore loincloths in female art classes, Eakins insisted on total nudity and encouraged students to pose nude for each other in his classes or in various outdoor locations where he would photograph them. After one much-discussed incident at the Pennsylvania Academy of the Fine Arts, where he had served as a faculty member for nearly a decade, he removed the loincloth from a male model in an all-female life studies class. Eakins was barred from ever teaching there again.

Another incident found Eakins painting a portrait of the buxom wife of a prominent businessman. He stepped away from his easel and poked his fingers into her lace bodice. "Feeling for bones," he blithely remarked. Yet another patron bolted from the room when Eakins expressed his joy in having her model. "How beautiful an old woman's skin is," he exclaimed. "All those wrinkles!"

Eakins' fellow artists turned out to be no more helpful to his reputation. They voted unanimously to expel him from Philadelphia's most respected art association. They made no specific accusations, at least not in public, and presented no hard evidence to a designated "morality" committee. However, rumors circulated of Eakins having committed acts "unbecoming of a gentleman." Underlying such rumors were stronger hints of scandal that roiled his career. In a letter to the chairman of the Pennsylvania Academy, Eakins defended himself by alluding to shameless backstabbing and a "secret conspiracy" of unnamed parties. "A man could easily be accused of lewdness, and his action be truthfully described in fearful terms, yet if the explanation were once listened to that he was an obstetric physician practicing his calling he might rest blameless," Eakins wrote. "To study anatomy out of a book is like learning to paint out of a book. It's a waste of time."

Thirty-eight of Eakins' students withdrew from the Pennsylvania Academy after his dismissal and joined him in forming their own artists' cooperative. Yet Eakins' later efforts to repair his reputation did nothing except further

alienate him from Philadelphia's established institutions and the millionaire elites who funded them. Fearful that his art, artistry, and "Parisian turpitude" would catch on, critics and patrons of the arts quietly agreed to quarantine the artist by having his work rejected from exhibition.

Neither did Eakins find a market for his art in Paris. Enthusiasm for impressionism and the introduction of post-impressionism made his brand of realism seem dated, almost quaint. Nearly a century later, the art and literary critic Richard Blackmur neatly summarized the problem when he was attributed as saying, "Talent seldom expresses the right thing at the right time in the right place."

Hostility became neglect, and with neglect came obscurity. Eakins' last several paintings were dark, almost elegiac. In 1907, at age sixty-three, Eakins retreated with his wife, the artist Susan Macdowell, into near-complete isolation in their Philadelphia home. In spite of several significant sales and belated honors, his paintings, more than three hundred in all, could not be sold or even given away. "No one collected Eakins but Eakins," one critic later remarked. "Few could paint like Eakins [and] even fewer seemed to want to," wrote another. At his own request, no funeral services were held for Eakins when he died in the spring of 1916. "My honors are misunderstanding, persecution & neglect, enhanced because unsought," he had written of himself.

The settling of accounts in Eakins' favor finally got under way forty years later. Thanks to his widow, Susan Macdowell Eakins, along with her companion, Mary Adeline Williams, who together made a substantial gift of his paintings to the Philadelphia Museum of Art, Eakins' creative genius came to the attention of a new generation of realist painters. The artist Reginald Marsh, heir to a Chicago meatpacking fortune, funded the first Eakins biography, written by Lloyd Goodrich, which was published in 1933. Though devoted to her husband's memory, Macdowell was initially skeptical that the general public would be interested in her husband's art. "I appreciate very much your desire to publish an illustrated discourse on the Eakins work," she wrote Marsh. "I believe, however, the Eakins pictures will never be popular, and for this reason, I think your project may not repay you for the time and expense." The help she provided the author contributed in no small measure to our appreciation of the artist today. Goodrich's acclaimed biography became

the definitive statement on Eakins and an atonement, however prosaic, for half a century of neglect.

Having been previously damned as a philistine, Eakins came to be declared a hero. Lewis Mumford, a father of modern American literary criticism, saluted Eakins' "hearty contempt for the hierarchies of caste and office," and Henry McBride, art critic for the small but influential literary magazine *The Dial,* drew parallels between the paintings of Eakins and the literature of Herman Melville. Literary critic F. O. Matthiessen, in 1941, compared portraits by Eakins to the poetry of Walt Whitman.

Like a dam breaking, a deluge of unabashedly laudatory praise followed. Critics likened Eakins' faithful rendering of anatomy and perspective to Leonardo da Vinci's, and compared his layered and textured use of oils to those of Rembrandt and Vermeer. And, where Eakins' own generation had seen oddity and immoral behavior, viewers now saw heroic character and charming eccentricity. "Only his greatest virtue, honesty, counted against him," wrote *Time* magazine's art editor Alexander Eliot in 1957. Critics were soon describing Philadelphia's previous "outlaw in an undershirt" as a "lonely visionary" and "uncompromising individualist" who triumphed against adversity and Victorian prudery to produce "timeless portrayals" of his contemporaries. John Canaday, the anti-modernist art critic for the *New York Times* in the 1960s, praised Eakins as "twice the rebel that most of the contemporary stable is, and ten times as original as the noisiest of them." Declared Darrel Sewell, curator of American art at the Philadelphia Museum: "Eakins, the opera, was opening to rave reviews."

The artist's late but rapid ascent from obscurity, however, was still incomplete. Key pieces of his story turned out to be missing, owing to a lack of biographical fact for a basis to examine his career. Eakins wrote no memoir and kept no personal diaries. In his lifetime not one full-length article featuring him was published. Except for a relatively modest archive of correspondence, sketchbooks, and photographs, and the scholarship of Lloyd Goodrich, biographers had nothing but Eakins' drawings and paintings—however rich a visual guide—to illuminate their probing of the contradictory impulses appearing to motivate his art. No one could say for certain how Eakins' personal life and relationships influenced the dark and troubled moodiness of his later

paintings, or who in the Philadelphia art community had masterminded the "secret conspiracy" to prevent his work from being displayed, or whether Eakins' love of nudity was driven by an elevated appreciation for the human body or by prurient desire. The big questions did not get asked, because they apparently could not be answered.

Just when it seemed the curtain was about to fall on Eakins "the opera," the artist's story received a few new plot twists, if not an entirely new ending. In what has been hailed as one of the most significant discoveries in recent art history, art curator Kathleen Foster and her assistant Elizabeth Milroy, at Eakins' alma mater, the Pennsylvania Academy of the Fine Arts, obtained a virtual Pandora's box of Eakins' personal papers, correspondence, and photographs.

The Eakins opera continued as this trove provided valuable new material for postmodern and other art historians and scholars to reexamine Eakins' life and career. It also opened the way for operatic extremes of lurid suppositions—used as platforms that magically transformed into fact, in turn used to launch further suppositions. Such approaches, epitomized by Henry Adams in 2005 in *Eakins Revealed,* curiously make rigid use of psychological investigation, in which, instead of following this discipline's need to be supple, the nuances of an artist's life are thrown automatically into the most extreme possibilities. An abundance of drama already informs Eakins' complex personal and artistic histories without having their life drained by imposing on them theory in ways that are mechanical, overly speculative, and themselves prurient. Eakins' psyche is easily shown to be complex enough and alive with transformation. Thus it seems ham-fisted to employ without balance the nuances of the artist's struggles and successes merely to illustrate the agendas of mannered theories. The story demands a more expansive voice.

Nevertheless, how these new documents came to be found and what they tell us about Eakins and the conflicted spirit of the age depicted in his paintings is a story brimming with melodramatic turn-of-the-century intrigue and curatorial sleuthing. Foremost among the players in the gathering, sequestering, and maintenance of these papers was Charles Bregler, Eakins' most devoted student and later personal secretary to the painter's widow, Susan Macdowell. For more than four decades Bregler had assisted in framing, cleaning, hanging,

and cataloging Eakins' paintings. His fierce, almost neurotic devotion to the Eakins family was not reciprocated to the degree he believed was warranted. In 1938, after the death of Susan Macdowell Eakins at eighty-seven, trust agents handling her estate excluded Bregler from the final disposition of Eakins' paintings and papers. He read about the sale of the Eakins family home in the newspaper and stopped by, he later claimed, for a "sentimental" last visit.

What Charles Bregler found inside the Eakins home stunned him. Every room was cluttered with debris. As movers had hastily carted away furniture, they left the contents of drawers and cupboards dumped on the floors. Heaps of correspondence, photographs, sketches, and unfinished oil paintings were piled alongside shattered fragments of plaster casts, paintbrushes, and picture frames. Certain that Eakins' heirs did not appreciate the artist's genius, and outraged by what he considered yet another undeserved injury to the memory of his former teacher, Bregler helped himself to everything he could haul away.

This was Bregler's explanation for how he came into possession of some five hundred photographs, three hundred sketches, two hundred letters, stacks of personal and professional papers, a dozen or more paintings, and the equivalent of a steamer trunk full of Eakins' clothing and effects. Bregler's account might well be true; it also deserves scrutiny. Handwritten notes attached to the correspondence and personal papers indicate that Susan Macdowell Eakins intended to have these items destroyed. "They are to be burned," read one such note. "Do not read, just destroy," read another.

Bregler stashed the trove of Eakins findings in his basement and under his bed and didn't reveal the full extent of the collection to anyone except the woman who became his wife. He eventually sold off various paintings, sketches, and other materials. The rest remained hidden until Kathleen Foster and Elizabeth Milroy tracked them to a run-down South Philadelphia townhouse in 1983, forty-five years after their removal by Bregler from the Eakins estate. The Pennsylvania Academy of the Fine Arts, the institution where Eakins first exposed a male model to the city's female students, is now home to an archive that provides a uniquely full and intimate glimpse of Eakins himself.

The Bregler documents do not disappoint. Eakins emerges as both a maligned innocent and a daredevil exhibitionist at odds with the status-driven and

monopolistic Philadelphia elite who built the museums where his art is now displayed. In an age much like our own, one of spiritual exhaustion, distrust, fear of commitment, and stupendous scientific and technological advancements, Eakins struggled to break new ground, setting remarkably high standards for himself while trying to earn his living doing it. He doggedly followed the path less traveled by his contemporaries, and suffered the consequences. Judging from the evidence now brought to light, added to the record of his paintings, all that sustained him was his impassioned and obsessive love of beauty in everything he saw, whether it was sunlight reflecting off a rower's muscles, an old woman's wrinkles, or blood on a surgeon's scalpel.

However dramatic certain facets of his life appear, Eakins was much more than just a swashbuckler, a paint-smeared Lothario, or an Easy Rider with an easel, as the Bregler papers also make clear. "Big artists," one critic has aptly said, "have big problems." Indications of insanity, as well as genius, ran in Eakins' family. The "secret conspirators" seeking to undermine his career were not only professional colleagues: they included his siblings, in-laws, nieces and nephews, along with art students and the father of a spurned lover.

The incident that eventually triggered Eakins' outright exile from the Philadelphia art establishment occurred when his brother-in-law Frank Stephens accused the artist of bestiality and incest. It was Stephens who worked to have Eakins barred from Philadelphia's premier art club. Another highly charged intrigue stemmed from Eakins' tutoring of his eldest niece, Ella Crowell, who, after several months of being confined to a mental hospital, returned home and shot herself. A third scandal involved another Eakins student, Lillian Hammitt, who was found wandering the streets of Philadelphia in a state of delirium, dressed only in a bathing suit. She too suffered a nervous breakdown and was hospitalized. In letters to Eakins, Lillian Hammitt identifies herself as "Mrs. Eakins" and asks her teacher whether she should turn to prostitution to support him and herself after his supposed divorce from Susan Macdowell, to whom the artist was in truth married.

Eakins responded to his brother-in-law's accusations with a formal affidavit in which he categorically maintained his innocence. "I never in my life seduced a girl, nor tried to," Eakins said. His statements may well have been true. Frank Stephens, who had been one of his "less remarkable" students at

the Pennsylvania Academy and had married Eakins' sister Caroline, provided no documentary or first-person evidence to the morality committee that passed judgment on Eakins. Moreover, Eakins' sister Margaret, whom the artist allegedly had violated, was no longer alive to bear witness when Stephens made the accusations. It is clear from family records that Margaret was on friendly terms with her brother all her life. But the committee judged Eakins on allegations and innuendo alone. Polite society didn't repeat, print, or try to verify the stories. People simply rejected the artist and his work.

Beyond Stephens' accusation of transgressions with Margaret, little evidence exists to suggest Eakins was a premeditated sex offender. He maintained close and lasting relationships with forty or more of his students from the Pennsylvania Academy. None of the extant nude photographs Eakins took of his students are overtly sexual in nature. If Eakins made a mistake in judgment by taking the photographs, it could have been more a result of his unstinting commitment to the study of the human body, his passion for beauty in all its forms, and his means of choice for stripping his students of what he believed to be prudish inhibition and shame. To Eakins' way of thinking, he committed no crime.

At an institution considered the nation's finest art school, however, where he was the sole painting instructor and a student's highest honor was the capital "E" that Eakins inscribed in the margin of a successful painting, it is conceivable that the opportunity for "conduct unbecoming of a gentleman" was present. Putting aside such issues as his encouragement of nude modeling, at least part of the reason the Pennsylvania Academy dismissed him appears to have been the rigorous academic demands Eakins placed on his students. He urged his pupils to study anatomy by attending autopsies and dissecting cadavers. Classes in such highly popular subjects as aesthetic theory, art history, and outdoor sketching were omitted altogether from Eakins' curriculum. Parents who sent their sons and daughters to art school so they might grow in refinement were naturally appalled by the curriculum. The incident with the loincloth precipitated a crisis that had been building for months if not years.

The recently discovered papers give new insights about Eakins' uncompromising and deliberate defiance of the conventions of nineteenth-century painting. His decision to focus on portraiture, his choice of whom to paint,

and the circumstances he posed his subjects in were decidedly not commercially driven; he rarely gained compensation for his paintings, and some of them took years to complete. Neither critics nor patrons provided him much encouragement. Eakins turned to portraiture out of a psychological need that lay at the deepest core of his artistic vision.

It is now clearer than ever that Eakins put himself to great lengths and personal expense to paint examples of achievement and character: people he admired or considered highly skilled professionals like himself. He furthermore repeatedly sought to picture his subjects in settings that presented a narrative synthesis: people in relation to striking objects and events as important to the artist as they were to the subjects. His portraits, perhaps more than for any other nineteenth-century painter, thus become an autobiographical tool, proving timelessly invaluable in viewing the artist and his environment. As the art historian David Lubin has said, Eakins' paintings, like the fiction of Henry James, can be understood as a finely tuned register of the social and professional values and discontents of a generation and a nation breaking new ground and defining a uniquely "modern" identity. Another art historian has insightfully described these tensions and rich evocations in equally elegant terms: "Each of [Eakins'] paintings represents a struggle between logic and emotion, with line, mathematics and perspective standing for the logical component, and . . . pigment standing for the erratic, unpredictable pattern of emotion."

Indeed, among the most intriguing disclosures to be explored about Eakins' work is just how he was able to achieve such technical truth in his portraits. Forensic studies of his major paintings reveal that Eakins relied not only on his own meticulous and superb skills as a draftsman to solve exacting perspective challenges—he made extensive use of photographs as well in preparing his paintings, sometimes shooting as many as forty or more pictures of a subject.

This practice has long been known to curators and scholars. The revelation is that he went further, projecting the images onto canvas and tracing from them, incising scratch marks to guide his brush, then camouflaging the incisions with layers of paint. Eakins carried out such work in the privacy of his home studio, and his wife took great care to keep the projection stage along with the source photographs a secret. She may even have sought to destroy

them, believing that knowledge of his working method could detract from his accomplishment. Her directive on family letters might as well have applied to evidence of his photo projections: "Just burn."

Yet all in all, in view of Eakins' power as an artist, as with his alleged indiscretions and scandals, such secrets and ciphers do not detract from a viewer's appreciation of his paintings. Instead, they put them in a fascinating new context. Eakins was a century ahead of his time. Photography-assisted painting techniques that he pioneered in his Philadelphia studio are now as commonplace at Parsons and Cooper Union as the use of fully nude models in teaching drawing. "Painters can't cheat," as David Hockney is fond of saying, "because the medium gives them no rules to break."

Eakins' paintings are now universally known and admired precisely because they appear to us as thoroughly modern. His works are celebrated not because he was a photo-realist, but because they are moody, and brilliantly nuanced. They are alive with conflict, complexity, contrast, and truth. His handling of paint, one brushstroke at a time, infused into his creations a highly distinctive narrative far beyond mere simulation of reality. Each painting is its own motion picture, revealing its insights in sequence and in whole. The paintings tell stories that allow a viewer to appreciate them even without a catalogue or a punch-in-the-number audio guide. Eakins' masterpiece, his portrait of Dr. Gross performing surgery, has been described by David Lubin, in the *Art Bulletin,* in these terms: "[Eakins' painting] furnishes a melodrama of life and death, light and darkness, knowledge and despair. . . . Its towering, bloody Mephistopheles looming out of the black shadows in the dark illumination from above . . . combines Mary Shelley with Caravaggio to put forth a scene that might later have been filmed by the German Expressionists." Paintings with such vivid revelations and themes appeared together in room after room during a touring retrospective of work by Eakins that set attendance records in 2001. The exhibition first opened at the Philadelphia Museum of Art—overlooking the river so enlivened in Eakins' first paintings—and then went to Paris, where Eakins' art appeared alongside that of other great master realists, among them Courbet, Degas, and Manet. From there the exhibition traveled to the Metropolitan Museum of Art in New York.

That Eakins' personal narrative was driven by contradictory impulses

and obsessions, and at times the possibility of psychological illness, only adds dimension to our perception of him as a neglected and tortured genius. He was a product of America in the staid Victorian age, and yet he was also one of the creators of the changing new world he devoted himself to picturing. Only in the twenty-first century can his achievements, along with his failures, his dedication to art, and his close and conceivably exploitive relationships with art students, be more clearly understood. People on both sides of the Atlantic finally got the message: Philadelphians' eyes were opened to the depth of Eakins' fidelity, tenderness, and force, and the French recognized his art with new insight too.

Master and Apprentice

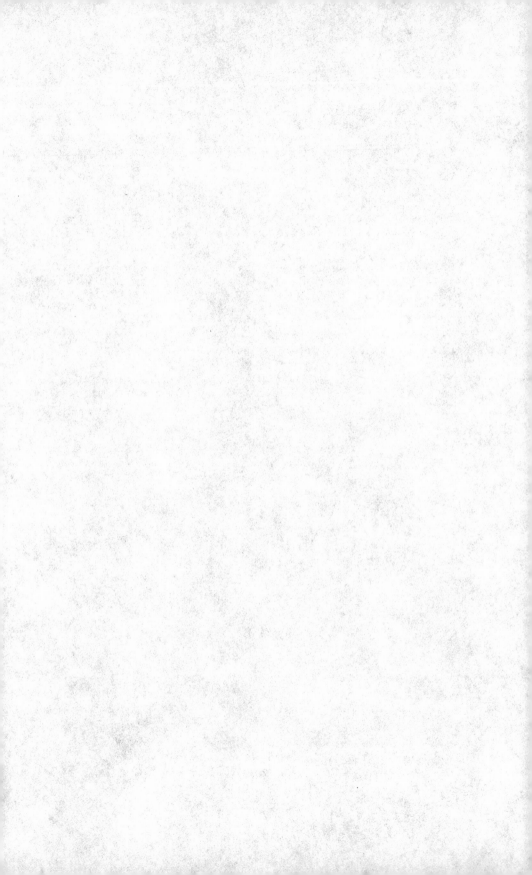

one

The Eakins Family of Philadelphia

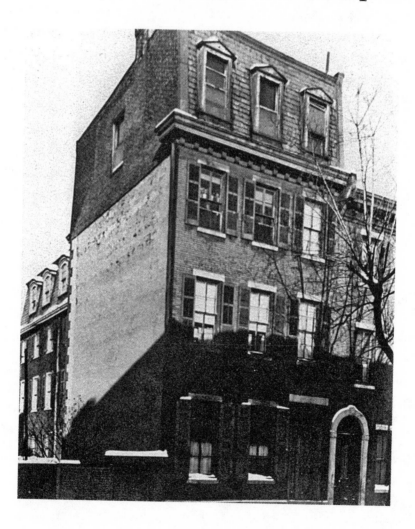

Twenty-year-old Thomas Eakins enrolled in a class of aspiring surgeons at Philadelphia's Jefferson Medical College in 1864. How committed he was to pursuing a career as a medical specialist is a matter of scholarly debate. All that can be said with certainty is that he had the intellect and temperament to have distinguished himself in the field. Fearlessness, devotion, discipline, and an informed mind—the very character traits most sought in a Pennsylvania operating room in the mid-nineteenth century—were qualities the young Eakins possessed in no small measure. He was endowed with an enormous appetite for knowledge, an abiding passion for human physiology, a clinician's trained eye for detail, and hands as adept with a scalpel as they would one day become with a paintbrush.

That Eakins soon chose to dedicate his formidable talent to the fine arts and not to medical science resulted from the considerable influence of his father, a distinguished instructor of penmanship at the Friends Central School. "Master Benjamin," as he was known throughout the city, had guided the unsteady hands of two generations of young Philadelphians. The son of an Irish handloom weaver from Valley Forge, Pennsylvania, he had arrived in Philadelphia in the early 1840s, married Caroline Cowperthwait, the daughter of a New Jersey cobbler, and gone on to establish a well-deserved reputation for kindness, stern morality, and absolute integrity. He was beloved by all who knew him, and no more than by Thomas, the family's eldest child and only surviving son, born in the summer of 1844.

The effect Benjamin Eakins had on his son's future art career can most tangibly be measured in dollars and cents. Never a rich man by Philadelphia's high standards, the senior Eakins, by thrift and diligence, provided a lifestyle for his family far beyond the expectations of his immigrant parents. For fifty-one years he earned a steady and reasonably good salary as a high-school teacher, which he supplemented through private tutoring in penmanship and by elaborately inscribing diplomas, deeds, invitations, marriage licenses, and testimonials. A savvy investor, Benjamin bought real estate, government securities, and railroad bonds, eventually accumulating eight income-producing rental properties and an estate that would be valued today in excess of $2 million.

Overleaf: The Eakins family home at 1729 Mount Vernon Street, c. 1940 (Courtesy of The Historical Society of Pennsylvania, Philadelphia, Society Photo Collection)

These prudent investments and his own shrewd skill in managing them provided financial security during his lifetime and supported his family after his death. The money made it possible for young Thomas Eakins to study in Paris, and it later provided him the luxury of not having to earn a living from his art. Eakins could choose his own portrait subjects and paint them when and how he pleased, without feeling beholden to anyone but his father. Nor did he ever have to court favor or compromise his exacting standards. "If you knew old Benjamin Eakins," one family friend declared, "you wouldn't give Thomas Eakins any credit."

Income such as that produced by the senior Eakins was made possible by Philadelphia's booming economy. Despite the city's rampant political corruption—reputed to be the longest sustained and most entrenched of any city in our nation's history—Philadelphia had successfully made the transition from being the breadbasket of the young republic to the nation's first modern industrialized city. In population and wealth, through the middle of the nineteenth century, it ranked behind only London, Paris, and New York. Three-quarters of Philadelphia's income flowed from manufacturing, mining, transportation, banking, and railroads. Factories, operating from dawn until dusk, driven by high-grade Pennsylvania anthracite coal, absorbed tens of thousands of unskilled immigrants. Five hundred or more ships a year arrived at the city's docks on the Delaware River, hauling such diverse cargoes as tobacco from the Carolinas, spermaceti from New England, coffee from Brazil, toys from Germany, and mahogany from Nicaraguan forests. Armies of factory workers in hobnailed boots trudged to work each morning through the cobblestone streets, steam-driven cranes and conveyor belts unloaded flatcars and coal hoppers at the freight yards, and soot-blackened tugs, whistles blaring, jostled for space at the quayside.

Although New York had eclipsed Philadelphia as the nation's economic powerhouse and arbiter of popular culture, Philadelphia maintained its preeminent status in building the largest steam engines, educating the most physicians, publishing more books than elsewhere, and establishing the country's first bank, city waterworks, public library, botanical garden, museum, and art school. Philadelphia also preserved its cultural identity in significant ways that other cities did not. More than forty sculpted artworks graced Fairmount

Park, along with dedicated hiking trails, bridle paths, playgrounds, dog runs, and other recreational facilities. City directories listed four hundred churches and eight hundred fraternal societies, political clubs, scholarly associations, and institutions of philanthropy, far greater in number and better attended than would ever be the case in New York or Boston.

Political and social egalitarianism in the tradition of Benjamin Franklin was so firmly rooted in Philadelphia that no other city offered its lower-income and middle-class citizens such a diversity of opportunities for education, leisure pursuits, and occupations. Two of Philadelphia's wealthiest businessmen had once been butchers. A third had launched his career selling bolts of cloth door to door. The city's public schools, considered the best in the nation, were defiantly practical, turning out leaders in medicine, science, and the applied arts. "I would have them taught facts and things, rather than words and [abstract theories]," proclaimed Stephen Girard on the occasion of his founding Girard College for orphans in 1831—a gift that was, at the time, the single greatest act of private philanthropy in the nation's history. Philadelphia was uniquely rich with cultural diversity as well as economic opportunity. To a man like Benjamin Eakins, the son of an immigrant craftsman, with no known formal education, the city could offer the chance to achieve a standard of living that made a Paris education for his son, or a Pennsylvania medical degree, not just a dream but a reality within his grasp.

Benjamin Eakins' business skills and his role in expanding the family's fortune made up only one aspect of his more enduring legacy. His most distinguishing character trait could be described as an enlightened and mature sense of himself and the community he lived within. Honesty, simplicity, and directness were values he cultivated in himself and instilled in his children. Benjamin Eakins' courtly and even-handed manner endeared him to graduates of Friends Central School. The respect fellow Philadelphians felt for him is evident in his decades-long relationships with such institutions as the University of Pennsylvania, which retained him twice a year to inscribe its diplomas. He had none of the smug inertia associated with the genteel class of Philadelphians whose diplomas he inscribed, or the tendency toward social climbing that was characteristic of the city's tradesmen. His wardrobe contained no ceremonial scimitars or embroidered robes.

Rather, Benjamin possessed a keen, often dry and self-deprecating sense of humor, flavored with a decidedly Irish anti-republican distrust of politicians, clerics, and the hugely popular fraternal associations with which the vast majority of Philadelphians of his generation identified themselves. "A staunch Democrat in a Republican City . . . [and] always neatly dressed, with a fresh collar," was how one neighbor described him. Benjamin didn't take himself as seriously as others took him, nor could he easily be fooled. His free time was invariably spent with his closest friends and immediate family, either at home over a game of chess in his parlor or outdoors, where he liked to hike, fish, hunt, ice skate, and sail. Family always came first.

Tom inherited his father's intelligence and industrious nature, as he did his short stature, round head, and heavy eyebrows, his high cheekbones and long upper lip. A childhood photograph of Eakins reflects his father's anatomical features and his alert and penetrating gaze. Tom's petulant smile—hinting a bit of mischievousness or insubordination—is what differentiates him most from his father. The difference may be a portent of things to come or could reflect merely a stage of the child's development: when Tom's photos were taken he had become a brother and was no longer the center of family attention. Frances, known as Fanny, came along in 1848, followed in 1850 by Benjamin Jr., who died before he was a year old; Margaret, or Maggie, was born in 1853, and Caroline, called Caddy, arrived in 1865, while Tom was attending Jefferson Medical College and studying painting at the Pennsylvania Academy of the Fine Arts.

Tom Eakins' russet complexion, suggestive of an Italian or Spanish coloring, his thick lips and dark hair, also evident in childhood photos, belong to his mother, Caroline Cowperthwait. A midcentury daguerreotype, from which Tom would later paint her portrait, shows her dark brown eyes, chestnut-colored hair, and high cheekbones. Caroline wears a black taffeta dress and tight high collar, indicating a woman in mourning; the photo may have been taken in 1851, the year Tom's younger brother died. Typical of the severe styles of the day, her shoulder-length hair has been parted in the middle and drawn smoothly back and knotted from behind.

Like many important details of Eakins' childhood and young adult years, little is known about his mother or the influence she had on her son. His family

correspondence provides only brief references to her, and not a single story about her has been passed down by her children or friends. In contrast to the long, richly detailed, and highly personal letters Tom later wrote from Paris to his father, whom he affectionately addressed as "Poppy," the infrequent letters to his mother are businesslike and impersonal, mostly detailing his expenses. The notable exceptions appear to have been observations about popular Parisian dress and hairstyles—perhaps unusual for a son, but not for one as curious and observant as Thomas.

The photographic record on its face, showing young Tom outfitted for several childhood pictures in a neatly pressed black dress fitted with a row of bright buttons and a ruffled white lace collar, suggests that his mother, at the very least, must have been a significant presence in the Eakins household. References to her engaged in needlepoint and embroidery indicate that her son may have inherited his manual dexterity from her as well as from his father. Thomas was named after one of Caroline's nine older siblings, an uncle whose gold pocket watch he later inherited. Caroline's brother Emmor Cowperthwait was a frequent visitor in the Eakins home, and her sister Eliza and their mother, Margaret, lived with the family for many years.

Although Caroline had been raised in the Quaker faith, her husband Benjamin taught in a Quaker school, and several of the family's closest friends were prominent members of Quaker congregations in a city where Quakerism was the dominant religion, no evidence reveals that after their marriage the couple, or their children, attended church services. The few clues that do exist shed little light on what may have been her religious beliefs, beyond a brief reference in family correspondence: as a teenager, she and an older sister needed to resort to subterfuge to hide their colorful dresses and bonnets from their maternal grandfather, who believed such finery to be unseemly. (Another sister was permitted to wear a pink bow on her bonnet on the condition that the bow was turned away from her father when the family sat in Quaker meeting.)

Master Benjamin's forebears were Presbyterians. Despite his and Caroline's turning away from their earlier religion, the young couple clearly incorporated Quaker values in their household. By word and by example Tom and his three sisters were taught simplicity of speech and dress, sobriety, and self-discipline. Qualities the family cherished—a hatred of hypocrisy and pre-

tension and a stubborn adherence to truth and honesty in the face of opposition—were also kindred to Quaker beliefs. Yet another Quaker-inspired rule Caroline and Benjamin likely practiced was silence at mealtimes. They were not altogether successful. Family friends reported that no sooner did the Eakins elders leave the dining table than the "merriment [among the children] would begin."

Although religion may not have been practiced formally in the Eakins family, it was respected. One of the few reprimands that young Tom was known to have received followed his teasing a second cousin, Sallie Shaw, for attending church and Sunday school. Master Benjamin reportedly "lit into Tom," and lectured him "so that he never did that again."

Benjamin's views on religious respect and tolerance were not necessarily shared by his neighbors, or for that matter by Tom during his formative years. The City of Brotherly Love, the Quakers' name for Philadelphia, became for Catholics the "City of Turmoil." Mobs of nativists, fearful of the growing population of Irish Catholic immigrants, routinely attacked Catholic residences and clergymen. In 1844, the year Tom was born, nativists burned the combined St. Augustine's Church, monastery, and school to the ground. The state dispatched a militia to protect St. Philip Neri's Church; fifty people died and sixty suffered serious injury there during an ensuing riot. St. Charles Seminary, a theological center that later figured prominently in Eakins' art career, had to be relocated to Overbrook, outside city limits, for safety.

Presumably Caroline shared her husband's views on religion and other subjects. How she met Benjamin has not been discovered. It is highly conceivable that she took private penmanship lessons from him in 1843, when her future husband first began advertising for clients from a studio on Sargent Street, only a few blocks removed from the Cowperthwait house, on Carrollton Square. It was in the Cowperthwait home—overlooking a chemical manufacturing plant and industrial park—where the young couple spent their first years of married life, where Thomas was born, and where, in 1850, his younger brother Benjamin Jr. died five months after his birth. Nothing is known of the circumstances surrounding the child's death or how his passing may have affected the family. Likely his death was caused by an epidemic of yellow fever and cholera that ravaged Philadelphia that year, killing one of every

five children in the city. The child's grave is marked by an angel kneeling on a pedestal in the Eakins family plot at Woodlands Cemetery, overlooking the Schuylkill River.

Tom entered grammar school in 1853 at age nine, the year after his family moved from the Cowperthwait home into an upwardly mobile neighborhood of recently built townhouses in the 1200 block of Green Street. Their second residence, although an improvement over the Cowperthwait quarters on Carrollton Square, was adjacent to a lumberyard and near a cluster of jerry-built dwellings at which pigs and other livestock were frequently tethered. Three years later, after Tom's sister Margaret was born, the family moved to the 500 block of Green Street, and in 1857, when he was twelve, into a spacious three-story townhouse on a double lot at what is now 1729 Mount Vernon Street.

Tom was of an age to have appreciated his family's rapidly improving net worth. Their new home was only four years old, raised by a bricklayer in a recently developed upper-middle-class neighborhood populated by families of merchants, lawyers, clerks, an undertaker, a photographer, and a book publisher. Typical of the recently constructed Philadelphia homes at the time, it was made of kiln-fired red pressed brick, enhanced by wide white marble steps and solid wooden shutters. Rather than purchasing the house and renting the land it was built on—a common practice in Philadelphia—Benjamin bought both at a sheriff's auction for the price of $4,800.

Like the three previous Eakins residences, the Mount Vernon Street dwelling, in what was then the city's far northwest corner, was removed from Philadelphia's most fashionable neighborhoods. It was cut off from the downtown shopping district, schools, and more stylish addresses of old Philadelphia by a belt of train yards and industrial buildings running between Market and Spring Garden streets. Among the house's less desirable features was its proximity to the city's largest steam engine and locomotive plant, at Broad and Spring Garden, which filled the air during early morning to late afternoon with clouds of soot from burning coal. A notorious Irish street gang, the "Flayers," controlled the neighborhood and put their moniker in chalk or charcoal on every factory wall and stable door. Until the 1870s, Philadelphians living on Mount Vernon Street carried pistols and few women walked unescorted. Further, unlike structures in Philadelphia's more centrally located districts, nearer the

city's new waterworks at Center Square, this residence had no central plumbing. An outhouse was located in the backyard, near two hydrants connected by wooden pipes to the city's underground public water utility. (A trough was later installed nearby for the family's many dogs, cats, and other pets to drink from.)

In spite of the location's shortcomings, Benjamin had made an exceptionally good investment. Over the next decade the house and its double lot tripled in value, and the neighborhood, thanks to the creation of an effective citywide police force, became one of the safest. The nearby Crowell family, whose children were approximately the same ages as the Eakins children, grew to be close family friends. Benjamin could walk the seven blocks to the Friends Central School at Fifteenth and Race streets, the children could easily ride a horse-drawn trolley to their respective elementary schools, and Caroline had easy access to a variety of shops and an open-air produce market on Ridge Avenue ("high society," living south of the railroad hub, shopped on Market and Chestnut streets). Equally important, the house was a short walk to the Schuylkill River and the Callowhill Street entrance to what soon became Fairmount Park, considered the largest and most picturesque public recreation area in the nation.

By comparison to the Eakins' modest first residence, the Mount Vernon Street house must have seemed palatial. Four times the size and considerably better constructed, the dwelling had a brick-paved backyard with trees and shrubs, tall first-floor windows, high-ceilinged rooms, and plenty of trim, glass doorknobs, and fancy moldings. There were bedrooms for the children on the second and third floors and an additional bedroom for Caroline's aging mother and for a selection of other family members who came to stay for months and sometimes years at a time. The second-floor master bedroom, where Benjamin and Caroline slept, contained a safe for securing important family documents. A maid, Mary Tracy, whom the family affectionately called Tuffy, helped with cleaning and cooking (a role she performed for the next thirty-five years). Family and friends passed in and out of the back, through the kitchen door. The front entrance was reserved for Master Benjamin's students and guests.

The Mount Vernon Street house's many rooms were soon filled with comfortable mahogany and rosewood furniture, upholstered armchairs, and

patterned broadloom carpets. A grand piano was added to the front parlor, and the rear study became home to a small library of reference books and literature, a cut-crystal decanter for Benjamin's homemade wine, his writing table, and a carved alabaster chess set.

The full measure of Master Benjamin's prosperity was written into this home. He and his wife would spend the rest of their lives here, as would one of their daughters and their son. Except for the three and a half years Thomas Eakins studied in Paris and traveled throughout Europe, nearly every important event in his life took place in the Mount Vernon Street house or within a twenty-block radius. The home would remain in the Eakins family for more than eighty years.

Virtually all of Eakins' major paintings were executed at this home or a studio nearby; within a short walk one could also have found most of the subject matter and people in the artworks. Even items of family furniture within this house repeatedly appear in his paintings, conveying an intimate and genealogical connection to his environment and, by extension, to his father. A particularly distinctive Jacobean-revival armchair, featuring an elaborately carved crest rail and velvet armrests, shows in more than twenty paintings and drawings over a forty-year period. As the decades rolled by, the chair can be seen reupholstered, with the people posing in it changing, but the chair itself has only moved from room to room, as if maintaining some umbilical connection to the home, the artist, and his father.

The senior Eakins' thrift and financial generosity not only kept a roof over his son's head, they provided, like the family armchair, the backdrop for Thomas Eakins' future career as an artist. The generosity of his father, however, came at a hidden cost. As a child and later as an adult, Thomas never had any real privacy. The home was not only his father's residence but his place of business for more than forty years. A constant parade of students passed through the house, along with his father's friends and his mother's extended family. Even after the death of his parents, after their estate had been settled and Thomas Eakins took ownership of the house as part of his share of the inheritance, there were never fewer than five members of his extended family in residence, and often as many as seven. Eliza Cowperthwait, his aunt, lived in an upstairs bedroom for forty-two years. Elizabeth Macdowell, his sister-in-

law, was still living in the house after Eakins himself died. He was not ever truly able to think of the home as his own.

Although Eakins took legal possession of the property, on a subconscious level the house and its furniture belonged to his father, because he had paid for them and his investments were what permitted the dwelling and household to be maintained. Even the placement of beloved furniture became so rooted in the collective childhood memories of Thomas and other family members that they seemed to hold a shared reluctance to shift the horsehair sofa, update the kitchen, or remove a family heirloom. Like the silver plate inscribed with his father's first initial and last name, forever fixed beside the front door, the house belonged to Master Benjamin. No one dared to remove the nameplate after his death.

two

Master Benjamin

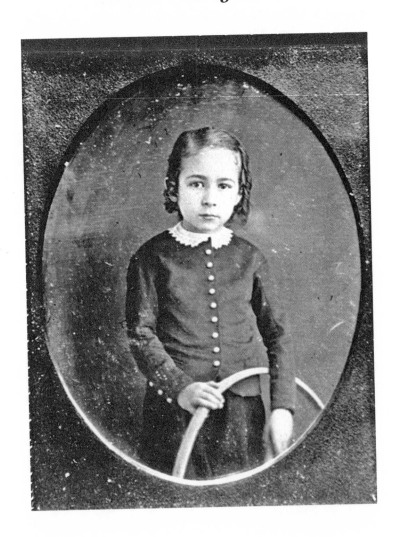

However consciously or unconsciously Eakins' dependence on his father might have become a psychological burden, Benjamin freely gave his support and Tom gratefully accepted it. Never grudging or cranky, Benjamin didn't put demands on his son that Tom did not willingly embrace. They appear never to have had a falling out or period of estrangement; their relationship lasted longer and meant more to Eakins than any other, with the exception perhaps of the one he had with Susan Macdowell, who became his wife. Master Benjamin's emotional support sustained his son throughout his youth and well into the artist's middle years. Their relationship inspired Eakins to paint more portraits of his father than of anyone else. In *The Chess Players*, from 1876, now hanging at the Metropolitan Museum of Art, Benjamin is portrayed much as his son thought of him: a wise and benign presence, quietly observing his two best friends play chess in the Eakins family study.

The remarkable bond between father and son is evident in an 1874 portrait Eakins painted outdoors, *The Artist and His Father Hunting Reed Birds*. Benjamin stands forward in a small skiff, his gun at the ready, while Tom mans a pole, steadying the craft as he pushes it forward through the marsh grass. As in *The Chess Players*, the painting is signed "Benjamini Eakins filius pinxit"—Latin for "Benjamin Eakins' son painted this." Such a tribute, unique in the greater body of Eakins' work, conveys the affection he had for his father, just as it emphasizes the genuine companionship they shared in their many activities together.

In the summer and early fall, Tom and his father would hike the heavily forested eight-mile round trip to the Schuylkill Falls, which offered massive trees, rocky ravines, moss-covered escarpments, and numerous meandering creeks and tributaries to explore. They rode horses and later bicycled in what grew to become the three-thousand-acre Fairmount Park. Weekend-long excursions began by ferrying across the Delaware River and then riding horseback to Tindall's Landing, near Fairton, New Jersey, where Benjamin and his close friends, the Hallowell and Morris families, jointly owned a two-story boathouse.

The "fish house," as the Eakins family called the boathouse, was large

enough to house accoutrements for many sporting activities and also to serve as a getaway when the summer heat and soot-filled Philadelphia air became overpowering. Nearby was the home of Addie Williams, a distant relative and childhood playmate of Tom and his sisters, where the Eakinses ate their meals. Margaret, Tom's sister, later wrote that it was not uncommon for father and son to arrive at the boathouse on horseback and charge directly into the river. The entire party, including horses and dogs, would go bathing, the boys without suits. Eakins had such a love for swimming, then and later, that he would take the first plunge as early as the first of May, when the water was still cold as ice.

Fishing for shad, snappers, and panfish was the favorite activity in Gloucester, New Jersey, south of Camden, while the anglers on the Schuylkill set their lines for catfish and perch. Tom and his father were often joined by family friend Charlie Boyer, a local gunsmith and the organist at a church in Bridgeton, New Jersey. It was Boyer, no doubt, who supplied Tom with the various guns he owned as a child and later as an adult. They included several small pistols, a double-barreled shotgun, and a Winchester rifle. Boyer also taught the Eakins daughters to play the piano. He attempted to do the same for Tom, but gave up in despair.

Sailing was a frequent Eakins family activity, practiced on a single-masted catboat that Benjamin kept at Cramps Shipyard on the Delaware River. Together with the rest of the Eakins clan, including mother and sisters, Tom and his father also rowed on the Schuylkill. Tom became quite adept as an oarsman and was said to have been a member of the Pennsylvania Barge Club, one of the many Philadelphia rowing clubs that enthusiasts established in the early 1860s. Rowing quickly became one of the city's most popular pastimes, and it was joined later in the decade by cycling. Rowing, like cycling, was a great sport for spectators as well. During regattas sponsored by the Schuylkill Navy—the Philadelphia association of amateur and professional rowers—thousands of onlookers would line the shores or stand on the bridges to watch sleek racing boats run courses of three and five miles up and down the unusually calm and gently curving river.

In the winter months the family's preferred activity was ice skating. Hudson's Pond, on the northwest corner of Fifth and High streets, was a favorite

spot. Benjamin was known to cut circles across the ice in much the same fluid motion that he used to embellish the words on testimonials with the stroke of his pen. Friends said that Tom could skate backward as fast as others could go forward. Benjamin was a charter member of the local skate club, and a day on the ice often culminated with a moonlight barbecue sponsored by the group.

Less athletic but equally intimate were the hours that father and son spent playing board games in the Mount Vernon Street parlor, designing kites, or working in a converted attic that Benjamin outfitted as a combination metal and woodworking shop. Tom learned carpentry here and later used his father's tools to make frames for his paintings. The attic shop was also where, as a young boy, Tom built a fully operational steam engine, later experimented with a microscope, tinkered with cameras, and, according to popular myth, practiced dissection.

As much as Benjamin encouraged scientific experimentation, he supported his children's right to their opinions. Nonetheless he placed conditions or limitations on the expression of their views and predilections. No subject was off-limits as long as what was studied or discussed was considered objectively and honestly, and gone into thoroughly. Music lessons, for example, were available on the condition that a child had talent and a demonstrated willingness to practice. Pets could be kept as long as they were properly groomed and fed. The children could go ice skating as long as they were willing to help maintain the apparatus of lifesaving blankets, ropes, and boathooks that were stored along the shore. Privileges were always accompanied by responsibilities. Deceit and cowardice were not tolerated.

A reference in correspondence that Tom later wrote from Europe suggests that the prevailing attitude in the Eakins household was one articulated by the popular British philosopher and sociologist Herbert Spencer, to whom father and son turned for solutions to moral and ethical dilemmas. According to Spencer, the responsibility was on the individual to lift himself or herself above the mass of humanity by means of intellect. "The habit of drawing conclusions by observation and experimentation can alone give the power of judging correctly," Spencer wrote. "Correct judgment with regard to surrounding events and consequences becomes possible only through knowledge of the way in which surrounding phenomena depend on each other."

Happiness, in Herbert Spencer's all-encompassing deterministic philosophy, could not be achieved through organized religion or manmade law, only through appreciating and adhering to nature's law, which was understood to be the human evolutionary destiny. Many Philadelphians subscribed to this approach to life. In the liberal, anticlerical, and distinctly intellectual atmosphere of the Eakins home, however, Spencer's book may have occupied a coveted place that would be reserved for the Holy Scriptures in other households. In young Tom, as in his father, Spencer's philosophy would have fostered an unusual love for scientific inquiry and independent thinking. Equally, reading Spencer would have instilled a disdain for affectation, pretension, and grandstanding. An Eakins did not lead a life born of luxury. Discipline, scholarship, and exacting standards were the rules.

No less influential in the Eakins household were the writings of another, equally popular nineteenth-century Spencer: this was Platt Rogers Spencer, of Poughkeepsie, New York, the father of the Spencerian method of penmanship. The Spencerian script, characterized by loose, graceful curves and elliptical ovals, aided by the invention of steel-tipped pens, provided the writing stylist with a means to display his or her individuality and accomplishment in a quick, clean, and legible manner while still maintaining the integrity of the letter forms. In an age when the best china, iron grillwork, and homes were increasingly gilded and embellished, superior skill at penmanship, as exemplified by a master of Spencerian script, was not only considered essential to a proper education, it was linked to high moral character and intellect, as advocated by Herbert Spencer. This was the style of penmanship taught by Benjamin Eakins, who may have gained his proficiency in a Philadelphia trade school or from Platt Rogers himself, who operated a penmanship school in Pittsburgh, Pennsylvania.

The art of the penman, Benjamin's vocation, was not altogether different from the craft of Benjamin's father, a handloom weaver: solitary, intensive, practiced, self-directed, and individual. It was creative in its inspiration yet shaped by formal and highly structured parameters, fluid yet exacting, inventive and yet inflexible. Perfection could be achieved only through rigorous training, nimbly maintained fingers, and a discerning, almost clinical, examination of the finished product. The penman's art, like that of the weaver, was

thoroughly modern in its presentation; at the same time it was grounded in centuries of tradition. These were the ingredients for commercial success and, by implication, personal achievement. The way Benjamin earned his living by using his hands skillfully would have as profound an impact on forging the career of Thomas Eakins as the income that work produced.

Art and accomplishment were one and the same in the Eakins household. Along with the steady stream of graduation diplomas, deeds, and certificates of appreciation penned by his father came the subliminal acceptance of what Tom was raised to believe was the natural order of his own destiny and the evolutionary development of humanity. The higher the degree of accomplishment, the more detailed and grand the documents were expected to be, and the higher the fee that could be charged to produce them. As several art historians have noted, three generations of Eakins men would carry with them the conviction that there was a tangible, immediate, and ultimately rewarding relation between process, product, and payment. The finely crafted portraits that would one day hang on the walls of the Eakins family parlor were extensions of the delicate, embellished documents on display in the hallway and the fine patterns in the hand-woven broadloom carpets on the floor, and reflected in the elaborate lettering on the polished silver nameplate beside the front door.

three

The Art of the Penman

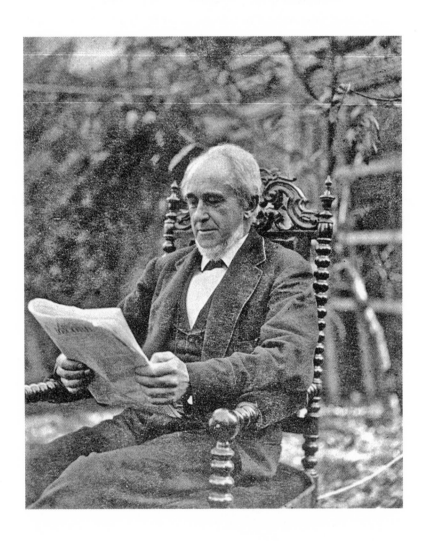

And so it was that the entire Eakins household lived and breathed the disciplined aesthetic of a master penman. Each June, in anticipation of the graduation ceremonies being planned throughout the city, every available flat surface in the house was covered with documents in various stages of completion. Adults and children would be employed in every part of production, from shuttling documents between rooms and checking spelling and punctuation to delivery, bookkeeping, and bank deposits. As the children grew older, their responsibilities increased. Margaret, at fourteen, was described as "quite a dabster at putting in hair lines" on documents. Tom grew adept in blocking out lettering and later came to execute complex scrollwork. A particularly handsome example of Master Benjamin's calligraphic repertory is a large decorative copy of the Lord's Prayer, which is preserved in the Eakins archive at the Pennsylvania Academy of the Fine Arts. It features a delicately drawn head and wings of an angel at the top, a feathered oval border, and a rendering of a tiny sparrow at the bottom.

The rulebook exactitude and methodology needed to create such a document provided the foundation for Thomas Eakins' later process in creating his art. Years before he picked up a brush, he was making fine, patient, careful lettering with pen and ink, conforming to accepted principles grounded in a studied technique. Each letter had to be properly weighted and balanced and placed squarely in a grid network of vertical and horizontal lines that determined the particular document's parameters. Lessons taught him by his father were followed by practice sessions from Spencerian copybooks or the hugely popular John Jenkins manual, which not only detailed the step-by-step preparing of paper before lettering could begin but provided the proper posture and mental attitude of the penman.

The Jenkins manual advised the penman to place the copybook directly beneath the right shoulder, letting the left arm form a square on the writing table, while leaning wholly on the left elbow. Proper posture, Jenkins noted, satisfied physiological requirements as put forth by prominent physicians, foremost among them Philadelphia's own Benjamin Rush, the Revolutionary War hero and father of Philadelphia's College of Physicians. Eakins later modeled his father in precisely the Jenkins pose for a painting he made in

1882, *The Writing Master (Portrait of Benjamin Eakins)*. Benjamin sits with his back perfectly straight, his head tilted slightly forward, left shoulder bearing the weight of his upper torso, and his right hand poised in a direct line in front of his right shoulder (plate 1). As delineated in the Jenkins manual, only in such a pose could "the action of the muscles and the circulation of blood" ensure "freedom of movement" to "the working hand."

The next step as outlined in the Jenkins manual, mirroring that of an equally well known text by the Philadelphia portrait painter Rembrandt Peale, stressed the careful formation of letters within a network of ruled and measured lines that were first added on the empty sheet. Success could be achieved only by first establishing the correct parameters, using mathematical calculation. Drawn with a straight edge, most often in pencil, these lines served as fields out of which the lettering would emerge, ensuring proper proportion, dimension, and, in the case of script, the vertical slope. After the right foundation was laid, and only then, could the eye and hand work in harmony to produce an exemplary product.

Tom was introduced to this formula at home and given ample opportunity to practice his technique in the classroom, where the Peale book was the required text in the Philadelphia public school system. As these texts and his father's exacting custom demanded, Eakins learned to begin all projects with careful deliberation. He was trained to divide and quarter each sheet of paper and not to proceed until he had a clear idea of what the finished product would look like. The importance of such lessons for Eakins' later art cannot be overemphasized: he would consistently exploit this same grid system in art school and then professionally as a means to more accurately transpose three-dimensional forms onto the two-dimensional surface of his canvas.

Nearly all preliminary sketches for Eakins' early paintings began with painstaking measurement and calculation of the portrait subject in relation to space. Preliminary drawings for *The Chess Players,* for example, reveal a mosaic grid of precisely rendered lines in which the chairs, tables, globe, wine glasses, and decanter are as carefully plotted and measured as the chess pieces themselves.

The penmanship lessons Tom learned at home and at school seemed built into the very landscape of his youth. The original layout of Philadelphia,

designed more than a century earlier by founding father William Penn, had ten named streets crossing at right angles with twenty-five numbered streets running from the Delaware to the Schuylkill. The city plan, strictly adhered to as Philadelphia became a modern municipality, provided the most literal exemplification and ultimate evolutionary success of the gridded system.

The Eakins home on Mount Vernon Street, near the edge of this expanding grid, was seamlessly incorporated into the city as its population and economy grew. Horse-drawn trams, which were later replaced by streetcars, operated along straight east–west and north–south rail lines as did the city's coveted underground sewer and water conduits. Cultural and racial divisions also ran along lateral boundaries, from the population of Chinese on Race Street to the Russian Jews on Marshall Street and the blacks of Wallace and Green streets. As a child, Eakins learned to navigate within this landscape of right angles and regular dimensions, railroad and trolley lines, row homes, shanties and manufacturing plants, and to see this as the natural evolutionary order. Henry James described the city in just this way: "The vast, firm chessboard, the immeasurable spread of little squares, [was] covered all over by perfect Philadelphians."

In addition to training his son in calligraphy, Benjamin exposed him to the fine arts through his friendship with George Holmes, an Irish-born landscape painter who operated a private art school out of his Philadelphia home. Thomas Eakins later painted Holmes's portrait as one of his father's two friends in *The Chess Players*. There is no evidence that Eakins took formal art lessons from Holmes or anyone else in his early youth, only that he accompanied Holmes and his father and sister Margaret on weekend hikes along the Schuylkill River. They would normally hike for five or six miles before stopping to picnic, at which point Holmes and the Eakins children would spend a few hours sketching or painting with watercolors. Holmes's interest in painting waterside industrial sites may have been the inspiration for the earliest known Eakins watercolor, a landscape study of a riverside mill. Holmes may also have provided Tom with an artist's copybook in which the adolescent Eakins sketched flowers, foliage, and trees; these are believed to be the earliest known examples of his drawings.

Facing Holmes across the table in *The Chess Players* is another friend of

Benjamin Eakins, Bertrand Gardel, a French teacher and patron of the arts in Philadelphia. Gardel exposed Eakins to sculpture while supervising the construction of a twenty-five-foot-high monument he commissioned for his wife's burial plot in the Mount Vernon Cemetery. This imposing pyramid-shaped memorial, gathering allegorical figures in mourning after a design by the Italian sculptor Antonio Canova, inspired Tom to try his own hand at a funerary design.

Equally important as Holmes and Gardel was the influence of the Philadelphia publisher and master engraver John Sartain, a flamboyant and highly successful Englishman whose specialty was producing high-quality mezzotint prints from European masterworks. He was also the most active and outspoken member of the city's artistic community since Charles Willson Peale opened his Philadelphia studio and art museum forty or more years earlier.

John Sartain, a strident Republican and grand master of Philadelphia's Masonic Temple, was never friends with Benjamin Eakins. The closer and more intimate family connection was through John's son, William Sartain, who attended the same elementary and high schools as Tom Eakins. Tom was much impressed with Will Sartain's many talents, among them the ability to balance a pocketknife across the bridge of his nose. Tom became good friends with Will, along with William Crowell and Max Schmitt, with whom he attended elementary school and high school. In the years to come, the friendship among the boys only grew closer. Tom Eakins found in William Sartain the brother he lacked, and Will found in Benjamin Eakins a hands-on father figure willing to take him hiking, fishing, and hunting—outdoor activities that his own father either had no interest in or was otherwise too busy to join due to professional concerns.

In John Sartain's richly decorated, luxurious home and studio on Philadelphia's fashionable Sansom Street, Eakins would have been exposed to a vast collection of prints and engravings of the works of such old masters as Rubens, Titian, and Correggio. Here could be found paintings by contemporary Philadelphia artists as well, such as Christian Schussele, Peter Rothermel, Thomas Moran, and John Neagle. Access to such a collection was a privilege limited to the very wealthy and well-connected. Art students today can view virtually any painting or sculpture from any period in world history in a matter

of seconds with a mere keystroke. In Eakins' time, most students had to cross the Atlantic to see such works.

In the course of his friendship with William Sartain, Tom also was introduced to the upper echelons of Philadelphia's social and political strata. He would have heard stories of John Sartain's friendship with Edgar Allan Poe, and perhaps met the city's other great art collectors, Joseph Harrison and James Claghorn. Like the earlier champion of the arts in Philadelphia, Charles Willson Peale, Sartain encouraged all his children to paint. Lessons taught to his son William and daughter Emily were likely learning experiences for Tom as well.

Another key early influence on Thomas may have been the inventor Charles Coleman Sellers, an Eakins family neighbor on Mount Vernon Street and a grandson of Charles Willson Peale. Sellers gave Tom his first introduction to the relatively new field of photography. Sellers later became best known as the mechanical engineer who designed the first immense dynamos for the Niagara Falls power plant, but as a co-founder of Philadelphia's Amateur Photographic Exchange Club and Photographic Society, he also built his own cameras. He patented several early versions of what he called the kinemotoscope, a machine that took a series of posed still photographs and flashed them onto a screen. Photographs of the adolescent Tom and other family members were probably shot in Sellers' studio, and at some early stage in Eakins' education the inventor most likely invited the young man into his laboratory to examine his collection of magic lanterns and optical projection devices. At around the same time that John Sartain was experimenting with printing and photographic techniques in order to publish copies of Renaissance master paintings, Sellers was developing a system that could be used to trace those captured images onto a canvas.

Family associations like these, along with penmanship lessons and a stable home environment, contributed heavily to Tom's sterling academic record. His four-year average at the Zane Street Elementary School—in an extremely rigorous program of study that emphasized reading, spelling, history, literature, and arithmetic, in addition to moral lessons and readings from the Bible— placed him in the top 2 percent of all grammar school students competing for admission into Philadelphia's most prestigious high school. Maps that Eakins

copied as a school assignment, which are now part of the Eakins collection at the Smithsonian Institution, show such precocious skill in handling ink and watercolor that they could easily be taken for the work of a college-educated professional, not a twelve or thirteen-year-old child.

Eakins was a brilliant student by any standards. The competition for entering Central High School in 1857, the year Tom was accepted into the ninth grade, was equivalent in today's terms to gaining entrance to an Ivy League college. Eakins was admitted at age thirteen, a year younger than the majority of the 124 students in his class.

The reason for such intense competition to attend Central High was that the school had actually once been a college, and by the terms of its accreditation it could still grant the degree of Bachelor of Arts to students whose grade average and course load met the requirements of a college education. Central High was moreover regarded as the most progressive and egalitarian public high school in the nation. Anyone could go, regardless of income, provided they could pass the school's highly demanding entrance examination. The exam had been designed, like the school's progressive curriculum and strict behavior code, by Alexander Dallas Bache, the grandson of Benjamin Franklin. Of the hundred or more parents and guardians listed for the 1857 entering class were eight clerks, eight storekeepers, seven leatherworkers, six printers, four clergymen, and three grocers.

Tom rose to the challenge of the Bache curriculum as effortlessly as he did to its strict behavior code. Even a lapse as seemingly innocuous as "making a noise with a pen," or "meddling with an inkstand," could bring demerits that significantly affected a student's grade, which was calculated, according to the Bache system, twice every day by each teacher. However mischievous Tom may have been as an adolescent, and would clearly become as an adult, he somehow managed to avoid punishment or even mention in the minute books recording untoward conduct at the school. Perhaps it was his exacting nature that pulled him through. As would later be said of him, "[Eakins was] unwilling to do clever or smart work or deceive himself by a dash."

Eakins applied himself to his courses with the same discipline expected of him at home. During his four years attending Central High he studied physiology, optics, calculus, history, chemistry, engineering, physics, astronomy,

draftsmanship, and geometry. There were no electives. He also took classes in French, German, Greek, and Latin, along with English and penmanship. The school's overriding emphasis was on applied science, technical mastery over language, and intellectual appreciation. The astronomy course, for example, presupposed knowledge of spherical trigonometry, logarithms, and algebra; these were used to convert time into degrees, minutes, and seconds in order to compute such phenomena as a solar eclipse and the distance between planets.

Central High was where Eakins became familiar with Philadelphia's medical community. All science, chemistry, and physics courses were taught by practicing physicians, who naturally shaped the Bache curriculum to reflect their primary interests in physiology and anatomy. Among his instructors was Dr. Benjamin Howard Rand, who later left Central High to work alongside the leading surgeon of his day, Dr. Samuel Gross. Rand, like Gross, provided a role model to Eakins as a younger man, and they continued to inspire him a decade later, when he painted their portraits.

The Rand portrait, in particular, now hanging in the Eakins Gallery at Jefferson Medical College, captures the spirit of knowledge and discovery that Eakins must have experienced while studying chemistry under Rand in high school. Painted in 1874, when Eakins was thirty years old, it shows Rand reading at his desk, pausing to stroke a cat that has invaded his study. Rand wears a formal topcoat but has removed his tie, as if he has just returned home from an important function and gotten back to work without bothering to change his clothes. His desk is crowded with objects: a microscope, test tubes, slides, and what can be presumed to be scientific reports. All have been painted with the precision that Rand encouraged in his students and practiced as a scientist. In the midst of these objects is a red rose wrapped in the blue paper it was delivered in. The inclusion of the cat, with whom Rand is at ease, suggests his love and affinity for all living creatures, a quality that inspired him as a physician and teacher. Like pieces of an elaborate puzzle, these intriguing, disparate elements have been seamlessly assembled to tell a story far beyond what might otherwise have been communicated in a mere studio portrait. The viewer begs to know who has sent the rose.

Perhaps it was Eakins himself. Rand was much loved, not only at Central

High and by the Jefferson Medical College graduates, but as well by oarsmen on the Schuylkill River, where he introduced several generations of Central High students to the sport of rowing. Rand was also likely the instructor who invited Eakins and other of his Central High students to attend anatomy lectures and surgical demonstrations at Jefferson Medical College and the University of Pennsylvania. It may have been on such a field trip that Eakins attended his first autopsy. All that can be said with certainty is that Eakins, while at Central High, absorbed medical language and concepts that remained a significant part of his future education and, along with his later studies as a medical student, gave him access to the inner circle of Philadelphia's College of Physicians.

Just as his Central High science teachers stressed the practical application of learned principles, Eakins' drawing instructor, Alexander MacNeill, taught draftsmanship based on logarithms and geometry as a way of helping his students become visually literate. As the art historian Amy Werbel has pointed out, "the chief goal of this drawing discipline was to fashion images of objects so precisely measured that machinists could then reproduce them." MacNeill's teaching, like Alexander Bache's, was based on the premise that mathematically precise draftsmanship would inspire clarity of thinking and, by extension, correct behavior. Self-expression was not encouraged, much less practiced. True mastery rested in perfect proportion and clarity achieved through technical competence—much the same lesson Eakins had learned at home. Echoing the philosophy of Herbert Spencer, one Central High student would recall: "Only with the just ideas of cause and effect, and the knowledge of the universal reign of law, gained in the laboratory and the observatory, does the student become prepared to understand the fact of language, history, art and literature, which thus find their natural relations, no longer isolated fragments of knowledge, but the records of the movements of the great tide of human endeavor."

The young Eakins, just short of his sixteenth birthday, saw himself as stepping into that momentous tide. Central High left him well trained. Though some graduates would lament that what they experienced there constituted academic tyranny, in students strong enough to withstand its rigid standards the

school fostered a correspondingly powerful urge toward freedom and individuality, providing a crucial link between established tradition and innovation.

Eakins graduated fifth in his class, in 1861, the first known member of his extended family to receive a coveted Bachelor of Arts degree. He did especially well in science, mathematics, and French. In the arts he had truly distinguished himself. During each of his four years he earned the perfect grade of one hundred. Evidence of just how good he had become with a pen and paper can be found at the Smithsonian along with examples of his childhood sketches. *Perspective of a Lathe,* executed in 1860, appears at first glance to be a photograph. Only on close inspection are the individual pen and brush strokes revealed. As he had from the start of his art career, on field trips with his father's friend George Holmes, he focused on what inspired and moved him, "flowers, axe handles, [and] the tools of workmen."

four

An Uncertain Future

The Eakins family had ample reason to celebrate their son's graduation. Tom had distinguished himself to the extent that he could go on to do virtually anything he desired. His degree permitted him ready access to the Philadelphia business community, where Central High graduates included a millionaire shipbuilder, executives at several large manufacturing plants, the current attorney general of Pennsylvania, and several prominent judges and newspaper editors. Eakins was reluctant to enter any of these professions because he had not made up his mind about his future career. He did not overtly express an interest in art, and he had not apparently taken a liking for the paintings he had been exposed to. His passion was for science and math. Even in these subjects, however, he believed his education was still inadequate, as he showed by his response to being invited to give a scientific address at the Central High graduation exercises. In behavior that would become all too familiar to Philadelphians in the future, Eakins declined the honor, declaring that he had done nothing original and that all he had learned had come from books, where others could read it for themselves.

His reluctance to commit himself to any particular field of endeavor after his graduation may have been a result of the volatile political and economic environment in Philadelphia and the rest of the nation at the time. In December of Eakins' senior year at Central High, the first of eleven states seceded from the Union, determined to preserve slavery and states' rights. Philadelphia was under no imminent threat from the looming crisis when Jefferson Davis declared the Confederate States of America in February 1861. Yet it was widely understood that, as the Union's second largest city, Philadelphia would have to play a vital role in providing both men and materials in the event of war. Its location on the major shipping and railroad lines between the Northern and Southern states would further make the city a major depot for arms and food shipments as well as for recruits bound for the front lines and wounded soldiers on their way home.

The Eakins family, like most Philadelphians, avoided being caught up in saber rattling in the same manner that captured citizens in New York or Atlanta. Although the city had a long abolitionist history, activist defenders of racial

Opposite: Thomas Eakins, perspective drawing of a lathe, 1860. Ink and watercolor on paper, 16¼ × 22 inches. (Courtesy of Hirshhorn Museum and Sculpture Garden, Smithsonian Institution, Washington, D.C.; gift of Joseph H. Hirshhorn, 1966)

equality were in a distinct minority. Philadelphians considered themselves equally economic partners to the South as members of the Union. Newspapers printed editorials and commentary reflecting both Union and Confederate sympathies. In this uncertain climate, throughout the early months of 1861 there were frequent peace rallies in the streets and a general belief that war could be avoided. President-elect Abraham Lincoln promised Philadelphians, in a major speech he gave there in February 1861, "There is no need of bloodshed and war." Right up to the final days before the war was actually declared, parades and rallies were being mounted to defend the Confederate point of view. Even then most Philadelphians denounced the forceful coercion of disloyal states. The overwhelming majority had faith that Lincoln could achieve a peaceful reunification.

Only with news of the fall of Fort Sumter, on April 15, when Eakins had just begun to study for his final exams, did the calm that characterized Philadelphia vanish. The city's bells were rung in earnest. Prayer vigils for peace and demonstrations of secessionist concerns transformed into a battle cry for the republic. Flags and bunting appeared on the buildings along Chestnut Street, Philadelphia's main thoroughfare, and recruiting stations sprang up in each of the city's four central squares. Volunteers stood in line for rifle practice in Fairmount Park, and buildings were hastily requisitioned as armories. Declared one of Eakins' Mount Vernon Street neighbors in his diary, "The town is in a wild state of excitement!"

Enthusiasm for the war swept through the city. Young men eager to share in the glory before the Confederacy fell were willing to pay fees as a high as one hundred dollars for the privilege of enlisting in particular regiments. Even after the defeat of the Union army at the Battle of Bull Run, in July 1861, when Eakins received his college degree and when the first trainloads of wounded soldiers appeared in the city, there was such a clamor to join in the fighting that soldiers were enlisting for three-year tours of duty.

The younger Eakins was not among them. Although it is clear from existing correspondence that Tom was sympathetic to the Union cause and to the Republican Party, to have enlisted would have been contrary to the wishes of his father, an ardent Democrat. Benjamin's party stood for accommodation and compromise with the Confederacy and considered Lincoln and the Re-

publicans dangerous radicals. The call to arms, they believed, was not fundamentally about the emancipation of slaves; it was a struggle between powerful economic factions vying for control over the government. "A rich man's war and a poor man's fight," was the message being put forth by opponents of the war. Judging from letters that Tom later wrote from Europe, it is clear he didn't agree with Benjamin's sympathies, but he abided by his father's preference that he not enlist.

Many other compelling reasons, as well as changes in the public perception of the war, came to bear on Tom's decision not to join the Union forces. He was an only son. As wounded soldiers began filling the Philadelphia hospitals after the second battle of Bull Run, the reality of the war started to sink in. Recruits in the city were no longer contributing money to join the cause; they were being paid to do so. Enlistees in one Philadelphia district were offered ten dollars each and free medical care for their families. A local manufacturer was providing a month's wages along with a four-dollar stipend to the wives of all employees who would join the company's regiment. Financial inducements for service rose steadily as the war dragged on. By 1864, the year when Eakins turned twenty and became eligible for the draft, the fee to avoid conscription had reached twenty-five dollars, a sum that Benjamin Eakins gladly paid. Considering what was still to come, he had made a wise decision not to delay. After the battle at Gettysburg, when a grim tide of more than ten thousand wounded soldiers arrived in Philadelphia by the trainload, the amount being charged to avoid the draft in the Eakins family's precinct had risen to three hundred dollars, and it would reach a thousand dollars in the war's final year.

Tom's decision not to fight must still have been difficult. More than a third of his Central High classmates had enlisted before graduation. His two best friends, young men he had known since grammar school, joined the Union cause in 1862. Max Schmitt, Tom's frequent swimming and rowing partner, who had graduated sixth in his class at Central High, just behind Eakins, joined first, soon to be followed on September 11, 1862, by the tenth-place graduate, William Sartain. The day before Sartain boarded a train leaving for the front lines, he and Eakins went on a moonlight boating trip down the Schuylkill. In a letter Sartain later wrote to his sister Emily, he described how he and Tom went angling for catfish, though they did not catch anything,

and how on the following morning, as Sartain gathered his gear to leave, he had a "sweet reminder of [his] pleasures in a pair of blistered hands." Less than a month later Sartain was in the thick of the fighting. "The rebels are . . . [tearing] up the railroad in the Cumberland Valley," he wrote. "The whole of Philadelphia seemed to pour into Maryland . . . three Professors of High School, hundreds of pupils, in fact everybody, almost."

The "almost" referred to Eakins. Sartain's mention of his fellow classmates and professors joining the battle surely would have bothered Tom; yet no evidence remains of how he felt not to be fighting by their side. If he had any regrets about not enlisting, the sight at the Philadelphia railroad depot in late September and early October would surely have made him feel grateful for not having gone. Forty-five hundred soldiers died in the Maryland campaign, and an additional forty-eight hundred would be killed at Antietam a few days later in the single bloodiest day of the war. By the war's close between eighty thousand and one hundred thousand Philadelphians had served in the Union army—more than half the male population between eighteen and forty-five years of age. Nearly one in ten would not return. One in five was seriously wounded or maimed.

Eakins occupied his time immediately after graduation helping his father tutor students and embellish documents. He decided to compete for a position teaching penmanship, drawing, and bookkeeping at Central High. Fitting the demanding and egalitarian nature of the school, applicants were judged by their performance on a grueling two-day test, administered in early September 1862. The details of the exam, later published by Philadelphia's board of controllers, show the high standard of skills sought in such an instructor. Among the twenty questions and tasks included was to "render a set of circular steps in perspective," "to draw, isometrically, the bounding planes of a cubical space representing three contiguous faces of the interior of a box or room, of which two are vertical and one is horizontal," and "to draw a pair of bevel wheels whose axis are inclined to each other at an angle of 18 degrees."

Eakins came in second place out of only four applicants who completed the examination. He was less than seven points behind Joseph Boggs Beale, another Central High graduate and Philadelphia oarsman, three years older than Eakins. Beale, the son of a Philadelphia dentist, was given the job. He was

a far more experienced artist, having studied at the Pennsylvania Academy of the Fine Arts, on Chestnut Street, and received a prestigious commission by the Philadelphia art dealer and painter Charles Haseltine to illustrate a volume of Shakespeare plays. It was perhaps Beale's professional expertise and Eakins' own competitive temperament that inspired Tom to further his own training by joining a sketch class at the Pennsylvania Academy later the same year.

Eakins continued to explore other career possibilities as well. Before war's end he was enrolled in the city's most prestigious medical school, the Jefferson Medical College, located at Tenth and Chestnut streets. Although many art students—following the French tradition—studied practical anatomy to advance their modeling training, Eakins took his studies considerably further. Even if he had been content to follow in his father's footsteps, teaching penmanship and embellishing documents, the option was not a realistic one. Just as the demand for skilled handloom weavers had abruptly collapsed with the arrival of the power loom two decades earlier, the art of fine calligraphy was already sliding into a downward spiral thanks to innovations in printmaking and lithography. Benjamin must have seen the end coming and urged his son to look in other directions.

five

The Medical Arts and
the Fine Arts

The foot soldiers of the Potomac fought the battles. Public institutions and private industry won the war. Nowhere was the alliance more evident than in the city of Philadelphia. The largest corporation in the nation, the Pennsylvania and Reading Railroad, whose granite headquarters towered above Chestnut Street, moved more troops and greater quantities of supplies faster and more efficiently than had ever been transported in any previous war in world history. A few blocks away on Chestnut Street, the United States Mint used new steam-driven milling machinery to produce more coins in less time than had ever before been minted. The Bank of North America was unrivaled in selling war bonds. The Philadelphia Trust and Safety Deposit Company set a new world record in processing the number of checks written and transactions made. The sprawling Delaware River warehouses on Front Street became the largest single depositories for guns, food, clothing, tents, flags, frying pans, iron plating, and medical supplies. Military orders that had previously been delivered by courier were processed by telegraph in a vast communications center on Third Street. More physicians in more hospitals ministered to more patients in a single day than doctors treated during Napoleon's entire European campaign. Philadelphia's civilian cavalry carried no guns. They used ledgers, slide rules, and scalpels.

From the vantage of a first-year medical student, Eakins was acutely aware of the transformation taking place. Twelve new hospitals were built in Philadelphia during the war years, adding a total capacity of more than 14,000 beds. Pioneer surgeons in the mold of John Neill, who supervised a 650-bed army facility at Broad and Cherry streets and the thousand-bed facility in Chestnut Hill, became heroes as celebrated as any of the city's decorated military commanders. The "cut and carve" surgery practiced on makeshift battlefield pallets was giving way to procedures in dedicated medical arts buildings with operating theaters, laboratories, and research libraries. Physicians, for the first time, were counting their cases, employing statistical record-keeping methods, and drawing conclusions from written accounts of likeness and differences. Progress was finally being made in studying the waves of epidemics that swept through the city each summer and early fall. As methods to treat illness grew

Opposite: Admission ticket to Dr. Pancoast's anatomy class, Jefferson Medical College, Philadelphia, 1864–65 (Courtesy of the Hirshhorn Museum and Sculpture Garden, Smithsonian Institution, Washington, D.C., Charles Bregler Archival Collection, 1966)

more precise, so did the instruments and the specialists who used them. The year 1860 in Philadelphia, as one physician wrote, was a time when a "jaunty, indomitable spirit" prevailed that would govern the medical profession for the next century.

The Jefferson Medical College stood at the forefront of the scientific revolution taking place. Although enrollment dropped precipitously during the war years, from a high of 630 to a low of 38, the school would graduate one-quarter of the nation's physicians and nearly one-third of its medical specialists in the decade to come. The imposing and thoroughly modern three-story building fronting on Tenth Street, with soaring twenty-five-foot-high windows, terra-cotta filigree, and handsome stone pediments, contained two of medical science's most current operating theaters and lecture halls capable of seating 450 students. In its lower floors were a research library, a medical museum, and laboratories where students delved into pharmacology, ophthalmology, biology, and dissection. As was true of all the large metropolitan medical schools of its time, Jefferson accepted only men, and it continued to bar the admission of women until late in the next century.

The chemist Howard Rand, who is presumed to have been Eakins' preceptor at Jefferson, along with the surgeons John Brinton, Jacob Da Costa, and Joseph Pancoast, viewed themselves as applied scientists rather than medical practitioners. The internationally renowned Samuel Gross, chief of surgery, was respected not only for his knowledge and training but for the manual dexterity that enabled him to make impressive strides with new surgical procedures. Rather than borrowing scientific breakthroughs from Europe, these men were discovering these insights for themselves. The introduction of anesthesia made it possible to perform intricate, intrusive, and time-consuming operations that had been unimaginable a decade earlier. Complicated and technically stupefying procedures, such as vascular ligations and bone resections, required teams of attendant specialists. It was only natural that the young Eakins should aspire to become one of these highly skilled experts.

In all, the appeal of the new methodology that was central to the Jefferson curriculum must have been irresistible for a student of Eakins' previous training and inclination. Technical competence and creative problem solving were the determining factors. Eakins' need to work with both his mind and his

hands, so integral to the success of the new breed of specialist, would no doubt have also satisfied his creative needs. Further, Eakins' agnosticism and his views on such topics as science and technology, evident in his youth and carried on throughout his career, more directly coincided with the accepted doctrine and practices of Jefferson faculty members than perhaps with any other fraternity of like-minded professionals in the city.

Eakins was also uniquely qualified to enter the Jefferson program. Few practicing physicians of his day had even attended college. The vast majority of incoming medical students were unable to read French, Latin, or German, the primary languages in which most medical textbooks were written. Eakins could read all three, and he was fluent in all but German.

How long Eakins attended Jefferson and when exactly he decided to forgo a medical career and devote himself to art is not known. He later told portrait subject Lucy Langdon, a close family friend, that he had not initially envisioned himself becoming an artist, but desired to be a physician, and that he didn't choose painting as his professed life's work until he went to Paris. Susan Macdowell, whom Eakins later married, told his biographer Lloyd Goodrich that he "likely contemplated both professions."

Eakins evidently came to his decision gradually, over a period of two years. His surviving cards of admission to Jefferson attest only to his having studied anatomy under Joseph Pancoast. Faculty members later recalled his having also attended the first-semester course on practical surgery and Dr. Gross's two and three hour surgical demonstrations and lectures, delivered twice a week in Jefferson's operating theater. Since no lengthy residency program or extended training was required to receive a degree at that time, and all necessary coursework could be completed in a mere eighteen months, Eakins may have been as much as halfway through the Jefferson medical program when the drawing classes he was attending at the Pennsylvania Academy of the Fine Arts began to consume the lion's share of his daily schedule. There were days when he conceivably could have been dissecting a cadaver in the morning and then, after racing half a block down Chestnut Street, sketching plaster casts of statuary in the afternoon.

Dr. John Deaver of Jefferson Medical College believed that Eakins could have made a great surgeon. He declared that Eakins knew more about anatomy

after his studies at Jefferson than 90 percent of the nation's practicing physicians. Henry Poore, who studied with Eakins at the Pennsylvania Academy, later said that Eakins "was well delighted to wield the scalpel as the brush," and that his colleague "was first a scientist and after that an artist." It was Eakins' intense desire for knowledge that impressed Poore most of all. "He began far back and stalked his quarry from the start of its trail," Poore said.

The Temple, as the Pennsylvania Academy of the Fine Arts was then called, was set back from the street in an aging Roman-Doric building that had been designed more for impressiveness than practicality. The towering columns and portico at its entrance led to a grand domed rotunda, where visitors were greeted by an imposing statue group of battling centaurs. Dark and cavernous rooms spread out from this common center, each chamber filled with Greek and Roman casts imported from the Louvre, along with a collection of etchings and prints from works by the old masters and an assortment of vintage and contemporary paintings of dubious quality but impressive proportions. Taken together, this collection, along with classes drawing from live models, held in the basement of the building, and anatomy lectures by physician Russell Thomas, composed the mainstay of the academy's education.

Typically for art schools of its day, the Pennsylvania Academy offered no art history or appreciation classes, no degree program, and no teachers dedicated systematically to classes. The nearest equivalent was a group of professional artists designated as Academicians, who shared their knowledge with students on an informal basis. Students were expected to copy paintings and draw from the collection of casts for months or years at a time before receiving permission to attend life drawing classes. Limited as this curriculum would be by contemporary standards, and furthermore offering no basic training in applied skills that might be required by a commercial artist or illustrator to earn a livelihood, the academy was still giving the closest thing to an art education as could be found in the United States. Three to four hundred students from as far away as Chicago and Los Angeles traveled to Philadelphia each year to study under the domed rotunda. During the three years Eakins attended classes there he would be joined by such future notable artists as Edwin Austin Abbey, Alexander Milne Calder, Mary Cassatt, Howard Roberts, and Daniel Ridgeway Knight. The physician Hayes Agnew also took classes

at the academy, as did the architect Frank Furness. Harry Moore, a deaf mute, began his training at the academy after being encouraged to attempt it by the nineteen-year-old Eakins, following their meeting on a field trip Eakins and his academy classmates made to the Pennsylvania School for the Deaf.

Unlike Jefferson Medical College, which cost upward of $125 a semester, tuition at the academy was free. Its board of directors collectively footed the bills. The board consisted primarily of bankers, merchants, attorneys, and physicians. John Sartain, the engraver, was the only artist among them. The reason more artists were not represented on the board was because the academy was not generally understood to be an art school as today's institutions are. It functioned more along the lines of an art museum and exhibition hall. Its rotunda was not only a place for art students to gather; it was where connoisseurs and collectors could display their good taste and indulge in civic-minded expressions of their largesse. They could deposit family heirlooms for exhibition and purchase art for their homes and offices. Moreover, a seat on the academy board required a significant financial commitment. Herein rested the school's inherent weakness from the point of view of a student. Its board was more interested in the academy's art gallery than in its training of professional artists.

Also unlike Jefferson Medical College, which prided itself on its innovative curriculum and expanding facilities, the academy had not altered its training program in any significant way in more than fifty years. The exception, important in its own right, was its admission of women, a policy that was instituted in 1860. In virtually all other areas, including the building's infrastructure, the academy, like most other art schools in America, lagged behind the times. The inertia was partly a result of resources being allocated to the war effort. A general belief also held sway among many Philadelphians, indeed in the country at large, that the United States had no intrinsic need for art or artists as the nation did for physicians and engineers. Paradoxically, in an age that fueled independent thinking in science, business, and industry, the country had no use for the sparks of innovation in the fine arts.

Constructed in 1805, and having undergone a severe fire in 1845, the academy building was also beginning to crumble. Its Doric columns were threaded with cracks. Roof shingles had become so decayed that when it

rained elaborate combinations of tubs, basins, buckets, and other containers had to be arranged throughout the building. Many spots on the floor had rotted. Edwin Austin Abbey, an academy pupil, described it as a "fusty, fugdy place . . . [where] worthy young men caught colds in that dank basement . . . [or] slumbered peacefully . . . during the long anatomical lectures." Another of Eakins' classmates concurred. "Over it all there was stillness," he wrote. "The smallest noise made an echo." Earl Shinn, who later became a close friend of Eakins, provided a more upbeat description: "The classes, distributed through a series of basements, were full in numbers and enthusiasm."

Complaining students were reminded that tuition was free and hence "that it was unbecoming in beggars to be choosers." Other than the Pennsylvania Academy, the alternative for the city's young artists was limited to a small rented studio on the corner of Chestnut and Juniper streets operated by the year-old Philadelphia Sketch Club. And yet, though the facilities lacked the ideal situation for artists, and the collections were not what students might have hoped for, the academy still towered above comparable schools in its influence and place in the art world. Its nearest rival, the National Academy of Design in New York, didn't come close to equaling the Philadelphia school's space or collection of paintings and art objects.

six

The Pennsylvania Academy

Following in the time-honored tradition, new students were immediately dispatched to the academy library to begin copying drawings and sketches made by other artists. Perhaps because of his previous training, Eakins appears to have skipped this copy work altogether. On October 7, 1862, he began in the second stage of the academy's training, drawing from antique plaster casts and statues. These classes were supervised by Isaac Craig, a painter of religious and historical subjects, and through occasional visits by John Sartain and other academicians. Students were also permitted to attend anatomy lectures in the dissection room at the University of Pennsylvania Medical School.

The nineteen-year-old Eakins had much to learn. He was still drawing in black and white, as he had done at Central High, but the emphasis now was on the human form. By gaining special skill at rendering the body, and by modeling one's work on casts of the ancient masters' sculptures, it was believed that the novice would establish a relationship with great historical works of art. Further, observing from casts isolated the issue of contour and mass, offering the beginner an opportunity to concentrate on outline, drawing, and the modeling of light and shade before taking on more difficult challenges. By mastering the ability to draw from casts the student was presumed to be able to draw anything.

Eakins tackled cast drawing with the same proficiency he had learned at Central High: reducing a complicated problem by rendering the human figure into its simplest components. Most typically, this meant selecting particular details of the sculpture to draw, such as a chin, neck, arm, or hand. To conserve paper, Eakins crowded several anatomical studies onto a single sheet, without attempting to sketch a full human. An entire year would pass before he attempted to draw a complete human figure. As he must surely have learned from his father, it was vital to accomplish one lesson before tackling the next. Complex problems had to be studied in their component parts. This sequence of progress, common to learning any discipline, led in time to knitting the components together into an integrated and coherent whole. Like any rite of passage, such a transition, as one academy student noted, was "a wrenching moment."

After months of isolating individual body parts, Eakins was encouraged

Overleaf: The Pennsylvania Academy of the Fine Arts, Philadelphia, c. 1860 (Courtesy of The Pennsylvania Academy of the Fine Arts, Archives)

to assemble a complete figure. Although there is little agreement among art historians and conservators on the dating of his work during this early period, it is reasonable to gauge Eakins' progress by comparing his poorly sketched rendering of a bust of Hercules with one of Menelaus, where he finally begins the use of strong highlights and deep shadows. Few other drawings exist from this period in Eakins' career. The quality of those that do, considering the relatively short two-month probationary period Eakins spent drawing casts, suggests that he had an easier time than most other students. Augustus Heaton, one of his classmates, spent ten months covering the same territory before advancing to life drawing. Joseph Boggs Beale, the new drawing instructor at Central High, did not graduate from cast drawing for more than three years.

On February 23, 1863, five months after joining the academy, Eakins was issued a card allowing him to join ten other students in drawing from life models. These classes were held in the academy's cavernous basement, which Earl Shinn described as the school's "dark and ill-ventilated cellars." Drawing sessions in the period Eakins attended them were held three evenings a week from seven to nine-thirty. The first two evenings were designated as male modeling nights, and the third was for female models. Invariably the models were posed against a neutral background, illuminated from above by oil lamps fitted with reflectors.

The life school, as it was called, was technically supervised by an artist's committee. In practice it was run by the academy's curator, a painter who was just five years older than Eakins. It was significantly different in character from the cast drawing meetings held upstairs. The life classes were conducted more along the lines of an artist's cooperative, or a gathering of like-minded artists grateful for the opportunity to draw from a living model. The majority of students, like Eakins himself, were in their late teens, and they shared a similar social and educational background. In the "silent temple" of the academy's basement there was a sense of camaraderie and adventure ignited by the power of creative experience and the romanticism of youth.

The lack of supervision and funding during this time worked to create a more relaxed and progressive atmosphere than might otherwise have prevailed. Although females were not permitted to attend the same drawing classes as men when nude models were used, a nascent feminism was growing among

the student body. Such students as Mary Cassatt, Eliza Haldeman, and John Sartain's daughter, Emily, had traveled extensively abroad and did not feel their sex would prevent them from achieving their artistic goals. A full twenty-one out of a hundred students who signed up for the antique class in the early 1860s were women, and many of them, such as Mary Cassatt, Fidelia Bridges, and Anne Whitney, would go on to earn national reputations as professional artists. Credit must also be given to board members, John Sartain in particular, who saw to it that women, for the first time, were issued permits to attend the anatomy lectures by Dr. Thomas.

Life classes were conducted as they had been since the 1850s. Students drew in charcoal from nude or nearly nude models, when available. Academy policy forbade males from posing totally nude in female classes. Because of the relatively unstructured nature of the class, students were always jockeying for position, to get the choicest view of the model or to set up their easels beside a more experienced artist's.

In spite of what would be written in reams of pages about art classes and Victorian inhibitions, full frontal nudity of unmasked models was the rule in male classes, not the exception, when Eakins was first a student at the academy. Moreover, there had been a relatively long history of nude or partially nude modeling in Philadelphia. One of several versions of what has been called "the first pose" is the tale of Charles Willson Peale, the distinguished Philadelphia portrait painter and one of the academy's founders, who, "finding nobody who would exhibit his person for hire to the students, whipped off his frills and ruffles and bared his own handsome torso for the class."

The challenge was not so much in the presence of nude models as it was in finding them. A number of artists' reminiscences indicate that the students themselves had to find willing subjects, either from lists of available models kept in the academy office or by procuring one from a brothel. Will Sartain, Eakins' friend since early childhood, later described how he and art student Daniel Ridgeway Knight once tried to recruit a young man off the street to model for the class. After being brought into the classroom, the young man became furious when the art students encouraged him to take off his clothes, and bolted from the room. As Sartain's correspondence substantiates, it was considerably easier to obtain the modeling services of a prostitute, owing to

brothels being in plentiful supply in Philadelphia. The red-light district off of Eighth Street sported thirteen brothels on a single block. By regulation of the academy, a designated academician or curator was present during nude modeling to see that nothing improper, such as "singing, whistling, smoking, loud conversation, or other indecorous conduct," would occur. Female models were given the option to wear masks, thus hiding their identity, and no conversation was permitted between the model and any members of the class.

Evidence exists that suggests students themselves posed nude in the life classes, and that Eakins may have been among them. In what is most likely a portrait painted in the academy basement, art student Charles Fussell depicted a nude Eakins seated beside an easel. Eakins himself is clearly painting a picture in this portrait, quite possibly that of Fussell, whom he is looking at. No such portrait of Fussell painted by Eakins has been found, but the Fussell portrait, taken in conjunction with what other students have said about the informal character of the life drawing classes, suggests that there were no hard and fast rules about modeling.

The academician who would have the most influence on Eakins in the life classes was forty-year-old Christian Schussele, an Alsatian-born artist and close friend of John Sartain. He was, by all accounts, a thoroughly trained exponent of the academic tradition in France; he had studied under Paul Delaroche and Adolphe Yvon in Paris before immigrating to America in 1848. He was, as it turned out, the only Philadelphia artist known to have taken a personal interest in the academy's students—no doubt the reason that Sartain later appointed him the academy's first full-time teacher.

Like so many of his contemporaries, Schussele taught the importance of truth in art, what he called "going to nature for all things." Most of his finished pictures during this period are large, more than five feet high and seven feet wide, and they depict engineering, literary, and religious themes in American history. Examples are his *Men of Progress: American Inventors* (1862), which survives in two painted versions as well as an engraving by John Sartain, and *The Power of the Gospel: Zeisberger Preaching to the Indians* (1862). Despite the stiff, formal presentations of his subjects, Schussele's art was extremely popular. Had his production not become limited in 1863, when he was affected by palsy in his right hand, he no doubt would have enjoyed a much longer

career as a painter. A few years later the paralysis became serious enough for him to seek medical treatment in France, where he and his wife remained for several years.

Another artist who helped Eakins was Peter Rothermel, also a friend of Sartain's and an academician who was active in several Philadelphia artist associations. As former chairman of the academy's committee on instruction, he was instrumental in upgrading the school after the 1845 fire destroyed most of the facility. Unlike Schussele, Rothermel was a native-born Pennsylvanian and had himself studied at the academy. His large-scale and colorful paintings from history and literature, notably his Shakespeare subjects, were widely popular and reproduced in their day. Rothermel's most important work was *The Battle of Gettysburg* (1872), a monumental sixteen-by-thirty-foot canvas, on which he labored for more than four years.

Like Schussele, Rothermel worked as an artist at a time when the new art of photography was eroding the place that portrait painting had once held. Rembrandt Peale was dead. The most important other Philadelphia portraitist, Thomas Sully, was in sharp decline in the 1860s, turning out poorly rendered images that were a shadow of his previous work. The only vitality in art in the previous two decades was provided by the landscape and genre paintings of the Hudson River school, led by Thomas Cole, Asher Durand, Albert Bierstadt, and Frederic Edwin Church. Theirs was a technique, however, that could not be mastered in a dark basement room, nor did it hold much interest for art students whose goal was to render the human form.

In his own strong-willed, independent way, Eakins made the best of a difficult learning environment. Examples of his work from this period include a series of twenty-one charcoal drawings, mostly male and female nude models. Though the drawings are not signed or dated, from the paper stock he used and the known identities of some of his models, clues exist to the chronology of his progress. Most notable are two sketches of females wearing masks. The sketch that is presumed to have been made earlier is comparatively labored and rigid, but the later one is richly articulated, replete with abundant attention to light and shadows and a fully developed background. Each is unique and distinct from the work of his fellow students in that it is a more painterly drawing. The charcoal strokes appear brushed on, creating a strikingly full

and rich presentation. His draftsmanship is sure and strong. The drawings are free of unnecessary idealization. The women are full bodied, and heavy pubic hair is not omitted. These works on paper are particularly distinguished in revealing Eakins' command of the human body, presenting the roundness and largeness of the individual forms, and their sense of weight.

If Eakins wasn't a born artist, it is clear from these drawings that he commanded a rare talent. It is further evident that he underwent a cathartic experience in the transition from studying plaster casts of Greek sculpture to observing living models. He discovered that what interested him about science and human anatomy could be applied to art. Phidias, the legendary Greek sculptor of the Elgin marbles and the Parthenon reliefs, had become his hero. It was not the artistic legacy of Phidias that captured Eakins' imagination so much as the revelation that he had accomplished what he did by "stealing from nature."

Phidias had created his monument to Athena not by imagining what she looked like or by imitating colorless, motionless, smooth casts. He and the other immortal, inspired sculptors of antiquity had used living, flesh and blood models. The sources of their greatness, Eakins felt, flowed from their knowledge of anatomy, their powers of observation, and their ability to faithfully represent the human form in the tiniest details of construction and kinesiology. As Bronson Alcott wrote, and Eakins took to heart, "The human body is itself the richest and raciest phrase book."

A Dangerous Young Adonis

The three years Eakins spent studying at the Temple were a heady, romantic, and in all ways emotionally charged adventure. The future was uncertain. Nearly everyone in the school was touched by the war, which was reaching its peak in 1864. Southern armies had invaded the state of Pennsylvania three times, and though Philadelphia was never under siege, the loss of life and the war's tragic consequences were evident to everyone.

As a release from their studies, and from the war, students laughed and flirted and played pranks on one another. Older and more experienced students enjoyed taking younger ones under their wing. Many had never before had an opportunity to mingle with the opposite sex without the supervision of parents or designated escorts. Dates sometimes involved shaping plaster casts of one another's hands. Innocent flirtations and clandestine rendezvous took place in larger-than-life surroundings: in darkened halls beneath mythic figures that were carved in the age of Pan, in the garden behind the academy rotunda, where there rose what was reputed to be the nation's largest hawthorn tree.

Eakins too had flirtations—Mary, Louise, Johanna, Amy, and Ida are names mentioned in his correspondence. Under the spreading limbs of the aging hawthorn he won the attention of a classmate's older sister, a willowy young woman whose dream was to become an opera singer. In one of the only extant teenage letters written by Eakins around this time—a single sentence embellished in a fine script worthy of the son of calligrapher—Eakins hinted at his liaisons when he invited his friend Will Sartain to pay him a visit. "Do come to see me and bring some of the boys, as I am again forbidden to leave the house after sundown." The apparent reason Benjamin grounded him was that Tom had been out entertaining girls, a pastime he alluded to in a letter he wrote home a few years later, when he fondly described himself as a very "noticing young man" of young ladies he came into contact with. "Beauty always impressed me very much," he glibly remarked, in a tone of cavalier understatement.

Eakins' most overt early reference to the charms of the opposite sex came in a letter to his sister Frances, written from Paris after seeing an exhibition of paintings by Thomas Couture. "Who that has ever looked in a girl's eyes or

Opposite: Thomas Eakins, c. 1861, Central High School graduation photograph (Courtesy of The Pennsylvania Academy of the Fine Arts, Charles Bregler's Thomas Eakins Collection; purchased with the partial support of the Pew Memorial Trust)

run his fingers through her soft hair or smoothed her cheek with his hand or kissed her lips or their corners, that plexus of all that is beautiful, must love Couture for having shown us nature again & beauty on canvas."

Eakins had, by 1865, grown to be quite handsome. At about five feet nine he was taller than his father, and the forcefulness of his appearance was emphasized by his thick dark hair, a broad chest, and the strong arms and legs he had developed from rowing on the Schuylkill and working out at a local gymnasium. Photographs taken in his twenties show Eakins as serious and confident, his complexion fairly dark, a determined mouth and jaw set off by intense yet slightly sad, searching eyes. His high-pitched voice, which several people remarked upon, was all that seemed out of tune with the rest of him. At least one of his classmates commented on Eakins' choice of attire, noting that he did not dress in a coat and tie as did other "educated gentlemen." He was said to be quite unkempt, preferring "rough outdoors clothing." As another of his fellow students, Earl Shinn, later essayed, "He ... converses in Italian, French and German, [but still has] the manners of a boy ... [and] restricts his conversation pretty much to stories of the Schuylkill boating club." This same student provided a warning to the sister of a close friend: the "son of the writing master," who was "tall, athletic, [with] black hair and splendid eyes," should not be regarded as a child. "Look out ... treating the dangerous young Adonis as a boy."

Added to Eakins' physical presence was a quick mind and a scathing wit. He once condescendingly described a student as speaking "French as an Irishman talks English." He characterized another as a "savage eater and drinker" whose mediocre talent "goes to show what riches will accomplish without effort." He was especially brutal with a student he described as a "contemptible little pimp" who he said was "in need of an education." To another, he paid the backhanded tribute: "To be spoken ill of by such people is always the truest compliment." Earl Shinn later described Eakins as "cultivated, taciturn, and rather aloof," but "one of the boys."

Then as later, he loved candy, drank large quantities of milk, and had a penchant for taking home stray animals. Lizard, the first of Eakins' dogs to be granted "house privileges," was so named for his habit of creeping across the carpet when he was a naughty pup. In addition to his many dogs, there

were pet rats and mice. Many of Eakins' female friends, among them Elizabeth Crowell, one of Will Crowell's younger sisters, found Tom's gentle and affectionate nature with pets one of his most endearing and charming character traits.

The combination of Eakins' keen intelligence and handsome profile made him a celebrity at the academy. Sallie Shaw, his cousin and a friend of his sister Margaret, said Tom associated with so many different girls that his father had concerns. Shaw herself was not one of those he charmed. She found him—especially toward women—domineering. According to Shaw, Tom didn't approve of higher education for women, and she faulted his influence for keeping his sixteen-year-old sister, Frances Eakins, from attending high school. Shaw's appraisal could well have been accurate. Eakins was later quoted saying, "I do not believe that great painting or sculpture or surgery will ever be done by women, yet good enough work is continually done by them to be well worth their doing."

Tom's chauvinistic views toward women were not shared by his father. Tom may have picked them up at Central High and at the Jefferson Medical College, where many of his teachers promulgated such attitudes. The leading surgeon at the University of Pennsylvania School of Medicine, Dr. Hayes Agnew, actually resigned his position rather than permit females to attend his lectures. Jefferson Medical School did not graduate any female physicians until the next century. No matter its cause, his opinion of women, along with his overall imperious and condescending demeanor, gradually underwent a change as he matured. His sisters Margaret and Caroline both attended secondary school, and at a time when most European art schools barred entry to women, Eakins eventually championed full access to females in the programs in which he taught.

A woman who ultimately helped reshape his opinion of female professionals was Emily Sartain, the older sister of his boyhood friend Will Sartain. Tom began escorting Emily to and from the academy while her brother was away fighting in the war. His interest in her began as an art school flirtation and soon developed into a circumstance more serious. Tall, elegant, darkly attractive, and well educated, she swept him off his feet. "Love had racked me & was tearing my heart," Eakins later revealed. "None suspected it."

Unlike his own sisters, who were patterned in a more homely and tradi-
tional role, Emily seems to have sprung full-grown from her father's progressive
liberalism, activist tendencies, and deep-seated beliefs in the emancipation of
women. After graduating from the Philadelphia Normal School—the female
equivalent of all-male Central High—she taught in the Philadelphia public
school system, trained to be an engraver like her brothers, and accompanied
her father on a year-long tour of Europe, featuring sojourns in Ireland, Scot-
land, England, France, and Italy. She stayed in Europe's finest hotels, visited
the great museums, and through her father's connections in the art world
met many of the modern masters of her day. Whereas her brother Will had an
antagonistic relationship with his father, decrying his many prejudices and his
habit of retouching his children's artwork, Emily adored him. As one family
friend suggested during that time, she was her father's pet and most intimate
friend. There was no other woman more important in his life.

As enthralled as Eakins was with Emily, he was intrigued by the house-
hold that nurtured her. In a complete antithesis to his own, the Sartain home
was a stimulating mixture of maternal devotion, paternal extravagance, sibling
rivalry, and exposure to theater, opera, spiritualism, artistry, and high finance.
John Sartain's entire life revolved around his social obligations and his ever-
increasing circle of professional contacts. His home, with its lavish sitting
rooms, stained-glass windows, skylights, ballroom-sized dining room, and
tables stacked high with foreign magazines and newspapers, personified his
myriad of interests, all geared toward spreading what he named "the gospel
of world art." John Sartain believed that artists were the "divine chemists of
all spiritual affinities" and that their primary goal and responsibility was to
uplift the moral values of society.

To Emily's mind, Eakins could be such an artist. In him she saw a dia-
mond in the rough. He was a young man with potential to go on and create art
of immense significance, if only he could become refined and worldly, like her
father. This much is transparent from her later correspondence with Eakins
and from conversations she shared with his sisters Margaret and Frances,
with whom she later became friends. Eakins' education, confident bearing,
and obvious talent captivated her. It was his careless personal appearance, his
taste for "old, rough and comfortable clothes," that needed to be worked on.

Though he had ambition, he lacked a gentleman's polish and the commercial edge that came from exposure to what she perceived as the "real world" of a successful artist.

Emily believed that such shortcomings could easily be improved upon and undertook to guide him in the project with great gusto. They may have visited art exhibitions and likely paid their respects at the private studios of the Sartain family friends and business associates. Their walks home from the academy may have included stops on Tenth Street at the Art Union of Philadelphia, the city's most prominent commercial gallery, and the private portrait studios of John Neagle, Emmanuel Leutze, Thomas Buchanan Read, and Jacob Eichholtz.

A trip they most surely made together was to Philadelphia's Logan Square to visit the great Central Fair of 1864, a fund-raising effort by the Pennsylvania Sanitary Commission on behalf of hospital care for Union soldiers. John Sartain served as secretary for the Central Fair's fine arts committee; the group included Christian Schussele and Peter Rothermel and several French and Italian artists who came to see their works displayed. More than a thousand pictures were exhibited in the art gallery, which extended across the entire north end of the massive fair complex. It was an extremely popular event, drawing an average of twelve thousand visitors daily.

Emily, who had recently been to Europe, knew many of the artists represented in the Central Fair and may have assisted her father in selecting the paintings that were hung. She could converse with the visiting artists in their native languages. Eakins must have felt provincial by comparison. He could read Latin, Greek, French, and German (and would later learn several other languages). Still, he wasn't yet fluent in the modern languages as Emily was, nor could he discuss art as easily as she could. Eakins sought to impress her in other ways. He once analyzed the etymology of his growing affection for her in a letter. "You call my attention to the childish word 'lieben,'" he wrote. "Did it ever strike you that even such a verb as 'to love' implies and contains motion as its principal element, and that one always loves to and not away from a person? I have affection for him . . . I yearn toward him . . . Ich habe gern."

He also focused on the language of love in subsequent letters to her. "No artist lives and loves," he quoted Robert Browning, "that longs not once, and

for one only . . . to find his love a language fit and fair." Eakins extrapolated on this theme for several paragraphs and then proceeded to translate several long passages from Latin into Italian for her.

Until he met Emily, Eakins' entire universe revolved around Philadelphia. His view began to change as she talked about Paris, which she described as possessing a culture more "sublime" than anything found on this side of the Atlantic. Her favorite book was Victor Hugo's *Les Misérables,* passages from which she knew by heart. She also described the charms of Italy, where she had fallen under the spell of Dante's sonnets. She had studied Giotto's portrait of the Florentine poet on the walls of the Bargello, visited his house, and made a pilgrimage to his monument in Santa Croce.

Just when flirtation and infatuation became intimacy is not known. All that can be said with certainty is that by 1866, when Emily was twenty-five and Tom twenty-two, they were spending evenings together reading Dante. Emily's letters to Eakins no longer exist. One of his, to her, written in Italian, quotes a passage in the *Inferno.* Eakins analyzes its meaning in detail and ends: "Bella, care Emilia, Addio." This and later letters leave no doubt that he was in love with her and that she returned his feelings.

Emily's influence may have been his inspiration to attend art school in Paris. Although it clearly would have been a financial stretch for him in a way that it would not have been for one of the Sartain children, he was willing to give it a try. Eakins had also, by this time, exhausted the academy's resources, or at least convinced himself that he needed more professional training than could be found at home. Benjamin Eakins, who had once traveled to Europe on a hiking trip, approved of the idea. If Tom could gain admission to a Paris art school, and believed that such training was necessary for a career as an artist, he would pay his son's expenses. Other artists in whose footsteps Eakins followed had not been so fortunate: Gilbert Stuart's father locked him in the basement of the family home to prevent him from boarding a ship bound for Europe; Mary Cassatt's father threatened to disown her.

Not surprisingly, Eakins chose to apply to the renowned École des Beaux-Arts. This was where his friends Harry Moore and Earl Shinn had sent applications, where Schussele had trained, and was John and Emily Sartain's recommendation. Even a temporary art study program in Europe, especially

Paris, would give Eakins a patina of continental sophistication that would help make getting a teaching position or obtaining commissions much easier. And if Eakins was fortunate enough to be accepted to study under an artist as distinguished as Jean-Léon Gérôme, a personal friend of the Sartain family and a painter whose work was known to art students all over the world, there was no telling how successful he could become. Gérôme's works of polished and meticulously crafted realism epitomized both commercial and critical success. His painting *Egyptian Recruits Crossing the Desert,* owned by Philadelphia collector Harrison Earle, was so popular that it had appeared in three Pennsylvania exhibitions.

Emily's father encouraged Eakins to write to his close friend Albert Lenoir, the école's secretary and chief administrator, requesting admission. He received a positive response in September 1866 advising him that the école was presently accepting foreign students. Lenoir wrote that Eakins need only "pick up a letter from your embassy to solicit permission from the Superintendent to study at the school, which he will accord you on presentation of your letter." Lenoir further indicated that many foreigners had been turned away the previous year, owing to lack of available space, but reassured Eakins that "today there is no more reason to raise obstacles." A few days after receiving the letter, Eakins applied for a United States passport and then bought a one-way, second-class ticket for eighty dollars from New York to Le Havre, France, on the steamship *Pereire.*

The irony was that Emily's encouraging him to study in Paris caused a separation between them when he left for the continent. His feelings must have been complex. Before knowing her, Eakins had talked about seeing his own country before going abroad. He was also proud of his middle-class background, and as revealed in his later letters he was sensitive to class differences, which he believed to be all the more pronounced in Europe. He also harbored lingering doubts about the education he would receive in Paris. A part of him firmly believed that study abroad was an unnecessary extravagance. Eakins was deeply attached to his family, his home, his friends, and his city. The decision was not an easy one.

Emily admitted to being in love with him. Now that he had decided to go, she was upset at his leaving. On the eve of his departure, September 22,

1866, twenty-two-year-old Eakins wrote her in Italian expressing deep sorrow at their parting. The intensity of her feelings for him was mutual; she had already detailed them in writing. Her letter no longer exists, but its contents can be inferred from his response.

"I received your second letter in Italian and read it with a mixture of pleasure and pain," he wrote. "I am pleased by a sentiment that assures me that though I leave, I will not be forgotten, and that a dear friend grieves at my departure. But here in my soul a great sorrow arises because Emily sorrows and I believe it will never pass ... wherefore, I beg you, so that I do not kill myself for the lack of it, pity my suffering. I myself depart not only from a friend but from all. I leave my good father and my sweet mother, and go to a foreign land, certainly not England, but stranger still, without relatives, or friends, or friends of friends, and I go alone."

Emily and her brother accompanied Eakins to New York, where the *Pereire* was to depart. Except for a trip to Montreal, Eakins had never been so far away from home. He spent a sleepless night at French's Hotel in midtown Manhattan fending off bedbugs. The next morning he and Emily said goodbye in a picture gallery and went their separate ways. He had talent, of this both were convinced. He also had ambition and possessed a self-confidence and intellectually wide range of knowledge that was rare for someone his age.

Tom's later correspondence suggests that he promised to be faithful to Emily as she to him. Less certain is the degree to which Emily's father, John Sartain, encouraged their romance. She was his favorite child and traveling companion. He had taught her his art and gone to great lengths to introduce her into the rarefied circle of Philadelphia's most influential families. Likely, he looked down on Eakins as the impetuous son of a mere tradesman. The family had no pedigree or wealth. Sartain was too politic and shrewd to have openly tried to interfere with his daughter's budding romance with his son's best friend, but as developments would later suggest, he was not above manipulating events in such a way that Eakins was physically removed, however temporarily, from his daughter and the other suitors courting her. Unbeknown to the young artist, John Sartain's personal interest in Eakins' career may have rested in having him leave Philadelphia.

From Temple to Palace

The allure of the Louvre's five thousand paintings and six miles of galleries was reason enough to cross the Atlantic. It was what lay beyond the museum's corridors that made the journey to Paris even more remarkable. France's egalitarian and reform-minded leader, Napoleon III, had transformed the ancient capital into the world's first modern metropolis. Tree-lined boulevards with paved sidewalks replaced 300 miles of twisted alleyways and medieval cobbled streets. Forty-five hundred acres were turned into public parks offering rolling lawns, reflecting pools, and gravel footpaths. Five hundred miles of new water mains and 260 miles of new sewers were installed, and 32,000 gas lamps turned Paris into "the City of Lights." Two-hundred-year-old monuments were repaired and new ones built. And just as the city's infrastructure had been revitalized, so had its institutions. Thousands of medical students, engineers, and artists competed for all-expense-paid scholarships, research grants, and government commissions. Not since the Renaissance princes and popes renovated Rome had one city so dominated the Western world. One art school, the École des Beaux-Arts, became its mecca.

Eakins was in the vanguard of foreign art students headed to Paris. Upon his arrival, on October 3, 1866, he found the city much as Emily and John Sartain had described it to him: a place where all forms of art were taken seriously, and cultural education was a matter of daily immersion. Unlike Philadelphia, the front pages of the leading newspapers were brimming with articles on art exhibits and artists. Fifty or more galleries could be found between the already storied districts of Montmartre and Montparnasse. Even bakeries and butcher shops displayed paintings, and corner grocery stores sometimes sold paint. "I found myself absolutely intoxicated, trembling and laughing and weeping ... almost hysterical," recounted a Bostonian who had discovered the city's artistic charms. "Amazing and idyllic," said another.

Having made the journey, Eakins checked in near the Louvre at the Hôtel Lille et Albion, recommended to him by a physician from Jefferson Medical College. He then set out in search of Lucien Crépon, a Paris painter who once lived in Philadelphia and studied at the Pennsylvania Academy. Eakins had no trouble finding him, and Crépon received him warmly and immediately

Overleaf: Students in the courtyard of the École des Beaux-Arts, c. 1868; photographer unknown (Courtesy of The Pennsylvania Academy of the Fine Arts, Collection of Daniel W. Dietrich II)

invited him to stay in his own studio in the rue de l'Ouest until Eakins could find his own lodgings. Crépon informed him of a complication that Eakins had not known: the letter he had received from John Sartain's friend Albert Lenoir did not guarantee him admission to the école. Due to overcrowding, no new students were being accepted. Harry Moore and Earl Shinn, Eakins' friends from the Pennsylvania Academy, had been waiting for more than a year. Crépon counseled Eakins to forgo the state-run école altogether and enroll in one of the city's many private art schools or ateliers, where he was sure to gain admission.

The next morning Eakins visited the studio of Edward May, another transplanted Philadelphia artist on his list of contacts. May confirmed that no vacancies were available at the school and that no foreign students had entered during the last semester or were likely to be admitted the next. One applicant, May claimed, had tried for nearly a year to enter the école and had finally abandoned his efforts. Like Crépon, May encouraged Eakins to enroll at another school, such as the École Gratuite de Dessin, or "petite école," run by the painter Horace Lecoq de Boisbaudran. Adolphe Bouguereau, another popular French painter, taught at the much-admired Académie Julian. The renowned Léon Bonnat operated his own independent school. Mary Cassatt was studying at Gérôme's private atelier. If Eakins was willing to travel outside Paris, he might be able to study with the famous Thomas Couture, under whom several important American artists, such as Morris Hunt and Eastman Johnson, had trained.

Even if Eakins could have afforded to study privately, which was unlikely given his modest budget, he was not inclined to do so. Eakins took another tack totally, availing himself of an errand John Sartain had asked of him back in Philadelphia. The elder Sartain had lost the manuscript of a report he had written on European art schools for the Pennsylvania Academy in 1855. He requested Eakins to obtain a copy of the report from his friend Lenoir, the secretary of the école. In a letter written home to his father, Eakins recounted: "It popped into my head to speak to this man."

This letter, one of more than 130 that he wrote home from Europe (which he did approximately three times a month), contains the first contemporaneous account that exists of Eakins in action: how he tackled a particular challenge

and his views on a variety of subjects, ranging from French bureaucracy to his driving ambition to distinguish himself as an artist. Reflecting later on what he referred to as his "siege on the École," Eakins wrote, "I cannot help thinking very often how slim had been the tight rope on which I walked."

Reporting to his father from the Hôtel Lille et Albion, Eakins described traveling on foot to the école's administrative center, located on rue Bonaparte, close to the Louvre and the Palais du Luxembourg. The ground floor of the main building displayed a collection of plaster casts of renowned sculptures like the Venus de Milo, from which a beginning student drew, many of the works already familiar to Eakins from the Pennsylvania Academy. The second floor housed committee rooms. Farther on were the principal ateliers and exhibition halls, which had been entirely refurbished and expanded during the overhaul of all the city's institutions. Artisans fitted three of the finest, up-to-date painting studios into the school, and France's most popular and successful artist-teachers conducted classes there. Eakins found the building, compared to the old academy, a true palace.

Eakins went on to describe walking down long corridors where uniformed attendants stood at attention, passing whole units of rooms, bureaus, and entryways, until an official finally ushered him into the presence of Monsieur Lenoir. Lenoir expressed pleasure at hearing indirectly from Sartain and promised to look for his copy of the report. Eakins then seized the opportunity to explain his own presence in Paris. "I want to be an artist," he earnestly declared. "I have left America to come to Paris to study in your school. I am a stranger here."

Eakins pleaded with Lenoir to find him a way to gain entry to the school. Lenoir was hopeful. He explained that Eakins only needed an official letter of application from the American envoy, John Bigelow. To the young artist's relief, Lenoir promised that once he had the letter in hand he would arrange the necessary formalities that would open the academic doors to the école.

The young Philadelphian proceeded immediately to the office of the American envoy, only to discover that Bigelow was temporarily absent. He would have to deal with the legation secretary, Colonel John Hay, whom Eakins condescendingly described as a "supercilious bureaucrat." Hay informed

him that to the best of his knowledge there were no vacancies in the école and that he could produce a letter from Lenoir's superior, Alfred-Émilien de Nieuwerkerke, the minister of fine arts, to confirm the matter. Further, he named several Americans in Paris whose applications had already been refused. Besides Earl Shinn and Harry Moore, there was Howard Roberts. All came from wealthy and well-connected Philadelphia families. Hay made it clear that Roberts and the others would be given priority.

Eakins was beside himself with frustration. He feared that Hay was working against him and would use the news of Lenoir's encouragement to find a place for the others instead of him. He was especially upset to have learned that one of the applicants was Howard Roberts—blond, blue-eyed, and rich— whom he described as "a disagreeable young man" who was "unworthy of an École education." Moreover, none of the others, including Roberts, spoke French. Certain that Hay and Roberts would quickly resubmit their applications to the school, Eakins was determined to get there before they did. That same day he rushed back to the école.

Lenoir was away from his office when Eakins arrived. Now truly desperate, he wrote the secretary a note: "Perhaps it has been necessary to exercise circumspection in the choice of applicants. Perhaps there have been among them rich young men who have the time [to wait]. I am not one of them. . . . I am sorry to give you the trouble but you will easily pardon it in considering that a word from you may perhaps determine the success of my life."

The next day Eakins returned to the école once more. This time he received the encouraging news that Lenoir had read his letter and had in turn written to Comte de Nieuwerkerke, the minister of arts, on his behalf. Lenoir's assistant handed Eakins a note confirming what Lenoir had said, assuring him that as soon as Eakins could deliver a letter from Bigelow, Lenoir would arrange for enrollment.

Eakins retraced his steps to the American envoy's office to discover that Bigelow had finally returned, but he learned that his suspicions had been correct. Hay was indeed a friend of the influential Howard Roberts and had already used the connection to ask Bigelow for a recommendation letter for admission. Bigelow, so far, had not yet acted on Hay's request. Prompted by

Eakins, Bigelow composed a letter approving Eakins' admission—as well as those of the other candidates. All the Americans were swept along on the wake of Eakins' initiative.

Now halfway to his goal, Eakins immediately returned to Lenoir with Bigelow's letter, only to learn that the admissions process was still not complete. Eakins would need permission from the école faculty member he wished to study with, Jean-Léon Gérôme. The normal process was for Nieuwerkerke first to approve the application and then pass the necessary paperwork on to Gérôme. Gérôme in turn would interview Eakins. Since Eakins had already gone to so much trouble, Lenoir felt there would be no harm in doing things out of order; to save time, Eakins could approach Gérôme directly. "He will give you a letter for the secretary," Lenoir told him. "Then you can begin work."

After racing across Paris to Montmartre, Eakins presented himself to the painter Gérôme in his private atelier on rue de Bruxelles. The studio, described by Eakins as the "finest" he had ever seen, was crowded from ceiling to floor with high art, rich fabrics, rusting bits of armor, and old halberds and swords, along with the artist's personal collection of centuries-old Middle Eastern antiques that Gérôme used as props in his paintings. The "big man," as Eakins described the thirty-nine-year-old artist, was dressed in a top coat and tie, and stood before a high, old-fashioned easel, painting from a live nude model. He was handsome and urbane, a dignified and towering figure with a military bearing and a cavalryman's mustache.

Eakins had mentally rehearsed, in French, what he was going to say. But when the time came to deliver his impassioned plea for acceptance into Gérôme's atelier, the most he could do was to provide his name and say why he had come. Fortunately for Eakins, this was all that was necessary. "Le patron," as Gérôme's students called him, did not even ask to see examples of the young man's work.

Gérôme merely put down his painting palette across from the model and welcomed Eakins into the école by writing a note to take back to Lenoir at the office. Secretary Lenoir would then submit the teaching master's letter to Nieuwerkerke at the government offices in the Palais des Tuileries. "I have the honor to introduce to you Mr. Eakins who presents himself to work in my

studio," Gérôme wrote. "I pray you will receive him as one of my scholars. Accept the expression of my most particular sentiments."

The ease of Gérôme's acceptance of him to his classes caught Eakins by surprise. The reason, he later learned, likely rested in the Frenchman's having had only one American student before Eakins arrived. In a desire to be accommodating, Gérôme did not apply the same rigid standards he did with students from other countries.

At this point Eakins could easily have delivered the letter to Lenoir and let the application process take care of itself. Instead, he was determined to have Comte de Nieuwerkerke affix his official signature before Lenoir changed his mind or Hay and Roberts could interfere. His only challenge now was getting past the guards and into the government offices at the Tuileries. Eakins, with the help of Lucien Crépon, the artist who had guided him since his arrival in Paris, hatched a plan.

Using his most elegant and oversized Spencerian writing, which his father would have been proud of, Eakins addressed a large and official-looking envelope to be delivered by hand to Comte de Nieuwerkerke. The envelope, as Eakins described it, was "about the size of a small window frame." All it contained was a small card bearing Eakins' name. Feigning complete ignorance of French, and pointing insistently at the address, Eakins pushed his way past the protesting guards to the minister's reception room and presented the envelope to Nieuwerkerke's secretary.

He met mixed results. Nieuwerkerke refused to see him without an appointment. He did, however, express an interest, via his secretary, in learning why Eakins had come.

Eakins returned to his hotel and composed a formal response. "I would not have dared address you this supplication," he wrote, "but I feel so much of my success depends on your kindness that I cannot resist. In leaving my home I have made great sacrifices to come here expecting to be able to enter the Imperial School. . . . Would it be too much to ask of you your signature without which I cannot commence my studies?"

After delivering the letter along with his documents from Lenoir and Gérôme to the imperial offices adjoining the expansive central gardens at the

Tuileries, Eakins felt satisfied that he had done all he could. Rather than bide his time at his hotel waiting for a response, he used the rest of the day getting to know more of Paris and looking up old friends. Earl Shinn was vacationing in the countryside and would not be returning to Paris for several weeks. Harry Moore, however, was easily located.

To Eakins' surprise, Moore was living in a luxurious apartment with his mother, father, and sister in the American part of Paris near the Arc de Triomphe. Everyone in Moore's family had come to France to see him get settled. But after months of trying to navigate the French bureaucracy, they had finally given up on the idea of Harry's ever gaining entrance to the école. The unexpected appearance of Thomas Eakins at their door raised their hopes that something could indeed be done. In fact, it had already been done, thanks to Eakins. For years to come, the Moore family sang his praises, as did Earl Shinn, whom Eakins also helped gain entrance to the école. "I was [out] rambling," Shinn wrote home, "[while] young Tom Eakins was exerting himself . . . investigating Directors and bothering Ministers, until he got the whole list of American applicants accepted."

Ten days after his arrival in Paris, Eakins was standing in the offices of the imperial household watching a deputy minister fill out his card of admission. As Shinn later wrote, "The Minister had yielded incontinently to . . . [Eakins'] merry eyes, [and] his excessive perspiration."

"I have done a month's hard work," Eakins declared in a letter to his father. "It may be some of it was unnecessary and I could have got what I wanted by patience, but I don't believe it." Furthermore, he expressed no regret for having used a bit of subterfuge to gain admission, and revealed his true feelings about how Colonel Hay had treated him. "I cannot feel ashamed of [those means] for they were practiced on a hateful set of little vermin, uneducated except in low cunning, who have all their lives perverted what little minds they had, have not left one manly sentiment."

Eakins was gloating at having successfully gotten around Hay, and indirectly Roberts, incarnations in his mind of Philadelphia privilege and pedigree. It was not, apparently, the French bureaucracy that so riled him as what he believed to be the injustice in how Hay had treated him. The vehemence in his reaction to Hay and Roberts suggests just how close to the surface Ea-

kins' emotions lived, along with how strong his determination was to study at the école. Although his comportment was always marked by self-control, an aggressive defiance seethed just beneath his outside demeanor, ready to emerge. Eakins clearly possessed a persistence and resourcefulness, amounting to plain stubbornness, in the pursuit of what he deemed were justifiable ends; he revealed as well an unmitigated contempt and intolerance for the "vermin" whom he thought stood in his way. Confidence, convictions, and prejudices that were driving him at age twenty-two were the same that acquaintances would see as impatience and arrogance two decades later.

nine

Heads and Hands

In many of the early letters Eakins wrote home from Paris, there is a sense that the young Philadelphian had already begun transferring his admiration and affection from one mentor to the next. That both Benjamin Eakins and Jean-Léon Gérôme enjoyed outdoor sports, devoted themselves to their work, loved teaching, and pursued a disciplined, professional, and even scientific method of instruction made the transition an easy one. His father remained the foundation for Eakins. It was Gérôme to whom he now became a supplicant.

"The oftener I see him the more I like him," Eakins wrote to his father. Another letter heaped praise on Gérôme for a painting of Dante. "No one else could have done it," Eakins announced. "Some painters paint beautiful skin, some find happy bits of color, some paint soldier's clothes and customs . . . & puppets & mawkish or sickish sentiment, but who can paint like my dear master, the living thinking acting men, whose faces tell their life long story. Gérôme has raised himself above his fellow men by his brain as man himself is raised above the swine."

Eakins was fortunate to have found in Gérôme a teacher worthy of his unqualified devotion. Although Gérôme's exotic subject matter—slave girls, snake charmers, casbahs, and Roman baths—did not fascinate Eakins any more than the grandiose landscapes being produced back home, "le Patron" possessed skills and interests that Philadelphia teachers did not: technical mastery and a dedication to the science of artistic realism. Gérôme studied anatomy, ethnology, archaeology, and architecture as a physician studied the nervous system, and like Eakins he had distinguished himself as a student of science and physics years before he launched his career in the arts. To a young student like Eakins, who was already demonstrating a predilection for analyzing and cataloguing the natural world, Gérôme was an ideal teacher. No one could paint heads and hands like le Patron.

Beyond Gérôme the painter's skills, Eakins knew little or nothing of his new mentor's rise to prominence or how he had become the dominating spirit of the école. Lucien Crépon would in time fill him in on several important details about the master, and Eakins would pick up stories from other students. He would learn how Gérôme, in his youth, had won distinction in the Paris salons, and how he quickly rose up the ranks by garnering several state

Opposite: Jean-Léon Gérôme, c. 1867–68; photograph by Charles Reutlinger (Courtesy of The Pennsylvania Academy of the Fine Arts, Collection of Daniel Dietrich II)

commissions. For his monumental mural at Amiens, *The Age of Augustus,* he was awarded the Legion of Honor. The money Gérôme received from this commission financed his first six-month tour of Egypt. In that intriguing land, he collected the imaginative storehouse of subject matter that he devoted his career to depicting.

Gérôme's fortunes rose with those of Napoleon III, and he now enjoyed the patronage of both Empress Eugénie and Princess Mathilde. How close in truth he was to France's first family is a matter of opinion. John Sartain might well have suggested to Eakins what had long been rumored: that Gérôme was not only the favored artist of the emperor but acted as a spy and courier for him in the Middle East during his routine travels, often in the company of French dignitaries. Gérôme's marriage in 1863 to the daughter of Adolphe Goupil, the most important art dealer and publisher in the world at that time, further extended the artist's reach, helping to establish him as a perennial salon favorite in London, Berlin, The Hague, New York, and Philadelphia.

Gérôme had truly become a force to be reckoned with. Even students who were not necessarily interested in learning his technique or sharing his brand of aesthetics sought admission to his classes for mere prestige. Gérôme's students also gained the greatest advantage and contacts for entry of their work into the salons and the competition for the Prix de Rome, the coveted award that once a year bestowed a fully paid scholarship for a French art student to study in Italy.

Gérôme's ultimate success, however, was not political patronage or the influence he wielded. The public liked his paintings. His large and powerful historical scenes of soldiers and slave girls, food stalls and street performers, evoked the opulent tableaux of the distant past unfettered by the trappings found in the grand historical moments chronicled by so many of his contemporaries. His paintings reflected the taste of a generation that could no longer believe in the myths of the past, but still desired its familiar topography. His paintings read like travel diaries or illustrated books, popular in their appeal, yet in his case masterful in their presentation. Nature was copied faithfully.

Master painters like Gérôme were loved, admired, venerated. Aspiring artists under them or their influence worked for years in the rigid hierarchy of the école. In their masters' studios novices absorbed a culture, an entire social

universe. No pupil left without learning to perfectly draw the human form, and none left who did not thoroughly understand proportion and art history. For these and so many other reasons the competition for the chance to study under such instructors at the école was fierce.

Eakins, because of his timing and tenacity and his connection to John Sartain, and perhaps because he was an American, had been lucky. "Americans are looked on in Europe as a people who may be allowed to do as they please," Tom later wrote in a letter to his sister Margaret and his school friend Max Schmitt. Now that he had gained admission, Eakins boldly plunged into his new environment with the naïveté of a rank amateur. His first day in class, in November 1866, turned out to be one of the most memorable.

Having at last received his card of admission, Eakins presented himself on the first day in the école lobby, asked his way to Gérôme's studio, and was summarily and purposefully misdirected from one classroom and dead-end hallway to the next, until a sympathetic employee eyed him most gravely and escorted him to the right room. Just as Eakins had mentally composed a neat little address for his first meeting with Gérôme, he had prepared a second speech for this occasion. When his guide opened the Gérôme studio door and announced the newcomer, words once again failed him. Gérôme wasn't even present. The students inside gave a great yell and promptly began to mock him and demand money. "Oh the pretty child!" they exclaimed. "How gentle . . . he is calling us Musheers . . . the fool . . ." As Eakins further explained: "They all pushed each other and fought and yelled all at once . . . twenty auctioneers all crying twenty francs."

Eventually the students invited Eakins to be seated, whereupon they suddenly jerked his stool out from under him; he landed on the floor. "A big fellow with a heavy beard . . . came and sat down with his face within a foot of mine and opposite me," Eakins recounted. "Then he made faces, and such grimaces were never equaled . . . I tried to look merely amused."

The traditional hazing aimed at a newcomer caught Eakins off guard. He didn't know how to respond to the students' demands for money and servitude either, so he did nothing. After later consulting with Crépon, he dutifully paid the "welcome fee" of twenty francs and, protesting only slightly, consented to stoke the fire in the stove, tell jokes, and perform what other

errands and demands were requested of him until the next new student arrived. That hapless fellow may have been Earl Shinn, who was set upon not only by Gérôme's other students but by Eakins himself.

Eakins quickly adapted to what he called the "fraternal camaraderie" of the école. In the process he came to see that what had happened to him was not as extreme as the pranks experienced by many other incoming students. One unsuspecting newcomer was forced to strip naked and be subjected to having parts of his body painted blue. Students welcomed another acolyte, perceived as particularly arrogant, by tying him to a ladder, propping him upside-down against one of the école's walls as a human sculpture, and leaving him to hang for several hours. A third arrival, whose behavior was felt to be particularly egregious, was locked in a wooden prop chest each day for more than a week until he finally dropped out of school. Eakins not only participated in the young man's incarceration; he described, by letter, the many reasons such treatment was deserved.

Even though he joined in the fun, Eakins' initial appraisal of his classmates was that they were an ill-mannered lot. Eventually he came to appreciate them in unexpected and endearing ways. They were "only rough on the outside," he said when Harry Moore arrived at the studio. Before Moore's entrance, Eakins told his fellow students about his friend's handicap in hearing, and they did not, as Eakins reported to his father, "amuse themselves at his expense." Afterward, he showed Moore around the école, introduced him to his friends, and took him out shopping for paints and other supplies he would need for his classes.

In the months that followed, Eakins came to like the seventy or more students in Gérôme's atelier far more than those in other studios he eventually would study in. The sculpture students of Augustin-Alexandre Dumont, for example, to whom he would pay a substantially smaller "welcome fee," and where Howard Roberts studied, he described as fat and dull by comparison. "Sculptors are not so noisy as painters," Eakins remarked.

As he appreciated them, fellow Gérôme students also came to enjoy Eakins' company. According to Earl Shinn's later report, they loved listening to Eakins' stories of hunting and fishing, which the young Philadelphian talked about incessantly. As students grew familiar with him, Eakins also got to know them. They were not, as Eakins noted, the "Howard Roberts type." Most

were extremely poor young men from the French countryside who survived on what food their families could send them. They lived in small garrets, sometimes with eight or more of them sharing a single bedroom. One student in particular was fed by handouts from fellow students. Another classmate, whom Eakins described as a fine painter, actually starved to death. "He was always laughing," Eakins said with mixed disbelief and remorse, so "no one suspected the truth." The incident apparently moved Eakins deeply; in the years to come he would routinely lend money to students in need and give to indigents whom he met on the street.

Eakins, by this time, had learned to hold his own. The picture that emerges is of the embodiment of an enterprising Yankee expatriate. His bookish French was replaced by fluent colloquial speech and student slang. After one fellow tipped him off that several students were going to play a trick on him, Eakins took them by surprise, arriving with a pair of pistols he had brought from Philadelphia. As the story was told, Eakins slid down the banister of a grand staircase brandishing a revolver in each hand and looking so formidable that he sent the pranksters running for their lives. On another occasion, when a boxing match was proposed, Eakins cheerfully stripped down to join the contest. A friendly bystander tapped his French opponent on the shoulder and said, "My good man, let me give you a piece of counsel: never box with an American." The Frenchman stepped aside.

Mayhem in this mode was particularly common at the all-male école because its twelve faculty members—seven painters and five sculptors—were present in the classrooms only a few hours each week. Considerable pressure was further brought to bear by competition within each studio and between studios for the many government prizes the école offered each year. The rigid studio hierarchy, in which students sometimes worked for years under the master before going off on their own, frequently provoked jealousy or near to it for the attention of the master. Favorite students, and those judged to be single-minded in their studies, gained prime spots to position their easels. Beginners and less-favored students were always in the outer circle or near the door.

The usual schedule among Gérôme's charges was to arrive on Monday morning at seven o'clock and draw from a nude model in a session lasting from eight until one in the afternoon. The model maintained the same pose

for five days a week. On Wednesdays, Gérôme joined the studio for a few hours to review the students' progress and offer criticism. Often he spoke nothing at all; he quietly painted over the student's work to show where he had gone wrong, or to suggest a better technique. Each week students were expected to have a finished study by Friday afternoon in time for Gérôme's final review on Saturday morning. Those whose work did not measure up to his standards at times did not get reviewed at all. If the student showed progress, he would be praised and moved to a position higher in the pecking order, closer to the model.

Earl Shinn, in class with Eakins, compared the review process to the same thorough manner their teacher brought to his painting. "Beginning at a corner of the studio floor, as if it were the corner of a panel, he progressively and minutely covers it with oversight, as he covers his pictures with drawing —slighting no person, omitting no duty, never failing, never waning . . . conscientious, implacable and admirable." Eakins described much the same review process. "Gérôme comes to each one, and unless there is absolute proof of the scholar's having been idle, he will look carefully and a long time at the model and then at the drawing, and then he will point out every fault. He treats all alike good and bad. . . . Nothing escapes his attention."

At the start Eakins wasn't allowed to paint, only to draw the live model. Repetitious for him as this was, the new atmosphere made it palatable. Merely standing amid dedicated colleagues, in a setting where devotion to creative striving—to learning the craft and art of painting—was the only goal, produced an experience nothing shy of exhilarating. Eakins at the same time was attending lectures by leading scholars in the history of art and aesthetics, and on art as it related to archaeology, anatomy, and physics. Philosophy at the école was taught by the venerated Hippolyte Taine, the foremost proponent of Herbert Spencer. Louis Pasteur held the lectureship in chemistry. Physicians lecturing on anatomy would go on to edit the seminal medical text of its time, Henry Gray's *Anatomy, Descriptive and Surgical.*

Eakins' letters home reflect his growing ability to articulate what it was he wanted to do and how to do it. "The big artist does not sit down monkey like & copy a coal scuttle or any ugly old woman like some Dutch painters have done nor a dung pile," Eakins wrote to his father. "He keeps a sharp eye

on Nature & steals her tools. He learns what she does with light the big tool & then color then form and appropriates them to his own use. Then he has a canoe of his own smaller than Nature's but big enough for every purpose except to paint the midday sun which is not beautiful at all."

His metaphor of the artist being borne in a watercraft had as much meaning for the younger Eakins as it must have had for his father. Eakins expanded on this theme in several other letters. "Once an artist was given sufficient practice," he wrote, that artist would soon "be sailing only where he wanted to, selecting nice little coves & shady shores or storms to his own liking." But Eakins also cautioned, "if ever he thinks he can sail another fashion from Nature or make a better shaped boat he'll capsize or stick in the mud & nobody will buy his pictures or sail with him in his old tub."

Eakins' outlook remained positive. "Whether or not I will . . . find poetical subjects and compositions like Raphael remains to be seen," he wrote his father. "Gerome says the trade part must be learned first. But with or without that I will paint well enough to earn a good living & become even rich."

More than anything else, Eakins expressed the pure joy at having himself set sail on his new career. In his most quoted letter, he wrote, almost as a sacred vow in secular form: "I love sunlight & children & beautiful women & men, their heads & hands & most everything I see & some day I expect to paint them as I see them and even paint some that I remember or imagine [or] make up from old memories of love & light & warmth."

Gérôme must have sensed the excitement of his new pupil, and equally his talent. Beneath what likely appeared as a provincial awkwardness in the young man, the tutor perceived some crucial factor out of the ordinary. In one of his first criticisms of Eakins' drawings, Gérôme was reputed to have said, with a diamond cutter's precision for the shearing of destiny: Eakins will "either become a great painter or would never be able to paint at all."

Eakins would soon find out for himself. After five months of his drawing in charcoal, Gérôme was no longer making changes in his work, and on several occasions said that he saw some "middling good parts" in his work and modeling technique. Only once did he tell Eakins that he was going backward. The best compliment Gérôme paid him at this point was to say he could sense in Eakins' work "a feeling of bigness."

In March 1867, the twenty-three-year-old Eakins was permitted to begin painting. He had advanced incrementally, first in Philadelphia learning penmanship and mechanical drawing, then studying anatomy, and then drawing the human form. Hard lessons in construction had come first, representation later. The process was logical and consistent, each stage being mastered before the next could begin.

ten

Letters Home

In spite of the excitement he experienced being in Paris, before the end of his first year there Eakins was homesick. He missed his mother's cranberry dressing, impromptu dances with his aging Aunt Tinnie in the Mount Vernon Street kitchen, and the fall colors on the Schuylkill River. "It must be very beautiful now with the red and yellow leaves of the trees," he mused in a letter to his mother. "The leaves are all changing here too, but they do not grow bright; they only fade and die."

Most of all he missed his family and friends, as they missed him. Max Schmitt, his high-school swimming companion, impatiently looked forward to Tom's return. "Then shall we again have belly smashers, back bumpers, [and] side switches," he wrote. "Then shall we [again] see . . . beautiful [diving] performances by the immortal [Eakins]."

Tom dutifully wrote to his mother or father several times each month and often managed to add at least one other letter to a friend or family member. Among the many details he shared about his life in Paris were exercising at a gymnasium, the trouble he had finding a pair of well designed ice skates, and hearing Adelina Patti, the Italian diva, sing in an opera. "It is not probable I can ever hear such singing again," he wrote.

Every month or two Eakins also sent an accounting of his expenditures, scrupulously recording every item he spent anything on, from a bar of soap, an undershirt, and postage stamps to a few sou he put in a church poor box. Purchases out of the ordinary were carefully explained, such as a book by François Rabelais, whom Eakins described as a "doctor of medicine and hater of priesthood," and the twelve francs he paid for a bottle of champagne, the result of losing a bet with fellow students. Of his expenses in general, he confessed to his father: "I have tried to act in moderation, without being liberal like a poor man or mean as a rich one."

To save money, Eakins moved out of the Hôtel Lille et Albion in October or November 1866 and into a basement room at 46, rue de Vaugirard, across the street from the Luxembourg Palace. "It was a nice large studio and I thought I could live there very well, but it was impossible to keep clean," he

Overleaf: The building at 62–64, rue de l'Ouest, where Eakins had his studio from 1867 to 1869. The two-story building in the center is number 62, where he moved first; to the left is number 64, where he relocated several months later. (Courtesy of the Gordon Hendricks research files on American artists, 1950–77, in the Archives of American Art, Smithsonian Institution)

reported after finding a more suitable rental. "I bought a big broom but the way the dirt would stick in those bricks was a caution. . . . I had to be very careful to tuck in the bed clothes well at night for if they touched the bricks they were soiled."

His amusements were simple. Many evenings he wrote letters, read about art, and, with the aid of a tutor, learned Spanish in anticipation of a trip he hoped someday to take to Madrid. Holidays were invariably spent with Harry Moore and his family. By early 1867 Eakins had taken it on himself to learn sign language, a skill he mastered as readily as almost everything else he studied. Conversing in sign language endeared him to Harry and to the entire Moore family. And though Eakins, in his correspondence, was generally critical of the people he met, he never had a bad word to say about Moore and only minor criticism of Harry's mother and father. He noted that they had the disagreeable habit of removing "souvenirs" from historic monuments and other tourist destinations.

Except for the Moore family, Earl Shinn, and other friends from Philadelphia, he rarely socialized with the American expatriate community. His relationships were with his French classmates. He attended art shows with them, as well as dog racing, bicycle trips, and a masquerade ball. He frequented the circus, a diversion he enjoyed more than any other in Paris. "Men & horses in motion" were his favorite spectacle, he wrote to his sister Frances. "If Paradise is prettier than this part of the circus I want to see it."

Eakins' letters to his father commented with frank pleasure about his taste for visiting the cafés where his classmates spent much of their free time, drinking and carousing. During one such evening, Eakins noted, he did not himself consume the spiked punch being served, he only pretended to do so. On another occasion he joined his classmates in what must have been a trip to a brothel. "The whole afternoon that I spent with them I don't consider as altogether wasted," Eakins wrote. "I saw more of new character and manner than I would ever have discovered by myself, nor am I either sorry or ashamed to have accompanied them to the place . . . but I would be ashamed if I had been in the least attracted to the vice which I saw there." Eakins was game for practically anything, though he drew the line when his friends urged him to join them in witnessing a public beheading.

In his love for the circus and French cafés he had become quite Parisian. In other ways he remained a tourist. "The French are strange even to the time of eating," he noted to his mother. "I felt very hungry one morning at half-past eight o'clock, and strolled into a restaurant. When they found that my business was to get something to eat, they opened their eyes wider than the Dutchman [who had visited Fairmount Park] when he saw Mr. Gardel put water in his beer. Nobody breakfasts till 11, many not till 12." Eakins also commented on the lack of public toilets and on having to pay to use a "back house" in the Latin Quarter, where the female proprietor owned three privies for men and two for women. "In place of the sixth she has a chair & sits there all day," Eakins wrote. "When I went in she was [sitting there] eating her dinner."

Writing to his mother, in a passage clearly for the benefit of his two-year-old sister Caroline, he described the differences between pets in Paris and those in Philadelphia. "Even the cats here are strange. They are larger . . . have long fur and bushy tails like foxes. There are a few however of our kind. . . . There are many dogs in Paris all muzzled, with leather bands or led by strings. They have neither nobility, dignity, nor intelligence. . . . The most respectable and well dressed gentlemen of Paris . . . [can be seen] walking along the promenades carrying these little whiffets in their arms and fondling them." Also, to Caroline, he depicted the proper French method of crushing fleas. "If you ever get one on you, you must spit on the end of your finger and quick dab your finger on him. The spit keeps him from hopping fast. . . . [And] when they are squeezed out very flat they don't care to bite people any more."

Although he mocked "French dandies" and their pets, he found "English snobs," who stuck together in groups, more offensive. "The only bearable ones are those who have lived in Australia a long time. . . . The latter might be tamed . . . but it would not be worth the trouble unless to one who could find neither an American [or] French [or] Italian [or] Spanish or Chinese . . . They are great hogs, so different than the French."

Since the female members of his family were particularly interested in Parisian fashions, he humorously described to them what well-dressed women were wearing. "The ladies of the court are said to dress very grand and to wear very low dresses which commence somewheres below the breasts." As for their personal hygiene and habits, he declared: "At church the only perceptible

difference between the duchess and the laborer's wife is that the duchess is the cleanest of the two . . . [and] the washerwoman goes home in a[n] omnibus and my lady in a state carriage mounted by flunkeys . . . [who] dress up like monkeys always with long white stockings and high hats with pompoms in them." He confided how fine he found the skin of Parisian women. "I doubt if powders & enamels are used here in anything like the quantity at home. They are afraid of spoiling their skin." In this same letter Tom facetiously remarked: "I am sorry that I did not learn dressmaking as well as grammar in my Zane St. school."

His commentaries extended to politics, an arena he promised his father he "would have nothing to do with." Reports of political unrest and thievery, he said, were greatly exaggerated in the press. As Eakins told his family, "There is a common saying here that your watch is safer in a gutter of Paris than in your pocket in London." In a letter to Max Schmitt he compared France and Germany to highly unstable chemical compounds invented by "Professor Bismarck and Professor Napoleon."

Like all école students, Thomas visited the Louvre, and he later obtained a pass to set up his easel there. "First, I went to see the statues," he narrated to his sister Frances. "They are made of real marble and I can't begin to tell you how much better they are than the miserable plaster imitations . . . [in] Philadelphia. But I left right away. Statues make me shiver, they look so cold." Eakins then moved to the picture galleries. "There must have been half a mile of them, and I walked all the way from one end to the other, and I never in my life saw such funny old pictures."

Eakins gives no further insight to his views of the art in the Louvre. Rather, he focused on Napoleon III's collection of historical souvenirs. He humorously described such curiosities as a toothpick composed entirely of diamonds used by Charles IX, a fish bone that nearly choked the mother of Charles XII, slippers of Mary Queen of Scots, and a Bible, Eakins noted, "as good as new," though identified as having been frequently used by Charles XII.

He was equally unsatisfied by the work shown at the Salon exhibition of 1868, France's premier, government-sponsored art event. "There are no more than twenty pictures in the whole lot that I would want," he wrote, adding that none of the "great painters" had submitted work to the Salon that year. To

his mind, the exhibition seemed to comprise nothing but pictures of naked women, whom he despairingly described as standing, sitting, lying down, flying, dancing, and doing nothing. These "smiling smirking goddesses of waxy complexion," Eakins went on, were displayed "amidst the delicious arsenic green trees and gentle wax flowers & purling streams running melodious up & down the hills especially up." Eakins blamed the poor showing on the imperial court, which lately, he said, had become "very decent since [Empress] Eugenie had fig leaves put on all the statues" in the Garden of the Tuileries.

In future letters Eakins would be characteristically intolerant of most artists, especially the hugely popular school of American painters practicing in Rome. "The nest of American artists at Rome is an infection," he said. "Their aim is to get big prices heavier than those commanded by the greatest artist. . . . Pickpockets are better principled than such artists, for pickpockets rob from strangers."

A follow-up letter hastened to assure his father that Eakins was not deriding all contemporary and classical art. He emphasized that very fine painting was being done by Gustave Doré, Ramón Rodríguez, and most of all his own mentor, Gérôme. One thing made clear in his correspondence is that Eakins himself saw no relevance or sincerity in what he described as "endlessly painted myths" and paeans "to the Emperor." If he saw works by the early impressionists, such as Edgar Degas and Edouard Manet, whose paintings were just beginning to be displayed in Paris, he failed to note it in his letters. He showed far more interest in the exhibits on view at the Exposition Universelle taking place on the Champs de Mars in 1867.

Eakins particularly admired the impressive heavy machinery on display from America. The new locomotives built at home, he said, made the English, French, and Belgian examples "look mean" by comparison. The most amusing American import was a soda fountain. He described it as causing such a sensation that French citizens waited in a line several blocks long for drinks from it. The French also took a liking to other American treats: mint juleps, peach cobbler, popcorn, and plug tobacco. The only offering they did not like was American artwork, which Eakins admitted was a "dismal failure."

Eakins was still making weekly trips to visit the exposition when the heartwarming news reached him of the arrival in Paris of his childhood friends

Will Sartain and Will Crowell, who had been studying at the Pennsylvania Academy. They had decided to visit Eakins and see the Exposition Universelle for themselves. The timing, in the early summer of 1867, could not have been better. The école was in recess for July and August, and Eakins was free to show them Paris.

Sartain was even more disappointed than Eakins in the paintings on display from the United States. However grand the locomotives and technical exhibits were, the art, he said, "looked sick." The paintings of every other nation "outstripped" those of their own.

The young Philadelphians encountered along the way a glimpse of hostilities that would, a few years later, result in war over Poland. "I was on the spot with Billy Crowell about five minutes before the thing happened," Eakins wrote his sister Margaret about a failed assassination attempt on Czar Alexander II. As Napoleon III was showing the Russian through the fair, shooting began. "When the Emperors discovered no one was hurt they immediately kissed one another," Eakins reported. "They came back to Paris at full gallop [with] a regiment of horsemen clearing the way."

Sartain and Crowell proposed to extend their vacation by hiking through the Alps, and invited Eakins to join them. He was reluctant to spend the additional money such a trip required or to be away so long from his painting. However, Benjamin, by letter, persuaded him to go.

Eakins and his companions stopped in Geneva before proceeding east to Martigny. From Martigny they took day trips to Chamonix and Mont Blanc, retracing a route Benjamin had traversed a decade before. The trio explored eastward to Visp, south to Zermatt near the Italian border, and headed north to Basel and then Strasbourg.

"The most God forsaken place I ever saw or hope to see," Eakins reported from Switzerland. He thought the people cretins, "near savages living in the midst of filth and Catholic superstition, who breed by incest altogether." As if such remarks did not adequately convey his views on the subject, he savagely went on to berate the country and the people he met along the way. "They stink, their homes stink worse, the water of the valley stinks," he continued. "An earthquake some years ago was a god send in destroying half of them."

The three visited Strasbourg, where an ill Christian Schussele had taken

temporary leave from the Pennsylvania Academy, hoping to regain his health at a spa. The main topic of conversation was the art curriculum at the école. Schussele expressed reservations about Gérôme's credentials as a teacher. His remarks annoyed Eakins measurably—and understandably, given his high regard for his teacher—and became the source of a long-running argument with Crowell on the return trip to Paris. Crowell, in a clash of views that bred implications about his future relationship with Eakins, believed an école education was unnecessary, and that the Pennsylvania Academy offered all that an art student needed.

Eakins' brutal commentary about his trip naturally caused distress at home. Benjamin recommended that he return to Philadelphia with Crowell and Sartain. Eakins demurred. He admitted being homesick, but said he could not justify the cost of a trans-Atlantic crossing or time away from his painting. "I love my home as much as anybody and never see the sun set that I do not think of it and I often feel lonely, but I can learn faster here than at home and stay constant [and] not think of wasting the expense of a voyage for a few weeks' pleasure. You miss but one from the family," he observed. "I miss all."

It was not only homesickness or attempts to justify his école education that were at the root of his prickly remarks about the Swiss or his arguments with Crowell. Eakins was increasingly frustrated over a lack of progress in his painting, in particular an inability to master the use of color. "For a long time I did not hardly sleep . . . nights," he later admitted, "but dreamed all the time about color & forms & often nearly always they were crazinesses in their queerness." Speaking of his classroom work he confessed: "How I suffered in my doubtings, & would change [my technique] again, make a fine drawing and rub weak sickly color on it, & if my comrades or my teacher told me it was better, it almost drove me crazy. Again I would go back to my old instinct & make frightful work again. It made me doubt of myself, of my intelligence, of everything."

Eakins worked at small analytic studies, focusing on sections of a canvas or bits of anatomy and some particular aspect of his task, as he had done at Central High and then at the Pennsylvania Academy. He was working so intensively that he decided to move to an apartment that, though more expen-

sive, had better lighting, where he could paint at night. Crépon helped him locate a ground-floor studio at 62, rue de l'Ouest, off the avenue du Maine in Montparnasse, south of his original lodgings. "The studio will enable me to commence to practice composing & to paint out of school which I could not before," he wrote to justify the added cost. "As soon as I can get knowledge enough to enable me to paint quickly I will make pictures, but I have been only 4 months at the brush & can't do it yet."

Eakins found the apartment damp and dirty, and several months later, in November 1867, he moved into an upstairs apartment at number 64, in the same building. "The studio is not so large as the other one but plenty large enough for my bed and then another place for my clothes and writing materials. I go to bed up a little latter and there is a door and balcony which will prevent me from falling down into the studio if I should take to sleep walking."

Gérôme lent him swatches of brightly colored Eastern fabrics, which Eakins took back to his studio and tried to transfigure in interesting ways with oil paints. Though struggling to improve, he confessed only to producing "very bad things." Gérôme as well was disappointed with his student's progress, and on at least one occasion he took Eakins' palette and mixed the colors himself. Still Eakins could not get it right, making "a devil of a mess" when he tried to mix the colors for the desired hue, saturation, and brilliance.

Other students in his class also were not advancing. Earl Shinn appears to have been having the most difficulty. His problem was directly related to poor eyesight, a condition exacerbated at the école by intensive study. As Shinn revealed in a letter to his sister, Gérôme "proceeded to demolish a part of my work as he had quietly done the *whole* of two days before, in his first visit [of the week]. I feel my whole heart sink in me when I see him coming to the easel."

Eakins took Gérôme's criticism equally hard. There were bouts of insomnia, depression, and finally ill health, apparently made worse by his new lodgings, which were drafty and damp. He started skipping classes at the école and spent days at a time in his studio. There he invariably found himself staring at the same canvas for long periods. "You make a thing mighty bad and see how bad it is, you naturally hunt to improve it, and sometimes find a way, but it keeps staring you in the face till you do," he wrote.

In these and other letters Eakins alluded to significant changes in his lifestyle. He was spending more time with his fellow students outside class and had taken up hiring models to pose for him. One, a girl named Anne, may have been a prostitute at a Paris brothel.

Benjamin responded to his son's uncertainties with obvious concern, prompting Tom in turn to adopt an even more defensive tone in his letters. He repeatedly assured his father that his only serious interest was in painting and that in time he would, "like a skater over rough ice," finally get it right. He was certain that when he finally reached that point, the money his father had invested in him would be money well spent. He prayed for the day, he said, "[when] I can stop my studies long enough to paint a good picture & relieve you of your share of an anxiety which would be nearly all mine, which in depression is harder than death to bear but which disappears in the joy of every progress felt or discovery made."

Undated work that Eakins may have made during this period reflects his struggle. His roughly painted *Study of a Girl's Head,* which the Hirshhorn Museum and Sculpture Garden now displays, is a broadly rendered patchwork of muted halftones against a background of earthy colors. Three related sketches in the Philadelphia Museum of Art, which may have been painted several months later, show attempts at capturing flesh tones, thinly brushed over penciled outlines. These same studies reflect Gérôme's advice to his students to produce thinly painted canvases using medium-thinned washes, which allow experimentation with light and hue in relation to the surface, rather than thickly finished studies layered with oils and glazes and applied with palette knife, as a means to develop one's range of technique.

Eakins' struggle and subsequent depression continued to concern his friends and family in Philadelphia—most of all Emily. His initial letters to her from Paris were especially warm, though not as plentiful as she would have liked. In one, written in Italian, he wrote, "Let not the long time that will elapse before you receive my letter move you to scorn, and do not deduce there from that I have forgotten you. Every time I see the painting Gérôme made of Dante, there comes to memory the beautiful evenings spent with you reading the Inferno. . . . I kept hoping from day to day [for good news to report] but had nothing but bad luck until last Friday and I did not want to have sad stories

reach my friend." In another letter, also in Italian, he declared that he would be "looking for agreeable and decent companions" worthy of her brother.

Emily included a photograph of herself in a follow-up letter to him. This time he replied in English. "I envy your drives along . . . those beautiful [Pennsylvania] hills with which are connected some of my most pleasant reminiscences. You say you had a slight sensation somewhat remembering pride in your native city. I feel like scolding you for such a weak avowal of your real sentiments. You should hear me tell the Frenchmen about Philadelphia. I feel 6 ft. & 6 inches high whenever I only say I am an American. . . . Philadelphia is certainly a city to be proud of, and has advantages for happiness only to be fully appreciated after leaving it. . . . Many young men after living here a short time do not like America. I am sure they have not known as I have the many reasonable enjoyments to be had there, the skating, the boating on our river, the beautiful walks in every direction."

The letters they exchanged, on his part, became shorter. He eventually stopped addressing her in Italian altogether. Evidence surfaced of their very differing opinions, not only of Philadelphia, but about Eakins' imperious attitude toward women. In response to a statement she is presumed to have made about a woman's right to an equal education, he said, "You never learned that from yourself Emily or my mother or your mother or next door at your sister Helen's." Eakins' own family must have become aware of his changing affections toward Emily. Frances, who considered herself Emily's friend, pointedly asked her brother if he was formally engaged to her or not. The response may not have been what Frances expected. "There was love between Emily and me which gave me an indefinite idea that maybe if I asked her to marry me she would say yes," he wrote.

The point of controversy seems to have emerged in Emily's attempts to polish what she viewed as his "rough" edges, something Eakins could not abide. "There are some women who want to run everything, men above all, and all the more so because they are weak and incapable of directing themselves," he wrote. "And when a woman is possessed of this folly she knows no doubts or discretion, but sticks her nose into everything by meddling in other people's affairs, puts in her word in family squabbles, plans her strategy, and conceives of others as belonging to her . . . and not as persons of good understanding,

reason, and feeling." If he ever took a wife, Eakins declared, she would not be a "New England she-doctor."

Emily's sister-in-law, Harriet Judd Sartain, was a homeopathic physician practicing in Philadelphia. Eakins did not approve of her. "I hope that you will never have anything to do with Harriet Sartain at all," he wrote to Frances. "I have always regretted Emily's acquaintance with her. I do not care to tell you my reasons but they are all sufficient."

Eakins stopped writing to Emily after this time. For half a year their dialogue fell silent. It came to life again only when she sent a letter in June 1868 announcing her intention to make an Atlantic crossing to Paris. She was to accompany the renowned Boston author and journalist William Dean Howells, a close family friend of the Sartains. "I will be glad to see you soon," Eakins wrote to her in reply. "It has been a long time since we were together."

References from Tom to his deteriorating relationship with Emily and frustrations with his art prompted father Benjamin and sister Frances also to plan a trip to Paris. His father may have thought his son needed cheering up, or, as Emily believed, better guidance.

Rough Around the Edges

Benjamin and Frances Eakins arrived in Paris before Emily Sartain. They left New York by steamship on June 13, arrived in Liverpool eleven days later, and spent ten days in London before leaving for Paris. Eakins met them at the train station, the Gare de Nord, on July 4, 1868.

"He is much thinner than when he left home, but his complexion is clear and he looks right strong," Frances wrote in her diary. "He's just the same old Tom he used to be, and just as careless looking . . . but he's the finest looking fellow I've seen since I left Philadelphia."

The reference Frances made to her brother's careless appearance stemmed from his attire, worn and stained, suiting the bohemian that Emily feared he had become. He wore a hat that one of his classmates said looked like a chamber pot. Earl Shinn described him dressed in a "nattily outlandish costume" that made him look like a fireman. (Firemen at the time did not dress in uniforms but in rough workclothes and were known for their "grubby" appearance.) "He is, however, a laconic companion," Shinn added with a flourish, "silent in seven languages." Eakins expressed total surprise at the reaction of Frances and his father to his attire. "You ought to see me other days," he confided.

Eakins dressed in similar clothes when he met Emily Sartain and the Howells family at the train station the next day. His appearance turned out to be the least of Emily's concerns when she met him. She had arranged the rendezvous at the station so he could meet Howells, whose literary fame and influence in the art community could offer the young painter crucial connections to further his career. Howells had recently been made a senior editor at the *Atlantic Monthly;* the mention of Eakins' name in one of his articles would go a long way to establish a reputation for an aspiring artist. Unfortunately, the initial meeting went poorly, leaving Howells unimpressed with Emily's "beau."

Eakins spent the next ten days escorting Benjamin, Frances, and Emily around Paris and on day trips to Versailles and Fontainebleau. He brought them to his studio, where they expected to see completed paintings, but only rough-looking sketches and studies lined the walls. Despite Tom's assurances that he was making great progress, their disappointment was obvious. Echoing

Overleaf: The children of John Sartain: sons John, William, Samuel, and daughter Emily in the parlor of their house at 728 Sansom Street, Philadelphia, c. 1870 (Courtesy of The Historical Society of Pennsylvania, Philadelphia, Sartain Collection)

the words of Gérôme, he told them that finishing such studies was "lady's work," and would only hold him back.

"There is a common mistake made by those who do not know drawing . . . that one should have the habit of finishing studies," he explained in a letter he subsequently wrote to his father. "This is a great mistake. You work at a thing only to assure yourself of the principle you are working on & the moment you satisfy yourself you quit it for another. Gérôme tells us everyday that *finish* is nothing [and] that head work is all & that if we stopped to finish our studies we could not learn to be painters in a hundred life times & he calls finish needle work & embroidery & ladies' work to deride us."

Benjamin decided the best remedy for his son was another vacation, this time accompanied by himself and Frances. Tom again was reluctant to leave his work. He believed he was on the threshold of a major step forward. Emily scolded him for being so self-centered. "The reviving of old associations and the forming of new ones," she wrote in a note to him, "would restore your right judgment—which I am afraid you have almost lost."

Holding back on accompanying his father and sister on a vacation was just one of several unpleasant topics of discussion between Tom and Emily before she left Paris ten days later. They argued about Gérôme's teaching ability and how Philadelphia's "natural wonders" compared with those of Europe. A more serious disagreement took place after a dinner party. Emily had arranged an evening with William Dean Howells at a fancy Parisian restaurant, to repair the first impression Eakins had made on him.

Emily's efforts did little good. The meal got off to a shaky start when Eakins arrived at the restaurant dressed in much the same outfit he had worn at the train station. Howells, accustomed to being the center of attention, went on to dominate the conversation, much to Eakins' annoyance. One of the more colorful stories Howells told involved his taking financial advantage of a Philadelphia business partner who was alleged to have made a small fortune in a shady government-related business deal. Eakins was indignant that Howells would brag of such a thing. Exactly what he said to Howells that night is not known, but it proved so embarrassing to Emily that she never repeated her mistake of inviting Eakins to meet her father's friends. It was to be the work

of Howard Roberts, not Tom Eakins, whom Howells would later praise in the *Atlantic Monthly*.

"I have never judged a man by his clothes," Tom later wrote Emily in an impassioned defense of his actions that evening. "[Howells] boasted of stealing . . . you heard him tell the story as well as myself."

The disastrous meal led to what Emily considered her final indignity: proof positive of just how corrupted Tom had become. He was escorting her on a stroll through the Luxembourg Gardens the next afternoon when they encountered a group of école students in the company of women of "ill repute." To Emily's surprise, the students and their companions betrayed an unconscionable familiarity with Tom. She was horrified. Eakins must have explained in his own defense that it was typical as well as necessary for students, himself included, to hire prostitutes as models; there was a plaza near the école where prostitutes with unusual or distinctive anatomical features gathered for this very purpose. Emily asked Tom to promise never to hire such a woman to model for him. He refused. Emily and Tom parted company that same day without making any further arrangements to see each other.

"People talked of the temptation of the great city you were going to," she wrote Tom a few days later from Geneva. "I smiled at their fears. I thought of your singleness and purity of heart, and believed too that the warm love you had for me would be a safeguard for you if any were needed. To my sorrow after only two years absence I found you laughing at things you ought to censure, excusing your companions for their vices and even I fear joining with them, making yourself like them. That afternoon . . . when those women passed us the expression on your face was terrible . . . I cried so much that night it made me sick for several days. . . . You are ill, bodily and mentally."

Emily's disdain for his friends, bohemian and professional, was as strong as his dislike of her traveling companion, William Dean Howells. Unwilling to let Tom sink into what she perceived as a morass of sin and degradation, she appealed to Benjamin and Frances for intervention. Her motivation, she said, was not for the sake of repairing her love relationship with Tom. It was for Tom's future.

Eakins was livid at what he considered her continuing meddling in his personal life. "I can't help thinking that Emily has been talking to you about

my affairs," he wrote to his father. "Perhaps she would like me to leave Gérôme & fetch her & see her home . . . & [in Philadelphia] we would drawey wawey after the nice little plaster busty wustys & have such a sweet timey wimey." In closing, he described what he viewed as Emily's Achilles heel. "Her insanity is great people," he wrote, referring to William Dean Howells and, by implication, the John Sartains of the world.

And yet, Eakins' final moments with Emily Sartain convinced him that he truly did need to leave Paris and be with his father and sister, if only to clear his head and assure his father that he had not come unhinged. He set off by train for Turin, in Italy, where he spent an afternoon at the Turin Museum and then joined Benjamin and Frances in Genoa. A day later they set sail for Naples, and after requisite day trips to Pompeii and Herculaneum, proceeded northward to Rome. Next they traveled to Florence, visiting the Palazzo Vecchio, which Frances ventured to say smelled "very bad," and then the Pitti Palace. They spent only two days in Venice. On August 22 they headed north for Munich and made the return trip to France by boat down the Rhine River.

Tom wrote his mother from Munich, talking of beer and paintings. The former, he noted, "comes in covered glasses or earthen mugs the smallest size being a quart." Of the latter, he described the magnificence of Spanish paintings he had seen and the less desirable works of nearly everyone else, including those of Peter Paul Rubens.

They made many other stops on their way down the Rhine. The most notable event had nothing to do with art or geography. Tom mistakenly opened a letter from Philadelphia that was addressed to his father by Will Crowell. The letter was short and to the point: a declaration of Crowell's love for Frances and of his intention to marry her. "It taught me what I never even dreamed of," Eakins later wrote of the incident.

Rather than minding his own business, Eakins promptly wrote to his friend, adopting a self-righteous attitude characteristic of so many of his other letters. He described the nineteen-year-old Frances as "not yet full formed," and hence "not ready and not herself knowing that she is not ready." In his own brash and judgmental way, Eakins may have been revealing that he himself was not ready for marriage and that since he was not ready, Frances, by default, could not possibly be ready either. The next day he apparently had the good

sense to add a postscript before mailing it to Crowell. "All I want to say is that anything I can do to promote the happiness of my old friend & beloved sister will not remain undone."

The situation was far from resolved when Benjamin and Frances left for Philadelphia. Eakins tried to reassure them that he was making progress in his chosen career, and repeated his defense about not completing any paintings. "I am working as hard as I can & have always the advice of a great painter. . . . I have made progress and can equal the work of some of the big painters done when they had only been studying as long as I have & as far as I have gone I see in their works that they have had the same troubles that I have had & the troubles are not few in painting. I have got to understanding much more than I did & though I see plenty of work ahead yet I am not altogether in the dark now but see it plain & sometimes how to catch hold of it. If I live & keep my good health I am certain now of one thing [and] that is to paint what I can see before me better than the namby pamby fashion painters."

Benjamin was not convinced. Before he left with Frances for the United States, or soon after, he elicited a promise from his son to return home for the Christmas holidays. Eakins did make the trip several weeks later, in time to enjoy his mother's cranberry dressing and the long-held family ritual of putting out stockings and decorating the house. If Emily or the senior Eakins harbored any fantasies that Tom was home to stay, they were surely disappointed. After two months in Philadelphia he returned to Paris, this time accompanied by Emily's brother Will Sartain, who planned to study painting with Léon Bonnat, the well-known French realist painter. Eakins' enthusiasm for the life of a Paris art student had not won Emily over to his way of thinking, but it had persuaded her brother.

twelve

The Artist and His Muse

Eakins' appreciation for the teaching of Jean-Léon Gérôme never wavered during the three and a half years he studied under him. "He loved and admired his master," said Susan Macdowell, Eakins' future wife. Gérôme was not, however, the young art student's only teacher, or even one whose style and technique would most be associated with Eakins' later work. Tom's letters home bear witness to a steady movement away from "le patron's" cold and icy surfaces and hard outlines. Eager as he was to extol his master's virtues and talents, he maintained his own identity.

Unlike his friends Harry Moore and Will Sartain, who became only sophisticated imitators of their Parisian mentors, Eakins was able to separate his hero worship from what skills and technique he could incorporate into his own style. This was perhaps why he was having such a difficult time making the transition from drawing to painting. He was not an artist, he said, that "runs his boat, a mean old tub, in the marks . . . of another man." He had to internalize the lessons he was taught, to make them "his own."

"Le patron" himself urged his students to study with other masters, especially while he was away from the école on his frequent trips abroad. Among the other artists Eakins studied under in his master's absence was the école's resident sculptor, sixty-seven-year-old Augustin-Alexandre Dumont, to whom Gérôme frequently sent students when the goal was to improve shaping and giving three-dimensional form in the subjects students chose to paint.

Dumont's art was a fusion of allegory and realism, neoclassical dignity and romantic liveliness and spontaneity. Winner of the Prix de Rome in 1823, Dumont was the last in a two-hundred-year-old family dynasty of painters and sculptors. His colossal *Génie de la Liberté,* a nude winged figure poised on one foot, prominently displayed in the place de la Bastille, had brought him a deluge of important commissions after its Salon debut in 1836. Among the commissions was a figure of Napoleon I, imperially positioned atop a column in the place Vendôme, and sculptures of King François I, Nicolas Poussin, Alexander von Humboldt, and the école secretary Albert Lenoir.

Eakins made no detailed comments in his letters about what he learned under the sculptor, only that Dumont—by personal example—admonished his students to work more with their "fingers and brains, and less with tools,"

Overleaf: Jean-Léon Gérôme, *The Artist and His Model,* 1895. Oil on canvas, 20⅛ × 15⅛ inches. (Courtesy of The Haggin Museum, Stockton, California, Haggin Collection)

advice Eakins later passed on to his own students. He benefited by learning to fashion wax and plaster models to better study a portrait subject's anatomy. Howard Roberts, who was also studying under Dumont at the time, apparently took from the sculptor much more. His work, along with that of Mary Cassatt, was featured in the Salon the same year, in 1868.

Lessons learned in Dumont's classes had at least one positive effect on Eakins. "My hard work since I have been back here is telling on me & my studies are good," he wrote home in September 1868. "My anatomy studies and sculpture, especially the anatomy, comes to bear on my work and I construct my men more solid and springy and strong. It makes one catch forms quicker & the slight movements of the model don't hinder or worry me, only show me plainer what I am doing."

Not long after entering Dumont's studio Eakins began intensively studying the paintings of Thomas Couture, a former classmate of Gérôme's during Couture's early years of apprenticeship at the école. He too was a realist. His work was more relaxed and less polished than Gérôme's, even though it took him just as long to complete a painting and required equally intensive preparations. His work appeared fresher and more animated than Gérôme's, a result of Couture's brighter colors and more highly textured surfaces. Eakins later described Couture as a "grand talent" and paid him the highest compliment he could bestow on another artist: he compared him to the Greek sculptor Phidias.

Couture was living outside Paris at the time, and Eakins tried unsuccessfully to meet him; he did study Couture's art on exhibit at the Salon of 1869 and purchased the painter's classic text, *Conversations on Art Methods,* published in 1867. Like Eakins, Couture was quite judgmental. Formal art education, the artist believed, was a luxury of use only for gentlemen seeking to "speak syntactically and cite Latin aphorisms," like "social parrots." He instead urged students to read voraciously. "You are young," Couture declared. "Digestion is easy for you." The point in which Couture agreed with the academic program was his conviction that the essence of great painting was learning to draw. "Musicians will tell you: scales, scales, scales. I tell you: drawings, drawings, drawings."

The most important lesson Eakins absorbed from his study of Couture

was the artist's emphasis on modernity. Couture felt that whatever his pupils looked at, whether ancient statues or paintings by the old masters, they must learn to see with their own eyes, not filtered through the work of others. Couture declared: "Human nature is always the same, but changes of governments, religions, and beliefs make human feelings appear in new guises; they take other forms, other aspects, and necessarily give rise to new arts." Studying the old masters, Couture said, was a way to learn the language of art. Once fluency was achieved in that language, it should be applied to the artist's own times and events.

Couture's advice helped Eakins along the path toward recognizing which subjects he wanted to paint. Studying Couture's work, however, did not help with what was still his greatest challenge: balancing one color with another. "Everything is in a muddle," Eakins admitted. "Even the commonest colors seem to have the devil in them. You see a thing more yellow, you put yellow in it, and it becomes only more gray when you tune it up. As you get on you get some difficulties out of the way, and what seems trying is that some of the things that gave you the greatest trouble were the easiest of all. As these difficulties decrease or are entirely put away, then you have more time to look at the model . . . and your study becomes more regular and the works of other painters have an interest in showing you how they had the same troubles. I will put my study as far and as fast as I can, [and] now I am sure if I can keep my health I will make better pictures."

Gérôme again left toward the end of the spring semester in 1869. In his absence, Eakins elected to study at the independent studio of Léon Bonnat, along with Will Sartain, in Montmartre. The choice was a good one for an artist still coming to grips with his palette. Color was one of Bonnat's specialties. Eakins never established the same lasting relationship with Bonnat as he did with Gérôme, but the influence Bonnat had on his later work was significant. Gérôme had taught Eakins to think like an artist; Bonnat helped him use technique to become one.

Born in Bayonne, in the Pyrenees, and raised in Spain, Bonnat studied at the Royal Academy in Madrid before arriving in Paris to enter the école. He distinguished himself with his debut at the Salon of 1857 and was named runner-up that year for the Prix de Rome. Bonnat eventually received the Le-

gion of Honor, in 1867, the same year that Eakins came to Paris. Like Gérôme, his friend and confidante, Bonnat came to enjoy the favor of the royal family, particularly of Empress Eugénie and Princess Mathilde; these ladies devotedly collected Bonnat's genre portraits of Italian peasants. Unlike Gérôme, Bonnat gave early interest and support to the impressionists. He championed the work of Edouard Manet and Gustave Courbet, as well as Edgar Degas; he and Degas became lifelong friends.

Bonnat, a realist in the Spanish baroque tradition, was deeply inspired by the paintings of Francisco Goya, Diego Velázquez, José de Ribera, and by Rubens and Rembrandt. It was not their subject matter he adopted, or their style. Lessons he took from earlier masters were in the line of superior construction and draftsmanship skills. Along the way he acquired the darker and more brutal aspects of Spanish realism, qualities that critics described as "unsettling representations of human anatomy." Bonnat went to great effort to capture the realism of this mode, sometimes requiring his subjects to sit fifty or more times before completing their portraits. The essential words to describe Bonnat's paintings, as well as his teaching style—as one of his students reported—were "truth and logic." Such a credo and practice appealed to Eakins: here was an artist who could, without resorting to myth and allegory to put a message across, apply color and texture in a way that conveyed truth. Like Eakins, Bonnat studied the human body with an almost religious passion.

Bonnat's personal struggles as an artist also resonated with Eakins. Writing to his father, Eakins related how Bonnat, as a young art student, had been deeply troubled by his teacher's wanting him to paint the same way he did. Bonnat couldn't oblige. "He saw better than his teacher, although he [Bonnat] was doing such bad work [at the time]," Eakins went on. "His teacher told him he would have to stop painting, & then he went to [another teacher who] . . . told him to go and be a shoemaker, that was all he was fit for. A few years more & he was as big as the biggest of them."

Many prominent figures in the Paris art world told such stories. Bonnat's travails had all the more impact on Eakins because he was only eleven years older than the younger artist. His earlier troubles were still fresh in his mind. His example gave Eakins strength to carry on in his own independent way.

A new self-confidence appeared in the letters Eakins sent home. "I am

less worried about my painting now," he wrote in March 1868. "I see color & I think I am going to learn to put it on. I am getting on faster than many of my fellow students and could even now earn a respectable living." In a follow-up letter written later, Eakins expanded on this theme: "I am getting on as fast as anyone I know. . . . One terrible anxiety is off my mind. I will never have to give up painting, for even now I could paint heads good enough to make a living anywhere in America, I hope not to be a drag on you a great while longer."

In spite of his apparent breakthrough, he was still determined to stay in Paris a while longer. "There are advantages here which could never be had in America for study and I will improve more this year than ever before. . . . I am [still] a little child yet alongside of the big painters around me and fear I will be for some time yet."

In his alternating bravado and apprehension, the artist no doubt sensed important new courses and challenges on the horizon, and by the autumn of 1869 the moment he had longed for finally was in sight. "I feel now that my school days are at last over and sooner than I dared hope. What I have come to France for is accomplished, so let us look to the Fourth of July . . . [as the day I will return home]. My attention to the living model even when I was doing my worst work has benefited me and improved my standard of beauty."

In the same letter Eakins compared himself with his fellow students and explained once again why he had been so adamant about taking one step at a time, and not rushing forward to complete a painting before he was ready. "The French boys sometimes do and learn to make wonderful fine studies, but I notice those who make such studies seldom make good paintings, for to make these wonderful studies they must make it their special trade, almost must stop learning, and pay all their attention to what they are putting on their canvas rather than in their heads, and their business becomes a different one from the painter's."

This theme, a key to Eakins' artistic instinct and temperament, was one he elaborated at length. "An attractive study is made from experience and calculations," he wrote. "The picture-maker sets down his grand landmarks and lets them dry and never disturbs them, but the study-maker must keep many of his landmarks entirely in his head, for he must paint at the first lick and only part at a time, and that must be entirely finished at once, so that a wonderful

study is an accomplishment and not power. There are enough difficulties in painting itself, without multiplying them, without searching what it is useless to vanquish."

In closing this letter Eakins wrote about his relationships with Gérôme and Bonnat. "Sometimes I took all advice, sometimes I shut my ears and listened to none. My worst troubles are over, I know perfectly what I am doing and can run my modeling, without polishing or hiding or sneaking it away to the end. I can finish as far as I can see."

thirteen
Picture Making

Eakins continued his progress through the winter months of 1869–70. He proudly wrote his father on November 5, 1869, that he constructed figures "as well as any of Gérôme's boys," and that his "handling of color was improving." He would definitively be shifting away from sketches and studies and beginning to paint complete pictures. Before coming home, however, he felt he still needed to learn to paint outdoors, a practice he believed would strengthen his perception of light and his use of color.

For winter vacation he planned to go abroad, either to Algiers or Spain, and return to Philadelphia in the summer. He envisioned the southern trip as a way to further his painting skills while compiling a portfolio of subject matter for future compositions. A return to Philadelphia right away was also out of the question because he was in no condition to make a winter crossing. Chronic intestinal problems and a persistent cough plagued him. In his damp room, bitter drafts blew in under the doors and window sashes. For a boy who had scarcely had an unwell day in his life before coming to Paris, he was now at times finding himself sick in bed for days at a stretch.

Eakins bought a ticket to Spain, a natural choice since both Gérôme and Bonnat advised many aspiring painters to complete their training in that country, or at the very least to make a pilgrimage of discovery there. As early as the 1830s, French writers and critics had praised the Spanish masters—Velázquez and Ribera and Goya—for their realistic representations of nature. "I will go straight to Madrid," he told his father, "stay a few days to see the pictures, & then go to Seville."

Fellow students from the école came to see him off at the station in the pouring rain on November 29, 1869. "I suppose you would laugh to see us all a hugging & kissing one another," Eakins wrote, "but that is the French way." Rain was still falling and a cold wind blew off the mountains when the train crossed the border, but as the cars descended the Pyrenees, his spirits lifted. The next day Eakins checked into the Hotel de Peninsular in Madrid. "The sun got up in a clear sky," he wrote to his father, "a thing I had not seen for a very long while."

After Paris, the trip was a much needed tonic. He found the Spaniards

"better than any people I ever saw," and Madrid the cleanest city he had ever been in. "The ladies of Madrid are very pretty," he declared, "but not so fine as the American girls." Such comments were unique in the greater body of Eakins' often critical correspondence, and must have come as a refreshing surprise to his family. So too must have been his announcement that he had attended mass. Other than to remark on the organ music and that there were no seats for worshipers, he made no comment on the experience. It was clear from this letter, however, and several comments he made in other letters, that despite his apparent agnosticism he had a fascination for the church that went beyond mere curiosity.

His enthusiasm for Spain swelled to outright excitement when Eakins visited the Prado Museum. Brimming with obvious delight, he reported to his father that he had finally seen "big painting." Such unbridled elation by a young artist who was familiar with the Louvre might at first seem out of character. The truth is that he really had not seen many Spanish paintings and was unprepared for the impact they had on him. Only one great collection of Spanish art, assembled in 1830, had traveled out of its home country, and only isolated examples of individual paintings could be found in various European museums. Not until the 1870s did collections of Spanish masters appear in Paris, and not for many more years would they reach the United States. Eakins was one of the first of his generation to study the art of Velázquez in its native setting. It is important that Eakins had progressed sufficiently by this time to appreciate what he saw in ways he may not previously have been able to do.

Discovering Spanish art was his pivotal European encounter. Velázquez's paintings struck Eakins as technically brilliant and at the same time "raw." They were public in their straightforward presentation, and yet strangely private and intimate. The Spanish master had managed somehow to build a style based on coolly rational and precise draftsmanship, embodying within it at the same time a sensuous and emotionally charged physical component. His paintings were forever after the personal benchmark Eakins set for his own work. He wrote: "Now I have seen what I always thought ought to have been done and what did not seem to me impossible. O, what a satisfaction it gave me to see the good Spanish work, so good, so strong, so reasonable, so free from every affectation."

Eakins filled pages of his notebooks with references to the paintings he saw at the Prado. The artists he wrote about included a diverse group of Europeans: Giovanni Benedetto Castiglione, Paolo Veronese, Anthony Van Dyck, and Titian. The great majority of his notes, however, dealt with observations on the Spanish masters: a still life by Luis Meléndez, a royal group portrait by Goya, the work of Ribera and Velázquez.

The single painting that captivated him the most, causing him to declare it "the finest painting" he had ever seen, was *Las Hilanderas,* by Velázquez. The mythological scene represents a dispute between the Arachne of legend and the goddess Minerva over their skills as weavers. Eakins was entranced by the brilliant immediacy of the painting. It seemed to mingle an unheard hum of the weaver's wheels with subtle shifts of color in light, creating a silent suspended moment in time. The painting palpably reached out to him and drew him inside the artist's illusion. Though it was clearly the result of cunning design and complex harmonies of color, the scene seemed to have been brought to life in a single instant, as in a vision.

What impressed Eakins most about the work of José de Ribera was technique. The artist layered paint and glazes to create definition in the shadows and endow his paintings with surfaces and depths that were luminous. Ribera's colors, Eakins said, "are almost made to slide on," even though the paint itself was thick and heavy. The technique was indirect and subtle, providing simultaneously, as he said, "both delicacy and strength."

Study of Velázquez, Ribera, Rembrandt, and Titian showed Eakins the richer qualities of the oil medium toward which he had been working instinctively. He had found, at last, artists whose viewpoint corresponded to his own. "I have seen the big work every day and I will never forget it," he wrote. "It has given me more courage than anything else ever could."

Notebooks from the Prado viewing also contain evidence of Eakins' limitations in knowledge and appreciation of art history. It was most pronounced in his appraisal of the Flemish painter Rubens; Eakins declared that he did not stand up to scrutiny. "Rubens is the nastiest most vulgar noisy painter that ever lived. His men are twisted to pieces. His modeling is always crooked . . . his people never have bones, his color is dashing and flashy. . . . His pictures always put me in mind of chamber pots and I would not be sorry if they were

all burnt." Eakins was blinded, one might say, to the various levels of meaning and allusion in the paintings of Rubens, and predisposed, given the direction of his own work, to be brutal. In the end, however, he did not let his dislike of Rubens detract from his enjoyment of the Prado or the rest of his trip to Spain.

His next stop was Seville in the Andalusian south, where, because of his dark coloring, he was often taken for a Spaniard. On December 4, 1869, he registered at the Hotel de Paris on the Plaza Magdalena, and then a week later found a larger and less expensive room at the Pasada Lobo on the corner of Espejo and Cid streets, in the heart of the city. He toured extensively, visiting the royal palace and other grand monuments of Spain's former rulers. He found Moorish architecture as "perfect an architecture as the Egyptian, Greek or Gothic and just as beautiful, maybe more beautiful & it is well built for it looks as new as if had just been done." He paid special attention to the Moorish influence, noting that it was the Moors who did the "big work for us" by their contributions in math, chemistry, astronomy, and geometry.

In the days that followed, Eakins witnessed a bullfight, reveled in Spanish music, and developed what became a lifelong fondness for Spanish cuisine. He found it easy to make friends with people he hoped someday to paint. His notebooks preserve many of them—Manuca Mermude, a "beau garcon" of eighty years old, Cencion García, a seventeen-year-old described as "tres belle," and the Flore family—Rosa, Pepe, and Juan—who lived at 80 Calle Verbena. "I know ever so many gypsies, men and women, circus people, street dancers, theatre dancers and bullfighters. The bullfighters are quiet, gentle-looking men."

Eakins' excitement about Spain and the Spanish was contagious. Harry Moore announced he would join his friend in Seville in January. Not to be left out, Will Sartain also said he would come. The three of them worked together for the next five months in the city of Seville and joined in several horseback excursions into the surrounding countryside.

"I am painting all the morning till three," he wrote his father. "Then I walk out into the country with Harry Moore. Then back to dinner, and then we sit in the dining room by the fire and talk, for I am the only one that can talk with him. . . . I am very well, and it seems to me when I breathe the dry

warm air, and look at the bright sun, that I never was so strong, and I wonder if I can ever be sick or weak again. The Spaniards I like better than any people I ever saw, and so does Harry Moore. He notices things, more than ordinary people, and remarks the absence of every servility and at the same time a great watching for the comforts or feelings of others. He can see farther out of the corner of his eye than anyone I ever knew."

Eakins wrote in particular about the three Philadelphians exploring a path along a river. It reminded him of walks at home in Fairmount Park. At every quarter of a mile they came to small gatherings of Spanish men and women, "much like our old picnic parties," Eakins said. They stopped a long while with one party, and passed the afternoon drinking wine and dancing.

"We take a day most every week to do nothing," one of Eakins' letters said. "Then we get horses and gallop off into the country, as we mostly average forty miles and that makes us sleep well. It is more pleasant than walking, for we go so fast and far, and then rest all the middle of the day and look at the sky and eat our dinner." In this fashion they explored the country for miles around Seville, visiting many of the small towns, and on one expedition of nine days to Ronda and the wilds of Andalusia they visited a medieval church and discovered what they believed was a triptych by Rubens, *Descent from the Cross*. Will Sartain described his excitement in a letter home: "It was hanging in rags at places & with holes through it. I remarked in Spanish (which by this time I was able to talk) that they [the parish priests] ought either to sell it or repair it. The next day the priest sent word that he would sell it—would I buy it? I agreed to do so for $200 and thought I had secured a marvelous bargain."

Back in their Seville studio the three Americans worked long hours at their canvases from the first light of day into later afternoon, sharing the same models. One of the first they singled out was a young gypsy street dancer named Carmelita Requena. Eakins persuaded her to pose in return for coins and candy. "She is only 7 years old and has to dance in the street every day," Eakins wrote his father. "But she likes better to stand still and be painted."

The bust-length portrait he made of Carmelita, now at the Metropolitan Museum of Art, is one of Eakins' first completed paintings. She is portrayed in profile, turned to the viewer's right, her head slightly bowed and her eyes half shut. As in Eakins' other studies from the école, she is silhouetted against

a neutral and undifferentiated background. Light enters from the upper right. It is strong, acrid sunlight, rather than the soft modulated light of the studio, and pulls the delicately modeled flesh tones of Carmelita's head into sharp relief, resonating with the vibrant red, white, and blue of her costume.

The painting is not very good. The saturated red and blue of Carmelita's jacket give little indication of its texture and quality. The shadows are muddy and without form. Across her shoulders and chest, Eakins loses control of her anatomy as well. He acknowledged his failure in this portrait and others he attempted to paint of her outside while she stood on the roof of the hotel where he was staying. "The trouble of making a picture for the first time is something frightful," he wrote home. "You are thrown off the track by the most contemptible little things that you never thought of & then there are your calculations . . . your paint is wet & it dries slow, just to spite you, in the spot where you are the most hurried."

Eakins was still green. He had not acquired enough familiarity with the various drying properties of his oil pigments, and his colors ran together. He knew and it bothered him. "Picture making is new to me," he said. "There is the sun & gay colors & a hundred things you never see in a studio light & ever so many botherations that no one out of the trade could guess at."

His Spanish notebooks are full of these and other thoughts about light. The challenge was to secure the utmost range of color and tone that the palette could offer, while still keeping within nature's scale of light. As he discovered, he could not apply pure white to appear in the daylight, as it would require lowering all the other values and thus restrict the picture's overall luminosity. Unlike the impressionists, he wasn't interested in light as a unique painterly subject itself, but rather for what the phenomenon of light revealed of form.

Eakins next began the most ambitious of his early efforts. He described its design as "the most difficult kind of picture," and predicted that "something unforeseen may occur" between concept and completion. This time Requena is presented dancing in a sunlit street while her father blows a horn and her mother beats a drum. The shadows of unseen spectators fall across the pavement. A woman with a child in her arms is watching from a window, and over a wall behind can be seen the roof of a palace, a palm tree, and the azure sky.

After more than a month he was still working on the same painting. "I

am not in the least disheartened," he wrote of the experience. "I will know so much better how to go about another one. My picture will be an ordinary sort of picture, with good things here and there, so that a painter can see it as at least earnest clumsiness."

This painting, now in the private collection of Erving and Joyce Wolf of Houston, Texas, has become known as *A Street Scene in Seville* (1870). It is clearly a labored canvas, showing marks of many changes and repaintings. The pathway of upper atmosphere and yellow sun, for example, have been painted so many times that the sunlit sky appears washed out, and the wall Requena dances against carries so much shadow that its flat expanse of neutral brownish-gray causes the three musicians to dwindle and dissolve. He had worked too quickly and impatiently, applying more paint and thicker layers before the underpainting and other preliminary layers dried. As a result the highlights soaked into the shadows. And notably, Eakins was unable to convey the central act of the scene, Requena's movement. Instead of enlivening her dance, her feet seem stuck to the cobblestones on which she performs. Yet this celebration scene is not without character and originality. Like his paintings to come, it spins out a fine sense of narrative.

At the end of the spring, having spent half a year in Spain, Eakins and his two companions departed Seville. Moore went on to Granada, there later to fall in love, marry, and also begin his professional life as an artist. Eakins and Sartain traveled northward, arriving in Paris at the beginning of June. Eakins lingered for two weeks, visiting friends and viewing the Salon of 1870, before boarding a steamship for home. The showpiece of the exhibition he had just seen was Henri Regnault's *Salomé,* and Eakins made careful notes about it.

More important than what he saw at the Salon was what he failed to see. A gallery outside the Salon had mounted a group of paintings that the école teachers and the show's administrators had rejected. The art in this "Salon des Refusés" was so radically different from Eakins' own sensibilities that it is doubtful whether he would have cared for the work even if he had seen it. Manet and his obscure group of eccentrics, who came to be known as impressionists, were only slightly older than Eakins. They painted in the open air and argued in the cafés about problems of sunlight, atmosphere, and pure color. It was still four years before they held their first independent exhibit,

but the revolution they ignited was already under way. Independent painters, sculptors, and writers began to link arms in anti-institutional solidarity, producing innovative and provocative works, and a spirit that would end the academic dominance of the école.

Similarly explosive political upheavals had also begun that would clear the way for the impressionist movement to take hold. On July 19, 1870, less than a month after Eakins embarked for Philadelphia, France declared war on Prussia. Paris itself was soon under siege. More people would be killed in a single week under German occupation than were during the six years of the French Revolution eighty years before. Napoleon III would be sent into exile, and many of the great "Palaces of the People"—with three notable exceptions, Versailles, the Louvre, and the Luxembourg Palace—would be knocked down or put to the torch.

Artist and Educator

fourteen

The Road Less Traveled

Back in the New World, Philadelphia was expanding outward and upward. The 1870s saw the demolition of the old Temple of fine arts and its rebirth as a Victorian cathedral, complete with vaulted ceilings and rose window. A block away, renovation was completed on the Masonic headquarters, a towering Romanesque fortress of multicolored turrets and spires. The new City Hall, erected like a castle starting in 1871, eventually dwarfed both buildings. Its four-and-a-half-acre complex of soaring colonnades, pediments, and cornices would be lauded by city fathers as the largest, most inspired municipal office in the nation. Less admiring appraisers merely called it "that perfected miracle of ugliness and inconvenience." The great Gilded Age cover-up had begun.

The building spree accompanied a buying spree, as Philadelphia's titans of industry joined their New York counterparts in ransacking European galleries to decorate new municipal palaces and grand homes. They purchased paintings by the square yard and sculptures by the pound. One French painting in particular, *Paris by Night,* hung in a massive arena across the street from the Academy of the Fine Arts, required forty thousand square feet of canvas and several hundred gallons of paint.

Along with European masterworks came plush draperies, chandeliers, fringed bell-pulls, and potted palms. The more ornate and ostentatious, the better. Female clothing grew heavy and voluminous, evolving into strangely shaped bustles and requiring elaborate constructions of whalebone, velvet, and crinoline, which covered the body from head to foot. The most mundane and simple objects attracted coverings of the pretentious and overdecorated, concealing what lay beneath with what was implied to be high art. Painters, too, were expected to embroider tedious reality by producing grandiose landscapes and flattering portraits in massive gilt frames. The only rule was that paintings be pictorially pleasing, expressive of the pervading spirit of prosperity and optimism.

The challenge for Eakins and other artists returning home from abroad was how to secure a place in the burgeoning new art market. Many painters simply chose not to. They found the insular cosmos of Philadelphia society —and its New York counterpart—provincial, their entrenched academicians resistant to all modern movements, and their patrons bullheaded and crass.

Overleaf: The Pennsylvania Academy of the Fine Arts, c. 1878; photograph by Frederick Gutekunst (Courtesy of The Pennsylvania Academy of the Fine Arts, Archives)

Mary Cassatt had arrived back in Philadelphia the year before Eakins did, and was the first to give up trying to earn a living there as a painter; along with Emily Sartain, in 1871, she returned to Paris. Howard Roberts, who had dedicated himself to sculpture, chose to straddle both sides of the Atlantic: he opened studios in Philadelphia and in Paris. Earl Shinn gave up painting altogether and chose instead, like fellow Philadelphia Sketch Club founder William J. Clark, to become an art critic. Charles Haseltine, another Sketch Club member and former academy student, also gave up painting; he opened galleries in Philadelphia, New York, and Boston, primarily selling imported European art.

Eakins, for one, never considered heading back to Europe or giving up an art career. He loved Philadelphia as much as he loved painting. He also had the unqualified support of his family; they believed in him as he believed in himself.

To welcome his son home from abroad Benjamin had renovated the unfinished fourth floor of the Eakins townhouse. His plan was for a large, light-filled studio with comfortable furniture where he and his son could work side by side and Aunt Eliza could sit in a rocker and be entertained by them. Tom had not been consulted. The arrangement he counterproposed put his father back into the parlor and his aunt and her rocking chair beside the downstairs fireplace. Except for his sister Margaret's dog, Harry, who took an immediate liking to Tom, the new studio would belong exclusively to him. The carpet and comfortable furniture were removed, soon to be replaced by paint-splattered dropcloths, fifty-pound sacks of plaster, and clay for modeling.

Eakins set to work immediately. Right from the start he elected to focus on portraiture, a decision driven as much by his dedication and interest in anatomy and the human form as it was by a desire to earn a living. Philadelphia had no genre or landscape movement comparable to that of New York. "Painting heads," as Eakins referred to portraiture, was a sure-fire way for a Philadelphia artist to earn a living. He saw himself stepping into the illustrious tradition of the Peale family, Thomas Sully, and John Neagle, whose portraits of the city's prominent scientists, physicians, merchants, and clergymen were displayed in prominent buildings with honor.

The first subjects he chose for portraits were friends and family. Their

modeling services required no monetary compensation and they could be counted on not to be overly critical of his initial efforts. He also felt compelled to focus on his family for other reasons. His mother, Caroline, had begun a slow descent into mental illness. Her condition, diagnosed as mania, was considered in textbooks of Eakins' day as a "mental malady," what is now described as manic-depression—bipolar affective disorder—or psychosis.

Caroline's medical records do not now exist, but in an era when many toxic conditions and nutritional deficiencies were poorly understood and frequently mistaken for mental disorders, the diagnosis was not uncommon. Her attending physician, Dr. William P. Moon, who was affiliated with the Philadelphia Hospital for the Insane, may well have followed then-current medical opinion that such a condition was brought on by menopause, or the result of too much exercise. Patients over the age of thirty-nine were considered incurable; Caroline was fifty. The most popular medical textbook of the time described changes undergone by a female patient, approximately the same age, with a similar diagnosis. The patient, said to be "an image of candor and virtue, equally amiable and modest, whose lips were never opened but to utter mild and generous sentiments," became, in her later years, a woman whose "mildness is converted into ferocity" and who "utters nothing but abuse, obscenity and blasphemy."

Signs of Caroline's early discomfort must have been apparent while Tom was in Europe. In a letter he wrote to his sister Frances on March 26, 1869, Eakins said he was "anxious" about his mother and asked his sister to "write . . . to tell me about Mommy." Eakins may still have been getting settled in his upstairs studio when Benjamin had Caroline briefly admitted to a Philadelphia hospital. Upon her return home, she was confined to her bedroom. Treatments would have included ice-cold baths two or three times a day, cold compacts, purgatives, and digitalis—a potentially lethal drug derived from the plant group known as foxglove. Everyone in the family must have felt the tragedy deeply, though they dealt with the crisis in private.

"Tom Eakins has been at home since July 4th," a family friend wrote to her daughter in the summer of 1871. "Since early autumn he has never spent an evening from home as it worried his Mother & since her return home [from the hospital] they never leave her a minute."

The absence of medical records and the near total lack of references to Caroline in extant correspondence make it impossible to know how her condition affected the family. Lloyd Goodrich, Eakins' first biographer, avoided speculation altogether, as has art historian and biographer Kathleen Foster, the leading authority on Eakins. Henry Adams, in *Eakins Revealed,* takes an extreme position by presuming that Caroline's manic episodes led to extravagant sexual behavior, and that this behavior may have given rise to an incestuous relationship between Eakins and his mother.

Provocative as it may be to consider a Freudian interpretation of presumed events in the Eakins household, doing so requires conjuring conclusive evidence from doubtfully applied theory and interpretation alone, and blatantly ignores the mutually supportive family bonds that existed among Eakins family members, and their choice, individually and as a group, to live peaceably and happily together under the same roof. Two sketches Eakins made, presumably from his early student days, show what appears to be Tom's mother affectionately cradling the infant Caroline, her namesake, in her arms. A letter Eakins wrote home from Europe suggests that his mother enjoyed family trips to Fairmount Park and other outdoor activities. Another letter makes reference to her cooking and doing needlepoint. "I never met such a devoted family as the Eakins," said one of their neighbors.

There would be no hints of a falling out between family members until sister Caroline, at age nineteen, married an avowed enemy of her brother in 1884, more than a decade after the death of their mother. Nor is there the slightest shred of evidence to suggest a sexual relationship between Tom and his mother. Rather, the evidence, taken at face value, suggests that Eakins was a normal, well-adjusted, and dutiful son. Along with his siblings, he was also a dedicated caregiver.

The single thing that can be said with certainty is that Tom turned to his seventeen-year-old sister Margaret for emotional support in this crisis. He also enlisted her for modeling assistance in the pursuit of his art. Their relationship soon became a deep and affectionate one. She lived with an independent hardiness much like his own, and her growing devotion to music corresponded to his passion for art. She too loved the outdoors and frequently joined him in sailing trips on the Delaware River, hikes along the Schuylkill, and target

practice with shotguns on the beach at Manasquan, New Jersey. Although she was not beautiful according to the standards of the day, she had a trim figure that was strong and supple, "like an animal," said one of her friends.

Margaret in Skating Costume, one of the first portraits he painted in 1871, reveals some of the difficulties and challenges—encountered in Spain in his first portraits—that Eakins had in getting started with his career back in Philadelphia. He was struggling to see and capture her likeness. Her dour and pained expression in this portrait may well be a result of his endless revisions and her hours of posing, rather than a characteristic of her personality. Besides her seriousness and glum look, little of Margaret is revealed. Her eyes, dark and lacking transparency, look downward without a hint of a smile. The portrait, which now hangs at the Philadelphia Museum of Art, is not much of an improvement over *Street Scene,* which he had painted several months earlier in Seville.

Portrait of Frances Eakins, another of his early efforts, is equally wrought with problems. He portrayed his twenty-two-year-old sister Frances in a white gingham dress tied with a red sash, seated in the Eakins parlor and playing the family's baby grand piano. Her head, pictured limned in profile, has little depth or obvious character and appears flattened against a brownish-gray wall behind her.

Eakins went on to paint several other scenes in this parlor with various of his sisters, either playing the piano or listening to others' music from it. The most successful is *Home Scene,* a twenty-one-by-eighteen-inch canvas now hanging in the Brooklyn Museum of Art, which Eakins likely painted in late 1871 (plate 2). The degree of improvement from his first efforts is remarkable. In *Home Scene,* he portrays Margaret taking a break from her piano playing. She glances down at seven-year-old Caroline, who is stretched out on a brocade carpet studiously writing or drawing on a slate chalkboard. Margaret rests her head in one hand and plays with a kitten that sits on her shoulder. A black cat, perhaps the mother of the kitten, stands behind Caroline, looking as if it has wandered into the scene while searching for its infant. A strong illumination from a window highlights the side of Margaret's face, her magenta-trimmed gray vest, and an open music book.

Eakins had taken a step—critical in retrospect—closer to capturing the

kind of narrative moment that would become his trademark. The half-darkened Mount Vernon Street parlor now has a particular ambiance. Its air of stillness is almost palpable. So too are Margaret's reflective gaze and her understated affection for her younger sister. Margaret is deep in thought, inviting the viewer to wonder what is running through her mind. Her posture and gesture create tension. Time and light seem suspended. The moment captured is a turning away from the sights and sounds of the world. It's an inward vision of the mind at work.

The same care and quality of construction in light and composition informs paintings Eakins made a few months later of Will Crowell's sisters, Elizabeth and Kathrin. They too were natural choices to appear as models for his early paintings, because Will was courting Eakins' sister Frances and Benjamin was tutoring Elizabeth in penmanship.

The younger of the two Crowell sisters, Elizabeth, whom family friends described as "very vivacious as well as pretty," is featured in *Elizabeth Crowell with a Dog* (plate 3; San Diego Art Museum). This portrait, painted on a fourteen-by-seventeen-inch canvas in 1873–74, emerges as by far the most ambitious, and perhaps most successful, of Eakins' early paintings. The domestic scene is once again acted out in the Mount Vernon Street parlor. Elizabeth, dressed in a black skirt, red blouse with black stripes, and elaborate white hat, is seated on a colorful carpet and leaning forward. Her outstretched hand is directed at Tom's dog Lizard, which has a cookie balanced on its nose. On the floor in front of Elizabeth several books are strapped together, suggesting that she has just come home from school. In the background the Eakins family piano is draped, almost ceremoniously, with a rust-red cover. An article of clothing, presumably Elizabeth's jacket, is casually laid on top. Nearby is the famous—in years to come—Eakins armchair.

Like the best of his paintings from this time forward, *Elizabeth Crowell with a Dog* captures the subtlety of a moment from everyday life: a teenage girl home from school, caught unawares as she trains a dog to do a trick. The narrative is saved from sentimentality by the serious, concentrated look in Elizabeth's eyes. There is no overt or subjective viewpoint, only the presentation of the moment. The power of the painting comes from an undertone of reserved but intense connection between girl and pet, and the viewer's

anticipation of what will come: Elizabeth will give the signal and Lizard will flip the cookie into the air and catch it in his mouth. Tom, no doubt, had taught Lizard this trick as he did Harry, Margaret's dog, who could toss a cookie all the way to the ceiling before catching it.

Of Eakins' paintings in this early period, the largest is one he made of Elizabeth's older sister in 1872, titled *Kathrin* and now hanging in the Yale University Art Gallery. The four-by-five-foot canvas poses the twenty-one-year-old Kathrin Crowell in a white dress in the Eakins armchair. In one hand she holds a red fan, and with the other she strokes a cat resting on her knee. She too has been unobtrusively observed. The viewer is left feeling as if the artist had been surreptitiously watching her from the next room through a partially opened door. The connection she has with her cat, similar to the way her sister was painted with the dog, evokes a deep and very humanist sentiment free from artifice.

In *Kathrin,* like the paintings he had made of his sisters, Eakins was developing a portrait process, to go with an inner vision he had arrived at to incorporate in his art, that he would repeat and refine throughout the rest of his career. Working from sketches and studies, Eakins first laid the picture out in thin color underpainting, probably covering the entire canvas in one sitting. Using thick colors, chosen to heighten or give the right under-hues for the eventual surface, he then established the first large masses and chief tones, then built the color up in semitransparent layers until the subjects depicted became more solidly formed. Most routinely he would do the heaviest painting around the subject's head and hands, leaving the background relatively transparent until the final stages of completion.

As he would in paintings to come, Eakins gravitated to dark, warm colors, mostly browns and grays. Flesh tones were equally dark and muted, with touches of red and yellow to give them a sensuous and rosy glow. Even in his brightest outdoor paintings his palette never approached the brilliant range of the impressionists. That he painted almost exclusively in a studio, by oil and gas light, could well have contributed to the lower tonal range. But the clothing of the times was dark, too, because it was easier to brush off and keep it looking presentable. Also dark were the red bricks and masonry used to raise most Philadelphia homes, the elephant-colored cobblestone streets, and the

surroundings of dark greens and browns of the Pennsylvania countryside. Chromic brilliance did not concern Eakins, only how it was subtly integrated with the form, space, and texture of the environment he depicted.

Light in these early paintings almost always originated from the left. Its source is rarely revealed, usually suggested only by shadows and the varying intensities of the colors. Although both of the Crowell sisters' paintings are extremely dark, the shadows are not impenetrable. Bright accents in these shadows lend substance and a sense of physical space. Tiny points of color reflect in the dark wood of the piano, in the bristling hairs on the pets, and in the folds of their dresses. Like the Spanish masters and Rembrandt, from whom he learned this technique, his use of light and shadow was a means of shaping subjects in ways far beyond the depiction of color. It is such careful modulation and contrast of light, more than anything else, that distinguishes Eakins' early accomplishment. He has learned, as he previously said in a letter to his father from Europe, to steal the "tools of nature," most specifically "what she does with light," which he declared was "the *big* tool."

Had there been any doubt of Eakins' promise as a portrait painter, his family was surely relieved by the time he finished *Home Scene* and *Elizabeth Crowell with a Dog*. Margaret, who was as opinionated as Tom, stepped in to manage her brother's career, and in the future she took on the significant task of keeping an ongoing record of his paintings and handling the correspondence and shipping related to their exhibition.

The arrangement proved to be a good one. Thomas could count on Margaret to tell him the truth, however painful as that could at times be. An example is the failure of an experimental watercolor inspired by a Longfellow poem. In one of his rare attempts to portray a romantic or sentimental theme, he pictured the breathless Hiawatha standing above the dead spirit guide, the corn angel. "It got so poetic . . . that when Maggy would see it she would make as if it turned her stomach," Eakins reported later on. Perhaps by mutual agreement the painting was destroyed. Later watercolors were far more successful.

Maggie's plan, and Tom's too, was to focus on public exhibitions as a way of garnering his first sale. The Pennsylvania Academy was not an option, because construction on the new building was still under way. The Union

League of Philadelphia sought to fill the gap, and by late 1870 it had begun a regular series of art exhibits, the first in December 1870 and the second the following February. A third, an event that the twenty-six-year-old Eakins was determined to exhibit in, was to open on April 26, 1871.

Eakins was committed, as he later said, to concentrate on certain basic themes grounded in reality: men and women, their faces and bodies, their clothes and houses, and their work and interests. "He who would succeed must work along the beaten path first and then gradually, as he progresses, try to add something new but sane, some thing which arises out of the new realities of life."

Champion Oarsman

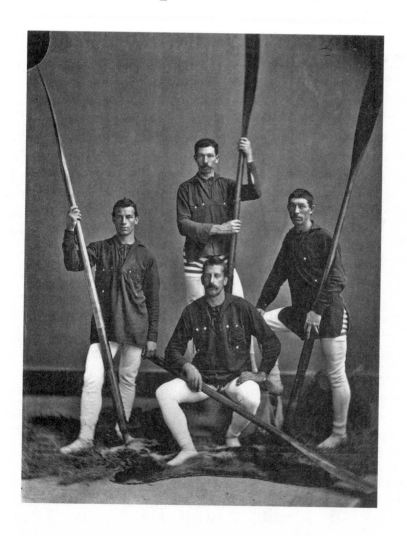

Eakins had two paintings in mind for the first public showing of his art. One was a portrait of Philadelphia attorney Matthew Messchert, an Eakins family friend. This painting, among others of Eakins' early works, is now lost. Little is known about it aside from a brief reference in a review of the subsequent show at the Union League, indicating that his work had been included. Eakins obviously considered the portrait better than those he had painted of his own family members, or else thought Messchert was a more important subject, because he submitted it rather than *Home Scene* or *Elizabeth Crowell with a Dog*. His choice, however, may also have been strategic. Messchert was a member of the Union League of Philadelphia. A positive reaction to the painting among its members could well have brought Eakins commissions for other portraits.

Submitting the Messchert canvas also provided a counterbalance to the second painting he intended to present, a work so technically ambitious in the dialogue of art history that there was no way of guessing what the critical reaction would be. He planned to paint his friend and swimming companion Max Schmitt, poised in a lightweight race boat on the gently flowing and reflective waters of the Schuylkill River. Provided he was able to accomplish what he envisioned, such a painting would be a powerful vehicle to demonstrate his mastery of human anatomy and complex perspective. It could also garner attention in ways that the Messchert portrait would not. Schmitt was the city's current rowing champion. At a time when rowing was a popular sport among the upper and emerging middle classes, he was a hero not only to the civic-minded Union League audience; he was revered by amateur athletes throughout the nation.

The inspiration for the Schmitt portrait may actually have been generated years earlier in Paris, when Eakins received newspaper clippings of his friend's victory as the city's single-scull champion of the 1866 and 1867 Schuylkill Navy regattas. Schmitt, rowing in his favorite racing scull *Josie*, named after his sister, had regained his coveted title on October 5, 1870, against four highly touted competitors over a three-mile course running from the Schuylkill's Turtle

Overleaf: The Biglin Crew, International Regatta at Halifax, Nova Scotia, August 31, 1871, photograph by William Notman. Left to right: Joseph Keye, Jr., Henry Coulter (seated), Barney Biglin, John Biglin. (Notman Photographic Archives, Courtesy of The McCord Museum of Canadian History, Montreal)

Rock to the Columbia Railroad Bridge and back. Eakins, recently back from Europe, stood on the shore with an estimated five thousand other spectators cheering Schmitt to victory as he crossed the finish line, three lengths ahead of his opponents.

Difficult as the challenges in creating such a painting were, Eakins believed himself uniquely qualified to attempt it. Superior draftsmanship was necessary to plot the boat's course and perspective on the river, just as knowledge of physiology would play a crucial role in capturing the scantily clad oarsman in the midst of his athletic activity. Equally important to the endeavor was the artist's own intimate knowledge of the sport. He himself may have been a longtime member of the Pennsylvania Barge Club, the same rowing association as Schmitt's, and reportedly had been urged by professional oarsmen to compete in amateur races. Eakins knew the geography of the river and the design and construction of race boats as only another rower could. And, like Thomas' sisters, Max was a willing and reliable model.

Foremost among the many conceptual decisions Eakins made was to forgo depicting Schmitt in the race for which he had garnered such acclaim. Instead he posed Schmitt in a practice session. In this way Eakins emphasized, rather than the twenty-minute race itself, the five years of training and discipline that went into Schmitt's victory. He refrained from commemorating his friend laboriously pumping the oars or raising his hands in victory. Rather than a genre scene depicting his fleeting moment of triumph, Eakins wanted a portrait emphasizing the man in a way that turned out to reveal the historic originality of the artist as well.

He portrayed Schmitt in his scull just as he straightened the boat from a turn (plate 4). The rower glides toward the viewer, his oars almost horizontal, with their feathered blades lying flat over the water's surface. The pose is entirely natural: a moment of partial relaxation at the end of one practice run and the beginning of another. One of Schmitt's hands rests on the handles of his oars to keep the boat stable, with the other casually poised on his knee. Such a pose afforded the best view of the boat's sleek design and Schmitt's large muscular back. The painter reveals Schmitt's face by having him turn his head toward shore, as if pausing to listen to something a coach or an onlooker

is telling him. By posing Schmitt in this way Eakins was not presenting a fuller portrait of the man but unfolding a narrative: revealing that the work the rower does is mental and inward as well as physical.

Eakins also decided to include other rowers on the river with Schmitt. These include a crew of oarsmen paddling an old-fashioned "barge," a craft that represented an early form of rowing on the Schuylkill. These barges were made of overlapping planks of solid oak weighing more than five hundred pounds, and accommodated up to ten rowers. Schmitt's boat, by contrast, shaped from paper-thin Spanish cedar, weighed a mere forty pounds. Eakins' motive here appears to be a desire to emphasize modernity, contrasted with the old-fashioned boat evoking Philadelphia's past. The precisely engineered racing scull, with its sliding seat and cantilevered oarlocks, was the fastest human-powered device ever before the advent of chain-driven bicycles. Eakins not only wanted the painting correct down to its smallest detail, he wanted to communicate the truth of the age.

Equally prominent in the painting is Eakins' depiction of a second rower in a scull similar to Schmitt's. He too faces the shore, but his boat is moving rapidly away from the viewer in the opposite direction from Schmitt's. This rower is placed not so close to Schmitt as to steal attention from the champion in the center of the composition, but not so far away that the viewer would fail to see the contrast between them. The second rower is hard at work, nearing the end of a stroke, straining with his arms and back. In adding the second rower Eakins enhanced the dramatic narrative, and at the same time showed the viewer what the art of rowing actually looks like. It further sends an important subliminal message: Schmitt has already become a champion and can now rest, while the second rower is still laboring to achieve his goal.

Eakins painted himself as the rower in the second boat, and just so there would be no mistaking who this boatman was he signed the painting by inscribing his name on the stern end of the craft's washbox. Including himself on the river was a natural addition to the scene. He had likely accompanied his friend during many practice sessions. By including the self-portrait, however small, in the body of the larger painting, he moreover may have been paying tribute to the Spanish master Velázquez, who had done the same with great success in his famous painting *Las Meninas*. Perhaps equally appealing to Eakins was

the message it conveyed. The portrait not only captured Schmitt's greatness; it propelled the artist who had painted it forward into the mainstream art world. Eakins was saying, in effect, exactly what he had told Emily Sartain: he loved Philadelphia, was proud to consider himself a native of the city, and was working hard to become a champion in his own chosen profession.

The time of day Eakins chose to put his friend on the river was likely determined for aesthetic reasons over technical truth. Schmitt, like Eakins, routinely rose at four in the morning and would be out on the river practicing at sunrise; this is presumably why he doesn't have a dark tan as one might expect on an outdoor sportsman. The early morning light, shining from close to the horizon and creating great contrasts, might well have turned out to be too dramatic. Eakins instead opted for late afternoon on a clear and crisp autumn day, when the sun could more fully illuminate Schmitt's arms, clothing, and face.

Other important details of the environment help capture the realism of the moment: four ducks in the water, the Girard Avenue and Columbia Connection Railroad bridges that spanned the river, a steamboat, a colonial mansion on the opposite shore, a stone house, and a locomotive approaching the city in the distance. These too were integrated in the scene, not only advancing the narrative but identifying Philadelphia as the setting.

Museum conservators and art historians, among them Helen Cooper, Martin Berger, Christina Currie, and Amy Werbel, have written at length about the many taxing challenges Eakins faced in creating this and others of his rowing paintings. Among the greatest difficulties he confronted was to meet the demands of perspective and the realistic portrayal of the environment while at the same time satisfying the conflicting and more painterly expectations of portraiture. This was to be an expressive work of art, not a photographic facsimile. Exactly measured and proportioned objects, such as the boats, buildings, and bridges, had to interact visually with such fleeting intangibles as clouds, steam from the locomotive, and the reflections on the gently moving water. The painting required a careful calibration of information, a balancing act between details communicating the movement of Schmitt's boat through the flowing river and those conveying the physiology and essence of the man in the boat.

Equally challenging was the need to capture the narrative moment: the

time of day, the flow and volume of the water, and the effects of the boats and oars in the river. Each rower leaves a trail of perfectly intact rings and ripples where the oars have been placed in the water or brushed its surface. Smoke from the locomotive creates a diminishing trail in the sky. Past events, such as the pattern of rings on the surface, at the same time anticipate the future. The train, seen off in the distance, would be crossing the railroad bridge as surely as the marks of the oar's contact with the water will disappear.

Eakins' fascination with the possibilities afforded by such a remarkable endeavor as this portrait became an obsession. The resulting painting, *Max Schmitt in a Single Scull,* completed in 1871 and now at the Metropolitan Museum of Art in New York, was the first of nineteen oils, watercolors, and drawings he made of rowers on the Schuylkill between 1870 and 1874. Others in this series of heralded rowers are *The Biglin Brothers Racing,* in the National Gallery of Art in Washington, *The Biglin Brothers Turning the Stake,* at the Cleveland Museum of Art, *John Biglin in a Single Scull* and *The Schreiber Brothers,* at the Yale University Art Gallery in New Haven, and his last, *Oarsmen on the Schuylkill,* in a private collection. The discovery of materials Eakins used to prepare these works, along with a recent technical analysis of the canvases themselves, now makes it possible to document the step-by-step process the artist used to create the paintings.

Field study came first. Eakins made multiple sketches in oil of Schmitt and his boat on the Schuylkill, during which he took notes on color and action. How long Eakins spent in this early planning stage must have been significant. Sketching trips began in the fall of 1870, and the river was frozen over by late December, when he likely put brush to canvas to begin actually producing the painting in his Mount Vernon Street studio.

After making his on-the-spot sketches and color keys he began careful measurements of the river, the boats, and their oars. The method he devised was both analytic and conceptual. Just as he had learned to do at Central High, he broke his subjects down into components, then plotted and rendered them according to linear perspective. Reflections on the water's surface were handled in much the same way. He used mathematical formulas to calculate the angle of reflection and wave motion and then plot them on paper. The plotted lines on the canvas served as horizontal and diagonal grids into which

Eakins inserted other important elements in the design. He applied a similar technique several years later in *The Chess Players,* the painting of his father with two friends in the family parlor. The artist's preliminary drawing for this painting shows the floor divided into squares, drawn in intricate perspective, and the central objects, such as the chess table and the players' chairs, placed in rectangular boxes and positioned on the floor plan.

Having completed the necessary measurements and preliminary sketches outdoors he returned to the studio and worked out perspective drawings of the composition's central elements. Such drawings would have shown a rendering of the scull from the side and another of its position in the river. Gradually he created more complex and detailed perspective drawings, eventually taking the step of placing Schmitt in the boat and the boat on the river. Variously colored inks delineated specific linear planes. Blue was for lines purely concerned with perspective, square footage, and the horizon and central vertical lines. Red ink enclosed complicated projections such as the end of an oar, the two bridges, and the trail of wavelets in the water. Finally, he outlined all the main forms in pencil, later strengthening these with black ink.

Concurrent with his perspective studies was anatomical research. Eakins likely made model figures in wax, experimenting with posture and proportion before settling on an exact pose. Only later would he have Schmitt actually model for him in his studio. One story, though not authenticated, had Schmitt hauling his scull up to Eakins' studio, where the artist stationed him in his boat atop the workbench. A story Eakins later told his students about the creation of one of his rowing paintings described fashioning a miniature shell out of a cigar box. He placed rag figures in it decked out with red and white shirts and blue ribbons around their heads.

The painting conservator Christina Currie, in her essay "Thomas Eakins Under the Microscope: A Technical Study of the Rowing Paintings," outlined the sequence of steps that came next: Once Eakins had carefully worked out the drawings, he copied them onto transfer paper and placed them over a finely textured and plainly woven canvas that had been commercially primed with a white ground layer of thin paint. Into this white ground he drew or scratched guidelines for the contours of boats, oars, waves, and principal figures. Microscopic, infrared, and X-ray examinations of the canvas reveal three distinct

types of markings. Prick marks and incised lines indicate a metal stylus or other pointed instrument. Incised short arcs, of the kind a compass would make, marked off other important points. These incised lines and compass arcs precisely positioned the major objects in the painting: Schmitt in his boat, the riverbanks, two bridges, the wake left by the waves, and important reflecting points. Tiny prick marks follow the outlines and contours of the rowers' heads, torsos, and clothing and delineate the rounded elements of the bridges. Eventually he joined these pricks in pencil and reinforced the entire outline with a drafting pen or fine brush.

After the transfer of the preparatory drawings to canvas was complete, Eakins began the painting process. He first modified the white ground with a translucent toning layer, similar to the way he had prepared canvases for the early portraits he made of his sisters. He completely covered the canvas, with the exception of Schmitt and his boat, which he chose to approach differently, using lighter colors to provide a more luminous surface effect for his central subject.

Eakins painted the boats and oarsmen first. He applied a beginning layer of pigment quite thinly, following the incised lines exactly to give the presentation a sense of precision and conviction. He built up the initial layers gradually, using lighter tones than in his previous portraits. While each layer of the painted figures was drying, which might take several hours, he moved on to fill in riverbanks, water, and sky. In these less controlled areas, as Currie has pointed out, his technique ranged from an aggressive and broad application of paint with a palette knife to the delicate and more precise brushing of opaque paint and thin glazes for the sculls. In his later painting *The Schreiber Brothers,* with its subjects more colorfully attired than his portrayal of Max Schmitt, he set down a bright red glaze and pink opaque paints on the oarsmens' caps and a deep red glaze on the shadowed side of their boat's metal struts. In *The Biglin Brothers Turning the Stake,* he dispensed with the thin, even layering of paint altogether, instead alternating thick and thin layers of pigment for landscape and sky (plate 5).

Eakins conveyed the fluid and reflective qualities of water by preserving portions of the light underpainting to create highlights in the foreground waves. Thus, the white highlights where the oars break the surface do not

appear applied to the painting's surface as much as they emerge from beneath. As Currie has pointed out, Eakins took the process a step further in *The Pair-Oared Shell*, by actually painting over the ground layer and then scratching through the paint to expose the white. For *Max Schmitt in a Single Scull* and *The Biglin Brothers Turning the Stake*, he employed a different device of reserving sections of the white underlayer to serve as highlights in the foreground waves. The greenish-yellow paint for the water in *The Biglin Brothers Turning the Stake* was likely mixed with a thin liquid and rubbed on the surface using a turpentine-soaked cloth or brush to give it an even, opaque sheen. The reflective surfaces near the sunlit riverbank were brightened with thin pigment and fluid, vertical brushstrokes, which descend into thicker horizontal brushstrokes where the slow-moving water closer to shore meets the faster current in the middle of the river.

The skies in all Eakins' rowing paintings are more thickly filled in with pigment and more turbulent than the water. First he used an intense cobalt blue, which he toned down with a lighter blue, and finally finished in a layer of creamy ocher applied with palette knife. The challenge here was to keep the sky's deep blue from overpowering everything else. The difficulty he had in this regard was apparent in both *John Biglin in a Single Scull* and *The Biglin Brothers Turning the Stake*. After much trial and error, he ultimately had to smear on thin, uneven layers of creamy ochre to reduce the brightness and warm the overall tonality.

Eakins did not achieve the same success in rendering the riverbanks as he did the water and skies. The problem was both technical and aesthetic. Unlike what a viewer would experience if standing beside the river and looking across to the opposite shore, Eakins did not diminish or blur the intensity of the color or detail. The branches on trees on the far side, for example, are carefully drawn, as are their reflections in the water. So too are the bridges. He did not let distance or light dissolve the outline of the forms. He let his skills as a draftsman overshadow his powers of observation, relying on his straight edge and slide rule rather than his eye. There is almost too much of a good thing, creating a discordant collage of finely rendered and technically perfect objects. Only in this single aspect does Eakins betray his inexperience.

The painting's overall effect, however, was more successful than he had

any right to believe it would be. He had subtly captured the rhythmic, fluid beauty and kinetic energy of the river, the sport, and the man. The perceived movement of the boats in the water and the play of reflected light combined to create a subdued and pleasing tension. The broad expanse of the Schuylkill, its acres of surrounding trees, the clear air, and the finely modeled bridge spans create a harmony in which Max Schmitt is presented with unconscious simplicity and truth. Schmitt is not the hero of a boat race but the Spencerian product of arduous practice and rigorous mental and physical discipline. He is a man, like Eakins himself, who relied on precision rather than brawn.

Eakins had created his first masterpiece. Nine months after his return from Europe, and five months after he had first begun *Max Schmitt in a Single Scull* (also known as *The Champion Single Sculls*), he submitted the canvas, along with the Messchert portrait, to the Union League of Philadelphia's upcoming art show. His choice of venue was a good one. The city's leading artists, many of them Union League members, were certain to see it. More important, Union League members and their guests included the city's important art collectors, among them Joseph Harrison, Jr., Henry Carey, and Fairman Rogers, on whose interest and patronage all Philadelphia artists depended.

For Eakins, a twenty-seven-year-old artist presenting his first work to the public, reviews were mixed, but not altogether unfavorable. The *Philadelphia Inquirer* reported that, although his rowing painting showed "marked ability," the whole effect was "scarcely satisfactory." The *Philadelphia Evening Bulletin* reviewer, who ignored the Messchert portrait altogether, was not so snobbish. The critic avowed that the painting, though "peculiar," showed "more than ordinary interest" and predicted a "conspicuous future" for the artist. Neither of his paintings received one of the Union League medals.

Eakins did not take the initial press coverage or failure to win an award as a portent of criticism to come. His attitude was more rationalist and pragmatic. Before he even received his first reviews he had already given the painting away, as a gift to his friend Max Schmitt, and begun outlining his next depiction of rowers on the Schuylkill.

sixteen

The Biglin Brothers Racing

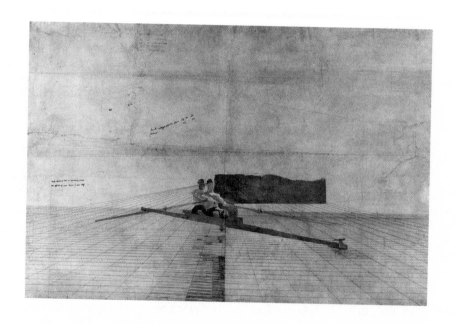

Caroline Eakins did not live to see her son complete his second rowing painting. She died on June 4, 1872, at fifty-two, leaving behind a household consisting of three unmarried daughters, a maiden aunt, Tom, and his widowed father. As with the earlier death of Benjamin Jr. in 1850, no details are known. City records list Caroline's cause of death as "exhaustion from mania." Her mental condition notwithstanding, it was likely the diet of purgatives and digitalis that killed her.

Two months after their mother died, Tom's sister Frances married Will Crowell. The young couple settled into an upstairs bedroom, where they remained for the next four years while Crowell attended law school and then opened his own law practice in an office on Fifth Street. In a gesture of goodwill and generosity, Benjamin promised to purchase a home for his daughter and new son-in-law once Crowell received his degree. Besides the letter he wrote to Will Crowell from Paris declaring that Frances was not yet ready for marriage, there is no indication of how Tom Eakins felt. As for his own views on marriage, he described the qualities he desired in a wife in a letter to his sister Frances after his breakup with Emily Sartain: "If I ever marry it will likely be with a girl of southern feeling [and] good impulses & heart healthy & able to bear strong beautiful children." Frances was such a woman. Over the next decade and a half she and her husband would have ten sons and daughters.

Perhaps feeling claustrophobic, desiring financial independence, and experiencing a diminished status in the household, Eakins devoted himself to his work with renewed vigor. After his Max Schmitt portrait he turned to oarsmen John and Barney Biglin. The two brothers had come to Philadelphia from their home in New York in late April 1872 to train for what was being billed as the greatest pair-oared rowing competition in the nation. The victors would bring home a purse of two thousand dollars, the highest sum that had ever been offered for any pair of rowers in a contest. Unlike the race in which Schmitt had won distinction, pair-oared rowers reached speeds far in excess of singles and required great coordination of the oarsmen. The two had to synchronize their strokes for their boat to follow a straight course; one of them

Overleaf: Perspective drawing for *The Pair-Oared Shell,* c. 1872. Pencil, ink, and watercolor on paper, 31¹³⁄₁₆ × 47⁹⁄₁₆ inches. (Courtesy of The Philadelphia Museum of Art; purchased with the Thomas Skelton Harrison Fund, 1944)

pulling ahead of or behind the other could prove disastrous. Should one miss a stroke by not properly feathering an oar, or by losing his grip altogether, a boat might overturn. At the speeds their boats traveled, a loose oar, propelled by the boat's momentum, could catch a rower in his ribs and slam him into the river. The spectacle of two pairs of champion oarsmen on the narrow Schuylkill River promised as much excitement as the Kentucky Derby.

The Biglin brothers, Philadelphia's favorites, brought great crowds of spectators to the shores to watch them practice. During such sessions Eakins came to know the brothers and make his beginning preparatory sketches. His first full painting of them, *The Pair-Oared Shell* (1872), now at the Philadelphia Museum of Art, finished approximately a year after *Max Schmitt in a Single Scull,* displays the rowers in one of these practice sessions. It differed dramatically from the earlier painting in that the scene was reduced to its bare essentials: the Biglin racing shell, two rowers, the stone pillar of the Columbia Railroad Bridge under which they glide, and the river's edge behind them.

Unlike his earlier Schmitt portrait, the distant background in *The Pair-Oared Shell* remains an ill-defined wall of green trees in the lengthening shadows of a setting sun. The highlights and detail come forward on the rowers and their boat: muscular figures in dark knee-breeches and blue-trimmed shirts, heads covered with dark blue scarves, looking up at the viewer as their sleek racing boat emerges from under the shadow of the Columbia Railroad Bridge.

The Biglins' race, held at four in the afternoon on May 20, 1872, was captured in Eakins' next two paintings, *The Biglin Brothers Racing* and *The Biglin Brothers Turning the Stake,* both from 1873. Eakins joined an estimated thirty thousand spectators who crowded the shores of the Schuylkill along a five-mile course that ran from just above the Reading Railroad Bridge to Connection Bridge, north of Girard Avenue. The rowers would race downstream for two and a half miles, then turn their sculls at a point in the river marked by two stake-boats anchored twenty-five feet apart. Once turned, the oarsmen would race back upstream to the finish line at the Reading Bridge. The best vantage points to view the contest were on the river itself, where gaily decorated steamboats and yachts and scores of small craft jockeyed for space along the race route. The next best viewing positions were on the bridges under which

the oarsmen stroked, and on tiny Peter Island at approximately the quarter-way point. Most everyone else watched from the high promontory overlooking the Philadelphia waterworks, where the Pennsylvania Museum would later be built, or from the banks along the river.

The odds on a Biglin team victory over Pittsburgh's Henry Coulter and Lewis Cavitt were running high. Favored as another likelihood was inclement weather. Mother Nature kept with the odds. Minutes before the race's starting time, a gust of wind brought a drenching rain. The storm whipped the normally calm Schuylkill into foam and churning water. High winds tore much of the bunting, streamers, and colorful flags from the poles in front of the boat clubs on the riverside. Spectators anxiously waited an additional two hours for the winds to subside before they heard the boom of the starter's gun.

Reporters chronicled the events that unfolded: "The Biglins won the toss for choice of positions and . . . selected the inside [lane] nearest the shore. . . . The referee . . . fired the pistol. . . . Coulter and Cavitt got away handsomely, gaining half a length, as the Biglins seemed to be taken by surprise and were slow to start, and then unsteady. Coulter and Cavitt . . . held a good course, rowing handsomely at 41 strokes [per minute] . . . until Peter Island was reached . . . and they went abroad, pulling off to the west bank, the Biglins passing them rowing 40 strokes, the latter keeping a splendid straight course to the second arch of Columbia street bridge, passing their opponents, who lost more distance by taking the third arch of the bridge, making a gap of about eight [boat] lengths between them. . . . The Biglins reached their turning-stake boat in 15 minutes, and were straightening out on the home course, when Coulter and partner, making a bad approach to *their* stake-boat . . . [fell behind]."

The Biglin Brothers Racing captures the key breath of time when the two brothers pulled ahead. The second painting, *The Biglin Brothers Turning the Stake,* represents the point just moments later when they have virtually clinched their victory. When the Biglins crossed the finish line, completing the course in thirty-two minutes, Coulter and Cavitt were fifty seconds behind. The spectators' shouting and blasting of horns lasted a full fifteen minutes.

The Biglin Brothers Racing and *The Biglin Brothers Turning the Stake* were not intended to be portraits as *Max Schmitt in a Single Scull* had been.

Everything about the paintings exudes the thrill of the race and the tremendous physical exertion of the rowers. In *The Biglin Brothers Racing* the two men are propelled through the current by the momentum of their last stroke, the yellow blades of their oars feathered in their bright red oarlocks, about to square in anticipation of their next stroke. Barney, in the bow, glances over to his left to judge the position of their competitor's boat. John, in the stern, is intently focused on maintaining their course and setting the pace. A large part of the power in the painting is generated by the intense concentration of the two rowers. They are in the heat of action, but their minds are as calmly composed as was Eakins' sister Margaret when he portrayed her playing the piano. Their moment of physical exertion is simultaneously one of mental poise.

The Biglin Brothers Turning the Stake is more ambitious. It focuses on the moment when the racers' boat comes to a virtual stop while it pivots at the halfway point of the course. John, in the stroke position, his blade deep in the water, stares over the stern, mentally calculating the distance of his oar from the stake as his boat is about to revolve around the halfway mark. Barney, who has been using the force of his oar to turn the boat, has just finished his stroke. He too monitors the boat's alignment with respect to the stake and to shore, and waits for his brother's command to begin the next stroke.

Like a film director framing a close-up, Eakins has captured a pregnant, tension-filled instant. The sky is a warm gray gold. The concentrated expressions on the rowers' faces are as calmly reflective as the surface as they align themselves and their boat for their final leg upriver to victory. Their muscles are bulging, their oars bite into the water, their minds focused on the split second just before what will surely be a furious unleashing of brute force.

The effect created in this painting, however, is significantly different from the one chronicling the earlier portion of the race. Eakins has made an essential innovation. As he would do in many of his most important portraits to come, he forces the viewer to enter into the narrative existence being portrayed. Only after one studies the placement of the oars in the water and the expressions on the faces of the two rowers does the scene make sense. By working to identify the segments of action, viewers must project themselves into the scene. A mental leap transports the viewer to understand what is taking place. The experience is similar to an audience seeing a motion picture. The viewer,

like Barney Biglin, anxiously awaits the command that will trigger the rowers to synchronize their oars for the return trip upriver and to victory.

On shore the spectators anticipate the boat's compass-turn in the water to reach completion and for the burst of speed to come. The riverbanks are swollen with watchers on horseback, in carriages, and on foot. Among the many spectators who have taken to the river in their own boats and skiffs to watch the event is Eakins himself. In *Max Schmitt in a Single Scull,* Eakins, as an artist and rower, is in training. Here he is shown as an observer in a scull, with one hand on the oars to keep his boat in position and the other arm raised, celebrating what will be the Biglin victory.

The artist indeed succeeded. The sensation of physical energy and tension in *The Biglin Brothers Turning the Stake* is a powerful combination, making this painting the most compelling of the nineteen images in Eakins' rowing series. The personal satisfaction he received from completing this painting also liberated him from straddling the divide between portraiture and genre scene paintings. Eakins was not only finding new themes to explore but testing the boundaries between them. His next painting of oarsmen, *The Schreiber Brothers,* from 1874, exemplifies the direction he was headed.

Dressed in white shirts, long dark-blue trunks, and magenta headscarves, the two Schreiber brothers, Philadelphians in their early twenties, are pictured in a pair-oared shell set against the same stone pillar supporting the Columbia Railroad Bridge that Eakins had previously painted in *The Pair-Oared Shell.* Behind them, partially hidden in shadows, a rowboat accommodates five fishermen, a man wearing a black-banded boater's hat, a young boy, and a dog. A barge is nearer to shore, and farther downstream a small boat takes two people for a pleasant afternoon excursion on the river. A parasol held by one of the boaters suggests they are a young couple, perhaps on a date.

Layers of protective varnish, applied over the years by well-meaning conservators, have darkened the canvas so that the full impact of the narrative is lost to most viewers. A dog, alertly poised on the bow of the fishermen's rowboat, is visible only in X-rays. Despite an overall darkness infusing the painting, however, viewers cannot help being pulled into the scene. The Schreiber brothers' rowing technique is noticeably imperfect. Compared with Max Schmitt and the Biglin brothers, they are rank amateurs. Henry, in the bow, is slightly

twisted around to his left, out of sync with his brother behind him. The pained looks on their faces reveal their awkwardness and lend an intimacy to the story being told. The painting is not only a portrait of two rowers; it is a meditation on the river as a place of recreation, a test, and a refuge.

seventeen

Hikers and Hunters

Thomas Eakins, still youthful at twenty-nine years, went on to do for other sports what he had done for rowing: exploring them as narratives to express character and truth. Having already grappled with the intricacies of boats and wave patterns, his natural next step was to depict sailboats in contest on a local racing site, the Delaware River.

The favored choice for Delaware River race enthusiasts was a type of catboat known as a hiker, rigged with a single mast and a long boom and capable of comfortably carrying three or four passengers over long distances. Like sculls, hikers were designed for speed over stability, hence their name: in a stiff wind, the crew members had to "hike out," suspending their bodies over the water to windward to keep the boat from capsizing. Like sculling, sailboat racing was a highly popular sport that drew hundreds of spectators to annual regattas.

Eakins chose a regatta that was held at Gloucester for *Sailboats Racing on the Delaware* (painted in 1874 and now part of the Philadelphia Museum of Art's permanent collection). In many respects this work is the most appealing marine painting of the group. Hikers of different colors spread in the wind over the wide expanse of the Delaware. A red-shirted skipper clutches the rudder as his crew of four leans backward over the cockpit edge to keep the boat from overturning. The day is hot and sunny and the lead-colored water dances in gentle waves with occasional whitecaps. The large unfurled sails are a rich creamy white.

Portraying the boats cutting through the waves posed significant problems beyond those Eakins had encountered in his rowing paintings. The challenge did not rest in capturing wave motion; it lay in the angle of the boat riding through them. "A vessel sailing will almost certainly have three different tilts," Eakins later wrote in a manual for the benefit of his students. "She will not likely be sailing in the direct plane of the picture . . . [but] tilted over sideways by the force of the wind, and she will most likely be riding up on a wave or pitching down into the next one."

Eakins would encourage his students to think of a boat in terms similar to a brick that has been tilted and raised on one side. He went so far as to have students place an actual brick beside their easels for modeling purposes, as

Opposite: Sailboats on the Delaware River, photograph by Thomas Eakins, c. 1880–90 (Courtesy of The Philadelphia Museum of Art; gift of Seymour Adelman)

Bonnat would surely have recommended to his students. Eakins in his own studio employed a more complex technique. His sketching notebooks are filled with trigonometric equations and measurements to calculate the correct tilt of booms, rudders, and masts. Figures he used in preparing *The Pair-Oared Shell* included the length of the reflection cast by the top of John Biglin's head. Pyramid-shaped meshes of diagonal lines chronicled the measurements of principal markers, items of clothing, and the crest of waves.

By today's standards, using geometry and higher mathematics to so meticulously pinpoint the correct tilt and pitch of the individual parts of a boat and its occupants may seem obsessive. It should be noted that Eakins was following in the tradition of the Italian master painters whose knowledge of the science of perspective—and likely mathematics from the Greeks, passed on by Arab scholars—had helped to bring about the European Renaissance. In any case it was not science, in any narrow sense, that Eakins was being slavish to. He was bound to nature. His technique for accurately depicting a boat was the same approach he used to paint a human body. The skeletal and musculature structure beneath the flesh provided the foundation upon which everything else rested. He applied this same principle when he painted his next series of sporting pictures: hunting for game birds.

Like rowing and sailing, hunting was a pursuit he knew intimately. He and his father most frequently practiced their sport where the Delaware meets the Schuylkill, in the marshes south of Philadelphia. A second popular location for game-bird hunting was the wetlands near the Eakins family's boathouse, where the Cohansey River emptied into Delaware Bay. The types of fowl most commonly hunted were clapper rail, a small, nearly inedible henlike bird with long legs, which was in season from early September to October, and plover, similar to rail only taller and more spindly, like a sandpiper. These and other game birds in the New Jersey and Pennsylvania marshes were usually hunted from a "Delaware ducker," a multipurpose, round-bottomed, double-ended boat indigenous to the Delaware River basin. Eakins himself had obtained a ducker from a noted Philadelphia boatbuilder by trading one of his paintings. The boat was particularly suitable for the local terrain and waters because it could be rigged and sailed as a catboat, complete with a centerboard and stern deck, permitting hunters to sail to the hunting grounds. Mobility like this

was especially important when hunting the New Jersey wetlands; they were nearly forty miles downstream from Philadelphia. Once the hunters reached shallow water, they could remove the sail, centerboard, and stern deck, so that one person could pole the transformed boat through the marshes while a gunman stood amidship.

Sailing (Philadelphia Museum of Art), painted in 1875, shows the outset of a rail-hunting expedition (plate 6). Harry Young and Sam Helhower, Eakins family friends, traverse the open sweep of the Delaware on their way downstream to the marshes known as the Schuylkill Flats. The pictorial challenges were not altogether different from those Eakins encountered in *Sailboats Racing on the Delaware.* Only to make the hunting narrative work he had to place the boat artfully in a position that would let a knowledgeable observer identify the action; Eakins needed to reveal the boat's distinctive construction and the gear it carried. A shotgun leans against one of the ducker's rib struts. An ammunition cartridge box lies next to the centerboard trunk, and a pushing pole is tucked under the forward brace. To a Philadelphian who knew something about bird hunting, the story is crystal clear. The strong midafternoon light reflecting off the water and the dark shadows on the boat tell us the time of day. The two men riding the tide have set out while they can still reach the marshes for a twilight hunt.

It was another such outing that Eakins portrayed in *The Artist and His Father Hunting Reed Birds* (1873–74, Virginia Museum of Fine Arts, Richmond). Benjamin Eakins stands forward in the ducker, his shotgun at the ready, while Thomas poles the boat through thick duck grass. What is crucial, like the tide, is the time of day. Rail birds can fly, though not very far or fast; they are more adept runners. Hunters flush them out at high tide when their escape on foot is impossible.

Eakins made a similar painting in 1874, *Pushing for Rail* (Metropolitan Museum of Art, New York), showing a rail in flight and three pairs of hunters and pushers: one hunter ready with his shotgun, one taking aim, and the last reloading (plate 7). In the distance can be seen similar pairs of hunters, along with the tall sails of Delaware River schooners whose hulls are hidden by the reeds. Eakins painted several other such scenes, all notable for their decidedly warm and realistic approach. They are not outright genre paintings; they are portraits

of people Eakins knew and hunted with. And in resonance with the portraits he painted in the Mount Vernon Street parlor, they are neither nostalgic nor heroic representations. In *Pushing for Rail,* Eakins displays the middle-aged paunch of shooter Harry Young, from Moyamensing in south Philadelphia, while his barefoot companion, Sam Helhower, does the poling.

The strength of these paintings, as in the artist's scenes of rowers, derives not just from the precision of his technique but in his ability to observe and subtly grasp the subdued sunlight and open flat expanse of sky without losing details of the action unfolding. Eakins described the scenes' quality he reached for in a letter he sent to Gérôme, himself an avid hunter. "I have chosen to show my old codgers in the season when the nights are fresh with autumn and the falling stars come and the reeds dry out."

Eakins further detailed how the hunt was conducted: "As soon as the water is high enough for the boat to be floated on the marsh, the men get up and begin to hunt. The pusher gets up on the deck and the hunter takes a position in the middle of the boat . . . his left boot a bit forward. The pusher pushes the boat among the reeds . . . [and] always cries out on seeing the bird because, for the better part of the season when the reeds are still green, he is the one who sees it first because of his higher position on the deck."

Left unsaid, but communicated well enough in the paintings, are the precise narrative instants that Eakins chose to open up. In *Rail Shooting on the Delaware* (1876), now at the Yale University Art Gallery, the gunman takes aim as the pusher steadies the boat in anticipation of a destabilizing kick from the gun. Subtle acts of coordination and balance are taking place. It is difficult enough for two people to stand in a small boat, let alone for one of them to be pulling his aim at a moving target. The posture of the gunmen and the pusher in this case tell us that these men are experienced rail hunters. The real subjects of the painting are mental focus and physical mastery.

In exactly the same manner as in *The Biglin Brothers Turning the Stake,* Eakins has engaged the viewer by anticipating the split second to come. The birds have taken flight. The shotgun is brought to aim. In the next instant the landscape will have changed. The air will be heavy with smoke from the exploded gunpowder. The shooter will be reloading. The pusher in the stern

will be poling the boat through marsh grass to collect their prey. Every boat and everyone in the boats will have changed postures, just as John and Barney Biglin will have done in the fraction of time after Eakins portrayed them on the Schuylkill. The intense segment captured tells the greater story.

In the space of approximately five months, from rowing, sailing, and hunting, Eakins turned his attention to baseball. According to legend, the sport had been introduced in New York in 1839 and reached Philadelphia in the 1850s, and it was growing in popularity every year. He painted two detailed watercolors of the city's first professional team, the Athletics, which was to become one of Philadelphia's most successful sports franchises; in the early years of the next century, under the direction of the legendary manager Connie Mack, the list of the team's players came to include Ty Cobb and "Shoeless" Joe Jackson.

The setting for both of Eakins' baseball watercolors was Columbia Park in North Philadelphia, where the Union army had once trained cavalry soldiers. In each of the scenes Eakins focused on a batter waiting for the pitch. "The moment is just after the batter has taken his bat, before the ball leaves the pitcher's hand," Eakins wrote to his friend Earl Shinn.

In one of the watercolors, *Baseball Players Practicing* (1875, Museum of Art at the Rhode Island School of Design), the batter, Wes Fisler, stands in front of the catcher, John Clapp. The background shows an assortment of ill-defined spectators in the bleachers. One of them could well be Benjamin Eakins, seated just above Fisler's bat. Elizabeth Crowell could have been the spectator sitting beside this figure, for she wears a red and black jacket similar to the one Eakins portrayed her wearing in the Mount Vernon Street parlor (in *Elizabeth Crowell with a Dog*). In the space between the spectators and the two players is another figure—presumably the baseball coach—sitting cross-legged on the ground.

As a result of the painting's simple design and the existence of preliminary sketches, perspective drawings, and the artist's notes on the subject, *Baseball Players Practicing* offers a useful introduction to Eakins' evolving method. In one of his perspective drawings, the vertical center line and the horizon are sharply drawn and easy to identify, as is the pattern of diagonal lines that

converge at the intersection of the two axes. Judging from the assortment of numbers written in Eakins' sketching notebook, it is safe to assume that he measured the players' heights and the distances between principal subjects, then transferred, by means of calipers, the size of unmeasured objects in relation to known dimensions.

The most interesting and ultimately insightful information to be gleaned from these calculations is found by comparing the scale and proportion of the sketches with those of the completed watercolor. As Kathleen Foster and other art historians have noted, Eakins made several significant changes. He halved the distance from the viewer to the ballplayers, making it much easier for the eye to gauge the distance between them and their relation to each other in space. The watercolor's composition, as well, pushes the stadium and bleachers farther into the middle distance. Instead of the spectators appearing distractingly close, pulling attention away from the batter and the catcher, the game's viewers are suitably blurry. Eakins narrowed the diagonal basepaths to make them appear less broad and assertive, and he removed altogether the various posts and braces that held up the roof of the stadium. The important point is that Eakins artfully manipulated the spatial coordinates and viewing distances from what was ostensibly a real and observed moment. He made changes that were subtle but operated as powerful means to focus the viewer's attention. In this way Eakins further developed linear perspective. It became just another tool to the artist in the larger and more complex construction of his paintings.

In a letter to his friend Earl Shinn, Eakins admitted that he was not entirely pleased with his baseball watercolors and thought he might someday paint one in oil. He never did. His real artistic interest was not baseball or hunting or even rowing in themselves. It was the opportunity to model and paint athletes. By his thirtieth year, Eakins had become a specialist. His portraits of sportsmen were painted with such precision and microscopic detail that observers of his work in 1874 began to wonder how the artist had been able to produce such paintings with mere brush and canvas. The truth would not be revealed for another century. In addition to his bringing to bear perspective drawings and field studies of his subject matter, Eakins had secretly taken the first tentative

steps toward incorporating photography into his painting technique. Just as the Renaissance masters had explored the devices of a new age, Eakins had availed himself of the revolutionary scientific advances of his generation—and along the way invented the art of realism in a new form.

Uncompromising Realism

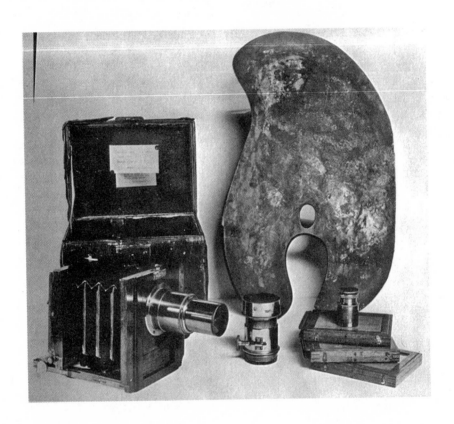

Projecting images to capture complex pictorial challenges was not a new idea. Photography had been developed, in part, for this very purpose. Early mechanical and optical devices, among them the camera obscura and camera lucida, employed fine lenses and mirrors to cast sharp, clear images that the early Dutch masters used as reference points to trace objects onto their canvases. The acknowledged genius Leonardo da Vinci wrote about the technique, and such masters as Caravaggio, Velázquez, Jan van Eyck, and Hans Holbein the Younger were said to have used the process. "The best modern painters among the Italians have availed themselves of this contrivance," wrote an art instructor in 1764. "Let the young painter, therefore, begin as early as possible to . . . make the same use of the Cameria Obscura, which Naturalists and Astronomers make of the microscope and telescope, for all these instruments equally contribute to make known, and represent Nature."

Artists themselves developed the first methods to permanently fix projected images onto paper. Most notable was Louis Daguerre, a French set designer who developed the first silver-coated copper-plate photographs in 1839. The process used today, however, was pioneered by the English mathematician, physicist, and linguist William Henry Fox Talbot, who developed glass-plate and photo printing techniques in 1840. By the early 1860s, most major cities harbored dedicated commercial photography studios. Related lantern-slide devices entertained parlor guests and audiences as commonly as vaudeville and organ concerts.

Eakins had grown up in the shadow of such a revolution taking place, and in fact he could easily have been among the first important painters to be photographed as a child. If he did not experiment with early camera technology in the home of his neighbor Coleman Sellers, he was certainly introduced by John Sartain to the very real benefits photography gave to artists and printmakers. Here he could witness firsthand the copying of daguerreotype plates for Sartain's early portrait engravings.

Eakins was surely encouraged by Jean-Léon Gérôme to explore the advantages photography provided to painters, for his Paris mentor photographed the elaborate props he used in many of his paintings, and he took photographers

Opposite: Thomas Eakins' camera with lenses, plate holders, carrying case, and palette (Charles Bregler Archival Collection, Hirshhorn Museum and Sculpture Garden, Smithsonian Institution)

along on his fact-finding and subject-gathering expeditions to the Middle East. As Gérôme later wrote, "The photograph . . . has compelled artists to divest themselves of the old routine and to forget the old formulas. It has opened our eyes and forced us to gaze on that which we have never before seen, an important and inestimable service it has rendered to Art. Thanks to [the photograph], truth has finally emerged from its well. It will never go back again."

Like Gérôme, Léon Bonnat championed photography for its "perfect accuracy," and he freely encouraged his students to use it in creating their compositions. Eakins could not have received any higher officially sanctioned approval. As one Paris art student of Eakins' time wrote, photography was a means to "preserve records of transient and beautiful effects, of difficult poses, and of unusual combinations of line."

In the early 1870s, when Eakins began looking to photography as a professional tool to more accurately depict his painted subject matter, Philadelphia artists Christian Schussele and Thomas Moran had already established a practice of doing just that. They routinely photographed their models and used the photos in place of "mechanical studies." Moreover, as the art historians Douglass Paschall and Mark Tucker and the conservator Nica Gutman have made clear in their detailed studies of Eakins and photography, a close rapport existed between the artists and photographers. Three members of the Charles Willson Peale family were photographers, and photographer Ridgway Glover was a close friend and traveling companion of Schussele's. Thomas Moran's younger brother John was a charter member of several Philadelphia photography associations and was known for having photographed the same Philadelphia vistas that appeared in his brother's paintings. Peter Rothermel, an early instructor of Eakins at the Pennsylvania Academy of the Fine Arts, had once been elected to the city's most prestigious photographic society.

Philadelphia painters did not publicly acknowledge using photographs for reference, however, out of fear that their talent and legitimacy as artists would be judged adversely. To admit having incorporated photography would create liability; the public would feel it took away from the "poetry," "inspiration," and "native genius" that they trusted as the stock-in-trade of the artist. The more painterly a studio could be made to appear—particularly by making sure cameras weren't visible in it—the better. In one case a noted nineteenth-century

artist who claimed not to rely on photography went so far as to have photos made of him painting a live model. Yet it has since been proved by conservators at the Philadelphia Museum of Art that the very paintings depicted in these photos were in turn based on photographs. Discretion was the rule. And so, although Rothermel was elected to join Philadelphia's premier photography association, he declined the honor for obvious reasons.

Still, despite inherent risks to an artist's reputation, the attraction of employing photographs must have been irresistible. A model's presence was no longer required for the months and sometimes years it took to complete a portrait. Nor were artists limited to working on their paintings when the sun was in the right spot or when the weather was good. A thriving industry took hold in Philadelphia providing magic lanterns and other optical devices to project portrait images on canvas. The images were then painted over with watercolors or oils. *The Magic Lantern,* a Philadelphia photography and science journal, devoted an entire issue to the subject in the 1870s.

The advantages photography offered an artist of Eakins' caliber and sensibilities were, even beyond their obvious usefulness, potentially profound. Eakins chose modern scenes from everyday life to paint. His precise renderings of light and shadow made it difficult to duplicate conditions from one day to the next. Rowers on a flowing river and boatmen racing to catch the tide did not stay in one place long enough to be sketched. The fact remains, nonetheless, that critics of Eakins' own day, and for a century afterward, believed that Eakins was "above" working from photographs. His widow, fourteen years after the artist's death, was quite clear in advancing this point: "Eakins only used a photograph when impossible to get information in the way he preferred, painting from the living, moving model. He disliked working from a photograph, and absolutely refused to do so in a portrait."

The truth, however, is indisputably otherwise. He used hundreds of photographs in the course of his work. And among the many portraits he created by referring to photographs were ones featuring his wife as model. Although Eakins did not own a camera or take photographs himself when he produced his rowing and early sports paintings—and not for another decade was he known to have used photo-enhanced painting techniques to replace perspective sketches for any of his major paintings—the foundation for his

photographic use to come was in place before the pigment had dried on *Oars-men on the Schuylkill,* the last image Eakins created of men in racing shells, painted in 1874.

The first instance that is known of Eakins using a photograph in a painting was two years earlier, in *Grouse* (in the Mint Museum of Art in Charlotte, North Carolina). The actual photograph developed for this painting was taken by Eakins' friend and fellow oarsman Henry Schreiber, who operated a popular Philadelphia photography studio; it was one that specialized in portraits of animals. The photograph involved in *Grouse* portrayed Henry's favorite hunting dog, for whom the painting has been named. The same photo print later appeared as the frontispiece in an 1873 issue of the *Philadelphia Photographer;* this reproduction gave the clue that Eakins scholars later used to connect the photograph to the painting. The picture in the *Philadelphia Photographer* is a virtual mirror image in monochrome of the 1872 portrait by Eakins.

It is not known for certain how this painting came about or what technical process Eakins used in creating it. Most likely the painting was an experiment commissioned by Schreiber, or possibly Eakins painted it in return for Henry and his brother's modeling for him on the Schuylkill River and in his studio. The projection system Eakins set up to transfer the image to canvas was probably a catoptric lantern, also known as a magic mirror, which would have been provided by Henry's father and business partner, Franz Schreiber; Franz was a pioneer in the use of lantern slides in Philadelphia in the early 1850s.

Grouse appears to contain an enlargement of the photo projected directly onto the primed canvas. Eakins either traced the dog's image in pencil or punched tiny holes in the canvas to mark important reference points. His motive in choosing a photograph to model the animal, as opposed to sketching or painting the subject from life, is obvious: the dog would not stay still long enough for Eakins to capture a pose any other way. His technique became the equivalent of a precisely detailed study drawing, such as the one he made of Max Schmitt in preparation for his first rowing painting. Eakins would repeat and then modify this same photo-transfer approach when confronting the challenge of picturing a sailboat and its crew on the Delaware River. Painting the boat in the choppy and ever-changing waves on the river was itself a complex

perspective challenge. Modeling people in the boat required an altogether different approach. Photography provided the solution.

No known photographic prints are believed to survive from which Eakins modeled the boat and its occupants in *Sailboats Racing on the Delaware,* but forensic studies conducted by the Philadelphia Museum of Art reveal that one or more must have been made. The technique for examining this and other Eakins paintings in the museum's collection was based on infrared reflectography, or IRR. This method, along with X-rays, is often useful in locating images of subsurface features in paintings, such as changes from one paint layer to the next or underdrawings in pencil or ink that set out positions of subject matter and focal planes. In many paintings by Eakins, examination in this way reveals underdrawings echoing his preliminary sketches, along with tiny incisions or tick marks he made to establish grid lines, as in *Max Schmitt in a Single Scull.* These devices were entirely expected. In *Sailboats Racing on the Delaware,* however, something different came to light.

In *Sailboats Racing on the Delaware,* researchers found tiny incisions or tick marks beneath successive layers of pigment wherever figures appeared. Each minute tick indicated the position and salient features of a crewman's pose and costume. Unlike the painter's earlier work with this process, the markings show a consistent descriptive specificity, setting out detailed features of what can only have been photographs. Although the source photographs for this painting have not been found, photos for later paintings in which he employed this technique have turned up. Hidden under the pigment are not conventional drawings following the photo images. The revealed markings are direct tracings of the photographs.

The method Eakins adopted was entirely his own. It reflects both his intensive involvement with photography and the innovation he brought to it. By scratching small holes in a primed canvas he could apply subsequent layers of paint onto particular areas without obfuscating his markers, until he was far enough along in the painting that the marks were no longer necessary. He could preserve his layered painting technique, with its many semi-opaque washes of diluted paint, without losing important reference information. Only when the painting was nearing completion, when the reference points were

no longer needed, did he cover them up. He simply dabbed a dot of paint over the incision.

Because of the difficulties involved in handling cumbersome wet-plate photography equipment on a boat, and the long exposure times required to capture an image, Eakins surely posed the crewmen in their craft on or near the shore. Given his association with Henry Schreiber around this time, and that Schreiber accompanied Eakins on subsequent trips to the New Jersey shores when photographs were known to have been taken, it can reasonably be assumed that the photographer was Schreiber or that he at least assisted the artist.

Eakins projected a photo once again for *The Artist and His Father Hunting Reed Birds.* A photograph, likely made by Henry Schreiber and now part of the Thomas Eakins Research Collection at the Philadelphia Museum of Art, shows Eakins standing in what can be presumed to be a photographic studio. His pose, like the hat he wears, is identical to the way he is portrayed poling his father through the marshes in the subsequent painting.

Just as in *Sailboats Racing on the Delaware,* Eakins had conceived and choreographed the pose he wanted to model for the painting, rather than devising a painting from a previously photographed image. His scripting of the photographs is vital to understanding how he would integrate photographs with increasing sophistication into his paintings in the future. He was not "stealing" an observed moment: he created the moment. He considered photography as a practical supplement to his work in the way he did perspective sketches and drawings. All the photographs he used and the props portrayed in them were selected in advance. They were, in fact, among the many levels and veils in a painting—each, layer by layer, modifying the others—until the final image was no longer hidden but complete.

No other photographs for *The Artist and His Father* or any of the other hunting and sporting paintings have been uncovered. Although the lack of them does not prove they never existed, there is no reason to believe Eakins used them for these works. Conservation studies show nothing out of the ordinary. The abundance of preliminary perspective studies used for the baseball pictures also argues against the use of photo tracings in these paintings. It is further unlikely that Eakins had photographs taken for his other sports paintings, because he had ready access to the models, and he could pose them in

conditions suitable for sketching. This would not have been the case when trying to model Henry Schreiber's dog or himself in a catboat. Photography proved again to be the logical solution.

To critics and fellow artists like Earl Shinn and Leslie Miller, photography integrated in this way would have been accepted as a reasonable practice. They, like the artist David Hockney a century later, would have been the first to point out the obvious: "The lens can't draw a line, only the hand can do that." Eakins himself was by no means the first Philadelphia artist to project photographs for transfer to canvas. But it was unlikely that he desired to go beyond using photos in what he did in these early pictures. The many intricacies of getting a good photograph, the relatively poor quality of commercially available lenses, the length of time it took to expose a glass-plate film negative, and the need for clear water to keep the glass plates moist before developing the images were all serious limitations. Photography was still too inconvenient and time-consuming for Eakins to make it a significant tool in his art. Seven years elapsed between his initial experiments with photography, in the sports paintings, and when he resumed using photo elements, in late 1881, for a series of oils and watercolors of shad fishing on the Delaware at Gloucester, New Jersey.

Eakins had personal as well as practical reasons for retreating from his initial explorations with photography. In the autumn of 1873, not long after painting Benjamin and himself in *The Artist and His Father Hunting Reed Birds,* and during a period devoted to putting the finishing touches on several of his other sports paintings, Eakins contracted malaria. More than likely an infected mosquito had bitten him when he was on one of his hunting trips to the New Jersey marshes. As the malaria parasites penetrated his red blood cells, he was confined to bed, overcome by alternating chills and fever. With clockwork regularity, the most serious attacks came every second day or third day, lasting for up to twelve hours at a time. Eakins, wrapped in sheets, began to shiver. During the worst of his chills his teeth chattered and his fingers blanched until they became dead white. Once the chills ended, a dry fever wracked him, his skin becoming burning hot and flushed. Along with such seizures he suffered mental confusion and delirium.

"I would have made the details of the marsh better if I had been able to finish my studies," Eakins later wrote to Gérôme. "While waiting for the season

that I represented in my picture I caught malaria pursuing this same hunt, and the fever took me badly. I was bedridden 8 weeks, senseless most of the time. They believed that I would die. When I came to myself, the trees no longer had leaves. For a long time I was too weak to work and my mind was also feeble.... The doctor forbids me to go hunting this year even though I have been used to going there since childhood. It will be dangerous to me."

Death had already twice visited the Eakins home. The family could count itself fortunate, however, that treatments for malaria had by this time progressed beyond the testing stages. Imported quinine was readily available in Philadelphia, and belladonna, extracted from the roots and leaves of the deadly nightshade, was prescribed in combination with quinine to fight the malaria. Had Eakins contracted yellow fever or cholera, each also associated with marshland, he probably would have died.

His recovery proceeded slowly. Housebound for ten to twelve weeks, but not likely to be idle, Eakins concentrated on finishing off paintings he had begun earlier and making concerted efforts to have his work shown. As a preliminary step to restarting his career, Eakins sent Gérôme a watercolor of one of his rowing scenes. In a letter dated May 10, 1874, "le Patron" expressed the pleasure he clearly felt at the progress Eakins had made. "I will not conceal from you that formerly in the studio I was not without anxiety about your future as a painter, from the studies that I saw you make," Gérôme wrote. "I am indeed delighted that my counsels, however tardily applied, have at last borne fruit, and I do not doubt that with perseverance, in the good path in which you are now, you will arrive at truly serious results."

Along with this vote of confidence, Gérôme suggested some improvements to the position of the rowers. Eakins reworked the watercolor and sent it back again, accompanied by two oils of hunting subjects for submission to Gérôme's father-in-law, the art dealer Adolphe Goupil. Gérôme was extremely pleased. "I give you my compliments and engage you to continue your work in this serious path which assures you the future of a man of talent," he wrote. "I am very pleased to have in the New World a pupil such as you who does me honor."

Eakins was understandably thrilled with Gérôme's response, and equally with the subsequent news that the important dealer Goupil had accepted both

his paintings. He immediately sent Gérôme four more oils of sporting pictures, which likely included *Sailboats Racing on the Delaware*. His intention this time was more ambitious: submission to the Salon of 1875. Eakins decided at the same time not to hold back on submitting his art for exhibition at home. He sent examples of his hunting and rowing paintings to exhibits in New York and Philadelphia.

He did not have long to wait for critical reactions. The first news came from Paris, where Earl Shinn wrote to alert him that his second shipment of paintings had not arrived in time for the Salon selection process. Since Eakins had not sent instructions in the event of such an unexpected turn, Gérôme went ahead and submitted the paintings that Goupil had taken for sale. Although Eakins believed they were of lesser quality, what transpired must have elated him: both paintings were accepted into the Salon.

His work attracted a good deal of attention in the Paris art world, but not for the reason Eakins had anticipated. The critic for *L'Art* seemed to sum up a general mood among critics: "Mr. Eakins, a disciple of Mr. Gérôme's . . . has sent from Philadelphia a mighty strange painting, but which is far from having no good points. *A Hunt in the United States* [the title Goupil gave to *Pushing for Rail*] is a work of genuine precision . . . rendered in a way that is photographic. There is a veracity of movement and details which is truly great and singular. This exotic product teaches you something, and its author is not one to be lost sight of." In a different conclusion, the critic of the *Revue des Deux Mondes* wrote: "These two canvases [*Pushing for Rail* and another of Eakins' hunting paintings], each containing two hunters in a boat, so much resemble photographic proofs covered over by a light local tint in watercolor, that one asks oneself if they were not specimens of an industrial process still unknown, and which the inventor has maliciously sent to Paris to trouble . . . the French school."

However close to the truth critics had come to identifying one of the techniques he had actually used, Eakins was taken aback by the mixed response. It was the realism of the paintings, in the vein of the Spanish masters, that Eakins believed the French would most admire, yet this was what the *Revue des Deux Mondes* critic found so unsettling.

Eakins had, by this time, sent several rowing and hunting paintings, both

watercolors and oils, to exhibitions in New York and Boston. The honor he desired the most was a showing at the National Academy of Design; the date for acceptance came and went. "The reason my . . . [painting] was not exhibited in New York I do not know," a distraught Eakins wrote to Shinn. "It was sent on in due time . . . I guess therefore my picture was simply refused. It is much better . . . than any one in New York can paint. I conclude that those who judged it were incapable of judging or jealous of my work, or that there was no judgment at all on merit, the works being hung up in the order received or by lottery."

Eakins was still puzzling over the National Academy's rejection when he learned that several of his paintings had been accepted at home, in Philadelphia, for showing at the Charles Haseltine Gallery. Again, however, the critical reaction was not what he expected. The *Daily Graphic* called his rowing paintings "fine muscular studies," adding that they "may not be of very high class of art, but they are exceedingly well done." The writer for the *American Art Review*, after viewing *The Biglin Brothers Turning the Stake* at a later exhibit, found his painting "not only utterly without color, but also utterly lifeless."

The critic for the *New York Daily Tribune* provided a different sense of awareness in his praise and encouragement. "[Eakins'] portraits of rowing and sculling celebrities in their boats, and set in landscapes that are as much to be enjoyed as the men, with their beautifully ugly muscles, or the skeleton boats [are] the only exquisitely artistic production of the American nineteenth century mind thus far. . . . Mr. Eakins has struck out a new vein in these subjects, and barring some slight exaggerations and some signs of timidity his work is very clever. . . . Mr. Eakins's drawings will be looked for with interest. It is not every year there is so prominent a first appearance."

The best overall review Eakins received concerning his rowing and hunting paintings was for *Starting Out After Rail*. A critic from *Art Amateur* declared that the painting bordered on the "miraculous." Yet he found fault with Eakins' lack of "felicity of touch," and with the "brutal exactitude which holds in a vise grip the scientific facts of wave-shape and wave-mirroring." Much the same was said of *The Pair-Oared Shell*, which the critic for the *New York Times* found "remarkable for good drawing, natural and quiet composition, and a pleasant feeling in the color," but lacking inspiration. "If it were possible

to conceive that an artist who paints like Mr. Eakins had a poetic impression, we would like to think that in this composition he had tried to express the peculiar charm that everyone has experienced when rowing out of the sunlight into the shadow of a great bridge."

Eakins' baseball pictures found much the same curious reaction. Philadelphia critics generally found the work "excellent in drawing, attitude, and expression," while at the same time they determined it was lacking in "poetry." The very photographic qualities that the French disliked about his work were praised in the United States and, conversely, the subject matter the French admired was found inadequate at home. Henry James, writing about the portraitist John Singer Sargent, pointed out much the same paradox. "It is a very simple truth, that when today we look for 'American art' we find it mainly in Paris," James wrote in *Harper's*. "When we find it out of Paris, we at least find a great deal of Paris in it."

Eakins once again adopted a positive attitude toward the reception of his work. He was convinced the future would bring him the full recognition and income he believed his paintings deserved. Apropos of the rejection, he wrote to Earl Shinn in the early spring of 1875: "My works are already up to the point where they are worth a good deal and pretty soon the money must come."

The money did not come. Of the paintings he had sent to France the dealer was able to sell only one, a hunting scene for which Goupil obtained sixty dollars. He fared equally poorly with those he sent to New York and Boston. Only one was sold: Eakins received eighty dollars for *The Sculler*, a portrait of John Biglin, which was purchased at the seventh annual exhibition of the American Society of Painters in Water Colors. His total earnings for a few paintings were barely enough to cover shipping costs, canvas, and the paint he had used to create all of his works. And yet, he had made his first known sale, a significant one, and was launched as a professional artist.

A Good and Decent Girl

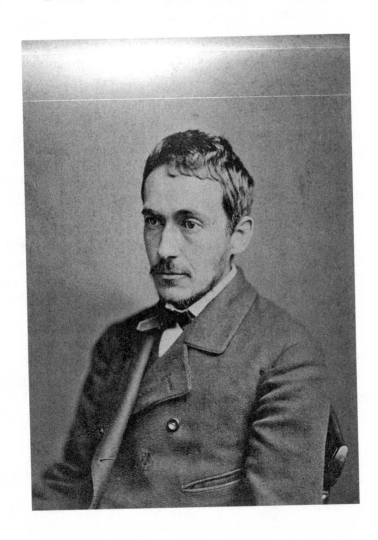

Eakins had every reason to believe that his recovery from malaria was complete. "He is all right, painting away," Benjamin Eakins wrote to his friend Henry Huttner on July 29, 1874. "He will be able to make a living, [and] that is all any of us get. This is a fast age and I hope it will not prove with him as it did with many of the old Master [painters]—[those who] receive great honors a hundred years after they had starved to death."

Tom's bout with malaria, however, might have resulted in an unfortunate side effect. His prolonged and extreme fever could have left him sterile. The irony is that just as Eakins was feeling back to his normal self, the subject of marriage and children was much on his and his family's mind. Frances, now twenty-five, had given birth to her first child, Ella, in December 1873, and was pregnant with another. Thomas, thirty years old, was not yet married. "I feel my love days long over & they will never come again," he had written to Will Crowell after his falling-out with Emily Sartain.

Family friend Sallie Shaw thought there was an entirely different reason for his bachelorhood: Tom was too busy playing the field. She further suggested that he "associated" with so many girls that Benjamin Eakins was becoming annoyed. According to her, Benjamin finally put his foot down and, early in 1874, chose the woman Tom became engaged to that year: Kathrin Crowell, twenty-three, the younger sister of Will Crowell, Tom's brother-in-law.

There is no documentary evidence to substantiate or refute Shaw's assertion, but there is every reason to believe it was true. In contrast to Eakins' romance with the dynamic and artistic Emily Sartain, his courtship of Kathrin, a plain-looking girl of little notable accomplishment, seems odd. Sallie Shaw, who knew her well, described Kathrin as "just a good and decent girl," but "not artistic." Unlike the convivial and outgoing Eakins, she did not mix easily with people she did not already know. Kathrin played the piano, but not very well. She liked art, but had no inclination to draw or paint. Nor was she known to have enjoyed the outdoors. She was physically weak and frail, a result of contracting yellow fever as a child. The illness could also have left her psychologically scarred, after her mother, without thinking, covered the youngest

Opposite: Eakins in the mid-1870s; portrait photograph by Frederick Gutekunst (Courtesy of The Philadelphia Museum of Art and The Lloyd Goodrich and Edith Havens Goodrich, Whitney Museum of American Art, Record of Works by Thomas Eakins)

Crowell child with an infected blanket Kathrin had used. The Crowells' infant daughter contracted the disease from the blanket and died.

Evidence for a passionate relationship between Tom and Kathrin is lacking. Letters that exist, written in late 1874 and early 1875, do not suggest the kind of burning love that had once inspired Tom to quote from Dante in his courtship writings to Emily. His letters to Kathrin appear not to have been addressed to someone capable of understanding his artistic aspirations. Most are as factual and passionless as press clippings, even when Eakins shares news as exciting as two of his paintings being accepted for exhibition or his work receiving a favorable review. "My pictures are all right," he wrote, and "My pictures are much liked." One letter is devoted to family pets and a visit from Emily Sartain, who stopped by the Mount Vernon Street house to see one of Tom's sisters. "Chippy is well. The cat is well. I am well. Em [Emily Sartain] looks well. Everybody is right well." The most emotion he could summon in closing another letter was, "I miss you very much." Only once in the surviving correspondence does he speak of his love for her, and when he did, it was in familial context. "My love to Lizzie [and] to your mother. I will be very glad to see them again. My love to your own self." He also signed his letters "Thomas Eakins"—hardly a gesture of intimacy with someone he was engaged to marry.

The greater mystery of their engagement is not why he proposed to Kathrin but why he did not choose her more energetic, vivacious, and comely younger sister, Elizabeth, whom Shaw claimed Eakins truly did love. Unlike Kathrin, and more like himself, Elizabeth was highly educated, fluent in several languages, and showed a decidedly artistic bent. The two portraits Eakins painted of her, compared with the one he painted of Kathrin, radiate sensuality, intellect, and spirit. Another of his paintings from this period, *The Courtship* (c. 1878, Fine Arts Museums of San Francisco), shows a young man relaxed in a chair gazing toward a young woman at a spinning wheel. If this painting did indeed reflect Eakins' own relationship with Kathrin, as it has long been supposed, the degree of their emotional involvement was severely limited. Rather than the urgent suitor suggested by the painting's title, the spectator is but a casual observer. Surely Benjamin Eakins and Sallie Shaw would have picked up on the scarce signs of passion expressed in *The Courtship* and in

his earlier portrait of Kathrin; and they must have noticed the romance and sensuality in his portraits of Elizabeth. The truth may simply have been that Elizabeth was not interested in Tom, or thought him too old. Kathrin was available and presumably in love with him.

Of equal interest was Tom's continuing relations with Emily. During the previous four years, while they had been apart, much had changed in both of their lives. Tom's correspondence reveals a marked humility that did not exist before the death of his mother and the mixture of negative reactions to his rowing and sporting paintings. Perhaps he had come to understand that becoming a successful Philadelphia painter required as much delicacy of touch in personal and professional relationships as it did with paintbrush on canvas.

Emily, too, had matured in unexpected ways. In her own desire to further her skills as a painter she had reached the same conclusion as Eakins: Christian Schussele and the Pennsylvania Academy of the Fine Arts did not offer the quality of education that could be obtained studying in Paris. Emily herself had gone to Paris in 1871 in search of a mentor, and there she joined Mary Cassatt and enrolled in the atelier of Evariste Luminais, a history painter who was one of the few instructors willing to teach women. Emily's experiences there had reconciled her to the very lifestyle for which she had once derided Eakins. She also mastered the techniques of academic realism to the degree that she now had a far greater appreciation of what Tom was reaching for in his art and of the professional struggles he had undergone in Paris. In his rowing paintings she must also have seen the flowering of a talent beyond the aspirations and capabilities of her own father and brother. Perhaps, too, she had begun having misgivings about her father; no longer was she the object of his undivided attention. The affection he had showered on her was now being given to one of her older brother's daughters, whom he took to Europe with him on holiday.

How Tom's reconciliation with Emily, his apparent love for Elizabeth, and his engagement to Kathrin influenced his career decisions is a difficult speculation. Eakins was popular and enjoyed the company of many of the city's young artists. Their warm reception to him was abundantly clear in his first teaching experience at the Philadelphia Sketch Club. William Clark, one of the

Philadelphia art critics who had praised Eakins' rowing paintings, extended the teaching invitation on the recommendation of Earl Shinn; the sketch club asked Eakins to attend twice-a-week sessions to give criticism.

Eakins was initially unwilling to volunteer his services, a reluctance stemming from his belief that students would not take what he said seriously. His own sensibilities as an artist seemed far from those of his colleagues, especially those of club member Howard Roberts, the favored sculptor of John Sartain and the Paris nemesis of Eakins. "If your friends of the Sketch club really want my corrections of their drawings they have them for the asking . . . [on the condition that] the majority of the club desires them," Eakins wrote to Shinn in April 1874. "I only fear some of them are of the kind who would believe themselves more capable of teaching me than I them."

In spite of his reservations, Eakins went ahead and started attending the twice-weekly sessions. He soon reported back to Shinn: "My life school boys seem to be getting on well considering the little time they have. Some are very earnest. But some continue to make the very worst drawing that ever was seen."

The number of students began to increase after Eakins began teaching at the club. "If the rooms were four times as capacious as they were they would scarcely accommodate the students who are anxious to avail themselves of the facilities which the class affords," Clark noted in his regular column in the *Philadelphia Evening Telegraph.*

Participants in the Philadelphia Sketch Club over the years ranged from artists of some experience, like Alexander Milne Calder, Howard Roberts, and Eakins' Central High classmate Charles Fussell, to less-experienced but promising students, among them Thomas Anshutz, James Kelly, Charles Cooper, and Frank Stephens. Assisting Eakins at the Sketch Club was his friend Will Sartain, who had completed his studies with Bonnat and had returned home from Paris.

Eakins' classes were very well received. According to Shinn, "Mr. Eakins at once demonstrated not only that he was thorough master of his subject but that he had a distinct genius for teaching." Further, Shinn recalled that Eakins' "pupils developed that enthusiastic regard for him which zealous learners always feel for a master whose superior attainments they unqualifiedly respect." Eakins was so popular, in fact, that the club awarded him a lifetime member-

ship, making him one of only two instructors to receive that honor in the club's history. The teaching experience must have been even more rewarding to him because he had grown up in a household in which scholarship and teaching were so highly prized. Eakins had always wished to please his father; the greatest tribute he could pay Master Benjamin was to emulate him.

The experience of teaching at the Sketch Club, along with his engagement, did not hinder his own artistic efforts, and may have actually provided needed support when the varied reviews of his rowing and sporting paintings trickled in from New York and Paris. Rather than succumb to discouragement over the modest sales of his art, he became all the more passionate about it, most specifically about a single painting that he worked on for more than a year. He sketched out the idea for the painting in March or early April of 1875 on the back of one of his rowing drawings. "I have just got a new picture blocked in and it is far better than anything I have ever done," Eakins wrote his friend Earl Shinn. "As I spoil things less and less in finishing I have the greatest hopes for this one."

Once again he was planning to paint a portrait showing a celebrated and accomplished Philadelphian in the arena in which he had won distinction. The painting was to portray seventy-year-old Dr. Samuel D. Gross, the distinguished chief of surgery at the Jefferson Medical College. Eakins intended to picture Dr. Gross in the midst of conducting one of the surgical procedures that had won him an international reputation as the finest surgeon the young nation had yet produced. Just as *Max Schmitt in a Single Scull* had been more than a portrait of an athlete, the Gross portrait was to be a symbol of Philadelphia's greatness and the ascendancy of medical science. That Eakins himself had been a medical student, he felt, could lend validity and accuracy to his portrayal, in the same way his experience as an oarsman had contributed to the authenticity of his rowing paintings.

Eakins envisioned this portrait as monumental in every way, from the sheer proportions of the canvas—approximately eight feet high and seven feet wide—to the epic scope of the scene it portrayed. Dr. Gross, distinguished by his silvery hair, fine brow, and strong features, would be attended by his entire medical team of five physicians as they performed a complex surgery on an anesthetized patient. Gross would hold his blood-covered scalpel as

he turned from his patient and surgical assistants to lecture his students and onlookers—including Eakins himself—seated in the Jefferson Medical College operating theater.

The composition Eakins sketched out had no prototype in American art. Only a few European masters had attempted such a painting, and even then, none of their works possessed the complexity and dramatic scope Eakins desired to bring to his canvas. The closest painting Eakins was aware of was Rembrandt's celebrated *Anatomy Lesson of Dr. Tulp.* In the Rembrandt painting, however, the patient was a lifeless corpse. Eakins was going to document an actual operation in progress on a living patient.

His decision to paint the portrait stemmed from a combination of factors. His recent illness and recovery had brought him back into contact with friends and associates at Jefferson Hospital, a place as familiar to him as the Schuylkill River. One of these friends, Dr. Howard Rand, his former Central High chemistry teacher, had gone on to join Dr. Gross's medical team. Eakins painted a portrait of Rand in 1874 that marked the occasion of his retirement from Jefferson. The success of this painting may have given Eakins the courage to try something more ambitious. Dr. Rand himself may have recommended that Eakins undertake the Gross portrait and helped to make the arrangements with the chief surgeon.

The income Eakins received from his rowing and sporting paintings, though not consistent, could also have inspired him to try something more commercial. Dr. Gross, a native Pennsylvanian, represented the best of Philadelphia and the medical community at large. He had, in fact, been one of Jefferson Medical College's first students, having enrolled in 1826, the year after the school was founded. In the forty-six years he had practiced, he had been elected the twentieth president of the American Medical Association, was the founder and first president of the American Surgical Association, and served as president of the Philosophical Society of America as well as of the American Academy of Sciences. The *Manual of Military Surgery,* compiled by Dr. Gross, was earlier used by both sides during the Civil War and was still consulted by physicians on the frontier. A portrait of such an admired and distinguished man in the finest of new medical facilities, Jefferson's operating

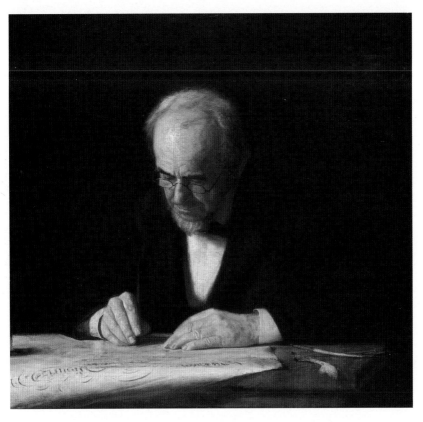

1. Thomas Eakins, *The Writing Master (Portrait of Benjamin Eakins)*, 1882.
Oil on canvas, 30 × 34½ inches. Courtesy of The Metropolitan Museum of Art, New York;
John Stewart Kennedy Fund, 1917.

2. Thomas Eakins, *Home Scene,* c. 1871. Oil on canvas, 21⁷⁄₁₆ × 18 inches. Courtesy of The Brooklyn Museum of Art, New York; gift of George A. Hearn and Charles A. Schieren, by exchange; Frederick Loeser Art Fund and the Dick S. Ramsay Fund.

3. Thomas Eakins, *Elizabeth Crowell with a Dog,* c. 1873–74. Oil on canvas, 13¾ × 17 inches. Courtesy of The San Diego Museum of Art; museum purchase and a gift from Mr. and Mrs. Edwin S. Larsen.

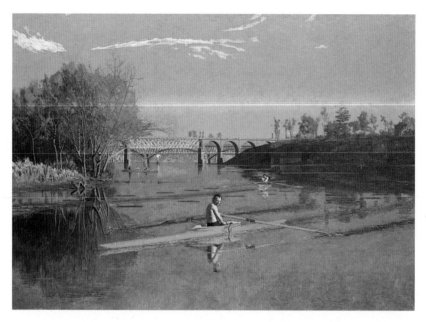

4. Thomas Eakins, *Max Schmitt in a Single Scull (The Champion Single Sculls)*, 1871.
Oil on canvas, 32¼ × 46¼ inches. Courtesy of The Metropolitan Museum of Art, New York;
purchase, The Alfred N. Punnett Endowment Fund and George D. Pratt Gift, 1934.

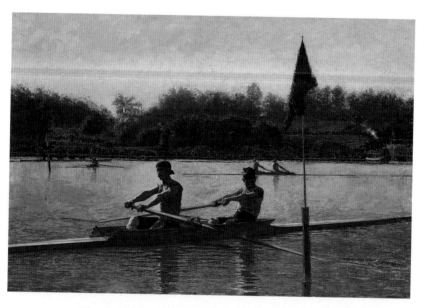

5. Thomas Eakins, *The Biglin Brothers Turning the Stake*, 1873.
Oil on canvas, 40¼ × 60¼ inches. Courtesy of The Cleveland Museum of Art;
the Hinman B. Hurlbut Collection, 1984.

6. Thomas Eakins, *Sailing,* c. 1875. Oil on canvas, 31⅞ × 46¼ inches. Courtesy of The Philadelphia Museum of Art; the Alex Simpson, Jr., Collection, 1928.

7. Thomas Eakins, *Pushing for Rail,* 1874. Oil on canvas, 13 × 30¹⁄₁₆ inches. Courtesy of The Metropolitan Museum of Art, New York; Arthur Hoppock Hearn Fund, 1916.

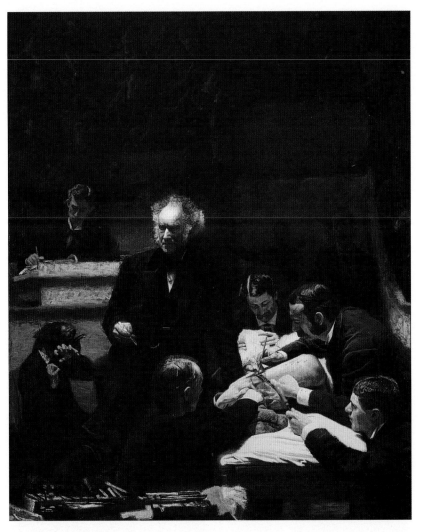

8. Thomas Eakins, *The Gross Clinic*, 1875. Oil on canvas, 96 × 78½ inches. Courtesy of Jefferson Medical College, Thomas Jefferson University, Philadelphia.

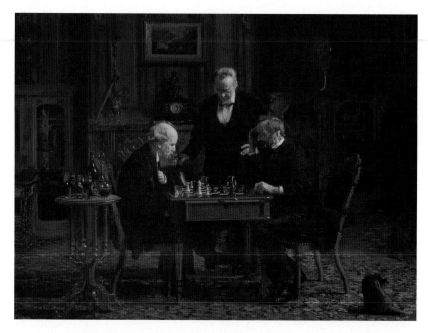

9. Thomas Eakins, *The Chess Players,* 1876. Oil on wood, 11¾ × 16¾ inches. Courtesy of The Metropolitan Museum of Art, New York; gift of the artist, 1881.

10. Thomas Eakins, *Baby at Play,* 1876. Oil on canvas, 32¼ × 48⅜ inches. Courtesy of The National Gallery of Art, Washington, D.C.; John Hay Whitney Collection.

11. Thomas Eakins, *William Rush Carving His Allegorical Figure of the Schuylkill River,*
1876–77. Oil on canvas, 20⅛ × 26⅛ inches. Courtesy of The Philadelphia Museum of Art;
gift of Mrs. Thomas Eakins and Miss Mary Adeline Williams, 1929.

12. Thomas Eakins, *A May Morning in the Park (The Fairman Rogers Four-in-Hand),*
1879–80. Oil on canvas, 23¾ × 36 inches. Courtesy of The Philadelphia Museum of Art;
gift of William Alexander Dick, 1930.

Opposite: 13. Thomas Eakins, *The Crucifixion,* 1880. Oil on canvas, 96 × 54 inches.
Courtesy of The Philadelphia Museum of Art; gift of Mrs. Thomas Eakins and
Miss Mary Adeline Williams, 1929.

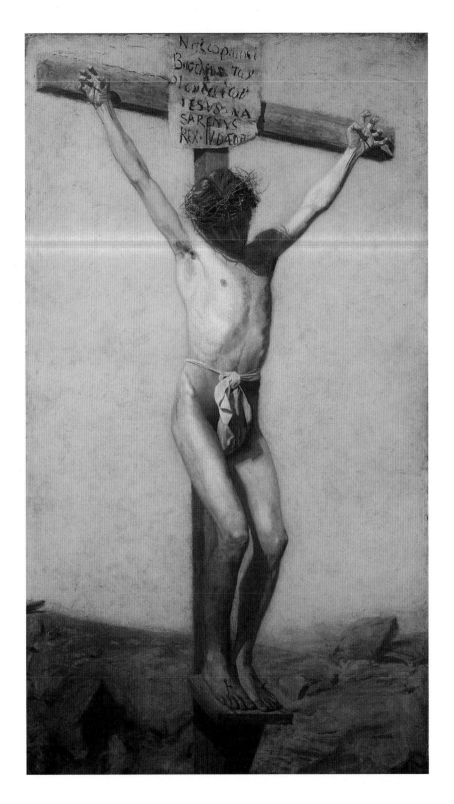

14. Thomas Eakins, *Singing a Pathetic Song,* 1881. Oil on canvas, 45 × 32½ inches. Courtesy of The Corcoran Gallery of Art, Washington, D.C.; museum purchase, gallery fund.

15. Thomas Eakins, *Shad Fishing at Gloucester on the Delaware River*, 1881. Oil on canvas, 12⅛ × 18⅛ inches. Courtesy of The Philadelphia Museum of Art; gift of Mrs. Thomas Eakins and Miss Mary Adeline Williams, 1929.

16. Eakins family and Harry at Gloucester, 1881, photograph by Thomas Eakins, used as the source for the foreground group in *Shad Fishing at Gloucester on the Delaware River*. Courtesy of The Pennsylvania Academy of the Fine Arts, Charles Bregler's Thomas Eakins Collection; purchased with the partial support of the Pew Memorial Trust.

17. Eakins family and Harry at Gloucester, 1881, photograph by Thomas Eakins, used as the source for the dog in *Shad Fishing at Gloucester on the Delaware River*. Courtesy of The Pennsylvania Academy of the Fine Arts; purchased with the partial support of the Pew Memorial Trust.

18. Thomas Eakins, *Mending the Net,* 1881. Oil on canvas, 32⅛ × 45⅛ inches.
Courtesy of The Philadelphia Museum of Art; gift of Mrs. Thomas Eakins and
Miss Mary Adeline Williams, 1929.

19. Detail of *Mending the Net*
showing locations of incised
lines diagrammed in red

20. Diagram of the location of pencil datum lines
beneath the paint in *Mending the Net* as detected by
infrared reflectography

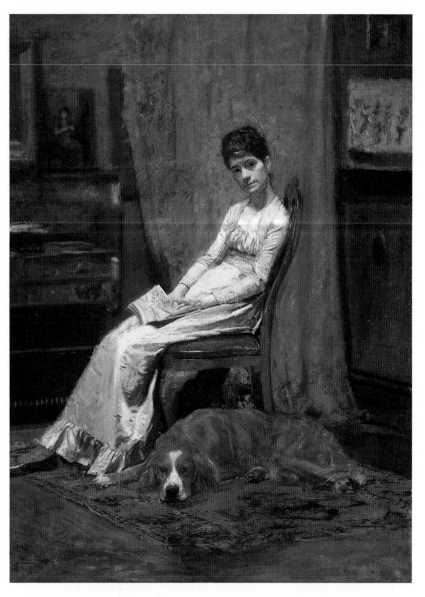

21. Thomas Eakins, *The Artist's Wife and His Setter Dog*, 1884–89.
Oil on canvas, 30 × 32 inches. Courtesy of The Metropolitan Museum of Art,
New York; Fletcher Fund, 1923.

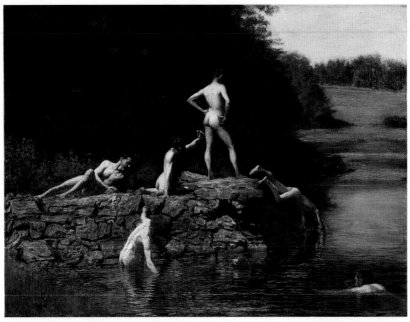

22. Thomas Eakins, *Swimming*, 1884–85. Oil on canvas, 27⁵⁄₁₆ × 36⁵⁄₁₆ inches.
Courtesy of The Amon Carter Museum, Fort Worth, Texas.

23. Location of incised line
in reclining figure's head

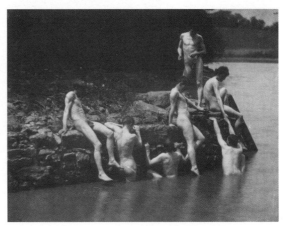

25. Location of incised lines
of standing figure's right hand

24. Eakins' students at the site of *Swimming*, platinum print,
photograph by Thomas Eakins, c. 1883. Courtesy of
Pennsylvania Academy of the Fine Arts, Charles Bregler's
Thomas Eakins Collection; purchased with the partial
support of the Pew Memorial Trust.

theater, might generate commissions from men of equal stature in the profes-
sional community. At the very least it would be noticed.

Equally appealing, Eakins admired Dr. Gross as a man of humble origins
who had risen to the top of his profession and, in word and deed, epitomized
much that the artist held sacred. Gross had a profound respect for the human
body. He insisted that his students understand the underlying principles of
whatever they studied, and taught them a Spencerian respect for knowledge
that could be verified and set down. "I never dealt with hypothesis, conjecture,
or speculation," Gross would later write in his memoirs.

One added factor, an important one, played into the decision to take
on this monumental subject. The city of Philadelphia was about to host the
first world's fair ever to be held in the Americas. Envisioned as more than a
collection of pavilions representing the various nations of the world, the fair
was planned as a six-month celebration of the United States' centennial: the
Union's birthday present to itself, scheduled to begin May 10, 1876. It would
feature thirty-six countries and more than a thousand organizations in a 236-
acre complex of showpiece buildings and exhibition halls in Fairmount Park.
Displays in the halls to be erected would showcase the latest in art, education,
archaeology, agriculture, manufacturing, metallurgy, and scientific discover-
ies. All of Philadelphia was talking about the event, including John Sartain, a
member of the fair's art selection committee. There could be no better occa-
sion or venue to present and display a portrait to reflect Philadelphia's best
and brightest. As Eakins wrote, it was the "finest thing he could possibly do
for so great an event."

twenty

The Blood-Covered Scalpel

The degree to which Eakins discussed his proposed painting with its subject, Dr. Gross, is a matter of debate. The one thing that emerges clearly is that Gross understood he was to be portrayed as medical students saw him in the Jefferson operating theater. On the operating table in front of Gross and his medical team would lie the patient, and sitting in the background above him in the Jefferson amphitheater would be medical students. The aspect of the painting Eakins may not have fully discussed with Gross was the sheer graphic and detailed nature of the portrayal that would result. Eakins intended from the start to depict, in the full surgical scene, Gross's blood-covered scalpel and the open incision of the patient.

Dr. Gross likely suggested the operation to be portrayed. The painting would depict him performing surgery for osteomyelitis, a crippling and often lethal bone infection that typically afflicted young men in their teens. Gross himself had pioneered the technique of removing the diseased bone; today the operation is considered as simple as having wisdom teeth extracted, but in the 1870s it was leading-edge surgery. Before that time osteomyelitis could be treated only by amputation; it had only been the relatively recent advance of anesthetic that made the surgery possible. The operation being observed in the painting was a significant medical breakthrough.

Osteomyelitis is characterized by infection of the body's longer bones, such as the femur, tibia, and humerus, and few people other than those between the ages of five and twenty-two are susceptible. Infection usually sets in after a sudden chill, causing the patient to experience high fever and excruciating pain. In the clinics at Jefferson during the 1860s and 1870s the treatment of diseased or dead bone occupied Dr. Gross more than did any other single surgical procedure. The problem demanded a great deal of patience: the surgeon did not dispatch his patient quickly as if he were removing a cyst or even performing an amputation. To highlight Dr. Gross's devotion to medicine, Eakins or the doctor may have decided to portray a charity case, a hotly debated supposition among art historians based on the artist's inclusion of the patient's mother in the painting. The law required all charity patients to be accompanied by a relative, when available, to avoid malpractice suits.

Opposite: Dr. Samuel D. Gross's surgical instruments, made by Jacob H. Gemrig, Philadelphia (Courtesy of Jefferson Medical College and Medical Center, Thomas Jefferson University, Philadelphia)

Once the operation to be portrayed was decided, the next step was to select details of this surgery that would distinguish it from others. To effect this, Eakins would portray the patient lying on his side with his left thigh exposed. The moment Eakins ultimately depicted was just after Dr. Gross had already made the incision. An assisting surgeon probes the wound, two other assistants hold the incision open with metal retractors, and a third assistant grips the patient's legs. At the end of the operating table an anesthesiologist holds a mass of chloroform-soaked gauze over the patient's face.

The motion picture nature of the drama could thus be captured in a single moment: Having completed his incision, Dr. Gross pauses while his assistant, Dr. James Barton, probes for a piece of diseased bone. The noble-browed professor, knife held in his crimson-soaked fingers, turns to the assembled students in the surrounding gallery to comment on some aspect of the operation. Eakins himself is seen sketching from his seat at the far right in the first row of observers. To Gross's right side is the patient's mother, clothed in a full-length black dress and bonnet, her head averted from the bloody scene taking place in front of her, raising her clenched hands in fright.

The drama of the painting's construction is generated by its many contrasts: the noble, magisterial calm of Dr. Gross, the agony and horror experienced by the patient's mother, the obvious helplessness and vulnerability of the patient, and the hushed attention paid by the students (plate 8). Eakins sets darkness against light, science against disease, and ignorance against knowledge. As in the Max Schmitt portrait, the less obvious details provide additional fidelity to a perception of the actual situation. A tray of operating-room instruments and gauze appears in front of Dr. Gross. Above the patient's mother, at a brightly lit lectern in the first row of the amphitheater, Dr. Franklin West records the clinical proceedings for the benefit of future medical students and researchers. In the right middle distance, watching from inside the doorway to the amphitheater, behind the operating table, is Hughey O'Donnell, the college orderly, and, in a more intense pose, Dr. Gross's son, himself a surgeon. For twenty-one smaller portraits in the painting, those of Dr. Gross's audience, Eakins also depicted real people.

Eakins did not, however, conceptualize the painting solely as a work of uncompromising realism. To miss this point would be to miss the painting's

most subtle and compelling innovation. Just as Eakins had done in *The Big-lin Brothers Turning the Stake,* he conceived Dr. Gross's portrait as making heavy visual and intellectual demands on the viewer. Eakins constructed the portrait in such a way that it adroitly yet realistically obscures certain parts of the events, and thereby draws the viewer into the scene taking place.

The patient, for example (presumed to be male), is almost totally hidden, his face covered by the anesthetist's cloth. All that is clearly visible of him is his left buttock and thigh and sock-covered feet. Also hidden is an assistant seated behind Dr. Gross: only part of his knee and his hand holding a retractor in the incision appear. Eakins—before even putting brush to canvas—knew that it would take the viewer minutes, if not longer, of studying the painting to understand what was transpiring.

These enigmatic elements were not intended to confuse; instead, they make it more likely that the viewer will study every detail. As anyone who has spent time with the completed painting can well attest, Eakins accomplished what he had set out to do. To be appreciated, the painting requires both the viewer's participation and imagination. Once the viewer is involved, the bloody detail sweeps over the viewing experience in ways that few paintings ever achieve.

Although he undoubtedly shared the painting's main points with Dr. Gross, Eakins likely did not try to convey all of his advance conception with him; once the details were in place, Gross probably had very little input. The extent of his active participation consisted of posing for Eakins under the skylight in the Mount Vernon Street studio. He may not actually have seen the portrait until well after its completion. How often the surgeon's presence in the studio was required is not recorded; what is known is that Gross reportedly grew so tired of posing he is reputed to have said, "Eakins, I wish you were dead!" Eakins also photographed him in his studio, and probably in the Jefferson operating room, although, unlike his work in *Sailboats Racing on the Delaware,* projected photographs do not appear to have been used for modeling any figures in the work.

After painting Dr. Gross's image Eakins enlisted the cooperation of the many other people who appear in the painting. Foremost among them was the doctor's medical team, which included physicians Charles Briggs, Joseph

Hearn, James Barton, and Daniel Appel. Eakins made oil studies of each of these men, along with several spectators who appear in the scene, including the Jefferson Medical College janitor and orderly, Hughey O'Donnell. Only one such study now survives, one of medical student Robert Meyers, whom Eakins pictured in the back row, third from the right. It is not known who posed for the patient and the patient's mother.

Work on the painting progressed through the summer of 1875. Eakins was most pleased with its coloring. As conservators have revealed, he suffused both lights and darks with a warm, unifying layer of red underpainting that brings the various elements into harmony. The red in the doorway pulls the distances closer. He used direct touches of other colors to report details of the surgical setting. The instruments in the left foreground are lined with bright green and blue. Pinks, blues, and purples describe the blood-soaked dressings at the very left of the table. On the right is gauze stained with reds and pinks of fresh blood. Underneath the end of the operating table, drops of red still gleam in a box of sand or sawdust positioned to catch the blood from the operation. Even in the more localized color, it is the red that dominates and draws the viewer across the painting and into the center triangle where Dr. Gross stands over the patient. In the blood-defined scalpel, Eakins brought together his most intense color and his sharpest focus.

Eakins wielded his brush with a hand as steady as the one Dr. Gross used to guide his scalpel. Every detail in the picture contributes to its overall dramatic value. Each person depicted shows elements of character. Though the painting was decidedly meant to be a scientific study, Eakins sought and captured the humanity of the event. He did not shrink from describing the unpleasant aspects of life. Rather he portrayed the disease and the pain truthfully. Out of the painting's truth of characterization, its strength and balance of design, comes its extraordinary power.

Much of Eakins' intense development over the years—which would require a long catalogue—leads to the ways the painting manages to communicate such power and mastery. Elements of the technique he built up were evident, almost without exception, in all the paintings he had previously completed. In this work, however, more than in any other, Eakins' technique could be judged most compelling. Art historian and critic David Lubin and many others have

noted that the painting evokes a curious, almost mysterious emotional presence. It plays off the tension between carefully planned spatial concerns and a more relaxed and, for him, free-spirited handling of paint. The same sense of a balancing act charges the story portrayed. The incision has already been made and presumably the diseased bone removed. Yet the emotional impact is projected into an uncertain future, intensified by the horror expressed by the patient's mother. Dr. Gross appears a model of complexity and interest. His steadfast bearing and scientist's realistic focus do not quite mask a healer's deep compassion.

Eakins accomplished something far grander than a merely daring reconstruction. As he later said in a letter to a friend, all a biographer would need to know about him was evident in his art. In this sense, *The Gross Clinic* of 1875 is nothing short of a bible. Its hero is a surgeon whose skill and deep understanding of human physiology have permitted him to triumph over his emotions to bring about the healing of his patient. The surgeon's detachment from the anguish that the patient's mother experiences is necessary to his work. Rigid self-control, discipline, and intense training are necessary to cut into human flesh dispassionately. The scalpel Dr. Gross holds in his right hand, in this sense, is not unlike Eakins' encompassing and passionate paintbrush. The droplets of blood—life force—and the crimson pigment on canvas are metaphors alike for science, medicine, and Eakins' own relentless pursuit through art.

The underlying truth Eakins may consciously or unconsciously have been communicating was his belief that the master surgeon and the great artist were one and the same. Eakins forces the viewer to examine the truth of the painting as the patient's mother must witness her son's surgery and the patient himself must undergo the operation to be healed. It is no accident or mere vanity on the artist's part that Eakins pictured himself sitting above Dr. Gross in the amphitheater intently sketching the scene that viewers will logically realize is the painting they are now looking at. These and other hidden or subliminal messages so artfully and compellingly conveyed were qualities that made the painting appear so modern in Eakins' time, and are today reasons it is considered a monument of world art. As early as 1926, art critic Henry McBride was proclaiming *The Gross Clinic* a masterpiece, "a picture

for modern times." The noted twentieth-century critic and author David Sellin wrote: "[*The Gross Clinic*] still stands as the greatest single painting in the history of American art."

The numerous psychological levels portrayed in the painting may have been lost on Dr. Gross, but they were not altogether overlooked by those who saw the portrait as it was being created. Eakins had progressed sufficiently by August 1875 that he permitted John Sartain a preview. Despite the fact that Sartain himself, earlier in his career, had been only marginally successful in trying to produce a portrait of Dr. Gross, he gave Eakins the impression that he was genuinely impressed. "Tom Eakins is making excellent progress with his large picture of Dr. Gross, and it bids fair to be a capital work," Sartain wrote to his daughter Emily, who was in Paris with Mary Cassatt.

The thirty-one-year-old Eakins was much pleased himself, as rightfully he should have been. Few artists had produced such an important painting only five years into their professional careers, and no artist since the Renaissance had overcome such challenges in the arrangement of figures and action or composed a work of such intellectual and metaphysical scope. As Earl Shinn reported, Eakins' only competition for an artwork produced by a native Philadelphian was a giant sculpture by his nemesis, Howard Roberts, which was being transported with much fanfare, and at public expense, from Paris to Philadelphia by the U.S. Navy.

twenty-one

A Degradation of Art

The Gross Clinic, as Eakins' portrait of Dr. Gross became known, had its first public exhibition during the winter of 1875–76 in the Haseltine Gallery on Chestnut Street, where Philadelphia's most prominent artists had begun to regularly send their best work. Eakins was so proud of his new painting that he ordered high-quality photographic reproductions made; he presented them as gifts to the Central High School and the Philadelphia Sketch Club. As a gesture of goodwill, and in the spirit of reconciliation, he also sent one to Emily Sartain in Paris. Emily, in turn, sent carbon photography of her latest work, *The Reproof*, to him. In contrast to his painting, Emily's was a historical genre scene, showing a seated older woman and a dutiful young lady-in-waiting, arrayed in elaborate Elizabethan costumes. Here too was unmistakable evidence of the moderating influence that her own life challenges had had upon her. Despite her progressive and passionate views toward women's liberation, she had depicted an old stereotype of a docile facet of femininity.

Eakins had every reason to be hopeful for his painting's acceptance at the Centennial Exhibition the upcoming year. John Sartain, whom Eakins believed was a steadfast supporter of his work, had been offered the job as superintendent of the fair's art department early in September 1875, making him the chief decision maker. The selection committee included Christian Schussele and Peter Rothermel, artists whose support Eakins believed he could count on. Furthermore, the American Medical Association, of which Dr. Gross was president, had decided to host its annual international medical congress in Philadelphia. Thousands of prominent physicians and medical specialists from all over the country would be coming to the city. They surely would want to see a painting that celebrated the medical arts and their most prominent practitioner.

In April, just days before the centennial selection committee was to pass judgment on the painting, Eakins' friend William Clark wrote the first review of it in the *Philadelphia Evening Telegraph*. "The public of Philadelphia now have, for the first time, an opportunity to form something like an accurate judgment with regard to the qualities of an artist who in many important particulars is very far in advance of any of his American rivals," Clark wrote. "To say that

Overleaf: Exhibit at the United States Army Post Hospital, 1876, featuring *The Gross Clinic;* official photograph of the Centennial Exhibition (Courtesy of the Fairmount Park Art Association and the Library of Congress)

this figure is a most admirable portrait of the distinguished surgeon would do it scant justice: we know of nothing in the line of portraiture that has ever been attempted in this city, or indeed in this country, that in any way approaches it. . . . This portrait of Dr. Gross is a great work—we know of nothing greater that has ever been executed in America."

Eakins must have experienced great and heady relief, at the least, on reading the first review. Its rock-sure praise placed him among the greatest artists of his country's history. It must have made what came next all the more difficult to understand. John Sartain had by this time already seen the painting, so it was up to the rest of the selection committee to stroll the four blocks from their offices on Broad and Cherry streets to view the artwork on Chestnut Street. Even by the most conservative estimates, the committee members had walked past Haseltine's five or six times a week and seen it through the window, and on the off chance that they had not, they had surely heard about Eakins' painting or seen one of the high-quality carbon photograph reproductions he had made of it. Meanwhile, Howard Roberts' Greek-inspired marble sculpture, *La Première Pose,* featuring a life-sized female posed nude on a thronelike chair, was receiving the lion's share of attention from the Philadelphia press. However, among artists and the much larger medical community, *The Gross Clinic* was the most talked about artwork in the city.

Eakins' concern came to focus on the selection committee's acting as if the painting did not exist. Four of his paintings, *Elizabeth at the Piano, Dr. Howard Rand, The Chess Players,* and *Baseball Players Practicing,* had been submitted and already accepted. But no news was forthcoming on *The Gross Clinic.* It would be natural for Eakins to assume the committee members were being tight-lipped, so as not to prematurely create a sensation around the painting, or they were deferring judgment until all the submissions had arrived. For one thing, the size of the painting alone required an entire section of wall to be dedicated to its exhibition.

Yet other troubling early-warning signs were in the air. In the seven months since John Sartain had become aware of *The Gross Clinic* he had accepted more than a hundred paintings without the selection committee passing judgment on them. This was an honor he seemed suspiciously reluctant to extend to Eakins. As would later become a matter of public record, Sartain had, in

fact, usurped the selection committee's power altogether. In the case of Albert Bierstadt, for example, Sartain went so far as to promise the artist a wall space of twelve by fifty-four feet without consulting any of the other members. To Philadelphia painter Thomas Moran, Sartain wrote: "Pictures like yours need no passing on by the Committee . . . only tell it not [to anyone.]"

In anticipation of more paintings to be included in the exhibition, an immense annex was added to what was already a gargantuan art pavilion. Expectation was that, at the very least, this was where *The Gross Clinic* would be placed. Since decisions of the committee were kept secret, however, Eakins still could not be sure what was to happen. Only at the very last moment was the painting moved from Haseltine's gallery to Fairmount Park, where the Centennial Exhibition was to take place.

Everyone in Philadelphia soon knew that the centennial celebrations were going to be everything the promoters had promised. Fairmount Park buzzed with activity; it was now a small city arisen in the open fields and woodlands across from the river where Max Schmitt had won his victory. It truly was a municipality, with its own railroad, post office, fire department, and police station, along with its own school, where experimental teaching practices would be demonstrated, and a fully operational hospital. The fair boasted the largest saltwater and freshwater aquariums in the world, the most powerful motor built in history, the largest printing press, and the greatest array of diversions imaginable, from giant fireworks displays to horseback riding, archery, rowing, croquet, and lawn bowling competitions. New gas and water lines and a sewer system were laid out, and telegraph lines were erected to connect the exhibition grounds with cities across the entire nation.

By May 10, when the fair opened, 180 newly minted buildings of iron, glass, and stone covered a landscape of 236 acres. The largest and most imposing exhibition halls rose along two main intersecting axes. Smaller pavilions, many designed to look like comfortable upper-middle-class houses, were situated more informally along winding tree-lined roads. "A vast system of eye education" was what the promoters wanted, and that was how the fair was designed and created. Visitors arrived most typically via the Pennsylvania Railroad at a temporary station erected at the main entrance, and transferred from there to a narrow gauge railroad that made a touring circuit of the exhibition

grounds. The following November, seven months after the fair's opening, more than ten million people had passed through the entrance turnstiles, bringing Philadelphia the enormous international recognition that community leaders had worked for so long.

The Eakins family joined nearly ten thousand other visitors at the giant fairgrounds on opening day. Many of the exhibits were not yet in place. Those that were, among them Alexander Graham Bell's new telephone, the great Corliss engine, and Lady Liberty's hand and torch—which would eventually grow to become the Statue of Liberty in New York harbor—created an instant sensation.

Eakins located his four smaller paintings in the main exhibition hall. John Sartain's favorites were well represented. Peter Rothermel and Christian Schussele had taken awards, as did Emily Sartain for *The Reproof.* Henry Moore, who had submitted a painting from Paris, had also won an award.

Howard Roberts' *La Première Pose,* which was displayed in the main American gallery in the Memorial Hall, had taken the top honors for an American artist. Critics called his marble sculpture a "masterpiece" of "abstract beauty" and "maidenly modesty," saying that it would appeal to both the "ordinary observer" and the "connoisseur." *La Première Pose* was, in fact, such a sensation that Roberts went on to receive a fifteen-thousand-dollar commission from the state of Pennsylvania for a pair of statues to grace the halls of its House of Representatives.

The Gross Clinic had not only failed to win an award, it was nowhere to be seen in the Memorial Hall, or in the secondary artists' galleries. After making inquiries Eakins was directed to the Army Post Hospital, hidden behind the U.S. Government Building. There he found his portrait hung on the wall of a mock army hospital ward. On either side of the painting, cots had been set up to hold poorly modeled papier-mâché patients. David Wilson Jordan, a friend of Eakins, would later say that the artist "nearly cried when he saw where his picture that he had counted so much on was put."

The omission of *The Gross Clinic* from the main art exhibition reflected the spirit of the reviews that soon appeared in print. The consensus of the critics was that Eakins' portrait was not suitable for viewing, owing to its "graphic nature." Clark, writing again in the *Evening Telegraph,* made the treatment of

the work the subject of one of his columns. "It is a great pity that the squeamishness of the Selecting Committee compelled the artist to find a place for it in the United States Hospital Building," Clark wrote. "It is rumored that the blood on Dr. Gross' fingers made some of the committee sick, but judging from the quality of the works selected by them we fear that it was not the blood alone that made them sick. Artists have before now been known to sicken at the sight of pictures by younger men which they in their souls were compelled to acknowledge was beyond their emulation."

The *Philadelphia North American* countered Clark by declaring that it was glad the painting had been hidden in a corner, and predicted that the corner would be "left alone" as long as the painting was installed there. The reviewer considered the work "large and pretentious . . . well but blackly painted." Most objectionable of all was Eakins' inclusion of the doctor's blood-soaked finger and thumb. This critic and many others recommended that "gentle men and women" avoid the "corner in which this grisly picture is hung."

In the years that followed, after the painting finally received its second and last showing, in New York, before being hung at the Jefferson Medical College, many other critics were to concur with the *Philadelphia North American*. The *New York Herald* thought the work "decidedly unpleasant and sickeningly real in all its gory details, though a strikingly life-like and strong work." The *New York Tribune* called it "one of the most powerful, horrible, and yet fascinating pictures . . . painted anywhere in this century. . . . But the more we praise it, the more we must condemn its admission to a gallery where men and women of weak nerves must be compelled to look at it. For not to look at it is impossible."

In an unusual second review of the painting, the *Tribune* critic had even more to say, this time in a piece that ran more than a thousand words. It was not the kind of picture to hang where "ladies, young and old, young girls and boys and little children would be visitors. It is impossible to conceive . . . what good can be accomplished for art or for anything else by painting or exhibiting such a picture as this. . . . The more we study Mr. Thomas Eakins's 'Professor Gross' . . . the more our wonder grows that it was ever painted, in the first place, and that it was ever exhibited, in the second. As for the power with which it is

painted, the intensity of its expression, and the skill of the drawing, we suppose no one will deny that these qualities exist."

Complaints were made about the darkness of the color, the strong lighting seeming harsh in the dramatic contrast of the operating theater, the realistic style—described as "the modern French manner"—and the "puzzle" presented by the patient's body and the sheer number of people surrounding it. It was the subject matter, however, that condemned the picture utterly in the eyes of most writers, especially that the artist had dared to show blood on the hands of the surgeon. "If we could cut this figure out of the canvas and wipe the blood from the hand, what an admirable portrait it would be!" one critic lamented. "A degradation of Art," said another.

Negative criticism even attached itself to Dr. Gross, who despite his eminent stature was far from immune to it. He was in particular offended by a rumor that got started that he was especially fond of using his scalpel. "Nothing could be more untrue, or more unjust," he answered in his defense. "I have never hesitated to employ the knife when I thought it was imperatively demanded to relieve or cure my patient; but that I have ever operated merely for the sake of display or the gratification of selfish end is as base as it is false." Perhaps as a result of the criticism, Thomas Eakins and his portrait went unmentioned in the doctor's autobiography, published in 1887.

The remarkable aspect of all the negative reaction was the amount of print space given to the picture. Even the writer who could see no reason why it was ever painted at all, let alone exhibited, spoke of it before any other works at the exhibition and devoted more than half of his review to it. The painting had struck a raw nerve. It seemed to Eakins that viewers saw what they wanted to find in the portrait. Ultimately, whatever they saw, it was not the supremacy of science and healing.

twenty-two

Painting Heads

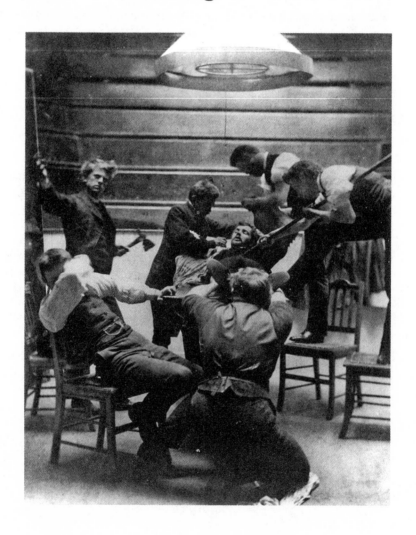

No date was set for Tom Eakins' wedding with Kathrin Crowell. The reason might well have been reluctance on the part of an unenthusiastic groom. Even more likely it was due to his uncertainty about whether he could support a wife and family on the income he received from his art. In Paris, Eakins had never doubted he could earn a living "painting heads." Now he was not so sure.

The continuing support from his Sketch Club students did much to boost his morale. In a moment of levity they produced their own burlesque version of *The Gross Clinic* in which they posed for a photograph in the Jefferson Medical College operating theater. Earl Shinn brandished a tomahawk in his hand as he looked up from a mock surgical demonstration while another student prepared to suffocate the patient with a blanket; James Kelly probed for diseased bone with a spear, and Charles Stephens, likely playing the role of the patient's distraught mother, shielded his eyes.

Enthusiastic Sketch Club students petitioned the board of directors of the Pennsylvania Academy of the Fine Arts for space to hold their classes at the new academy building, on Broad and Cherry streets, scheduled to be finished in April 1876. Their motive was obvious. The new academy building was the largest and best-designed facility of its kind in the nation, and perhaps the world. Large, well-proportioned galleries for viewing the academy art collection filled the second floor of the block-long structure. The first floor and the basement were occupied by the art school. On the south side, facing Cherry Street, five galleries accommodated students drawing from the collection of antique casts. Farther on, spacious rooms made well-lit studios for the life classes. Lecture halls and various administrative offices and artists' cubicles and dressing rooms for models were arrayed along the north side of the building.

Eakins was quite pleased with the structure, and he credited himself to a minor degree for helping to design it. He had been friends with the architect, Frank Furness, since Central High. Furness invited Eakins to join the building committee. Recommendations Eakins made about the placement of windows and other lighting considerations were incorporated into the building's design.

Opposite: Philadelphia Sketch Club in a parody of *The Gross Clinic*, 1875–76 (Courtesy of The Philadelphia Museum of Art; gift of George Barker)

The Sketch Club petition, signed by all of its members, cited the academy's obligation, in the interest of "public patronage," to consider the club's interests as a way of demonstrating the institution's "practical usefulness." They were willing to pay for the hiring of models and to provide at no cost the services of their instructor, Thomas Eakins, whom they described as a professional Paris-trained artist. The students would also be responsible for their drawing materials: charcoal, pencil, ink, washes, notebooks, and specialty papers.

The request was not unreasonable, considering that the Sketch Club was not a rival organization; it was an artist's collective that had formed when the academy suspended classes while construction of the new building was under way. Moreover, the academy had no immediate plans to hold classes and solicit students until September, a full five months after the building was to be completed. By granting the Sketch Club request the board could have sped up its own efforts, availing itself of both students and an instructor at no cost to the academy.

John Sartain, who headed the academy's committee on instruction, decided against the request. He informed the Sketch Club in a letter that it was "inexpedient to grant the use of the room." Sartain's committee further reported that the position of chief instructor "may in fact be regarded as already filled." The ailing Christian Schussele, whose palsy had become so serious that he could no longer hold a paintbrush steady, was chosen as the academy's instructor of cast drawing and supervisor of the life modeling classes, for which he would be paid a yearly salary of twelve hundred dollars. The issue of his palsy was not deemed an obstacle to his function as an instructor. As one board member hastened to point out, the time might come when "he would be unable to paint, but he would not be incapacitated for teaching." To round out the curriculum and to aid Schussele, Jefferson Medical College physician William Keen was hired to serve as chief demonstrator of anatomy, for which he would be paid ten dollars a lecture.

The news did not sit well with members of the Sketch Club. Not to be dissuaded by Sartain, they circulated a second petition, this time offering to make their instructor available to give all academy students free lectures on perspective, a subject that was not part of the academy's outlined curriculum. Sartain ignored this petition altogether. A full year passed, and then, local

artist James Kirby was named as lecturer and instructor in perspective and architecture, at fifteen dollars a lecture.

Sartain's actions sent a clear message to Eakins and everyone who knew the young artist. Just as the academy's elder statesman had not believed Eakins' portrait of Dr. Gross worthy of being hung in the artists' pavilion at the Centennial Exhibition, he did not consider Eakins a desirable presence in the academy. The root cause of his condemnation may have lay in the young man's talent; Eakins had succeeded in painting a portrait of Dr. Gross that was far beyond the artistic force Sartain himself was capable of producing. Perhaps Sartain also felt threatened by his daughter's lingering emotional attachment to Eakins and by his son's willingness to be Eakins' assistant at the Sketch Club.

William Clark alluded to the subject that was on everyone's mind in his column in the *Evening Telegraph*. "Matters are to go on in the same old-fashioned style that they did in the old Chestnut Street building," he wrote of the academy's reopening. In this same column Clark described Eakins as a "thoroughly accomplished artist" whose reputation was "steadily growing in the regards of those who know what fine artistic workmanship really is." Further, Clark pointed out that life classes would be held only three times a week. "Exactly why there should not be a life class and a drapery painting class in operation [at the academy] not only every evening, but every day, from one year's end to the other . . . is difficult to understand."

Sartain's name was not mentioned, but anyone familiar with the academy and the Philadelphia arts community could read between the lines. Philadelphia's old guard stood in direct opposition to the new. Earl Shinn, among others of Eakins' friends, thought it an outrage that the artist was not offered a teaching position at the academy. Moreover, failure to take advantage of Eakins' expertise was viewed as only one of several points of contention between the arts community and Sartain. Before the appearance of Clark's column on the reopening of the academy, Sartain had been blamed for the failure of the Centennial's art exhibition to gain critical respect in the greater world art community and for delays in the construction and final opening of the academy's building. As a result, a behind-the-scenes power play had taken place. The previous June, the board had quietly replaced Sartain with the engineer Fairman

Rogers as chairman of the academy's building committee. It was under the auspices of Rogers that a crew of eighty workmen stepped in to speed the building process along. Sartain's rejection of the Sketch Club students and their instructor was his own way of trying to shore up his power base on the board and his perceived clout in the Philadelphia arts community.

Rogers, Sartain's chief rival at the academy, had built for himself impressive credentials and social prominence. The son of a Philadelphia iron merchant who had amassed a fortune during the great building boom in the late 1860s and early 1870s, Rogers had distinguished himself as a civil engineer, as an alumnus, professor, and trustee of the University of Pennsylvania, and as a backer of civic causes. He was as well one of the fifty original members of the National Academy of Sciences, a founder of the Union League of Philadelphia, and a founding director of the Academy of Music and the American Philosophical Society. His circle included some of the richest and most prominent families in the country; Rogers routinely vacationed with the Belmonts, Havemeyers, Vanderbilts, and Whitneys. Among his many homes were a spacious townhouse on Philadelphia's prestigious Rittenhouse Square, a stud farm near Springfield, Pennsylvania, and an elegant summer mansion at Newport, Rhode Island.

Sartain's previous standing as a wielder of influence in the Philadelphia community was fading. One reason was his embarrassing power grab for control over the selection of art for the Centennial Exhibition. More devastating in the long run, however, were his financial setbacks resulting from a failed attempt to launch a national arts magazine. Although he gave the appearance of having great wealth, and his family luxuriated in apparent splendor in their sumptuous Sansom Street home, he was living far beyond his means. His investments were dwindling. His much touted collection of fine art consisted of several forgeries and a growing inventory of poorly executed second-rate paintings by contemporary artists. Will and Emily, who had gone to Europe to complete their education, had done so with money they themselves earned. Desperate to maintain his highly esteemed position in the community, which provided him with income-producing venues for his engravings, he resorted to petty politics. Christian Schussele was beholden to Sartain in ways that Eakins never would be.

Sartain also knew that Sketch Club students had little real choice but to transfer their allegiance to the academy. Except for the instruction provided by Eakins, there was little reason not to. The new academy building offered the best of new classrooms along with its library, large collection of casts, painting and print collection, and exhibit space. It was not only the oldest but was now the largest and most complete art institution in the nation, and it was expected soon to play a significant role in the greater world art community.

Had Sartain embraced and supported Eakins at this critical point in the artist's career, the greatness of *The Gross Clinic* might have been followed by paintings of similar scope and ambition. Instead, Eakins retreated to more modest genre and portrait subjects in an effort to earn a living. These invariably were paintings that would offend no one and are today recognized more for their craft than for any message or innovation they put forth.

Among the finest of Eakins' early genre compositions was *The Chess Players,* the portrait he made of painter George Holmes, French teacher Bertrand Gardel, and Eakins' father Benjamin in 1876 (plate 9). The two friends are seated at a table while Benjamin stands above them looking on. Just as Eakins constructed *The Gross Clinic,* the painting is designed along the lines of a pyramid, with the head of his father at the top and the two chess players at the sides. Beyond this there is none of the tension between the raw and defined areas that Eakins captured in the portrait of Dr. Gross. That it was considerably smaller, approximately eleven by sixteen inches, and was painted on the smooth surface of a wooden panel, may have encouraged a more refined and detailed approach.

Eakins succeeded in this painting as he had previously done in the portraits he made of other family members. The concentration of the players studying the board is conveyed by their postures. Holmes, who seems to be winning the chess match, straddles a leg of the game table while Gardel crosses his legs in a gesture of submission. Benjamin Eakins, his hands on his hips, appears equally absorbed. The atmosphere in the room is tranquil. Even the cat on the floor seems at ease. A moment has been captured, but there is no evidence of the searching or penetrating insight that compels a viewer into the scene.

Eakins did not achieve such a powerful focus in *Dr. John H. Brinton*

(a portrait now on loan at the National Gallery of Art), either, which he painted in 1876, soon after *The Chess Players*. Dr. Brinton, a faculty member at Jefferson Medical College and a prominent Union army veteran, is today best known for his editing of the *Medical and Surgical History of the War of the Rebellion*, a text used by Civil War historians for several decades. The materials he assembled for this book became the core of a comprehensive collection that is now part of the National Museum of Health and Medicine of the Armed Forces Institute of Pathology. Brinton was a protégé of Dr. Gross, and a year after Eakins painted his portrait he succeeded Gross as president of the Jefferson medical staff, a position he co-chaired with Dr. Gross's son. Eakins asked the doctor to pose, and when the work was finished the artist presented him with the portrait as a gift.

The painting portrays Dr. Brinton seated in his study in a contemplative pose, his heavily lined face and strong, relaxed hands delineated sharply by the fading daylight. His writing materials are placed on the desk to his right, and an open book rests on the reading stand to his left. Dr. Brinton is identified by the painting's title as he is by his name, visible on a discarded envelope, in a fire bucket on the floor behind the physician. As in Eakins' earlier painting of Dr. Rand, the portrait is impressive in the solidity of the figure portrayed and its rich range of robust color. Yet it has none of the mystery and moodiness Eakins captured in *Dr. Howard Rand,* which may have been why the artist considered the painting inferior.

Eakins moved out of doors for what is possibly the best painting he did in 1876, *Baby at Play,* a life-sized, full-length portrait of his two-year-old niece, Ella Crowell (plate 10; National Gallery of Art, Washington, D.C.). The child wears a white sundress and sits on a garden terrace of red brick in the Mount Vernon Street backyard. The location can today be easily identified because of a photograph that has been discovered among Eakins' papers. It shows baby Ella and her mother, Frances Eakins, at the same location.

Baby at Play surrounds Ella with her playthings: a toy horse and cart, a rag doll, and a half-completed tower of alphabet blocks. The afternoon sunlight bathes everything around her in warmth, highlighting the child's body and revealing the rich green backdrop. The canvas was surprisingly large, at just over four feet across, broader than all except one of his known outdoor

sporting paintings, and much larger than any of the portraits Eakins painted of his sisters. The scale lends the painting an unnerving monumentality, erasing suggestions of sentimentality that might otherwise adhere to the subject. As with many of the earlier portraits Eakins made of family members, this was a private work he never exhibited to the public.

In many respects it is unfortunate Eakins did not publicly display *Baby at Play* in his lifetime. As in his best canvases, he captured a moment of meditative stillness that radiates psychological truth. Ella has turned away from her other toys to stare fixedly on the building blocks. A window has opened in the child's imagination. The child's focus is so intense and natural that the viewer cannot help sharing the quality of suspended time, of a captured tranquil instant in the experience. "I love sunlight & children & beautiful women & men, their heads & hands & most everything I see & some day I expect to paint them as I see them," Eakins had written from Paris a decade earlier. In this observed child, he had accomplished just that.

Eakins gave the painting to his sister and brother-in-law for a going-away present. Will Crowell had completed law school. As Benjamin Eakins had promised, he loaned the couple what amounted to just over five thousand dollars to purchase 113 acres of land containing an early-eighteenth-century wood and stucco farmhouse. The farm was in Avondale, thirty-five miles southwest of Philadelphia, in the rich rolling countryside of Chester County. Although it must have been Benjamin's intention that the home he promised to purchase for them would be in the city, nearer to him and other family members and the Philadelphia business community at large, Crowell had other ideas. Distaste for legal work led him to abandon pursuing a career as an attorney in favor of becoming a gentleman farmer. The Avondale acreage, abundant in apple and peach orchards, fields that yielded corn, wheat, and oats, and rich pastureland, proved an ideal setting.

The Crowell farm would become, in the years ahead, a second home to Eakins and his students. "Here he forgot his quarrels with the outside world," said one of the Crowell children in a memoir. "Here he could wear sloppy clothes without criticism, come to lunch in his long-sleeved underwear and bring his artist friends. Everyone was welcome in our informal and loving family."

twenty-three

The Unflinching Eye

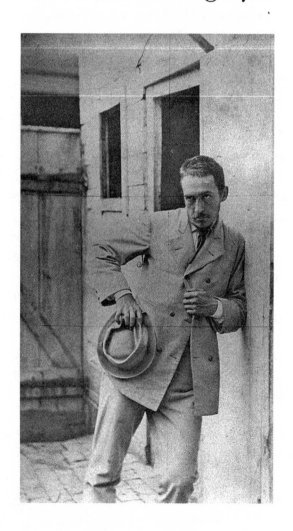

Religion and politics, like high finance, were topics the Eakins household was not known to have discussed at any length. Early in 1877, however, these subjects could have turned into a focus of family conversation, as Thomas Eakins actively sought high-profile commissions outside the circle of his friends and contacts in the medical community. In the course of less than a year he came to portray Philadelphia's first archbishop, James Frederick Wood; the president of the United States, Rutherford B. Hayes; and General George Cadwalader, chairman of the board of Philadelphia's largest insurance company.

Archbishop James Wood (St. Charles Borromeo Seminary, Overbrook, Pennsylvania) was painted in Wood's offices on Race and Seventeenth streets, adjoining Philadelphia's Cathedral of Saints Peter and Paul. Records have not revealed how the commission came about, or whether money changed hands. Eakins was likely introduced to the sixty-three-year-old prelate by Dr. Gross, a staunch friend and ally of Philadelphia's Catholic archdiocese. As the guest of Dr. Gross, Eakins could have attended the archbishop's consecration at the Philadelphia cathedral in 1875. This event was surely what inspired the artist to sketch several undated scenes of high-ranking clergymen in the midst of an apparent installation ceremony (Hirshhorn Museum and Sculpture Garden, Smithsonian Institution).

Just before or immediately after painting *The Gross Clinic,* Eakins may further have been in contact with the archbishop in relation to *Descent from the Cross,* the damaged painting believed to be by Rubens that Will Sartain had purchased from parish priests in Ronda, Spain, in 1870. Correspondence leaves out whether Sartain wanted to sell the painting to the Philadelphia diocese, to authenticate it, or to see to its repair; ultimately Eakins secured the painting's sale to Wood for display in the St. Charles Borromeo Seminary in nearby Overbrook, the seat of the archbishop's main activity in the 1870s. The fledgling seminary, thought of by most Philadelphians as "Wood's folly," became, in Eakins' lifetime, the most important institution of Catholic higher education in the country's third largest diocese.

It is quite conceivable that Eakins nurtured a fondness for the archbishop's first great achievement, the building of the Philadelphia cathedral. The adolescent

Opposite: Thomas Eakins leaning against a building, c. 1870–76 (Courtesy of The Pennsylvania Academy of the Fine Arts, Charles Bregler's Thomas Eakins Collection; purchased with the partial support of the Pew Memorial Trust, 1985)

Eakins, back in the early 1850s, would no doubt have watched raptly as the magnificent edifice with its vaulted copper dome and Palladian facade gradually rose into the sky above the nearby Friends School, where his father taught. Unlike the city's austere Protestant churches, simple Quaker meeting houses, and Georgian-style Independence Hall, the Catholic cathedral was inspired by the fluid, emotionally evocative art and architecture of the Italian Renaissance. While most Philadelphians, it seemed, decried the construction of such an ornate display, the young Eakins, immersed in drawing antique casts at the academy when the cathedral was completed in 1864, was susceptible to admiring the courage of a persecuted Catholic community in erecting such a radiant monument to its faith. After he returned from Europe, the sight of the cathedral had power to stir pleasant and nostalgic memories of Paris and Madrid.

Beyond finding a home for the Rubens painting, Eakins' meeting with Archbishop Wood resulted in a continuing relationship with several clergymen and what was possibly a portrait commission. Eakins did not convert to Catholicism, nor was the idea a likely consideration in his pursuit of Archbishop Wood as a portrait subject. In his autobiography, Cardinal Dennis Dougherty, whom Eakins painted in 1902, stated (in an opinion that would have reflected points of doctrine), "[Eakins] didn't believe in the divinity of Christ; whether or not he was an atheist I have not heard."

A letter Eakins wrote to his sister Frances from Europe contains one of the most illuminating references he made to organized religion. He described a church service as a "little parade" with "gildings & tinsel," "little bells" and "money clinking," and "nasty low priests who live without work." He urged Frances not to attend church and declared, with an attitude not uncommon among those of Quaker background, that the sight of people genuflecting in front of "clap trap & wood virgins [with] gilt & statues in clay with gold crowns all jeweled on their heads" made him want to laugh. Eakins had also stated, in an earlier letter to Frances, a more telling comment about his feelings toward hierarchies, in this case about the rules and pronouncements of grammar: "All this springs from such a fact as simple as the religion of Jesus Christ & see what men & grammarians have done for them both."

Nonetheless, and equally revealing, Eakins went on in his "little parade" letter to laud the life of "a healthy religious," who lived in a "pure landscape"

of "silent prayer" and who did not "pay anyone to pray for him or to explain to him [the scriptures]." He praised Gérôme for painting such an individual—a Muslim—kneeling in the desert to pray. "How simple & grand," Eakins wrote. "How Christ like."

The written record does not disclose how Eakins classified Philadelphia's archbishop. It is possible he reacted to Wood much as he did to a Louisiana Jesuit he met on the steamship bound for France. Writing to his family, Eakins described the priest as "the most learned man I ever saw . . . [who] has read all the books with which I am acquainted and knows them . . . [as he does] anatomy, medicine, and all the languages of Europe." This priest, Eakins declared, "never tried to convert me although he knows I belong to no church."

Perhaps, in Archbishop Wood, Eakins encountered a man with whom he could discuss the "big question" of divinity, a subject that increasingly engaged him and, in most unexpected ways, became manifest in his art. In the years to come Eakins painted fourteen portraits of Catholic clergymen and one of a mother superior at a local convent, as well as a depiction of the crucified Jesus.

At the very least, Archbishop Wood impressed Eakins as a man of great learning and accomplishment, one whose character and faith had produced tangible contributions in the city. A native Philadelphian, born on Chestnut Street, Wood had worked as a bank clerk and was a Protestant before his conversion to Catholicism; like Eakins he had sailed for Europe to further his education, and then returned home to follow his calling in the city he most loved. As Eakins' continuing relationship with Emily Sartain had expanded his attitude toward favoring higher education for women, Wood may have been the first of several clergymen who altered his outsider's perception of Catholicism, or deepened his appreciation for the "pure landscape" of the "healthy religious."

Eakins' initial concept was to picture Wood standing on the steps of the cathedral, against the tangible backdrop of his great accomplishment. This pose, however, could have proved too taxing, for the archbishop suffered from rheumatoid arthritis. (His joint tissue eventually deteriorated so much that he could no longer conduct services.) Eakins instead seated him, robed in flowing violet vestments, on the bishop's throne, his hands resting on an embroidered

apron. However fine the vestments and monumental the proportions of the chair, they do not overshadow the man, nor do they glorify his stature alone. Wood's kindly face, revealing both humility and stolid certainty, prominently engages the viewer. Curiously, most critics could not let themselves be impressed by the painting. Perhaps the archbishop did not appear sufficiently holy. Nothing about him stood out as other-worldly. "Fleshy" is how the *Art Journal* characterized the painting. The portrait Eakins had painted of John Brinton appeared along with his portrait of Wood in the academy's annual exhibit of 1877 and, though Eakins himself had declared it inferior, was the portrayal that delighted critics. "In some important respects, [Brinton's portrait is] the finest work that Mr. Eakins has yet executed."

The portrait of Archbishop Wood today does not convey with justice the quality of the original work. In a botched effort to clean the canvas several decades after it was painted, restorers inadvertently removed layers of carefully applied washes and shading. Only a preparatory oil study, now at the Yale University Art Gallery, shows evidence of the finished work belonging among the artist's most significant early portraits.

Another tragic fate lay ahead for the portrait Eakins made next, of President Rutherford B. Hayes.

Eakins undertook this portrayal at the behest of the Union League of Philadelphia. Correspondence between the artist and the league members describes their desire for a portrait to be placed in the league's sumptuous offices on Broad Street, alongside paintings of other distinguished leaders. Prestigious though the commission was, the Union League's expectations were modest, calling for a small half-length portrait that Eakins was to model from photographs.

Pleased though he was to be offered his first paid commission, Eakins characteristically proposed that he paint something grander. In a letter to George McCreary, the chairman of the league's committee, Eakins outlined his desire. "If . . . [the president] is disposed . . . for a full-sized portrait similar to the Dr. Brinton composition I would undertake it with equal spirit." The league consented, though Eakins agreed to accept four hundred dollars, the same amount that was to be paid him for the half-length portrait.

Eakins also urged McCreary to give serious thought to contacting the

president to see if a personal sitting could be arranged. He did as Eakins asked, perhaps at the recommendation of Union League members Fairman Rogers, who also sat on the board of directors at the Pennsylvania Academy, and Dr. William Keen, the academy's instructor of anatomy, whom Eakins knew from the Jefferson Medical College. Rogers and Keen may not have been able to help Eakins sidestep John Sartain as the chairman of instruction at the academy, but through their association with the Union League they were able to cast a vote of confidence in Eakins, as did Philadelphia's Roman Catholic community.

On August 4, Colonel Samuel Bell, a Union League member and friend of Hayes, wrote the president a letter of recommendation for the painter. "It is with pleasure that I introduce to you Mr. Thomas Eakins of this city, the Artist selected to paint your portrait for presentation to the Union League of Philadelphia. . . . Mr. Eakins very justly ranks among the foremost Artists and I have no doubt will succeed in obtaining a picture creditable to the Artist and satisfactory to yourself and the gentlemen desiring it. The style of picture will be decided upon after Mr. Eakins has had an interview with you and he will consult your convenience as to the times of sitting."

The president obliged, setting aside time in late August and early September, during which Eakins commuted back and forth to Washington by train. His plan was to sit quietly and observe the president for several sessions, to "learn his ways & movements and his disposition," as Eakins later wrote, before deciding on the pose.

"The portrait was far from conventional," Eakins wrote a friend in 1912, reflecting back on the experience. "Mr. Hayes knew nothing of art and when I asked for time for sitting he told me that he had already sat for a distinguished artist who had required only fifteen minutes of sitting . . . [so] all I could get out of him was permission to be in the room with him as he attended affairs of state and received visitors. As I was very anxious to please my patrons, I accepted the President's terms foolishly perhaps, but determined to do my best. The President once posed, I never saw him in the same pose again. He wrote, took notes, stood up, swung his chair around. In short, I had to construct him as I would a little animal [that wouldn't sit still]."

After realizing he would never get Hayes to pose for him, Eakins abandoned his scheme for a full-length portrait and decided to portray the president

sitting at his desk. Once he had determined the pose, he set up his canvas and easel in front of Hayes and proceeded to block in the underpainting. "The president gave me two sessions," Eakins wrote to Kathrin Crowell, his fiancée, on August 29. "He posed very badly. I have succeeded in the sketch, to which I have given some movement. Tomorrow I will try to get the upper hand in the pose."

Over the next two and a half weeks Eakins camped out in the corner of Hayes's office, working as quickly as he could. He put in a total of seventeen hours. Judging from the diary entries Eakins made in his sketching journal, he learned a lot about how the president conducted his affairs but obtained little that was "conducive to portraiture," in Kathleen Foster's description. He noted visits from an elderly gentleman from North Carolina, bankers from New York, philanthropists concerned with Native Americans, and an eccentric spiritualist. Dispersed among these entries were quick pencil sketches of Hayes in action along with Eakins' notes of train arrival and departure times.

While the resulting portrait was not the full-length canvas Eakins had hoped it would be, he considered the finished product a truthful, though unconventional, likeness of the president. It showed Hayes dressed in an alpaca office coat seated at a table, his right hand holding a lead pencil. As was now typical of the painter's work, light came from the left side, illuminating half the president's head and leaving the rest in shadow.

Members of the Union League were not impressed. They doubtless expected something in the way of red velvet curtains with gilt tassels, a white marble column, and a figure with the noble attitude of a decorated Union army veteran and distinguished chief executive. They received a portrait of a dignified elderly gentleman with a patriarchal beard, dressed in ordinary clothes, and engaged in his daily work. There were no traces of idealization or heroics. His sunburned face glistened with summer perspiration.

Records show that the Union League committee that commissioned the work initially refused the picture, but that upon later intervention by several key members was persuaded to accept the portrait as it had been painted. The problem revolved around Hayes's face, which looked flushed from the heat. Union League members believed viewers might misinterpret the ruddy coloration in Hayes's face and somehow assume the president—a well known

teetotaler—had been drinking. Despite such criticism, the painting was put on display at the Haseltine Gallery in December 1877 and was then mounted at the Union League building among the club's more conventional presidential portraits.

One critic, who was in the minority, went so far as to say that it was the only truly good painting in the Union League collection. "This portrait gives a very different idea of the President from that given by any of the photographs of him or by any of the painted portraits that have yet come under our notice. Not only does it give a different idea, but it gives a much more favorable one, for Mr. Eakins has fixed upon his canvas the features of a man of very strong and very pronounced traits of character. . . . It would be a matter for congratulation indeed, did we have portraits of all the Presidents which, like this one would have stamped upon them an uncompromising truthfulness."

Another critic, whose opinion was more reflective of the Union League members' views, said the "picture almost needs a label to suggest the now familiar features of the new President . . . [and] utterly fails to meet the first requirements of the painter's art. Mr. Eakins is evidently a follower of Rembrandt's most extreme theories of chiaroscuro, and in this particular instance has quite lost sight of his model in his search for effect. It is not impossible that President Hayes, if seated in a darkened room, with one bright ray of light striking his right temple from behind, might look exactly as he does in this portrait, but as the general public have never seen him under such circumstances, they will, we fear, be quite unable to appreciate the final excellencies of the painting. . . . The result is rather anatomical than artistic."

The painting soon vanished from the Union League's collection. A few years later an entirely innocuous and lifeless portrait by a second-rate artist was hung in its place. "I had to handle the matter delicately as the friends of [Eakins] . . . were jealous lest the removal of the painting might injure his reputation," wrote Loudon Snowden, a prominent Union League member and confidant of the president. "This work of Eakins is such a caricature that it gives no pleasure to any of your friends." A month later, Snowden went ahead and sent Eakins' portrait to the president, writing, "I fear when you receive it, Mrs. Hayes will banish it to the rubbish room."

Apparently that is what happened. The painting has not been seen since

it left the Union League. Other than the four hundred dollars Eakins received, all that remains of his experience with the nation's president is a preliminary drawing he made from a photograph and a sketch of the view of Lafayette Park from the president's window, which the artist presumably made while waiting for Hayes to pose.

Not all of the portraits he did around this time were as indifferently received. The trustees of the Mutual Assurance Company of Philadelphia commissioned Eakins to paint two portraits of their chairman of the board, General George Cadwalader, a member of an old Philadelphia family. Charles Willson Peale, Gilbert Stuart, and Thomas Sully had produced earlier portraits of him. Cadwalader was a handsome man in his early seventies, possessing a strong rugged face. The first portrait Eakins painted of him was a half-length figure, depicting him in his uniform as a major general. The other, which displayed his head at bust height, had him dressed in civilian clothes. The general died before the two portraits could be completed, and Eakins worked from a picture a photographer had taken to finish them. Unlike the Hayes portrait, these paintings seem to have satisfied his clients. A third commissioned portrait was of Mrs. William Shaw Ward, sister-in-law of Mrs. John Brinton. Thanks to these lesser paintings, the Philadelphia art establishment was finally making room for Eakins.

twenty-four

Talk of the Town

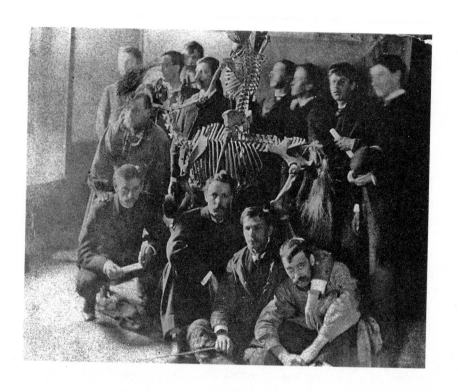

Fifty-two-year-old Christian Schussele had not weathered the Pennsylvania Academy's six-year hiatus very well. His palsy and paralysis had advanced to the point that he needed to be helped in and out of the classroom. Evening classes were especially taxing. At the urging of students in his life modeling classes—many of whom were former members of the Philadelphia Sketch Club—he unofficially agreed to a special arrangement: Thomas Eakins was invited to attend the academy's evening classes as a supervisory volunteer instructor. Nothing was put in writing and no board members were consulted. Eakins, along with six other members of the Sketch Club, including Earl Shinn and Will Sartain, were merely issued credentials permitting them full access to the academy's facilities.

To say that Eakins made a strong first impression on the academy students is an understatement. By November 1877, halfway into his first semester as the unofficial instructor in life drawing classes, the thirty-three-year-old Eakins was the academy's most popular teacher. His youth, by comparison to Schussele's older years, had some bearing. The depth of his knowledge and commitment were likely the most compelling reasons. Even the students who did not at first take to him or were critical of his exacting standards had no doubt of his total devotion to his craft and his willingness to share his insights. An art critic who met and interviewed Eakins around this time noted that he was "more like an inventor working out curious and interesting problems for himself [and his students] than like an average artist." He was, said another, more critical journalist, "a scientific mind that has made the mistake of taking up art."

The relationship Eakins sought to foster with his students was not that of a master and scholars; he conceived it more in the vein of the artist's coopera- tive he had helped to create at the Sketch Club. As academy student Robert Henri later wrote, "In those days it was an excitement to hear his pupils tell of him. They believed in him as a great master, and there were stories of his power, his will in the pursuit of study, his unswerving adherence to his ideals, his great willingness to give, to help and the pleasure he had in seeing the original and worthy crop out in a student's work." Such was his popularity that soon he was helping Dr. Keen as the volunteer deputy chief demonstrator

Overleaf: Students at the Pennsylvania Academy of the Fine Arts, c. 1878; photographer unknown. Eakins may be the figure seated on the floor at lower right. (Courtesy of The Philadelphia Museum of Art; gift of George Barker)

of anatomy. Dr. Keen, in fact, was honored to have him. In Eakins he found an artist whose knowledge of anatomy, strikingly, was beyond that of most practicing physicians.

Eakins' female students at the academy appreciated his teaching as the men did, although they had less access to his instruction, because their classes, supervised by Schussele, met in the mornings. Eakins was occasionally invited to stand in for Schussele then, too, but he did so only occasionally. Among the women who valued such visits was Susan Macdowell, the twenty-six-year-old daughter of a Philadelphia engraver. In addition to her work at the academy, she took private life drawing classes from Schussele, and one morning at his house she and Eakins were formally introduced. She later recalled that Eakins gave a short and chivalrous bow, and then proceeded to help her fasten the button on her glove. "That was it," she remembered years later. "I fell in love with him right then and there."

At this juncture in their relationship, in 1877, it is difficult to see whether Eakins was similarly enamored with Miss Macdowell. Compared with Kathrin Crowell, Susan was vivacious and joyful. She was exceptionally talented as an artist, having honed her skills, as Eakins had done as a young man, by working alongside her father. Eakins recognized her talent at the very outset of their relationship, and in the months that followed he sat on a jury that selected one of her paintings as the best work by a female at the academy. Later still he would say she was "the best woman painter in America."

In spite of what Sallie Shaw later asserted about Eakins' chauvinistic attitude toward female education, he in fact encouraged many female students besides Macdowell to pursue careers in art. Perhaps influenced by his relationship with Emily Sartain, he was now quite adamant that women should be given equal access to all educational opportunities at the academy. More than this, he did not want to see the academy become a finishing school for young ladies. He had the same high standards for his female students' work as he did for the men. Later, when Eakins actually did become a full-fledged instructor, he did more than any faculty member at the academy to defend women's rights at the school. In any case, even in the early days, when he was only substituting for Schussele, Eakins was urging equal opportunity.

Eakins' views on "liberated" female participation in the life studies classes

turned out to be only one marked difference between his approach and Schussele's. Rather than students' creating meticulous copies of antique casts, which Schussele required for entrance into life drawing, Eakins was convinced that students would be better served by learning to draw directly from the nude. Under Schussele, some of the students were barred from drawing anything except casts. Much to the annoyance of Eakins, one female applicant was rejected for the life class because her portfolio—which consisted of what he considered excellent life drawings—contained no sketches from antique sculpture.

Now that Eakins was active in the academy, he became quite vocal about how money was being spent by the board. Rather than increasing the number of life classes, which would mean hiring models for a dollar or two an hour, depending upon their sex, the academy, as directed by John Sartain, was purchasing expensive artwork. The sum spent on modeling in one year ran just over a thousand dollars; a full twenty thousand dollars went to buy a single painting (*Venice Paying Homage to Catherine Cornaro,* by Hans Markart).

Eakins had his views on practically everything and was eager to share them. Less than three months after taking over the night classes, he boldly took it upon himself to address a letter to John Sartain himself, chairman of the committee on instruction, requesting that an advertisement be placed in the *Public Ledger* for female nude models. His reasoning, as Eakins described it in the letter, was that nude models were a necessity, and that the "old plan" of having students or academy officers visit houses of prostitution to procure them was unseemly and inappropriate to the curriculum's standards. "This course was degrading & would be unworthy of the present academy & its result was models coarse, flabby, ill formed & unfit in every way for the requirements of a school, nor was there sufficient change of models for the successful study of form," Eakins wrote. Just as the buildings had been renovated, he argued, the old way of doing things had to be revised.

No advertisement appeared in the papers. Rather, the board of directors ordered Christian Schussele not to delegate his authority or duties to any other person. Further, he was to give his personal attention to the instruction of regularly established evening classes. Immediately following his request, Eakins was informed that his services to the academy were no longer needed. He could not officially be fired, because he had never been hired.

The result was a dramatic mass exodus from the academy's evening life studies classes. How great or small a role Eakins played in the boycott is not established. All the record reveals is the subsequent forming of a new artist's collective along the lines of the Sketch Club. They called themselves the Art-Students' Union, and operated out of a rented room on Juniper, above Arch Street. Their acknowledged primary, if only, purpose was to study nude modeling under Professor Thomas Eakins, which they summarily began practicing for four to five hours daily. The cost of joining the new Art-Students' Union was an initial two-dollar entrance fee and one dollar a week thereafter. Eakins again gave his services without pay.

The Art-Students' Union became so popular that by the winter of 1877 it was the subject of a featured story in the *Sunday Mercury,* where it was reported that Thomas Eakins and his "new school" had become the talk of the town. "To show how very much in earnest and how resolved some of [Philadelphia's art students] are to devote themselves entirely to study, we learn that quite a large number of Academy students, not content with the limited hours assigned to the life classes there, have taken a suitable room, furnished and provided it with all requisite conveniences, all the expenses of which are defrayed by the members of the club," the article stated.

Less politic than the *Sunday Mercury*'s commentator, the writer from the *Art Journal* came right out and gave the real reason for the formation of the Art-Students' Union. "The principal causes of their dissatisfaction are said to have been the facts that only nine hours a week were devoted in the Academy to the study of model by daylight, and that Mr. Thomas Eakins, whose instruction they valued, had not found favor in the eyes of the directors."

Eakins' female students at the academy soon made it clear that they had appreciated his teaching as much as the men did. Susan Macdowell, who had become secretary of the women's life class, wrote to the academy's directors petitioning for additional life drawing classes for women. "Our desire in having this class is to offer an additional opportunity of studying from life at a very convenient time, for those students whose private work prevents them from having the full benefit of the early morning class, added to this the great advantages to all the students of having more opportunity to study from the nude." Macdowell and her fellow female students further encouraged the hiring of

Thomas Eakins, whose departure she and others lamented. "His good work of last winter at the Academy, proved him to be an able instructor and a friend to all hard working students."

This time the directors took the matter under consideration and decided to add an evening life class for women. The additional class, however, was to be taught not by Eakins but by Schussele. The added responsibility only aggravated Schussele's steadily deteriorating health. The worse his condition grew, the more attendance fell at the academy. Meanwhile, the life classes Eakins was teaching at the Art-Students' Union were filled to capacity.

Paintings that Eakins may have made while teaching at the Art-Students' Union give clear evidence of how he felt he was being treated. The most overt example is a small preliminary oil titled *Columbus in Prison* (now at the Kennedy Galleries in New York) that pictures the historic explorer shackled to an iron ball. In this painting Eakins chronicled the aftermath of the third voyage Columbus made to the New World: he was charged with cruelty in his administration of Hispaniola, and Spain's emissary, Francisco de Bobadilla, shipped him home bound in chains. The painting suggests Eakins viewed himself as an explorer in uncharted territory, one who was condemned by an enemy, John Sartain. The work was never completed, likely owing to Eakins' finding a historical subject he could identify with more closely—and a more fitting vehicle to convey his deeply felt beliefs about the importance of life classes and their role in students' training. The resulting painting, *William Rush Carving His Allegorical Figure of the Schuylkill River* (Philadelphia Museum of Art), completed in 1877, was a potent view of a classical and locally historic theme.

Other historical scenes Eakins painted during the late 1870s and early 1880s could be directly related to subjects close to the Eakins family. *In Grandmother's Time* (Smith College, Northampton, Massachusetts) shows an elderly woman as she works at a spinning wheel. *Fifty Years Ago* (Metropolitan Museum of Art) depicts a young woman wearing a long dress from the 1820s, as does the model in *Retrospection* (Yale University Art Gallery). *The Courtship* (Fine Arts Museums of San Francisco) shows a couple in early-nineteenth-century clothes. As Susan Macdowell later recounted, old dresses were brought down from the Mount Vernon Street attic for these works. *Wil-*

liam Rush Carving His Allegorical Figure of the Schuylkill River, however, was the project over which Eakins became obsessed.

The subject of this painting was William Rush, a prominent early American sculptor best known for carving figureheads for ships, painting high-profile public figures on commission, creating statuary for public parks, and as one of the co-founders, with Charles Willson Peale, of the Pennsylvania Academy of the Fine Arts. The year Eakins depicted was early in the nineteenth century, and the setting was Rush's studio on Front Street, in downtown Philadelphia. He pictured the sculptor in the midst of carving a wooden female figure from a single block of white pine, soon to be painted to imitate white marble and installed in Philadelphia's Center Square (now known as Penn Square), at Broad and Market streets, to commemorate the city's celebrated new waterworks. Rush's figure, a life-size nymph clothed in a clinging Greek costume that left little to the imagination, holds a bird on her shoulder, and out of it a stream of Schuylkill water was to splash into an encircling pool.

Rush's skill as a sculptor, his love of Philadelphia, and his role in establishing the Pennsylvania Academy obviously made him a fascinating subject for Eakins, as did the symbolism of the Schuylkill River. Most important to Eakins, however, was the opportunity to focus his attention on a fundamental principle of his painting: respect for and knowledge of the human body. As Eakins conceived his painting, Phidias, an artist who modeled from nature, would be reborn as Rush, sculpting his voluptuous model—Louisa Vanuxem, twenty-eight years old, the daughter of a respected Philadelphia shipowner—posing in the nude.

twenty-five

Nymph in the Fountain

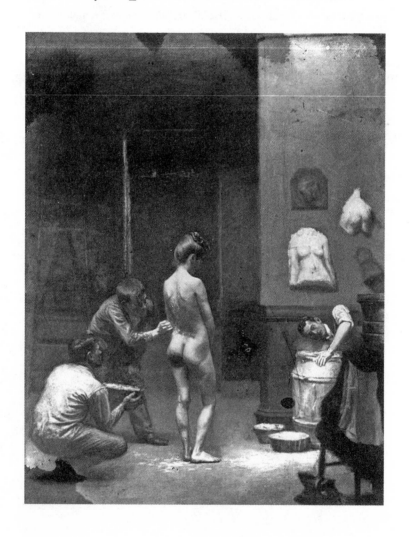

A story is told in the city of Edward Shippen, a gray-haired patrician of nineteenth-century Philadelphia known to take leisurely walks after dinner. Coming upon the Pennsylvania Academy of the Fine Arts one evening, he decided to see what the young art students were up to. He entered on Cherry Street and ambled down the hallway. Finding a light shining from inside a partially open door, he stepped into the room. Artists were busy at work. He tiptoed behind them, looking over their shoulders at charcoal drawings on their easels. Round he went until he noticed a platform in the center of the room and on it what appeared to be a plaster cast of a nude statue. Like a scene from a horror film, the statue suddenly moved. "My God!" Shippen exclaimed as he bolted from the room. "She's alive!"

Eakins, in his painting *William Rush Carving His Allegorical Figure of the Schuylkill River*, would challenge viewers to enter Rush's studio as Shippen had wandered into a life modeling class at the academy. He showed the aging sculptor in the midst of carving his nymph, while Louise Vanuxem, nude and seen from behind, stands on a block of wood, modeling for the artist (plate 11). Instead of placing a stuffed bird on her shoulder, Eakins depicted Vanuxem balancing a large book, which more realistically incorporated the artist's step-by-step progress from concept to completed work. A detail like this emphasized that the real subject was education. Upon Vanuxem's shoulders rested knowledge—abundant as a river, was the implication—flowing as the mythic source that nourished humanity. It was a powerful and entrancing overlay of elements, and not the least of it was the nymph's form.

To be certain everyone seeing the painting would make no mistake about the portrayal and the eminence of Rush in the Philadelphia art community, Eakins chose evocative symbols for the setting: in the background he placed the statue for which Rush was best known, the portrayal of his friend and fellow patriot George Washington, then on display in Philadelphia's Independence Hall. Further, Eakins included a chaperone for the model, an elderly woman whose role was ensuring everything in the session to be in keeping with propriety.

Opposite: Attributed to Thomas Eakins, *Life Casting*, oil on canvas(?), 1890–92, known only from a gelatin glass negative from the collection of Eakins' student Edward W. Boulton (Courtesy of The Philadelphia Museum of Art; purchased with funds given by Mr. Seymour Adelman)

Eakins biographer and art historian Elizabeth Johns, in a groundbreaking study of the painting, has pointed out that in all likelihood Vanuxem did not model in the nude in Rush's studio. In this sense, the painting was more a work of imagination than a strict historical reconstruction. So too was Eakins' inclusion of the George Washington statue, which Rush did not sculpt until later in his career. Eakins had concocted the scenario with the undraped model—ostensibly Vanuxem—and the chaperone as a way of conferring legitimacy on his efforts to include nude models in his painting and teaching, and perhaps also as a backhanded way of driving his point home to the academy's board. As John Sartain and all the board members knew, Rush was not only the city's most distinguished sculptor; he was a veteran of the Revolution, a member of Philadelphia's city council, and an academy founder and first board member. In order for this painting to be effective, however, Eakins had to create a work of art so compelling that it would stand on its own beyond any historical framework or intended message.

Eakins was not about to cut any corners. The painting would be thoroughly researched and then painstakingly detailed to capture Rush in his moment of bringing into being what was to live on as a landmark in the city of Philadelphia. Eakins would describe the intimate space of the working artist, with the artist concentrating on the task at hand, and thereby convey his own commitment to study from the live model, along with his sense of connection to Philadelphia's artistic traditions. As had already been the case once before, in *The Gross Clinic*, nothing like it had appeared before in American art. The closest any of his contemporaries had come to portraying the unclothed figure were the idealized, wrinkle-free works of Bouguereau, Lawrence Alma-Tadema, and Frederick Leighton—paintings that could be described, along with the Howard Roberts sculpture *La Première Pose*, as "peach blossom" nudes.

Eakins' first step was to visit the statue itself. The original pine sculpture had some time before begun to rot. By 1850 it had been moved from Center Square to the recently renovated waterworks at Fairmount Park. Near the original stood a bronze replica that had been cast in 1872. Eakins measured and sketched both, recording many alternate views and details, though he did not ultimately use them in the final painting.

As Gérôme had conducted extensive research on his historical subjects, so

too did Eakins delve into his. He journeyed to Front Street below Callowhill where Rush had once worked in his studio. An industrial complex now stood in its place. Eakins did, however, manage to find several elderly residents of the neighborhood who remembered Rush, and they helped him determine what the artist's working place had looked like. He next visited several Philadelphia woodworking shops, until he found one similar to Rush's, and these he sketched also. This trip proved the most rewarding of all because he managed to locate, preserved by Rush's apprentice, one of the sculptor's original sketchbooks. Although it contained no specific information about the carving of the allegorical water nymph, it recorded drawings that would have been displayed on the walls of Rush's workshop. In addition, Eakins studied the clothing of the era from prints and a historical painting by John Krimmel at the Pennsylvania Academy that showed, on site in Center Square soon after its installation, Rush's statue.

Eakins' next stage was creating small wax models for the subjects he wished to incorporate in the painting. Following his method for the rowing pictures, he set these figures in various combinations so he could judge their relation to one another, conveniently turning and posing them to ascertain the effect from different vantages. For the wax figure of Rush, Eakins fashioned a composite from Rush's sculptural self-portrait and from an oil painting of him by Rembrandt Peale on display in Independence Hall.

Eakins made several preliminary painted studies. Kathleen Foster and Elizabeth Johns, in their surveys of Eakins' preparatory work, point to one sketch in particular that shows all the chief elements that are found in the final painting. The only difference between this study and the finished work is the way the chaperone is seated; in the final version she is facing away from the nude model rather than toward her. Slight variations include how Rush is dressed: in the study he is outfitted in workman's clothes; in the finished painting he is dressed as a gentleman. Another variation is the Vanuxem figure. Eakins had not yet hired the model who was to sit for him. The one he ultimately chose, eighteen-year-old Anna Williams, a schoolteacher at the Philadelphia House of Refuge, a home for "wayward girls," was shapelier than the model in the study.

Eakins met "Nannie," as Williams was known, through one of his sisters.

She did not initially want to pose for him; she finally agreed on the condition that her name not be revealed. She posed standing on a raised block of wood, as she does in the final painting, balancing a thick book on her shoulder in lieu of the water bird. The experience must have been a positive one, because Eakins recommended her to a young English engraver, George Morgan, who was studying the academy's collection of antique casts in search of a suitable profile for a commission he had received from the United States Mint. After posing for Eakins, Williams sat for Morgan, becoming the "Goddess of Liberty" depicted beneath the "E Pluribus Unum" on silver dollars that were minted over the next twenty-five years. The handsome, strong-jawed profile of Nannie Williams was later featured, with varying hairstyles, on half dollars as well as on quarters, dimes, and gold eagles.

Eakins clearly intended the female nude to be the central focal point in his painting of Rush. In this location she is bathed in warm afternoon light, while Rush and the chaperone are left in shadows and relative darkness. A small splotch of pink draws attention to the highlights on the model's naked buttocks. The light and color in the painting lead the viewer to look directly at these highlights, and therefore directly at the nude.

The dramatic narrative of the painting, however, was created not only by the nude model. Showcased among the flickering shadows are the young woman's brightly illumined clothing, undergarments, and silk stockings draped casually over the chair beside her, where they also communicate the back story. Eakins has created, as one of today's critics has remarked, "a still-life striptease." The girl has undressed in front of the sculptor before assuming her pose. The presence of the chaperone gives respectability to the act; she sits in her chair calmly knitting while Rush, mallet in hand, carves the statue. Also looking on in spirit, in the form of his statue, is George Washington.

Like so many of Eakins' best paintings, *William Rush Carving His Allegorical Figure of the Schuylkill River* is not easy to read fully in the beginning. Its small size, only twenty by twenty-six inches, makes the task more exacting than with *The Gross Clinic*. Only after the viewer concentrates on the details, composition, lighting, and form does the captured moment become clear. Viewers are thus pulled into the scene in the manner of certain classical and later artworks as they might be into a peep show.

If Eakins' painting was intended to convey his strongly held principles about nude modeling, the message was lost on critics. *William Rush Carving His Allegorical Figure of the Schuylkill River* was first exhibited at the Boston Art Club in January 1878, and soon afterward in a showing at the Society of American Artists in New York. One critic dismissed the painting simply because he thought the model Eakins portrayed was ugly, lacking the "peach-blossom" beauty that was expected in serious art. "If belles have such faults as these to hide, we counsel them to hide them," he wrote. Another critic remarked: "It is not an attractive, still less a beautiful subject. But the homely figures, including the rather ugly back of the model, are wonderfully painted."

Similar comments emanated from the critic for the *New York Times*, who conveyed the generally accepted opinion on the work. "What ruins the picture is much less the want of beauty in the nude model . . . than the presence in the foreground of the clothes of that young woman, cast carelessly over a chair. This gives the shock . . . and at once the picture becomes improper!" Yet another critic went so far as to suggest that the painting "would be improved by the wiping out of the female model [altogether]."

As he had done in the past and would do again in the future, William Clark of the *Evening Telegraph* rose to Eakins' defense. "The comments made on the picture are curious and amusing," Clark wrote in March 1878. "One person objects to the subject; another allows the subject, but thinks that the artist might . . . have treated it in a different manner; a third admits that the workmanship is clever . . . but suggests that it lacks refinement; a fourth concedes the refinement, but disputes the color-quality. . . . The substantial fact is that the drawing of the figure in the picture . . . is exquisitely refined and exquisitely truthful, and it is so admitted by all who do not permit their judgment to be clouded by prejudices and theories about what art might, could, would, and should be. . . . The best comment on this picture was that made by a leading landscape artist of the old school, and who, being of the old school, certainly had no prejudices in favor of works of this kind. This was that he had not believed there was a man outside of Paris, certainly not one in America, who could do painting of the human figure like this."

Interesting and insightful as these responses were, only Earl Shinn, writing

for the *Art Amateur* under the pseudonym Edward Strahan, articulated the real point Eakins had set out to bring to light. "The painter of the fountain seemed to have a lesson to deliver—the moral, namely, that good sculpture, even decorative sculpture, can only be produced by the most uncompromising, unconventional study and analysis from life, and to be pleased that he could prove his meaning by an American [of Rush's status]."

The message that Eakins sought to convey did, thanks to Shinn, reach the board members of the academy. By the time that happened, however, they had already begun on their own to reconsider their position on the service that Eakins could provide to the school. Schussele's deteriorating health forced the board to address, in the closing months of 1877, what it described as "unpleasant business squarely in the face."

Schussele needed help, and Eakins was ready and willing to provide it. In December 1877, the board rescinded its previous resolution that Schussele could not seek help in his classes; he was now "authorized to avail himself of such assistance as he may consider desirable in any or all of the classes." They then authorized the actuary of the academy to write Eakins a formal letter, which read in part, "I take pleasure in expressing to you the thanks of the Board of Directors, for valuable services given freely as instructor in the life classes."

In this strange, roundabout manner the members of the board of directors saved themselves the embarrassment of having asked Eakins to leave and then bringing him back. John Sartain, who must have been infuriated by their decision, stepped down as chairman of the committee on instruction, and soon he resigned from the board altogether. "Not enough 'voice' was being given to artists in running the place," Sartain told reporters. Will Sartain later contradicted his father on this point by suggesting that the real reason was that not enough voice was being given to John Sartain.

Fairman Rogers was now in charge. Under his direction, not only did the academy invite Eakins back, but it also brought in another unsalaried teacher, the academy's first female instructor, Anne Drinker. The new board members were so grateful and relieved at the prospect of Eakins' return that they offered to let Schussele go and hire Eakins, at full salary, instead. Out of allegiance to his former instructor, whose sole livelihood was his income from the academy,

Eakins turned them down. Though he did not agree with how Schussele taught, he did not wish to be responsible for the artist's termination. He preferred to accept a lesser status as an instructor and work at a reduced salary than to be responsible for ending Schussele's career. All the same, without breaching Eakins' sense of honor and his loyalty to his own teachers, a door previously shut had now been opened.

twenty-six

The Open Door

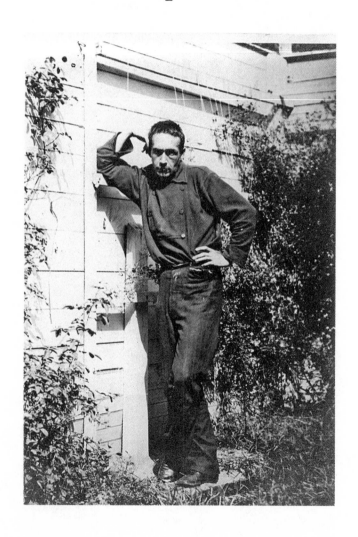

Honors that eluded Eakins the artist came easily to Eakins the teacher. Most notable was a feature-length article that appeared in September 1879 in *Scribner's Magazine.* Despite its title, "The Art Schools of Philadelphia," the article, written by literary critic William Brownell, focused exclusively on the Pennsylvania Academy of the Fine Arts and on how Thomas Eakins was re-vamping the curriculum along new and radical lines. The same magazine that had berated the "horror" that was *The Gross Clinic* now honored its artist as a cutting-edge instructor devoted to bringing the academy into the modern age. Christian Schussele was still officially in charge of the academy when the article was written, but it was Eakins who was exclusively featured.

The Brownell article and several others written about the academy made it clear that the overriding focus of the school's new curriculum was where Eakins wanted it to be: on the rigorous study of the human figure. This focal attention was not, of course, a departure from the accepted realist tradition. Study of the human form had been the centerpiece for academic art training since the Renaissance and at the academy since its formation. The difference in what Eakins was doing at the academy was the degree to which the human form was studied.

Life classes took place from early morning until late at night, supple-mented by intensive anatomy lectures, demonstrations, and classes in dissec-tion. Sculpture was taught as a means to develop a sense of three-dimensional form and weight-bearing structure. Students studied perspective systems and higher mathematics to guide them in a scientific understanding of figures in their environment. The approach was fiercely rational and analytically compartmentalized.

After he had toured the school, joined students in a dissection, and inter-viewed Eakins at length, Brownell concluded, "Exhaustive is a faint word by which to characterize such [intensive] instruction. . . . The students [are taught to] build up their figures from the inside, rather than fill them up after having lined in the outside."

In his own article about the academy, published in the *Penn Monthly* in 1882, Fairman Rogers wholeheartedly endorsed the school's new emphasis. "Great stress is laid upon the weight and solidity of the figure," he wrote.

Opposite: Eakins at about thirty-five, in 1880; photographer unknown (Courtesy of The Thomas Eakins Research Collection, Philadelphia Museum of Art)

"[The drawn figure] must stand upon its legs and show exactly what part of the general movement each portion of the body is bearing, and must look as if it is made from a real living body, and not from a pasteboard silhouette."

In his effort to overhaul the curriculum and better emphasize the academy's new mission, the first step Eakins took was to diminish the importance of the antique drawing classes as a means of training students. He encouraged everyone, from first-year novices to seasoned professionals, to put down their charcoal and pencils and pick up brushes. This change was, according to Brownell, nothing short of revolutionary. The new practice went totally against the academy's longest held tradition. "The first things to attend to in painting the model are the movement and the general color," Eakins told Brownell. "The figure must balance, appear solid and of the right weight. The movement once understood, every detail of the action will be an integral part of the main continuous action; and every detail of color auxiliary to the main system of light and shade."

As the innovation went against the system that he himself had been taught and that Schussele had continued, Eakins was specifically queried whether this was a good idea. "Don't you think a student should know how to draw before beginning to color?" Brownell asked. "I think he should learn to draw with color," Eakins replied. "The brush is a more powerful and rapid tool than the point or stump. Very often, practically, before the student has had time to get his broadest masses of light and shade with either of these, he has forgotten what he is after. . . . The main thing that the brush secures is the instant grasp of the grand construction of a figure. There are no lines in nature . . . only form and color. The least important, the most changeable, [and] the most difficult thing to catch about a figure is the outline. The student drawing the outline of that model with a [pencil] point is confused and lost if the model moved a hair's-breath; already the whole outline has been changed, and you notice how often he has had to rub out and correct; meantime he will get discouraged and disgusted long before he has made any sort of portrait of the man. Moreover, the outline is not the man; the grand construction is. Once that is got, the details follow naturally."

Such comments, Brownell reported, "would excite wonder and possibly reprehension from the pupils of the National Academy." Brownell qualified

himself, however, by pointing out that Eakins was not completely dismissing what a beginning artist could learn by drawing from the antique casts. "Mr. Eakins did not say 'the antique be hanged,' because though he is a radical he is also contained and dispassionate," Brownell wrote. " 'I don't like long study of casts,' he said, 'even of the sculptors of the best Greek period. At best, they are only imitations, and an imitation of imitations cannot have so much life as an imitation of nature itself. . . . Practically copying Phidias endlessly dulls and deadens a student's impulse and observation. He gets to fancying that all nature is run in the Greek model; that he must arrange his model in certain classic attitudes, and paint its individuality out of it; he becomes prejudiced, and his work rigid and formal. The beginner can at the very outset get more from the living model in a given time than from study of the antique in twice that period.' "

The same theme echoed through other articles that were written about Eakins. As his students remarked, one of the statements heard most often in academy classes was "Don't copy." "Feel the forms," Eakins would say. "Feel how much it swings, how much it slants—these are big factors. The more factors you have, the simpler will be your work." Another remark frequently heard in the classroom was, "A few hours' intelligent study is better than a whole day of thoughtless plodding." In rephrasing the advice, Eakins was quoted as saying, "Don't paint when you are tired. A half an hour of work that you thoroughly feel will do more good than a whole day spent in copying." Drawing, Eakins told Brownell, as he told his students, had to go beyond merely looking good. He wanted the work of his students to look solid. "Make it so it would look right in case you would go around to the side and back of it," he said. "Attack all your difficulties at once."

Rather than dwell on the casts, Eakins recommended a series of standard exercises in which students selected engaging three-dimensional objects to sketch. Eggs in particular were favored, recommended by Eakins "to learn the nicety of drawing," because they were similar to human flesh in color and texture. The egg shape was also so familiar to students that drawing them offered the novice a way to concentrate on the practice of painting rather than struggling with form. As a next step, Eakins had the students paint eggs that had been colored red, black, and white, and he instructed them to depict the

eggs separately under different lighting conditions. Another common exercise was for students to depict colored ribbons and various colored fabrics.

Along with diminished attention to antique drawing came a renewed interest in sculpture. Here again the emphasis was on the human form. Rather than give students the antique casts as subjects from which to copy technique, the school provided nude models. Knowledge of the human body based on careful observation was the mission. Shaping clay and sometimes wax, aspiring sculptors were expected to faithfully render the full human form. Painters too were sent to the sculpture studio when they were having trouble with solidity, just as Eakins had been at the école under Dumont.

"When Mr. Eakins finds any of his pupils, men or women, painting flat, losing sight of the solidity, weight and roundness of the figure, he sends them across the hall to the modeling-room for a few weeks," Brownell noted. Fairman Rogers also supported using the sculpture studio in this way, as he detailed in his own article. "[This practice] is in accordance with the general theory of the school, that the students should gain accurate information rather than merely acquire the knack of representing something; and nothing increases more rapidly the knowledge of the figure than modeling it. The student studies it from all sides and sees the relation of the parts, and the effect of the pose upon the action of the muscles, much more distinctly than when painting from the one side of a model exposed to him from his fixed position in the paintings class."

As observers described it, under Eakins the study of anatomy in lectures, demonstrations, and dissection was as comprehensive as that taught in the first year of medical school. Every part of the body was studied in detail, down to wrinkles in the skin and lines on a model's palms. Beginning students started their training by attending Dr. Keen's twice-a-week lectures; they were illustrated by a skeleton and a plaster manikin whose muscles, tendons, and bones were painted in different colors. Dr. Keen, interviewed for the Brownell article, said his course of lectures was "not a study of pure anatomy, but of anatomy in its relation to form."

Once a preliminary grounding was in place, Keen brought in live models to demonstrate the anatomical functions and actions being discussed. To emphasize certain muscle groups, the model was asked to lift weights and

other apparatus. Mild electrical shocks were applied to demonstrate muscular action. As one student later remarked, "There were [times in] Dr. Keen's anatomy lectures when a skeleton, a stiff and a model, and . . . Henry [the academy janitor] all jerked and jumped together when a battery was turned on. Henry yelled."

Students advanced to more in-depth study in the dissecting rooms in the academy basement, where they investigated animals and human cadavers; students also made casts of muscle groups and body parts. An entire body at times was cast when the class obtained a particularly well-proportioned or handsome cadaver. Once the casting dried, the common practice was to paint the muscles red, the tendons blue, and the bones white. The superintendent of the Philadelphia dog pound supplied the academy with suitable canine subjects for anatomy class, and the Jefferson Medical College provided human cadavers. Occasionally the Philadelphia Zoo also donated specimens. The death of an old lioness provided students with an especially memorable dissection subject, one they cast in plaster and added to the collection.

Eakins himself performed dissections and would appoint student assistant demonstrators to help. "To draw the human figure it is necessary to know as much as possible about it, about its structure and its movements, its bones and muscles, how they are made and how they act," Eakins said. Emphasis here and elsewhere was on understanding the skeletal structure as a means of capturing nature. Brownell wrote a detailed description of the dissection room. There reposed, he said, "the ugly, not to say horrible 'material' with which it is of necessity provided; its arsenal of dread-looking implements; its tables and benches, disclosing only too plainly their purpose, and finally, the dead and dismembered semblance of what was once a human being."

Field study was another focus of anatomy classes; they took regular trips to North Philadelphia to dissect horses at Shoemaker's glue factory. In the summer students were invited to model horses at the stud farm belonging to Fairman Rogers. This experience eventually led to studies devoted exclusively to horses. In the 1880–81 season, for example, a horse was brought to the modeling class, and the students worked from it for six or seven weeks; during the same time they dissected a dead horse. Later the following year, a cow was investigated in the same way.

Although no one was required to study dissection or make field trips, a large majority of the students, including the women, did so. Brownell expressed concern that such study might become inappropriately scientific, if not repulsive. Eakins countered by freely admitting that the subject was indeed repulsive. "I don't know of anyone who doesn't dislike it," he said. "I feel great reluctance to . . . [begin teaching it each semester]. It is dirty enough work at the best."

Eakins mentioned a student who initially abstained from dissection classes. Then he took it up when he saw his colleagues were getting along faster than he. "No one dissects to quicken the eye, or delight in beauty," Eakins said. "He dissects simply to increase his knowledge of how beautiful objects are put together to the end that he may be able to imitate them. Even to refine upon natural beauty—to idealize—one must understand what it is that he is idealizing, otherwise his idealization . . . becomes distortion and distortion is ugliness."

Brownell did not seem entirely convinced that such intensive study was warranted. He did, somewhat reluctantly, admit that one "begins to appreciate first how much less liable the young men and women [who] study here are to draw impossible legs, arms, trunks, than they were before . . . [and that one comes] to feel that, after all, it is the province of an art school to provide knowledge and training, and not inspiration."

In addition to supervising the work in the dissection room Eakins lectured on perspective and mechanical drawing. He also began preparing a book, a drawing manual for students based on his teaching, although he abandoned the project several years later. (The existing manuscript, including illustrations he made for the book, was finally published only recently, in 2005.) Just as he had been taught, he presented the subject by instructing his students to establish a grid work of lines. Academy students followed this schemata by forming squares one foot apart on the studio floor, introducing a table or other object into the grid, observing its position, and then copying the object on a corresponding ground plan, laid out in the drawings, in perspective.

The purpose of these and other exercises reflected a strategy of divide and conquer (different from his advice for sketching with paints, to first capture the main segments whole). Students broke problems down into components

and then solved each one separately. The emphasis was on the rational and analytical rather than the intuitive; everything was done step-by-step. Precision was the goal. Eakins gave students concrete problems to work out using mechanical drawing methods. The most advanced was his preferred assignment: correctly depicting a yacht sailing. "A boat is the hardest thing I know of to put into perspective," he would explain to his pupils. "It is so much like the human figure [that] there is something alive about it." As he later told his students: "All the sciences are done in a simple way. . . . In mathematics the complicated things are reduced to simple things. So it is in painting. You reduce the whole thing to simple factors. You establish these, and work out from there pushing toward one another."

Lecture notes and formal papers Eakins wrote on mechanical and isometric drawing, reflections in water, shadows, sculptured relief, focus of the eye, and "framing the picture" were kept on file in the library, along with an ever-growing collection of published books and periodicals. These provided academy students with a wealth of anatomical studies and illustrations. Such archival collections had been maintained in the academy's library since its inception. The significant differences while Eakins was in charge were the sheer volume of new material, and the emphasis given to the human form.

In the past, the academy library collection consisted of paintings and prints. Under Eakins, it grew to include a vast documentary photographic reference archive. Particularly handsome or intriguing academy models were photographed, along with students and other volunteers of different ages and body types. Typical examples included photographs of an old man with a beard, a nude gymnast, and an adolescent boy. One series that may have been part of the academy library consisted entirely of students modeling Greek costumes in poses emulating those depicted on the Parthenon. Documentary photographs of this kind at this time in art study were by no means unique; yet they were rarely taken by art institutions themselves. Eakins was using the camera to compile a more complete dossier of human figure types for comparative study than had ever been done before. Cameras were brought not only into the life studies classes but into the dissection room.

The library resources, like the anatomy and sculpture programs, were designed to assist the students in their life studies classes. This was in fact the

centerpiece of the program Eakins established: the study of the nude. Between the separate men's and women's life and clay modeling classes, more than sixty hours a week were devoted to working from nude models, more than all the other classes combined, and significantly more than was offered in any other art school in the world.

On the orders of Eakins, models were changed as often as possible. "It is only by constant change that pupils learn that one model does not look at all like another," Eakins said. "There is as much difference in bodies as in faces. ... On seeing a hand one should know instinctively what the foot must be ... [because] nature builds harmoniously." As he had in the past, and would in the future, the stress was on getting what he described as the subject's "character." As Eakins told his students: "If a man's fat make him fat; if a man's thin make him thin; if a man's short, make him short; if a man's long, make him long."

Classes varied regular models on occasion with athletes, trapeze performers, and sportsmen. The poses were simple, usually standing ones, as these were easy to hold and taught the student to look for construction and character rather than more spectacular qualities. At first more male than female models posed, ostensibly because female models were more difficult to find, but eventually the sexes became equally represented. If a model was unusually good or had any interesting peculiarity of form or action, he or she was held over for extended modeling sessions. Eakins was reported to have searched for the best possible physical specimens.

As in the past, the academy conducted modeling from nudes separately for male and female students, although the students attended anatomy and other lectures together. And though women were not initially permitted into the dissection rooms, eventually they were given access. Eakins did not hesitate initially to pose male and female models together in the life classes—as he said, "in order that the student would get a better understanding, by comparison, of the construction and movement of spine and pelvis in walking."

Nude modeling was the rule and not the exception. The academy was the only school in the world, Eakins noted, "where women could study the [nude] figure without annoyance." Eakins cited medical schools as setting the right example for helping females overcome the inhibitions he believed were holding them back. "The most dreadful diseases are shown them. ... And while

students, these young [women] spy into each others' piddle with a microscope and do a hundred other unconventional things, from which the novelty now being worn off, even mild derision can hardly be excited against them."

Eakins clearly wished to bring the academy further along in this way. "As the population increases, and marriages are later and fewer, and the risks of losing fortunes greater; so increases the number of women who may be compelled at some time to support themselves and figure painting is not now so dishonorable to them."

He also noted that education at the academy allowed women "to decline ineligible offers" of marriage, because what they were learning would provide them with some means of support. "A certificate of prudery would not in this age help sell a figure piece by a young lady," Eakins declared. He cited the example of a successful female artist studying in Paris: "She must assume professional privileges. She must be the guardian of her own virtue. She must take on the right to examine naked men and women. Forsaking prudery, she locks her studio door whenever she wishes, and refuses admittance on the plea that she has a model. And without these privileges, she could not hope in any way to compete with men or either the intelligent of her own sex."

Eakins acted as if it was a sacred duty for each student to come to terms with his or her own nudity, and with nudity in general. By forcing women to confront what he said were their "feminine" inhibitions and to confront the realities of the world, however ugly they might at first seem, was to understand nature and to obtain a detached and objective attitude toward the human body. He urged women in the academy to join equally with the men in the grisly work of the dissecting room, denigrating by contrast the common female occupation of painting designs on china. There was no place in the academy for "feminine" interests of this kind.

The Brownell article clearly articulated such progressive attitudes in its text as well as in the accompanying illustrations. Susan Macdowell, said by many academy pupils to be Eakins' most favored student, was prominently featured. The article reproduced photoengravings of two of her pictures, and she herself appeared in a third illustration by classmate and friend Alice Barber. Macdowell also later received the newly established Mary Smith Prize, given to the best female painter in the academy's annual exhibition, in April 1879.

Eakins, as he served on the jury, must have had mixed feelings about presenting the award. His reluctance did not reflect Macdowell's ability as a painter. Rather, he did not encourage giving out prizes as a way of stimulating students. He wanted them to work hard, at all times. "Strain your brain more than your eyes," was one of his most frequent instructions to students, as quoted by Brownell, as well as in later articles and books by his students. One girl's claim that in the past she "had her little ways" of solving problems did not fly. "There are no little ways," Eakins declared. Learning to be an artist was hard work.

Eakins rarely praised his students' attempts. He spent about thirty minutes on each visit to the classroom, patiently offering individual criticism to the more capable artists. At times he would sit in front of a student's painting and study it long and intently—as Gérôme had done—then rise without a word and go on to the next easel. On occasion this might happen to half the class; some members might not receive any criticism from him for weeks. In the case of a weaker student, Eakins sometimes sat down at the easel and did not utter a word. He was not overly critical, but his silence was "sufficient criticism," as one pupil noted. Students who showed surface finish without sound construction could be demolished in the process. Henry Ossawa Tanner, for example, had made a good start on a study. Then he stopped working on it for fear of spoiling it. This infuriated Eakins. "Get it, get it better, or get it worse. No middle ground of compromise." If a student was incompetent or lazy, the sooner he or she gave up the study of art the better.

The only honor he gave was to put his initial, the letter E, on the lower corner of the best studies his students made; the studies were then kept for display by the academy. "It meant he could see some improvement," said his student Adam Emory Albright. "It had nothing to do with how one's work rated as compared to someone else's, but was entirely personal, signifying that one had risen above one's former self and past performances." Any other awards were not necessary. "The capital E was a real prize, carrying many times over the thrill of the prizes and scholarships today," Albright said. "Tommy's E stood for no favoritism or politics: it meant progress toward 'Excellent' and from the master of excellence, the one and only Eakins."

twenty-seven

A May Morning in the Park

The man who was permitting Eakins the freedom to revamp the academy curriculum was the millionaire engineer and iron merchant Fairman Rogers. He not only championed Eakins' views in the academy board room; he demonstrated continuing support by commissioning a painting that would draw on the artist's talent and the creative innovations he had made using photographs to capture difficult modeling challenges. *A May Morning in the Park* (Philadelphia Museum of Art), begun in 1879 and completed in 1880, set out to record, for the first time in the history of art, the anatomical truth of a horse in motion (plate 12).

Eakins could not have asked for a more accommodating or knowledgeable patron than Rogers. Both men were well-educated Philadelphians, enthusiastic sportsmen, progressive and democratic in their views on art and education, and lovers of science and technology. There is little doubt these common interests and complementary viewpoints bridged major differences between them. Eleven years Eakins' senior, Rogers was born to wealth, married the heir to another large fortune, and sat at the highest rungs of Philadelphia society. Among his friends was Alexander Dallas Bache, who had developed the curriculum at Central High; through his association with the National Academy of Sciences and the University of Pennsylvania, where he taught engineering, Rogers knew the scientists Eakins had only read about. Given the significant differences in the way they lived and that Rogers was technically Eakins' employer at the academy, true friendship was out of the question. The distance did not, however, prevent them from working on several important projects together.

A May Morning in the Park (also known as *The Fairman Rogers Four-in-Hand*) grew of their mutual interest in photography and animal physiology. Rogers' expertise in both these areas was considerable. He began experimenting with cameras as early as the 1850s, and in the late 1860s he designed an effective shutter mechanism that allowed a photographer to shoot multiple images on a single commercially produced glass-plate negative. Rogers used his enhanced camera system to document his life's great passion: horses and horsemanship. Among his various experiments was a series of photographs showing the legs of a trotting horse. He presented the results of his work at a

Overleaf: Fairman Rogers in the box of his four-in-hand coach, c. 1879 (Courtesy of The University of Pennsylvania, Philadelphia)

meeting of the Photographic Society of Philadelphia in 1871, a full seven years before the English-born photographer Eadweard Muybridge published the results of similar, more extensive experiments he conducted at railroad tycoon Leland Stanford's ranch in Palo Alto, California.

The publication of the Muybridge photographs rekindled Rogers' interest in the subject. The challenges both men faced came from the long exposure time it took to capture a photographic image and the lack of flexible film stock, which had not yet been invented; the Eastman Company did not sell the first commercially produced roll film until 1889. Another three years passed before Thomas Edison patented the first motion picture camera.

Muybridge had earlier devised a system that stationed a battery of twenty-four cameras side-by-side along a track. Trip wires along the track set off the cameras in rapid succession as the horse paced past them. The result was a series of photographs of successive phases of motion. The main technical drawback to this system was that the photographer could not adequately measure the successive phases of the animal's gait in relation to the moment of exposure. There were no timing devices beyond the trip wires, nor was there a practical system of notation to graphically diagram the sequential movements in the photographs. While they were interesting to look at, from a technical standpoint they provided little real scientific insight into animal locomotion.

Rogers and other engineers, among them the French physiologist Étienne-Jules Marey, sought to overcome the timing problem by fitting a single-camera glass-plate system with a revolving spring-action shutter that was in turn attached to a clock-driven timer. Their inspiration was the slotted drum of a zoetrope, a popular children's toy, which had first been developed in 1867. In the zoetrope, light passing through the slots on the spinning drum conveyed the illusion of continuous motion.

Eakins was as intrigued by Rogers' ideas on time-lapse photography as Rogers was interested in the realism that Eakins brought to his paintings. Together they studied the Muybridge photographs. The impression the photos made on Eakins was considerable. Here, for the first time, was a way to scientifically portray the anatomical truth of a horse in motion.

In anticipation of being able to convey this truth in a painting, Rogers and Eakins had the Muybridge photographs traced onto lantern slides by a

young academy student who was particularly adept at drawing in miniature. Then, using a modified zoetrope, they projected the slides on a screen. The students were as fascinated as Rogers and Eakins by what they were doing. One later remarked, "I whirled the cylinder myself and looked through the pinhole at these early moving pictures, astounded at the phenomenon." Another viewer of the pictures would say, "There is a feeling of awe in the mind of the beholder."

Yet, like Rogers, Eakins found the Muybridge results inconsistent. Either the horse Muybridge photographed had not been traveling at a consistent speed along the track or Muybridge had left several important sequential photographs out of his published series. Further research has shown that not only did Muybridge delete photos from the published sequence, he combined horse photographs from one session with those of other series to make the sequence more convincing. He had, in short, cheated, at least as viewed from the scientific perspective that interested Eakins. Though inconsistencies in the photograph sequences would forever taint Muybridge's work in Eakins' eyes, it did not detract from his enthusiasm for trying to convey the real thing in a painting. Rogers was quick to accommodate, inviting Eakins to model live horses at his Springfield stud farm, and later at his summer home in Newport, Rhode Island.

Rogers' favorite mare, Josephine, a horse he described as "nearly as possible perfection in all her points," could likely have been the model for the first picture of a horse Eakins ever sketched. In any case, he did feature Josephine in the most prominent position in his finished painting, where she appears in the forefront leading the team of horses. Josephine even served Eakins as a model after she died several years later; Rogers gave the mare to the instructor and his students to dissect in 1882.

The experimental sketches Eakins made of Josephine excited Rogers, as they did Eakins. The study and correct depiction of a horse's gait held potential as a way of gaining significant new insight into animal locomotion. At the very least, continued work in this area could become a learning tool for art students at the academy. "The horse enters so largely into the composition of pictures and statuary," Rogers wrote, "especially into works of higher order, such as historical subjects, and is generally so badly drawn, even by

those who profess to have made some study of the animals, that the work seems to be of value."

It was discussion on this topic that led Rogers to commission a painting from Eakins illustrating the full cycle of a horse's gait. Rather than paint several differing images of the same horse, they chose instead for him to paint a team of four horses, each representing a different phase of movement. Rogers offered Eakins five hundred dollars for the work, triple what the artist was then asking for a portrait, and a hundred dollars more than he had been paid for painting President Rutherford B. Hayes. They agreed on a painting that would depict Rogers' horses and his favorite "park drag," known as a four-in-hand coach, which he had ordered specially built for him in England and was quite proud of. Rogers' thinking on this subject was twofold. He not only loved horses; he was a charter member of an exclusive club of horse-drawn coach drivers. Fairmount Park offered a favored course for the club's members. A coaching picture, rightly done, would be of great personal as well as scientific interest for Rogers. Beyond the obvious challenge of scientifically portraying the horses in motion, the coaching theme held particular appeal for Eakins. Properly managing a park drag required bodily strength, concentration, and coordination to keep the horses in line and all pulling together. These were much the same skills possessed by champion oarsmen in a racing scull. Also an element of interest was the location, Fairmount Park, a prime recreation area for coachmen and rowers alike.

Due to Eakins' teaching responsibilities and the care he approached the project with, it took him more than a year to complete the painting. In advance of his location and subject studies came a series of composition sketches and perspective drawings that fully reveal the painstaking attention to detail Eakins brought to bear on the work. Most remarkable of all is that they do not reflect the composition he eventually painted. Unlike almost all other preliminary sketches Eakins made in anticipation of what he would paint, in these cases they contain a wide assortment of other subject matter and themes. The final painting shows Rogers' park drag, pulled by four horses, racing through Fairmount Park. The sketches Eakins made show such disparate elements as a vagabond with a dog wandering in the park, a rider on horseback, and a Conestoga wagon.

Since no dates appear on these sketches it is difficult to establish definitively the order in which they were drawn. Kathleen Foster, who has made an in-depth study of this work, has said that the first of these sketches is likely to have been a depiction of Rogers' park drag appearing at center, cropped tightly; this sketch presents the same angle as in the final painting. A vagabond or a pedestrian is clearly seen, as is his dog. The existence of this sketch in particular suggests that the scene had either not yet been chosen or that Eakins had a different conception from Rogers of the moment he wished to depict. The presence of the Conestoga wagon in another sketch, and those containing a man in the distance poling a skiff, along with a locomotive in the distance, provide additional evidence that Eakins may have conceived a grander theme than animal locomotion, coaching, and Fairmount Park. Just as he had in his portrait of Max Schmitt, the artist may likely have intended to make a statement about modern life and the history of transportation. At the very least, the sketches suggest a desire to put Rogers' park drag in a historical context. The inclusion of the outmoded Conestoga wagon would have contrasted with Rogers' gleaming coach, just as the old-fashioned barge in the Schmitt portrait contrasted with Max's sleek new racing scull.

Eakins did not pursue this grander theme, though, presumably at the request of Rogers. The portrait he commissioned was to be of his horses and coach, and the title it was given, *A May Morning in the Park*, suggests Rogers may have conceived the scene as a reconstruction commemorating the first major outing of the coaching club on May 4, 1878, rather than a study in animal locomotion. Given that Rogers was his benefactor, Eakins may have uncharacteristically suppressed his desire to do more with the painting than Rogers wished. Correctly portraying the horses in motion was challenge enough.

The artist's state of mind may have been an equally contributing factor. On April 6, 1879, just as Eakins was exploring the themes and subject matter he was to include in the painting, his twenty-seven-year-old fiancée, Kathrin Crowell, died of meningitis. How she contracted the disease and how long she suffered is not known. She had never been particularly robust; as a child she had contracted yellow fever, an illness that may have impaired her immune system. Eakins did not make a single reference to her death in his letters, nor

has any mention of it turned up in other family correspondence. Only the dates of her birth and death are recorded in the Crowell family Bible.

Eakins must naturally have been distraught. Perhaps as a needed tonic at a difficult time, Rogers invited Eakins to spend part of the summer at Fairlawn, his mansion in Newport, Rhode Island, working on the painting. As in many instances of death-related events in Eakins history, the truth of how he felt is likely to remain unknown. Kathrin's death may even have reduced the tension of Eakins' ambivalence, if it was that, about marrying her. But it was ironic that, just as he reached a point in his career that he could afford a wife and family, the girl he was engaged to was taken from him. In any case, Kathrin's death coincided with Eakins' revived passion to break new technical ground with his art. Although his Rush portrait had gone against convention in its portrayal of a nude model, Eakins had retreated from his previous enthusiasm to experiment with the kind of technical innovations he intended to bring to *A May Morning in the Park*. Photography became a key to creating this painting, as it was in the production of several others he painted in rapid succession within the next year.

On June 16, 1879, just two months after Kathrin died, Eakins got his first view of the Rogers park drag at his patron's mansion in Newport. The carriage resembled other coaches that transported passengers from one city to another, and it functioned much the same as well. It was significantly different, however, in its construction, for it had been designed expressly for speed and maneuverability. The driver, often accompanied by passengers, rode on the roof. The interior was occupied by servants, except in inclement weather. Rogers was active in a coaching fraternity whose members often attended rallies in such coaches and sometimes drove in relays. The scene Eakins ultimately depicted could easily have documented the inaugural May 4, 1878, relay that members drove from New York to Philadelphia and back again, passing through Fairmount Park along a coaching trail.

Eakins measured the coach for a perspective drawing, made pencil and color oil sketches, and most likely took photographs. He had the carriage repeatedly driven back and forth in front of him so he could study and sketch its movement under natural light. The resulting oil sketch of the coach in

motion, probably painted by Eakins at this time, presents the configuration of the horses' legs with startling accuracy. Passing from left to right, the coach and horses are set against the rocky Newport landscape and shoreline. This oil sketch might be an early draft of the final painting or simply a preparatory sketch he made for Mrs. Rogers as a gift from a grateful houseguest. Eakins painted this sketch, like others that came later, on a ten-by-fourteen-inch wooden panel that slipped into the grooved lid of his painting box. Besides the sketching and painting he did in Newport, Eakins could have begun making sculptures of Josephine and the three other horses that would appear in the painting.

Before the end of the summer Eakins was back in Philadelphia, on Belmont Drive (now Belmont Avenue) in Fairmount Park, making more sketches and color studies. As Foster has explained, two surviving landscape sketches, painted on wooden panels, suggest that the Philadelphia setting had already been determined: Like a surgeon preparing for an operation he was about to perform, Eakins methodically studied the landscape and isolated particular features of the terrain that would serve his purposes in the completed canvas. Dense patches of lush green foliage and areas of dark shadow were removed; the sandy peach-colored Belmont Drive carriage path, the masonry of a stone embankment, and stands of tall trees remained fixed.

The painting's final arrangement portrayed Rogers, his wife, and four members of their extended family, along with two grooms, riding atop the coach as it makes its way along the carriage path. Every feature of the horses and the coach were to be documented in fine detail, from the elegantly painted, polished, and reflective woodwork on the park drag to the spotless color-coordinated outfits worn by the grooms in the back. The coachman is Rogers, portrayed leaning back on a bolster, both feet planted on the footboard, his whip at a forty-five-degree angle—posed exactly as Rogers described the ideal position in a coaching manual he later published. Thanks to notes on one of Eakins' preparatory sketches, the horses themselves can be identified: in addition to Josephine, they are Williams, Chance, and Peacock.

Eakins' solution to the perplexing problem of correctly depicting the horses' gait did not come strictly from his own observations; photographs were necessary. Although it has repeatedly been said that Eakins modeled the horses in his completed painting from four frames of the Muybridge studies,

this was decidedly not the case. None of the Muybridge photographs match the poses in *A May Morning in the Park*. Having already determined that the series of Muybridge photographs was unreliable, Eakins likely used photos provided or produced by Rogers. Eakins then modeled them in clay and sketched them before projecting them onto his primed canvas.

How to suggest movement—not only of the horses but also of the coach—posed the greater challenge. Unlike in his rowing and sailing paintings, no river flowed in the scene for his subjects to leave wave trails or droplets of foam in to imply motion. Other than the suggestion of a slight breeze blowing through Fairmount Park's lush spring foliage, all Eakins had to work with was the horses' legs and his depiction of the coach's wheels.

The wheels presented their own unique technical challenge. If he was to truly portray the horses as their legs were positioned at a particular moment in real time, it only stood to reason that he would have to picture the coach's spinning wheels in the same stop-action mode. Following through this way, however, would make the coach appear to the viewer as not moving at all. The movement of a horse's legs at a trot or a canter is more perceptible to the naked eye than the spokes of a spinning wheel. Moreover, the true position of the horses' hooves did not necessarily reflect a viewer's idealized vision of where they should be. Three of the horses showed what a viewer would think realistic, while the fourth horse, the near-wheeler at the right in the painting, appeared to be walking, when in fact it was actually trotting. It only appeared to be walking because of the instant Eakins portrayed in the stop-action presentation.

Conservation studies of the completed painting definitively reveal that Eakins originally painted the spokes on the wheels as he did the horse's legs: in an instant frozen in time. The result must have been so disconcerting that he repainted the wheels to make them look somewhat blurred in the center, as they would appear to a bystander in real life. Like a photographer adjusting the shutter speed for an exposure, he chose a moment when the clearly delineated horses' legs and the outer part of the wheel spokes appeared to be static, but the inner struts of the wheel were blurred, confirming the movement of the carriage. Eakins was, in essence, using his knowledge of science and math to update the realist tradition that was the inspiration for his art.

Eakins' accomplishment, however, was lost on the critics who later reviewed the painting. Much as had been the critical reaction to his rowing paintings, they attacked *A May Morning in the Park* for the very reason Eakins believed he had succeeded. They universally agreed that Eakins brought to the task "the ablest dealing with the toughest problems of painting, of anatomical knowledge and accurate drawing," but they found the result "unsatisfactory" anyway. The critic for the *Philadelphia Press* detailed the painting's shortcomings in a small essay. "Mr. Eakins is a builder on the bed-rock of sincerity, and an all-sacrificing seeker after the truth, but his search is that of a scientist, not of an artist," the *Press* reviewer wrote.

> As an example, to make this meaning plainer, let us consider Mr. Eakins as a student of the figure, the highest walk of study an artist can enter upon. In this walk he has advanced further than any other man in America. . . . He has acquired this knowledge and skill by arduous study, study not confined to outward phenomena, but dealing with constituents, from the skeleton to the skin. . . . But suppose these studies, instead of being held as means, become an end, knowledge being pursued for its own sake? Then such pursuit may develop a good demonstrator of anatomy, but never an artist. . . .
>
> [*A May Morning in the Park*] is simply a puzzle to an ordinary observer. . . . The instantaneous photograph has demonstrated that with all our looking at horses we have never seen how they move their feet, and in view of this discovery Mr. Eakins has formulated certain theories, mathematical and anatomical, which this work purports to illustrate. As a mechanical experiment it may be a success; on that point we express no judgment, but as to the matter of framing the experiment, hanging in a picture gallery . . . we have to express a judgment decidedly adverse.

Even Mariana Griswold Van Rensselaer, one of the foremost art critics in the nation, couldn't fully grasp or appreciate the whole measure of the painting's innovations. She summarized what disturbed her in a single sentence: "[The painting is] scientifically true; but it is apparently, and so, I think, artistically false."

Rogers was not put off by the reviews, and he himself later used the painting as a principal illustration in the manual he wrote about coaching. He also encouraged Eakins to further adapt ways for photography to be a tool for artists, and to perfect a single-camera serial-action photograph technique. Most important in the long run was his unflagging support of Eakins at the academy. Following the death of Christian Schussele on August 21, 1879, and before the first public showing of *A May Morning in the Park,* Rogers formally submitted to the board his recommendation that Eakins be named the academy's professor of drawing and painting, at a salary of six hundred dollars a year. The board gave him the job, paving the way, in 1882, to the academy officially appointing Eakins its director, the most prestigious position in the finest art school in the nation.

Eakins, now thirty-four and fully mature in his career, immediately shared the news in a letter to his most highly regarded student, Susan Macdowell. Their relationship had progressed to the point that he was candid not only about his enthusiasm at finally receiving the job but about the internal politics that had made the event long overdue. His only concern was what "old Sartain" would have to say about the appointment. "I fear his rage may bring on a fit," Eakins wrote.

Jerusalem in New Jersey

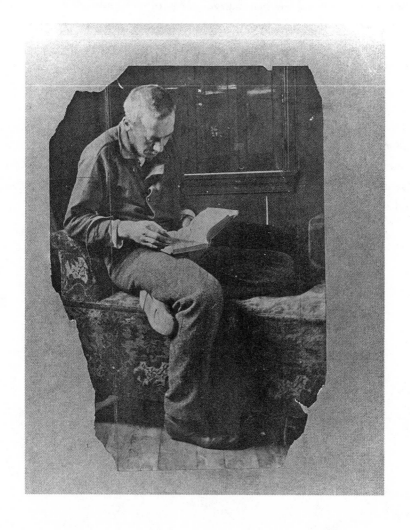

Photography continued to inspire Eakins as he conceived of more innovative ways to bring greater realism than ever to his painting. His natural next step was to purchase his own four-by-five-inch box camera and darkroom supplies. By 1880, following several technical breakthroughs in photography along with the additional income from Rogers' commission and his new salary at the academy, he apparently no longer felt any need to wait. Cameras could now be easily taken into the field, and film negatives could be developed and printed in a home studio. The more intriguing question was not why he held back nearly a full decade before shooting his own photographs, but what inspired him to choose the subject matter in the first painting he made using them: Jesus on the cross. The paint was barely dry on *A May Morning in the Park* when Eakins began carving a twelve-foot-high cross. He ferried it across the Delaware River to a secluded spot near Pennsauken Creek in southern New Jersey, and there set up his camera.

Although the photographs Eakins took on this trip no longer exist, their creation was later recounted by the academy student who modeled for them. Eakins chose sixteen-year-old Irish-born John Laurie Wallace for his handsome physique and dark complexion. Wallace's willingness to pose nude, outdoors, on a cross, must also have figured into the equation, and played a significant role in what without doubt was one of the most unusual modeling sessions on record in New Jersey's rural woodlands.

No sooner did Eakins raise his massive cross and strap Wallace onto it than a party of hunters wandered out of the forest. What the startled hunters thought is anyone's guess. Wallace reported only that he and Eakins packed up their cross and equipment and moved to an even more remote location. Eakins may have shot additional outdoor photographs on the roof of the Mount Vernon Street home. Legend has it that the second modeling session was also interrupted, this time by neighbors concluding that Eakins was suspending a corpse above his studio window.

The painting that resulted in 1880 from the New Jersey photographic expedition, *The Crucifixion* (Philadelphia Museum of Art), is nearly as monumental and imposing as *The Gross Clinic*. In the artwork, the dying Jesus, set

Opposite: Thomas Eakins reading, 1884; photographer unknown (Courtesy of Samuel Murray Archival Collection, Hirshhorn Museum and Sculpture Garden, Smithsonian Institution)

against an empty blue sky and a desolate rocky landscape, occupies almost the entire eight-by-four-and-a-half-foot canvas (plate 13). The figure hangs from the cross at an oblique angle to the picture plane, with the weight of his pale torso, sagging and marked with grime, borne by his hands, nailed and clenched in agony and dripping with blood. Physical features down to Wallace's underarm hair are visible. His head is hidden in deep shadows, crowned with a band of interwoven and threateningly long, sharp thorns. All is depicted in ultra-realistic detail, from the parchment scroll tacked to the top of the cross to the folds of Jesus' knotted loincloth, dirt-smeared feet, and broken, uncut toenails.

As in Eakins' rowing painting *The Biglin Brothers Turning the Stake,* there exists a deliberately unresolved quality in his application of paint and the contrasting elements it depicts. Lines and subtle variations of color appear and disappear in light and shadow and filmy clouds of dust. The effect is unnerving, like watching the flickering images in a nickelodeon movie. Jesus has either just died or is losing consciousness. Rather than trying to find signs of life in the missing detail in his eyes or somehow in his blood engorged feet, the viewer becomes swept into the totality and power of the narrative moment. The Jesus that Eakins painted is very much a man of flesh and blood; yet the moment captured is altogether supernatural.

It is above all this mystical quality that Eakins brings to his subject that makes *The Crucifixion* so enigmatic. No one commissioned him to paint it. No one in his circle of intimate friends at the time was known to have been particularly religious. Nor is there evidence that his own views on religion or the church had changed. Eakins was apparently agnostic and perhaps an outright atheist. He had never before tackled an overtly religious subject, nor would he paint one again. That he loved this painting, however, or at least was deeply attached to it and knew he had created a masterpiece, was shown by his hanging the painting in the entrance hall to his home, where anyone coming or going from the house was certain to see it.

The reason most often suggested for Eakins' choice to paint *The Crucifixion* is that the subject was unavoidable for an artist who sought to become a modern master. In portraying Jesus in what was a most important moment in his ministry, Eakins entered into a long and hallowed tradition of great art-

ists who had come before him. Representing the crucifixion had been a rite of passage for European masters since before the Renaissance. Eakins commented in his Spanish notebooks on Ribera's compelling treatment of biblical subjects and praised Velázquez's *Christ Crucified*. Eakins' mentor, Gérôme, poetically depicted the crucifixion by showing only the shadow of the cross. Léon Bonnat had also tackled the subject. In his desire to bring great realism to his painting, Bonnat modeled his Christ from an actual cadaver that he nailed to a cross in his Paris studio. Eakins did not go to the same extreme with his model, but his photographic approach achieved similar results. In choosing this subject, he was paying tribute to an important cultural, religious, and even political fount of his art, and in his graphic depiction of the scene he carried the realist tradition to a new level.

In addition, few if any more fitting subjects existed that could allow Eakins to demonstrate his understanding of anatomy and mastery of the human form than to paint the physical agony of a partially nude body hanging on wooden beams. His Christ painting, in this sense, culminated the years he had spent studying at the Jefferson Medical College and the lectures he delivered in the academy dissection room. There was likely no artist of his generation more qualified to depict the strain of muscles and tendons, the stiffened fingers and swollen feet, shown in this painting. It is possible, as well, that Eakins felt his own lack of orthodox religious conviction would allow him to be one of the few artists to paint the scene objectively.

Beyond the subject's deeply influential tradition, and the appeal of using his photographic and technical skills to push the boundaries of his art, Eakins' choice of subject begs for deeper psychological study. Enticing as it may be to suggest that the artist was exploring themes of his own pain and suffering, that does not appear to be the case. Eakins at the time did not feel persecuted by the established art community, as he had when drawing Columbus in chains or depicting the scandal over Rush's nude modeling sessions with a girl from Philadelphia's high society. His honeymoon at the academy was at a high point. He had the unqualified support of Fairman Rogers in overhauling the curriculum and the unstinting devotion of its students. Kathrin Crowell's death was behind him. Eakins was in love with Susan Macdowell, who was as enamored of him as he was of her. And though Eakins still had not sold a major canvas,

and he continued to encounter opposition with the exhibition of *The Gross Clinic*, he was well on his way to earning a national reputation.

That Eakins was so vocally against religious structures in his early years may be the only clue to unraveling the deeper mystery surrounding *The Crucifixion*. Eakins did not ignore the church or religion in his correspondence. Just the opposite. He rarely missed an opportunity during his student days in Paris to mention his seeing priests and monks on the street or to point out the indignities and folly of organized religion. Although he himself did not admit to having faith in the church or its institutions, he was extremely interested, even obsessed, by people who did. Rather than turning away from a foundation of Christian belief, he chose to confront the subject in strikingly modern terms. Eakins appears to have been saying that Jesus was a human being. Divinity rested in the absolute perfection of flesh and bones, his and our own. In dying on the cross Jesus entered what Eakins called the "pure landscape" of "silent prayer."

The composition Eakins conceived for his painting conveys what must have been the artist's own declaration of faith. There are no soldiers and no Virgin Mary or Mary Magdalene. No wound is visible in Jesus' side. Rather than adding dramatic lighting of an impending apocalyptic storm, Eakins painted a desolate rocky hill and empty blue sky. All that differentiates the figure in this work from that of any other crucifixion is the crown of thorns, the scroll identifying the man nailed to the cross, and the sublime (is it divine?) calm and composure on the dying man's face.

The narrative moment Eakins has captured gives yet another insight into what must have attracted him to the religious experience. In nearly all the major portraits Eakins painted, his subjects are turning away from the business or concerns of the world to briefly enter a fleeting moment of transcendence. This is true of Margaret Eakins reflectively looking away from her piano in *Home Scene,* and Ella Crowell pausing to study a building block in her hand in *Baby at Play*. Max Schmitt has unaccountably stopped rowing to look toward shore. Dr. Gross looks up and outward from an operation in progress. In the instances when Eakins' subjects are most in their world they are also out of the world. His Jesus in *The Crucifixion* is in the supreme moment of turning away from his human experience.

Beyond the nails driven into Jesus' hands and feet and the battered and abused condition of his body, Eakins has offered the viewer a significant added clue to the nature of the "human experience" from which he turns. The Greek and Roman lettering on the scroll tacked to the cross is scrawled in a clumsy and nearly illegible hand. A purposeful ugliness and crudity by which Eakins has inked in the lettering conveys the haste, ignorance, and hysteria of the people who have ordered the crucifixion. By contrast, the clean and sensuous lines of the subject's body suggest the grace and precision of a "Master Penman" and a mystery of creation. The spiritual statement Eakins made in painting his Jesus could well be seen, not as an aberration, but as the very essence of his art.

In a related theme—iconography that suggests sacrifice or transcendence —as the contemporary critic and art historian David Lubin has aptly pointed out, comparing *The Gross Clinic* to *The Crucifixion,* "the lean, white, bent-at-the-knee flank of the youth on the operating table reappears in the body of the tortured Christ. The youth's feet are clad in dark gray socks; Christ's feet are clad in blood, dirt, and iron nails. A chloroform-infused pillow covers the young patient's head to render him unconscious; a crown of thorns covers Christ's head."

The critics of Eakins' own generation did not miss connecting the blood, wounds, and naked flesh of the two paintings—only their reaction to both was not of divinity, but loathing. A reviewer from the *Art Amateur* declared: "Mr. Eakins' 'Crucifixion' is of course a strong painting from the scientific side, but it is difficult to praise it from any other point of view. . . . The mere presentation of a human body suspended from a cross and dying a slow death under an Eastern sun cannot do anybody any good, nor awaken thoughts that elevate the mind." Another critic, writing for the Philadelphia *Independent,* described the effect as "revolting beyond expression" and declared that Eakins' Jesus "is the subject of the dissecting-room table—sickening, repulsive to the last degree." The writer from the *Art Journal* concurred: "The artist who undertakes anything of the kind should endeavor to present it in a reverential light. . . . [Otherwise,] the ideal which everyone holds is degraded, and we realize that, in an age tending so strongly toward realism, there are subjects which should be left untouched."

Eakins' friend William Clark, defending the painting in the *Evening Tele-graph,* put his finger on the crucial point. "What he has done primarily has been to conceive of the Crucifixion as an actual event. Certainly, if that event meant all that Christendom believes ... it would seem that, if it is to be represented at all, the most realistic treatment ought to be the most impressive. It is undoubtedly the case, however that many who believe themselves to be good Christians fail altogether to appreciate their religion or the events upon which it is based as realistic; and to such, a picture like this has no message to deliver."

One influential critic of Eakins' generation did see the painting as a work both of brilliant draftsmanship and of spiritual truth. Thirty-year-old Mariana Griswold Van Rensselaer, writing for *Lippincott's Magazine,* declared that "the canvas was something more than a mere anatomical study of a martyred form seen under bright light." In it she found loneliness, abandonment, isolation, and pathos. "It is extremely difficult to put into words the impression made by such a picture, so strong, so repulsive in some ways, yet so deeply pathetic, partly by reason, perhaps, of that very repulsiveness. I can only speak for myself when I say that after seeing a hundred crucifixions from modern hands this one seemed to be not only a quite original but almost a most impressive and haunted work."

Before publishing the *Lippincott's* review, Van Rensselaer had persuaded her editor at the *American Art Review* to let her interview Eakins in anticipa-tion of profiling him. Their meeting, on June 11, 1881, was a disappointment for her. She had recently written a two-part article on Eakins' near contemporary William Merritt Chase, a cosmopolitan who favored velvet jackets and enter-tained clients in his plush New York showrooms, and when she met Thomas Eakins, whom she found wearing stained canvas pants and an undershirt, operating out of the fourth-floor Mount Vernon work space, he fell well below her expectations. The art writer who seemed most to understand Eakins' painting could not fathom the man who produced it.

"He is most modest and unassuming, like a big, enthusiastic schoolboy about his work," Van Rensselaer wrote to her editor. "I do not believe he knows how good it is or how peculiar. He was very polite & pleasant, & ready to do all he could to further our wishes. But he was not ... a man of tolerably good

appearance or breeding. His home & surroundings & family were decidedly of the *lower* middle class, I should say, & he himself a big ungainly young man, very untidy to say the least, in his dress—a man whom one would not be likely to ask to dinner, in spite of the respect one has for his work! I used to wonder why he did not put better clothes and furniture into his pictures, but now I wonder how he even managed to see anything so good [as what he depicts in his portraits]! His want of a sense of beauty apparent in his pictures is still more so in his surroundings. His studio was a garret room without one single object upon which the eye might rest with pleasure. . . . [There were props and] some skeletons & some models of the frame & muscle which looked . . . like the contents of a butcher's shop!"

Van Rensselaer added, "The American public does not seem to appreciate him at his proper worth. He has about all his pictures on hand in his rooms at present." Of *The Gross Clinic,* she wrote: "It is much the most important picture he has painted—one of the very most important, it seems to me, we have yet produced."

Unfortunately, the *American Art Review* went bankrupt before typesetters received Van Rensselaer's article. It would have been the only one ever published in his lifetime that focused exclusively on Eakins the painter, and would have captured the artist at the verge of a critical turning point in his career. The only satisfaction Eakins took from the experience was a few prophetic paragraphs she subsequently wrote about him in the *Atlantic Monthly*.

"Of all American artists he is the most typically national, the most devoted to the actual life about him, the most given to recording it without gloss or alteration," Van Rensselaer wrote in the *Atlantic*. "That life is often ugly in its manifestations, no doubt; but this ugliness does not daunt Mr. Eakins, and his artistic skill is such that he can bring good results from the most unpromising materials. In spite of a deficient power of coloring, his brush-work is so clever, his insight into character so deep and his rendering of it so clear, his drawing is so firm, and his management of light so noteworthy that he makes delightful pictures out of whatsoever he will. . . . The day will come, I believe, when Mr. Eakins will be treated, as he deserves, far above the painters of mere pretty effects, and a good way above even men of similar artistic skill who devote themselves to less characteristic and less vital themes."

twenty-nine

Tripod and Easel

How much Eakins relied on projected images to create *The Crucifixion* is not known, because the photographs he took for it have never been found. It is impossible to say, for example, how detailed a transcription he made of the source photographs or the degree to which he manipulated the image. This is not the case for paintings Eakins produced the following year. A near complete record of the photographs along with color sketches survives for these projects.

His choice of subject matter for his next portrait was the diametric opposite of *The Crucifixion*. *Singing a Pathetic Song,* painted in 1881 and now hanging at the Corcoran Gallery of Art in Washington, D.C., was another of his ongoing studies of contemporary life and a return to the female-dominated parlor scenes he had painted on his return from Europe ten years earlier. It differs from *Elizabeth Crowell with a Dog* and *Home Scene* only in the sheer amount of detail Eakins brought to its principal subject, and in its size. *Singing a Pathetic Song* is nearly three feet wide and four feet high; *Home Scene,* by comparison, is approximately half its size.

Singing a Pathetic Song presents the academy student Margaret Harrison standing in a Victorian parlor performing an "empathetic" passage from what is presumed to be an aria (plate 14). The furniture in the room and the broadloom carpet suggest that the location is the Eakins family parlor, where frequent musical gatherings took place. Accompanying her on the piano to Harrison's left is Susan Macdowell. Behind Harrison and Macdowell sits cellist Charles Stolte, a member of the Philadelphia Orchestra. Light floods the room from the upper left corner, highlighting Harrison's delicately braided brown hair, the silky sheen of her lavender dress, and the pages of sheet music in her hands. Everything about the painting, from the yellow-green vase in the upper left corner to the red patterned carpet on the floor, suggests a warmly felt and compellingly depicted event from everyday life.

The painting's strength derives from the remarkable fidelity with which Harrison has been captured. Eakins recreated her elaborately sewn dress, with its many ruffles, with crystalline clarity, as well as the delicate modeling of her

Opposite: Margaret Harrison posing for *Singing a Pathetic Song;* photograph by Thomas Eakins, c. 1881 (Courtesy of The Pennsylvania Academy of the Fine Arts, Charles Bregler's Thomas Eakins Collection; purchased with the partial support of the Pew Memorial Trust, 1985)

face and lips, engaged in her holding a certain note. "You can almost hear her voice," fans of the painting have frequently remarked. The artist rendered Stolte with considerably less detail, and even less for Macdowell; he clearly meant for Harrison to be the center of attention.

Compelling as the painting is in its realistic particulars, several inconsistencies in its overall construction suggest the difficulty Eakins had incorporating photography into his painting technique. Most disconcerting is the disproportionately smaller size of Harrison in relation to her accompanists. Harrison, who was thirty at the time, is known to have been petite in stature, but here she appears downright tiny in comparison to Macdowell. A framed picture above the piano is placed preposterously high on the wall. Also disturbing is the unusual seating arrangement of the musicians. Stolte sits facing Harrison's backside, making it impossible for him to visually receive musical cues from the singer and the pianist or mirror their dynamic changes in his accompaniment. Macdowell would have to crane her neck ninety degrees to make eye contact with Harrison and do an about-face to see Stolte. The positioning of the trio fails to give the slightest indication of where their presumed audience might be in the room. The viewer is left with the distracting feeling that family members or friends attending the performance are somehow suspended or hovering in the air above the piano.

The narrative Eakins described in this moment is further muddled by the ambiguous expression on the singer's face, in which he appears to have been trying to depict Harrison sounding the final note of *Elijah.* As he did with the horses' hooves in *A May Morning in the Park,* Eakins captured an anatomically correct but ultimately unconvincing pose. The emotions he has tried to bring forth are aesthetically upward and inward—impressions heightened by the suggestion that the singer has lowered the sheet music in her hands. The effect, however, is not the transcendent instant from life both in and out of time that Eakins captured with Max Schmitt and Dr. Gross. Instead, Harrison's face suggests complacency. To many people viewing the painting for the first time, she looks downright bored.

The most likely explanation for Eakins' uncharacteristic failure to realistically portray the scene was the novelty of working directly from photographs

for modeling his principal subject. In the painting, Harrison's image appears as if the artist has superimposed it on the scene, and the photographs Eakins employed for the painting suggest that this, in fact, was what he did.

The artist modeled Harrison from a series of eleven different photographs that were shot in his upstairs studio. These glass-plate images reproduce the exact details of her dress, her posture, and the light that infused the completed painting. None of the extant photographs, however, are exact mirror images or transcriptions of her pose in the final painting, and none contain her two accompanists. This seems to be why Eakins got into so much trouble with perspective; he did not have Harrison pose in the setting that surrounds her in the final painting. Apparently he had not yet mastered the technical challenge of properly placing his subject in relation to the room and her accompanists.

The eleven photographs Eakins modeled Harrison with show that his working method was still in an experimental stage and provide further clues to what may have been the source of the problems he encountered with scale. Several of the photographs allow glimpses of the artist's easel and his partially completed canvas, where he had blocked in Harrison's basic posture but little else, including no details of her dress or facial features. A large swatch of wallpaper is tacked to the studio wall behind her as a guide to the painting's intended background. These and other indicators suggest that Eakins originally conceived of the painting as a portrait of Harrison standing alone, and that he later modified his partially completed canvas to include Macdowell and Stolte. He may not have ever actually had his three subjects in the same room together, which resulted in a shifting picture plane with a distorted perspective. In his desire to use photography to capture the delicate sheen and minute folds of Harrison's silk dress, Eakins let other design considerations get away from him.

Not only were the accompanists modeled later, but Eakins appears to have made considerable alterations as he worked their images into his already half-completed canvas. The most startling change occurred in his rendering of the pianist. Infrared studies of the painting, as detailed in the research and scholarship of Philadelphia Museum conservators, reveal that the original model was not Macdowell; Eakins painted her image over the figure of another.

Evidently he was unhappy with other aspects of the subject matter in the painting, because he also reworked several portions elsewhere in the canvas, most notably the floor's carpet.

In spite of the failure and frustrations he must have experienced while creating *Singing a Pathetic Song*, Eakins continued experimenting with photography in a series of pastoral landscapes and fishing scenes he made in Gloucester, New Jersey. This time, however, Eakins succeeded in developing a more effective system to keep the various design elements in proper perspective. Most notable about these paintings, beyond being some of the finest work the artist did, is the almost total lack of supporting materials he made in creating them. Perspective sketches, compositional plans, and scribbled notes in his painting diary have disappeared altogether. In their place are hundreds of photographs. Not only did Eakins produce the paintings almost entirely from photographic images, he pieced together his composed reality by combining elements from different photographs into the same painting. Thanks to the pioneering research of conservator Mark Tucker and curator Nica Gutman, who subjected several Eakins paintings to infrared reflectography and studied them under a microscope, the "invisible" elements in many of the artist's finest works have now been made visible.

Like *The Writing Master*, the portrait of his father that Eakins painted around the same time as *Singing a Pathetic Song*, the Gloucester series can be seen as a return to the conservative and more organic themes of his earlier career. Their inspiration must have been much the same as that of his earlier hunting and sports paintings: capturing a contemporary outdoor scene he had known and loved since childhood. Judging from the comments later made by an Eakins family friend, the Gloucester subjects may actually have been on his mind for years, since before he tackled the Schmitt portrait.

The unifying theme of the five Gloucester paintings is shad fishing, an activity practiced primarily by commercial fishermen deploying drift nets. The fishermen typically set out each April and May when the shad began their migratory spawning runs up the Delaware. Teams of as many as thirty at a time embarked in the early morning in long flat-bottomed barges and hauled their cargo full of three and four-pound fish to shore in late afternoon.

It was on a picnic or a photographic field trip in April or May 1881 that

Eakins took seventy or more pictures of shad fishermen returning to shore with their catch. The fishermen in the photographs, many of them wearing yellow slickers and wide-brimmed dark hats, stand in their boats or in the gentle surf as they take up their nets. Eakins likely made oil sketches to capture color during the same field trip. After returning to his studio, he selected two photo prints as the basis of his first two Gloucester paintings. Both, from 1881, are titled *Shad Fishing at Gloucester on the Delaware River.*

His process for the first painting (now at Ball State University Museum of Art in Muncie, Indiana) is the more easily discerned of the two: he projected the source photographs onto his prepared canvas and then traced their outlines in pencil. Eakins copied details of the barge, oars, fishermen, and the principal reflections in the water precisely. From the second photo of this location he transferred, freehand, minor variations in the background. A steamboat pier and the distant shoreline, for example, have been moved closer in the viewer's field of vision.

The second version of shad fishing (Philadelphia Museum of Art) differs significantly from the earlier painting in that Eakins included a group of tourists watching the activity of the fishermen from the shore (plate 15). Again he used a single photograph to frame the central image, the general view of the fishermen, and from other photographs he added details or clarified elements of the composition that he wished to include. The important difference in creating the second painting came from the degree to which Eakins manipulated the photo imagery to capture his desired effect. Three of the fishermen who appear in the central or establishing photograph were omitted from the painting because they appear to have been looking up at the camera when Eakins took the picture. Two other figures, who sit atop a pile of nets, have been merged into one. The head of another was turned into a profile.

Eakins went a major step further with the changes he made to the group of tourist onlookers: he deleted the group shown in the establishing photograph altogether. The reason is obvious. They were ill-configured for pictorial purposes and obscured the activity of the fishermen. Eakins replaced this group with images from two other photographs he had taken of members of his own family, including his father and one of his sisters, in a different setting; he used one of these photos as the model for the bystanders in the painting, and the

other for the dog sitting beside them in the sand (plates 16–17). The care that Eakins brought to matching the camera's focal length and the angle of the sun with those of his earlier view reveals the important perspective lessons he had apparently learned while painting *Singing a Pathetic Song*. Only by matching the point of view and other spatial and lighting conditions could additional imagery be incorporated into a scene.

In another painting from this series, *Mending the Net* (Philadelphia Museum of Art), also from 1881, Eakins applied this technique to combine photographic images to enhance the narrative point in time he sought to capture. The painting shows the shad fishermen standing atop a grassy knoll toward evening (plate 18). The exact location can still be identified today as a ridge overlooking the estuary of Gloucester's Big Timber Creek. A man carrying a basket—perhaps for a picnic—walks into the scene from the left. Two children alongside a pair of fishermen watch the action unfold. Off to the right, under a shade tree, a lone tourist in jacket and straw hat sits on a pile of lumber and reads a newspaper. A gaggle of geese, off to the lower left, look as if they have inadvertently wandered into the setting.

No overall or single thematic photograph exists for this painting. Judging from the complexity of its construction it is doubtful that one was used. The entire composition appears to have been created from thirty or more separate photographic studies of the subjects found in it. The most easily recognizable are those of the fishermen mending their net, the tree under which the tourist sits, the gaggle of geese, and the two children. A detailed photograph of the tree, for example, has been traced so precisely that individual leaves are delineated.

The varied elements in this painting, and the way they have been seamlessly combined to create a whole, show just how far Eakins had come in refining his technique. As the museum researchers have found, there is internal consistency in the focal length of the lenses Eakins used to shoot the pictures, the angle of the sun, and the horizon line. A series of studies he made of the children watching the fishermen yields evidence of how intent Eakins was to create the image that appears in the final painting. The original photograph of the children was not shot on the beach at Gloucester at all, but on the roof of his Mount Vernon studio.

Thanks to the work of conservators, it is clear that Eakins' first step in tackling the complexity of this project was to lay out the horizon line and broader topography of the site on his prepared canvas. Forensic studies clearly depict the horizon and a carefully placed grid of lines ruled in pencil. Above the horizon line Eakins added placement lines for the figures (plates 19–20). Though it is impossible to know for certain, he likely next projected the image of the tree directly onto his canvas. The limbs and leaves were traced in pencil, as was the pile of lumber beneath the tree. He then underpainted the rest of his canvas and projected separate images of the fishermen, the children, and the man reading the newspaper. As in his rowing paintings, he made tiny marks with a stylus or other sharpened instrument, using these to locate key reference points as he added subsequent layers of paint. Thirty or more such reference marks are evident in the figure carrying the basket; as many as five hundred marks have been found on the completed canvas. Only after he developed the forms with successive layers of paint did he finally cover up these placement indicators.

The cohesive consistency of the photographs and the complexity of the painting's construction provide overwhelming evidence that Eakins had a firm idea of what he was doing at every step of the painting's production. Even in advance of his photographic field trip he had decided what the narrative would be and how to encapsulate it. He intended to pull the viewer's attention to the top of the knoll and the line of figures standing on it. He succeeded. The viewer is drawn into the story of events much as Eakins must have witnessed such a scene on the Big Timber Creek estuary in his youth. Perhaps Eakins himself had been one of the children standing at the feet of the fishermen while his father sat with a newspaper beneath the adjacent tree.

His Gloucester series, along with *Singing a Pathetic Song,* were exhibited widely in the winter of 1881. In striking contrast to *The Gross Clinic* and *The Crucifixion,* they were almost universally well received, especially in Philadelphia, where one critic singled them out as being among the most "genuine, fresh, and clever" paintings Eakins had ever made. Earl Shinn praised the Gloucester paintings in particular for their "great calmness, breadth of treatment, and harmony," claiming that "seldom does a landscape painter find such vital and authentic figures," and "seldom does a figure-painter succeed

in throwing his figures so integrally into the conditions of the landscape which forms his setting." *Mending the Net,* in particular, was one of Shinn's favorites. He found power in the subtle but precise detail of its imagery. "The mere back views of a series of boatmen's pantaloons, whether of oil-cloth or of worn linsey-woolsey, broken into folds that explain a motion, or patched or stained with accident that explain a toilsome life, are a positive revelation."

The writer from the *Art Journal* described *Singing a Pathetic Song* as "one of the best in the collection [and] also one of the best that Mr. Eakins has exhibited in New York." Van Rensselaer also unabashedly praised the work: it was "admirably painted and . . . absolutely true to nature," she wrote. Leslie Miller, a noted critic and a professor at the Philadelphia School of Industrial Art, said the painting showed Eakins at his best. "There is almost an utter absence of accessories, and no attempt at anything like prettiness," he wrote. "There is no nonsense anywhere, but plenty of downright earnest sentiment."

The only newspaper to come out negatively against the Gloucester series was the *New York Times.* "His old vigor and point are gone," the *Times* critic wrote. "Probably shad fishermen on the Delaware are not particularly pictur-esque creatures at the best, but why need Mr. Eakins make them so utterly dull and uninteresting that they have not even action? There is little or no effort at composition, little color, and some good drawing."

The writer for the *Philadelphia Press* made perhaps the most insightful comment of all, though it was unlikely the critic knew just how prescient his words actually were. He remarked that Eakins' latest series of paintings included "some exquisitely drawn and intensely real figures in miniature, un-compromising as photographs." Leslie Miller made a similar observation, de-scribing *Shad Fishing* as "hard" and "photographic." Of the artist's Gloucester paintings in general, Miller said he found them depressingly commonplace. "In their labored feebleness of execution, as well as their singularly inartistic conception, one wonders what relation they can possibly bear to art."

For an artist who was aware of the deeply rooted prejudice in the larger art community against dependence on photographs to model subject matter, the comments must have been especially worrisome. The practical benefits

and appeal of using photography as a substitute or an aid for perspective stud-
ies, however, proved irresistible. As would soon be evident, photography was
becoming less a painterly tool he could incorporate into his technique and
more a destination toward which his art and artistry were taking him.

thirty

Nudes and Prudes

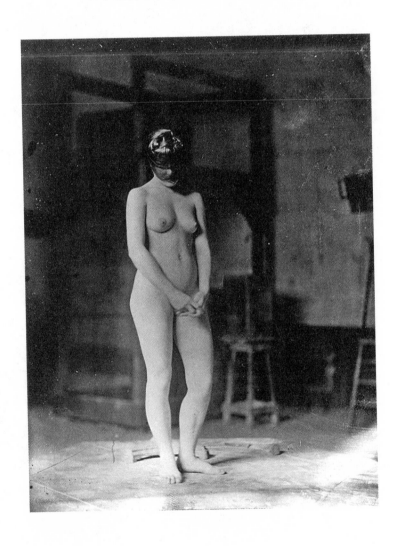

Eakins' passion for photography—with its lenses, plates, and the eerily precise illusions of photo prints, playing tricks with sight and time while appearing to capture reality—was spilling over to almost all aspects of his personal and professional life. He shot his first photographs for personal use in the backyard at Mount Vernon Street. They show his sister Margaret and his pupil Susan Macdowell posed with the Eakins and Macdowell family dogs. Margaret's setter, Harry, was photographed by himself and with the Macdowells' setter Dinah. A dog known to the family as Nance was the subject of several other pictures, and later so was Bobby the monkey, yet another Eakins pet. The many cats that were longtime residents of the house also frequently turned up as portrait subjects. Eakins photographed his father sitting in a chair reading a paper and later on a bicycle excursion in the Pennsylvania countryside. Caroline, Tom's sixteen-year-old sister, was featured in a white dress standing on the rear steps of the family home.

The first photographic field trips Eakins took with his family were to Manasquan, New Jersey, about halfway between Asbury Park and Toms River, several miles south of the area where the Philadelphia elite summered. The Drexel, Biddle, and Claghorn families typically took a private Pullman car from downtown Philadelphia and bypassed Manasquan altogether on their way to Sea Girt. The Eakins family, often accompanied by Susan Macdowell, her sister Elizabeth, and her brother William, took the ferry to Camden and then a Jersey Central coach train to Arnold House, in Point Pleasant, or the Union House in what is now Brielle. Five of the photographs he took on one of these trips include the six younger members of the Macdowell and Eakins families. One of the pictures shows that Eakins was particularly interested in documenting footsteps in the tidal sand dunes and along the shore. Margaret, standing for another picture with Harry, was silhouetted against the ocean and sky.

Margaret stood still for more of her brother's early photographs than practically anyone else. Invariably she appears sullen and downcast, much as she does in the paintings he made of her. The only existing photograph that seems to show her enjoying herself was taken on a family trip to Clinch Mountain, in southwestern Virginia. Margaret's failure to smile for the camera, as biographer

Opposite: Female nude with a mask; photograph by Thomas Eakins, c. 1883 (Courtesy of The Pennsylvania Academy of the Fine Arts, Charles Bregler's Thomas Eakins Collection; purchased with the partial support of the Pew Memorial Trust)

Henry Adams has noted, may have been a reflection of what he deems her "un-happy" disposition. More reasonably it was a result of the difficulty of holding a pose long enough while an exposure was made. Most photographs of this period make their subjects look wooden and somber compared with modern photos. Paintings of the period show similar tendencies. Another reason could be an indication of her deteriorating health. The last known photograph of Margaret was taken in 1882, during a trip she and Eakins made to visit their sister Frances and brother-in-law William Crowell at their farm in Avondale, where they had moved after leaving Mount Vernon Street.

On December 22, 1882, soon after the Avondale photographs were developed and printed, and while Benjamin Eakins was on a hiking trip to Canada, Margaret died of typhoid fever. She was twenty-nine. As in the case of Kathrin Crowell, few details have been found to show how her family coped with her sudden passing. Less than a month earlier she had been of sufficient health that Benjamin had encouraged her to join him on his trip north. Her physician, Dr. Duer, following standard procedures of the time, likely administered high doses of carbolic acid and iodine followed by a turpentine-soaked flannel poultice placed on the abdomen. Perhaps Margaret also received hypodermic injections of ether as a stimulant. In the end, peritonitis, a fatal complication of the disease, would have brought on a painful death.

"The heartbreak was manifest among the neighbors to a degree I never again experienced during all the ensuing years," said a nearby resident of Mount Vernon Street. Margaret's dog Harry grieved too. He waited by her bedroom door listening for her footsteps, and refused to eat. "It required many days before Eakins could revive Harry's interest in life," wrote Seymour Adelman, who later became a friend of Susan Macdowell.

The emotional loss to Tom of his beloved sister must have been great; Margaret was his friend, business partner, and frequent model. Susan Mac-dowell comforted him and took over the responsibility of handling the shipping and exhibition of his artwork. She also became his model, and he later portrayed her sitting at the family piano in the parlor, where Margaret had once sat for her portrait.

The expansion of Eakins' use of personal photographs and those he took

for paintings paralleled his activities at the Pennsylvania Academy. In this endeavor he had the full support of Fairman Rogers, who, although winding down his involvement pending his retirement in 1883, saw to it that the school continued to be the most progressive in the nation. Photography was to play a major role in the curriculum. A darkroom was set up in the basement across the hall from the dissection room. The ground-floor life studies classrooms, which were flooded with natural light, also served as photography studios. The library was expanded to include collections of photographs, and guest lecturers were invited to give talks. Among these guests was Eadweard Muybridge, who presented his latest sequential images of horses, cows, sheep, deer, and men in motion. Rogers later arranged for the University of Pennsylvania to bring Muybridge back to Philadelphia to continue his photography experiments. Eakins was appointed to the supervisory commission, where he worked alongside Muybridge.

The impulse to expand the use of photography at the academy was perfectly in keeping with a curriculum that encouraged the scientific study of subject matter. In the classroom and on field trips cameras were not only welcome but positively embraced. Rogers himself, as chairman of the school's committee on instruction, acknowledged the fundamental importance of photographing models for reference purposes. "A number of photographs of models used in the Life Classes were made in cases in which the model was unusually good or had any peculiarity of form or action which would be instructive, and a collection of these photographs will thus be gradually made for the use of students," he wrote.

Out of this program came what has been called the "naked series," after a reference in an academy account book in 1883. In April of that year one student wrote to another: "Tommy Anshutz, Wallace & myself are now 'Academy photographers.' Nearly every Thursday we photo nude models for Eakins. Each one we take in seven different poses. When completed they are to be hung in the life class room. . . . [They are] projects to show how action of the same pose differs in different individuals."

More than thirty of the "naked series" of sequential photographs exist today; as many as two hundred more were probably made by Eakins or students

working under his guidance. The seven basic poses included the model photographed from the front and rear, with arms raised, with hands clasped behind, and with the weight on one foot and then the other.

Diversity of subject matter and a uniform and regimented modeling approach were the hallmarks of these studies. The subjects included children as young as nine or ten, and adults ranging from their late teens to their fifties and sixties. George Holmes, the Philadelphia painter and Eakins family friend, was photographed in all seven poses. Particularly good photographs, including those of Holmes, were printed and then mounted side by side in a rotational sequence to provide students with a permanent record of the modeling session, and a means to compare their anatomical features with models displayed on other cards.

The images themselves evidence their stated purpose. None of the surviving photographs show the models posed in any provocative or lewd manner. The settings are barren of furniture or other props. The majority of the female models wore masks. Chaperones accompanied children and sometimes were photographed with them. Adult sitters, too, were often attended by witnesses, students or additional models who are visible.

A further indicator of the photographs' intended use is revealed by drawings that were made directly on some of the photographic prints or outlined on tracing paper as an overlay. The markings' purpose was to illustrate the model's center of gravity, a line roughly contiguous with the spine, from which students could determine the shifting volume of a model's weight and posture. "Get life into the middle line," Eakins admonished his students. "If you get life into that, the rest will be easy to put on."

In spite of the efforts that were obviously being taken to conduct the "naked series" photography sessions on the highest moral plane, the practice provoked sufficient concern by an academy board member that eventually many of these photographs were destroyed and the remaining ones were relegated to a safety deposit box.

The reason for removing these photographs from circulation was clearly the result of the growing mood of conservatism sweeping the country. The anti-vice campaigns led by Anthony Comstock, begun in the late 1870s, had broadened in scope in the early years of the 1880s. Not only were journalists,

political radicals, and proponents of birth control put behind bars on charges of indecency; art dealers and gallery owners were as well. Headlines had begun to warn of the "tide of obscenity" flowing unchecked into American cities from Paris. Paintings by Gérôme, among other French artists, came increasingly under attack by moral reformists. (Eakins himself, on his return from Paris, may have removed nude drawings from his own collection to circumvent potential trouble at the New York customs office.)

The Pennsylvania Academy had not yet become a battleground, but troubling signs were emerging that it would. Concerned about the impact of "horrid nakedness" on "the morals of our young students," one parent of an academy art student appealed in writing to board member James L. Claghorn in 1882. Defining "true art" as that which "purifies the mind," the writer questioned the cost of nude study at the expense of "womanly refinement and delicacy," and a system in which "the Professor walked around criticizing that nudity, as to her *round-ness in this part,* & swell of the muscles in another."

The writer of this letter openly challenged the board to stop the practice of nude modeling. "Now, Mr. Claghorn, does this pay? Does it pay, for a young lady of refined, godly household to be urged as the only way of obtaining a knowledge of true Art, to enter a class where every feeling of *maidenly* delicacy is violated, where she becomes so hardened to indelicate sights and words, so familiar with the personas of degraded women and the sight of nude males, that *no possible* art can restore her lost treasure of *chaste and delicate thoughts.*"

Eakins, who had been conditioned by more than two decades of working from nude models, along with his dissections and medical studies at the Jefferson Medical College, dismissed these and other complaints as prudery and "over-refinement." The urbane and intellectual Fairman Rogers, adept at smoothing out difficulties, appears to have handled the matter privately. However, nude modeling increasingly became a subject of discussion among board members. Comstock's point man in Philadelphia, the grammar school teacher Josiah Leeds, had an important ally in the *Christian Statesman,* an influential city newspaper. A single letter to the editor about nude modeling activities being permitted at the academy might be enough to unleash a torrent of criticism.

Eakins acted as if oblivious to the changing moral climate in the city. He

continued to encourage students to participate in nude modeling sessions, and he signaled his own commitment by posing nude in at least four of the "naked series" photographs. His designated assistants at the academy, John Wallace, Jessie Godley, and George Agnew Reid, also appeared in that collection. Later, these and other academy students were photographed nude in less regimented poses and in outdoor settings. This practice, too, though controversial, was still in keeping with Eakins' conviction that a figure's beauty lay not in conformity to a single ideal but in the varied refinement of "nature's engineering."

Like the naked series, the outdoor photographs were not implicitly or overtly sexual in nature. Several academy students posed for Eakins in a group of nude portraits among trees and rock formations. Susan Macdowell, the only female student known to have been photographed naked in an outdoor setting, posed sitting under a canopy of overhanging tree limbs and standing beside a horse. Eakins' nieces and nephews were photographed nude as they played beside a gently flowing stream on the Crowells' farm in Avondale. Photography sessions like these would clearly have provoked concern in the greater Philadelphia community, which could be why these works did not become part of the academy's life study and library collections.

Many of what appear to be unorthodox photography sessions can be linked to specific painting projects involving students or Eakins. This is true of a photograph series of nude and semi-nude figures posed in a meadow beside willow trees and a stream. Academy student John Wallace, Eakins' model for *The Crucifixion,* was presented naked playing pan pipes, as were Eakins himself and his nephew Ben Crowell. Other photographs that may be related to the "pan-pipe series" show students dressed in classical Greek and Roman costumes, stationed on divans or among the academy's collection of statuary and sculptured relief casts. Eakins posed students dressed as Diana and Aphrodite. Students wearing togas modeled the three Fates from the Parthenon pediment. In one particularly cinematic photographic essay, Greek maidens danced in a circle.

Photography scenes depicting dancers in diaphanous gowns and naked students frolicking outdoors would seem to go well beyond the acceptable mores of the academy curriculum and be totally out of character for an instructor dedicated to chronicling scenes of modern life. This was not necessarily

the case in 1883, though, when most of these photographs were taken. Eakins' interest in such themes grew from his own understanding of how Phidias and other sculptors of antiquity had created their masterpieces using live models. In shooting these photos, he was communicating to his students the classical tradition that he and Rogers sought to establish at the academy.

Proof of these photographs' relevance to one of Eakins' projects is abundantly clear: they are linked directly to "Arcadia," an incomplete series of paintings and sculptures that he began in the summer of 1883. These works depict nude and semi-nude figures and combinations of figures, standing and lounging in an idyllic and timeless world of sunlit green meadows and flowing streams. In choosing to paint "Arcadia," and involving academy students in the production, Eakins was again driving home the quintessential message of his teaching. The human form was the most beautiful object in nature—not an object of desire but a miracle of muscle, bone, and blood. He sought nothing less than to follow in the footsteps of Phidias; like Plato, he was convening school in the "groves of academe."

One of the Arcadia paintings, titled *Arcadia* (c. 1883, Metropolitan Museum of Art), is a partially complete canvas celebrating three naked figures in a grassy meadow beside a stream: a young man standing and an adolescent boy reclining play pan pipes, while an androgynous figure lounges on the grass listening. In *An Arcadian,* a smaller oil, the same androgynous figure, this time wearing a Greek gown, sits in the same meadow. Eakins modeled three reliefs of similar subjects. One presents a seated youth entertaining a varied group of listeners, who include three women, an old man, a young man, and a dog. In addition to this work there are two oil studies for a third painting that apparently did not get beyond the planning stages. These studies show Phidias and his students watching men on prancing white horses in anticipation of the sculptor carving a relief for the Parthenon.

Like *The Crucifixion,* significant insights into the artist's thinking can be gained by observing certain elements that Eakins chose to leave out of these classically inspired paintings and sculptures. No overt literary or mythological themes or icons occur in them. Eakins was not portraying nymphs, satyrs, gods, and goddesses; they were living people in harmony with nature. Nor did he graphically depict the sex of his models. In *Arcadia,* all three bodies

could easily be taken for males; only the hair bun on the head of the model lying with her back to the viewer identifies her as a woman. In all likelihood the model was Macdowell, though none of the nude photographs Eakins took of her reveal her in this exact pose.

How much was going on between the thirty-two-year-old Macdowell and her thirty-nine-year-old instructor is open to speculation. Charges in Eakins' 1883 ledger for extracurricular activities, denoted as "pleasures and presents," indicate that their courtship had begun in earnest. Another document produced that same year, which may have been a result of his intimacy with Macdowell, was a curious agreement Eakins made with his father regarding the use of his fourth-floor painting studio. In addition to setting a specific sum—twenty dollars—which was to be paid by Eakins to his father for use of the studio (along with room and board), it included the provision that Eakins would be allowed "the right to bring to his studio his models, his pupils, his sitters, and whomsoever he will . . . , [it being] understood that the coming of persons to the studio is not to be the subject of comment or question by the family."

The reason cited in the agreement for this provision was a recognition of "the necessity and usage in a figure painter of professional secrecy [sic]." Likely, the motivating force had less to do with secrecy than it did privacy. Macdowell and any other students who modeled nude for Eakins' photographs could not be expected to pose on the roof or in the backyard of the family home, or in the meadows at his sister's Avondale farm. Perhaps too, the agreement was a formal declaration of his independence and autonomy; he was no longer merely the son of a master penman but a recognized artist and art teacher who anticipated soon being a husband.

Eakins' love for Macdowell came as no surprise to anyone who knew the couple. In addition to Susan and her family spending time together with Tom and his sisters on the New Jersey shore, they enjoyed afternoon picnics with Tom's nieces and nephews at the Crowell farm in Avondale. They always had a good time. Susan's lively sense of humor and quick intelligence endeared her to Eakins as it did to everyone who knew her. "She possessed a positively rollicking sense of fun," said Seymour Adelman. "Beneath the basic seriousness of her temperament, there was an irrepressibly humorous outlook on life."

Eakins and Macdowell were married on January 19, 1884, at the Macdowell family home on Race Street. No photographs of the ceremony have been found, nor are many details known, but subsequent photos of Macdowell and Eakins family members together are evidence of the supportive and continuing relations that existed between the two households. A portrait Tom painted of Susan, *The Artist's Wife and His Setter Dog,* presumably begun around this time but not completed until several years later, is one of Eakins' most colorful and endearing works (plate 21). Susan, dressed in a pastel-blue floor-length silk dress with red stockings and black slippers, is shown seated in what appears to be the Chestnut Street studio, holding a Japanese picture book on her lap. Harry, the dog Tom had inherited from Margaret, rests comfortably on the floor at her feet.

Fairman Rogers was not present in Philadelphia to share in the news of the union. As Eakins and Macdowell became husband and wife, Rogers was celebrating his retirement by cruising the Eastern seaboard in his fifty-foot steam yacht *Magnolia.* In the following months he moved to Europe to live out his remaining years in London and Paris. He wrote to Eakins, "I leave the Academy with regret, as I have many pleasant associations with my work there, not the least among them the hours spent with you."

Eakins and Macdowell would miss Rogers' presence in their personal lives as much as at the academy. The new board, headed by the wealthy industrialist James Claghorn, a friend of John Sartain, could not be counted on to support Eakins' progressive curriculum. Nor could Claghorn be compelled to make good on the promise Rogers had made to double Eakins' salary. The number of classes at the academy had doubled, enrollment had grown to capacity, and students were earning reputations in national art exhibitions; in spite of all this, Eakins was earning only one hundred dollars a month. Directors at similar institutions had salaries far in excess of his. Former academy classmate J. Alden Weir, director of the Cooper Union, was receiving two thousand dollars a year, and Will Sartain was being paid more as a part-time instructor in New York than Eakins earned working full time in Philadelphia.

The additional income Rogers had promised Eakins would have made his transition to married life considerably easier. Rather than purchasing their own home, he and Macdowell arranged through academy student Arthur Frost to

rent a studio for twenty-five dollars a month at 1330 Chestnut Street. What the studio lacked in comfort—it had one large room, heated by a cast-iron stove, on the fourth floor of a commercial building without an elevator—was made up for by its location. It was a short walk to the academy, several theaters, and the downtown restaurant district. "My own little home," Eakins later called it, "where I have been very happy."

Benjamin Eakins must have been saddened to see his son leave, but he was not lacking for company at his house for long. On June 14, Caroline Eakins married Frank Stephens, one of Eakins' students at the academy. "The Kid," as Stephens was known at school, moved in at Mount Vernon Street and presumably took over the studio on the fourth floor. (Eakins removed his painting gear along with his woodworking equipment just before Stephens arrived.)

By all accounts, married life thoroughly agreed with Eakins, as it did with his bride. Macdowell later wrote, in counseling a fellow art student looking for a husband, "My notion of marriage is the joining of two hearts and each would give up every worldly consideration that the other might be happy." There is every reason to believe Macdowell did just that. "She gave up her life and career for Tom," classmates at the academy would say.

In Macdowell he found a mate who was totally responsive to his needs. Her lively sense of humor and cheerful disposition balanced his periodic obsessive behavior and moodiness. And although they had decidedly different tastes in reading material—she enjoyed romantic fiction while he studied logarithms and pored over the sports pages—both shared a passion for pets, hiking, casual clothing, music, and painting. She too, in the early years, preferred to rise early and then turn in for the night by ten o'clock. The newly married couple liked wearing slippers around their home; a photograph of their studio suggests that their easels were positioned so they could share the same palette and paints.

His students loved visiting their Chestnut Street home and studio because they could be assured of much laughter, and often heated discussions that lasted long into the night. No subject was off limits. Macdowell, who was as uninhibited as her husband, joined the students in dressing in ludicrous costumes and presenting impromptu stage acts and musical performances. Milk

and candy were always in plentiful supply, along with bottles of Benjamin's homemade wine.

Painting and photography occupied the lion's share of Tom and Susan's daily activities. The subjects Macdowell chose were much like the early portraits her husband had painted of friends and family members, and several were rendered with such similar techniques that they are frequently mistaken for his own work. Eakins, however, did not get back to finishing the paintings in the Arcadia series he had begun with such passion the year before.

One reason he did not complete the series was his supervising the construction of a new kitchen and studio in his and Macdowell's home. There were also his duties at the academy, his photography work with Muybridge at the University of Pennsylvania, and an ill-fated commission to produce a pair of relief panels to decorate James P. Scott's new townhouse on Philadelphia's Rittenhouse Square. Eakins did brilliant work for this project; his depiction of a spinning wheel and chair was said to have been so precisely measured that a machinist could have reproduced accurate facsimiles of them. Perhaps they were too finely rendered for what Scott had in mind. After seeing the clay models Eakins produced, he wrote to say that "the price seemed high for a thing [he] might not even use" and that a "less finished version might do just as well." These same panels were also rejected for exhibition by the Society of American Artists, prompting one of its members, Augustus Saint-Gaudens, to send Eakins a letter from New York: "I write simply to say that I am in no way responsible for the rejection of your charming little reliefs. I was astonished that they were not received when I saw them after their rejection."

An even more significant factor, however, in Eakins not returning to complete the Arcadia series was that academy trustee Edward Coates, who had replaced Rogers as chairman of the committee on instruction, proposed an important new commission that might be added to the school's permanent collection. Eakins was so confident in his teaching and in the direction he was headed as an artist that he did not hesitate to choose a subject that was bound to be controversial. His idea was to feature six men, including himself and several academy students, in a pastoral scene at Dove Lake, just outside Bryn Mawr, Pennsylvania, swimming and sunning themselves naked.

thirty-one

The Lovely Young Men
of Dove Lake

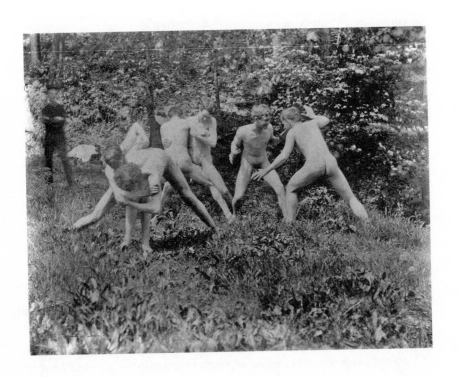

Thomas Eakins, by this time forty years old, intended *Swimming* to be a pictorial manifesto that would express the high purpose of his aims as an artist and teacher. The painting's composition, color, construction, paint handling, and above all its bold and daring depiction of nudity would make a statement he believed commensurate with his position as the head of the country's most progressive art school, and set the standard for the academy curriculum for years to come. Just as he had broken new ground in *A May Morning in the Park* by accurately and realistically depicting the sequential movements of the legs of trotting horses, he planned to present the human form in a full range of poses, from reclining, sitting, and standing to diving and swimming. His painting would be a springboard from which generations of art students could derive inspiration.

Less obvious is why the thirty-eight-year-old Coates commissioned the painting. Unlike his predecessor, Fairman Rogers, Coates's interest in the academy's curriculum was neither progressive nor scientific. He came from a conservative accounting and investment background and is not known to have been a collector of modern art. His personal tastes tended toward idealism rather than realism, historicism over modernity, and academicism over the avant-garde. As the academy's treasurer, a position he had held for eight years, his previous interactions with Eakins primarily involved the artist's failure to present receipts in a timely fashion or accurately project expenses to be incurred. Further, Coates devoted much of his time at the academy to cutting costs by securing faculty and guest lecturers who were willing to serve as volunteers.

In spite of his conservative leanings, Coates had high hopes that Eakins would produce something extraordinary. This was evidenced by the fee he agreed to pay Eakins, eight hundred dollars, which was much in excess of the five hundred Rogers had paid for his earlier commission, and four to five times his usual asking price for studio portraits. Coates also fully expected to donate the completed work to the school, which he confidentially communicated to Eakins by letter. "One of my chief ideas," he wrote, "was to have from you a picture which might some day become part of the Academy collection."

Opposite: The boys of Dove Lake wrestling naked, 1884; photograph by Thomas Eakins (Courtesy of The Pennsylvania Academy of the Fine Arts, Charles Bregler's Thomas Eakins Collection; purchased with the partial support of the Pew Memorial Trust)

At least one of Coates's thoughts for commissioning Eakins to paint *Swimming* was a desire to supplement the artist's income without having to ask the board to give him a raise. Coates may also not have known what Eakins intended to paint. There is no evidence he discussed the subject or worked with Eakins to develop its composition, as Fairman Rogers had done with *A May Morning in the Park*. Coates reportedly did not see the actual painting until its presentation at the academy's annual exhibition of 1885.

The truth about how the commission came about was likely to have been more complex. As chairman of the committee on instruction, Coates must have known that Eakins was in the midst of his most intense work painting nudes. On display in the artist's Chestnut Street studio, and perhaps in his academy office, were several of the Arcadia paintings in varying degrees of progress, along with wax models for his Arcadia reliefs. Coates was also aware that the models Eakins was using were students. He may not have been fully aware of the extracurricular nude photo sessions, but he undoubtedly knew of the naked series of photographs being taken at the academy. His committee oversaw their production and wrote the checks that made the modeling sessions possible. Coates had also been appointed to the supervisory commission for the work that Muybridge and Eakins were doing at the University of Pennsylvania, where nude models of students were involved on an almost daily basis. Even if Eakins had not specifically revealed the exact nature of his composition for *Swimming*, Coates must have known, or at least suspected, what the subject matter was to be.

The subject of the Arcadia series and Eakins' intentions for *Swimming* were also not as foreign to Coates's sensibilities as later events would suggest. The Arcadia paintings did, in fact, strike a personal chord for him. Coates had majored in Greek and Latin at Haverford College, and he kept a large collection of classical texts and nude statuary in his Spruce Street townhouse. His wife, Florence Earle Nicholson, a Paris-educated poet of modest accomplishment, championed classical themes and sentimental devotions to antiquity in her writing. Many of her poems were populated with gods and goddesses, set in the ancient world.

Eakins may well have presented his ideas for *Swimming* along the lines of his Arcadia series: a scene from Greek antiquity in which bathers share a

moment of uninhibited male companionship. Rather than stressing the modernistic and scientific study of the nudes he intended to portray, Eakins may have emphasized the painting's more timeless qualities: life in an innocent golden age in which people lived in harmony with nature. Eakins may have actually promoted his teaching to Coates in the same way as he did his art. Plato himself, in his desire to cultivate a student's mind and body, would convene school outdoors in the "groves of academe." Nude wrestling and swimming were indispensable for a well-rounded education in Athens.

Even so, regardless of any miscommunication or even deceit that may have been in play, Eakins was certainly aware of the growing conservatism of the academy's board where nude modeling was concerned. His intention to go ahead with *Swimming,* in which he would depict nude portraits of six recognizable men, four of whom were either current or past academy students and one of them their teacher, can only suggest that Eakins was dolefully out of touch, or intolerant of the academy's conservative board of directors. There would be no togas or pan pipes in *Swimming* (plate 22).

Eakins must have contemplated the commission with grand expectations and youthful enthusiasm. He envisioned a composition not unlike *The Gross Clinic,* in which a single central figure stands at the apex of a pyramid of others. To the left of this figure Eakins would paint kneeling and reclining figures. On the right would be the diver, and Eakins himself, swimming in the water with his dog Harry.

As in his Arcadia series, Eakins began by creating a detailed mental picture of the portrait's look before he scouted for an appropriate location or made preliminary sketches and photographs of his subjects. Doreen Bolger and Sarah Cash, museum curators who have examined these materials and brought together the work of many researchers for an in-depth study of the painting, have detailed the artist's working process. They found that little actual experimentation took place in the painting's creation: Eakins' concept from the start was to portray muscular young men assembled on or near a rocky pier. The spot he chose was near Mill Creek, as it flows into the Schuylkill River at Gladwyne. The stone pier he selected, once the foundation for a mill wheel, provided an idyllic setting where his nude men could be set against a background of trees and, in the distance, fields sloping down to the water's edge. For

optimum effect he set the scene on a sunny day, when his subject's glistening bodies would stand out against the dark shadowed woods and sparkling water.

Eakins may have had Dove Lake in mind from the start, or on a short list of possible locations. He may have gone swimming, fishing, and hiking there as a child. The actual stone pier leading out into the water might have been a childhood favorite. It is conceivable that he and other academy students at times visited Dove Creek on sketching field trips, as the brother of James Claghorn, the school's president, owned property adjacent to the lake. Coates, too, may have been familiar with the location, for he later became the owner of the Claghorn property.

Eakins spared no expense in creating the painting. Payments documented in his account books for 1884 and 1885 show numerous expenditures for transportation, photography, and models. Although he would create the actual painting in his studio, by now the customary approach for all of his larger canvases, he began preliminary work on location, painting the first oil sketches some time in early summer of 1884. Susan Macdowell later described this earlier work as "sketches on the spot, for color of flesh, the green [of the foliage], the water and the sky, on a sunny day."

Photographic evidence suggests that Eakins did not make his final decision about who would model for the painting until his field work was completed. On one preliminary field trip, he and a party of seven male students traveled by train to the Bryn Mawr station and then hiked the three miles to Dove Lake. Eakins brought along his camera equipment, and likely also his painting kit. He choreographed a dozen or more preparatory photographs of his students in the nude, and many of the photos show them swimming or sunning themselves beside the lake. Others depict scenes of the students wrestling, engaging in a tug-of-war, and boxing. They had clearly anticipated these activities before leaving Philadelphia, since the students had brought boxing gloves and other sporting equipment with them. Like a film director creating the right ambience on a set, Eakins' purpose in having his students engage in nude sporting activities may have been his way of relaxing the models in front of the camera and increasing the camaraderie he sought to communicate in his painting.

The differences between the poses in the photographs and the depictions

of students in the final painting also reveal Eakins' desire for spontaneity. The field trip was not intended as a formal photo shoot in the contemporary sense, though this was indeed its purpose. Eakins was "boss" to the students and ostensibly their supervisor, yet he also participated in some if not all of their activities. He appears nude in three of the photographs. The photographer was presumably Thomas Anshutz, the student who was put in charge of the naked series at the academy, and who was also helping Eakins and Muybridge with their work at the University of Pennsylvania. There is also no indication from these photographs or later accounts of the Dove Lake field trips that anything occurred to embarrass or upset his models. Furthermore, the models who appeared in the completed painting were all consenting adults, and several of them went on to act as frequent models in Eakins' later work.

The figure depicted standing half in and half out of the water in the finished painting was twenty-year-old Benjamin Fox, the most easily identifiable because of his red hair. The son of a Philadelphia awning maker, Fox later became a professional artist in Philadelphia before suffering from "acute mania" and being admitted to the Lunatic Asylum of the Philadelphia Hospital. Standing atop the stone pier, at the apex of Eakins' composition, was Jessie Godley, twenty-three, a direct descendant of John Hart, one of the signers of the Declaration of Independence. After attending Philadelphia's Friends Central School, where he likely studied under Benjamin Eakins, he became a student of Thomas Eakins at the academy and went on to marry another academy student.

The student kneeling on the rocks with one arm raised was twenty-two-year-old John Laurie Wallace, the one who had posed for Eakins in *The Crucifixion* and *Arcadia*. By the time Eakins photographed him for *Swimming*, Wallace had already left Philadelphia to take a position teaching art in Chicago, a job Eakins had helped him to obtain. He had returned to Philadelphia on a short visit, during which he visited the academy and posed for *Swimming*.

The student Eakins depicted diving into the water was George Reynolds, forty-six years old and, like Wallace, born in Ireland. In addition to studying at the Pennsylvania Academy, he had attended the Brooklyn Art Students' Association and the National Academy of Art, and had served as a cavalryman in the Civil War. He was a widower at the time the painting was done. The fifth swimmer was thirty-six-year-old Talcott Williams, a well-known journalist

and prominent figure in Philadelphia society. He and Eakins had become friends in 1881 when Williams stopped by the academy to introduce himself. A graduate of Phillips Andover Academy and Amherst College, Williams was the associate editor at the *Philadelphia Press* and later became its managing editor, a position he held for thirty-one years. In addition to many articles, he was the author of two books.

Not all these men were photographed on the initial field trips, and Godley and Williams may never have been to Dove Lake at all; Eakins photographed or modeled them in his studio. Just as he did in *Mending the Net*, Eakins used the photos of his models, as well as photographs of the landscape and shoreline, to create what visual art students today might term "virtual reality." The process is clearly seen by comparing rock formations and the shoreline in the photographs with those of the final painting. The rocks are not the same in size or shape, nor are the far shore and the house in the photographs seen in the same locations. The painting is not a detailed transcription of the source materials; Eakins was not so much working from his photographs as he was working with them.

In addition to taking multiple photographs on location, Eakins also painted compositional sketches and color schemes of the scene for later reference. The only extant sketches for this work are in oil, but it is highly likely that he also made pencil and charcoal sketches. Given the hurried brushwork in the oils, Eakins evidently worked quickly. His purpose was to record the colors of skin and hair, the green of landscape, and the different tones of water and sky on a day flooded with sunlight. He posed at least one of his models on the stony outcropping, in the sun, and then quickly painted the effect. Another oil sketch, which captures the hues of the foliage, was done almost entirely in shades of green. Yet another shows the figures in various flesh tones. A third oil sketch survives of Harry, his dog. The most detailed sketch explores qualities of the water and a grassy area at the lower left.

Kathleen Foster, in a comparative study of the sketches with the finished painting, has noted several basic changes. Both the first sketch and the finished painting show the same pyramid construction of figures who are reclining, standing, diving, and swimming against the edges of foliage. Many other details differ. In the painting the standing figure turns his torso more to the left,

the boy emerging from the water twists to the right, and the diver leaps away from the viewer rather than parallel to the picture plane. These and other changes suggest uncharacteristic tinkering, which may have been the result of the complexity of the figures Eakins portrayed—or they may have come from his growing awareness of the critical reaction to the nudity of his subjects. Genitals and pubic hair are evident in the photographs but not in the finished painting. As in the Arcadia series, the subjects are either turned away from the viewer or posed in such a way that their legs cover their genital areas.

Back in his studio, Eakins moved on to the final canvas to block in the major masses of the landscape. Art conservator Claire Barry, in her examination of the painting, detailed the process. Eakins first laid down a cream-colored ground layer, on which he blocked in the trees and the distant shore. Once he had the major contours of the background in place, he drew two lightly scored axes that intersect at the center of the canvas, just below where the central figure would be standing. As in *Mending the Net,* these ruled lines indicate the horizon line and the central axis of the composition, to help position the viewer before the scene; a grassy patch at the left established a shore where the imaginary viewer would be standing.

Referring to his field sketches and photographs for guidance, he gradually filled in the rest. He spread a resinous medium in varying proportions throughout the backgrounds and also toned this area in luminous glazes, which helped him to detail shadows in the foliage. For the blue sky he worked with broad, thickly applied brushstrokes while leaving parts of the cream-white ground exposed. He waited until the landscape was close to completion before painting the water and then the more ephemeral reflections in the water.

Once these aspects were nearly complete, he started shaping the figures, which he considered one at a time. Similar to his method in *Mending the Net,* Eakins chose photographs taken on location or in his Mount Vernon Street studio and projected them individually onto his primed canvas. Incised marks found in conservation examinations of the painting reveal his detailed and precise approach (plates 23–25). Like constellations formed by stars, fifteen such marks traced out Godley's right hand; five others created the curvature of Williams' ear. One such mark, which extends into the water to the left of his eyelashes, is still visible to the naked eye.

The single figure Eakins did not apparently model from a photograph was George Reynolds, the diver. The underlayers show no projection marks corresponding to this figure. He was recreated from life, as evidenced by payments to him for modeling services that Eakins recorded. Eakins also showed his students a figure he had modeled of Reynolds and then mounted on a wooden spindle through the middle, so it could be turned upside down and still hold the pose.

How Eakins combined his live modeling sessions with photographic projections, and in what order, forensic studies have not revealed. It is interesting to note, however, that he painted the diver with the same density of pigment over the figure as the others, and it shows no changes. By contrast, the three figures to the left of Godley were all altered as Eakins worked on the composition. Wallace, for example, was moved a quarter inch down to the right, closer to the standing figure. Infrared studies of the painting reveal a dark hollow above Wallace's raised arm and head and along his left side: apparently the ghost of an earlier rendering of the figure that Eakins scraped away.

This reworking, it should be noted, is noticeable only in forensic studies. All his figures have been painted with tightly controlled strokes of pigment. The short, exacting brushmarks, referenced with the photographs, enabled him to add such details as musculature and blue veins in legs and arms. The resulting images are uncannily lifelike. The diver looks as though he has been captured in a high-speed blur from the shutter of a camera. A viewer can almost hear the sound of laughter and taunts of the boys on the pier and the involuntary yelps prompted by sun-warmed bodies striking the cold water.

The yearlong efforts Eakins made to perfect his painting paid off. He captured a moment as no artist before or since has been known to accomplish. Not even Michelangelo, in his famous *Battle of Cascina,* the ultimate male bathing scene, incorporates such a range of motion or a figure in a midair dive. Eakins' mixture of sharper and softened lines enhances the luxurious contrasts on the swimmers' bodies. Illumination floods the scene, seeming to encapsulate each figure in his own envelope of sunlight, and in other places appearing cool and diffuse, pulling the viewer's attention back to the narrative events in immediate time. As in his best work, Eakins lived up to what he had strived to do in Europe. "In a big picture," he had declared, "you can see what o'clock

it is afternoon or morning if it is hot or cold winter or summer & what kind of people are there & what they are doing & why they are doing it."

Today, the masterpiece Eakins brought to life and the Dove Lake photographs he consulted to create it have made the artist's work the center of much debate and speculation. Prominent art historians and scholars have cited them to suggest that Eakins was homosexual or bisexual, or at the very least, that this painting in particular reveals evidence of homoerotic interests. The Dove Lake expedition, it has been said, was symbolic of the "font where men are baptized in the religion of loving comradeship." In another evaluation, the fact that none of the students are directly looking at one another in the photographs, and in the painting itself, reinforces the notion that Eakins, who is the only figure actually swimming in the scene depicted, is leading his students toward self-discovery of their manhood and the overcoming of Victorian cultural prejudice and inhibition. And alternately, the inclusion of Eakins in several of the photographs and in the final painting has been said to suggest the sexual attraction on the part of an older man as observer or voyeur, that of "love of youth expressed."

However a viewer chooses to psychoanalyze the painting's subject and design, the unassailable point is Eakins' masterly evocation of a mood and a message, as conveyed in the works of the artist's contemporary Walt Whitman, who later became a friend and whose poetry celebrated such common elements as male bonding, mentorship, and the exuberance and physical refreshment of nudity in the open air. In his image of himself swimming toward his naked students, Eakins seems to give voice to a passage from *Leaves of Grass:* "Touch me, touch the palm of your hand to my body as I pass; Be not afraid of my body." Eakins has, in a large sense, gone beyond depicting himself as he did in the bleachers of the Jefferson Medical College in *The Gross Clinic* or as fellow rower in *Max Schmitt in a Single Scull.* He has portrayed himself as the only participant actually engaged in the act of swimming. He is, in one sense, setting the example as the students' detached yet calmly attentive mentor.

Critics in Eakins' time picked up on similar elements in his painting, only they were too uncomfortable with the scene he had presented to express themselves in print the way contemporary critics have done. Such a reticence was most certainly the case in October 1885, at the academy's fall exhibition,

when Eakins unveiled *Swimming*. Despite what one critic from the *Philadelphia Inquirer* said, that Eakins had sent "an important work" sure to provoke "abundant" positive and negative commentary, even Eakins' most vocal critics could not bring themselves to put their feelings into words. The painting elicited barely a murmur of polite acknowledgment—even though the exhibition catalogue listed Coates, one of the most important figures at the academy, as owning it, and Eakins, the academy's director, as having painted it. No one appears to have stated what must have been on everyone's mind: the graphic nudity of academy students. Two of the students, in fact, could be readily identified by portraits of them hanging in the same exhibition only a few feet away from Eakins' canvas.

One reviewer did offer praise, listing Eakins' artwork as among "the best" in the show. Yet in his description of the artist's work, represented by three paintings, he had nothing to say about *Swimming*. A second critic, for the *Evening Telegraph,* made a nod to Eakins' "interesting [subject] matter"; he did not say what that subject matter was. The same critic, incidentally, praised a harem scene by another artist as "exquisite workmanship" and described a second artist's turning a "thoroughly commonplace" beach scene into "true poetry" by his use of color and brushwork. Such faint praise was overshadowed by lukewarm criticism from the writer for the Philadelphia *Times,* who found *Swimming* "not agreeable." The chief complaint was that the painting was "evidently intended to show the results of instantaneous photography" yet failed to suggest motion effectively. This critic judged both the color and flesh in the painting "unpleasant." In another review, Professor Leslie Miller, principal of Philadelphia's School of Industrial Arts, didn't comment on the figures at all; instead he focused exclusively on the presentation of the Dove Lake terrain. "Mr. Eakins has done some very strange things [in the past]," Miller wrote. "In nothing that he has done however has his work been so persistently and inexcusably bad as in the landscapes which he has introduced as backgrounds for his figures." Long articles appeared in the city papers on the merits of other paintings in the exhibition, which included those by academy students William Trost Richards, Cecilia Beaux, and Margaret Harrison's brother Alexander, but most failed even to mention Eakins' name.

The painting would have only one other public exhibition in Eakins'

lifetime, in 1886, in Louisville, Kentucky, and it was then returned to what was becoming Eakins' growing personal collection of his own work. Once again the painting garnered a resounding critical silence. During the following three decades, no evidence suggests that anyone outside of Eakins' immediate circle of family and friends even saw it. Today it is prominently hung in the Amon Carter Museum in Fort Worth, Texas.

Coates himself must have experienced a visceral discomfort on seeing it displayed for the first time in the exhibition that was probably the academy's most important event of the year. The narrative was obvious to everyone: students and their professor together in the nude. To the academy's directors, and to the parents of students who had come to the exhibition to see their children's work, Eakins was less a modern-day Phidias and more an art-world Pied Piper of Hamlin.

Even if he liked what Eakins had done, Coates could not in good conscience accept the painting. If he did, the academy board members would view his patronage as support for Eakins' controversial study of the naked body. Instead, Coates wrote Eakins a short letter the following month asking to exchange *Swimming* for another of the artist's works. "My reasons for this," Coates wrote, "I would probably express better in person than by note."

Eakins was either oblivious to the trouble he had stirred up in his *Swimming* painting, or he was careless, even disdainful of public opinion and the concerns of board members. On April 8, 1885, before Coates accepted *Singing a Pathetic Song* in exchange for *Swimming,* Eakins wrote to the academy board demanding his long overdue raise.

Exposed and Expelled

thirty-two
Philanthropists and Philistines

The Pennsylvania Academy's board of directors did not discuss Eakins' salary at their session on April 13, 1885, or at any others held that year. Among topics they addressed, however, were measures to limit the chairman of the committee on instruction and the academy's director from making budgetary decisions and financial commitments without first gaining the entire board's approval. Not only would Eakins be denied a raise in pay; the freedoms and discretionary decision-making powers previously afforded him would be greatly reduced. Eakins could no longer issue free passes to promising but impoverished students seeking to study at the academy. Nor could in-kind modeling, photography, or classroom supervisory services be traded for a break in tuition.

From a financial point of view, the board's new policy initiatives were not entirely unexpected, and in fact they were perfectly in keeping with directives set forth upon Fairman Rogers' retirement. As has been made clear in a study of Eakins and the academy by Maria Chamberlin-Hellman, tuition was not enough to cover the school's operating expenses. The treasurer was reporting losses upward of seven thousand dollars a year—a considerable sum in the 1880s. As a result, efforts were inaugurated to trim the budget and simultaneously launch a capital campaign to raise an endowment of one hundred thousand dollars to address the school's long-term needs. Doubling the director's salary and giving some students "a free ride" would only increase the deficit and send the wrong message to the academy's director and to potential donors.

A consideration that factored into the board's decisions stemmed from a growing awareness that the academy had grown in reputation and stature to the extent the school could no longer function without a more clearly defined managerial structure. Thanks to Eakins and Rogers, the fundamental problems of providing space, facilities, and instruction had been worked out. A system was in place for admitting students and promoting them from one level to the next. Classes began and ended on a set schedule. Models were in plentiful supply, along with an able body of skilled instructors and assistants trained by Eakins at the academy for this very purpose. Devoted as his students were to Eakins, he was no longer necessary to the continued functioning of the school. To the board's way of thinking, they had more need of a professional admin-

Overleaf: John Sartain in Masonic robes (Courtesy of Moore College of Art and Design Archives, Philadelphia)

istrator than a truculent individualist, no matter how talented. Extending him the courtesy of a new contract they deemed unnecessary and imprudent.

Eakins, who was in the midst of renovating his home and studio, did not take the news in stride. Deficits claimed by the board, despite their protests otherwise, were not the result of overly generous salaries, model fees, equipment costs, and building maintenance, but the way the board spent the tuition it received. Money that had previously gone to supporting the curriculum was redirected to enlarging the school's permanent art collection. In this regard, Eakins' concerns had merit beyond what Coates or his fellow board members were willing to admit. Expense records for a typical three-month period in the 1883–84 school year show that receipts for tuition exceeded curriculum operating expenses by several hundred dollars. Income that might otherwise have been put toward Eakins' salary request was being used to enlarge the academy's museum collection. It must also have been especially difficult for Eakins that none of his own paintings were purchased for the collection, while works brokered by John Sartain, once again a force in academy affairs, were routinely acquired.

Disputes over salary and discretionary spending were only the first of other administrative changes that drove a wedge between Eakins and the academy's overseers. The board passed down new policy directives governing the admission of minors to the life classes. All minors seeking permission to study from nude models would have to obtain parental permission, in writing. A second order issued several months later required that the names of all students seeking admission to the life studies classes be submitted and then approved by the committee on instruction. Delays in granting such approval had the net effect of greatly reducing the number of students enrolled in life classes and slowing the previously speedy transition of students from the antique classes to life modeling. The following year the board announced yet another regulation, limiting access to anatomy and dissection classes.

None of the new regulations were without precedent at the academy. Minors had never been permitted into the life classes without permission from parents or guardians, and transition from the cast drawing classes into the life classes had always required the approval of the instructors. The difference rested in the degree to which the board exercised more direct supervisory

control over school policies and activities. Decisions that were previously made by instructors and academicians were now being made by board members who were attorneys and businessmen without any formal art training. Eakins could no longer promote a student into the life studies classes at his sole discretion, nor could he easily give favorite pupils preferential treatment based on what he judged to be the quality of their work.

Also, the list of what the board considered "unseemly" conduct was growing. The directors adopted formal policies barring students from modeling nude in academy classes, along with a regulation barring the use of totally nude male models in female classes. Male genitals would have to be covered. Rules regarding the admission of distracting visitors, male and female, to the life studies classes and the positioning of a screen at the door to the modeling room were also to be strictly enforced. Here too the board was not instituting a new policy, but rather returning to the system that had been established in the early days of the venerable "Old Temple." In carefully worded statements given later to the press, board members alluded to the changes at the academy as arising from the board's commitment to "better meet the needs of students and parents."

In spite of bitterly divided press coverage that was to come, the board members of the Pennsylvania Academy of the Fine Arts were neither the enlightened philanthropists they wanted to appear to be, nor the provincial philistines legend has created. The policy decisions were driven as much by Eakins' failure to abide by commonly accepted standards of conduct as they were by the city's changing cultural landscape. Fairmount Park could be favorably compared to Hyde Park in London and the Bois de Boulogne in Paris and rivaled in scale and splendor any park in America; the hastily constructed Memorial Hall that had housed the great Centennial Exhibition art collection was now the Pennsylvania Museum, and was destined to become a national landmark. Eakins' Chestnut Street studio had electric lights; Mount Vernon Street had asphalt paving, neighbors first shared a telephone in 1887, and residents no longer carried guns. The great epidemics that had once ravaged the city were being brought under control as a result of breakthroughs in medical science and water purification systems.

Like our own times, however, great civic and technological achievements

were coupled with labor unrest and anarchist bombings. Corporate and institutional monopolies and the status-driven millionaire titans who ran them believed themselves to be the chosen custodians of moral truth and arbiters of good taste. The "gospel of wealth," as espoused by Andrew Carnegie and practiced by Philadelphia's managerial elite, rested on the cheerful assumption that prosperity and justice were one and the same; never mind the poverty-stricken newcomers who filled out the city's expanding grid. From the safe vantage point of ironclad Market Street towers, factory owners and financiers could count their profits without the distraction of observing the misery that they fostered. Then, as now, the youth of the nation were the first to respond to what has been described as a decade of spiritual exhaustion. Their cultural heroes were rebels like Eakins, who was unwilling to measure success by the clothes he wore, the filigree on the building that housed his studio, or the galleries where his art was hung.

In this environment of conflicting values, Comstock's anti-vice campaign had finally taken root in Philadelphia, where morality committees led by Josiah Leeds were circulating petitions calling for the legislature to pass obscenity and indecency laws. "Purity in Art" was a subject on everyone's mind. And while Fairman Rogers may have been willing to debate what constituted a "pure nude" as distinguished from an "impure nude," the decidedly more conservative board represented by James Claghorn chose to censor itself rather than risk potential embarrassment in the press. The academy's benefactors could not be expected to dip into their pockets to support a capital campaign that encouraged "horrid nakedness."

A brief comment in a letter from Coates to a fellow board member in May 1885 reflected the new concern for the public's perception of activities at the academy. "It will I think be best not to issue any tickets for Mr. Eakins' [anatomy] lecture to press reporters until I have some talk with him," Coates wrote in May 1885. "The lecture will be more or less private in character, and will probably be repeated more publicly next winter." Coates's worry was not directed exclusively at Eakins. Previously he had instructed Dr. Keen to omit his usual lecture on the sexual differences of human anatomical form, due to the board members' fear "that it might give rise to unfavorable criticism." Keen accepted Coates's judgment and dropped the subject from his presentations.

Eakins, however, was not about to modify his practices. Study of the naked human form was a core of his beliefs as an artist and art instructor, his training at the école, and his accomplishments as an administrator in what had become, under his leadership, the most comprehensive and arguably the best art school in the nation. As if issuing a call to arms, Eakins continued to urge his students to study the human body as they would an engineering blueprint: construct, model, and then paint. "Be sure you have a human that could function before penning him up with a line all around him. . . . Be sure you don't break any bones. Remember the ribs enclose vulnerable parts that must be protected, and they are therefore rigid. The bending is in the lumbar region. Make the pelvis wide enough to fasten on two leg bones. . . . If it's a woman . . . give her a pelvis wide enough so that she won't die in child birth."

Most students appear to have understood and embraced these teachings. "[Eakins] loved the beauty of living things and revered the structure beneath it," declared Adam Emory Albright. For him, the arrival of a new cadaver from the University of Pennsylvania Medical School was a cause for celebration. He and other students would march in procession, ceremoniously "chanting a dirge" as the fresh corpse was carried from the dissecting room to the lecture hall.

Participants in classroom demonstrations described their fascination when Eakins once arrived with a gunny sack containing a dog's hindquarters, which he used to demonstrate muscular action, and when he attached ropes and pulleys to a horse's dissected leg bones to imitate the motions of trotting and galloping. "I felt a very hard-boiled and heroic person," reminisced Albright's classmate Alexander Stirling Calder (whose son, Alexander Calder, would become the most inventive sculptor of his generation).

Calder and others recalled the delight they felt at seeing Eakins doing pull-ups and other gymnastic feats, or sliding down the banister from the upper gallery rather than taking the steps. Knowing that he enjoyed their company, they would gather in groups at the foot of the academy's steam-driven elevator to chat with him when he arrived in the morning or left in the evening.

Eakins' informality, in his students' eyes, was refreshing. In a day when middle-class Philadelphians wore white shirts, starched high collars, well-pressed black or gray suits, vests, suspenders, and shiny high shoes (and sel-

dom left home without an umbrella and overcoat in the winter), Eakins wore a flannel shirt and a rumpled black suit and paint-splattered boots. All the protection he had from the rain was a round felt hat with an unusually wide brim. And no matter what his mood, Eakins was always entertaining. One student would never forget the day, during a dissecting class, when Eakins showed a model one of the school's cadavers, remarking, "That's how you'll end up." The model bolted from the room and never returned.

"I can remember the flutter that swept us all when he appeared," said Albright. "He was always accompanied by his dog, a big brown setter, a fine intelligent animal who would lie quietly by his chair all through the session. When Eakins came to the life class, he always held the door open for him, with a 'come in, Harry.' When we heard that 'Come In, Harry,' our careful studies suddenly seemed poor things . . . and we felt like turning them around and sneaking from the room before the master got a chance to look at them. . . . Like Christ among sinners, he saw something of good in everyone. But . . . had there been a faker or poseur among . . . [us], Tommy [Eakins] would have spotted him and cast him into the limbo of oblivion."

"Thomas Eakins' formidable personality held unrivalled sway over the students," explained Cecilia Beaux, an academy student who went on to earn an international reputation. She was not fond of Eakins or the curriculum, but she acknowledged that he was a gifted teacher. "No one who studied under him ever forgot his precepts, or could be interested in any principles of Art that did not include his. They were rock-bottom, fundamental, but somehow reached regions, by research, that others could not gain by flight."

The very things about Eakins that the students loved were what infuriated administrators. Rather than giving in to the demands of board members that he alter his teaching practices and present what they considered a more dignified role model, Eakins continued to act in such a way that the results were a foregone conclusion. Particularly egregious was his continuing use of academy students as nude models in his photographs. The problem was potentially far more dangerous than his representation of nude students on canvas; the generally accepted "rules and practices" that protected an artist did not apply to a photographer. As Comstock had proved in federal court in 1884, a photograph did not legally constitute a work of art. August Muller,

a New York art dealer who was prosecuted for selling "licentious Parisian nudes," went to prison not for the oil paintings that hung in his gallery but for selling photographs of the same paintings.

thirty-three

The Hanging Committee

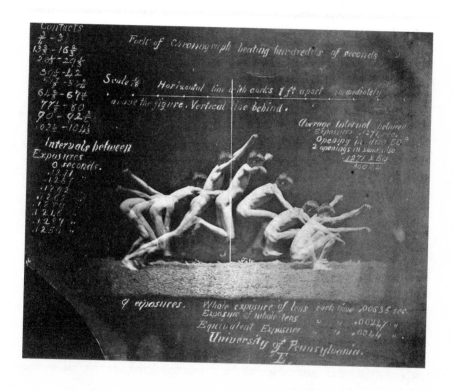

In the two-year period following his field expeditions to Dove Lake, Eakins shot several thousand nude photographs of academy students and professional models as part of his ongoing research at the University of Pennsylvania with Eadweard Muybridge. Photography had, in fact, become such an obsession for him, he neglected his own painting career almost entirely. He believed he was on the verge of a major breakthrough in how photography could be used to expand the kind of contemplative narrative depth of a moment he captured in his paintings. As Roland Barthes later observed, "cameras . . . were clocks for seeing." Eakins was no longer trying to capture a single instant in time, but searching for the means to extend it.

The initial work Eakins and Muybridge undertook at the University of Pennsylvania in June 1884 was to duplicate Muybridge's Palo Alto human and animal locomotion experiments. In the courtyard of the Veterinary Hall and Hospital, a laboratory was built for this purpose. As in Muybridge's first study, a line of twenty-four cameras was arranged along a track. The only significant difference between the old and new experiments rested in the camera technology.

Rather than using trip wires to trigger the exposures as in the Palo Alto method, the University of Pennsylvania cameras were equipped with electro-magnetic shutters that released in a sequence of equal intervals fired by contact motors. Their purpose was stop action, or freeze motion, but in doing so Eakins and Muybridge were unwittingly creating the basis for motion pictures. All that was necessary was to recreate the motion by projecting the individual photographs in rapid succession before the eyes of an audience.

Eakins built such a device—a modification of the zoetrope using an arc light and lens—and put on demonstrations at the academy. Each revolution of the wheel duplicated the action in the photographs. Monotonous as these images would appear to today's audiences—a horse repetitiously going through its paces again and again each time the wheel completed one revolution—the results were like magic to those who first saw them.

Overleaf: Motion-study photograph by Thomas Eakins, with an unidentified model and notations by Eakins or Muybridge, 1884–85 (Courtesy of Hirshhorn Museum and Sculpture Garden, Smithsonian Institution; transferred from Hirshhorn Museum and Sculpture Garden Archives, May 24, 1983)

As the designated overseer of the experiments, Eakins was obligated to work side by side with Muybridge as an observer only. Eakins, however, had ideas of his own on how the investigations should be conducted. Through his previous work with Fairman Rogers he had perfected an instantaneous shutter of his own invention based on the Marey wheel. The Eakins time-lapse photography system did not rely on multiple cameras. It combined a single camera with counter-revolving plates. As slots cut in the rotating wheels repeatedly aligned in front of a fixed lens, the successive stages of the model's action could be captured in a multiple exposure. The advantage was a uniform perspective, which would make modern motion picture photography possible.

Eakins was increasingly unhappy with a drawback he perceived as his colleague's failure to apply a scientific approach to his studies. Muybridge was less interested in conducting research than he was in capturing titillating and exotic imagery; the board of supervisors who underwrote his research would ultimately declare his contributions marginal, at best. (This became abundantly clear when Muybridge, early in his experimentation, spent several weeks photographing nude women dancing together arm in arm.)

Recent studies by Marta Braun have shown that Muybridge, in an effort to win popular acclaim for his work, actually edited and combined photographic plates from several sequential studies, thus "obliterating"—as art historian Douglass Paschall has described it—the objective value of his research. Eakins, on the other hand, who saw no difference between high art and good science, demanded a more scientific and rigorous approach. By the time the University of Pennsylvania professors supervising the work understood what Muybridge was doing, however, the board had already committed itself. "They would like to fire the whole concern but they have gone too far to back out," wrote Eakins' academy assistant, Thomas Anshutz.

Muybridge must also have been difficult to work with as a partner. "Erratic" was the term most often used in describing him; he changed his name when it suited him, as he did details of his personal and professional accomplishments. After receiving a head injury while traveling through Texas in 1860, he returned home to New York and killed a man he presumed to have been his wife's lover. (Muybridge was acquitted on the grounds that the homicide

was justifiable; he took a steamer to South America, only to reappear in the 1870s in San Francisco, where his work came to the attention of railroad tycoon Leland Stanford.)

Differences of opinion on how to proceed with further experimentation led Eakins and Muybridge to part ways in the summer of 1884. Eakins was still ostensibly overseeing Muybridge, but thanks to the support and encouragement of Edward Coates and University of Pennsylvania faculty members William Marks and Harrison Allen, who came to see the greater value of Eakins' approach, funding was found so he could conduct his own parallel experiments. Eakins did not receive a research grant as Muybridge had; rather, departmental monies from the academy and the University of Pennsylvania were diverted to cover Eakins' expenses. The camera Eakins used, for example, was "on loan" from the University of Pennsylvania physics department.

Eakins and his students built a shed in the same courtyard as Muybridge had, and over the next eight months they shot several thousand photos. While Muybridge gradually focused his attention on photographing dancing nude women and exotic animals he borrowed from the Philadelphia Zoo, Eakins made studies focusing exclusively on particular human muscle groups. Nude men were photographed walking, running, jumping, and pole vaulting; nude female models also appeared in sequences, though their activities were limited to walking in front of the camera. Like Eakins' nude photographs at the academy, they are not, by today's standards, sexually provocative.

Eventually Muybridge dispensed with multiple cameras in favor of the Eakins technique. By this time, early in 1885, Eakins himself had moved on to a hybrid camera system of his design that permitted him to take twice the number of exposures in significantly less time. He had also gone well beyond Muybridge's practice in his choice of subject matter. In one of Eakins' most notable experiments, probably shot at the University of Pennsylvania, he and his students dissected the leg of a horse, paring away one muscle after another until it was determined that the leg could stand and bear the weight of a human being by the counterforces of its bone and tendons alone. Another Eakins image was *History of a Jump,* showing a nude man caught by the camera as he leaped across a grassy enclosure. This photograph in particular was chosen for an international exhibition of photography organized at the

Pennsylvania Academy. Not included in the exhibit was a scene that pictured Eakins, himself nude, carrying a nude female toward the camera—an act that was in direct violation of the academy rule barring male and female models from posing together.

Much good work continued to come out of Muybridge's and Eakins' respective projects. Their differing philosophies and approaches, however, gradually grew considerably more divergent. As Muybridge prepared a collection that at the time was the largest compilation of photographs of animals in motion, Eakins was amassing an encyclopedic reference library of nude humans in motion. As never before, art and science had come together for him. His innate frankness, his training in medical school and life classes, and his teaching of anatomy had made him immune to seeing the human body as his peers did. He had no more shame about what he was doing than a physician would. Nor did he have patience with people who did not share his detached scientific attitude.

In the midst of achievements that might be considered Eakins' greatest technical success, the first motion pictures, emerged irrefutable evidence for what would ultimately lead to his untimely departure from the academy. The Muybridge photographs were selectively edited, published, and distributed. Thomas Edison later praised them as one of the inspirations for his invention of the single-action motion-picture camera. The Eakins photographs, which were produced at a fraction of the cost and were scientifically superior to the Muybridge pictures in several significant ways, would not be published in the artist's lifetime. The cost of producing an additional volume by Eakins was deemed prohibitive. There must have been other considerations too. The identifiable nude models appearing in the Eakins photographs were academy students.

thirty-four

Point of No Return

The degree to which the forty-one-year-old Thomas Eakins had become a liability to the Pennsylvania Academy was growing more obvious to board members with each passing day in late 1885. Among the legion of offenses he was rumored to have committed was an incident in a female drawing class, where he was explaining an anatomical point about the curvature of a woman's spine. When the designated model failed to appear for class, Eakins, it was said, asked a student, in place of the missing model, to remove her blouse so that her fellow classmates could see her back. The student burst into tears and bolted from the classroom. On another occasion, as reports had it, Eakins put his hands on the hips of a professional model and proceeded to manipulate her posture.

His continued disregard for the school's modeling policies coincided with a growing distrust among board members of his teaching methods. Under Eakins' direction, the board felt, the new academy was eroding the tradition of art as a polite avocation, one that gave board members standing in the community and artwork for their homes. Along with that erosion came an awareness that the academy under Eakins was not an environment where proper Philadelphia families could be sure of keeping their daughters out of mischief until marriage. Under Eakins, young ladies who wanted to learn such genteel accomplishments as china painting and watercolor sketching were being challenged to take up higher mathematics and to study anatomy and dissection. Landscape painting was not even included in the curriculum. Horses and cows and nude men were being used as models. The curriculum's narrow focus on the human form left no room for students who were interested in architecture, stained glass, or industrial design. Art history, appreciation, and criticism—studies that would provide pleasant conversation at dinner parties—were likewise not being offered.

Academy students do not appear to have complained about the stench of formaldehyde that permeated the lower floor of the academy, but the board members did. In another incident that was soon added to the ever-growing list of embarrassments perpetrated on the academy by its director, a dead horse was dropped down the school stairwell while John Sartain and his fellow

Opposite: Thomas Eakins carrying a nude woman at the Pennsylvania Academy of the Fine Arts, 1883–85 (Courtesy of The Pennsylvania Academy of the Fine Arts, Charles Bregler's Thomas Eakins Collection; purchased with the partial support of the Pew Memorial Trust)

Masons were holding a solemn function in one of the galleries. Eakins was not on the premises at the time, and he had, in fact, previously left instructions for the proper disposal of the cadaver. But he was held partly responsible because the students who perpetrated the practical joke were judged to be inadequately supervised.

Lack of supervision increasingly became an issue as Eakins devoted the greater share of his time and energy to experimental photography at the University of Pennsylvania. Among the episodes brought to the board's attention was one or more male students' rearranging the anatomy of a cadaver, and in a related event, relocating the penis of a corpse being studied in the women's class.

Resentment was at the same time building among students who chafed under Eakins' authoritarian approach. Everyone seemed to agree that Eakins was a hardworking and totally dedicated instructor. Beyond this, opinions diverged on how well he responded to students' needs. Some would later go on record describing him as "gentle, kind, helpful, and honorable," while others found him "blunt" and "prejudiced." On one occasion Eakins allegedly flew into a rage when a student challenged his judgment. On another, he smashed a student's sculpture, the claim went, because he did not believe it worthy of the student's talent. Yet another story told of a model appearing before the class, nude, wearing a bracelet, and Eakins seizing the bracelet in anger and throwing it to the floor.

Some of the more outspoken criticism came from a student named Horatio Shaw. "Eakins found a great deal of fault with my picture last week," Shaw wrote of his experience at the academy. "I feel a relief when he has come and gone, as [do] a great many others in the class. [He] told one fellow his figure looked as if it was rotten. Told me one of the legs looked like a great fester and complimented another fellow's picture that was rough and dauby and hadn't the first flesh color in it that I could see."

Like Shaw, Helen Sloan described Eakins' teaching practices as obsessive. "Our crowd didn't have much interest in studying with Eakins himself," she wrote. "He was so much concerned with anatomy that he thought a student was not serious if unwilling to carry home an arm or a leg to dissect in the evening." Increasing grumbling came from students, such as Cecilia Beaux,

who had been to Europe and seen paintings by the impressionists. She reported trying to avoid Eakins altogether, fearing that by "succumbing to [the] obsession of his personality" she would only become a "poor imitation" of what was "deeply alien to [her] nature."

In previous years, when attendance at the academy had been free of charge, students had no recourse for grievances other than to leave. Now that they were paying customers, the board felt compelled to listen to their complaints and expected the academy director to respond accordingly. Perhaps too, the student body had undergone a subtle change. The students whose parents could afford to pay may have been more accustomed to an educational environment that coddled them.

Matters came to a head after class members returned from winter vacation in January 1886. In an act that would be in complete defiance of academy rules, Eakins removed the loincloth from one of the male models in front of a group of female students. Rumors about the incident reached Coates, who promptly sent Eakins a letter of warning. The fallout over this occasion, however, could not be contained. After a special meeting of the board of directors, held in early February, Coates requested Eakins' resignation, and received it. "In accordance with your request just received, I tender you my resignation as director of the schools of the Pennsylvania Academy of the Fine Arts," his terse note read.

No students were known to have made specific allegations against Eakins publicly, but rumors of a "secret conspiracy" to destroy his reputation soon spread throughout the school. Male students held a meeting at which a petition was drawn up, and signed by all present, requesting the academy's board to persuade Eakins to return. All signers expressed their "perfect confidence" in Eakins and praised his competency as an instructor and a gentleman. "His personal relations with us have always been of the most pleasant character," they wrote. During this same meeting, presumably in one of the academy classrooms, the students talked of boycotting the school if the board did not consent to their wishes. "The class as a whole is perfectly satisfied with Mr. Eakins," a spokesman told newspaper reporters afterward. "The disaffection is confined to a comparative few who have exhibited a prudery that is . . . unbecoming among those who pretend to make a study of art."

Following the meeting, at ten o'clock at night on February 15, 1886, the students marched down Chestnut Street to Eakins' studio and home. As the newspapers reported the story, "Each man wore a large E on the front of his hat as a symbol that he was for Eakins first, last and all the time. On reaching this point they came to a halt and cheered lustily for their head instructor. After waiting a reasonable length of time for him to appear, and seeing no signs of his appearance, they dispersed to their homes." The next morning, Eakins' women students met and drew up a petition similar to the one the male students had written. The document was reportedly signed by all but twelve of the ninety female students enrolled at the academy.

Students' hopes of gaining a voice in the affairs of the school were rudely shattered. "We will not ask Mr. Eakins to come back," one of the directors said in an interview with the press. "The whole matter is settled, and that is all there is about it. The idea of allowing a lot of students to run the Academy is ridiculous. All this talk about a majority of them leaving school amounts to nothing. Let them leave if they want to. If all left we could close the school and save money. The school is not self-supporting. This very fact makes it presumptuous on the part of the students to tell us what to do. If any of them left it would be their loss, not ours."

The academy's students responded the next day by calling another meeting to decide whether they should take this remark at face value and actually secede from the institution. Eakins himself was unusually circumspect in talking to reporters. He said, in one of the few statements he made, "I could not give ... [my students] the same advantages they have at the Academy. Of course, if a new school was organized, and I was requested to take charge, I would take a businesslike view of the matter and probably accept. But I would take no steps to organize such a school. That I can say positively, and I don't believe any will be organized."

The dismissal of the academy's most esteemed professor continued to be covered with fervor by the newspapers in the days to come. Despite the tumult, however, the forces aligned against Eakins had no public face. Like the secret ceremonies being held at the nearby Masonic Temple, everything happened behind closed doors. No one stepped forward with specific charges or allegations. All correspondence was kept confidential. Even the minutes from the

board meeting in which Coates was directed to relieve Eakins of his duties contain no indication of why sudden intervention was deemed necessary or who had called for Eakins' resignation.

The *Evening Bulletin* adopted the most conservative account of events: "Mr. Eakins' resignation and the foolish proposition of some of the young men of the . . . [academy] to form an independent class . . . grew out of a failure to appreciate the fact that the . . . Academy is a benefaction established by the directors. . . . It is their school and nobody else's. . . . The general facts which have led to the present difficulty are these: Mr. Eakins has for a long time entertained and strongly inculcated the most 'advanced' views, as they are often called, regarding the methods of study. . . . Teaching large classes of women, as well as of men, he holds that . . . Art knows no sex. He has pressed this always-disputed doctrine with much zeal and with much success, until he has impressed it so strongly upon a majority of the young men that they have sided with him when he has pushed his views to their last logical illustration by compelling or seeking to compel the women entrusted to his directions to face the absolute nude."

The *Art Interchange* took a decidedly more liberal stance. "If Mr. Eakins offended the modesty of the women and men of his class by an excess of realism, it was intended for their benefit, and they should not have overlooked the well-known fact that he always had their welfare at heart. . . . Many of Mr. Eakins' pupils say that if he is not reinstated at the Academy they will leave it and form an Art League similar to that which has been successful in New York. The best wishes of all who love truthful study will attend the formation of the students' class, and whatever Mr. Eakins' errors may have been, we most earnestly wish that he may be forgiven by his enemies, whom it is to be hoped will never commit any greater sins than those of which he has been accused."

The *Philadelphia Press,* like the academy directors, clearly wished that the matter would blow over. "The whole thing, in my opinion, is rather a tempest in a teapot," an unidentified academy director was quoted as saying. "Professor Eakins is an excellent teacher. He is a pupil of Gérôme and a thorough artist. He loves art for art's sake. But you know artists never agree among themselves. He had a number of enemies who made trouble for him and the committee thought it best for the interests of the school that he should resign."

A second unidentified board member also suggested to the *Philadelphia Evening Bulletin* that the matter was routine in nature and had been reasonably resolved. "Professor Eakins' resignation was the result of complaints from several students of the life class regarding his methods of instruction. They were unsatisfactory. The trouble is not a recent one. It has been brewing for some time, and the action of the board of directors in requesting the professor's resignation was not decided upon without long and careful consideration. The board went about the matter very carefully, and heard both sides."

For a man as outspoken as Eakins, whose income and prestige as an artist were intimately linked to the Pennsylvania Academy, the speed with which he had tendered his resignation and his failure to defend himself in the press came as a surprise to the many students who loved and admired him, to the point that they were willing to boycott the academy in protest. In the past, regardless of the consequences, he had always spoken his mind. The reason for Eakins' silence was to remain a mystery, one that would not be unraveled until a century later.

thirty-five
Demons and Demigods

In his lifetime, and for many years to come, rumors of a "secret conspiracy" to end the career of Thomas Eakins were treated as idle gossip spread by disgruntled students. Many leading authorities on Eakins have argued that no such conspiracy was likely because none was necessary. Eakins himself laid the groundwork for his demise by his many actions that ran contrary to the academy board's express wishes and the cultural climate in Philadelphia in the late 1880s. The loincloth incident was one of many known offenses committed by Eakins, the academy's director.

It wasn't until a century later, through diligent scholarship, that the rumors could be substantiated: in 1985, Kathleen Foster, curator of the Pennsylvania Academy, and her assistant, Elizabeth Milroy, tracked down a cache of personal papers that had belonged to Eakins. These papers, now in what is known as the Charles Bregler Collection at the Pennsylvania Academy of the Fine Arts, along with documents found in the archives of the Philadelphia Sketch Club, tell the striking story of an "inner circle" of Philadelphians who had dedicated themselves to forcing Eakins' resignation.

The prime mover of this conspiracy was Thomas Anshutz, seven years Eakins' junior and his designated assistant and chief photographer. Among other members of Anshutz's group, who gave themselves in correspondence the name of "inner circle," were James P. Kelly and Colin Campbell Cooper, who had studied under Eakins at the academy; Frank Stephens, a sculptor who married Eakins' sister Caroline in 1884; and Frank's younger cousin, Charles Stephens, who was engaged to marry academy student Alice Barber. Paradoxically, they had all been part of the Philadelphia Sketch Club movement to install Eakins at the academy when the new building was opened in 1876. The young renegades, once champions of Eakins' teaching, had since joined the old guard academicians responsible for his removal.

The initial motivation for Anshutz and the inner circle was to distance themselves from instruction they described as "faulty." Their zeal had nothing to do with concerns of "horrid nakedness" or "conduct unbecoming of a gentleman." Anshutz was the academy's photographer for the naked series, in addition to working alongside Eakins in his nude photography experiments at the University of Pennsylvania. Moreover, Anshutz reportedly continued

Overleaf: Thomas Eakins at about age forty, c. 1879–84; photographer unknown (Courtesy of The Thomas Eakins Research Collection, Philadelphia Museum of Art)

shooting the naked series photographs at the academy for several years after Eakins submitted his resignation. Kelly had assisted Anshutz in photographing the naked series, and later replaced him as the chief demonstrator in the academy's anatomy program, which Eakins had devised and Dr. Keen conducted. Eakins trusted both these men. During the tenure of Fairman Rogers as the chairman of the committee on instruction, Eakins had promoted Anshutz and Kelly to faculty positions after the board prevented him from issuing free passes to promising students. Eakins had such confidence in these two men and the others that he did not have the slightest clue that his own assistants and their friends were the ringleaders of the efforts—not idle gossip but a true conspiracy—to have him dismissed.

The origins of Anshutz's disaffection with Eakins' teaching methods can now be traced back to 1884, when he and other members of the inner circle began holding informal meetings at the Philadelphia Sketch Club to discuss recent trends in art. The conviction that all members appear to have held in common was disagreement with the importance Eakins placed on higher mathematics, dissection, perspective, and the early transition from drawing to painting—the very innovations that Eakins had brought to the academy. Frank and Charles Stephens, in particular, also harbored a growing personal animus against Eakins that was triggered by Frank's engagement and subsequent marriage to Caroline Eakins and Charles's engagement to Alice Barber. Although Eakins considered the two Stephens cousins to exhibit lesser talent than Anshutz, Kelly, and Cooper, extant correspondence suggests that he treated them with respect. He did not know or suspect subterfuge on their part until several months after he submitted his resignation to the academy and complaints were lodged against him with the Philadelphia Sketch Club, where he had once taught, and the three-year-old Academy Art Club, which was composed of academy students and alumni.

The discussions held by the circle at the Philadelphia Sketch Club in 1884 appear to have centered on what constituted an art education. As Anshutz's personal correspondence reveals, he believed "true art" could not be created by "laboriously following the sign of the eye mechanically," but by using one's "natural sense of sight as an instrument." Anshutz said it was better for an artist to "unconsciously" feel the placement of the model's feet, rather than to be

"governed" by perspective or higher mathematics as Eakins taught. While Anshutz's correspondence from 1884 does not specifically mention Eakins by name, he repeatedly contrasted the "lower approach" taught at the academy to the way "the true artist" expressed himself. Anshutz believed the artist on the right path would "feel light in his picture" and boldly present his view on canvas rather than "paint cautiously after the most careful [mechanical] comparison."

Out of the Anshutz group's informal meetings came a more structured series of lectures and forums that were held weekly at the Sketch Club offices. Among the more prominent speakers invited were James McNeill Whistler and his friend Oscar Wilde; each advocated "intellectual stimulation," which they avowed fueled the "mysterious hidden power" invoked by a true artist. "If you paint a young girl, youth should scent the room," Whistler told his students. "If a thinker, thoughts should be in the air; an aroma of the personality . . . and, with all that, it should be a picture, a pattern, an arrangement, a harmony such as only a painter could conceive."

In striking contrast with the Anshutz group's championing of Whistler's art was Eakins' own aversion to it. Literary and decorative aspects of popular art did not interest him. "I think [Whistler's work] is a very cowardly way to paint," Eakins once told an academy secretary. Asked whether Eakins did not—at the very least—see something "charming and beautiful" in Whistler's paintings, Eakins was at a loss for words. "He never thought about it that way," the secretary reported.

Given Eakins' appraisal of his fellow artist's work, and what was then a powerful new trend in the art world, it was no surprise that the Anshutz group should rally together. A lecture delivered by group member Cooper, in October 1885, summed up the direction the circle was headed. "It has always appeared to me that the art education which one receives in this city is . . . very faulty in one great particular, that it does not teach its students . . . to produce works of art," Cooper told his audience. "We are taught the source and uses of the various muscles of the body, the names and positions of the bones and the relative proportions of the anatomy of man and other animals . . . how to perfectly construct our picture in its perspective, and how to draw a wheel placed at an acute or obtuse angle from the eye. . . . Though all these technical acquirements are absolutely necessary for one to be able to paint, the intellec-

tual development of an artist is . . . just as important. . . . The study of the lives and great works of the masters is very well, but the study of the writings of the great poets and the doings of great men in history is just as necessary."

Fueled by a vision of creating "noble art"—a quality they believed could not be reached under the Eakins curriculum—the "inner circle" made plans to remove themselves from the academy and begin their own Philadelphia art school. The plan fell through, presumably for lack of funds. The circle then focused on taking over the academy. Eakins had unwittingly invited them to do just that. He was away from the academy much of the time, with work at the University of Pennsylvania. In his absence, his assistants—Anshutz and Kelly—took charge. Once they had the run of the school, it appears, they instigated a covert manipulation of student opinion and board opposition against Eakins. Rather than try to unseat Eakins by attacking his curriculum on aesthetic issues, they went for his Achilles heel: nude modeling. The much discussed loincloth incident was relatively minor by comparison to the laundry list of alleged transgressions provided to academy board members by Anshutz and Stephens, and later allegations made by members of the "inner circle" to the Philadelphia Sketch Club and Academy Art Club.

The correspondence does not tell whether Anshutz and the others met with board members individually or as a group. Nor does a verbatim record exist in the writings of what they told the board. However, subsequent letters retrieved by Foster and Milroy, in which Eakins determined to defend himself, revealed the nature and specificity of the charges lodged against him. The correspondence further shows that Eakins appeared before the committee on instruction thinking he was going to be reprimanded about the loincloth incident. He was thus unprepared and taken totally by surprise when the members asked specific questions aimed at events that had occurred over a seven-year period. "The thing was a nightmare," he wrote to Coates immediately after the committee's tribunal.

The first significant charge against Eakins stemmed from the practice of female academy students modeling nude for one another and for Eakins in life studies classes—a direct violation of board policies. Anshutz and the others went beyond describing mere generalities. They gave the names of female students who had posed nude in the past, and those from the present. Among

them were Alice Barber, Charlotte Connard, Mary Searle, Mary Trotter, and Eakins' sister-in-law, Elizabeth Macdowell. Although academy directors later told reporters that Eakins was given the opportunity to defend himself regarding incidents "which had come to their attention," the existing correspondence suggests that the board failed to supply him with specifics. How they became aware that these female students had taken part in nude modeling, and who had lodged charges, the board members kept to themselves.

Eakins left his initial meeting with the board thinking the women had filed the grievances. This was not the case. No extant evidence suggests that the women complained to the board, either in person or by letter. It was the all-male "inner circle" who had made the accusations; they claimed to be working on behalf of women Eakins had offended by "making improper demands upon them." Only later did it come to light that Anshutz and the others were not even in contact, necessarily, with the women they purported to represent. The only exception apparently was Alice Barber, the fiancée of Charles Stephens, who may have been coerced into cooperating with the accusers. The other female students were not aware that their names and activities were being talked about by board members until after the fact. Nor did any of the women, with the exception of Barber, model in the nude for Eakins in private sessions. They had modeled for other members of the female life studies classes when paid models were either unavailable or not present.

How Anshutz and the others gathered the names of female students who had engaged in nude modeling reveals the insidious nature of the intrigue. In one account, a student accidentally left her drawing book—recognizable by her distinctive style—in the life studies room at the end of a women's modeling class. A male student found the book and turned it over to one member of the inner circle, who then used it to document which female students had removed their dresses and undergarments to model. A similar but slightly different version of the story had Alice Barber showing her sketchbook to her fiancé, Charles Stephens. Charges stemming from Alice Barber's nude modeling were significantly more serious than the repercussions for her fellow female students. She had served as a model for the naked series of photographs, and may have posed nude as well for Eakins at his Chestnut Street studio.

When confronted by the board, Eakins in his defense did not deny the

events. Instead he argued that Barber was a consenting adult who had volunteered to pose for the photographs, and that her further nude modeling was not at the academy but at his studio, where she had been accompanied by a chaperone. Eakins' response was not enough to pacify Barber's fiancé, Charles Stephens. Enraged to discover that his betrothed was modeling unclothed, Stephens burst into a private meeting where Eakins was further defending himself and demanded that the artist "confess" his transgressions.

An even more inflammatory charge brought to the board concerned former academy student Amelia Van Buren. According to the circle, who had heard the story secondhand—likely from Alice Barber—Van Buren had asked Eakins, while she attended a dissection lecture, about the movement of the pelvis. Eakins allegedly invited Van Buren into his studio and there explained the matter by removing his pants and then showing her the pelvic motions. The board specifically asked Eakins about this incident. He did not deny it had happened; he only said he "gave her the explanation as I could not have done by words only."

Eakins further justified himself on this allegation by pointing out that Van Buren had come to him, that she had continued to be his student after the incident occurred, and that she was a long-standing family friend. Eakins could have, and perhaps should have, said more. He was unsure how to respond because he felt blindsided. Van Buren was ill and living in Detroit when the accusations were made. Though it turned out not to be the case, the way the board confronted Eakins led the artist to believe Van Buren herself had filed the complaint. To the contrary, she held Eakins in the highest regard, and in the years to come she was a staunch defender of him and took pride in ownership of his work.

Van Buren remained a close friend of the Eakins family. She would also continue studying with Eakins as one of the few female students in the renegade Art Students' League of Philadelphia, which was formed immediately following Eakins' resignation from the academy. However, her unfailing support for her instructor, and her absence from the academy when the charges were brought against him, does not, of course, obviate that Eakins had committed a serious infraction of academy policy. Eakins' easy acceptance of nudity as essential for an art curriculum was no excuse for his actions. As Kathleen

Foster has documented in her study of the Bregler documents, Eakins knew the potential consequences of involving female students in nude modeling activities, and he exhibited cavalier and insensitive behavior at best.

Eakins, as the record shows, invited this tragedy upon himself, but he appears to have been totally unprepared for the confrontation that ensued. Taken by surprise by the specificity of the charges against him, and convinced that the women themselves had gone to the board, he believed he had no choice but to resign. He may even have recommended that Anshutz and Kelly step in to replace him. In any case that is what happened. Unbeknown to Eakins, the pair conveniently had already offered their services to the board at a greatly reduced salary; Anshutz and Kelly were subsequently promoted to full instructors and given the responsibility of adjusting the curriculum. Less than a year after his resignation, the program at the academy returned to what it was before Eakins had arrived. Along with the formal announcement of curriculum changes came news of significant new pledges to the fund drive to create a permanent endowment for the school. The goal of one hundred thousand dollars was reached in a matter of months.

It was not until March, two months after Eakins resigned, and his renegade Art Students' League had begun meeting, that he became aware of the event he then privately began referring to as the "secret conspiracy." Elizabeth Macdowell, Susan's sister, had helped him understand what had taken place. Though she would not stand up for Eakins during his moment of crisis—likely out of fear that her nude modeling would become public information—in time she came to regret not going to the board on his behalf.

Alone at his desk, surrounded by four walls, Eakins turned his fine hand, first trained by master calligrapher Benjamin, and then by years of exacting art, to carefully composed writing. In a series of letters Eakins sent to academy officials, friends, and former students over the next fifteen months, he patiently and rationally sought to set the record straight. Coates, either as committee on instruction chairman or on his own, returned Eakins' letters and refused to enter copies into the academy files.

In one particular letter to Coates, Eakins made clear to the board the "injustice" he believed he had been subject to. "I myself see many things clearer now than I did when in my first surprise I was stabbed from I knew not

where . . . [and saw] half remembered or wholly forgotten things brought forth perverted. It was a petty conspiracy in which there was more folly than malice . . . and the actors in it are I think already come to a sense of their shame. My conscience is clear, and my suffering is past." In another letter, Eakins wrote, "I see no impropriety in looking at the most beautiful of Nature's work, the naked figure. . . . I believe I have the courage of my convictions. I am not heedless. My life has been full of care and thought, and governed by good moral principles, and it is very wicked and unjust to misfit my doing to motives which a very little consideration would show did not govern them."

Eakins also wrote to Emily Sartain, perhaps hoping that she—now the principal at Philadelphia's School of Design for Women, a position Eakins had helped her to gain—could set the record straight. "I send you a statement which I leave entirely to your discretion," he wrote. "A number of my women pupils have for economy studied from each others' figures and of these some have obtained from time to time my criticism of their work. I have frequently used as models for myself my male pupils: very rarely female pupils and then only with the knowledge and consent of their mothers. One of the women pupils, some years ago gave to her lover . . . a list of pupils as far as she knew them, and since that time Mr. Frank Stephens has boasted to witnesses of the power which this knowledge gave him to turn me out of the Academy, the Philadelphia Sketch Club & the Academy Art Club, and of his intention to drive me from the city."

Eakins also wrote Emily about the nude modeling of Amelia Van Buren and Alice Barber. "Being the only painter in Philadelphia habitually using the naked model, I have whenever not too inconvenient to me allowed my most promising pupils to work from my models. I have also encouraged advanced pupils to work from each other when the state of their purses precluded the employment of regular models at home, and I have corrected much of such work. I have also made many photographs of the naked figure including my own. I have spoken of medical things with the freedom of a physician. Misrepresentations of these affairs plain enough to professional artists or cultivated people were made by participators the basis of an indecent attack upon my personal character. . . . My life has been very simple and honorable, and singularly free from complications and is all of it open to any friend."

However "clear" Eakins' conscience, and however much he had unwittingly come to think he could repair the damage he felt had been done to him, his reputation was tainted far more than he supposed. His brother-in-law, Frank Stephens, had testified before the academy board and to the Philadelphia Sketch Club to "perversions" more damning than Coates or anyone else was willing to discuss with Eakins in person or by letter. Eakins did not find out about these added allegations until three months after his resignation, at a time when John Sears, director of the Philadelphia Sketch Club, called for a formal inquiry. Piled on to statements about the "nude modeling business" carried out in Eakins' Chestnut Street studio, and allegations that Eakins and Susan Macdowell were not legally married, a further charge capped it all. Stephens had accused Eakins of incest with his sister Margaret.

thirty-six
The Family Skeleton

The amount of misery Stephens' allegations heaped on Eakins and his immediate family members may never be known, but the impact must have been enormous. The matter of nude modeling, of course, was not a new complaint to Eakins by this time, and questions about his marriage could be easily resolved by showing the Sketch Club investigators his marriage license. It was the spreading of tales concerning illicit involvement with his deceased sister Margaret that overwhelmed Eakins. As a result, he may in fact have suffered a nervous breakdown.

Letters about Stephens' charges indicate that Eakins did not at first believe his brother-in-law had accused him, nor moreover that anyone would take such claims seriously. Eakins was grossly mistaken. Stephens, presumably accompanied by his cousin, along with Anshutz and other members of the circle, appeared before a closed session of Philadelphia Sketch Club directors on March 6, 1886. The directors then appointed a special committee of three artists to investigate. It was hardly an impartial group. John Sears, who headed the committee, and Walter Dunk, though former Eakins students, were good friends of the Stephens family. The third member, Henry Poore, also a former student under Eakins, was a close business associate of Frank Stephens' father, the operator of a Philadelphia design studio. This committee, after discussing matters among themselves, requested Eakins to appear before them to answer charges of "conduct unworthy of a gentleman."

Aware of the serious and potentially explosive nature of the accusations, Eakins sought the counsel of his wife's brother, William Macdowell. Macdowell stood in high regard in the Philadelphia business community. He was, in Eakins' estimation, in the same class of worldly sophisticates as Coates and the academy board members. At the very least he would be listened to. The reason Eakins apparently did not seek legal advice, but instead turned to a family member, was the potential impact the charges would have on an already divided Eakins family should Stephens' claims be made public. Stephens was not only married to Eakins' sister, he was living in the Eakins family's Mount Vernon Street home. William Macdowell, along with Will Crowell and Eakins' sister Frances Crowell, believed the matter could be handled privately.

Within days of being notified that a proceeding was under way, the belea-
guered Eakins, with Macdowell's counsel, responded by letter to the Sketch
Club charges. He declined to appear before the investigating committee until
the committee could submit to him a list of specific grievances and charges
made by Stephens. "It would be folly for me to appear before your committee
to answer an indictment the points of which I am not permitted to know in
advance: and it is an injustice on the part of the Club to proceed against anyone
by calling him to appear at a stated time to answer injurious charges which are
not to be stated until the time at which the answer is to be made."

Rather than respond with a detailed list of accusations, the committee
repeated its demand for Eakins to appear as requested. "The Committee have
a very delicate and uncongenial duty before them and I regret to say that if
you refuse to appear before them on account of the technicality which you
set forth that your actions in so doing cannot fail to produce a feeling in your
disfavor," Walter Dunk wrote.

Eakins held his ground. "I could come to no conclusion until something
specific is placed before me in the form of a written statement properly signed
giving the details of occurrences as to times, place, and persons witnessing
the same, and who are expected to give evidence as to the matters alleged
against me."

The artist clearly wanted to avoid the kind of fiasco that had taken place
when he previously appeared before the academy board. He hadn't known
precisely then what it was he was accused of committing. At this point, Eakins
may also have been emotionally unstable. Samuel Murray, a young man who
would later figure prominently in the artist's life, remembered first meeting
Eakins around this time. Murray, the son of a gravedigger, encountered Eakins
wandering in Woodlands Cemetery. Though Murray did not know why, the
artist was obviously distraught. Woodlands was where Eakins' sister Margaret
and their mother Caroline were buried.

Eakins' refusal to appear before investigators until they put detailed
charges into writing prompted the committee to approach Anshutz, Kelly,
Cooper, and the Stephens cousins for written statements. Not one was ini-
tially forthcoming. A member of the committee soon reported back to Sears:
"[They] feel that they have made a mistake in making the charges in the first

place, as they did not appreciate the fact that their assertions would have to be backed by absolute evidence, which they are unwilling to give."

After looking further into the matter, the investigating committee reported that Anshutz, Kelly, and Cooper had backed down and withdrawn their charges. Frank Stephens, and presumably his cousin, did not. "Frank Stephens insisted in pushing the thing to the utmost, regardless of any impropriety he may be guilty of in so doing," the committee reported to Sears.

Frank Stephens at last produced a letter detailing the charges. His statement is no longer known to exist, but based on Sketch Club correspondence and Eakins' rebuttal, his written charges were vague to the point of being useless in further investigating the matter. Stephens agreed to be more specific in person, and arranged for the investigating committee to interview him at the Mount Vernon Street home on May 29, 1886. In what can only be presumed to have been at Stephens' request, Eakins was to be excluded from the proceedings. Representing his interests were William Macdowell and Will Crowell. Benjamin Eakins may also have been present, but Caroline and her sister Frances Crowell were not.

The meeting took place as scheduled. The committee members walked through sharp shadows to the Eakins front door. In the house where Thomas had once painted his beloved sister Margaret dressed in a magenta-trimmed gray vest, their younger sister Caroline stretched out on a colorful brocade carpet, and his father and friends in contemplation over a chessboard and a glass of homemade wine, the dark-suited men's voices fell and rose as they paced in the parlor. Perhaps one of the accusers even occupied the famed portrait chair.

According to Crowell, the author of the only extant letter providing details of this meeting, Stephens initially denied making any specific claims against his brother-in-law. Later in the meeting, however, he admitted to having appeared before the academy's board members and the directors of the Philadelphia Sketch Club and making claims of crimes Eakins had perpetrated on his sister Margaret. The substance of his charges rested on purported conversations he had with Margaret about nude modeling before her death in 1882. Caroline, too, was allegedly told of these events and more by Margaret, though she would not come forward to testify in person or by letter.

Exactly what Stephens accused Eakins of, and when he was supposed to have committed the alleged crimes, is not clear anywhere in the thirty-six-page letter Crowell wrote to Eakins as a follow-up to the meeting. The reason was not necessarily that Stephens failed to be specific. Rather, Crowell thought the accusation too obscene to put into words. He refers to the offense only as the "unhappy business," the "horrid charge," and the "grisly calumny against the honor of the family, living and dead." The inference is that Margaret confided to her teenage sister Caroline that she had modeled nude for Eakins and further-more may have had sexual relations with him. This confidence evidently was communicated to her younger sister as a warning that she should not let the same happen to her.

In Crowell's extremely long and detailed letter, he declared that "the true and only source of the proceedings which have been taken to ruin the life of my brother-in-law" was "nothing higher nor deeper than an intense—I may fairly say—insane, resentment in the minds" of Frank and Caroline Eakins Stephens. Crowell outlined point by point the inconsistencies in Stephens' account of claims of how and when he had heard Margaret's alleged admissions, and he emphasized that it was unlikely that Margaret would have confided such things to Caroline, let alone Stephens, while keeping them from her older sister Frances, with whom she was on more intimate terms.

Crowell's letter further stated: "Maggie Eakins always spoke of him [Tom] with extreme kindliness and liking, mixed with amusement, at what she seemed to consider his extravagant ways of acting and talking and thinking; and very frequently too, tempered with a humorous, half troubled sense of the oppres-siveness of his juvenile personal devotion to her. . . . It was habitual for her to say that she felt like a mother toward him, and to speak of him as a large child. . . . Is it not likely . . . that in her frequent visits to her elder sister, my wife, between whom and herself there was a degree of love and confidence, unusual even with sisters . . . that in some of her very frequent letters, she should have made some allusion to this terrible 'family skeleton'[?] Yet you are asked to believe that she hid this skeleton from her elder sister and entrusted the key of its closet to the youthful Mr. Stephens, and the very young lady, now his wife."

Crowell went on to detail the many years he had known and lived with Thomas Eakins. He openly spoke of once having fallen out with him, and

witnessing various transgressions and incivilities relating to Eakins being, as Crowell said, "openly contemptuous of the opinions and sentiments of others." But never, Crowell said, was there "so much as a suspicion . . . of impure conduct or depraved sentiment" on his part. Crowell hammered this point home, and without hesitation Frances Eakins Crowell and Benjamin Eakins did as well. Crowell wrote, "My opportunities of judging have been such, that if ever one man can be justified in saying that he knows another, I may say of Thomas Eakins that I know he is not, nor ever has been lewd, profligate, or depraved."

Crowell instead offered an altogether different idea. He suggested that the root of differences between Caroline and Thomas Eakins had nothing to do with Margaret. They could be traced to an unfortunate incident in Caroline's early teen years, when Tom—on orders from Benjamin—killed Caroline's pet cat. Crowell implies that the cat was rabid, or at least ill, and beyond saving. Caroline did not agree and blamed her brother for his "callousness" and "disregard" of her feelings. Her distrust in him festered in the intervening years and, according to Crowell, turned to "poison."

Added to the Crowell letter are several signed affidavits on Eakins' behalf that were sent to the Philadelphia Sketch Club and presumably also to the academy. "During all my life I never heard of any act of immorality committed by my brother," Frances Eakins wrote. "I never heard of any such act being even charged against him. There was never any suspicion of him in either my own mind, or in that of my deceased sister. . . . I need hardly add that I consider Frank's charges most infamous, false, and cruel."

Lacking any affidavit or first-person statement by Caroline to judge Eakins' guilt or innocence, the conclusions that Frances Eakins Crowell and her husband reached must be taken at face value. No court of law would have convicted Eakins. At the same time, it is impossible to dismiss Stephens' allegations as completely fanciful. As Foster points out, there existed a sexually charged atmosphere surrounding Eakins' life as well as his art. He had previously encouraged young people to model nude for him and would do so in the future. Moreover, Frances and Will Crowell would later come to regret the implicit trust they put in Eakins when "Uncle Tom" began giving art lessons to their own children.

The paintings and many photographs Eakins made of Margaret provoke further speculation about the nature of their relationship. Invariably, Margaret looks unhappy, almost haunted. A case in point is *Home Scene,* the portrait he painted of her seated at the piano and looking over her shoulder at Caroline, who is lying on the floor. A viewer aware of the tenor of Stephens' charges might not be able to help wondering what Margaret was thinking about while she plaintively looked down at her young sister. Caroline is soon to reach puberty in this painting. It is possible to speculate that Margaret entertained fears about her brother taking advantage of Caroline as he might have with her. Yet it is hard to image Eakins choosing to portray Margaret entertaining such a thought.

Another painting that invites behind-the-scenes conjecture is one of Caroline that Susan Macdowell Eakins made in 1884, two years before the academy and Philadelphia Sketch Club crisis. Macdowell modeled Caroline from a photograph Tom had taken of her sitting in the velvet armchair that figured in so many Eakins portraits. Caroline, in her late twenties and about to be married, is turned away from the viewer, her face partially hidden. At the very least, the photograph gives her an unhappy cast. A viewer might go so far as to say that, as Margaret appears in paintings by her brother, she looks similarly haunted; in light of the Stephens' campaign, her appearance could seem downright tortured. If, as Eakins later said (no doubt with a different purpose in mind), all a person needed to know about him could be found in his art, the seemingly innocent domestic scenes he painted of Margaret and Caroline could, with more factual information, speak volumes. It's just that what is being communicated is both simple and complex, and ultimately unclear.

The truth may never be known. As a result of the inconclusive investigation at Mount Vernon Street on May 29, 1886, the three-member Sketch Club committee decided that the alleged acts in question were outside their jurisdiction. As a precautionary measure, nevertheless, they decided to erase Eakins' name from their membership roll, and no doubt recommended that the Academy Art Club do the same.

Eakins' only recourse at this point would have been to press criminal charges against Stephens for slander. He thought about taking this action, but it was William Macdowell who advised him against it. Macdowell believed

no good would ultimately come of an open hearing. Better that Eakins was accused and found guilty of "conduct unbecoming of a gentleman" than risk the indignity of having "incest" and "bestiality" added to a list of his alleged transgressions and made public. Susan Macdowell, by contrast, believed some further action was needed to protect her husband's reputation, and she devised a plan of her own, though we have yet to know what it was. Her brother William pleaded with her to remain silent, arguing that it would only make matters worse. "Your own worn appearance tells the tale of worry and I grieve that you announce a plan that means no end of trouble except insanity or death," he wrote to her.

The damage already done, however, was becoming more than Eakins could bear. In a letter to Frances he told of people he knew on the street ignoring him. "No amount of good painting," he said, could remove the "stain" on his career. His only consolation was the continued support of his father. Benjamin Eakins summarily asked Caroline and her husband, once she had given birth, to remove themselves from the family circle on Mount Vernon Street, and for Tom, along with Susan, to move home. Eakins, heeding his father's request, and perhaps desiring to show that he and his father were standing together during this family crisis, returned home, accompanied by Macdowell. He kept his Chestnut Street studio, but it was from Mount Vernon Street that his letter writing campaign continued.

"I never in my life seduced a girl, nor tried to," Eakins wrote to Coates in a last desperate attempt to have his case reviewed by the academy officials. "But what else can people think of all this rage and insanity?"

Insanity did overshadow the whole briar-strewn trail of proceedings. Eakins could not shake off the injustice he believed the accusers had done to him the way he could a bad review of one of his paintings. Around this time, the poet Walt Whitman was introduced to Eakins, likely by Talcott Williams, and reportedly spent a long weekend at Mount Vernon Street. Whitman later described the artist then as being "sick," "rundown," and "out of sorts." Conclusions of any certainty about his mental state must be inferred from changes he made to several of the paintings he admired the most, and from a sudden decision, likely recommended by the same physician who had earlier treated his mother's mania, to leave Philadelphia for the Dakota Badlands.

About this time, or later, having no success relieving his anguish with pen and ink in letters, he returned to brushes and paints to express his turmoil. In the privacy of his Chestnut Street studio, Eakins began altering the background colors of *Swimming*. To what was once a rich and varied tonality and bright palette, Eakins added darker, ominous shades of black and brown. By accident, or in a fit of anger, he splashed a caustic liquid over the central figure standing on the rocky pier, and the liquid dripped down onto the diver. Eakins also covered the brilliant blue sky of *The Crucifixion* with a dull gray, and rubbed darker tones into the flesh of Jesus. He added a similar darkening and more to the painting of his wife, *The Artist's Wife and His Setter Dog*. Like Oscar Wilde's fictional portrait of Dorian Gray, which miraculously changes to reflect its subject's inner turmoil, Eakins added years of worry to Susan's complexion. No longer was she pictured as dreamy and a bit melancholy. He made her look haggard, old beyond her years.

thirty-seven

Black Care

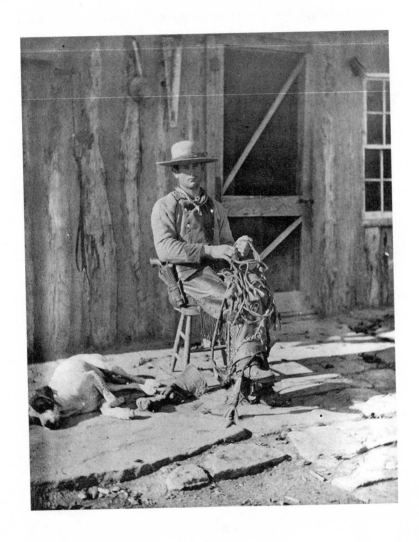

Phidias, too, paid a high price for his art. Legend held that the Greek sculptor rendered a portrait of himself and Pericles on Athena's shield, an impiety that his jealous assistant, Menon, used to betray him. Phidias, accordingly, was sent to prison. Eakins could count himself fortunate in this regard. Had Frances Eakins Crowell and their father not been alive to defend him, "the mischief," Eakins said, "might never have been stayed."

Eakins, at age forty-three, must have tried to banish such thoughts as he boarded a Northern Pacific Pullman car bound for Dickinson in the Dakota Territory in the early summer of 1887. Dr. Horatio Wood, a University of Pennsylvania specialist in the treatment of nervous disorders, likely assured Eakins that leaving Philadelphia for the wilderness of the Dakota Badlands would do him physical and mental good. According to Wood, the "Camp Cure" was the best remedy for what the physician characterized as "the trials and tribulations of city life." A ranchman's "vigorous open-air existence" was certain to restore the troubled artist. The future president Theodore Roosevelt was the owner of the Maltese Cross and Elk Horn ranches near Dickinson and chairman of the Little Missouri Stockman's Association. His duties had taken him through Dickinson several months earlier. He expressed best the healing forces of the Badlands. "Black care rarely sits behind a rider whose pace is fast enough," Roosevelt wrote.

Dr. Horatio Wood had taken the camp cure himself the previous summer on a Dakota hunting trip. He returned to Philadelphia with a financial stake in the B-T Ranch, forty-five miles northeast of Dickinson, Eakins' ultimate destination. Like many easterners, Wood dreamed that his modest investment would earn him a fortune in what Broad Street speculators were calling the "great beef bonanza." Unfortunately for Wood, his cattle investment coincided with the winter of 1886, the worst on record in the Dakota Territory. The first moon of the new year, which the indigenous native population came to call the Moon of Cold-Exploding Trees, had brought with it blankets of snow three and four feet deep, and the snow then piled up into drifts a hundred or more feet high. Thousands of cattle froze to death or were buried alive; the rest starved to death when they were unable to dig through the frost to reach

Opposite: Cowboy in Dakota Territory, 1887; photograph by Thomas Eakins (Courtesy of The Pennsylvania Academy of the Fine Arts, Charles Bregler's Thomas Eakins Collection; purchased with the partial support of the Pew Memorial Trust)

the prairie grass below. Like Wood's neighbors up and down the Little Missouri River, his livestock investment was suddenly transformed into bleached bones that cattlemen were selling for fertilizer. By summer the melting snow had brought the prairies back to life; where several months before the land held countless carcasses of cattle, wildflowers now grew.

A series of westbound express trains brought Eakins to Chicago. He boarded the St. Paul Express for the second half of his 2,400-mile, week-long journey. By sunset on July 25, his train crossed the Red River at Fargo, leaving the settled states and entering the vast unfettered expanse of the Dakota Territory. Lulled by the locomotive's clattering wheels and rumbling across the trestles, and the endless vistas of wide open plains dotted with sagebrush, he must have lost track of time. A day later, as the train finally pulled into the Dickinson depot, he was met by Albert Tripp, the B-T foreman, and Horatio Wood's sixteen-year-old son George, who was working on the ranch for the summer.

Tripp intended to leave by horseback for the Badlands the next morning. Owing to Eakins' trunk failing to arrive with him, the final leg of the artist's journey was delayed. Eakins likely stayed at the Kidder Hotel, where a traveler could have a private room, along with breakfast and a steak dinner, for $1.25. Compared with Philadelphia and Paris, the cities Eakins knew best, Dickinson must have seemed rather starkly the mere cattle-crossing it was. The town boasted the finest hotel west of Bismarck and had its own newspaper, courthouse, laundry, and bank, but the stockyards were what kept it on the map.

The next day Eakins purchased a horse. With Tripp's help, he selected a gray and white mustang, and he named it Billy. "I like my horse very much," he wrote to Susan with obvious enthusiasm. "He is so gentle & bright & intelligent. You ought to see him prick up his ears when hears me coming to give him . . . a blume of gumbo grass."

In Dickinson Eakins was outfitted as well with chaps—a necessity in rattlesnake country. The leather on a properly made pair of chaps was just thick enough to prevent a snake's fangs from penetrating it. Luxuries came later: a buckskin coat, a broad-brimmed hat, bandana, cartridge belt, and a .45-caliber pistol in a holster. No doubt with selections made by his hunting buddy Charlie Boyer, a Philadelphia gunsmith and piano teacher, Eakins brought his own firearms.

The artist's trunk, containing his guns, painting supplies, and photog-

raphy equipment, arrived on his third day in Dickinson. Tripp gave orders that they would depart for the ranch the first thing in the morning. Eakins, in his eagerness to get started, accustomed as well to sunrise boat trips on the Schuylkill, rose at four in the morning and had to wait several hours for Tripp and Wood to arrive. They brought a buckboard loaded with supplies, and Eakins' trunk and other belongings were stowed on board.

The party headed out of town along a sluggish swirl of silver water that constituted the Green River. They saw no sign of human life save for an almost invisible wagon trail running north through the high flat plains. The buffalo that had first brought hunters to the Badlands were long gone. In one year alone, 1872, fur hunters and sportsmen slaughtered more than five million bison. The last scattered remnants of the great herds—a band of around forty bulls and cows—had been hunted down the year before Eakins' arrival.

In the open prairie, Eakins tried out his Winchester rifle on an antelope that same day. "I got a shot at one 400 yards off," he later reported. "The ball must have struck very close by the dust it threw." Instead of antelope for dinner, the travelers ate rabbit.

At the journey's halfway point, near the south fork of the Knife River, rolling hills grew steeper and blue creekbeds became deep ravines. The sight must have been invigorating, in its patches of three-foot-high grass and cottonwood trees and the Killdeer Mountains looming before them. Even this panorama, however, did not prepare Eakins for the environment the party came upon at evening of the second day. As if a curtain had been lifted, the land exploded into an unworldly dreamscape of twisted pale gray buttes and crimson canyons. They slept that night under the stupendous arching of brilliant Dakota sky. Though the ground was damp from rain, Tripp had brought along so many blankets that Eakins slept comfortably—perhaps for the first time in many months.

Like ranches to the west along the Little Missouri River, called by locals the Little Misery, the B-T was nestled pleasantly in a rich bottomland affording a magnificent view of rolling buttes to the west. Nearby meandered the White Tail Creek, where cattle herds grazed. Eakins would always remember the view: rolling lavender hills slashed with mineral and sage layers of yellow, pink, blue, and white.

The ranch contained several low-slung bunkhouses of rough-hewn cedar timbers, a stone fireplace for cooking, a barn and livestock corrals. The main house was little more than a cabin with a chimney for the stone fireplace; here Mrs. Tripp cooked and the men gathered in the evenings around a fire of cottonwood logs. Eakins liked Mrs. Tripp from the start, noting that she was "sick" of the ranch, much enjoyed talking to their neighbors, and did not like speaking to her husband at all.

Beyond the perimeter of clustered ranch buildings, the range was public property. There were no fences. Cattle from several ranches intermingled on the same land and were only separated out during the two major roundups each year. The devastating winter had prevented the spring roundup that year, so summer roundup would have to be all the larger. The cattle, like the cow ponies, were fat and restless, and the ranch hands were eager to get down to work. It was like watching the "Buffalo Bill show every day," Eakins wrote.

One horse for each man was not enough. Eakins bought a second, a white-nosed, large-headed, dark-colored Indian pony, from George Wood, who was returning to Philadelphia after the roundup. Eakins renamed the pony Baldy, and he declared the animal "the ugliest you ever saw but a fine cow horse." In the days ahead Eakins most appreciated Baldy's stamina and gait; they made the horse easy to ride. "I do not get stiff or tired . . . [and] can ride all day and not feel it, but I get sleepy as soon as night comes and sleep right through till daylight."

Eakins later wrote at length to Macdowell, back on Mount Vernon Street, about long rides he took on Baldy. On several occasions he was accompanied by a retired Indian fighter named Charlie Trask. Trask had been dispatched by Tripp to round up horses that had strayed into the Killdeer Mountains. Along their route he showed Eakins a gulch he said was the site of the capture of the great Sioux chiefs Sitting Bull and Rain in the Face. Trask taught the artist how to examine hoofprints and manure droppings to track a horse's whereabouts, and "a hundred significant things that we would never see." Eakins also wrote, "The Indian fighter made a beautiful sight riding on his old Indian war horse," obviously most impressed with his guide's riding. "The man swung on him so easy & graceful he looked like a part of the horse."

Since Eakins had arrived a mere four days before the summer roundup, he did not have time to learn riding and roping skills to make himself as useful

as the cowboys. Tripp, however, was happy to have him along because there was much to do in the way of hauling supplies and preparing camp. Eakins put in so much helpful work that Tripp would not consider taking money for letting him live at the ranch. Eakins reported, "[Mr. Tripp] says I am earning a great deal more than my board."

Fifty or more men from several ranches participated in the week-long roundup. Cowboys rode the perimeters while the cook and Eakins, traveling by buckboard, hauled food, bedding, and other provisions. "The living on the round-up is better in quality than in the palace Pullman cars," Eakins noted. "We eat beef three times every day, and beans & bacon, and canned corn, canned tomatoes, rice and raisins, and everything of the very best. I think you would laugh to see me devour a big hunk of meat lifted out of the big fat pot it was fried in."

Eakins especially liked the people he met, and they in turn also liked him. "I would have trusted any of them without the least fear, but if I had put on any airs I think I would have been hoisted," he wrote. George Wood later reflected on the pleasure of Eakins' company. "Ranch activities were an entirely new episode in the life of Eakins and if it had not been for his geniality and generosity, his ignorance of the customs of the country would have made him an open mark for the cowboy's sense of humor."

The roundup offered Eakins a chance to see much of the countryside, including Medora, home to one of Roosevelt's two ranches; he breakfasted there before riding into Dickinson for supplies. "The town is already full of cowboys and in every direction you see the herds of ponies. . . . Lots more of cowboys and ponies are coming in. Some few horses are shod, the blacksmith is working and all stores are open. Sunday is unknown to cowboys. Their work is just the same every day."

Not long after the roundup was over, Eakins proved himself as a hunter. "I killed a big rattlesnake the other day and will bring home the rattle for Ella [Crowell]," he wrote to his wife in August 1887. He had by this point learned his way about alone. Though he promised Horatio Wood he would not go much beyond sight of the ranch unaccompanied, he soon felt comfortable ranging much farther on his own.

Eakins took photographs of the ranchmen and the open land, along with

many of the ranch's horses and dogs. Thirty-six of his photos are now in the Pennsylvania Academy of the Fine Arts collection, and three prints exist in other collections. He made plenty of sketches, sometimes in tandem with his photographs. The only surviving oil sketches from this time depict cowboys and a mounted cowgirl. Not until Eakins returned home to his studio, however, would he complete an actual painting: he eventually produced four small indoor pictures of cowboy life and three oils and a watercolor of ranchmen in the outdoors.

Cowboys in the Bad Lands (1888, private collection), nearly three feet high and four feet wide, features two ranchmen with their horses standing on a high bluff and gazing out over miles of pale brown hills and tinted green valleys. The moment captured is peaceful, almost tranquil, as the last rays of sun, glowing with a phosphorescent brilliance, fade into an ashen blue-gray sky. The painting is the closest the artist ever came to impressionism, with the possible exception of his Arcadia landscapes. Unwilling or unable to find a buyer for the painting, Eakins eventually gave the canvas as a gift to the architect John Hemenway Duncan. Though Eakins could not have known in his lifetime, in 1971—over eighty years after he painted it—*Cowboys in the Bad Lands* broke all auction records for an American painting when it sold at a Parke-Bernet auction for $210,000.

It was not his artistic work in the Dakotas, however, that aroused his greatest enthusiasm. Eakins loved the cowboy life. On September 26, a Monday morning, he eagerly reported his first Badlands adventure. A stranger who introduced himself as Monte had ridden up to the ranch and was treated to dinner and a bunk for the night. He spent the next morning with Eakins taking photographs of a nearby butte. Afterward, Monte again joined Eakins and the others for dinner, and they launched into singing around a campfire. "He was very merry and gave us a lot of comic songs and tunes on the mouth organ," Eakins wrote. It turned out that Monte had been followed to the B-T Ranch by bounty hunters from Wyoming; they caught up to him on the third day. Monte was in truth Jimmy O'Conner, a horse thief with a three-hundred-dollar reward on his head. He made his escape, and all the B-T ranchmen joined in the chase, except for Eakins, who was left to watch the ranch in case Monte doubled back.

"They tell me my own part is a most useful one," Eakins wrote. "I am to hold down the camp for there's a lot of food here and he cannot live in the Bad Lands [without provisions]. . . . If he should appear I am to hold him up, cover him with my Winchester. . . . If he makes the slightest attempt at resistance or disobedience I am not to hesitate to shoot him as he [is] known to be a cool and desperate villain."

Eakins had his hands full just running the ranch by himself. When twin calves broke out of the stable, he tied a lariat and exhausted himself trying to rope them. He would get within forty feet of the calves, only to see them turn and run. "An animal as obstinate as a calf has no business to look as innocent as it does," Eakins observed.

The thief was captured the next day by cowboys on a neighboring ranch. The Dakotas, Eakins noted, would now have the novelty of a legal trial. "A very short time ago horse thieves were hung as soon as caught," Eakins wrote, now adopting the tone of a seasoned ranch hand.

A humorous story Eakins sent home had to do with visiting a Dickinson gunsmith, who happened to share the same office space as the local bank. Eakins and several B-T ranchmen were sitting on nail kegs near the entrance when an Indian stepped inside and asked the gunsmith to pull a festering tooth. "The old gunsmith rather impatiently told him that he had no tools [to remove the tooth] & the Indian groaned to show his pain. The young [bank] cashier then said 'Dad why don't you pull his tooth for him any tool will do.'" Eakins then described several attempts that were made to examine the tooth, including one with the suffering man's own ten-inch Bowie knife. Eventually extra help was brought in, but the patient by this time had changed his mind. Back at camp that night, Eakins entertained the cowboys with a pantomime of the entire story.

Eakins did not write of missing home the way he had from Europe. That he still loved Philadelphia, however, was clear, and that he fully intended to return was not in doubt. He had the saga of his return already planned out. Baldy, the Indian pony, would be given to the Crowell children. Eakins urged Susan to pass the word on. "The contemplation will give them perhaps almost as much happiness as the pony itself." As for himself, "I will come riding down Mount Vernon St. and you will be looking out for me and then I will bring the

two horses into the yard and show them to Aunt Eliza, and Harry will smell at them as soon as he finds time to get away from me and on Saturday you will go down on the morning train to the farm and I shall ride down stopping at Concord for dinner and getting to the farm in the afternoon."

About to return east, he wrote to his friend and former student John Wallace in Chicago, hoping to meet him there as he changed trains for Philadelphia. As it happened, Eakins missed his train in Dickinson and caught a cattle car to Chicago, putting him two days behind schedule. "We come very fast but stop to feed and let the cattle stretch themselves outside the cars," Eakins reported.

By October the fourteenth he was at the Transit House in the Chicago stockyards; there he met with Wallace before heading on to Philadelphia. He reached the city with his horses on the twentieth. As much as he had relished the thought of showing off his horses and cowboy outfit on his ride home from the train station, he did not arrive in Philadelphia until the middle of the night, and no one noted his passing. The next morning, with a fresh set of clothes and decked out in his full western regalia, he made good on his promise to deliver Billy to his nieces and nephews. Benjamin went along to the Crowell's Avondale farm by carriage. Susan, on horseback, got there ahead of Tom to alert the children.

Excitement among his ten nieces and nephews was everything he had envisioned it would be. "Little Baldy is ridden everyday," Eakins proudly wrote to Wallace. "The school children are allowed to ride him by turns. . . . [On visits to] the village he is met by another crowd of children who would like to ride him. . . . So I have been a public benefactor with the little beast besides giving the children the greatest happiness they have ever had. Nor is the pleasure confined to the children only. My sister is very fond of the little beast and often rides him in the afternoon when she has finished her work and Susie rides him whenever we go down to the farm."

Billy also became a much loved addition to the Crowell farm. He grew so attached to Frances that she was at trouble to keep him from following her into the house. When the door was shut he put his nose against the kitchen window and steamed up the glass.

In the days and months ahead Eakins made repeated trips to the farm,

where he taught the Crowell children to shoot his guns, throw a lariat, tie half-hitches, and splice rope. He frequently arrived alone on the evening train, and slept on a blanket on the floor of the Crowell living room. Young Will Crowell, Jr., fondly remembered him sitting cross-legged on the floor reading scientific books. The children once put a copy of James Fenimore Cooper's *Deerslayer* in his hands; he became thoroughly engrossed until, exasperated, he put it down. The children constantly encouraged him to read *Great Expectations,* but he would have none of it.

Eakins told cowboy stories for years to come. His two-and-a-half-month sojourn to the Badlands, however, was not the therapeutic and transformative experience his physician believed it would be. He had returned rugged, bronzed, yet the demons that chased him to the Dakotas returned with him to Philadelphia. The anguish created by his departure from the Pennsylvania Academy and the break-up of his family had changed the artist in fundamental ways. Except for a short trip to Maine to paint the portrait of a leading physicist, he would never travel away from home for an extended time again. Photography no longer held its earlier interest or possibilities for technical breakthroughs in his art. The oil sketches he made in the Dakotas were the last outdoor canvases he ever painted.

thirty-eight

The Bard of Camden

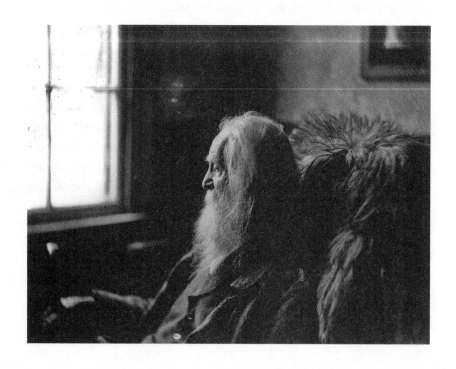

In mid-November of 1888, several weeks after his return from the Dakotas, Eakins and his friend Talcott Williams, known as "Talk-A-Lot," visited another artist, one whose medium was words, Walt Whitman. Whitman, by then a legend, was living in partial retirement a short ferry ride across the Delaware River from Philadelphia, on Mickle Street in Camden, New Jersey. Whitman remarked to Horace Traubel, his young disciple and later his biographer, "[Eakins] seemed careless, negligent, indifferent, quiet: you would not say retiring, but amounting to that." Rather than being put off by the artist's obvious lack of social graces, the aging poet found his unscripted remarks and unconventional behavior refreshing. He invited the artist to paint his portrait. "Mr. Eakins, the portrait painter, of Philad; is going to have a whack at me," Whitman gleefully wrote to a friend.

Whitman and Eakins had encountered each other at least once before, in August or September 1887, as Eakins was in the midst of defending himself from the onerous Stephens accusations. Talcott Williams had become a close friend of Eakins since he had posed for *Swimming*; Williams had been a great friend to Whitman and most likely made the introduction. In 1884, the same year Williams was a subject in *Swimming*, he and other friends of Whitman had shown extraordinary dedication in pooling their resources to buy the poet a horse and carriage, and in organizing a fund-raising campaign that paid the salary for a nurse to care for Whitman and look after his house.

Williams had every reason to believe that Eakins and Whitman would enjoy one another's company. To both, the human body was a marvel of nature's engineering. They each loved animals, especially horses. Boats, rivers, and muscular oarsmen were topics of discussion in the Whitman household as they were in that of Eakins. Both artists also delighted in cataloging and chronicling the accoutrements of modern life, from surgical gauze to the latest steam locomotive. Furthermore, both men were shameless about nudity—their own and others'—and struggled in their art to give it fresh expression. Eakins' works were not banned as were editions of Whitman's *Leaves of Grass,* but only because Josiah Leeds had overlooked his paintings in Philadelphia while Anthony Comstock was crusading against Whitman in Boston. Their chief

similarity, however, did not rest in their respective visions of what constituted high art: it was their passionate devotion to their country and the democratic ideal of egalitarianism, combined with sufficient confidence to disregard the conventions of Victorian America. They were mavericks and outcasts. Even the clothing the men wore was similar, being loose, informal, and unconventional. The baggy pants and ill-fitting sweater modeled by Whitman in the Eakins portrait was likely similar to the attire worn by the artist painting him.

There were, of course, significant differences between the two men. Whitman, at age sixty-nine, was infirm, after suffering a stroke that left him partially paralyzed. He was at the end of his career; in its course he had published more than 500 poems. Eakins, at forty-four, was still trim and youthful. He was about midway through his career—having painted some 250 pictures. Many of his finest portraits were still ahead of him. And though both men loved to catalogue the spirit of the age they lived in—and did so with such memorable impact that these elements became signatures of their respective arts—Whitman opened up immense sweeps of imagery in passages of his poetry, while Eakins primarily concerned himself with depicting individual men and women in the settings most comfortable to them. The painter's work was more specific to time and place, avoiding the greater universe of open skies and what Whitman called "the splendid silent sun." Whitman championed the common man—laborers in the field and in the factory—while Eakins most often exalted the more accomplished of his generation—surgeons and opera singers. "The average man is a nincompoop," Eakins confided to one of his friends.

The most significant difference between them resulted from Whitman's talent for self-promotion. Eakins was a neophyte in this department. Although Whitman, like Eakins, had not earned much income from his art, he was internationally recognized as one of the preeminent poets of his generation. His public success, against all odds, and in the face of several protracted legal battles, was possibly what Whitman's friends believed the painter might most benefit from. The earlier meeting between Eakins and Whitman during the 1887 Stephens controversy may have been arranged to bolster public support for the artist at a critical moment in his life. Talcott Williams surely believed then that Eakins could pick up a few career pointers, perhaps even the bard of

Camden's stamp of approval. (In addition to writing poetry, Whitman some-
times wrote art criticism for New York newspapers.) In this regard their initial
meeting was a success. In September 1887, an article appeared in *North's
Philadelphia Musical Journal* linking their names: an announcement, however
premature, that Eakins would be painting Whitman's portrait. Months, if not
a full year, elapsed before the artist once again made the hour-long journey
across the Delaware to Mickle Street.

Whitman was pleased to see him. "The uncompromising touch of the
plains," Whitman said, had done the artist good. No doubt Whitman's ap-
preciation for colorful stories and risqué jokes, helped to break the ice. On this
trip or on a subsequent visit, Eakins gave Whitman one of the photographic
reproductions of the Gross painting. It was not for another two or three weeks
that Eakins decided to get started on *Portrait of Walt Whitman* (also known as
Portrait of a Poet, Pennsylvania Academy of the Fine Arts). "Eakins turned up
again—came alone," Whitman reported to secretary and biographer Traubel,
taking obvious delight in the artist showing up unannounced on his doorstep.
"[He] carried a blank canvas under his arm: said he had understood I was
willing he should paint me: he had come to start the job. I laughed: to him I
was content to have him go ahead: so he set to: painted like fury. After that he
came often—at intervals for short stretches."

Just after their first portrait session, Traubel wondered about Whitman's
candid opinion of Eakins. "I asked: 'Does Eakins wear well? Is he a good
comrade?'" According to Traubel, Whitman responded in a characteristic
stream-of-consciousness catalogue of observations: "He does: he is: he has
seen a great deal: is not too ready to tell it: but is full, rich, when he is drawn
upon: has a dry, quiet manner that is very impressive to me, knowing, as I do,
its background." Then Traubel asked: "Did you find him to lack the social
gifts: he is accused of being uncouth, unchary, boorish." Whitman replied:
"Perhaps: I could hardly say: 'Lacking social gifts' is vague: what are social
gifts?" Then after further cognition, Whitman said: "The parlor puts quite
its own measure upon social gifts: I should say, Tom Eakins lacks them as, for
instance, it would be said I lack them: not that they are forgotten, despised,
but that they enter secondarily upon the affairs of my life. Eakins might put it

this way: first there is this thing to do, then this other thing, maybe this third thing, or this fourth: these done, got out of the way, now the social graces. You see, he does not dismiss them; he only gives them their place."

Thanks to Traubel, a nearly complete record has been left behind of Walt Whitman's insightful observations of Eakins. The poet's comments ring with a truth that is found in no other recollections of Eakins, during his lifetime or beyond. The critic Mariana Griswold Van Rensselaer, who loved his art but couldn't fathom Eakins the man, might have learned an important lesson. "Eakins was 'no unusual man,' but he did 'not lack the graces of friendship,'" Traubel reported the poet as once saying. "He had 'no parlor gallantries' but 'something vastly better.' At first sight 'he might be taken to be negative in quality, manner, intuition' but that surface impression wears off after a few meetings."

Eakins soon returned the compliments. As he related to one of his portrait subjects, "Whitman never makes a mistake." Opera singer Weda Cook, another mutual friend, a native Camden girl who had known Whitman since childhood, and whom Eakins would paint several years later, remembered the high regard Eakins had for him. In a later interview, she said Eakins often talked with her about Whitman and "would sometimes quote verses of his; particularly about the body." Eakins was not known to have read poetry since the years he had courted Emily Sartain, so Whitman's words must have greatly impressed him. Eakins would, while he stood with brush and palette painting Weda Cook's portrait, recite passages from *Leaves of Grass* with the same ease he had formerly recited Dante. The lines he most enjoyed were about "the hands of the mechanic, the hand of a sculptor, the hand of the surgeon." The aspect of Whitman that most appealed to him, she recalled, was "the realistic; the observation, the truth, the sense of coming direct out of life."

Eakins worked on his Whitman portrait through March 1888, during which time the poet entertained a steady stream of admirers and supporters in his simply furnished downstairs parlor and in his equally spartan upstairs bedroom, surrounded by stacks of books and manuscripts that represented a lifetime of work. Unlike so many of Eakins' other portraits, created in the privacy of his studio, all of his portrayal of the poet took place while Whitman was seated beside a window in his own upstairs bedroom. And unlike previous

portraits of Whitman, most notably one by Herbert Gilchrist, who had painted his less than a year earlier, Eakins' working routine with Whitman permitted the poet to watch the painting come to life in front of him.

Preliminary work consisted of a small oil study. It is unusual for Eakins in that it does not show the whole composition, only the head. The position of the head and the lights and shadows on it are the same as in the final painting. In the oil study, however, Whitman's eyes are closed. He was asleep. Posing in one position can be arduous, and he was old. Though the sketch is only five inches square, it is one of Eakins' most moving and emotionally compelling compositions.

Susan Macdowell joined her husband and Whitman, bringing with her Harry, their dog. On January 8, 1888, she wrote in her diary: "Over to Camden with Tom stop at Walt Whitman to see the portrait Tom is painting of him, we have Harry good dog along with us."

The full-scale portrait in progress—thirty by twenty-four inches—had already, by this time, revealed a different Whitman from any painting or photograph of him before. The contrast with John White Alexander's *The Good Gray Poet* invites the viewer to wonder if the two artists were painting the same man. The Herbert Gilchrist painting bears more resemblance to the one by Eakins, but it is a prettified portrait of the poet. Eakins did not think much of the Gilchrist work, hanging in Whitman's downstairs parlor. "Quite horrible, missing at every point," Eakins remarked.

His finished portrait showed Whitman's ruddy face, flowing white hair and beard, wide collar with lace endings, and his jovial good-humored countenance (plate 26). The poet is clearly a veteran who has lived much of his life in the open, has seen and experienced much and is brimming with memories that cannot be contained. There surfaces, however, nothing supernatural or introspective about him. He gazes at the viewer and does not look inwardly at himself. And as one contemporary critic has noted, the bard has a slight, almost Mona Lisa, smile. His large head is more animated than photographs show him to be. The painting gives no trace of idealization. Eakins painted what he saw: a venerable old man, human and humorous, rich in experience and memories, still vigorous in mind if not in body. Mystic, prophet, the legendary Moses—the taglines Weda Cook and Talcott Williams used to describe their

friend—these personas can no longer easily be found in the Eakins portrayal of Whitman.

On many occasions the poet was asked what he thought about Eakins' painting. He encountered some hesitation when he saw it at first; not so Traubel, who took an immediate dislike to the portrait. To him, Eakins had painted the man and not the soul. Whitman was initially uncertain if Traubel's appraisal was true or not. He had his nurse Mary Davis carry the portrait downstairs so he could look at it in a different light and setting. Eventually the painting was moved so often that it had no single or fixed location. The canvas moved from room to room when Whitman did. On February 28, 1888, Whitman wrote his friend Sidney Morse: "Eakins' 'pict.' Is ab't finished—It is a portrait of power and realism ('a poor, old, blind, despised and dying king')."

Eakins was still making finishing touches on April 15. "The portrait is very strong," Whitman declared by then. "It contrasts in every way with Herbert Gilchrist's, which is the parlor Whitman. Eakins's picture grows on you. It is not all seen at once—it only dawns on you gradually. It is not at first a pleasant version to me, but the more I get to realize it the profounder seems its insight. I do not say it is the best portrait yet—I say it is among the best; I can safely say that. I know you boys object to its fleshiness; something is to be said on that score; if it is weak anywhere perhaps it is weak there—too much Rabelais instead of just enough. Still, give it a place; it deserves a big place."

A day later, on April 16, Traubel reported Whitman making one of his most insightful and most frequently quoted comments: "I never knew of but one artist, and that's Tom Eakins, who could resist the temptation to see what they think ought to be rather than what is."

The same day Whitman moved the painting to yet another location. "Does it look glum?" Whitman asked Traubel. "That is its one doubtful feature: If I thought it would finally look glum I would hate it. There was a woman . . . here the other day: she called it the picture of a jolly joker. There was a good deal of comfort to me in having her say that—just as there was when you said . . . the other day that it made you think of a rubicund sailor with his hands folded across his belly about to tell a story."

On May 10, Whitman was still talking to Traubel about paintings and the

art of portraiture. On Eakins' work he remarked, "He affects the unceremoni-ous—the unflattered. Of all portraits of me made by artists I like Eakins' best: it is not perfect but it comes nearest being me. I find I often like the photographs better than the oils—they are perhaps mechanical, but they are honest. The art-ists add and deduct: the artists fool with nature—reform it, revise it, to make it fit their preconceived notion of what it should be. We need a Millet [Whitman's favorite painter, Jean-François] in portraiture—a man who sees the spirit but does not make too much of it—one who sees the flesh but does not make a man all flesh—all of him body. Eakins almost achieves this balance—almost—not quite: Eakins errs just a little—a little—in the direction of the flesh."

Four days later, on May 14, Traubel found Whitman still obsessing over the canvas. "The Eakins portrait gets there—fulfills its purpose: sets me down in correct style, without features—without any fuss of any sort. I like the picture always—it never fades—never weakens."

On May 15, Traubel recorded Whitman speaking of the Gilchrist and Eakins portraits, saying that they excited in him some remembrance of two paintings of Napoleon. "[One] crossing the Alps on a noble charger, uni-formed, decorated. . . . [Paul] Delaroche, not satisfied with such a conception, took the trouble to investigate the case—to get at the bottom facts. What did he find? Why, first this: that Napoleon rode on a mule—that the mule was led by an old peasant—that the journey was hard, the manner humble—that the formal-picturesque nowhere got into it. . . . Well, Herbert [Gilchrist] painted me—you saw how: was it a success? Don't make me say what I think about that. I love Herbert too much. Then Tom Eakins came along and found Walt Whitman riding a mule led by a peasant."

Whitman, an erstwhile art critic, continued his daily reflections on the portrait on June 5: "Look at Eakins' picture. How few like it. It is likely to be only the unusual person who can enjoy such a picture—only here and there one who can weigh and measure it according to its own philosophy. Eakins would not be appreciated by the artists, so-called—the professional elects: the people who like Eakins best are the people who have no art prejudices to interpose."

On June 8 Whitman was comparing Eakins' portrait to the painting by John Alexander. "Alexander came, saw—but did he conquer? I hardly think

so. He was here several times, struggled with me—but since he left Camden I have heard neither of him nor of his picture. . . . I never liked [the portrait]. I am not sorry the picture was painted but I would be sorry to have it accepted as final or even as fairly representing my showdown. I am a bit surprised too—I thought Alexander would do better, considering his reputation. Tom Eakins could give Alexander a lot of extra room and yet beat him at the game. Eakins is not a painter, he is a force. Alexander is a painter."

By January 13, 1889, Whitman's friends, according to Traubel and others, had openly begun to disparage the Eakins painting. Whitman was described as being "obdurate" in his defense of it. He would have none of their criticism. "For my part I consider that a masterpiece of work: strong, rugged, even daring." As to the criticisms: "We don't care: we'll go on holding our own view: I stick to it. . . . I have told you before, I think, of a speech I heard from Webster: it was years and years ago. He started off with saying: 'I come, not to tell you pleasant things but true things.' . . . It always hits me that way with this portrait: not what he wanted to but what he did see."

Whitman proved his obduracy yet again on February 7. As to Eakins' work in general, he declared: "I should suppose it to be high tide product: his best canvas, his crowning canvas, so far seems to have been the Gross picture in Jefferson College." Traubel then asked Whitman if he had seen the original. The response came: "No: I have not seen it [except in reproduction]—have never been there [to Jefferson]: but I realize its manifold adequacies—its severe face: the counterfeit [reproduction], much as it necessarily must have lost, is convincing."

After Whitman had seen it every day for more than a year, one of his friends, on February 26, 1889, asked the poet if he was still "stuck" on the Eakins portrait. "Yes: closer than ever—like molasses holds on to the jug." On September 10 of the same year, Whitman delighted in Traubel's recitation of how Eakins had once snatched the bracelet off the wrist of a nude model at the academy. "It was just like Eakins," Whitman said. "And oh! A great point is in it, too!"

Eakins continued visiting Whitman, producing several fine photographs of him. One transforming quality of their relationship came soon. Their portrait sessions and talks had a healing effect on the artist, and were surely re-

sponsible for Eakins resuming friendships with many of the people he had known before the academy crisis. Whitman also enjoyed the visits. The poet loved telling visitors about the occasion when Eakins had just finished the painting and had asked, "Well, Mr. Whitman, what will you do with your half of it?" Whitman, no doubt, smiled devilishly, pleased to be intellectually engaged with how the painting might be divided up, and played along by asking which half belonged to the artist. "Either half," was the painter's reply.

Although the portrait stayed in Whitman's house, Eakins at one time borrowed it for an exhibition at the academy (where it hangs today). Apparently Eakins was happy to settle the question of ownership in his own mind: he listed the painting as "Portrait of a Poet. Property of Walt Whitman."

thirty-nine

A League of His Own

Eakins' ten-week absence in the Dakotas and his excursions to Camden did nothing to dampen the enthusiasm of the students who had seceded from the academy to form the Art Students' League of Philadelphia. They had no building—the league simply rented rooms where and when tuition permitted. Nor was a formal curriculum offered other than drawing and painting from the nude—Eakins lectured and gave demonstrations when it was necessary or deemed appropriate. And the students too, like their controversial instructor, were under the scrutiny of the academy board members who had a vested interest in seeing the league fail. Predictions of the school's imminent demise, however, were premature. Classrooms and curriculum didn't define the league or determine the school's success as much as did the character of its instructor and his renegade students, otherwise known as "the boss" and "his boys."

The student who played the most significant role in the school's formation was forty-seven-year-old George Reynolds; Reynolds had, in 1884, modeled as the diver in *Swimming* and in 1886 led his fellow students on the march down Chestnut Street to protest the dismissal of Eakins. His primary challenge in creating the league was not rallying support for its instructor but the more practical concerns of raising the money to rent studio space. Once the renegades fully understood they would be forgoing an education in the most respected and best outfitted art school in the country for a one-room studio without electricity and plumbing, only sixteen of the fifty-five students who had signed the petition made good on their pledge to withdraw from the academy.

Further, Edward Coates and his fellow board members did not make the students' decision an easy one. Eakins had resigned at the start of a new semester, and the committee on instruction made certain that no tuition refunds would be forthcoming. Stirling Calder was one of those students who faced such a dilemma. "I remained at the Academy because my year's tuition had been paid [in full]," he later wrote. Adam Albright, who went on to be a noted landscape and figure painter, continued at the academy for the same reason. "It was with great regret that I forbore to follow the rest of my class in this revolt,

but my tuition at the Academy was paid up in advance to the end of the year, and my finances did not allow for any further investment in art instruction."

Reynolds took such challenges in stride. As a corporal in the New York cavalry during the Civil War, his bravery had won him the highest decoration for a soldier, the Congressional Medal of Honor; he had overcome much greater obstacles. He handled the crisis with poise and equanimity, maintaining a dialogue between the students who left the academy and those who desired to remain. Thanks in no small part to Reynolds, five students who had not signed the petition eventually enrolled at the league. On the first day of classes, held in a rented room on Market Street on February 22, 1886, twenty students arrived to paint the model employed for them, a local newsboy.

Thanks to Reynolds, the league received donations of supplies and equipment, including a collection of plaster casts and art objects that mysteriously vanished, one at a time, from academy classrooms. Reynolds and other students worked with various institutions that were willing to make in-kind contributions. Animals from the Philadelphia Zoo routinely appeared on loan for modeling; a bone-boiling establishment gave skeletons for reference purposes, and a glue factory that league students fondly called "horse-heaven" provided specimens for dissection. On one "collecting" trip, Reynolds and classmates were returning to school with a burlap bag containing body parts from the University of Pennsylvania Medical School. As they passed the Episcopal Cathedral the students—singing lustily and merrily swinging the sack—were stopped by the police. (No doubt they had left a trail of blood behind them.) The suspicious officer insisted on looking in the bag; a good deal of explanation was needed before he would set them once again on their way.

In addition to becoming the league's first curator, Reynolds posed for one of Eakins' first portraits of a student. Despite the antics Reynolds was known to have taken part in, students described him as having a "serious demeanor," which was how Eakins rendered him in 1885 in *The Veteran* (Yale University Art Gallery). Beyond the title Eakins gave to the painting, no indication appears of Reynolds' rank or distinction as a Medal of Honor recipient. The painting's power comes from its subject's dark and penetrating stare and contemplative pose. Reynolds' hair is black, his mustache and beard dark chestnut brown,

his well-worn overcoat mottled gray. The subtlety of Eakins' characterization all together brings the portrait to life.

Reynolds left the league after its second semester, having found paying work as an illustrator for *Harper's Weekly* and *Appleton's Journal.* Fellow classmates lamented his departure, as well as his sudden death two years later in New York. Reynolds' indomitable spirit made the league possible, and his work was carried on by league president Edward Boulton, who put together the school's first business plan and drew up the league's charter. He modeled both documents on those of the New York Art Student League, where students themselves governed the school and elected a board of control consisting of a president, vice president, treasurer, and secretary. Added to these officers were several committee chairmen and three members not holding official positions; the tasks of these three ranged from procuring models to maintaining the classroom. In a school that never had more than forty students and sometimes enrolled as few as twelve, this structure permitted virtually everyone to participate directly in its decisions.

Boulton, like Reynolds, envisioned the league as a place for both men and women. The men who joined, however, outnumbered the women four to one. The disparity was no doubt caused by the earlier furor over nude modeling, and the ever-present fear of scandal that hovered over the league like a storm cloud. Such fears were not imagined. One notable instance took place not long after the league's founding. An undercover reporter from the *New York Times* enrolled with the intent of writing an exposé on nude modeling. He changed his mind, as it happened, and confessed once he discovered that the models were almost exclusively boys and men, and that all students—including him—were expected to study higher mathematics and practical anatomy. Another potential critic of the league, a British artist who like Eakins had studied under Gérôme at the école, was similarly impressed by what he discovered. "If you boys knew how good your school is and the teacher you've got, you wouldn't waste a minute of your time," he declared.

The league's first courses provided day classes in drawing and painting from one to four, modeling three mornings a week, and a special class in portraiture taught by Eakins. Night classes in drawing, painting, and modeling

also were held, though not on a regular basis. No antique classes were offered. Lectures on artistic anatomy and perspective, when given, were open to non-members. Dissection classes too were later offered through the University of Pennsylvania for interested students. Tuition, initially set at twenty-five dollars for eight months, running from late September to early June, had to be recalculated. The fee became forty dollars for the September–June season and was later raised to fifty dollars.

Joining Reynolds, Boulton was an early model. Besides being the subject of an Eakins head and bust portrait (today with the Boulton family of New Preston, Connecticut), he posed for *Cowboys in the Bad Lands,* Eakins' painting featuring two ranchmen on a Dakota mesa. The model for the other cowboy in the painting was Boulton's good friend Franklin Schenck. Schenck replaced Reynolds as league curator and became without doubt the school's resident eccentric and most popular model.

League students—the boys—made an intriguing group. With his long mop of auburn hair, full beard, and colorful bohemian attire, Schenck was part painter, poet, composer, and performance artist—what could loosely be called a Victorian beatnik. His name for himself was Pythagoras, and he might well have been able to read the mystic mathematician's writing in the original Greek, except no one knew what his formal education had been or if he had even been to school. The only time he wasn't broke was when he was paid by someone to pose. He ate only when fellow students invited him out, or when Eakins and Macdowell brought him something from home. His residence was anyone's guess. More often than not he slept on a bedroll he kept in the league classroom beside his guitar and banjo. Fellow students adored him.

At one of the league's anniversary parties Schenck dressed as a ballet dancer, his large feet squeezed into tight gold slippers. By the end of the party he was drunk. When he stepped outside in the freezing cold to say goodnight to the last of the party's stragglers, the wind blew the door closed and locked him out of the classroom, where he had counted on spending the night. Classmates wrapped an overcoat over his ballet costume, brought him tiptoeing over to the Eakins house, and put him to bed.

Another event involved Schenck and a large copper-lined bathtub that Eakins donated to the league after renovating his Chestnut Street studio. Schenck

decided one morning to take a bath, even though the tub's plumbing had not yet been installed. Unable to find a stopper, he stuffed newspaper into the drain and filled the tub, only to discover later that bathwater had leaked onto the floor, through the ceiling, and onto a shipment of flour in a dry-goods store below. An irate shopkeeper marched upstairs and berated the naked Schenck.

Schenck faced further embarrassment after Eakins asked him to take care of emptying the ashes from the league's Franklin stove. A city ordinance banned putting ashes out on Chestnut Street, so Schenck, as curator, had been shoveling the refuse into a closet, which eventually became filled to overflowing. Schenck, leading a party of cohorts, solved the dilemma by hauling the ashes to the roof in buckets and pouring them down adjacent chimneys. The problem was left for others to deal with when they came to work the next morning and found their offices covered in ash.

Though little is now known of Schenck's talent as an artist, he was a fine standup comic who delighted in entertaining his classmates with stories and impromptu musical performances. He became a frequent visitor to the Crowell farm in Avondale; Eakins' nieces and nephews were as intrigued by Schenck as his classmates were. He joined the younger Crowells on an ice-skating trip to Goose Pond, and there related to the children a skating adventure he'd had with a pack of wolves. Whether to believe his tales, the children never knew. During the evening, after skating, Schenck brought out his guitar and banjo and joined Will and Frances Crowell on the organ and piano to play Christmas hymns.

After Schenck left Philadelphia he settled on the north shore of Long Island, New York, where—in the spirit of Thoreau—he built his own house, lived alone, bartered for goods with food he grew himself, and painted romantic landscapes. As his friend the poet Edwin Arlington Robinson wrote, the relationship between Schenck and Eakins was "an illustration of the broad mindedness of the realist and the independence of the dreamer." Eakins responded to Schenck's dreamy quality in the portrait he painted of him in 1890, *The Bohemian* (Philadelphia Museum of Art). "Lustily carolling" was how one critic later described Schenck in the painting.

Another league student, Tommy Eagan, had come over from the academy

with Reynolds and Boulton, and Eakins also painted his portrait, now at the Terra Foundation for the Arts, Evanston, Illinois. Eagan was habitually teased by Schenck. Once, Eagan completed a standard Eakins painting assignment—depicting an egg—and Schenck tacked the painting on the wall, declaring, "Wait till the boss comes!" When Eakins arrived to view the painting, Schenck grandly announced, "Tommy wasn't satisfied with a hen's egg, he's got a goose egg." The boys broke into laughter. Nonetheless, Eakins gave his stamp of approval. "There's good painting there. That's fine."

Eagan, like several academy students before him, was put off by the way Eakins seemed purposefully to take no notice of his work. When it appeared to Eagan that Eakins had ignored him for a full year, a classmate advised him to put on his hat and coat and give up trying to be a painter. Eagan stuck to his studies. Before the end of Eagan's long tenure at the league, Eakins declared that a gladiator he had depicted was the best painting made by a league student.

Unlike for most of his classmates, the league experience overall was hard on Eagan. In an anatomy class, he gave up trying to learn the names of the muscles. Eakins took him aside and taught him a simple memory technique using the Latin derivates. Eagan also was frustrated doing certain exercises. He was asked to put into perspective a large wheel going tilted around a corner, and on another occasion twelve steps of a winding staircase—just as Eakins had been taught at Central High. Eagan finally got it right, but only after an extended struggle.

More than anything else, Eagan was remembered for his quirky observations and enthusiasm for ice skating. Eakins would later say, "He skated as he painted—broad." In his efforts to learn the fundamentals of musculature, Eagan found during dissection a particular tendon that was overlooked in medical textbooks, which he brought to his skeptical instructor's attention. Much to Eakins' surprise, Eagan had indeed made a physiological discovery.

Eagan was remembered, as well, for routinely putting the studio cat on the horizontal stove pipe that crossed one wall of the classroom. The cat would run along the pipe until it neared the hot stove and then make a flying leap, landing on whoever had placed his easel closest to the stove. Eagan's antics with the cat, in time, backfired. When another student, Sam Murray, cut off

the cat's whiskers, Eagan was unfairly blamed and took the wrath when Susan Eakins arrived on the scene.

A hard worker, Eagan labored each summer to earn tuition for school. He eventually became a draftsman and mechanical engineer in Conshohocken, Pennsylvania. A broken hip forced him into premature retirement, and he returned to painting.

Of all the league's students, Samuel Murray was Eakins' favorite. The two had met in 1886, during the Stephens accusation crisis, when the seventeen-year-old Murray happened upon Eakins strolling through Woodlands Cemetery. Murray might well have followed in the footsteps of his father, a grave-digger, had he not struck up a conversation with Eakins and been invited to study at the league. Murray showed up at the address Eakins gave him and approached a group of students standing outside the building. Eagan showed Murray the way upstairs and helped him to get started. Murray never looked back. He devoted himself to art from that day forward.

In the years ahead, Murray grew to be like a son to the childless Eakins and his wife. He loved horseback riding and sailing, like Eakins, and joined him on overnight bicycle trips and on day-long excursions with Benjamin Eakins. He once impressed Eakins' nieces and nephews by riding Billy from Avondale to Philadelphia to fetch ice cream—and returning before it melted. Murray had the privilege of accompanying Eakins to visit Whitman in Camden. He volunteered to shepherd the poet to Harleigh Cemetery, where Whitman was having a tomb built for himself. Knowing the poet's fondness for the monument, Murray photographed the poet standing in front of his own grave. The encounter proved all the more eerie when poet and photographer discovered that the tomb already had a date on it—1890, the year of its commission. Since the poet was still quite alive (he didn't die until 1892), someone had to put the mix-up right with the cemetery staff; the strange task fell to Murray.

Beyond his sporting prowess and willingness to join in the romps with other league students, Murray's Irish good humor was contagious. His specialty was to tell inflammatory anti-academy stories. A particular one concerned a wealthy dowager who had planned to make a substantial bequest to the school. As an academy stockholder she was entitled to free admission to its gallery. Yet when a prickly secretary, for bureaucratic reasons, wouldn't let

her into an art opening unless she paid the twenty-cent admission, she stormed out in a huff and changed her will. Her art collection and fortune then passed as her gifts to the Pennsylvania Museum in Fairmount Park. The museum later moved across the river and became the Philadelphia Museum of Art; there many of Eakins' paintings reside today.

As he did with many of his students, Eakins made a portrait of Murray. *Portrait of Samuel Murray* (Mitchell Museum, Mount Vernon, Illinois), from 1889, captures the young man's boyish innocence and earnest romanticism. His brown hair is combed straight back from his forehead; his piercing green eyes suggest intelligence, while his flowing purple tie, blue jacket, and rumpled collar bring to mind youthful energy and wistful abandon (plate 27).

Once he chose sculpture as his specialty, Murray advanced more quickly than the others. In 1890, with Eakins' help, he obtained a teaching position at the Philadelphia School of Design for Women. He worked under Emily Sartain, who had become the school's principal. Murray ended up teaching there for the rest of his life. He married the school actuary and became one of the city's most sought-after sculptors. His work was featured in nearly every annual academy exhibition for a period of forty-five years, a distinction his teacher Eakins would never achieve.

Murray, however, was not the league student who played the pivotal role in helping future generations understand the behind-the-scenes intrigues that could drive a man like Eakins, who had already endured so much travail in his art and life, to despair. It was Charles Bregler, the league's most self-effacing though dedicated student, who took it upon himself to compile and preserve the cache of personal letters, photographs, sketchbooks, and other documents that academy curator Kathleen Foster and her assistant Elizabeth Milroy eventually tracked down in the home of Bregler's widow in 1985. Bregler never had his portrait painted by Eakins, as many of the other students did, but he was, as one Eakins family friend wrote, "the most faithful of any of his pupils."

Bregler grew up in relative poverty in Asbury Park, New Jersey. His father, a Civil War veteran, died when Bregler was three years old. Out of dire necessity, he went to work at age twelve, selling paper, art supplies, and handmade leather novelties out of his home. His drawing skill earned him a scholarship to Philadelphia's Franklin Institute. At age nineteen he registered at the academy,

where he joined Tommy Eagan in drawing casts and progressed into the life modeling classes. He was twenty-two years old when he signed the petition demanding that the academy board reinstate Eakins.

The notes Bregler took detailing Eakins' teaching methods have in recent decades become the subject of numerous articles and critical studies of Eakins. Judging from the reminiscences he left behind, a high point of his years at the academy was accompanying Susan Macdowell home one day and hearing Eakins' young bride confide to him her lack of experience as a homemaker—she did not know how to cook and clean and perform the duties that were expected of a proper Philadelphia housewife.

Regardless of what talent Bregler may have had as an artist, his veneration for Eakins was unqualified. An example of Bregler's esteem and adoration was his decision to frame and prominently display the only piece of correspondence between him and his instructor that survives. The item was a postcard dated May 15, 1888. It read: "Please don't come tomorrow as I have an engagement / come the next day Thursday if you can." This postcard may well have been the most intimate contact Bregler had with Eakins outside the classroom; not a single other reference to Bregler has turned up in any of Eakins' correspondence, nor was Bregler remembered, except in passing, by fellow league students. Mild, easygoing, and totally unassuming, he was easy to overlook. "I wish you had a little, just a little, deceit and bluff," Murray once wrote to him. "Ability and modesty don't count."

Discouraged by lack of success, Bregler returned to leathercraft and lived in near isolation while he cared for his mentally ill wife. Only later, in the 1920s, did he reenter the life of the Eakins family when he went to work part time for Susan Macdowell Eakins, by then a widow. Among other duties, he catalogued, cleaned, rebacked, restretched, framed, and revarnished the vast collection—two hundred or more pieces—of her husband's unsold paintings and sketches. After Macdowell herself, he became the leading authority at authenticating and pricing Eakins' work, and dealing with collectors interested in it. Museum curators later deplored the relative crudity of his conservation techniques, but he did no major damage to Eakins' artworks, and to his credit he was a determining factor in preserving them for posterity. As one family friend declared, Bregler was the "keeper of the gate."

After Susan Macdowell Eakins died, in 1938, the Eakins family home on Mount Vernon Street was closed up and plans were made to have it sold. All things deemed of monetary value, including Thomas Eakins' paintings, were removed. Bregler, having once been the "gatekeeper," may have kept a key, which was likely how he gained entrance for what he later called his "last sentimental visit" to the house. His primary purpose in going inside, as he later said, was to collect the Eakins armchair and other personal items that he claimed Macdowell had promised to him. Finding the armchair gone—it had been sold at auction along with other furniture—Bregler helped himself to the leftover "debris," as trust agents termed the piles of materials Bregler found lying around the otherwise empty house, apparently destined for the trash.

He gathered up letters, photographs, glass negatives, drawings, oil sketches, plaster casts, and clothing. Among the assortment of memorabilia he retrieved were the letters Eakins had written from Paris and the Dakota Territory, affidavits from William and Frances Crowell, the artist's paintbrushes and cowboy outfit, and an old leather wallet that Bregler presumably had made and presented to Eakins. Not everything that Bregler appropriated came from this collecting journey to Mount Vernon Street; other items were given to him over the years by Macdowell. But the great bulk of the art and other treasures that came into his keeping did—and his preservation of this collection has since proved to be of monumental importance to our understanding of Eakins and his life and work. "These things are all for future students," he prophetically told Samuel Murray. "That is the thought and hope that prompts me to care for them."

forty

Dressed and Undressed

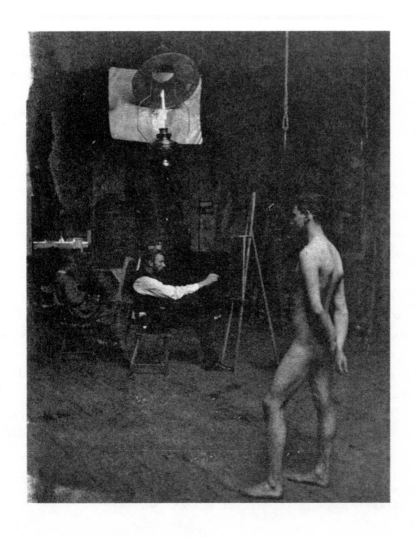

Eakins received no salary from his teaching at the Art Students' League. He surely would not have been able to give freely of his time had he not been invited to other institutions—he lectured and taught part time at five other schools during the seven years the league operated. In New York, he taught at the Arts Students League, the National Academy of Design, and Cooper Union. Closer to home, he gave classes at the Art Students' Guild in Washington, D.C., and at the Drexel Institute of Art, Science, and Industry in Philadelphia. Rather than receive an income from his own Art Students' League, he took home, as Charles Bregler said, "the love and devotion of the students." When Eakins entered the classroom, the refrain was "Hats off!"

The camaraderie that flourished both in and out of the league's classroom developed well beyond the fellowship that existed at the école or among academy students. The main reasons were that the students were few in number, no restrictions were placed on Eakins' teaching methods, and the students in turn worked harder because they had something to prove to themselves and the greater Philadelphia arts community. The letter "E" that Eakins had once bestowed on distinguished work at the academy, the same letter that students proudly displayed on their hats when they marched in protest after his dismissal, now represented membership in an even more privileged fraternity. His students considered themselves part of the Eakins family. As if *en famille,* dressed and undressed, they posed for one another and for Eakins. And in the tradition of Renaissance art schools, the students were permitted to contribute their skills to the master's work. Eakins let his students paint the leg of a chair, or fill in the background for a portrait—as one said, "something that didn't require much art." Eakins, further, helped them solve technical challenges in their work in ways he hadn't the time or inclination to do at the academy. He visited their homes and they visited his. The studio on Chestnut Street was open day and night, and in the later years, when enrollment dropped and tuition was not enough to meet expenses, Eakins conducted classes at his Mount Vernon Street home.

Examples of the lively camaraderie between students became most evident during the league's anniversary celebrations each February. Invariably

Overleaf: John Wright modeling as Charles Brinton Cox sketches at the Art Students' League, with possibly Ella Crowell at left; photograph thought to be by Thomas Eakins, 1886–92 (Courtesy of The Metropolitan Museum of Art, New York)

the league staged a costume party featuring a burlesque performance and concert, complete with a printed program full of what has been described as "excruciating youthful humor." The program for the third annual celebration, held in 1889, announced that "the entire Opera of Faust will be given, with an augmented Orchestra, and Chorus of 1000, on a scale of magnificence never before attempted." Eakins appeared at one anniversary party dressed as Little Lord Fauntleroy; at another, as the celebrated Scottish tenor Harry Lauder, he wore a kilt and sporran and performed a Scottish sword dance. For the 1891 party, billed as a "Round-up," he arrived as an Italian organ grinder. The program highlighted what it dubbed the great finale: "By special request the 'Boss' will give an organ recital, supported by the whole orchestra and connived at by the audience."

Though much was burlesque, not all of the music was. Opera singer Weda Cook, a longtime friend of the league, performed for the third anniversary. The program, now preserved at the Hirshhorn Museum, reads in part:

> *Special Notice*—The audience are requested to
> restrain their indignation, and not to assault the
> alleged performers with deadly weapons.
> 1. The Orchestra . . . will begin the torture with
> one of Bakeovern's Moonlight Snorters.
> 2. Brer Barrow will add to the misery with a song.
> 3. Brer Schenck will intensify the audience's
> longing to go home . . .
> 4. Brer Pollock will empty the room with a tenor solo.
> 5. The Orchestra will perform the Serenade by Titl.
> 6. Brer Spiel will perform a Fantasie by Singeless
> (Not of "The Record")
> 7. Brer Murphy will sing a pathetic song . . .
> During this number sheets will be provided to wipe off
> the tears and tubs to wring'em out in; also, we have
> thoughtfully caulked the floors to prevent the lower stories
> from being flooded, and one of Cox's shoes will be
> moored handily as a life boat.

This and other celebrations lasted long into the night. They took place not only in the classroom and the Chestnut Street studio but at the Avondale farm, where Eakins invited students to come and paint. The Crowell children later fondly recalled Murray helping build a horse-drawn milling machine in the barn and Schenck's capacity to consume large quantities of kidney stew with dark pumpernickel bread. Ella and Ben, riding Baldy, raced Boulton, on foot, across the open field in front of the farmhouse. One year on the Fourth of July Eakins and the students showed up with fireworks. After cavorting in nearby White Clay Creek and enjoying a picnic dinner washed down with a barrel of beer, they set off skyrockets into the summer night.

Eakins often took students to the family boathouse in Fairton, New Jersey, as well, for swimming, sailing, and shooting. He painted one student there in stocking feet. Will Crowell, Jr., recounted one of the group pointing out that Eakins' picture was "all wrong": he should have put a hole in the toe of the student's sock. To everyone's delight, Eakins stepped back to the canvas and made the correction.

All was not fun and recreation at the league, however. A bundle of correspondence, saved from final destruction by Charles Bregler, suggests that the storm of scandal that had driven Eakins from the academy cast a long, lingering shadow into the league classroom. In the painting *Girl in a Big Hat* (1888, Hirshhorn Museum and Sculpture Gardens), Eakins portrayed league student Lillian Hammitt peering intently at the viewer through steel-rimmed spectacles. By all accounts she was everything the painting suggests—a plain-looking, clever eighteen-year-old. According to Susan Macdowell and league students who knew her, Hammitt was also "poor, unhappy [and] demented." Eakins never finished her portrait for reasons that have been chronicled in a comprehensive study Kathleen Foster made of Hammitt and her relationship with Eakins.

Hammitt had enrolled at the Academy in the fall of 1883. Three years later she seceded with other students to form the league, where she was known to have done exceptionally fine work and received favorable mention in the academy's 1887 annual exhibition. Eakins and Macdowell considered her a friend despite their suspicions that she and her companion, Charlotte Connard, were among those earlier academy students responsible for "infamous rumors in-

dustriously spread." To allay any potential misunderstanding—"clearing the air," as Will Crowell said—Eakins invited Hammitt and Connard to read "some paper relating to a criminal conspiracy against me." The page or pages in question could well have been from a transcript of the Stephens allegations. "You industriously made yourself somewhat conspicuous in an unjustifiable attack at the instance of someone more crafty than yourself," Eakins, according to Macdowell, told Connard, and by implication, Hammitt.

Shortly after the league's formation, Hammitt had expressed her desire to go to Europe with Connard to further their art education. Her financial position at the time, and for years to come, precluded making such a trip. Hammitt's father was dead, her mother infirm, and her brother unwilling or unable to help out. A letter she wrote to Eakins from New Hampshire—penned in an uneven and frequently illegible scrawl—suggests, as Kathleen Foster has said, "another kind of instability." Though her feelings at this point were not overtly expressed, Hammitt was in love with Eakins. Clearly, she was also distraught. Hammitt declared that she was looking to get married, for the sake of her own security. Anyone would do. At this stage, Macdowell advised her against such a plan, recommending that Lillian should mix more with people her own age, read less, and attend to her personal appearance. Reading between the lines, it can be presumed that Macdowell believed Hammitt was neurotic, or at the very least socially maladjusted.

Hammitt had continued to correspond with Eakins while he was in the Dakotas, and she rejoined the league on his return. Macdowell's diary notes show that Eakins began painting her portrait at his Chestnut Street studio at this time. Then his work on the picture came to an abrupt halt. *Portrait of Lillian Hammitt,* as the painting was likely being called, would henceforth be known only as *Girl in a Big Hat.* Hammitt had written him an "inexpressibly shocking letter," according to Eakins, which she evidently left in his studio mailbox on February 28, 1888. Her letter was not included in the correspondence that Bregler years later spirited away from the Mount Vernon Street home, but the subsequent response Eakins wrote to her was. Hammitt claimed to have consulted an attorney. Her letter to Eakins announced that she was looking forward with great anticipation to his divorce from Macdowell and her own forthcoming wedding with him.

Eakins was mystified. "That you should have consulted a lawyer as to my getting a divorce is so extravagant that I must excuse it on the suspicion of mental disorder," Eakins wrote to Hammitt on March 2. "You are laboring under false notions and will surely injure your reputation if you give expression to them." He reminded Hammitt of her long friendship with Macdowell as well as his own "many expressions of devotion" to his wife that she had personally witnessed. Eakins recommended that she move to Alabama to be with her mother or live with her relatives in Delaware County, where she could be looked after.

Eakins went on, "I still advise you . . . to give up your little studio especially as the spring opens and go home and work there, and study and struggle as many other young painters are doing. You are strong in many ways and in your little country home, you have around you the sky, the animals, landscapes, [and] a wealth of beautiful materials to choose from. I sincerely trust that time will calm your troubles and that I may again be useful to you in your painting."

Exactly where she went and what she did then is not clear. In at least one instance, witnessed by Murray, she burst into Eakins' studio and threw herself at him. Other students saw incidents that can only be interpreted from their accounts—commonly agreed but not specified—as sociopathic behavior. Correspondence from her brother Charles, in Alabama, alluded to her having earned a "bad reputation," further suggesting that Lillian Hammitt lived in a fantasy world that included Eakins as one of several men with whom she had delusional relationships.

Eakins gave Hammitt train fare home, an action that was later interpreted by her family and her subsequent employer as a way of "ridding himself of her." The truth was likely more complex. Eakins had cared for his mentally unstable mother and was in the midst of looking after his Aunt Eliza, who was suffering from dementia. In later years she needed round-the-clock attention; Eakins installed a trigger mechanism under the carpet in front of her bedroom that sounded a bell when stepped on, alerting family members to her movements.

From these and other firsthand experiences Eakins knew and recognized mental instability and was doing what he believed best for Hammitt. She

needed constant care from people who knew and loved her. Hospitalization was not a reliable and effective means of treatment; the Eakins family may have learned this lesson while treating their own mother.

Later correspondence from the employer and Hammitt's brother suggests that she did eventually board a train for Alabama to care for her ailing mother. After her mother's death, Hammitt—then age twenty-three—took work in nearby Atlanta, Georgia, as a seamstress and domestic servant. Perhaps, around this time, she may have been gripped by an obsession with another man she believed was going to marry her. She desired to gain a teaching position, and was convinced, as she wrote to one of Eakins' Philadelphia colleagues, that "my dear friend Mr. Eakins would I know be very glad to help."

Consequently, more love letters, penned by Hammitt from Atlanta, arrived at the Chestnut Street studio while the artist was busy lecturing at the Woman's Art School of the Cooper Union in New York. In this correspondence Hammitt cited matters that she was talking over with her employer, Mrs. L. B. Nelson. Her main concern was the best way to support herself. Hammitt expected Eakins to bring her back to Philadelphia, presumably to consummate their marriage. Without responding to her directly, Eakins appealed for help from her brother Charles, notifying him of her worsening state. "The condition of your sister Lillian has been for some years a source of anxiety to my wife and myself. Her mind is affected by delusions. The most dangerous one at present is that [she thinks] I am anxious to take her from Atlanta and marry her. She has had similar delusions with regard to other men, but we were so fortunate in one case as to prevent trouble, and the delusion disappeared. The knowledge of her condition now much worse, should I think be confined to as few persons as possible in the hope she may entirely recover."

In closing, Eakins tried to give his letter an upbeat spin. "She has a great talent for painting, artistic training and knowledge, and an intellect unusual in a woman. Her hard study, her sorrows, the nursing of her mother, the death, the disappointments at not earning in Philadelphia at her art a compensation somewhat proportionate to its merit have probably accented [her] mental peculiarities."

Discussions between Hammitt and Nelson, her employer, further embroiled Eakins in an already untenable situation. Hammitt was now talking

about turning to prostitution and nude modeling to support herself, and painting pictures Nelson judged to be profane and decadent. "I am sure he is the one responsible for her erroneous beliefs," Nelson wrote to Charles Hammitt. "She seems completely in his power." Charles concurred. "[Eakins has] turned you infidel, and after getting enough of you now cast[s] you off on the plea of insanity," he wrote to his sister.

Nelson, after studying the Eakins correspondence to Hammitt, and finding what she determined to be evidence of "criminal" intent, took matters even further: she fixed on a plan to blackmail the artist. Either Eakins would be responsible for Hammitt's expenses or she would go public with embarrassing disclosures.

On June 19, Eakins responded to Nelson. "I have from you a letter which assumed that I am in some way responsible for the expenses of a young lady living with you, or that I know parties who are morally responsible, and from whom I might be willing to conspire with you to quickly extort hush money in view of disclosures she had made or might make. You mistake my character and that of the young woman you interest yourself in. Though mentally disordered she is an honorable woman, a woman of intellect and talent, well educated, an orphan suddenly thrown on her resources . . . [and] anxious to earn an honest living in the studio, the workshop, or the kitchen. Philanthropic effort in her behalf can only be directed toward furnishing her suitable employment, preferably in her art where she could easily give people much more than the value of her compensation. Both Mrs. Eakins and myself have long realized the great difficulties in dealing kindly with her, shielding her from the consequences of her many indiscretions and . . . [her] eccentric opinions, but our sorrow at her condition has always outweighed our vexations. I think you extremely injudicious and wanting in tact, an easy arrival at hasty and false conclusions and with the kindest heart and best intentions in the world doing things which cannot afterward be undone, but which entail harm instead of good. . . . Nothing could ever convince her, an old life class student, that there was obscenity in the beautiful body we are told was formed in God's image."

A response to Eakins came directly from Hammitt on July 3, 1890. Nelson had inexplicably left town without paying Hammitt her wages. Her situation, however, was looking up since she had found work cooking and housekeeping

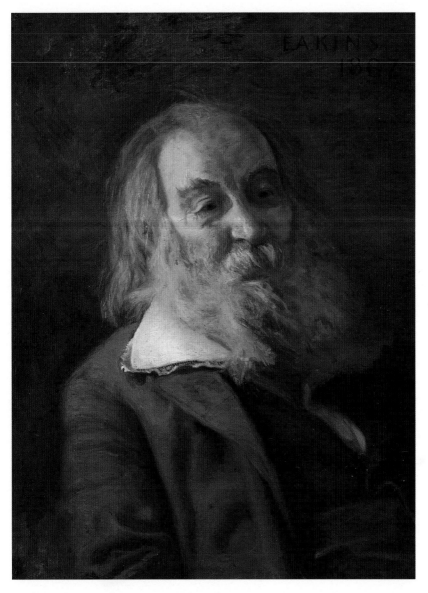

26. Thomas Eakins, *Portrait of Walt Whitman (Portrait of a Poet)*, 1887–88. Oil on canvas, 30⅛ × 24¼ inches. Courtesy of The Pennsylvania Academy of the Fine Arts; general fund.

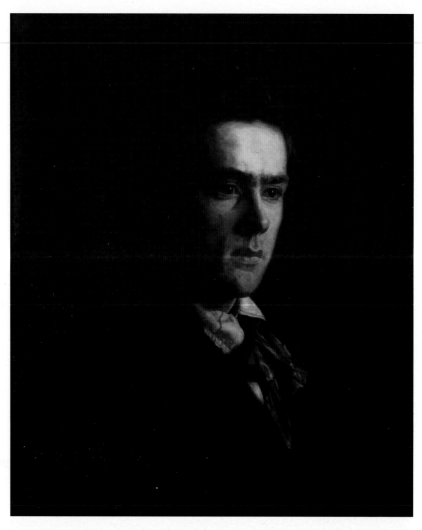

27. Thomas Eakins, *Portrait of Samuel Murray*, 1889. Oil on canvas, 24 × 20 inches. Courtesy of The Cedarhurst Center for the Arts, John R. and Eleanor R. Mitchell Foundation, Mount Vernon, Illinois.

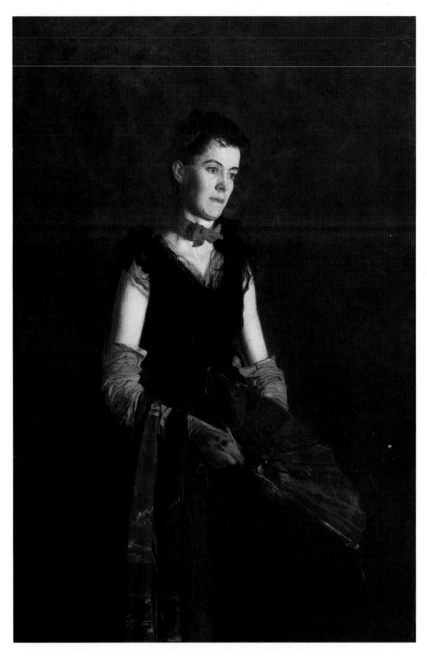

28. Thomas Eakins, *Portrait of Letitia Wilson Jordan,* 1888. Oil on canvas, 59^{15}⁄$_{16}$ × 40^{3}⁄$_{16}$ inches. Courtesy of The Brooklyn Museum of Art, New York; Dick S. Ramsay Fund.

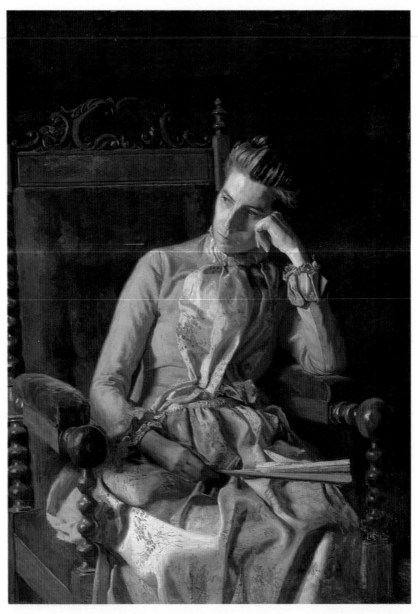

29. Thomas Eakins, *Portrait of Amelia C. Van Buren*, c. 1891. Oil on canvas, 45 × 32 inches. Courtesy of The Phillips Collection, Washington, D.C.; acquired 1927.

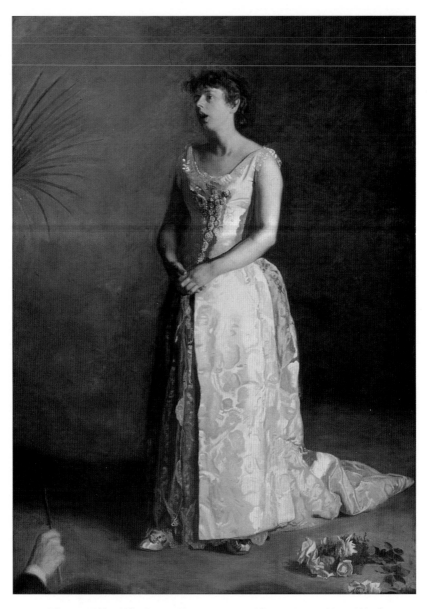

30. Thomas Eakins, *The Concert Singer,* 1890–92. Oil on canvas, 75⅛ × 54¼ inches. Courtesy of The Philadelphia Museum of Art; gift of Mrs. Thomas Eakins and Miss Mary Adeline Williams, 1929.

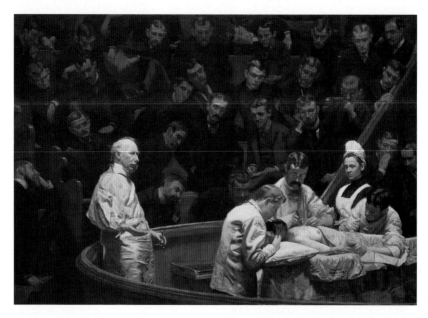

31. Thomas Eakins, *The Agnew Clinic,* 1889. Oil on canvas, 84⅜ × 118⅛ inches. Courtesy of The University of Pennsylvania, Philadelphia.

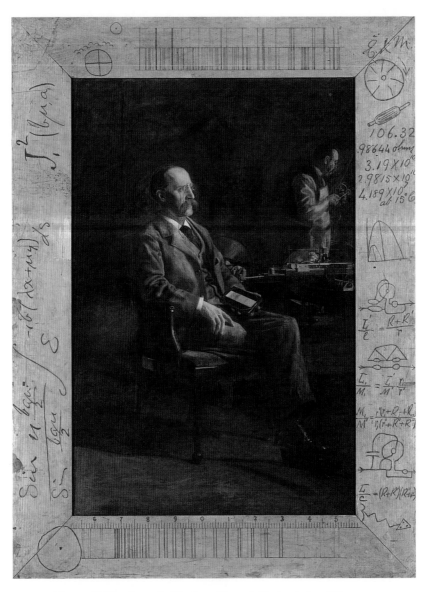

32. Thomas Eakins, *Portrait of Professor Henry A. Rowland*, 1897. Oil on canvas,
80¼ × 54 inches. Courtesy of The Addison Gallery of American Art, Phillips Academy,
Andover, Massachusetts; gift of Stephen C. Clark, Esq.

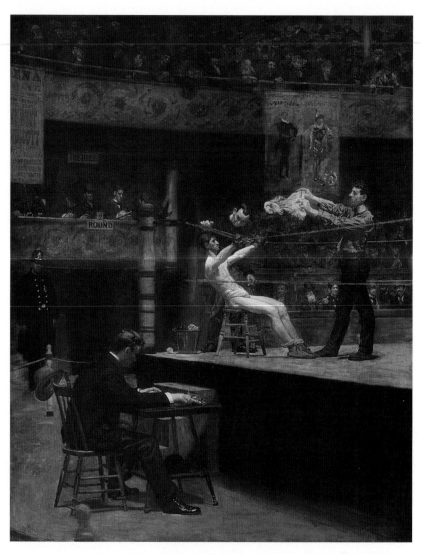

33. Thomas Eakins, *Between Rounds*, 1898–99. Oil on canvas, 50⅛ × 39⅞ inches. Courtesy of The Philadelphia Museum of Art; gift of Mrs. Thomas Eakins and Miss Mary Adeline Williams, 1929.

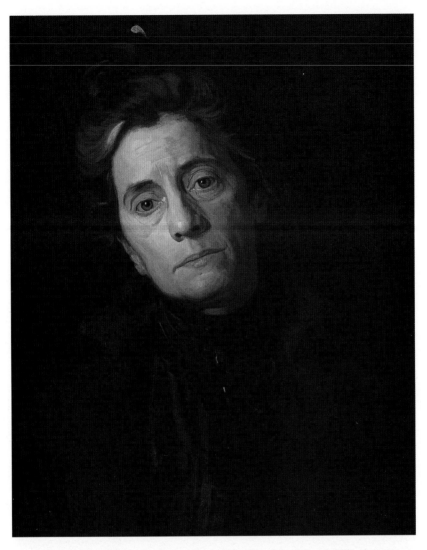

34. Thomas Eakins, *Portrait of Susan Macdowell Eakins (Mrs. Thomas Eakins),* c. 1899.
Oil on canvas, 20⅛ × 16⅛ inches. Courtesy of Hirshhorn Museum and Sculpture Garden,
Smithsonian Institution, Washington, D.C.; gift of Joseph H. Hirshhorn, 1966.

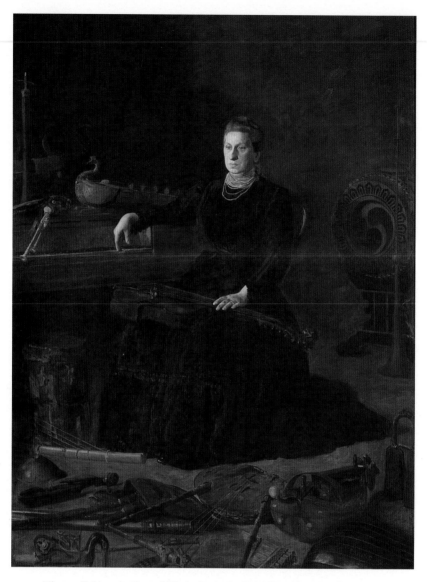

35. Thomas Eakins, *Antiquated Music (Portrait of Sarah Sagehorn Frishmuth)*, 1900.
Oil on canvas, 97 × 72 inches. Courtesy of The Philadelphia Museum of Art; gift of
Mrs. Thomas Eakins and Miss Mary Adeline Williams, 1929.

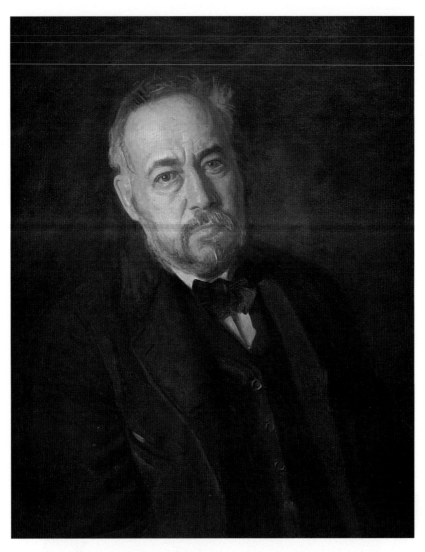

36. Thomas Eakins, *Self-Portrait,* 1902. Oil on canvas, 30 × 25 inches. Courtesy of
The National Academy Museum, New York.

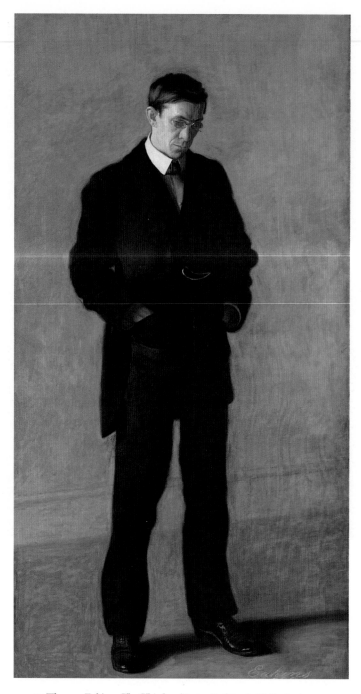

37. Thomas Eakins, *The Thinker (Portrait of Louis N. Kenton),* 1900.
Oil on canvas, 82 × 42 inches. Courtesy of The Metropolitan Museum of Art,
New York; John Stewart Kennedy Fund, 1917.

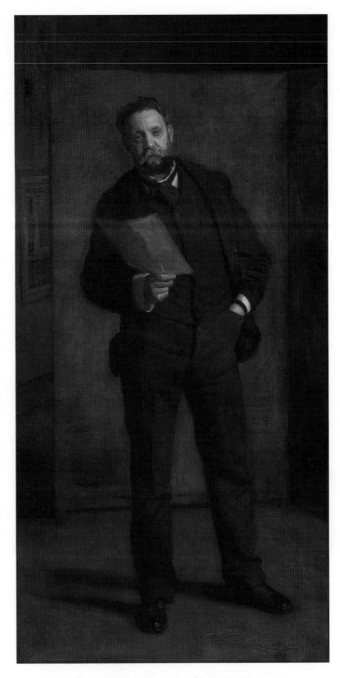

38. Thomas Eakins, *Portrait of Leslie W. Miller*, 1901.
Oil on burlap canvas, 88 × 44 inches. Courtesy of The Philadelphia
Museum of Art; gift in memory of Edgar Viguers Seeler by
Martha Page Laughlin Seeler, 1932.

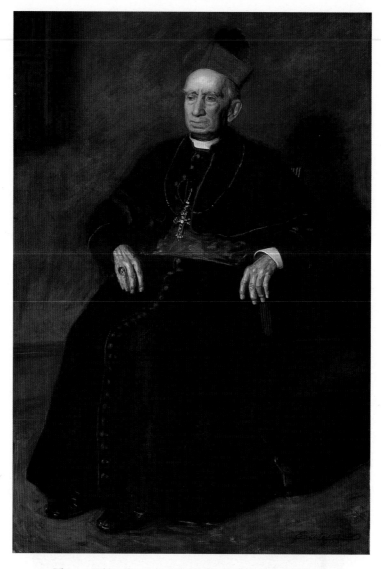

39. Thomas Eakins, *Portrait of Archbishop William Henry Elder*, 1903.
Oil on canvas, 66⅛ × 41⅛ inches. Courtesy of The Cincinnati Art Museum;
museum purchase: Louise Belmont Family in memory of William F. Halstrick,
Bequest of Farny R. Wurlitzer, Edward Foote Hinkle Collection,
and Bequest of Freida Hauck, by exchange.

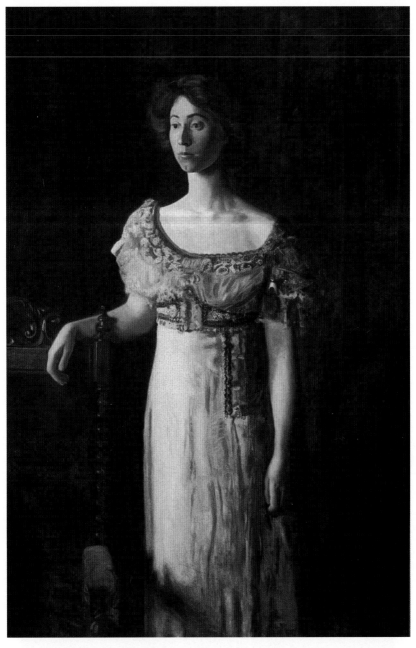

40. Thomas Eakins, *The Old-Fashioned Dress (Portrait of Miss Helen Parker)*, 1908.
Oil on canvas, 60⅛ × 40³⁄₁₆ inches. Courtesy of The Philadelphia Museum of Art;
gift of Mrs. Thomas Eakins and Miss Mary Adeline Williams, 1929.

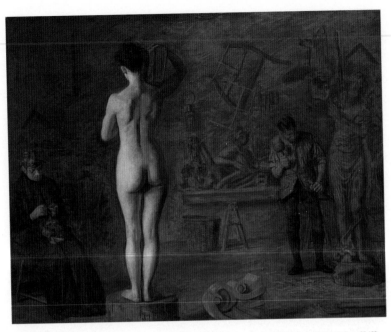

41. Thomas Eakins, *William Rush Carving His Allegorical Figure of the Schuylkill River,* 1908. Oil on canvas, 36⁷⁄₁₆ × 48⁷⁄₁₆ inches. Courtesy of The Brooklyn Museum of Art, New York; Dick S. Ramsay Fund.

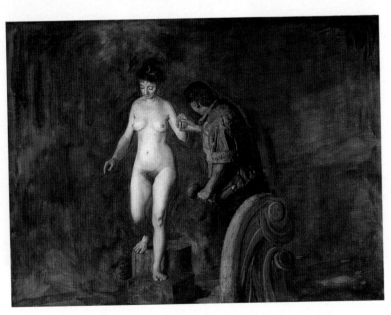

42. Thomas Eakins, *William Rush and His Model,* c. 1908. Oil on canvas, 35¼ × 47¼ inches. Courtesy of The Honolulu Academy of Arts; gift of the Friends of the Academy, 1947.

for a friend of Eva Watson, one of Eakins' former academy students who traveled in the circle of women, along with Elizabeth Macdowell and Amelia Van Buren, who were involved in the nude modeling scandal in the 1870s. In her letter, Hammitt characterized herself as completely sane. Her liberties of speech, like her artwork, were no different from Eakins'—so she claimed—but she was being judged by different standards. Students like Schenck could dress and act the way they wanted and participate in nude modeling exercises and be called bohemian, while she was labeled "insane." The difference, she said, was her gender. "My love is always welcome [to you]," she wrote, in closing. "More than that—always returned."

In the midst of Eakins' continuing drama with Hammitt, on November 30, 1889, his sister Caroline Eakins Stephens died from typhoid fever. She and her brother had never reconciled; no evidence is known that they had communicated since her husband had brought charges against Eakins before the Philadelphia Sketch Club. Her death did not put the family skeleton finally to rest, unfortunately. During the same year, the subject of his alleged indiscretions was on the minds of many when Ella Crowell, age fifteen, and her sister Margaret, thirteen, asked their parents if they could live with their uncle Tom and study art at the league. Frances and Will Crowell were sensitive to their children's desires. Yet they harbored serious misgivings about involving Ella and Margaret, as they said, with the "business of nude modeling."

There remains no question that the Crowell children, without exception, adored their uncle. They had known him since birth, were frequent visitors to Mount Vernon Street, and watched with rapt interest when he painted. Will Crowell set up a painting studio for his brother-in-law to work in when he visited the Avondale farm, and Eakins gave Ella and Margaret painting lessons there; league students, among them young Samuel Murray, also gave them pointers. Murray would remember Margaret, who was called Maggie, as the more feminine of the two, rather delicate, and possessing a talent for landscape painting. In his memory Ella, once the model for Eakins' *Baby at Play,* was more of a tomboy, too restless by nature to become a good painter; what she may have lacked in "painterly disposition" she made up for with enthusiasm. Murray's younger sister, Gertrude, knew her quite well.

In April 1890, in spite of misgivings, the Crowells granted their daughters'

wish to study with their uncle Tom. Frances, writing to her brother with a mother's "anxious heart," expressed her desire that her young girls, "so innocent, and ignorant of every existence of evil," be protected from "the society of young men" and the "necessary Art surroundings." This was not to say, however, that she believed her brother anything less than a first-rate instructor. "There could be no better teacher in that line," she said. Her wish was that Tom should protect them, and that they should never be asked "to pose nude" or "to strip in any way." Yet despite her concerns, Frances was letting them move to Philadelphia to live with their aunt and uncle. "I feel almost as if we were sending them to probable destruction," she added.

Tom did not respond to Frances' first letter; Susan did. In an undated draft (which many people wrote before crafting a final version) of her response, Susan agreed to her sister-in-law's conditions and further to watch over the young girls. However, she urged Frances to listen to her heart. If Fanny sensed future trouble, she should not send the girls at all, or at the very least she should insist that when they lived with their aunt and uncle they should stay out of their uncle's upstairs studio. Art instruction would take place at the league classroom, by then located on Market Street, with the rest of the students. Either Frances did not pass this rule on to her children, or Ella and Maggie were determined to have things their way. After they moved into an upstairs bedroom at Mount Vernon they came to be frequent visitors to Eakins' studio.

Two days after the Crowell girls left Avondale for Mount Vernon Street, Tom wrote his sister to further assure her that they would be looked after well. "That you should feel so anxious over having them go out from you, even as far as here, I will understand, but you can be sure that they will have from me & Susie a watchful and loving care. Yet the dangers you would have me guard them against are no real ones until they pass from our control into the world, if ever they have to, and then I think the better they are educated . . . the better they are armed [and] can resist. I am sure the necessary art surroundings you mention are not coarsening & the society of the young men in the class room is better for them than that of a strictly girls school."

To his mind, what Eakins could give the girls was a sound education. He believed that Ella, who loved animals as unabashedly as he did, might have a future as an animal painter, and, like other forms of portraiture, this specialty

required a thorough grounding in anatomy. He also qualified the promise that Susan had made to his sister in response to her concerns. "Closer observation of the joints and other machinery," he declared in a letter to Frances, would be necessary for the girls' education. They might well have to model and "see any time any part of my body or Susie's, or any professional or private model." The study of the naked figure, he said, was "neither wholly right or wholly wrong," but a necessity.

Her brother's letter must have been most unsettling to Frances. She sent an immediate response (dated April 7) and once again raised the subject of the "nude modeling business," reminding her brother of all the "trouble, estrangement, distress of mind and even disgrace" that had come as a result of his practices. She made it clear that she was withholding "parental consent" for her children to model for him or for fellow students. "I thought you had given up girl students posing," she wrote. "Surely your experience with it was hard, and cost you dear. Think how it broke up two families, how we lost Caddie through it, the misery it cost Papa and all of us, yourself and Susie included. Nothing but evil came of it, sorry and bitter feeling. A strong weapon which enabled your enemies to force you out of your high position and dealt other hard strokes from which you are only just recovering." In closing, she suggested that the girls be sent home, even though they had been living with their uncle for only four days.

The girls did not return to Avondale. Will and Frances Crowell assumed they were not sent home because Eakins had acceded to their wishes—"at least," Will wrote to Tom on April 10, "with reference to their personal posing." He, as his wife had in her earlier letter, reminded his brother-in-law how he had defended him "when every one known to me except your father & Frank Macdowell & Fanny seemed to justify or at least excuse the brutality of the treatment to which you were subject." Will conveyed his feelings in no uncertain terms. He described his brother-in-law as something of a Pied Piper whose "proselytes . . . [run] riot in unjust denunciation" when confronted by the realities of life outside the Eakins studio. The reference here may have been to students like Hammitt, for whom study of the nude encouraged imagination and expectations that ran contrary to the accepted behavior of the times. In sum, Crowell did not want his children participating

in what he described as that "exceedingly offensive agglomeration of pettiness that is called 'Bohemianism.'" Eakins' obsessive "worship of the nude," he said, was "a kind of fetish."

The change in tone from Crowell's earlier letters was remarkable. He had not previously objected to his brother-in-law's practices—he had indeed defended them—until the students were to be his own children. Crowell clearly expressed his misgivings in his April 10 letter. How much more was said in this communication, however, may never be known, because a large section of the existing letter had at some point been purposefully torn away. Events still in the future ended up causing yet another serious rupture in the family, giving every reason to believe that the missing portion of the letter was destroyed before Charles Bregler retrieved the document from the Eakins estate.

Had the Crowells been aware of the prolonged Hammitt drama, Frances' "anxious heart" would surely have compelled her to bring Ella and Margaret home. Instead, a third child, Will Crowell, Jr., followed his sisters to Mount Vernon Street, where he too began studying to be a painter. For the time being, the subject of nude modeling ceased to be a point of contention between the two families. Nor would it become one while the Art Students' League operated. The three Crowell children had ready access to models without having to set foot inside Uncle Tom's studio.

forty-one

Portraits by a Modern Master

Two years after her last correspondence with Eakins, Lillian Hammitt was committed to a psychiatric hospital in Norristown, Pennsylvania. The potential for a full-blown scandal posed at that time by her delusional mental condition was thus averted. Ella and Margaret Crowell's art education was proceeding without any problem; the girls mixed freely and happily with other league students. Eakins for his part would look back on his league years as a time of professional renewal. Beyond the many portraits of his students, he made several paintings that helped him regain a foothold in Philadelphia society.

Portrait of Letitia Wilson Jordan (Brooklyn Museum of Art), which Eakins made in 1888, was the result of a chance encounter he had at a party with the younger sister of David Jordan, a friend and former academy student. Judging by the portrait Eakins painted of her, Letitia Jordan was striking; she has a sheen of black hair, drawn back, a high forehead, hazel eyes, full red lips, and a warm golden complexion (plate 28). Eakins first spotted her standing on a staircase in a floor-length black evening gown. She wore long buff gloves, a red ribbon around her neck and a scarf across her arm, and she held a delicately embroidered gold fan in her hands. The next day Eakins asked her brother if she would model for him dressed as he had seen her the night before.

The resulting painting became the first formal portrait the adult Eakins made of a woman outside his immediate family, close friends, or students. No record has been left of how long she modeled or how she viewed the experience. All that can be said comes from the painting, augmented by what critics of the time thought of it. Eakins gave Letitia vitality, individuality, and substance; what he did not contrive on canvas was the kind of polished beauty that made John Singer Sargent the most sought-after portrait painter in New York that year. To be "done by Sargent," for the princely fee of five thousand dollars, was considered a rite of passage among members of high society. Though Letitia Jordan's black evening gown, red bow, buff-colored gloves, and fan were details found in many Sargent portraits, the resemblance ended there. Eakins made no concession to an idealized form of his model's thoughtful and captivating appearance. Jordan—in her mid-thirties—is presented without a fashionably prominent bosom (possibly due to her posture or dress) and with a slight

Overleaf: Eakins in his studio at 1330 Chestnut Street, c. 1892; photograph by Susan Macdowell (Courtesy of the Gordon Hendricks research files on American artists, 1950–77, in the Archives of American Art, Smithsonian Institution)

double chin. Critics no doubt referred to such aspects when they described her portrait in such terms as: "painted, apparently, with that unsparing realism for which Mr. Eakins is famous."

Eakins never finished *The Black Fan—Portrait of Mrs. Talcott Williams* (Philadelphia Museum of Art), another painting he began around this time whose subject was a woman standing in a long evening gown and carrying a fan. The attractive, gracious and ever-elegant Sophie Royce Williams, forty, wife of Eakins' friend Talcott Williams, was shown in a floor-length oyster-white taffeta dress, her head tilted a little to the left. No doubt Eakins thought Mrs. Williams was as remarkably lovely as he had thought Letitia Jordan. But Mrs. Williams did not share his vision when she saw the nearly completed portrait, and she refused to return for further modeling. Elizabeth Dunbar, biographer of Talcott Williams and also a friend of Eakins, offered another explanation. "To end a lie of nearly half a century I am telling you this incident as told me by the artist," Dunbar wrote. "Mrs. Williams had been posing and the work was nearly finished. One day a man at the head of the Delsarte movement [a once popular method of dramatic training based on bodily deportment] came in for a moment and at sight of him Mrs. Williams tucked in her belly and stood like a stuffed manikin. When the caller had gone nothing could induce her to resume the original pose, whereupon Mr. Eakins—big child as he was—gave her a tap and said, 'don't hold yourself in here.' Whereupon she flounced off and told ... [her husband] she had been insulted." Many years later Talcott Williams, who had come to adore the portrait of his wife, tried to buy the painting from Eakins, but the artist repeatedly declined to sell it to him. (After Eakins died, art appraisers valued this painting higher than all but one of his portraits of female subjects, at three times the usual price for his work.)

Eakins painted yet another woman holding a fan in 1891. *Portrait of Amelia C. Van Buren* (Phillips Collection, Washington, D.C.) portrays the young woman whose modeling in the nude had caused such a stir at the academy four years earlier. She is shown in a pink dress seated in Eakins' Jacobean-revival chair (plate 29). Her lean, brooding face, aquiline nose, and black hair streaked with gray give the painting a melancholy air, in striking contrast to her bright and delicately patterned pink dress with its lacy white ruffles. Van Buren's rotated but graceful pose is the quality that pulls the viewer into the painting. She

looks off to her right, toward the light, leaning her head on one hand while the other rests in her lap holding the barely opened fan. The painting—given what is now known or at least speculated about Van Buren's sexuality—presents her as Eakins must have seen her, and how, as the viewer might empathize or guess, she thought of herself. Van Buren is unhappily lost in thought, trapped and vulnerable as a caged bird. As Edwin Austin Abbey said, when asked why he refused to sit for Eakins, "He would bring out all those traits of my character I have been trying to conceal from the public for years."

Amelia Van Buren lived at the Mount Vernon Street home while Eakins rendered her portrayal, and she became a frequent houseguest and close friend of Susan's sister, Elizabeth Macdowell. She eventually gave up her own painting and turned to photography. To her dying day she loved the portrait Eakins painted of her, and she turned down substantial overtures from buyers before finally agreeing to part with it in 1927. "I accept your offer," she wrote to the collector who purchased it from her, "and while I shall miss the picture I shall like to think of it in your gallery where I hope to see it sometime soon. Mr. Eakins' friends have always been sure that his work would be appreciated in time."

Of these works, the best known and perhaps most loved portrait Eakins painted of a woman was *The Concert Singer* (Philadelphia Museum of Art), featuring the twenty-three-year-old opera performer Weda Cook. Set against a warm golden-green background, Cook stands center stage, singing in a low-necked sleeveless pink gown trimmed with lace and pearl beadings (plate 30). A floral tribute of roses, the color of her dress, rests on the floor in front of her trailing gown and pink slippers. Toward the lower left can be seen the hand of a conductor with a baton, in the upper left a palm frond. It all has been painted with loving detail, including a wrinkle across her bodice. A visitor to Eakins' studio one day asked why he had included it. Eakins replied, "Why, what's the matter with that? It's there, isn't it?"

Similar to his portraits of Letitia Jordan and Sophie Royce Williams, Weda Cook is not peach-blossom comely. Her nose is a little bit upturned, her face and hands are somewhat fleshy and ruddy in complexion, and her chin recedes. Yet Eakins has captured with mastery a living image of an altogether beautiful, vital, and believable woman, one who is fully engaged in the act of singing. This painting, his second largest known image of a woman, has a

claim to being Eakins' most sensuous female image. Cook is painted at life size (she was five feet two inches tall) on a canvas more than six feet high and four and a half feet wide. To compare *The Concert Singer,* which he completed in 1892, with *Singing a Pathetic Song,* the painting of Margaret Harrison from 1881, for which he used a combination of photographs and live modeling, is a revealing way to see how far Eakins had come in portraiture. The important elements—form, light, and color—are finely balanced. Cook is solid, modeled convincingly in the round, yet light and bursting with life.

The stories told by students and other artists of Cook's posing are many. Eakins' usual custom was to demand silence from his sitters. It was not the case with Cook. He would ask over and over to hear her sing an aria from Mendelssohn's *Elijah,* "O Rest in the Lord." His avowed purpose was to observe the muscles of her mouth and throat so he could closely capture her form in singing. "I got to loathe [singing the aria]," she later admitted to Lloyd Goodrich, Eakins' first biographer.

Having to sing the same song repeatedly, however, was not the reason she stopped modeling for Eakins before he completed the painting. It took another two years for him to finally brush in the last detail, her pink slipper showing from beneath her trailing gown. (Eakins accomplished it without Cook's help—he jury-rigged a model by hanging her dress over the slippers.) She broke off posing because Eakins was trying to talk her into modeling nude for him. The artist made his eyes "soft and appealing" and dropped into using the Quaker vernacular of "thee"—employing "gentleness combined with the persistence of a devil." Assisted by Murray, Eakins did manage to persuade her down to her underclothes, but Cook refused to go any farther.

Besides Murray, the sculptor William R. O'Donovan was present at many of Weda Cook's posing sessions. O'Donovan, another friend of Walt Whitman's, was completely smitten with Cook; so too was league treasurer Francis Ziegler, who claimed to have been in love with her his entire life. O'Donovan was so taken by her that he brought flowers on the days she came to pose for Eakins; the roses that appear in her portrait are from him. "He fell in love with me, the old fool," Cook said of O'Donovan.

A final detail about the painting bears mention. The hand with the baton was originally painted from a league student holding a paintbrush, but the

position of the baton and the hand gripping it didn't fit the rest of the picture. Eakins painted the hand over a number of times before he finally resorted to hiring a professional to wield it for him. Charles Schmitz, one of the city's leading musicians and the conductor of Philadelphia's Germania Orchestra, held the baton for Eakins in the exact position his hand would be, signaling Cook as she voiced the last notes of the aria. To make clear what he was doing by posing the baton in this way, and in capturing Cook's exact pose, Eakins carved the musical notes for the opening bars of "O Rest in the Lord" right into the chestnut frame in which the painting was mounted.

Eakins also made many fine studies of men around this time. Beyond the portrait of Walt Whitman and those of his students—paintings of Murray, Boulton, Schenck, and George Reynolds are among those that stand out—he portrayed his friend Horatio Wood, the physician from the University of Pennsylvania who had arranged for the artist to visit his ranch in the Dakotas. *Dr. Horatio C. Wood* (Detroit Institute of Arts), likely painted in 1889, is a full-length portrait showing the subject seated at a mahogany desk that is covered with scholarly books and papers. Wood rests an arm on the desk and holds a pen. The painting is not entirely successful, conveying an unsettled quality about Wood's posture. It is possible that Wood could not sit still for long; Murray remembered him as very nervous indeed. During lectures he took out his watch, laid it down, picked it up again right away; then he put it back down only to repeat the sequence a few minutes later.

A second University of Pennsylvania physician appeared in *Portrait of Dr. Jacob Mendez Da Costa* (Pennsylvania Hospital). When it was finished, in 1892, Da Costa made it no secret that he did not like the result and asked Eakins to paint another; and Eakins did the following year. The doctor was unhappy to discover that the second was similar to the first. Despite what Da Costa and his friends thought about it, Eakins was of no mind to glamorize his subject. "It is, I believe, to your interest and to mine that the painting does remain in its present condition," the artist wrote to his subject. "I do not consider the picture a failure at all or I should not have parted with it or consented to exhibit it. As to your friends, I have known some of them whom I esteem greatly to give most injudicious art advice and to admire what is ignorant, ill-constructed, vulgar, and bad. . . . I presume my position in art is not second to your own in

medicine, and I can hardly imagine myself writing to you a letter like this: Dear Doctor, the concurrent testimony of the newspapers and of friends is that your treatment of my case has not been one of your successes. I therefore suggest that you treat me a while with Mrs. Brown's Metaphysical Discovery."

Eakins had an altogether more rewarding experience painting *Professor George W. Fetter* (private collection). This painting, honoring the principal of the Philadelphia Girl's Normal School, was commissioned by his pupils for the twenty-fifth anniversary of his principalship, and was presented by them to the school on February 3, 1890. Murray remembered Fetter's habit of arriving for his sessions with a box of oyster crackers for Eakins' dog, Harry. He loved watching Eakins line the crackers up in the shape of an H, which Harry would then gobble up. Fetter's young students often accompanied their professor to Eakins' studio to watch the artist paint. They were equally impressed with Harry. A line drawing of the Fetter painting appeared on the front of the 1890 program for the year-end ceremonies when students presented Fetter with the portrait. On the program's back page was a picture of Harry with the letter H spelled out before him in oyster crackers.

Portrait of Talcott Williams (National Portrait Gallery, Smithsonian Institution) is believed to have been painted around the same time as Fetter's portrait. The journalist is portrayed in a conservative dark coat and tie; his head, featuring a chestnut brown mustache, is turned slightly to the left. It is unique among Eakins' many portraits for having traveled so far from Philadelphia. Unlike the portrait the artist had begun, but not completed, of Talcott's wife, Williams liked his painting so much that he carried it with him to Beirut, Paris, London, and elsewhere on newspaper assignments.

Portrait of Rudolph Hennig, also known as *The Cello Player* (Pennsylvania Academy of the Fine Arts), painted in 1896, was one of several portraits Eakins made of musicians playing instruments. This one was noteworthy for Hennig's reluctance to pose for the artist. He agreed only on the condition that he practice playing his cello while sitting for the portrait. In the final painting, three of the four strings of the cello rise in a straight line. The fourth string, which the bow touches, is vibrating.

In these and many other portraits, the artist was exploring the character and seeking a truth in representation of the people who sat for him. They

contain a striking and palpable bodily presence. Like Renaissance masters before him, Eakins accomplished his task so successfully that his portraits stand out today as brilliant views of reality in another age. He has captured the underlying structure of a sitter's bones and muscles, the forms of the body beneath their clothes, and of their heads and hands.

Eakins created a similarly strong presence and more in *Frank Hamilton Cushing* (Thomas Gilcrease Institute of American History and Art, Tulsa, Oklahoma), painted in late 1894 or early 1895. Cushing was a pioneer ethnologist known for his studies of Native Americans. Eakins incorporated Cushing's achievements directly into the painting.

Eakins met the thirty-eight-year-old Cushing when he visited Eakins' studio to have some pottery mended and casts made of Native American artifacts for display at the archaeological museum of the University of Pennsylvania. The celebrated ethnologist had collected the artifacts during the five years he lived at the Zuñi pueblo in New Mexico. He had been adopted as one of the Zuñi people and given the privilege, rare for a nontribal person, of initiation into their priesthood. Hardships he underwent in New Mexico had resulted in failing health, and he arrived in Philadelphia to be treated at the University of Pennsylvania Hospital for chronic stomach problems.

Cushing, whom Murray described as "gentle" and "reasonable," speaking in a "beautiful voice," was portrayed by Eakins in the costume he wore in New Mexico—a combination of the traditional garb of a Zuñi priest and a western cowboy. He wears buckskin moccasins and a dark blue head scarf; his deerskin trousers and leggings gleam with silver buttons and scarlet garters. Draped with turquoise necklaces and an accompanying earring, Cushing holds a war club and flourishes an array of prayer feathers. Behind him a feathered spear and Zuñi headdress lean against a shield that displays the Zuñi iconography of a sacred bird above bolts of jagged lightning. Even if the exotic outfit and setting were removed, this subject would appear imposing. With long brown hair and an auburn mustache, Cushing presents the viewer with a thoughtful yet strong face disfigured by smallpox and many "tortures," as he named them, that he claimed were the price he had paid for acceptance by the Zuñi.

As with many Eakins portraits during the league years, students took part in the painting's creation. They helped outfit the studio as a pueblo,

complete with fireplace and floor of pressed clay bricks. Eakins even had a fire burning during modeling sessions to capture the effect of smoke in the room. Gertrude Murray stood in to wear items of Cushing's outfit when Cushing himself couldn't come to pose. Like her brother, she listened with delight and fascination to Cushing's many stories retold from the Zuñi. Zuñi tales, Cushing said to her, always ended with "Thus shortens my story," or "Thus long is my story." Her brother preferred hearing about life in the pueblo, especially a story of the U.S. government shipping canned food to the reservation. Not knowing that what was in the cans was food, the natives emptied the containers to use them as decorations. Charles Bregler described Cushing's recital of Zuñi prayers as "beautiful music." When the painting was completed, Cushing helped Eakins give it a unique frame made of rough-hewn molding tied with leather thongs and decorated with a carving of a macaw, the sacred bird of the Zuñi tribe.

Cushing, in turn, was entertained by a menagerie of pets. Eakins kept a monkey that he named Bobby, and the monkey did not get along with all of the cats that also had the run of the studio. If a cat got too close, Bobby bit it. If Bobby targeted a cat that was out of reach, he would try to club the feline with whatever was at his disposal, taking "fiendish delight," as Eakins liked to say, "if it hits."

The artist followed Cushing's portrait with a painting of his wife, Emily Magill, titled *Mrs. Frank Hamilton Cushing* (Philadelphia Museum of Art). In contrast to her husband's, Magill's is a three-quarter-length portrait of her in a black evening dress with short puff sleeves, her bare arms resting in her lap. As Murray remembered, everything about her was small and fragile. His words for her were "peach" and "baby doll"—but also "cantankerous." Magill did not revel in studying the Native American life as did Cushing; her idea of a meal was not his camp provisions of jerked beef. She had returned to Philadelphia before her husband.

Impressive as these unique paintings are, they are not the work future art critics and historians would most associate with Eakins during his years with the Art Students' League. *The Agnew Clinic,* begun in 1889 and painted in a mere ninety days, was the largest and possibly the most ambitious painting Eakins would ever create.

forty-two

Horrors of the Dissecting Table

The history of medical portraiture in Philadelphia began more than a century before Eakins dropped out of medical school to turn his full attention to live modeling classes at the Pennsylvania Academy. No other artist, however, painted more portraits of the city's physicians or did more to celebrate their values. During the forty years between the artist's painting of the chemist and physician Howard Rand in 1874 and his unfinished rendering of anatomist and brain surgeon Edward Spitzka in 1914, Eakins portrayed twenty-five Philadelphia physicians. Although *The Gross Clinic,* his masterpiece from 1875, may be his most brilliant, *The Agnew Clinic* is the most monumental. The painting, now displayed at the University of Pennsylvania School of Medicine, is nearly six feet high and eleven feet long. Dr. Hayes Agnew, professor of surgery at the University of Pennsylvania and president of the Philadelphia College of Physicians, is the principal subject. Contained within the painting are thirty smaller portraits of doctors, medical students, interns, and spectators, as well as Agnew's nurse, his patient, and an image of Eakins himself (plate 31). Not for another half century would an artist, Furman Finck, attempt such an ambitious construction of a Philadelphia operating theater.

Dr. Agnew had been a professor for twenty-six years at the University of Pennsylvania Medical School. In February 1889, on the eve of the seventy-year-old surgeon's retirement, the university approached Eakins to paint him. A native Pennsylvanian and son of a respected Philadelphia physician before him, Agnew had earned distinction for supervising the Hestonville Military Hospital during the Civil War and for serving as medical consultant after a mentally disturbed gunman shot President James Garfield in 1881. Medical experts assigned his three-volume *Treatise on the Principles and Practice of Surgery* as required reading at the University of Pennsylvania Medical School and many other institutions, including Pennsylvania's chief rival, the Jefferson College of Medicine. Physically strong and tall, Agnew evoked high regard from students for his boundless energy and clear, concise explanations of complex concepts and procedures.

In keeping with the custom for retiring faculty, the University of Pennsylvania commissioned a portrait that was to be presented to Agnew at the year's closing exercises. Eakins was well acquainted with the annual event, as his

father had inscribed hundreds of the school's diplomas over three decades. And since Eakins had known Agnew for almost twenty years and had recently painted his colleague Horatio Wood, he was the natural choice. The commission was to paint a full head-to-foot portrait, for $750, a sum to be gathered by subscription from Agnew's students. Eakins had a more ambitious plan in mind. Though he would have only three months to complete the assignment, the artist proposed that he depict Agnew in the midst of surgery and that he include, without added cost, images of Agnew's students viewing the procedure in the operating theater.

Eakins' proposal was warmly received. After several trips to Agnew's weekly demonstrations at the theater, Eakins quickly sketched the painting's general features and painted a small preparatory oil. Later, back in his studio, he made a far more detailed study of the surgeon (Yale University Art Gallery). Eakins' vision for the painting was not unlike his concept for *The Gross Clinic,* only it was designed not vertically but horizontally, a format that would make it easier to bring Agnew's students into the composition. The design would show the surgeon and his medical team in the operating pit with students and spectators seated around and above them in tiered rows of bleachers. Working with extraordinary energy, Eakins launched into the painting. He cast Agnew in an attitude, or posture, that by then had become an archetypal Eakins pose: the surgeon was captured turning, gazing out and away (and one could say profoundly inward at the same time) from the operation in progress.

The operation he brought into view on the wall-sized canvas today is known as a partial mastectomy, or lumpectomy. Eakins must have known he was treading in slippery territory by graphically portraying a partially nude female undergoing such a procedure. It is difficult to say why he chose this particular operation; few written records about *The Agnew Clinic* exist. Eakins did not discuss the decision with his students, and Agnew, who died not long after the painting was finished, left no clues in his personal papers. The lack of such documentation has led, in no small part, to numerous and diverging interpretations of the painting. Among scholars and students of gender studies, *The Agnew Clinic* is one of the most hotly debated of Eakins' works.

The most extreme interpreters of *The Agnew Clinic* suggest that Eakins was consciously or subconsciously expressing a hatred of women. The semi-

nude, anesthetized patient, stretched out in a submissive posture in a room full of men, falls under the complete control of Agnew and his team of male surgeons, who mutilate her breast. To such interpreters, Eakins is reacting to harbored emotions, convinced of treachery on the part of female students who had modeled naked for him at the academy, betrayal by his sister Caroline, and harassment due to Hammitt's insanity. They purport that Eakins was suggesting, in effect, that his life and career would be better off if women looked and acted like men. Removing a patient's breast, the most prominent and vulnerable symbol of a woman's femininity, was the artist's way of evening the score.

Theorists alleging a misogynist message in the painting point to a statement that Eakins had made earlier: "Great painting or sculpture or surgery will never be done by women." They also cite Agnew's own adamant opposition to higher education for women. In 1871 the physician had resigned from the University of Pennsylvania rather than allow female students to attend his lectures; he eventually agreed to a compromise and the university reinstated him in 1877, but his opinion on the subject did not change. His biographer wrote, "[Agnew] believed that the ideal for women was at home."

From another perspective, arresting as it may be to read misogyny into *The Agnew Clinic,* the argument seems difficult to sustain, and may have no more basis in fact than would attaching a homosexual bias to *Swimming* and Oedipal paranoia and castration anxiety to *The Gross Clinic.* Eakins considered the human body, male and female, the most beautiful form on earth. And although a current of male bias was abundantly evident early in Eakins' career, his attitudes toward women's education had changed considerably. Among the sweeping innovations he had brought to the academy in 1880, and later to the Art Students' League, were equal rights for female students. His activism in this regard could balance the scale in considering possible motives behind the painting. Interpreting literature by presuming to plumb an artist's intent from the finished work has been considered an intentional fallacy in literary criticism, and the same principle certainly applies to visual art as well. Yet one can infer, associate, find levels of resonance and suggestion; this approach allows for an assertion that comes, in addition to the artist's will, from the artwork itself in the making.

Agnew's bigotry must also be placed in context. He discriminated against

women in education; but he was unique among the city's preeminent physi-
cians in his support of women's health concerns. An example among many
is his adamant opposition to women wearing corsets, which he rightfully be-
lieved, as we know today, to be injurious to a woman's body, if not her psyche
as well. It might be said that he did not hate women in a polemic way. As pa-
triarchal and patronizing as it also seems today, he likely felt he was motivated
by a desire to protect and liberate them. Agnew declared before his retirement,
"A modest-minded physician would naturally shrink" from the task of expos-
ing young women to the "unpleasant sights and facts" of medical science. His
biographer concluded that Agnew "held the [female] sex in great respect and
consideration, and did not belittle their powers of capability for work."

The misogynist theory about Eakins' painting is further diluted by the lack
of emphasis on femininity or eroticism in the patient portrayed, the solemn
demeanor of the male spectators, and, most of all, the presence in the paint-
ing of Agnew's female nurse, Mary Clymer. Unlike Hughey O'Donnell, the
male orderly in *The Gross Clinic,* Clymer was a professional. The year that
the painting was made she had graduated from the University of Pennsylvania
School of Nursing at the top of her class and received the Nightingale Medal
in recognition of her talents. Clymer is presented as dignified and alert. She
does not writhe in agony as the patient's mother understandably does in *The
Gross Clinic.* Her presence appears calming, in the manner of Vanuxem's
chaperone in Eakins' portrait of the sculptor Rush. Agnew's patient is not in
pain, and neither is Clymer.

The work's design is another argument against a radical interpretation
of its subject. In contrast to *The Gross Clinic,* the operation is easy to read.
Although a surgeon, holding the patient's left breast, swabs the incision, Ea-
kins does not force the viewer to study the gruesome details to understand
what is taking place. Remarkably little blood appears on the patient's chest.
Eakins spares viewers the brutal specifics of removing the bloody tumor. Had
Agnew or the artist conspired to portray carnage, they could have depicted
the scene with far more graphic detail.

Rather than depicting a grisly event, invoking hatred of women, the paint-
ing portrays an advanced surgical procedure. To have selected a lesser surgery,
such as the removal of a bullet—the operation for which Agnew was best

known—misses the work's point of demonstrating the advances in medicine as the surgeon's legacy. Nearly every surgeon who had earned credentials during the Civil War developed a reputation for bullet removal and amputation. By the 1880s, bullet extraction had become such a practiced procedure that a surgeon of Agnew's standing would not have devoted one of his weekly demonstrations to it. Removing a festering tumor from a woman's breast, as the procedure is presented in *The Agnew Clinic,* was both innovative and daring.

The pathology of metastases and mammary carcinomas were just beginning to be understood in the late 1880s. The general rule, as put forth in the textbooks of the time, was "better out than in"; it was "safer, therefore, always to excise the entire breast or both of them." A radical mastectomy, however, is not what Agnew and his team of surgeons are shown doing. Judging from the painting itself and surgical commentary in the historical archive at the Philadelphia College of Physicians, Agnew was conducting what would later become known as a partial mastectomy. The surgeon's purpose was to remove as little of the glandular tissue as possible, taking only what was "ulcerated and foul smelling." As Agnew freely admitted, the experimental procedure, then rather than now, rarely saved the patient's life, but neither did removing the entire breast. The debate over how much or little to remove would be carried on into the twentieth century and to the present.

The modernity of the procedure for the era is further emphasized by the physicians' white surgical smocks, an innovation adopted by the University of Pennsylvania two years earlier. Female patients, like their male counterparts, could surely regret the length of time it took Philadelphia surgeons to accept the principles of Listerism, which had been put into practice in Paris as early as 1876; but the use of antisepsis in the performance of operations had finally been embraced. The days when Dr. Gross wore his "lucky jacket" and his surgical team dressed in dark everyday clothing was gone.

Beyond Eakins' attention to the prefiguring of modern science, and what may or may not have influenced his decision to represent breast surgery, the painting is altogether straightforward. Agnew, holding a scalpel in his left hand (the surgeon was ambidextrous) stands to the left side of the scene; his medical team is positioned over the patient on the right. Dr. William White, who was to succeed Agnew in the university's chair of surgery, and later have his

retirement portrait painted by Sargent, applies the dressing to the patient's left breast. Dr. Joseph Leidy, whom Eakins would paint again the following year, is pictured taking the patient's pulse; the young Dr. Ellwood Kirby administers anesthetic. Like Agnew, they posed for Eakins in his studio, where league students had constructed a mock operating room.

All the encircling spectators have been identified over the years as members of the University of Pennsylvania Medical School class of 1889. Eakins did not predetermine their positions in the painting the way he did the surgeons; where they were placed arose from the students' willingness and availability to model for the portrait. This circumstance led to much bickering among the students. Those who made substantial contributions toward Eakins' fee believed they should have a more prominent position in the painting than their classmates. Disagreements among them ultimately resulted in his full commission remaining unpaid for nearly a decade, until all the students made good on pledges. Eakins was finally paid the $750, with interest.

In the process of making the portrayal, since the canvas was too large to be mounted securely on an easel, Eakins laid the stretchers, or backing framework, on wooden strips on the studio floor and worked on his hands and knees. The creation was intensified, and further complicated, by the short time Eakins had to complete the canvas, given his expansion of the university's original idea to focus only on Dr. Agnew. He painted from early morning until late into the night. When he became too tired to continue, he took a couple of hours for a nap on the floor—as Charles Bregler once found him—and then went on. The long schedule of toil took its toll. Eakins came down with the flu and had to be put to bed, losing precious time.

Agnew reportedly spent a considerable time posing for Eakins. Though invariably he showed up and said, "I can give you just one hour," he gave as many poses as were needed. After the portrait he regularly visited the Chestnut Street studio and the league classrooms. On one visit, he found Murray suffering from an infected finger. Dr. Leidy, to whom Murray had already shown his wound, had wanted to cut his finger open. Murray refused and went back to the league classroom. Agnew was more sympathetic to his wish to avoid having a scalpel probe the wound. He gave Murray a dime and sent him down to Fluke's Pharmacy at Juniper and Chestnut to buy vinegar. The

bohemian Schenck heated the vinegar, Murray soaked his finger, and the treatment was a success.

The only aspect of the painting that Agnew objected to was the depiction of blood on his scalpel and hands. Eakins argued that the blood had to remain for fidelity to truth; Agnew ordered the artist to paint it over. Agnew had heard, no doubt, of objections that Gross encountered after that surgeon's portrait went on display and was not about to risk having the same shocked reactions attach to his reputation. Eakins obeyed the order partially: blood still spots the surgeon's gown, but none is shown on his hands.

League students and others helped Eakins complete this commission on time. Macdowell later described how she stepped in to add the miniature portrait of her husband, standing at the far right just inside the entrance to the operating theater, listening as a physician whispers in his ear. Schenck's hands and knees were painted for a medical student who did not arrive at Chestnut Street on time. Murray's contribution was to build benches and a mock operating pit in the studio. He made a statue (now part of the Hirshhorn Collection) that could be of Eakins in the midst of painting *The Agnew Clinic*. The sculpture shows him cross-legged on the floor with a palette and brush in his hands.

Eakins, according to accounts passed down in later years, completed the painting, once he started on the large canvas, in ninety-six hours. The stories give an image of someone working at white heat. Despite the constraints of adding so many students to the scene, he had masterfully achieved a delicate balance between Agnew, the portrait's subject, and the operation taking place. Agnew, standing to the side, dominates the composition but does not overpower it. He is given a presence of intelligence and dignity. His medical team, the patient, and the nurse, standing to the right, provide the counterweight. The student spectators provide the background. Each is a unique character study in a distinctive pose. A particularly attentive student takes notes, another leans forward to better observe the operation, a third provides whimsical relief to the rows of intent faces—he appears to be sleeping.

While the painting succeeds in recording an essential enactment of Agnew, his students, and the operation, it cannot compete with *The Gross Clinic* as a view of a cinematic moment. By comparison, *The Agnew Clinic* is merely a

motion picture set; Eakins does not so much enshrine a moment as merely present one. The viewer's eye is not forced to search for meaning and subtlety, because the faces of all the principal players and the procedure taking place are clearly seen. No pools of light and shadow form contrasts, nor does a delicate range of fine and broad brushstrokes create nuance. Eakins' power to guide his viewer through events as they occur, a skill that could in a sense be compared with Frank Capra's talent behind a motion picture camera, is nowhere evident.

Yet Eakins can justifiably be forgiven his lapse of technique—he spent more than a year working on *The Gross Clinic* and only ninety days on *The Agnew Clinic*. Moreover, the surgeons' white smocks, the white shroud of linen that binds the patient, and the harsh overhead lighting presented another dimension of challenge. The tragedy for lovers of Eakins' work is that *The Agnew Clinic* is the last of the artist's daring tributes to the achievement and self-discipline of a fellow Philadelphian.

Eakins mounted the painting in a plain wooden frame into which he carved an inscription (in Latin): "D. Hayes Agnew M.D. The most experienced surgeon, the clearest writer and teacher, the most venerated and beloved man." Eakins' painting then went on display at Philadelphia's Haseltine Gallery, and on May 1, at year-end ceremonies held at the Academy of Music on Locust Street, the university presented the painting to the physician. "This is our Agnew day," declared the spokesman for the graduating class. A veil covering the portrait was lifted and loud cheers of "Agnew" echoed throughout the auditorium.

Agnew and his students and friends received the painting well. The tribute that Eakins most appreciated was related to him by league student Tommy Eagan, who chanced to encounter Agnew's housekeeper as she viewed the canvas. She stood transfixed. "He must be a great painter to be able to paint him that way," she declared.

Public reaction to *The Agnew Clinic* did not bring praise along with condemnation as had *The Gross Clinic*. The work was greeted, as one critic would later say, by "resounding silence." Eakins did, however, have reason to be hopeful: the Pennsylvania Academy asked him to submit *The Agnew Clinic* for its forthcoming 1891 annual exhibit. Four years had elapsed since he had

any official contact with the school, and the artist likely viewed the invitation as a sign that animosity toward him had relaxed. Eakins took the request at face value and made the submission, only to hear from the hanging committee, at the last moment, that it was rejecting *The Agnew Clinic*. The grounds were that the painting had previously been shown at the Haseltine Gallery.

The committee's letter reached Eakins on January 31, after the show had opened. It informed him that "every member of the Artist's committee . . . regrets that your portrait of Dr. Agnew was not hung, particularly as we had [previously] decided before soliciting the picture that its having been seen in the Haseltine Gallery was not to render it ineligible." Four days later Eakins walked down Broad Street to Cherry and into the academy's administrative office to query Edward Coates, who was now chairman of the school's board. Eakins pointed out the obvious: the academy had decided its admissibility before requesting that Eakins submit the canvas, and several other paintings in the annual show had previously been exhibited far more widely than *The Agnew Clinic*. One in particular had been mounted in the window of the Earles Gallery in Philadelphia for three months. Another had appeared at an Art Club exhibit held at the academy. Coates told Eakins, in confidence, that the academy had "other [undisclosed] reasons for not wishing to hang the picture." Members of the board "thought the picture not cheerful for ladies to look at."

The following year the painting was rejected for exhibit by New York's Society of American Artists, prompting Eakins to sever his long-standing relations with the organization. "For the last three years my paintings have been rejected by you, one of them the Agnew portrait, a composition more important than any I have ever seen upon your walls," Eakins wrote. "Rejections for three years eliminates all elements of chance; and while in my opinion there are qualities in my work which entitle it to rank with the best in your society, your society's opinion must be that it ranks below much that I consider frivolous and superficial. These opinions are irreconcilable."

Eventually, *The Agnew Clinic* was offered for view in a much larger public forum. In 1893 it was shown along with *The Gross Clinic* at the Chicago World's Columbian Exhibition's display of American works. Philadelphia's correspondent there, for the *Public Ledger*, declared that "the advisability of

including his portraits of Dr. Agnew and Dr. Gross, which are merely excuses for depicting the horrors of the dissecting table, will be severely questioned." A second critic, from the *Art Amateur,* was even more stirred. "It is impossible to escape from Mr. Eakins's ghastly symphonies in gore and bitumen. Delicate or sensitive women or children suddenly confronted by the portrayal of these clinical horrors might receive a shock from which they would never recover. To have hung the pictures at all was questionable judgment. To have hung them where they are [in the main gallery, where anyone could see them] is most reprehensible."

The unveiling of *The Gross Clinic* provoked intense discourse about the portrait's value as a work of art. Eakins the artist was now ignored altogether, though he figured in the controversy by omission. At issue was not only the painting's graphic subject matter but the sullied reputation of the man who had created it. Even the most open-minded critic, Mariana Griswold Van Rensselaer, would not give him a column inch.

The forty-five-year-old Eakins had previously given up outdoor painting and the innovations of photography. After the extraordinary effort and intensity he had mounted for *The Agnew Clinic*—even bringing in his family of league students—only to see the work rejected and savaged, his paintings henceforth were to be portraits only, with little if any accompanying detail about their subject's place and contribution in the Philadelphia community. Nor would Eakins ever again paint a portrait that showed his subject in the complex, evocative moment of overtly "turning away." Eakins was now the one who turned away, and more. In the Max Schmitt portrait, the artist portrayed himself rowing on his beloved Schuylkill River. The Gross portrait prominently shows him seated in the first row of spectators, witnessing the drama of a breakthrough in surgical medicine. The Agnew portrait has Eakins standing at the door to the operating theater, looking downward, next to one of the physicians.

After the portrait's rejection from the academy exhibition, rumors about the artist and his work were traded in all corners of polite Philadelphia society. "[People are saying] Eakins is a butcher," Weda Cook reported the artist telling her, with tears in his eyes. "They call me a butcher, and all I was trying to do was to picture the soul of a great surgeon."

The failure of *The Agnew Clinic* to find a receptive critical audience, and

Eakins' failure to anticipate the psychological impact in his time of a second painting chronicling a graphic surgery, coincided with a gradual demise of the Art Students' League. The older students who earlier had formed the league to protest Eakins' resignation now left to pursue their own careers. Arthur Frost, George Reynolds, and Franklin Schenck migrated to New York. Frank Linton embarked for Paris to study at the École des Beaux-Arts under Gérôme. Francis Ziegler became a reporter and art critic for the *Philadelphia Record*. Younger Philadelphians, who knew Eakins only by reputation, chose to study at the academy, where impressionism was now part of the curriculum. Diminished revenue from tuition forced the league to give up renting a classroom. The league continued during this time by operating out of its instructor's Chestnut Street studio.

forty-three

Casting for Commissions

Eakins welcomed his students, especially the dynamic Sam Murray, into his studio. Murray's preference for sculpture proved fortuitous for both master and pupil. Increasing national wealth, along with renewed patriotism driven by American expansion, spurred a proliferation of new public buildings and monuments celebrating the nation's arriving as a world power. The decade before the turn of the new century, the time when Murray, under Eakins' tutelage, first began molding his first clay images, would become known as the golden age of American sculpture and mural painting.

More Italian stone masons were employed in New York City than in Rome. Chicago, which had risen like a phoenix from near total destruction by fire in 1871, emerged in 1893 as the embodiment of the nation's desire for grand and celebratory sculpture. Critics who condemned the display of *The Gross Clinic* and *The Agnew Clinic* at the Columbian Exhibition marveled at the "grandeur and magnificence" of Frederick MacMonnies' elaborate fountain and gilded statue of the Republic rising from the reflecting pool of the exhibition's "Court of Honor." A thoughtful witness of the age, Henry Adams, who shared Eakins' taste for realism in art, found the MacMonnies sculpture garish and distasteful. "I am puzzled to understand . . . the inward meaning of this dream of beauty," Adams wrote—but the twenty-seven million people who visited Chicago were spellbound.

Determined to help "the boss" recapture the momentum of his earlier career and to make the most of a bull market, Murray may have urged Eakins to use his credentials as a former student of the celebrated Dumont to obtain a sculpture commission. An opportunity came his way in January 1891 through New York sculptor William O'Donovan, who had grown to be friends with Eakins in the late 1880s while the artist was painting *Portrait of Walt Whitman* and *The Concert Singer*. O'Donovan had agreed to produce reliefs of Abraham Lincoln and Ulysses S. Grant for the Soldiers' and Sailors' Memorial Arch at the entrance to Prospect Park, in Brooklyn, New York. He subcontracted Eakins, assisted by Murray, to create two statues of horses for incorporation into the heroic sculptures.

Opposite: Samuel Murray, Thomas Eakins, and William O'Donovan in the studio on Chestnut Street, 1891–92; photograph attributed to Susan Macdowell Eakins (Courtesy of The Pennsylvania Academy of the Fine Arts, Charles Bregler's Thomas Eakins collection; purchased with the partial support of the Pew Memorial Trust)

O'Donovan's Lincoln and Grant reliefs were to be installed on inside faces of the seventy-one-foot-high and eighty-foot-wide marble arch. The reliefs were commissioned by the memorial's designer, John Hemenway Duncan, who was also the architect of Grant's Tomb, then rising on the banks of the Hudson River in upper Manhattan. Frederick MacMonnies, who came to the project later on, was to carry out the arch's upper section; it would be surmounted by a four-horse chariot driven by a goddess who represented the spirit of America, attended by two palm-bearing and trumpeting winged victories. The arch's two piers were to contain added groups of heroic figures to symbolize the superiority of the nation's army and navy. However modest Eakins' and O'Donovan's contributions to the work would be, the assignment was both high paying and high profile.

O'Donovan left no uncertainty about his intentions for the two reliefs and for choosing Eakins to sculpt them. He wanted to show "real men on real horses." Eakins' photographic studies with Fairman Rogers made the artist the perfect candidate. "There is probably no man in the country, certainly no artist, who has studied the anatomy of the horse so profoundly as Eakins, who poses such intimate knowledge of its every joint and muscle," noted Cleveland Moffett in an article about the creation of the reliefs for *McClure's Magazine* in 1895.

Eakins surely was relieved to be back at work, and to be delving into a project that demanded mathematical precision and extensive knowledge of equine anatomy. Although the two sculptures were technically reliefs, they were to be almost completely sculpted in the round. Only a small portion of the horses' flanks, sides, and heads would be married to the background plane, giving the viewer the impression that they were free-standing.

Eakins was also pleased to have the company of Murray, for whom the experience would be great training, and O'Donovan, who provided twenty years of technical experience and political savvy. Genial and gregarious, the forty-five-year-old O'Donovan was entirely self-taught. After serving during the Civil War in the Confederate Army, he had moved to New York and opened his own studio, where he established his reputation by sculpting several fine portrait busts and reliefs of George Washington.

O'Donovan's concept was to portray Lincoln on horseback reviewing

passing troops. The president's head would be turned to the viewer, his signature top hat in his right hand, and his horse champing at the bit. O'Donovan supposed that any good-looking horse would do; Lincoln did not ride show horses or chargers and was not a battlefield commander. Grant, too, would be mounted, only he would ride alongside his troops, looking neither left nor right. O'Donovan, however, wanted Grant's horse, unlike Lincoln's, to be anatomically perfect in every detail: it should have the strongest legs, the most powerful shoulders, and a suitably "heroic" profile. Eakins talked O'Donovan into modifying this approach. They would choose a living horse that presented a union of superior qualities. Finding and modeling the horses was left up to Eakins while O'Donovan tracked down death masks and photographs he would use to model Lincoln and Grant.

Eakins decided on his own Billy for Lincoln's mount. The horse met O'Donovan's specifications, was pleasing to the eye, and was readily available in Avondale. Locating a horse for Grant was considerably more difficult. Their first stop was Grant's alma mater, West Point, where Captain Craig, the cavalry instructor, arranged for the sculptors to inspect several hundred saddle horses and riders. The sculptors did not find the horse they were looking for, but they did obtain valuable suggestions for how they might pose Lincoln and Grant in the saddle. Eakins and Murray continued their search at horse shows in Newport, Rhode Island, and Long Branch, New Jersey. They briefly considered circus and race horses. All were eventually rejected in favor of Clinker, a black saddle horse owned by railroad magnate Alexander Cassatt, the brother of former academy student Mary Cassatt. ("Clinker" was not a pejorative term at the time, but rather connoted excitement, as in bells ringing.)

Eakins found with Clinker a horse that was both heavy and compact, built for speed as well as endurance. "In 'Clinker' there is not a pound of waste matter," Cleveland Moffett wrote. "He is a short-coupled horse, with just room on his back for a saddle, as a charger should be, [and] with great breadth of chest."

Once they decided on the horses, Eakins and O'Donovan had Clinker shipped from Cassatt's stud farm in Berwyn, Pennsylvania, to Avondale, where they studied and photographed the animals in action. The artists took turns riding, and then appointed a forty-six-year-old fellow artist to model. The

model—described as having "soldierly build and bearing"—was to ride in the nude, which allowed Eakins and O'Donovan to better observe and sketch specifics of anatomy. Coats, trousers, and boots were mere appendages. "The body comes first," as Eakins liked to tell his students.

Before starting the real work of sculpting, Eakins and O'Donovan were contractually obligated to deliver quarter-sized plaster models of the riders and horses for approval by Duncan and the monument committee. As Eakins had been taught by Dumont, he first made small wax models before sculpting the quarter-size models in clay and then casting them in plaster. The Crowell children later described seeing this work done in a field facing their Avondale farmhouse. To facilitate modeling the actual statues, Eakins and Murray built a fifteen-foot-high platform equipped with a ladder and a trap door. Each horse was measured, marked with red ochre, and tethered in position under the platform. Standing on the top, Eakins could observe the horses from above as well as view them in profile from the ground.

Clinker was sculpted first. The modeling took nearly a year. The sculptors worked the piece in ten sections of clay over wooden armatures, and later shipped it to the Chestnut Street studio for assembly and further sculpting. Eakins enjoyed himself thoroughly. Murray's storytelling and O'Donovan's often ribald humor were the ingredients for a grand time. A photo taken of the three men around this time shows them seated around the dining table in Eakins' studio drinking wine. Two bottles are on the table. A third is on the floor behind O'Donovan's chair.

The sculpture commission permitted much travel. In addition to the sculptors' trips to Newport and Long Branch, Murray described a visit to New York City, where they went to O'Donovan's East Seventeenth Street studio and the National Fine Art Foundry in Astoria. Murray, traveling away from home for the first time, later recounted seeing the Brooklyn Bridge and making the rounds of art-supply houses and galleries. He and Eakins stayed at the Putnam House hotel in a room with beds that folded down from the wall; Murray found the arrangement greatly amusing. They took meals at Moretti's Restaurant, where they could get a spaghetti dinner for eighty-five cents; a more voluminous meal, with wine, cost a dollar.

The sculptors enjoyed trips to Camden as well; there, they photographed

Whitman in anticipation of O'Donovan creating an uncommissioned bust of the poet. Whitman later groused about posing for the photographs, yet he loved the results, lavishly praising one image in particular that showed him in profile. He called the photo "a direct catch—no middleman . . . [one] out of a thousand, which hits a close mark." A cropped version of the picture appeared in Whitman's subsequent book, *Good-bye My Fancy*.

O'Donovan began work on the bust in April 1891. A month later, on May 31, the three sculptors celebrated Whitman's seventy-second birthday. The event proved notable for Eakins, as he was compelled to join thirty-two other guests in paying tribute to the poet by making a brief speech. "I am not a speaker," Eakins demurred. "Much the better," Whitman countered. "You are more likely to say something."

The tributes to the poet were most timely; Walt Whitman died the following spring. O'Donovan's sculptor team, already occupied with casting the features of Americans whose places in history were great, arrived at Mickle Street the day after. They made plaster casts of the poet's face, shoulder, and right hand that are now in the Houghton Library collection at Harvard University. Eakins and O'Donovan served as pallbearers at Whitman's funeral and hosted a wake for the poet at the Chestnut Street studio. At the wake, to Weda Cook's surprise, Eakins picked her up and stood her on the dining table. There, at the behest of the artist and other guests, she bade the poet farewell by singing Whitman's favorite poem-inspired song, from his own "O Captain! My Captain!"

Eakins finished sculpting Clinker a month later. He had done superior work. His depiction of the horse not only demonstrated his knowledge of equine anatomy and command of the differing characters of individual horses; he brought the large animals into palpable shape with great vitality and depth. Not even Eakins' extraordinary paintings of horses capture, as these reliefs do, the sensation of powerful forward movement impelled by all the muscles of a horse's legs and shoulders. The only criticism of the work by today's standards might derive from Eakins depicting Clinker, and later Baldy, with such strength. The horses dominate O'Donovan's riders, Lincoln and Grant.

Sections of the assembled plaster cast of Clinker were pulled apart once again and shipped to O'Donovan's Seventeenth Street studio in early July

1892, where the horse sculpture was put back together and O'Donovan's sculpture of Grant mounted upon him. The completed piece was then sent to be cast in bronze at the National Fine Art Foundry, where it was reportedly the largest mold the firm had ever made. Eakins did not start sculpting Billy, the model for Lincoln's mount, until nearly a year later. John Hemenway Duncan, designer of the Brooklyn Memorial Arch, had offered a second, more lucrative, commission: to create two reliefs for his Trenton Battle Monument, a 135-foot-high stone pillar to be erected in Trenton, New Jersey.

Like Duncan's Brooklyn Memorial Arch, the Trenton Battle Monument would be heavily embellished with sculptures and reliefs. Duncan gave O'Donovan the more prestigious task of sculpting for the apex a thirteen-foot-high bronze statue of George Washington. Eakins' commission was for two four-foot-high, eight-foot-wide reliefs to be mounted twenty-five feet above the ground. One relief would celebrate George Washington and his troops crossing the Delaware, the other would depict Alexander Hamilton commanding troops to fire the first artillery shots of the Trenton battle. A third relief, showing the surrender of Hessian mercenaries who defended the city may have been Eakins' assignment as well, but owing to the artist's obligation to complete Lincoln's mount the commission was given to Cincinnati sculptor Charles Niehaus.

While O'Donovan went to work on preliminary studies for his statue of Washington, Eakins started on the two relief panels. Gaining accurate information was not a challenge. He consulted with William Stryker, adjutant general of New Jersey and president of the Trenton Battle Monument Association. Stryker had for some time been gathering data on the battle's history for a book he later published on the subject. The detailed knowledge he passed on to Eakins is likely the contribution that made his reliefs markedly different from the many other portrayals of the same event.

In *The Continental Army Crossing the Delaware*, Eakins pictured sturdy double-ended freight boats carrying the troops across the river. This type of craft, called a Durham, was not the lightweight boat pictured in Emanuel Leutze's huge canvas, painted forty years earlier, of the same scene. The boats Eakins sculpted instead are thirty or more feet long, flat bottomed, and manned by fishermen from Marblehead, Massachusetts. Nor are the boats rowed across

the river; the water was too shallow for that. The fishermen are poling the boats toward shore.

At the bow of the nearest boat, to the left of the relief, stand three officers: Captain William Washington, the lieutenant of his company, and James Monroe, future president of the United States, who were both later wounded in the battle; and Colonel Edward Hand, whose Pennsylvania regiment of riflemen occupy the boat and were to lead the attack on Trenton. Colonel Hand, not George Washington, points to the shore. Washington, the legendary chief commander, along with artillerist Colonel Henry Knox, cross in a much smaller boat nearby, rowed by a New Jersey farmer.

Several other notable differences between Eakins' portrayal and Leutze's canvas appear. George Washington does not stand in his rowboat, as he would likely have capsized the small craft. (Had horses actually reared up, as Leutze portrays the scene, the boats would never have reached the other side.) Nor does anyone crossing the river wave the Stars and Stripes; the flag was not adopted until the following year, in 1777. And though chunks of ice are visible in both works, Eakins knew better than to add actual icebergs as Leutze portrayed. Eakins grew up on the Delaware River, where ice forms into flat cakes.

For the second relief, *The Opening of the Fight,* Eakins showed six young men of the New York Artillery firing their cannon down Trenton's King Street; Duncan's pillar was to be situated on the exact spot where historians believed the cannon was positioned. Nineteen-year-old Captain Alexander Hamilton has taken up a place behind the cannon, seated on a gun-shy horse that has recoiled from the blast. Another mounted officer, sword in hand, rides toward Hamilton from the extreme right. The enemy has broken ranks. One dead or dying Hessian lies on the ground beside his expired horse and three other Hessians run for cover.

Eakins had to apply a significantly different approach to these sculptures than he did with the Brooklyn commission's. The Lincoln and Grant sculptures were reliefs only in that they were attached to the background plane. By contrast, the Trenton scenes by design projected only a shallow distance from the monument plane. It was necessary for the artist to blend the principal figures seamlessly into the background without losing their three-dimensional

fullness. The cannon's left wheel in *The Opening of the Fight* could be most representative of Eakins' technical challenge. Only a small portion of the wheel and its metal studs are raised above the flat background, yet the wheel has depth and weight.

In a more difficult challenge still, Eakins decided to project movement into the background landscape. In *The Continental Army Crossing the Delaware,* he wanted the ice to be seen floating across the river; in *The Opening of the Fight* there were to be windblown garments, cannon smoke, and retreating soldiers. Eakins had to bring convincingly three-dimensional reality—a moment arrested in time—to a fairly flat surface. His ingenuity and skill in solving the difficulty bears favorable comparison to reliefs made by the Renaissance master Donatello. No sculptor in America, possibly excepting Augustus Saint-Gaudens, had been able to equal in such low relief Eakins' illusion of depth and movement. Unfortunately, viewers of Eakins' generation could not fully appreciate his sculptural artistry because the reliefs were positioned twenty-five feet above the monument's base. Today, museumgoers have an easier time of it, for the reliefs have since been moved to the New Jersey State Museum in Trenton, where they are not only better protected but their finer details can easily be seen.

Eakins' determination to solve technical challenges could well have caused him to miss the deadline for delivering the reliefs. He shipped his plaster casts late to the National Fine Art Foundry, and they were not cast in time for the monument's dedication ceremonies in Trenton on October 19, 1893. The one hundred thousand people in attendance who viewed the reliefs saw plaster casts painted to simulate bronze. Reviews for the Trenton reliefs were in general good, helping to make up for the debacle that greeted Eakins and O'Donovan's Brooklyn sculptures.

The distinctly unheroic realism O'Donovan and Eakins brought to their Brooklyn sculptures struck viewers and critics in stark contrast with the wedding-cake version of grandeur for the chariot on top. The *Brooklyn Daily Eagle* led the attack on Eakins and O'Donovan, demanding that their statues be removed. The *Art Amateur* declared "grave faults."

Critics focused on the Lincoln sculpture as especially poor; one described O'Donovan's depiction of the president's hat as "shockingly bad." The *Art*

Amateur critic wrote: "If this bit of 'realism' was intended to distract attention from faults of the horse and figure, it fails of its object. The figure is poorly modeled, and the horse's legs are notably weak. The Grant figure has one good point: it sits the horse well. But the latter is one of the ugliest beasts that we have seen . . . and trails his right foreleg like a tired donkey."

The critics set the tone for what was to come. Only "under protest" did the Brooklyn Parks Department accept the reliefs. The council did not pass the bill covering the sculptors' work until the members decided that under the arch commission's contract with the National Fine Art Foundry there was no avoiding payment. "The work has been declared unartistic by those who profess to be critics; and there has been a public demand for the removal of the bas-reliefs," stated the commission's annual report. A committee formed proposing to remove the reliefs and install in their place tablets bearing the names of Brooklyn's famous soldiers and battles in which Brooklyn regiments fought.

The reliefs were not removed. The commission and parks department approved a total of $17,500 for the Eakins and O'Donovan works. Of this amount, the city paid $7,500 or more to the National Fine Art Foundry, leaving the sculptors approximately $5,000 each, less expenses. The sum Eakins likely realized for his Trenton reliefs was around $2,800. High as these figures were, and though far more grand than what Eakins earned for his paintings, his payment was insignificant next to the $150,000 that Frederick MacMonnies received for providing the Brooklyn arch's charioteer and palm-fronded trumpeting winged victories.

Given the adverse press after the Brooklyn monument's dedication, demands for more sculptures from the team of Eakins and O'Donovan were not forthcoming. Of Eakins' associates, Murray was given the next commission, in 1895, and he discreetly hired Eakins as his subcontractor and silent partner. This project was Murray's first major sculpture commission (and, as it turned out, Eakins' last), for which the artists were to produce ten larger-than-life statues of biblical prophets for installation on the uppermost pediments of Philadelphia's Witherspoon Building, headquarters of the Presbyterian Board of Education.

The eight-floor Witherspoon Building, in its day the equivalent of a

skyscraper, occupies the whole block of Juniper Street between Walnut and Sansom. The building's designer, the young Philadelphia architect Joseph Miller Huston, awarded Murray the commission. Important as the sculptures were, the more prestigious commissions were for two nine-foot figures of the fathers of American Presbyterianism, which were to stand at the building's entrance. The twenty-six-year-old Alexander Stirling Calder—who had been Eakins' pupil at the academy and was a friend of Huston's father—would sculpt these figures. Stirling Calder's father, Alexander Milne Calder, another former Eakins pupil, had supplied numerous sculptures for Philadelphia's huge City Hall, culminating at the top in a thirty-seven-foot statue of William Penn. (Third-generation Alexander Calder later continued the family dynasty into the late twentieth century.)

It probably arose from their many personal and professional connections that Huston commissioned Murray, then only twenty-seven, to sculpt the eighth-floor statues. If Huston had first desired to hire Eakins, he no doubt wished to avoid negative criticism among the Philadelphia elite. Eakins may have been a prophet to his students, but few among the city's religious elders would champion his portrayal of biblical prophets. In hiring Murray, at the rate of three hundred dollars for each statue, Huston knew he would be getting help from Eakins, whose studio Murray shared.

"I personally selected Mr. Murray as the sculptor of this work," Huston wrote in 1921, making no reference to Eakins. "The information upon which he worked was given me by the distinguished Hebrew scholar, Professor William Henry Green, of the Princeton Theological Seminary, who selected the prophets and gave us the most accurate description in literature of them, and you will notice that there are two women prophetesses, Huldah and Deborah, showing that the ancient Hebrew were strictly up-to-date." The prophets were Moses, Samuel, Elijah, Isaiah, Jeremiah, Ezekiel, Daniel, Deborah, Huldah, and John the Baptist. On September 9, 1896, Huston wrote Murray: "Please proceed . . . at once and finish them as quickly as possible."

Eakins and Murray worked together on the commission. Because the statues were too large and numerous for the Chestnut Street studio to accommodate, and hauling them down four flights was too inconvenient, the artists rented a ground-floor studio on Wissahickon Avenue. In the mode of the

Brooklyn monument commissions, the figures were designed to be made in high relief, nearly completely in the round. Specifications called for sculpting in plaster and casting in terra-cotta, a lightweight building material favored by Huston. Once the modeling was completed, the statues would be divided into horizontal sections and shipped to a foundry that would cast and fire the terra-cotta in a kiln.

Having arrived at the commission after many years of practicing portraiture, Murray and Eakins modeled the prophets' faces and bodies from real people. To hire models would not do; friends were "more interesting and more beautiful," Eakins later said. While no one has found a record that details the selection process, their search must have been engaging and fun.

Art historian Maria Chamberlin-Hellman has identified six of the sculptors' models. Walt Whitman was their choice to portray the majestic figure of Moses, carrying the Tablets of the Law. The prophet Jeremiah was William G. Macdowell, Eakins' father-in-law; Murray and Eakins considered him a modern Jeremiah, preaching reform and threatening doom. Macdowell's thoughtful pose, chin in hand, was said by Eakins' friends to have been borrowed from Michelangelo's fresco of the prophet in the Vatican. The painter George W. Holmes, who had appeared in Eakins' *The Chess Players* in 1876, was chosen to portray the messianic Isaiah. Franklin Schenck was to be Samuel. Huldah, with her arms outstretched in prayer, was Susan Macdowell Eakins. Deborah was sculpted from Jennie Dean Kershaw, Murray's fiancée and a fellow instructor with Emily Sartain at the Women's School of Design. The other four models have not been identified: all that survive of them today are indistinct photographs. Daniel was said to look like Benjamin Eakins, and Ezekiel may have been Talcott Williams. The other two, Elijah and John the Baptist, involve far greater speculative leaps. One is tempted to imagine the joy Eakins could have experienced in portraying himself as John the Baptist, and Murray as Elijah, looking down on John Sartain's townhouse.

The artists may have envisioned the ten oversized sculptures following the pattern of Dumont's allegorical figures for the exterior of the Louvre in Paris. Sketching the figures was likely the first step. Next may have been the creation of three-foot models of each in plaster. After these important prefigurings they would have worked on the full-sized sculptures, planned to be ten and a half

feet tall. No records exist for how the modeling was carried out, but given the time frame, it is logical that they were tackled individually, allowing a complete figure to be shipped to the foundry for firing while modeling was begun on the next. Having started in September 1896, Murray and Eakins were still at work on the sculptures in October 1897.

Murray's and Calder's statues were duly installed on the building, where they remained for the next sixty-three years. After the building was renovated in 1961 they were removed in the interest of pedestrian safety. Calder's were preserved and later installed on the grounds of the Presbyterian Historical Society.

Eakins and Murray's prophets, however, met a far stranger fate. Each was sold for $319, the cost of crating and shipping. Moses and Elijah were bought by Arthur Garrett of Skagway, Alaska, and eventually donated to a Catholic church there. The remaining eight became cemetery statuary in Frazier, Pennsylvania, where all but Samuel, as biographer Lloyd Goodrich noted, "fell prey to vandalism, weather, or neglect."

The partnership that began out of necessity for Eakins and desire to learn for Murray blossomed into a lifelong friendship. Eakins never publicly claimed co-authorship of the statues, suggesting that he wished both to promote Murray's budding career and to protect him from any judgmental reaction among Philadelphians that the young sculptor had been ill-advised in his selection of a partner. When Jeremiah, the only statue publicly exhibited before its installation, went on display at the Pennsylvania Academy, it was listed in the catalogue as Murray's work. If one considers another era, Eakins might have felt something like a blacklisted Hollywood screenwriter. His art was admired as long as it didn't have his name on it. At what would be Eakins' inaugural solo exhibition—which also turned out to be his last—presented at Philadelphia's Earles Galleries on May 11, 1896, Eakins put more than thirty of his paintings on display. He was unable to sell a single canvas.

"Eakins was in exile," wrote Harrison Morris, who replaced Edward Coates as managing director of the academy. "He had committed a sin against the law of the nude, had impiously touched a nerve . . . and was in outer darkness."

The Pied Piper of Philadelphia

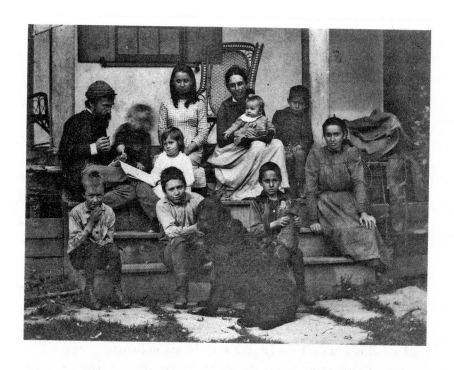

The teaching practices that had once earned Eakins an international reputation at the Pennsylvania Academy of the Fine Arts resulted, poignantly, through changes wrought over time and circumstance, in his leaving the classroom altogether. In the 1890s he had joined the part-time faculty of several leading institutions in Philadelphia and New York. "Certain scholars have felt offended at something in the matter or the manner of one of your lectures," the director of the National Academy of Design wrote Eakins in 1894. "[The] council, appreciating the sincerity of your point of view, and the enthusiasm with which you treat your subject, is convinced that you will willingly avoid hurting anyone's feeling, and will be considerate of the point of view of any of your scholars if it differs from yours."

This warning, addressed to Eakins by Edwin Blashfield, aimed specifically at the artist's presentation of nude male models to female students. Eakins' response carried no apology for his rigidly held principles. "I had no intention surely of hurting the feelings of any one & do not see just where can arise between me and my pupils, any serious or offensive difference of opinion in elemental descriptive anatomy."

The following semester the National Academy did not renew Eakins' contract. He confronted a similar problem with administrators at Philadelphia's Drexel Institute, after a replay of the Pennsylvania Academy loincloth incident. However, unlike that previous unveiling of a male model in a class where female students were present, Eakins at Drexel pointedly discussed in advance, with the model's chaperone and his students, what his plan was: to remove the loincloth. Eakins had further made clear his intention to display nude male models in the terms of his contract with the institute. Yet a maelstrom of controversy brought his teaching career at this school to an abrupt end too. The important difference was that Eakins seriously considered bringing legal action against the Drexel directors for breach of contract.

Drexel's president, James MacAlister, alleged that the school's stated policy forbade total nudity, and that the term "nude," as the word appeared in Eakins' teaching contract, happened to be defined by faculty and adminis-

Overleaf: The William Crowell family of Avondale, Pennsylvania, 1890; photograph by Thomas Eakins. Ella Crowell is seated on the second step at the far right; her sister Maggie is in the back row, center, and next to her, holding a baby, is their mother. (Courtesy of Nancy Reinbold, Brookline, New Hampshire)

trators to mean "partially draped." MacAlister knew he would have a difficult time arguing this point in court. The head of Drexel's art department, Clifford Grayson, had registered to study in Eakins' live modeling classes at the academy before studying under Gérôme at the école, both places where "nude" meant "naked."

Grayson had hired Eakins. He resented being pulled into the controversy any further than he already found himself. He paid Eakins for the remainder of his contract, although the artist had given only three out of fifteen scheduled lectures. Having thus been paid, Eakins would have no cause to claim monetary damages. "In view of your weakness for cheap notoriety, this no doubt will be a sad disappointment to you," Grayson sarcastically, and gratuitously, noted in a letter to the artist.

The "cheap notoriety" Grayson alluded to may have been a veiled reference not to Eakins' previous troubles at the academy but to a more recent scandal. Lillian Hammitt, Eakins' former pupil at the Art Students' League, had either escaped or been released after spending the previous two years at the mental institution in Norristown, Pennsylvania. The Philadelphia press reported that police had found the young Hammitt forlornly wandering the city's streets, dressed in a bathing suit and claiming to be Mrs. Thomas Eakins.

Insult was added to injury when Eakins made the painful discovery that Hammitt's classmate, former league secretary Francis Ziegler, had filed the press report. Ziegler claimed that he had tried to inform Eakins in advance of his intent to write the story, saying that he stopped by the Chestnut Street studio but found only Murray present, after which he went ahead with the news report. Ziegler declined, he said, to exploit the more "sensational" details, though he included Hammitt's claim to the police that she had had carnal relations with her former instructor. After the reporter later reappeared, presumably to offer an apology, Eakins slammed the studio door in Ziegler's face. "Never come here again," Susan Macdowell reported the irate Eakins saying, in an undated draft recounting the incident. "Mr. Eakins reproaching Mr. Ziegler with want of delicacy in exposing to the public the sad afflictions of a most unfortunate lady and requests him in consequence to discontinue his habit of visiting the studio."

The circumstances surrounding what now had become yet another public

scandal were particularly unfortunate, since both Eakins and Macdowell had treated Hammitt with kindness and compassion after she departed from the league. If it was true that Eakins had seduced her, as she told the police, the allegations left out the larger story of her delusional outbursts, mental illness, and attempts by her brother and her employer to blackmail Eakins. The latter history, which could be documented, was not made public.

The ensuing Hammitt scandal triggered further aggravation for Frances Crowell and her husband in their anxiety over Eakins' "worship of the nude" and "exceedingly offensive agglomeration of pettiness"—as Will Crowell wrote to Eakins—into which they had somehow sent their children. Concern over Ella and Margaret's stepping into their uncle's studio was not at issue as long as the Art Students' League remained active. By 1893, however, the league had all but disbanded, and instruction was by then given in Eakins' Chestnut Street studio, and at times in his studio at home. At this stage, according to Macdowell's diary, Ella and Margaret "decided to work from one another as the most economical & easiest way to continue [their study]." It was a decision that did not please Macdowell. Only after Ella's "earnest and untiring solicitation" did she and Eakins, Macdowell wrote, consent to the arrangement. There were, however, two conditions: "not in this house" and they were "not to let their mother know."

A record composed of Macdowell's diary entries and drafts of letters to Frances has come to light thanks to Charles Bregler. The documents, coupled with the research and scholarship of Kathleen Foster, who charted the chronology of events taking place in the Eakins household, narrate a new chapter, remarkable by any measure, in Eakins' dedicated and colorful though troubled life history. Ella appears to have been the motivating force behind their modeling activities. Macdowell described her behavior as that of a "highly emotional" and defiant young woman who enjoyed flouting her parents' wishes and having her own way. A notable instance—Macdowell later described it as Ella's "poor self-government"—happened when her parents refused to let her ride horseback from Avondale into Philadelphia. "She got on one of the horses and at a furious rate rode around the farm until the beast was exhausted, then betaking herself to the meadow stream remained in swimming until exhausted

herself, this followed by sickness." Exhausting her strength, Macdowell wrote, was Ella's way to "vent her passionate rebellion against restraint."

After she and her sister moved in with their aunt and uncle on Mount Vernon Street, Ella was extremely critical of her mother and father and their provincial lives in Avondale. She described her parents as "without honor"; she said her father was "dull," "weak," "pitiable," "idle & hopeless," and a "melancholy, unhappy, and disappointed man" who "longed for city-life, but despaired of ever making a change, partly through his lack of spirit and through consideration for his wife, who was contented in the country." Macdowell did not encourage such confidences. Rather, she counseled Ella not to speak "so fully of her home affairs."

Unbeknown to the Eakins family, Ella was at the same time criticizing life on Mount Vernon Street. To her parents she complained about Macdowell's housekeeping, cooking, extravagant purchases, and neglect of Ella's grandfather Benjamin and his sister-in-law, Eliza Cowperthwait, who was also living at the house. While Ella was telling her aunt and uncle that she wanted to live permanently with them, she was suggesting to her mother and father that Benjamin and Eliza should be moved into a smaller, and presumably healthier, environment.

In the midst of all this came a revelation. Ella either confessed to her parents about one of her art activities on Mount Vernon—modeling for her sister in the nude—or Macdowell informed the Crowells. Evidently upset, though pleased that the truth was in the open, they accepted a letter from Eakins that informed them he had decided not to permit Ella or her sister access to his studio. "As long as I had a life class the children were entirely welcome to work here, but I am no longer teaching."

Eakins' letter, therefore, presumably was warmly received by the Crowells, and stilled troubled waters. Margaret enrolled in life classes at the academy, where she continued her studies, and she was joined by her younger brother Benjamin; by then he had also come to live at Mount Vernon Street.

Ella decided on a different course of study from Margaret's. After spending the summer of 1894 back at Avondale, helping Eakins and Murray prepare Billy to be modeled for their sculpture, she returned to the Eakins' home in

September and studied music. Her music lessons were brief, and she abandoned them in favor of pursuing a career in nursing. On February 1, 1895, Ella enrolled in a two-year course at Presbyterian Hospital. On at least one occasion she brought a group of her fellow nurses to the Chestnut Street studio to watch her uncle working.

The crisis over nude modeling appeared to have passed. Frances and Will Crowell's allowing three of their children to live in the Mount Vernon Street home suggests they had put their concerns to rest. Macdowell, however, noted a new form of disturbing behavior on Ella's part. Ella informed Macdowell that "she did not entirely trust" her uncle, and that she felt "degraded" because of him. "I asked her how the hand she had accepted all her life could degrade her, and [told her] that if her Uncle Tom knew she did not trust him, all familiarity would cease instantly between them," Macdowell recorded. "I then asked her what her purpose was in smiling to his face while she stabbed him in the back. I did not use this expression but what I said amounted to that, and I planted the first seeds of remorse for the contemptible part she was playing. Her expressions often were of regret & fear for the mischief she had brought to her Uncle Tom [by nude modeling]. Although all was freely forgiven by us, during her last winter here at the University [hospital program] I remember distinctly two notable instances, one her assertion that she had yet to see a man whom she was afraid of. The other, an occasion of some musical affair, her Uncle Tom refusing to accompany her, the night being stormy. After long coaxing she ended by reproaching him with losing his interest [in her]."

An inference in Macdowell's account is that Ella, like Lillian Hammitt, who had received so much attention from Eakins, now felt abandoned by him. At the same time, Ella continued what had become a diatribe against her mother and father and the lives they lived in Avondale. "[Ella was] dwelling on the misfortunes of her country home, saying the farm was going down, worsening every year, her mother was the only one who did any work, her father was idle, spending his time reading newspapers and talking about politics and morality until they [the children] were all sick of it."

Meanwhile, relations in the Mount Vernon Street household grew further strained when Ella's brother, Benjamin Crowell, accepted an entry-level position in Frank Stephens' design firm—a decision that was said to have been

made by the children's father, Will Crowell. Eakins and Macdowell naturally were disconcerted. It was no secret that they had never forgiven Stephens for driving a wedge between family members in 1887, and they suspected that Stephens was trying something similar now. According to Ella, a plan, in part promoted by Stephens and the Crowells, was in the works to have Tom and Susan leave the Mount Vernon Street house; Frances and Will Crowell would then move back to the family home to care for Benjamin and Eliza.

As Macdowell described the situation, Ella, now entering her twenties, felt trapped by her conflicting desires for love and approval from two remarkably different father figures, and she suffered from a steadily deteriorating sense of self-worth. Her sister Margaret, now in her late teens, was a more talented artist and was getting on well in her studies at the academy. Brother Ben, a year younger than Maggie, was supporting himself in the design business with Frank Stephens. Ella, further, hated nursing and believed herself unsuited to her tasks in the hospital. According to Macdowell, she confided to her grandfather Benjamin Eakins that she "regretted going to the hospital [everyday], that it did not suit her, she was tired of it, and her reasons for going there were that it was necessary for her to earn her living and she saw no other direction where it would be possible, and then told him . . . of the hopelessness & unhappiness . . . [of her alternative in Avondale]."

Ella's unhappiness, along with a foreshadowing of her unstable mental condition, was apparent at least to some members of the Eakins circle, including Sam Murray's sisters, Gertrude and Margaret. On one occasion, Ella arrived at their house unexpectedly. Upset at not receiving the day off from the hospital, she sat and banged on the piano with "nervous" and "exaggerated" gestures. "That girl's sick," Margaret said to Gertrude. Ella then appeared back at the hospital and confronted her supervising nurse with a gun. The head nurse took the gun away from her, but she did nothing else other than to give Ella the day off.

It apparently was in a state of continuing uncertainty and confusion that Ella, five days later, mistakenly administered to a patient a near lethal dosage of chloral hydrate, an antidepressant. After a reprimand for her carelessness, Ella went into a hospital washroom and swallowed an equally toxic dose of the same drug.

Ella's symptomatic behavior continued to deteriorate. One report had her arriving at Gertrude Murray's house with a gun, possibly her uncle Tom's, and threatening to shoot her friend, Weda Cook, Eakins, and herself. Her parents stepped in this time, and like Lillian Hammitt before her she was committed to the mental hospital in Norristown at the end of the summer in 1896.

The painful reality of Ella's hospitalization triggered the first accusations from the Crowell family that Tom was responsible for her unstable condition. A letter Frances Crowell wrote to Benjamin Eakins calls Ella's attempt to support herself as "Ella's flight . . . to escape Tom's approaches." Margaret initially defended her uncle to her family. Yet after further conversations with her parents, she too became convinced of his guilt. Her brother, Ben, went so far as to claim that "Uncle Tom" had driven Ella "out of her mind." Daughter Frances Crowell, the next to youngest sibling, concurred: Uncle Tom had "contaminated her sister with his beastly ideas." According to Macdowell's continuing record, she fired back a letter to the Crowells, condemning their "attitude toward Tom" as "detestable and outrageous."

The type of impropriety the Crowells accused Eakins of committing finally became clear, like a developing photograph, in an October 18, 1896, letter Susan wrote to Frances. "Maggie is freely talking at the Academy against her Uncle Tom. The stories are that her sister Ella's insanity was brought on by the wearing effect of unnatural sexual excitements practiced upon her in the style of Oscar Wilde. Such stories and behavior will injure her own reputation as well as Ella's. Fortunately I am able to record Ella's whole life here, and her trust in her Uncle Tom and her affection for him, have been remarked up to her last moments here."

Macdowell's reference to Oscar Wilde adds yet another perplexing turn to the many intrigues alleged by former Eakins students. Easy as it may be to dismiss the remark as a poorly understood and confused reference to unnamed acts, that is likely not the case. Oscar Wilde had lectured at the Philadelphia Sketch Club in recent years and was a well-known figure in the city. His trial was prompting front-page headlines in Philadelphia's newspapers in the spring of 1895, as Margaret and Benjamin Crowell were spreading stories at the academy of their uncle's alleged transgressions. The flamboyant author of the recent works *The Picture of Dorian Gray* (1890), *Lady Windermere's*

Fan (1893), *A Woman of No Importance* (1894), and later *The Importance of Being Earnest* (1899), Wilde was convicted and imprisoned for consorting with male prostitutes and newsboys. Macdowell, like Frank Stephens and the Crowells, was not naive to the reality of the charges. What Wilde was really on trial for was homosexuality. Macdowell's chronicle, particularly in its reference to Wilde, suggests that the "unnatural sexual excitements" Ella had been exposed to were homosexual acts.

As with the earlier allegations by Frank Stephens, lack of documentation makes it impossible to know what, if any, licentious or criminal behavior may have been acted out in the Eakins house. Assuming that Ella was subjected to "unnatural sexual excitements," and that they were somehow homosexual in nature, it doesn't necessarily follow that they had anything to do with her uncle. Eakins' many scandals all involved women. A cavalcade of nude men modeled for him, and his long association with Walt Whitman provides evidence of his ability to be friendly with a homosexual man, but little more can be said. Eakins' friendship with the aging poet grew from their shared difficulties and a mutual appreciation of each other's artistry. And though Eakins' correspondence makes no mention of Oscar Wilde, it seems unlikely he would have found the author's avant-garde activities and militancy anything but morally reprehensible—given the uprightness and healthy discipline that marked Eakins' upbringing and his later condemnation of unprincipled behavior. For all his love of spontaneity and nurturing of bohemian creativity, a truly rigid core had grown within him, and was no doubt often expressed toward himself. For all his innovations in nude modeling, beyond his artist's contract with the representation of reality, a central portion of his personality held to his era's conventional attitudes. He was in many ways both out of his time and firmly within it. Regardless of what Ella experienced, it is unlikely that it was homosexual or "deviant" activity by her uncle.

However, there are suggestions in the historical record, albeit slight, that point to an alternate source of homosexual relations that Ella might have confronted in the Eakins home: she may have witnessed a sexual intimacy between two females or herself become involved in some kind of tryst. Gabriella De-Veaux Clements and Ellen Day Hale, both Eakins students, have long been surmised to be lesbian, in part because they lived together for much of their adult

lives. Eva Lawrence Watson and Amelia Van Buren have also been thought of as a "couple." Like Clements and Hale, Van Buren spent her last years living with a woman, at an artist's colony in Tyron, North Carolina. References in Macdowell's diaries to Eakins' female students modeling nude for one another, and of a highly charged emotional relationship between Macdowell's older sister Elizabeth and Amelia Van Buren, both regular houseguests when Ella lived at Mount Vernon Street, bring the speculative orbit closer to home.

In the liberal and free-spirited Eakins household, where appreciation and love of the human body filled the artistic atmosphere breathed there daily, a guest's sexual preferences did not meet with overt censure. The source of what has been variously described by friends as Ella's "restlessness," "Tom-boy manner," and "dislike of men" might have stemmed from confusion about her own sexual orientation. The anguish and complexity of her situation was that she was drawn to the Eakins household, even as it caused disturbance in her, because it also offered her solace. The references in letters between the Eakins and Crowell families seem veiled particularly for the benefit of the elder, Master Benjamin, whom neither family wished to cause distress.

Beyond what Eakins' role may have been as a disturbing influence for Ella, the artist made the easiest target for blame. The combined weight of previous scandals, including his dismissal from Drexel and the National Academy, was enough in the greater art community's mind to make him culpable. Parallels between Eakins' impressionable twenty-one-year-old niece and the twenty-three-year-old Lillian Hammitt, who both were committed to the same mental hospital, cannot be ignored. His wife had also modeled for and fallen in love with her instructor, for Eakins was a powerful and attractive figure who could inspire behavior outside the socially acceptable moral confines of the community they lived in. Eakins was more than just an exciting teacher and a brilliant artist; he personified, as Whitman described him, "a force" to be reckoned with.

Evidence is clear that the Crowells, like most Philadelphians, came to view Eakins as a Pied Piper leading children to certain destruction. Ella Crowell and Lillian Hammitt were "imperiled innocents" under his beguiling spell. More accurately, as Kathleen Foster has described it, Eakins became "a lightning rod" for the conflicted values of his generation. By his art, his unfettered love for the aesthetic vitality and truth he found in the naked human form, in his

sheer talent and in his stubborn adherence to a life without artifice, Eakins had found himself perched precariously on the fringe of late-nineteenth-century culture, where the intertwined impulses of both art and sexuality struggled to find expression. In this situation, an unhappy ending thickened like a condensing mist around the Crowell and Eakins households.

Ella Crowell's story took a decidedly more tragic turn than Hammitt's. On July 2, 1897, after returning to Avondale following two months in the Norristown hospital, she committed suicide. Rumors later spread that she took her own life in Eakins' Chestnut Street studio, though it was not the case. Ella had told friends she wanted to go back to her aunt and uncle's Mount Vernon Street house to live. Her parents prevented her from doing that; on her release from the hospital they had brought her back to their farm in Avondale.

Benjamin Crowell witnessed her death. He and her other siblings, as he recounted later, were teasing Ella about having to return to Norristown, when she went into the Crowell living room, stood by the piano, and began neurotically whittling a three-pronged stick. Moments later she took the family shotgun off the fireplace mantle, put the stick in the barrel, and shot herself point blank in the head.

Eakins was blamed in Philadelphia as surely as if Ella had taken her life with his own gun in his own studio. He did not, however, write letters in his own defense or take any actions to dispel the rumor mongering. He silently accepted the Crowells' condemnation without protest, along with his banishment from Avondale and permanent estrangement from his only living sibling. His nieces and nephews, who had long been a part of his life, were forbidden to speak his name. Eakins gave up their company, and he did the same with his students. He either resigned from his lectureship at Cooper Union—the last of his teaching positions—or was fired. It is only known that his teaching stopped. Too weary, unable, or unwilling to sort the truth from fiction, he gave up fighting. A neighbor on Mount Vernon Street described Eakins as looking like "a broken-down old man."

In a letter written previously to Harrison Morris, who headed the academy's exhibition committee, Eakins penned an epithet he believed would be his obituary. "My honors are misunderstanding, persecution, & neglect, enhanced because unsought."

Forgiven and Forgotten

forty-five

Portrait of a Physicist

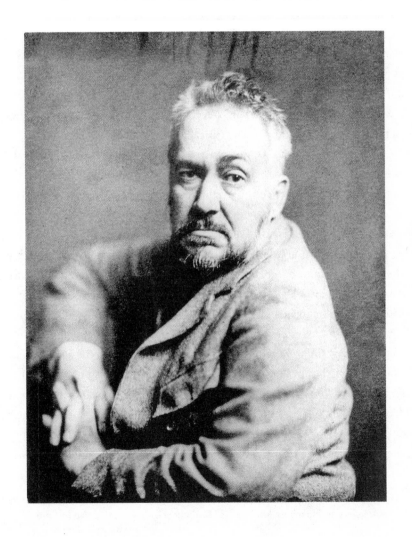

Eakins did not retreat into his studio and disfigure paintings as he had in the aftermath of the Stephens accusations in 1886. He launched into a new project in a new place, leaving for Maine to paint an uncommissioned portrait of Dr. Henry Rowland, a distinguished physicist on summer leave from Johns Hopkins University in Baltimore. Correspondence Eakins sent to his wife while he was gone gives no clue how long the two men had known each other or why Eakins traveled nearly seven hundred miles to paint his portrait in 1897. Concern for his own mental health and a simultaneous invitation from Rowland could have persuaded the artist. His departure from Philadelphia less than two weeks after Ella Crowell's death suggests that he or a doctor felt a "camp cure" was necessary to give his body and spirit a lift.

Craigstone, Rowland's palatial summer house on remote Mount Desert Island, had no cattlemen or brilliant crimson canyons, but much like the Dakotas the island contained a vast and largely unpopulated wild setting, now part of the forty-seven-thousand-acre Acadia National Park. Amid fog-shrouded forests of birch, maple, and spruce trees, granite-domed mountains, and uncharted miles of jagged rocky shoreline, "the big painter," as Eakins liked to use the phrase, had ample opportunity to contemplate "Nature's big boat." As Eakins had written from Paris nearly three decades earlier, "once an artist was given sufficient practice" he would "be sailing only where he wanted to, selecting nice little coves & shady shores or storms to his own liking."

The artist likely traveled by train, overnighting in Bangor, and completing the last forty-five-mile leg of his trip by horse-drawn coach and then ferry. Alternately he could have taken the more direct and costly route by steamship, which departed twice weekly from New York City. Rowland, a balding, distinguished-looking man with a walrus mustache, four years Eakins' junior, would have met Eakins on arrival at the docks or provided directions to Craigstone—not that they would have been needed. Everyone in the small fishing village of Seal Harbor knew the island's most prestigious summertime resident. In Craigstone, on Oxhill, overlooking the harbor, Rowland and his wife Henrietta entertained a steady stream of distinguished visitors, among them the photographer and engineer Coleman Sellers, Eakins' Mount Vernon Street neighbor, with whom Rowland had been a partner in designing the power

plant at Niagara Falls. Eakins probably knew Rowland through Sellers; aware of the Eakins family tragedy, Sellers could have arranged for Rowland to extend an invitation to Craigstone. A more likely point of contact, however, could have been Rowland's close friend George Barker, a University of Pennsylvania physics professor whom Eakins had come to know through his work with Muybridge.

However much planning went before Eakins' painting *Portrait of Professor Henry A. Rowland* (Addison Gallery of American Art, Phillips Academy, Andover)—hinted at in a few brief references to Rowland in Eakins' correspondence—the two men became good friends over the course of the artist's visit. Eakins addressed his first letter to Rowland, on June 16, 1897, as "Dear Sir." He began an August 17 letter, written after his two-week stay, "My Dear Rowland." Writing home from Maine, Eakins said, "We get on famously together, our tastes being similar." In this and other references in letters, clues reveal the joy Eakins found in painting someone he could study with and learn from. Each man had devoted himself to investigating the physics of light—Eakins on canvas and Rowland in his laboratory. Each had become the best in his respective profession, and each was an era ahead of his colleagues—their work anticipated the accelerated change, the role of speed and technology in the century just around the corner. Rowland, like Eakins, had married late in life. Though the physicist was recognized and esteemed by his peers in ways the artist was not, Rowland, too, had paid a high price for maintaining his independence from Victorian ideology and prejudice. "I am very curious to watch Rowland's ways of thinking and doing," Eakins wrote in a letter to Macdowell soon after his arrival in Maine.

Rowland's résumé was the most impressive of anyone's that Eakins painted, except perhaps that of President Hayes and Archbishop Wood, whose credentials were earned in different fields. Rowland was born in Honesdale, in northeastern Pennsylvania, and had been expected to follow in the footsteps of four generations of Rowland men by attending Yale University and entering the Protestant clergy. Henry's great-grandfather had used his pulpit to denounce colonial rule, and then had to flee his home when the British fleet invaded Providence. Young Henry had inherited equal courage, but he devoted his talent to chemical and electrical engineering, most particularly to

the study of light. In 1872, when Eakins upset art critics with his depictions of "wondrously ugly" oarsmen on the Schuylkill River, Rowland was stirring up controversy at the Rensselaer Polytechnic Institute. Critics could not fault the twenty-four-year-old physics professor's devotion to science or the precision with which he conducted his research, but they responded to his outspoken condemnation of fashionable education practices, which he called "the foolish pomp and circumstance" of "narrow mediocre minds." Rowland either resigned or was fired. Daniel Coit Gilman, the first president of the newly founded Johns Hopkins University, came to his rescue by appointing Rowland as the school's first physics professor and giving him complete freedom to develop the curriculum. Rowland dismissed the notion that teaching and research were separate endeavors or that they should be subject to meeting the needs of the business community. The "pure science" was his objective—or, as Eakins might say, "physics without artifice."

Rowland's greatest contribution to physics began in 1882 when he undertook the study and construction of diffraction gratings—reflective plates that dispersed light into component colors, or wavelengths, which could then be used to investigate the light from distant stars. By analyzing a star's reflective spectrum, physicists could determine the star's chemical composition and temperature. Rowland's genius was to engineer a ruling engine that employed a diamond-tipped cutting head to etch spherically curved plates, which in turn produced spectra of far greater precision and resolution than were previously available. In one of his most notable experiments he mapped a spectrum of the sun that proved ten times more accurate than earlier spectra in determining the composition of the sun's atmosphere. His "photographic map" from that experiment stretched thirty-five feet long and displayed tens of thousands of spectra lines. To this day, astronomers use grating systems inspired by Rowland, who is known as "the father of spectrometry." A unit of wavelength measurement is named a "rowland" in his honor.

Although Rowland was credited with numerous discoveries and patented inventions—in 1897, the year Eakins painted his portrait, he built the first multiplex telegraph, the precursor of today's facsimile, or fax, machine—his career was an uphill struggle. One of the major scientific lawsuits of his gen-

eration involved him, threatening to end his career and becoming a taxing burden on his wife and three children. His unstinting work, long hours, and an untreated diabetic condition took a mental and physical toll. It was in this mien that Eakins chose to portray him: the veins on Rowland's high forehead suggest a capacity for concentration, as do his sharp nose, determined chin, and thick glasses; his heavily lined hand belongs to a man who has applied, along with his intellect, the physical effort and manual dexterity that Eakins knew well, beginning with his master penman father.

Mirroring the innovations Eakins brought to his painting of ethnologist Frank Hamilton Cushing, the artist incorporated iconography from Rowland's professional life in the portrait. In the large canvas—nearly seven feet high and five feet wide—Eakins set Rowland in his Johns Hopkins University laboratory, seated in front of the ruling engine he was best known for (plate 32). Rowland wears his working attire: a gray-brown three-piece suit and tie. Behind him in the shadows Rowland's assistant, Theodore Schneider, in an apron, operates a tooling lathe. Rowland holds in his hand, resting on his crossed legs, an example from the machine behind him: a card inscribed with the spectrum lines of solar light cast by his diffraction grating. The bands of colors are clearly delineated, held at an angle to the light entering the laboratory, so they are luminescent, standing out in stark contrast to the dark brown and ill-defined background. The spectral light shines at the viewer.

Of lesser prominence, but still highlighted, are the curved disks of the grating machine. They too are rendered with care; subtle reflections in their bronze sheen suggest rotation. The challenge and the ultimate success of the painting—many critics consider *Professor Henry A. Rowland* the finest example of Eakins' later paintings—depend on capturing the tools of Rowland's trade without letting them overpower the character of the man who uses them. Rowland is facing directly to the light, as it strikes his strongly delineated face, while the engine behind him, though large, along with his assistant, is cast in partial shadow. The engine is precisely constructed in paint in its circular and planar elements, and yet it remains a mysterious and attractive accoutrement between the physicist and his assistant. The figures and elements are not so much competing for attention as combining into a well-modulated whole.

Eakins' technique, however complex, results in a forceful, clear directness of effect. The painting is, in more senses than one, a portrait of a scientist and a machine for negotiating not only the universe, but time.

Craigstone had no electricity or plumbing. The grating machine was too heavy and expensive to transport, so Eakins modeled Rowland in Maine and painted his assistant and the machine at Johns Hopkins. In the absence of preliminary sketches or studies, and relying on a letter the artist wrote to Rowland, referring to the canvas's shipment from Maine to Philadelphia, one concludes that Eakins painted a near complete image of the professor seated in his chair while they were still on the island.

The modeling took two weeks, perhaps longer, but it was not the only activity that consumed Eakins' time at the Craigstone estate. Rowland enjoyed the outdoors, like Eakins, and had been summering at the island for seven years, perhaps much longer. In the warm season, islanders could see humpback whales migrating just beyond the harbor, and find blueberry patches laden with berries. Lobsters and mussels—neither yet considered rare delicacies—could be scooped up at low tide. Rowland could have taken Eakins on a day-long hike to Thunder Hole, a small inlet carved out of the rocks that led to an underwater cave; jets of water as high as forty feet roared up as waves crashed into the cave. The Hudson River school of artists, including Thomas Cole and Frederic Church, were known to have painted such sites. If Eakins did not, at least he must have been moved by them.

Eakins, however, did not readily take to diversions. "[Rowland] wanted to go out sailing," Eakins wrote his wife on a Tuesday afternoon in July. "So out we went & didn't get back till so late that by the time we had our lunch the sun was in the room and I hardly got any painting done at all. I hope there won't be any wind to tempt him today."

On another occasion, artist and scientist took it upon themselves to build the perfect kite. Apparently their creation failed to fly: after returning to Philadelphia, Eakins bought two Japanese kites and a ball of twine and posted them back to Rowland, with his compliments. From his letter, his only disappointment was his lack of success in finding "bird kites with pretty red wings," suggesting that the two men also spent time or at least talked bird watching—a favored activity on an island where more than three hundred known species nested.

Eakins went on to encourage Rowland to take up bicycle riding, an activity the scientist had been unwilling to try. Eakins wrote, "I hope that as soon as you find the time to count up your money" (a reference to Rowland's recently having obtained a patent on his multiplex telegraph), "that you will have so much left that you can dance right off to the bicycle shop." In the evenings, Eakins likely impressed Mrs. Rowland with his knowledge of handloom weaving; Henrietta took pride in her own skills as a weaver and kept a loom in the Craigstone parlor. Other evenings developed a more intellectual tone. Among them was a dinner party for scientists and engineers in nearby Bar Harbor; there Eakins, according to lore, was introduced to Thomas Edison.

The artist's work by the end of July was almost complete—apparently in record time. "I am going over the head again," he wrote to Susan Macdowell. You know I had finished it all in an hour & a half. It was pretty strong in a way but coarse. A head can hardly be gone over in that time. The work I did yesterday was I think pretty good. I cannot afford to miss the refinement of the man. . . . Since I got in his hand and the spectrum he is greatly interested in the work and poses very well." Rowland was as excited about the painting as Eakins. "He sees how much it looks like him."

On August 17 Eakins shipped his unfinished portrait to Philadelphia and left for Baltimore to study Rowland's ruling engine and, possibly, model his assistant Schneider. Macdowell wrote how pleased she and the Eakins animals—a rabbit and a turtle had been added to the menagerie of pets—would be to have him home, especially Bobby, the monkey, who in Eakins' absence had been up to great mischief.

"The directness and simplicity of the [diffraction ruling] engine has affected me and I shall be a better mechanic and a better artist," Eakins wrote to Rowland from Baltimore on August 28. "I have changed somewhat my idea of the composition of your picture. I am going to give the engine a little more prominence than I had at first intended. Putting it on a lower table or bench will keep it away from the head and I shall let in on it some of the direct light, instead of lighting it only by that reflected from walls."

Eakins made alterations on the portrait through September. Around this time he became inspired to build a special frame for it. "My exhibition frames are mostly plain chestnut gilded right upon the wood and showing the grain,"

Eakins wrote Rowland on October 4. "Now it seems to me it would be fine to saw cut shallow some of the . . . [spectral lines] which you were the first man to see. . . . Would there be some simple & artistic way I wonder of suggesting the electric unit [the rowland] that I heard of your measuring so accurately[?]"

Eakins had in mind a version of what he had done for *The Concert Singer*, where he had carved musical notes directly into the frame. Here he would push the concept to the extreme. Using data supplied by Rowland, Eakins created a pastiche tableau of handwritten coefficients, mathematical formulas, computations, electrical diagrams, pictographs, and lined spectra original to Rowland's study of electricity and light. Deciphering the imagery is not necessary. Eakins employs scientific iconography to evoke phenomena that cannot be seen with the naked eye—pushing forward a sense of the illusion in the painting, and pointing the way toward the art of the next generation: cubism, dada, and collage. Eakins' *Professor Henry A. Rowland* spans centuries of artistic genius, possessing the classical realism of Leonardo and the modernism of Picasso.

On November 17, five months after he had begun, Eakins still continued to make finishing touches on the canvas. He wanted to create a greater impression of the atmosphere in the laboratory. "I have concluded that before taking up the background of the portrait I must see you. I shall therefore send the picture to you at the John Hopkins & come down some day soon. I want to look over the drawing of the engine with you."

Eakins finished the portrait before the end of the year in 1897, and included his signature in flowing script, drawn in perspective, on the laboratory floor. He was so delighted with the project and proud of the portrait that he offered to sell it to President Gilman of Johns Hopkins, the university that had made Rowland's research possible. Gilman thought the painting "wonderfully good," but was doubtful the trustees would purchase it; he claimed they had never bought a painting before. Regardless of whatever pressure Gilman may have brought to bear, the board did gratefully decline to make the purchase. Later the following year, however, or soon thereafter, another, more traditional full-length portrait of Rowland appeared on campus.

In January 1898, when Eakins submitted the painting for exhibit at the Pennsylvania Academy's annual show, it was accepted. He listed the portrait as "lent by Mrs. Henry A. Rowland," an indication that she may have expressed

an interest in buying it, or a promise to do so, although later showings of the work do not list her as the owner. Rowland died in 1901, and the family, involved with costly lawsuits over patent rights, may have been distracted or unable to acquire it. The portrait became another addition to the artist's expanding and significant collection of his own art.

Down for the Count

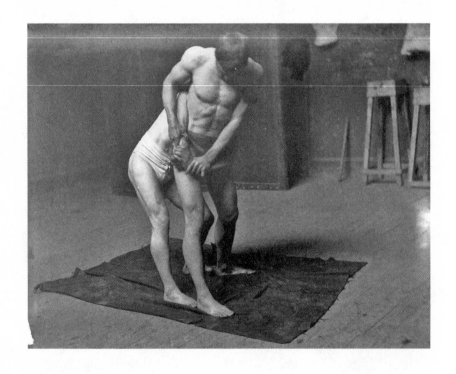

A day painting in the studio often ended with a night out on the town. During Eakins' courtship and the early years of his marriage, he and Susan would often walk together to the theater or a concert. Macdowell—a talented pianist—enjoyed hearing Beethoven and Mozart, while Eakins found most intense pleasure in watching the musicians. Years later, with the approach of the new century, the couple's tastes gradually changed. It could be that they felt snubbed by elements of Philadelphia's fashionable elite, or that Eakins—whose gut, like his beard, had grown—no longer felt comfortable dressing for formal occasions.

Many *fin de siècle* evenings may have been spent visiting nickelodeons and silent films (where distinctly "lower class" audiences came with cabbage and other produce to throw at the screen if they didn't like the show). One destination they found pleasant was Philadelphia's Little Italy, where Tom and Susan enjoyed mandolin music and a puppet show. And increasingly, Eakins joined Sam Murray for the Friday night fights at the Philadelphia Arena; the artist couldn't keep from obnoxiously squirming in his seat while he mimicked the boxers in the ring.

Eakins loved the uninhibited roar of the spectators as much as watching the half-naked men under the spotlights. According to Philadelphia sportswriter Clarence Cranmer, Eakins had attended nearly three hundred fights by the end of the century, and he grew to be such a perceptive spectator that Cranmer did not hesitate to ask his opinion of a fighter's ability. Eakins eventually asked a boxer back to Chestnut Street to pose for him. Three large portraits, painted in 1898 and 1899, resulted: *Taking the Count* (Yale University Art Gallery), *Between Rounds* (Philadelphia Museum of Art), and *Salutat* (Addison Gallery of American Art, Phillips Academy).

His preoccupation with boxing came as no surprise to friends of Eakins. He had learned from Max Schmitt to box in high school. In Paris he had cheerfully volunteered to square off with a hapless classmate. After returning home Eakins kept trim at the Philadelphia Athletic Club, the sponsor of the fights at the arena. At the club he would have found sparring partners ready and willing to go head to head with him. As with rowing, his earlier pastime

Opposite: Wrestlers in Eakins' studio, 1899; photograph attributed to Thomas Eakins (Courtesy of The Philadelphia Museum of Art; purchased with funds given by Seymour Adelman)

and art subject, boxing at the arena level featured men who had developed highly envigored musculature and magnificent bodies.

The action in a ring, as on a river, was furthermore a creative endeavor requiring years of physical and mental training. In many ways, fighters were people Eakins could relate to, given his own professional struggles. In painting, as in boxing, a solitary man achieves greatness by sheer force of will, by building discipline to give structure to inspiration. A fighter was judged as Eakins desired to be judged: by his character as demonstrated in performance or in the midst of great challenge, not by what critics and pundits had to say about the fighter's life outside the canvas-covered ring. Fighters were also proud of their battle scars. As art historian Marjorie Walter has made clear in her extensive study of Eakins and his boxing paintings, the artist was at a point in his career when he seemed to relish his own rough-and-tumble reputation.

The significance of the Philadelphia Arena's location across the street from the Pennsylvania Academy of the Fine Arts would not have been lost on Eakins. He would have noted the day the first match was announced at the arena, in the former Cyclorama building on the corner of Broad and Cherry streets. As the sport's popularity grew in the early 1890s, the simply designed octagonal building found new life as a boxing arena on Friday nights and a Barnum-style one-ring circus during the rest of the week. Flying an American flag on top and displaying a giant billboard across the front, the arena was as distinct from the neo-Gothic splendor of the academy Temple as were its patrons. An "eye-sore," the director of the academy called it.

The refined and worldly group who years earlier had demanded Eakins' resignation and subsequently rejected his art—those who quietly strolled the red carpets of the academy gallery whispering among themselves at each new annual exhibition, who were careful not to upset or be upset, who properly and thoughtfully checked their umbrellas and parasols in the coatroom lest a painting or sculpture inadvertently get poked, who preferred their nudes draped strategically, rather tribally, covered with fig leaves—would not often dare to be seen among the rabble across the street. Spectators in the arena yelled, stamped their feet, hissed, booed, applauded, smoked cigars, and spat on the wooden floors. Undoubtedly some attendance crossed over, for the five-dollar price of a ringside seat was equivalent to the cost today for a similar

vantage on a fight at Caesar's Palace in Las Vegas. The important difference was that the Philadelphia rich who attended fights at the arena enjoyed the company of boilermakers from the Baldwin motorworks factory and freight handlers on the Delaware River docks. And unlike academy patrons, who were inclined to judge an artist's work by what critics had to say about it, for an audience the measure of a fighter was what he displayed in the ring. Arena spectators cheered the unabashed partial nakedness of the manly arts in ways that did not, consciously at least, dominate in the fine arts.

The erstwhile highly regarded art of boxing, as practiced by Greeks, championed by Romans, and refined in Britain, was considered a "hotbed of depravity" in Philadelphia. One city journalist termed boxing "pornography." It was thought not much more respectable than cockfighting, a form of entertainment in the Italian quarter, or the immensely popular sport of "ratting," practiced along the Delaware wharves, where gamers threw formidable river rats into pens with pit bulls. "The character of prize-fighters and of the company which witnesses their contests," a journalist declared, "consists always of the offscourings of human society—gamblers, thieves, drunkards, and bullies."

The *Public Ledger,* which printed more sporting news than any other city newspaper, made it editorial policy to exclude coverage of prizefights—despite the five thousand boxing fans who turned out for major bouts. Rowing and yachting, along with hunting, fishing, bicycling, and college athletics—these sports the *Ledger* considered worthy to write about. Except for occasional historical overviews or articles denouncing the brutality of boxing, news of the fights was limited to the *National Police Gazette* and Philadelphia's lesser papers, the *Record* and the *Inquirer,* no more than tabloids. Such public outrage gathered over boxing matches that the city of Pittsburgh stopped issuing permits for fights. Philadelphia was poised to follow suit, but politicians in city hall blocked the ban; gambling proceeds funded reelection campaigns, as did donations from the distilleries that bankrolled the matches.

There existed, of course, ample reasons for public outrage. Beyond the gambling and drinking that went along with the fights, the gloves used by boxers gave less padding for their hard fists than they do today. In 1897 the fighter Billy Vernon died from head blows in a Philadelphia ring. And less than three weeks before Eakins saw the match he depicted in his first boxing painting,

Philadelphia's favorite George Stout died in Columbus from the effects of a knockout punch delivered by "The Omaha Kid," Oscar Gardiner.

The usual arena program consisted of five fights of six rounds each. Preliminary bouts pitted light and middleweight fighters against one another. More than once, the first bout of the evening was preceded with "pugilistic displays" by adolescents or children as young as five and six. The headline fight, announced on a billboard on Walnut Street, was known as the "wind-up" and came last. Depending on how long earlier bouts lasted, the wind-up could get started as late as eleven o'clock at night. The arena was rarely empty before midnight.

Through his acquaintance with the sportswriter Clarence Cranmer and the referee Henry Walter Schlichter, Eakins got to know many fighters personally. He featured local fighters in his paintings, lightweights and middleweights in particular. His choices were driven by aesthetics as well as practical reasons. Modeling sessions with local and less well known fighters were most easy to arrange and did not require large modeling fees. In what later became a routine, Eakins began by watching the fighters in action during an event and then arranged for them to model in the studio; with Murray's help, he set the place up to resemble a gym. At times the fighters put on boxing demonstrations to show off tricks or moves they were especially good at.

Philadelphia's Charlie McKeever, the twenty-five-year-old featherweight pictured in *Taking the Count,* may have been the first fighter to visit the Chestnut Street studio. He retired from the ring soon after the painting was made and opened his own gym. "Turkey Point" Billy Smith, another boxer who posed for Eakins and later sat for a sculpture by Murray, became good friends with both artists. Elwood McCloskey, a boxer dubbed "the Old War Horse," visited the studio most frequently. Known to Murray as "the Enforcer," McCloskey took on the responsibility of "collaring," in Murray's term, fellow boxers who failed to show up for modeling. "Hey, you son of a bitch," McCloskey said to one fighter. "Haven't you got a date to pose for Mr. Eakins? Come on now, or I'll punch your godamn head off." In later years, after he had gone blind and was operating a cigar store, he came now and then to visit the studio or the Eakins home for a chat with the artist or whoever happened to be there.

Taking the Count, Eakins' first completed boxing painting—like several

of his rowing paintings that documented actual events—chronicled a scene from a fight between Philadelphia's McKeever and Jack Daly of Wilmington, Delaware, on April 29, 1898. The portrayal of the event by Eakins shows the ring raised several feet from the ground, at the center of the circular auditorium filled with spectators. Two ropes on each side, anchored to corner posts by long iron brackets, mark the ring's boundaries. The gloved fighters are clad in short trunks and high, soft-soled leather boots. Referee Henry Schlichter, attired in a tuxedo, stands center ring between the fighters, putting "the count" on Daly, who has fallen to one knee. McKeever stands to the side, his biceps bulging, waiting to see if Daly will rise to his feet before the referee declares McKeever the victor.

The *Philadelphia Inquirer* anticipated an exciting match that evening: "At the Arena tonight Charlie McKeever and Jack Daly will meet for the second time in their careers. At their last meeting the battle was one that anyone who saw it then will under no circumstances miss it this time. . . . The Wilmington lad has gained much in experience and has thrown off the habits of dissipation that were such a handicap to him in all his previous encounters. . . . McKeever is also as fine as silk, not having let up in his training since he 'trimmed' Matty Matthews at Cleveland on the 14th of this month. The meeting should prove a crackerjack, and both boys will certainly know they have been in a contest when it is over."

The *Record* reported the results the next day: "Charley McKeever easily bested Jack Daly in a six round bout at the Arena last evening . . . both men sacrificed strength to speed, and as a result it was a very fast bout, with little damage done. . . . There were a whole lot of harmless mix-ups which looked pretty, but which amounted to nothing."

The *Inquirer* reporter was more impressed. The exchanges between McKeever and Daly, he wrote, were a "rattling fast mill from end to end with mutual hard exchanges." The *Record* and the *Inquirer* agreed that the sixth round was the high point. "It was the chef d'oeuvre," as the *Inquirer* described it. "McKeever landed with his left on the face and Daly got back hard on the wind. In one of the mixes that followed McKeever caught Daly hard on the side of the jaw, and Jack looked tired. He came right back, however, but he was too tired to inflict any serious damage."

This sequence was likely the round Eakins chose, though he may have taken liberties in his portrayal. McKeever, the victor, won on points scored. It is unlikely Daly went down on one knee to take the count as shown in the painting; had there been a knockdown during the fight, the newspapers would have reported it. Eakins took this liberty, most likely, to better fit his conception of portraying the narrative excitement of a fight in progress. He conveyed his concept not only by the dramatic pose of the fighters but by the spectators bestowing their appreciation for the moment. Among them are City Commissioner T. J. Ryan and a number of his friends, a magistrate judge, a police commissioner, several lawyers, a member of the school board, along with doctors and other professionals. On a more personal note, Eakins included his father, Benjamin, who is seen on the far left at ring level in a light-colored hat. Above Benjamin sits a person who appears to be Walt Whitman, and Eakins himself may be the figure sitting next to his father at the far left.

As in *The Agnew Clinic,* Eakins stretched a giant canvas—just over eight feet high by seven feet wide—and brought his nearly life-sized figures close to the picture plane, permitting detailed portraits of the principal subjects as well as room for a background filled with avid fight fans. The viewer's position is ringside, directly opposite the referee. McKeever and Daly stand out because of the brighter skin tones on their rippling muscles and the sweaty sheen of their bodies, contrasting strikingly with the dark clothing worn by the packed spectators. Except for the kelly green sash around McKeever's waist, a spot of pure cadmium yellow for the referee's ring, and the red laces of the fighters' gloves and boots, not much vivid color distracts attention from the boxers. Eakins represented the skin tones and anatomy fittingly, conveying the fighters' strength and solidity; he did not fully succeed in pulling off the greater challenge of freeze-framing the athletes' dynamism, capturing their mobility on canvas. McKeever and Daly, like Schlichter, appear somewhat wooden and altogether static compared with McKeever's handler motioning from ringside and an animated fan gesturing with his fist. Eakins learned his lesson in this first fight depiction. He avoided making the same mistakes in his second, *Between Rounds.*

Featherweight Billy Smith, whose local moniker was "Turkey Point," is featured in *Between Rounds* (Philadelphia Museum of Art). The twenty-four-

year-old Smith had reached the middle of a somewhat unremarkable boxing career when Eakins made his portrait. He turned out to be the ideal Eakins model: eager, friendly, and thoroughly accommodating. He loved posing in the mock ring Eakins had installed in the studio and would, when given a chance, coach anyone who happened to be around. He showed advanced moves to the artist, as well as to Benjamin Eakins and Murray. "Billy was a favorite not only among fighters," Susan Macdowell Eakins said. "He attracted by his good nature & his honesty."

For this painting, Eakins again presented his fighter in a specific match, held at the arena on April 22, 1898. Although he selected a format about half the size as his previous painting, for *Between Rounds* he chose such an unconventional, and difficult, angle to view the scene—at ring level looking off to the arena's side—that the viewer is given the advantage of far more information about the environment and the fighters than a conventional setting (plate 33). Smith is catching his breath on a stool between rounds, his outstretched arms resting on the ropes. Billy McCarney, his second, fans the fighter with a towel. Ellwood McCloskey, the manager, leans toward Smith to offer advice. Others of the boxer's accoutrements further define the scene: a brass bucket, sponge, bottles (whether of water or, not improbably, whiskey), and a cut lemon.

The ring, spectators, and smoke-filled arena are all depicted in *Between Rounds* more interestingly than in the first boxing painting. A timekeeper sits at his station just below the ropes, ready with a bell and a stopwatch. A policeman stands guard at the ground-floor entrance. Above, a press box holds a sketch artist, journalists, and a telegraph operator (the curly green telegraph wires show in the corner). On a poster above the press box, the setting, date, and time are clearly readable.

Without these details the painting would still have been recognized now as a great success. Billy Smith, sitting at the composition's center, under strong light, is rendered with manifest skill. The delicate curve of his spine as he leans back shows an elasticity that is missing from the earlier figures of McKeever and Daly. The timer is portrayed just as convincingly, as are Smith's manager and second. No awkwardness intervenes, no sense of art-school formulaic poses. The background spectators appear much the same as in the earlier painting, though from the angle they are viewed, Eakins was able to create much more

effect with light and shadow, resulting in a rich layered atmosphere that is visually arresting. Eakins has fully, believably, brought to life the moment of the painting's title.

One of the most interesting aspects of this painting, beyond its constructed elements, is the canvas: its weave shows through over the entire painting. Eakins did not load his brush or palette knife with paint to represent his forms. The canvas holds little pigment, except in the light tones that build up Smith's body, and yet all elements inhabit the setting with substance. Only up close can a viewer detect the weave of the canvas. From farther back, as the painting was meant to be seen, the brushstrokes and canvas texture disappear; the painting takes on a translucence, as if it were being projected on a wall.

The crowds who had been at ringside for the fight pictured in *Between Rounds,* as accounts claim, set up a decidedly raucous din. The *Inquirer* reported that these spectators, in the mode of "snakes" and "geese," "hissed vigorously." Spectators were so worked up by the spectacle of the bout that they broke out into their own fighting, forcing the police to wade into the melee.

About the fight that Eakins would dramatize in his next portrait, the *Philadelphia Press* reported: "Tim Callahan and Billy Smith, the very clever 115 pounders, appeared in the semi-wind-up. The contest was a very clever one, in which both displayed a great deal of science. It was an even thing until the last round, in which Callahan had slightly the better of affairs." Although Callahan won the fight, Eakins depicted Smith—in the last of his boxing pictures—as the victor. The painting titled *Salutat,* Latin for salutation or greeting, features Smith stepping from the ring. He raises his hand, in the style of a gladiator, to the crowd's applause. The Roman theme was inscribed on the painting's frame, where Eakins carved, in Latin, "With His Right Hand the Victor Salutes Those Acclaiming Him."

Salutat, a medium-sized canvas, four feet high by three feet wide, contains many fine smaller portraits in addition to Billy Smith's. The spectator at the far left, wearing eyeglasses and a bow tie, is the artist's friend Louis Kenton, the man who was about to enter into a brief and rocky marriage with Susan Macdowell's sister Elizabeth. Waving his bowler hat next to Kenton is Clarence Cranmer, the sportswriter. The distinguished-looking man standing beside Cranmer, to his left, is David Jordan, the brother of the woman Eakins

portrayed in a black evening gown with a fan. Alongside Jordan sits Louis Husson, a photoengraver and photographer whose portrait Eakins would paint the next year. Murray is seen just to the right of the boxer's raised hand; Benjamin Eakins, wearing a soft gray hat and holding a cane, sits behind Murray. Benjamin looks especially old and frail, as he indeed was, although he did live to see the painting displayed. Many other Eakins friends and associates undoubtedly appear in the painting as well. According to Murray, if you happened to wander into Eakins' studio or wanted to be included in one of the boxing paintings, all that was required was that you show up and pose. Eakins would say, "Stay a while and I'll put you in the picture."

It is interesting to note that in this painting, as in all of his boxing scenes, Eakins never pictured a fight in progress, as George Bellows did a generation later. The reason may have to do with a message he wished to communicate—he was not trying to present the brutality or pain of the combat, but rather the character of its participants. It could be, as well, that after his struggles to show movement with *A May Morning in the Park,* he found the technical challenge of motion too distracting from his essential goals in portraiture. As it was, he took significant leaps forward. *Between Rounds* is in many ways the most visually complex interior scene of his career. And in its colossal scale and proliferation of details, *Taking the Count* was like nothing the Philadelphia art world had ever seen. Before Eakins, the closest anyone had come to portraying fighters in their milieu were crude sketches in the tabloids.

Of the three paintings, *Salutat* was exhibited the most often. It first appeared in January 1899, at the academy's annual show. The few critics who made note of the painting were not pleased. The *Art Collector* said: " 'Salutat,' by Tom Eakins, is hardly the representative canvas of that strong anatomist. . . . The audience is too obtrusive. Eakins has brought them so far forward as to give the impression that both victor and audience might easily shake hands. The coloring also would lead one to suppose the fight took place in broad daylight. . . . The technique and close observations of the lines of anatomy are in the same style as of old, always coarse, never beautiful, but often true." *Between Rounds,* also on view at the academy annual, met with similar criticism. "Feeding the new popular taste, 'Between Rounds' is a realistic emanation at the hands of Thomas Eakins," wrote the collector and art critic W. P.

Lockington. "You all know, however, that he can do better." *Taking the Count* was not exhibited at all. Rather than undergo further humiliation, he lent the painting to a Philadelphia rowing club, where it hung on loan for more than a decade. His other boxing paintings he gave to his models or retained in his collection.

Discouraged, Eakins gave up portraying boxers, and after one brief experiment depicting a Philadelphia Athletic Club wrestler, he abandoned sports subjects altogether. The highest praise any of his boxing paintings received during his lifetime was voiced by the fighters who adored Eakins' work as they did him. As "Turkey Point" Smith later wrote, after hanging up his gloves to become an officer in the Salvation Army, "Mr. Eakins, to me was a Gentleman and an Artist, and a Realist of Realists."

forty-seven

Outlaw in an Undershirt

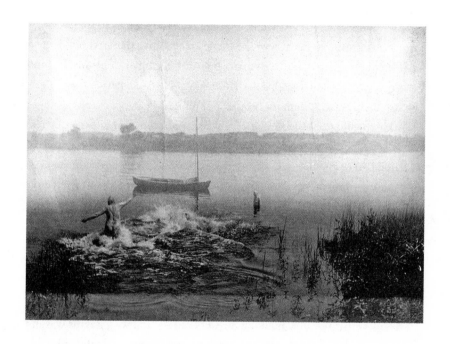

In the early years of the new century, Rear Admiral George Melville, retired, a great fight enthusiast, posed for two portraits by Eakins. Melville recalled going with the artist to the Friday night matches at the Philadelphia Arena. Jostled by the crowd, he brushed against Eakins, only to discover that his companion, a man he regarded highly as an accomplished artist and scholar, carried hidden beneath his jacket a large revolver. Melville was incredulous. In all the many ports the admiral had visited—Hong Kong, Yokohama, Manila Bay—he had not once felt the need to arm himself. Yet Eakins, in midtown Philadelphia, twelve blocks from home, in the company of friends, carried a concealed weapon. Eakins gave no explanation and Melville, unwilling to pry, apparently did not ask.

Bravado may explain why Eakins brought a gun to the arena that night. At heart, Eakins must still have been the young art student in Paris who slid down a banister at the École des Beaux-Arts brandishing a pair of pistols. Beyond these speculations, however, Eakins had enemies. He could never know for certain whether Lillian Hammitt's brother or Frank and Charles Stephens might be lurking among the shadows on his walk to Mount Vernon Street. There was no telling how many angry husbands, boyfriends, or brothers—believing the artist had corrupted or humiliated their loved ones by having them pose in the nude—might also have thought of taking justice into their own hands. Mindful of such chances, even harboring an inchoate desire for a showdown, Eakins might have tucked the pistol into his jacket out of prudence or for self-assurance, harboring as well a touch of Dakota frontier élan. What can be said for certain is that he carried a Smith and Wesson revolver on more than one occasion, and he converted the basement at Mount Vernon Street into a practice shooting range, complete with a sheet of metal to stop the bullets.

However real or imagined the threat of retribution was, Eakins was not chastened by the long catalogue of indiscretions and perceived infidelities that had made him close to a pariah in the greater Philadelphia arts community. Instead, he embraced the role of a confirmed impenitent, a gun-toting cowboy. Even Murray, ordinarily circumspect and loyal, suggested that his mentor was acting like a man who knew his damaged reputation could not be salvaged and

Overleaf: Thomas Eakins at about sixty-five with Samuel Murray and unidentified man at Fairton, New Jersey, c. 1909 (Samuel Murray Archival Collection, Hirshhorn Museum and Sculpture Garden, Smithsonian Institution, Washington, D.C.)

was hence unwilling to repair it. In this state of affairs, following his depictions of boxers, the many portraits Eakins painted, most of them so darkened they were declared "black," were as intriguing as the stories that have been told about how they came to be painted.

Over the years Eakins upset many of his female sitters by trying to wheedle them into posing naked, or merely offended them with his unkempt appearance and lack of decorum. He still read math and medical texts for fun, and kept up his study of Latin by diagramming sentence structure on a blackboard he had installed in the dining room, but on a stool beside his easel lay a book of risqué stories and dirty jokes. "[I] could never get [it] away from him," said Frieda Douty, who regretted lending the book to him. The artist relished reading passages from the book aloud, reciting one so often that Eakins' friends despairingly referred to it as his "plum story."

The dignified Mrs. Elizabeth Gillespie, a doyenne of old Philadelphia, refused to model for Eakins after he received her in his studio wearing paint-splattered trousers and an old undershirt. (The artist's belly, prominent at this point in his later career, may also have been a disturbing sight for her.) Along with Admiral Melville, Mrs. Gillespie must have admired Eakins' meticulous brushwork and composition, though she could not reconcile how a man who labored so carefully to depict the rich and varying textures of his sitters' clothing could pay no attention to his own.

During a session with Josephine Kern Dodge, the wife of a prominent Philadelphia inventor and longtime family friend, Eakins approached and poked into the bosom of the buxom woman. Startled, Mrs. Dodge demanded to know "what the devil" the artist thought he was doing. As if he had done nothing inappropriate, Eakins replied, "Feeling for bones." (Records show that Dodge was either pregnant or had just given birth. Her rosy fullness, especially around her breasts, must have intrigued him.)

Other sitters were offended because Eakins let Bobby, his pet monkey, run riotously through his studio. Bobby had a pair of prized silver dollars. Horatio Wood recalled watching in stunned disbelief as the monkey climbed onto Eakins' shoulders and pounded the artist's head with the dollars; Eakins nonchalantly went on with his painting. ("Here I come, Eakins; lock up that damned monkey," Taylor Snow, an Eakins friend, would say before entering the

studio.) Helen Parker Evans, a family friend who posed for *The Old-Fashioned Dress*, witnessed mayhem when Bobby poured a bottle of ink over the artist's desk. Unfazed, Eakins termed the animal's behavior "emotional," nothing to be concerned about. (Later, after Eakins died, Bobby was donated to the Philadelphia Zoo in Fairmount Park.)

Eleanor Pue, twenty years old, recalled Eakins, then sixty, disconcertingly following her around the room at a party given by former league student Frank Linton. He could not take his eyes off her. Linton advised Pue to pay him "no mind." He was mentally painting her. Another woman Eakins met at a party was also put off by his staring. "Mr. Eakins, why do you look at me like that?" she asked. His reply was as direct as his gaze: "Because you are so beautiful."

Eakins clearly was tactless to the point of rudeness, as when he suggested to a young woman that she couldn't sit still for her portrait because she had to "go pee." As with his telling of the plum story, he seemed to derive a certain unexplained pleasure in seeing the woman blush. Lucy Langdon, a friend of his sister-in-law, Elizabeth Macdowell, suggested to biographer Lloyd Goodrich that Eakins' provocative behavior was intended to embarrass his sitters and their chaperones. Regardless of whether this was true, Eakins apparently took considerable pleasure in playing off of his subjects' concerns by behaving just as they expected him to. During his session with Langdon, he tried shocking her with uncouth language and immoral stories. Instead of showing offense, she ignored him, and he stopped carrying on.

Most sitters tended to be less offended by the artist's behavior than by how he chose to depict them. He seemed to delight in wrinkles, blemishes, and birthmarks. In one portrait, he took more care in painting the veins on a woman's hand than he did in rendering her face and dress. "I remember his telling me of an old model who came to see him and he found her whole body a network of beautiful *fine* wrinkles," said Helen Parker Evans. In another case, working from a photograph, Eakins was painting the deceased father of Dr. Henry Bates. The artist was determined to find a photo that showed the texture of his subject's skin, especially his wrinkles. Eakins asked the banker William Kurtz to go unshaven for twenty-four hours before posing.

Many other sitters, including Josephine Dodge, were none too pleased

with the results. Dodge thought the portrait of her gave her the look of a fish-wife, and she banished it to a third-floor bedroom. Helen Parker Evans broke out in tears when she first witnessed her portrait displayed. Pianist Mary Hallock Greenwalt, who posed for Eakins in 1903, wanted her painting destroyed. A portrait of the seventy-nine-year-old iron manufacturer Edward Buckley was likely burned by his daughter, who did not wish, she said, "his descendants to think of their grandfather as resembling such a portrait." Eakins saved another unsatisfied subject, Jacob Da Costa, the trouble of ridding himself of the image he believed unflattering. After the esteemed physician complained of how old he looked in the portrait, Eakins removed the canvas from the stretchers and cut it into small pieces.

As one friend later wrote: "If Eakins had possessed even a modicum of social flair he might have successfully cultivated those circles that would have extended a helping, albeit a somewhat patronizing hand. But Eakins did no such thing. Instead he liked best to be among [boxers] . . . [For an evening's good time] he brought prize fighter friends home to his tiny, ladylike wife."

Nothing was markedly new about Eakins' behavior, his desire for realism in his portraits, or his tendency to give animals the run of his studio. The traits only appeared to have become more extreme with the advent of the twentieth century. In one of the most egregious examples of his behavior, Eakins theatrically presented himself stark naked in front of a young woman posing for Murray. "You've never seen a naked man before," Eakins announced. "I thought you'd like to see one."

An entry in Susan Macdowell's diary expresses the desperation she felt. She described dressing herself in a bright, gay costume, perhaps intended to encourage her husband to adopt a more elevated and dignified manner. "I try on rich stuffs to tempt Tom to paint," she wrote in 1899. Eakins invited her to pose, but the resulting picture, *Portrait of Susan Macdowell Eakins* (Hirshhorn Museum and Sculpture Garden), presents her dress as a dark green taffeta. Her large expressive eyes are almost mournful. A black scarf, like a tourniquet, wraps around her neck (plate 34).

The black scarf may have been a projection of what Eakins knew to be a tragedy in their relationship. The academy pupil Eakins had singled out as "the finest female painter in the country" had abandoned her art to run his

household and help him fight his many losing battles with the Philadelphia art establishment. "She shielded him from household chores, extended constant hospitality to his students and a large circle of friends, answered his correspondence, [and] supervised the shipping of his pictures to exhibitions," Charles Bregler, Eakins' former art student, later recalled. Her love and steadfast support for Eakins and his art, over the decades, was unqualified. "Because she believed so intensely in the importance of her husband's work, for years she surreptitiously gathered up (and hid away in closets) his sketches, studies and perspective drawings that are, today, museum treasures, and which Eakins himself had tossed into the trash bin." Bregler, who later retrieved many of these same items, further declared: "Mrs. Eakins was kinda killed ... [by Tom]. She would have been a great painter if she hadn't married."

Even more painful for Eakins could have been the torment and hardship he knew he brought on his father. After having well earned a high reputation in the Philadelphia business community, and after nearly fifty years of service as an instructor at the Friends Central School, Benjamin Eakins, along with his achievements and his family's good name, had become overshadowed by abject notoriety. Benjamin's only living daughter and all his grandchildren were alienated from the household. His son's art, made possible through Benjamin's great personal sacrifice, had brought the most meager financial returns, and the situation showed no signs of improvement.

In the same spirit as Macdowell, Benjamin Eakins remained the artist's steadfast companion to the end. Though he and Tom had given up hunting and rowing together, they still rode bicycles through Fairmount Park and took fishing trips to Fairton. Murray recounted seeing father and son arrive one night in a dinghy at the family boathouse. As Tom poled from the stern through the shallows toward shore, Benjamin stood in the bow holding a fresh-baked pie aloft on the flat of his hand. "Yoo-hoo," chortled Benjamin. Just then the boat struck a submerged timber and Benjamin, still holding the pie, walked straight off into the water and waded ashore without losing his balance.

Shortly after Aunt Eliza Cowperthwait died, on January 2, 1899, and perhaps knowing that Benjamin too could soon pass, Eakins painted his father for what was the last time. *Portrait of Benjamin Eakins* (Philadelphia Museum of Art) shows the dignified eighty-two-year-old father and grandfather younger

than his age would suggest. Eakins did not emphasize Benjamin's devotion to his craft as he did in *The Writing Master*. Instead he presented his father's more ephemeral qualities. A darkly austere, mysterious expression inhabits his eyes—the presence of a man who has confronted, and risen above, calamities that could have devastated a person of lesser character. Benjamin remained vital right up until the end; at age eighty-one he was still riding his bike and walking the Jersey shores.

Master Benjamin died at the end of that year, on December 29, 1899, and was buried in a private ceremony alongside his wife, Caroline, their two daughters, and an infant son. No eulogy from Eakins or letters about his father's death have come to light. The emotional void created by Benjamin's death could only have added to the psychological burdens that contributed to Eakins' often strange and erratic behavior. His father had been his best friend, companion, a base of his emotional support over the artist's entire life. Losing his father late in his own life, when the artist's personal and professional failures were most apparent, very conceivably made it hard for him to maintain his already precarious emotional balance. On the other hand, Benjamin's absence, along with the financial security his father's will assured him, allowed Eakins to succumb to impulses that gave an illusion that he had nothing to lose—he could vent his frustration on unwary portrait subjects and flaunt his disregard for Philadelphia society and public opinion. Eakins' sharp sense of humor and often childish petulance may have combined to allow him a release and help pull him through these most recent difficult times.

At fifty-six, at the dawn of a new century, Eakins transformed into a caricature of his former self. One moment he could be affectionate, spontaneous, and generous, and the next vindictive, brusque, and petty. Adolphe Borie, a fellow portrait painter who visited Eakins' studio during this period and became his friend, described him as "the grandest man he ever met." Another described him as "very kindly and humorous." Catherine Janvier spoke of "his delightful friendly side . . . how full of fun he could be—like a boy—and what good company he was, and very loveable." Charlie McKeever, the boxer, was touched by the artist's willingness to post bail for jailed fighters. Josephine Dodge found it remarkably sympathetic that he cried when listening to music.

On the other hand, Nicholas Douty was one who found him wholly

insensitive. "If anyone did him an unfair injury he would never forgive them—would simply have no more to do with them," Douty declared. The only communication between Frances Eakins Crowell and her brother since Ella's suicide was a short note from Tom alerting her of their father's imminent death.

Master Benjamin's estate by will was portioned in thirds among Tom, sister Frances, and the children of Caroline Eakins Stephens. Eakins kept the house as the bulk of his share of the inheritance. According to his father's dying wish and his wife's desire, Eakins invited Mary Adeline Williams, an unmarried family friend and distant relation, to live at Mount Vernon Street. Three decades earlier, from Paris, Tom had described Addie in a letter to his sister: "She is a pretty little girl & I guess just as good as she is pretty, or she belies her blood. We owe a great deal to her father & mother for their unvarying and disinterested kindness to us . . . and to her."

Benjamin had previously asked Addie Williams to move in with them in 1882, after Margaret's death; she declined, not wishing, as Sallie Shaw claimed, to encourage an intimacy between herself and Benjamin's unmarried son Tom, toward whom she felt a special attraction. Nevertheless, they remained close. An entry in Susan Macdowell's diary records a bicycle trip that she, Tom, Addie, and Benjamin (at age eighty-one) made from Egg Harbor to Atlantic City. After Benjamin died, and in view of a close, deeply felt friendship she had developed with Susan, Addie accepted Tom's invitation, and remained a member of the Eakins household for nearly four decades to come.

A clue to Mary Adeline's initial reluctance to move to Mount Vernon Street, and a foreshadowing of the discomfort many women experienced in their relations with the artist, is visible in the portrait Eakins painted of her in 1899, just before Benjamin's final days. *Addie, Woman in Black* (Art Institute of Chicago) shows Eakins' childhood friend, now middle-aged, wearing a full-length black suit, wide-striped blouse, and high collar with a bow. Eakins portrayed her in his typically unsparing manner: lines crease her brow, her mouth, and around her eyes. Susan described her friend's appearance in the portrait as "rather worried."

It is not hard to imagine that Addie had reason to be. Beyond packing his pistol to Friday night fights, and the artist's disregard for his portrait subjects'

requests concerning how they were represented (after all, he painted most at his own invitation, without fee), Eakins compulsively endeavored to entice reluctant models—many of them close family friends—to disrobe and pose naked. Curiously—naively, trustingly, or insensitively, or some combination—he made these overtures in his wife's presence at his Mount Vernon Street home, where many of his portraits now took shape. (Eakins and Murray, who had shared the Chestnut Street studio, vacated it in 1901 because the building was due for demolition. Murray moved his studio to West Philadelphia, where, with the help of Eakins, he purchased a home.)

Mary Adeline Williams' entry into the Eakins household did not bring on any trauma that she could have anticipated. A second portrait Eakins made of her, *Addie* (Philadelphia Museum of Art), rendered not long after she moved in, depicts an altogether happy, at ease, Mary Adeline. Her anxiety has evaporated. Her canvas projects, as Macdowell later said, a "more relaxed and more tender" countenance, now that she had filled a place, Macdowell further revealed, as "a beloved companion in the house." In this painting, Addie Williams turns her face fully to the light. Eakins has recast her earlier worried brow and sagging flesh with sparkle and warmth in her eye, and full red color to her lips. Her mouth holds a hint of a smile. The unusual shape of the canvas, vertical but far narrower than his typical later portraits, draws the viewer into an unusually intimate, for Eakins, relation with her. Unlike in the previous painting, for which she had donned a black dress, Addie is arrayed this time in a coral-striped blouse enhanced by red frills and velvet bows. Photographs taken before and after her arrival on Mount Vernon show a similarly striking transformation.

Many friends of Eakins believed the changes wrought in the second painting were to some degree intrinsic to the process of the portraits, yet they felt the transformed rendering resulted directly from Williams' giving in to Eakins' campaigning for her to pose for him in the nude. Murray and others advanced claims that she and Eakins had become lovers, adding that Macdowell did not mind her husband having the affair, that she had in fact encouraged their relationship.

"You know, of course, that Uncle Tom made love to Addie Williams," one of the Crowell children many years later confided to an art critic. A frequent

visitor to the Eakins household once suggested that there was a ménage-à-trois arrangement there, although he later admitted, under cross-examination from his wife, that he did not know any such thing beyond his own impression. From various accounts, it can be said with confidence that the new resident in the Eakins house acted with a familiarity toward the artist that seemed to breach conventions of Victorian propriety.

The truth of the difference between the two images of Addie, at least, may be as simple as her relief at being able to give up the drudgery of working in a corset factory and the isolation of solitary living in a small apartment in North Philadelphia. The relaxed and free-spirited Eakins household would have been therapeutic, given any latent flexibility on Addie's part, for a woman previously resigned to passing her remaining years alone. A letter Eakins wrote to her the year before she moved to Mount Vernon Street invited her to celebrate the new year and new century. Other letters had summoned her to the house, where she might spend an afternoon creating needlepoint images with Macdowell, or joining them for an evening out at the theater, or for forays to the circus, or attending lectures. "Jamie Dodge is going to explain to his workmen and friend the principles of moving photographs and will show the very latest improved apparatus," Eakins notified her in a letter, hoping she could join him and Macdowell.

Regardless of the entwinings of love and desire that may, unaccounted, have wound through sheets in the privacy of the master or any other bedroom at Mount Vernon Street, or of ordinary friendship in the three stories, Mary Adeline Williams made no secret of her happiness in the Eakins household. Tom Eakins was not the monster he was often purported to be. She and Susan Macdowell grew to be best friends during Eakins' lifetime and the closest of companions for more than two decades after his passing.

Disconcerting as a good many people found the artist's actions, the points must be emphasized that, although he carried a concealed weapon, Eakins didn't brandish it in public, and however much he embarrassed his female portrait subjects by suggesting they pose unclothed, he did not force himself on them. For every incident of discomfort or outrage a friend or portrait sitter encountered, many more examples of benign and gentle behavior, combined with a relentless pursuit of truth in his art, strongly mitigate any exaggerations

or his idiosyncrasies. Eakins the confirmed, pistol-packing impenitent and Eakins the dedicated and sensitive artist, as the complexities of even less fraught lives demonstrate, existed simultaneously. Age and misfortune intensified by his father's death could have left the artist unbalanced in the minds of many portrait subjects. From another perspective, these conditions merely liberated the artist's character. Eakins, for the first time in his life, could feel completely free to do and say exactly what he wanted.

Melville's discovery of Eakins' pocketed revolver joins the experience of Elizabeth Dunbar, Talcott Williams' secretary, as telling of the difficulty Eakins' generation had in reconciling the seemingly contradictory signals the artist gave out. Dunbar, a frequent visitor to the Eakins home in the early 1900s, was clearly fascinated by the artist's persona as much as she was with his art, and thought she would interview him for a biographical newspaper sketch.

In the company of Macdowell and others, Eakins told her—though she did not necessarily believe in his characterization—that she was an extremely beautiful woman. He did not put any undue pressure on her, but he made it clear he wanted her to model nude for him. "[I] was asked several times by the painter to run upstairs to the studio and pose for a life study," she said. Dunbar's modesty put her off the idea. Later in life, after Eakins had died, she regretted not taking him up on the offer.

It was around this same time that Dunbar arrived unexpectedly in Eakins' studio—the place he called his "droring room." Perhaps, like Mary Adeline, she expected to find the artist stark naked, or engaged in a nefarious, compromised, or undecipherable activity. As she discovered, Eakins was stretched out comfortably on his old sofa, wrapped in his favorite close-fitting navy-blue knit sweater. The book in his hands was neither a text on math or anatomy nor his favorite book of risqué stories. He was reading, in Latin, the New Testament.

forty-eight
Pictured Lives

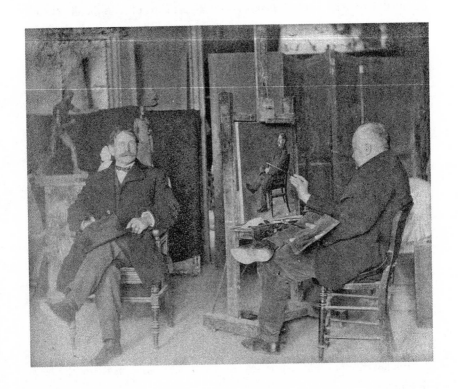

During the first five years of the new century Eakins produced an astonishing 110 portraits, turning his brush and eye from capturing the most unassuming clerk to an archbishop of the Catholic Church, and in what may be among his finest, an image of himself. These paintings stand today as a bulwark safeguarding the artist's reputation as our nation's greatest portraitist. Each canvas is entirely singular, unique to itself. Few of the works are the same dimensions. Each subject appears in a distinct pose, posture, and arrangement of elements that are as unduplicated as fingerprints. Refinements in his technique change so subtly they are best recognized by visiting the Metropolitan Museum of Art, the Philadelphia Museum, and the Pennsylvania Academy, where portraits that were painted within several days or months of one another can be viewed side by side. Many were painted in sessions lasting only a few hours, barely more than the time it took for the artist to pack his painting supplies on the back of his bicycle and ride from one sitter's house to another.

The paintings of this period do not present a motion-picture-like narrative in the way Eakins portraits did in previous decades—projects that took months and sometimes years to realize—yet they continue to embody the character and flavor of Philadelphia and its citizens' life by depicting, as Eakins said, "living thinking acting men [and women], whose faces tell their life long story." Two portraits of Rear Admiral George Melville are prime examples of Eakins' achievements.

Eakins' association with Melville began around 1903, when Eakins painted Admiral Charles Sigsbee. Sigsbee was renowned as captain of the *Maine* when the battleship was blown up in Havana harbor, an event that occasioned sensational calls for war with Spain in newspapers, unleashing the full practice of "yellow journalism." Eakins undertook the Sigsbee portrait upon the admiral's appointment as the new commandant of Philadelphia's League Island Navy Yard. Sigsbee considered the resulting painting a great success. He was able to see its strengths without distraction, in all likelihood because military commanders, like scientists and clergymen, were not given to the same impulse as socialites and businessmen who wanted the artist to remove features they deemed facial and bodily imperfections. To military heroes such as Sigsbee

Opposite: Eakins painting a portrait of Frank St. John, 1900; photograph thought to be by Samuel Murray (Courtesy of Charles Bregler Archival Collection, Hirshhorn Museum and Sculpture Garden, Smithsonian Institution, Washington, D.C.)

and Melville, a deeply lined face, like a scar, presented a well-earned, living emblem of courage. "I have intended writing you concerning the portrait," Sigsbee's letter informed Eakins after his painting was put on display. "I have delayed chiefly because I desired to get criticisms of my friends. Please let me say that there is one judgment that is common to all:—'The man who painted that picture is an *artist*.'"

High praise from Sigsbee in itself would have pointed to Eakins as a natural candidate to paint another naval commander. It was possible, however, that Sam Murray rather than Sigsbee introduced Eakins to George Melville, and Murray may have invited Melville to join him and Eakins for bouts at the Philadelphia Arena. Murray was commissioned to sculpt a statue of Melville for the League Island Navy Yard; he would also sculpt a bust of the admiral's wife for the Lancaster General Hospital.

Eakins' first portrait of Melville, painted in 1904, depicts him in full dress uniform, his epaulets and collar bearing the two stars of a rear admiral, his chest decorated with three medals, including a medal Congress had awarded him for his heroism in attempting to save the lives of shipmates during an ill-fated voyage in an attempt to reach the North Pole.

The following year, 1905, Eakins painted Melville again, picturing him in full face, looking directly into the eyes of the viewer. Melville's strong rough hands are clasped at his waist, his epaulets replaced by simple shoulder straps. This time Melville wears only one medal, the order of St. Stanislaus, presented to him by the tsar of Russia.

In both portraits it is Eakins' portrayal of Melville's remarkable face, featuring his high domelike forehead, flowing white hair and beard, and somber, brooding eyes, that rivet the viewer's attention. A century since the works were painted, Melville's presence is all the more captivating. He does not sit ramrod straight as a naval hero might be expected to pose; no effort has been made to shrink his middle-age paunch or to remove the wrinkles and calluses from his hands. Melville emerges out of a dark, nearly impenetrable blackness, and stares at the viewer with every bit of extraordinary courage and physical strength for which he was best known.

Eakins' portrait of Sarah Sagehorn Frishmuth, *Antiquated Music* (Philadelphia Museum of Art), from 1900, has much the same appeal. Frishmuth, a

Mount Vernon Street neighbor of Eakins and the wife of a successful tobacco manufacturer, is shown seated in her family parlor surrounded by her large collection of antique musical instruments (plate 35). Among the twenty instruments Eakins depicts with characteristically fine detail are bagpipes, a harp, cymbals, drums, and a hurdy-gurdy; a particularly unusual instrument is shaped like a duck, another like a peacock. In the background appears a tall Lama horn from Tibet. A rare Japanese stringed instrument, a precursor of the koto, occupies a side of the foreground. In the opposite corner, on an overturned lute, Eakins has signed his name. He would have enjoyed the stories Mrs. Frishmuth told about acquiring these various instruments, much as he would have appreciated listening to Melville's adventures.

In the midst of her intriguing collection sits Mrs. Frishmuth, wearing a high-necked, long-sleeved formal black dress. Circling her neck are a blue scarf the color of her eyes and a six-stranded pearl necklace. Her fingers touch the strings of an English viola d'amora affectionately cradled in her lap; her other hand rests on the polished keyboard of an eighteenth-century piano. Though her fingers come into contact with the instruments—her forefinger presses down an ivory piano key—she is not playing music. Nor is music or instrumentation directly or ostensibly the message of the painting. The portrait celebrates Mrs. Frishmuth as collector and her love of musical instruments: she had just donated a large portion of her collection—a gift numbering close to two thousand instruments—to the forerunner of today's University of Pennsylvania Museum, where Eakins intended her portrait to be hung. "I should be delighted to have Mrs. Frishmuth's portrait in the Museum," wrote Stewart Culin, one of the curators.

Although Eakins gave the instruments prominence in the painting, just as he featured medals in his first portrait of Melville, his depiction of Mrs. Frishmuth's head in the end most draws the viewer's attention and elevates the painting to masterpiece status. Subdued light greatly veils the instruments; Mrs. Frishmuth commands the viewer's gaze. She is not a conventionally attractive or pretty woman: "heavy-necked, square faced," was how the art historian and Eakins biographer Sylvan Schendler described Mrs. Frishmuth. Nor does her ample figure naturally lend itself to a classical vision of matronly comeliness. As if none of these matters of fashion have weight, Eakins depicts her as

a person of character and substance. He brings such care and sensitivity of expression to representing her that she dominates the assemblage of instruments around her. Mrs. Frishmuth, an authentically singular and lovely woman, is the music in this painting. (Later asked by a former pupil, Elizabeth Coffin, why he painted "such homely women," Eakins thought for a moment, then said, "I never knew that I did.")

Technical demands of accurately depicting the array of instruments, and the scale of the canvas—eight feet high by six wide, making it the artist's fourth largest painting—possibly led Eakins to return to his earlier method of carefully preparing perspective drawings. Eakins presented these sketches to his friend and colleague Leslie Miller, a professor at the Philadelphia School of Industrial Art. Miller wrote to thank him: "I shall take pleasure in showing them to such students as are likely to understand and appreciate the lessons which they embody."

Eakins donated the Frishmuth portrait to the University of Pennsylvania Museum, although the painting eventually was separated from the collection of musical instruments depicted in it. Eakins borrowed the canvas from the museum for an exhibition, and by the time he attempted to return it, Stewart Culin, the curator, had shifted positions to the Brooklyn Museum. The new administrators of the university museum did not want to receive the painting again. Evidently they did not feel an urgent need to care for Mrs. Frishmuth's collection either, for a large portion of her donated instruments came to be dispersed.

John Gest, the eighty-one-year-old president of the Fidelity Trust Company, sat for one of Eakins' most uncompromising portraits (Museum of Fine Art, Houston). Gest apparently accepted his portrait without reservation. His painting was unusual in that it was one of two later portraits by Eakins that were commissioned: Gest paid the artist seven hundred dollars on the painting's delivery in 1905. Typical of Eakins' half-length portraits, Gest sits in a high-backed chair against an ill-defined black background. As with Melville and Frishmuth, the rendering brings him to life. In his case his countenance is neither subtly heroic nor charming. His bony knuckled hands clench tightly in his lap. His pointed aquiline nose, determined mouth, trimmed white hair and beard, and steely, piercing eyes suggest more a coldhearted banker than a benevolent public figure.

Eakins depicted financier Asbury Lee (Reynolda House, Museum of American Art, Winston-Salem, North Carolina), a commission in 1905, with much the same stony countenance as Gest. Lee's hawkish nose, large iron jaw, heavily lined cheeks, and featureless staring eyes convey every bit the willful predator; the impression is heightened by his smooth clawlike hands and polished nails, which seem ready to grab the viewer (or perhaps the painter of his portrait). Lee hated the painting. "You will receive the painting back . . . while not accepted by me I send you a check for $200 anyway."

Self-Portrait (National Academy of Design, New York), painted by Eakins in 1902, may be the artist's best head and bust portrait of all. The artist, dressed in a conservative black coat, tie, and vest, his gray hair mussed, mustache and beard unkempt, stares directly at the viewer, conveying weariness and a forlorn sense of sadness and pain (plate 36). Eakins biographer Lloyd Goodrich concisely summed up the generations of art historians and museumgoers who have regarded this small but monumental canvas with special respect: "not only one of his finest . . . likenesses, but a revealing human document; in the direct look of his remarkable eyes one can see strength, penetrating intelligence, and a touch of ironic humor."

Painted in just under two months to mark his designation as an associate-elect of the National Academy, the painting was accepted by the academy immediately, conferring upon Eakins, on March 12, 1902, a position that had been accorded Will Sartain and William O'Donovan over two decades earlier. Academy members, however, quickly made up for their delayed recognition of the artist. On May 14, less than two months after being named associate, Eakins was elevated, in record time, to the status of full academician.

In striking contrast to the richly detailed head and bust portraits by Eakins is that of Louis N. Kenton, the barest of Eakins' full-length portraits, known as *The Thinker* (Metropolitan Museum of Art). Little is known of Kenton except for his stormy marriage to the artist's sister-in-law, Elizabeth Macdowell, who was referred to in the Eakins family as Lid. The author David Sellin wrote that the marriage "barely outlasted the honeymoon." Susan Macdowell's diary contains such extracts as "Louis strikes Lid in the face and she leaves him immediately" and "[Lid] thinks she must leave Louis he is so mean to her."

Kenton was born into a family of shoemakers, clerks, and motormen.

City directories listed him as a bookkeeper, and his occupation is suggested by the studious, bookish demeanor of Eakins' portrait of him, as well as by photographs taken by his wife's close friends, Eva Watson and Amelia Van Buren. Eakins' painting from 1900 shows a young man in an ill-fitting dark suit with his hands shoved into his pockets (plate 37). The space behind him is virtually empty—only the suggestion of a baseboard tells the viewer the subject stands in front of a wall. Beyond a dull brown background, the white of Kenton's poorly fitted dress shirt, the flesh tones of his face, and small highlights—Kenton's loosely knotted floral bow tie, gleaming watch chain and pince-nez—the painting is a study in blacks. The shades of Kenton's black hair, black suit, and black shoes are masterfully played off one another to convey a sense that he is naked, even though clothed. Eakins indeed may have painted or sketched him in the nude prior to his donning his ill-fitting, yet to Eakins' eye physiologically informing, garments.

The painting's intensity is generated not by Eakins' brilliant layering of tar-black pigment, but by Kenton's relaxed pose and penetrating expression. He is neither handsome nor particularly distinguished. He stands in an informal, relaxed posture, projecting a thoughtful, un-self-conscious expression. The moment embodied is not a studied set piece; Kenton appears entirely unaware that he is being painted. A vague melancholy hovers about him; the painting somehow hints that the mood is ever present. Kenton is lost in thought, as if trying to untangle a particularly thorny dilemma. In any event, the painting's ownership later took a perplexing dimension, likely the result of the on-again and off-again Macdowell and Kenton marriage. At exhibitions, *The Thinker,* also known as *Portrait of Louis N. Kenton,* was listed four times as owned by Elizabeth Macdowell, twice the property of Kenton, and four times without ownership. Like the Frishmuth portrait, it eventually returned to Mount Vernon Street.

Clearly Eakins thought highly enough of the painting to put it on exhibition as often as he did. Critics, too, thought well of the portrait. The *Philadelphia Press* declared the oil to be "of unusual excellence . . . one of the best works that has ever come from Mr. Eakins' studio, and vital with new forcefulness." Charles Caffin, in 1904, wrote: "The very crudity of the realism is in the highest degree impressive. . . . The subject, indeed, has been surprised as he

is pacing the floor, deep in some mental abstraction; he seems utterly unaware of the painter's presence, and the latter has forgotten himself in his absorption in the subject. As a result, the truth of the representation is so extraordinarily convincing, that one loses sight of the ugliness of the picture and becomes fascinated by the revelation of life and character."

Another portrait Eakins made of a standing male figure was of Leslie Miller, a professor at the Philadelphia School of Industrial Art, where Eakins presented his Frishmuth perspective sketches. Eakins had known Miller as both a student and a colleague. Beyond a mutual interest in anatomy (Dr. Keen, who was close to both men, taught at the Pennsylvania Academy and at the Philadelphia School of Industrial Art), the men shared a passion for photography. Their relationship had not always been good. Miller, in press reviews, was critical of Eakins' fishermen at Gloucester, calling the works "depressingly commonplace." The artist did not entirely forgive Miller's reproach, though he warmed to his fellow art instructor when Miller stood up for Eakins when he was fired from Drexel. In Eakins' defense, Miller wrote a widely circulated letter that reads in part: "Mr. Eakins I have known for a number of years and in him I recognize a man who in my opinion has no superior in the knowledge of anatomy. He is in the fullest sense, however, an enthusiast on the subject of the nude in art, but in following out this line of study I believe he has the purest and noblest purposes. He is, in my opinion, free from any thought of indecency and is advocating what I think he sincerely believes is the study of the higher art."

When Eakins came to portray Miller, he had him stand in his classroom addressing unseen young art students. Behind Miller, in partial shadow, a screen of color charts illustrates Egyptian architectural ornaments, and behind the charts a gallery is hung with drawings. Miller has one hand in his trouser pocket, and in the other he holds a document. The presumption has always been that the document contains his lecture notes—but not necessarily. Miller could be holding the letter, a correspondence well known at the time, that he wrote to Drexel defending Eakins.

Painting Miller's portrait, and by association revisiting past trials, must have been both disconcerting and a relief to Eakins. Twenty years earlier not a serious art student in Philadelphia, or even New York, would have failed to

recognize him. But when he visited Miller's classroom unannounced to paint the professor's picture, the students did not know who Eakins was. Charles Sheeler, one of Miller's students, later recounted the event:

"One day a stocky little man, gray-haired and gray-bearded, passed through our workroom. . . . A few days later he returned and passed to the life-class room, just beyond where we were working. . . . The stocky little man was beginning a portrait of the principal of the school . . . and before long the plan of the picture was indicated. . . . As the artist's work continued we witnessed the progress of a perspective drawing which was made on paper and then transferred to the canvas, to account for charts of ornament [depicted on the screen]. . . . This careful procedure led us to the conclusion that the man, whoever he was, couldn't be a great artist, for we had learned somewhere that the great artists painted only by inspiration, a process akin to magic. Several months were thus consumed; then came a day, as we discovered through the convenient knotholes [through which students viewed the portrait being painted] when another perspective drawing was made and transferred to the canvas, on the floor to the one side. The letters spelled Eakins. The name was not familiar to us."

The finished artwork, *Portrait of Leslie W. Miller* (Philadelphia Museum of Art), from 1901, was one of Eakins' best, both in perspective and in anatomy. The lines of the screen and gallery behind Miller are not parallel with one another or the picture plane. Like the floor shadows, all following different paths, these elements combine to weave concrete depth and shape in a room that is only barely seen. Miller, on his feet squarely in the middle of the room, looks straight at the viewer (plate 38). And yet, as the screen behind him is set off center and not exactly parallel to the picture plane, Miller's body turns a bit askew. His torqued pose, rather than detracting or drawing attention from Miller's face, enhances the portrayal. A viewer follows the anatomically correct, naturally graceful line from his legs to his hips and to his head. Miller is solidly planted; the turn of his body animates him, revealing his muscularity, like a boxer's, or as Sheeler, his student, could have said, echoing Walt Whitman's own observation, "a force to contend with."

Miller was not prepared for the work Eakins delivered. He thought the artist would paint a small head and bust, a portrait to display in the Philadel-

phia School of Industrial Art studio, where students might study it. It was for this reason that Miller supposed Eakins had asked him to dress casually for the occasion. "[Eakins] not only wanted me to wear some old clothes but insisted that I go and don a little old sack coat—hardly more than a blouse—that he remembered seeing me in, in my bicycle days, which I certainly would never have worn facing an audience."

Miller dwelled on his unkempt appearance in the portrait in an article he later wrote. He thought, for a time, that encasing the picture in a grand frame might help to offset what he couldn't help considering as his less than respectable attire; such an imposing frame might better convey to the viewer his elevated position in the Philadelphia arts community. "The primitive, even shabby frame represents Eakins' taste rather than mine as do the old non-descript clothes in which the subject is garbed which he begged me to rescue from the slop-chest and put on for the occasion, and personally I should be very glad to have the frame at least spruced up a bit," Miller wrote. "Ever since I found out how much of a picture he was going to make of it, I have been haunted by a mild regret that I didn't insist on his painting me . . . in habiliments that would at least have been more like those which I would have worn when appearing in any such character as that in which he has done me the honor to portray me."

In Eakins' lifetime, the painting came to be one of his best known and most highly respected portraits. Even before the Miller portrayal was completed it drew rave reviews. "The likeness is excellent, and from present prospects the picture promises to be one of the most successful of Mr. Eakins' recent productions," one critic wrote. A week after Eakins completed the painting, a photograph of it appeared in the *Philadelphia Press,* announcing the work's display on the school premises, accompanied by the notice that "Friends of Mr. Miller say the likeness is true and the atmosphere real."

On February 16, 1901, Miller's portrait and several other examples of recent Eakins paintings, along with a selection of Samuel Murray's sculptures, went on exhibition at the Faculty Club at the University of Pennsylvania. The critic Riter Fitzgerald trumpeted the exhibition, eulogizing Eakins and praising the Miller portrait: "I desire to remind the Art patrons of Philadelphia that our city possesses the leading painter of male portraits in America. I refer

to Thomas Eakins. He is a remarkable painter, and I am glad to say that he is at present painting better than ever. His full length portrait of Louis Kenton is full of character; the attitude is capital. But I prefer the full length that Eakins has just finished of Leslie W. Miller. . . . It is a particularly fine portrait in an unaffected attitude that is far better than the stereotyped pose portrait-painters generally give to their subjects. . . . It is a strong likeness. . . . Eakins is an unusually modest man, with one of the kindest natures, and belongs to that class of painter who never attempt to advance themselves in anything but their Art. In this he has steadily advanced, and if he were in New York instead of Philadelphia, he would be recognized at once as the leading portrait painter of America."

As was Eakins' custom he gave the portrait to Miller, but borrowed it back for the exhibition circuit. At the National Academy of Design in 1905 it was awarded the Thomas R. Proctor Prize of two hundred dollars for the best portrait. In 1907 the same painting won a second-class medal along with an award of a thousand dollars from the Carnegie Institute. Just when Eakins reached the point where he no longer cared what critics and fellow Philadelphians thought of his work, the art community had begun to take an awakened and keenly appreciative notice.

Pontiffs and Prelates

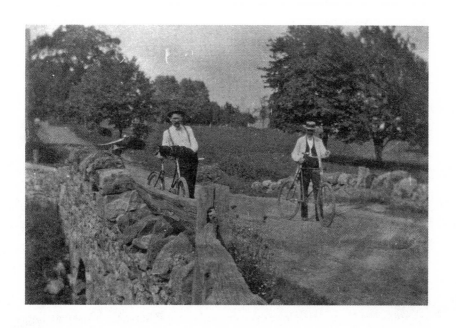

Eakins' interest in the Holy Scriptures did not mean in his later years that he had finally converted to Catholicism. "His reading the Bible had nothing to do with religion, any more than had his reading anatomy," said Elizabeth Dunbar. As she and Eakins' friend David Jordan pointed out, the artist was not a prisoner to ideas and ideology. He sought truth from scripture as he did from dissection, logarithms, photography, and the Elgin marbles. Eakins' theology was written in the crescent of fine lines around a woman's eyes and in the subtle grace of an aging man resting in a comfortable armchair. Eakins' purpose was to get beneath the surface to reveal, in his term, the "divinity" of nature's creation.

Sam Murray did not believe Eakins was a Christian any more than Dunbar did, never mind that he painted the archbishop of Philadelphia and a seven-foot crucified Christ. Eakins would no more be liable to take directions from the pope than he would from the Catholic prelates whose portraits he painted, usually, on weekend trips with Murray to St. Charles Borromeo Seminary in Overbrook. This is not to say, however, that he ridiculed the spirituality and commitment of the priests he painted, or, as biographer Henry Adams has suggested in his Freudian interpretation of Eakins, that he was attracted to the subject because the clergy were "men who wear dresses" similar to the one worn by his mother. Rather, Eakins could identify with these men in unique and compelling ways.

Like the great physicians and scientists whose work Eakins embraced, the prelates impressed him as dedicated educators and accomplished professionals whom he could relate to and learn from. Of the fifteen portraits he was known to have painted of clergymen, most, if not all, were launched at the artist's request and expense. And wide as the gulf between ecclesiastical doctrine and Eakins' theology of flesh and bone might be, the artist pedaling through Fairmount Park, and the men who greeted him eight miles farther on at Overbrook, had absolute faith in the divinity of God's creation.

Eakins' connections to St. Charles went back long before he met Murray. Eakins had been instrumental in the fledgling seminary's receiving *Descent*

Overleaf: Samuel Murray and Benjamin Eakins, with bicycles, 1895–99; photograph by Thomas Eakins (Courtesy of Hirshhorn Museum and Sculpture Garden, Smithsonian Institution, Washington, D.C.; transferred from Hirshhorn Museum and Sculpture Garden Archives)

from the Cross, purchased originally by Will Sartain in Ronda, Spain, in 1870. The painting was gratefully accepted at St. Charles and placed in its Immaculate Conception chapel. (Today it can be found in the main hallway of the seminary college at St. Charles; it is now identified as *The Disposition.*) In 1877, Eakins painted Philadelphia's first archbishop, James Frederick Wood, whose fund-raising allowed the seminary to grow into a sprawling complex on 125 acres of rolling Pennsylvania countryside. Later he lent the seminary *The Crucifixion,* his great masterpiece.

Eakins visited St. Charles on a near-regular basis for fifteen years after Murray, a devout Catholic whose sister was a nun, became Eakins' pupil and friend in the 1880s. After a long hiatus following his 1877 portrait of Archbishop James Wood, Eakins painted nine portraits of priests between 1900 and 1903, and another five in the years following. In the mold of his secular Philadelphia sitters, the subjects were men of achievement and intellect whose interests transcended any particular locality. They were teachers, writers, editors, and linguists. All spoke Latin as well as Italian, like Eakins, and one priest whom he was particularly fond of spoke Chinese. His clerical sitters were not concerned with social standing. Like Eakins they were people who stood by their convictions and were persecuted in Philadelphia for what they believed. And—like Murray and Eakins—they were virtually all of Irish descent.

St. Charles cordially welcomed Murray and Eakins, who often remained for dinner and evening mass. Eakins is said to have especially enjoyed vespers in the Immaculate Conception chapel, with the sweet smoke of incense and the line of seminarians carrying lighted candles in procession as they sang, in Latin, the Pange Lingua. Eakins appreciated the communal spirit he found there; he noted with obvious pleasure the sight of the priests and young seminarians humbly serving one another at meals. Murray was said to have first come to St. Charles dressed with dignified formality, while Eakins always dressed in his usual knit sweater and short bicycle pants. After the archbishop complimented Eakins on what was described as his "informal costume," Murray too dressed more casually.

Among Eakins' closest friends at St. Charles, of whom he painted two portraits, was Reverend James Patrick Turner. Age forty-five when Eakins first painted him, Turner was a native Philadelphian who had been ordained at St.

Charles in 1885. He was among the most liberal-minded of the clergy Eakins encountered there. While Turner surely knew of Eakins' sullied reputation, he did not hold any of it against him. He was the priest most likely to have engaged the artist in frank theological discussion of what Eakins called the "big question" of Christ's divinity, a subject not necessarily otherwise open for discourse in the ranks of St. Charles clergy. Turner's many articles, edited for the *American Catholic Quarterly Review* and contributed to *The Catholic Encyclopedia*, presented a flexible, rather than overly rigid, doctrinal approach to such topics.

Eakins painted the first of two Turner portraits (St. Charles Borromeo Seminary), a relatively small head and bust, about 1900 when the priest was secretary to Archbishop Ryan of Philadelphia. Eakins showed Turner in plain black clerical garb, wearing pince-nez. He looks directly at the viewer, his nearly bald head cradled in the crook of his unusually large hand. The modeling of his head and hand makes this one of Eakins' most sculptured paintings. It is the man's intellect that Eakins captures: Turner's contribution to the seminary is also a result of his writing, the work of his hands.

The second portrait, painted in 1906, after Turner was elevated to the rank of monsignor, is a full-length canvas (seven feet high and nearly four feet wide) depicting him clad in luminously colored raspberry red vestments while he officiates at a funeral in Philadelphia's Catholic Cathedral of Saints Peter and Paul. (The portrait hung for many years in the Mercy Catholic Medical Center collection and is now in the Nelson-Atkins Museum of Art in Kansas City.) In this second painting, perhaps more than in the first, a viewer senses Turner's humility. Here the vestments do not make the man; the man imbues the vestments.

In 1902 Eakins painted the rector at St. Charles, sixty-year-old Dr. Patrick J. Garvey. Despite Dr. Garvey's stern countenance, Eakins had a particular fondness for him. Like his own father, Garvey was a man without pretense and affectation. Born in Ireland, he emigrated to the United States as a teenager, attended St. Charles Seminary, completed his theological studies at the North American College in Rome, and was ordained in 1868. Garvey was known as a strict disciplinarian, which is how Eakins painted him. *Dr. Patrick Garvey* (St. Charles Borromeo Seminary), stares sternly off to his left; were it not for

his clerical collar and black garb he might appear to be a referee at the arena boxing matches.

"Dr. Garvey was not . . . a man of transparent amiability," a colleague wrote of him. "His personality was complex and opaque. His glance was coolly appraising; his humor acid. He was quick to puncture the pretensions of the self-important and the illusions of the ingenuous. . . . Somewhat forbidding in his outward appearance, he was capable of the most delicate thoughtfulness of others."

In 1908, not long after Garvey's death, his portrait disappeared from the seminary. Eakins knew Garvey had not found the painting to his liking, and he may have heard what many seminarians knew for fact: after the artist gave it to him Garvey kept the canvas hidden under his bed. Eakins went in search of it after Garvey died. "I hope the painting has been found and hung in the seminary," the artist wrote to Garvey's friend Dr. Herman J. Heuser. "I cared much for Dr. Garvey and feel his loss."

The painting had indeed become "lost." It had left the seminary altogether. Garvey's portrait was found fifty-one years later in a locked closet in St. Michael's Rectory, where his nephew had been pastor. The painting has since returned to Overbrook and hangs in their Eakins gallery.

A portrait of forty-year-old Reverend Hugh Thomas Henry (St. Charles Borromeo Seminary), in 1902, is the only clerical painting by Eakins in which his subject is pictured in the activity he was best known for. Dr. Henry is portrayed behind a desk wearing the robes of a doctor of letters, engaged in translating *Poems, Charades, and Inscriptions* of Pope Leo XIII, whose portrait (also in the seminary collection) hangs on the wall behind him. A Latin inscription refers to the pope as Cygni Vaticani, the "Swan of the Vatican." An example of the artist's exemplary penmanship appears in Eakins' signature on Henry's desk front.

Like Reverend Turner, Hugh Thomas Henry was elevated to the rank of monsignor and was considered one of many intellectual giants who served on the seminary faculty. A professor of physical sciences, English, Latin, and ecclesiastical music, he later became a professor of homiletics at Catholic University. As a translator of Latin poems, inscriptions, and historical documents

he had few peers; he contributed more than 115 articles to the *American Ecclesiastical Review.* His musical scholarship and authority in church music was largely responsible for the quality of the seminary's music, which gave Eakins such pleasure.

Eakins painted only two commissioned portraits at the seminary, one a portrayal of the fifty-year-old James A. Flaherty, who sat for his portrait in 1903. Flaherty was not a priest but a layman active with the Knights of Columbus. The resulting commission was not well received; fellow Knights of Columbus thought Flaherty looked too old and severe. However, as in the case of seminary rector Patrick J. Garvey, Eakins' Catholic sitters were less inclined to overtly express their views of how the artist chose to depict them. It could well be that vanity played a less significant role in their sitting for a portrait, or that they were more appreciative of the sacrifice in time that Eakins, whom they knew was not Catholic, was devoting to them. Eakins received no money from the Catholic clergymen he portrayed or from the seminary. With one notable exception, his unfinished portrait of Archbishop Diomede Falconio, Eakins gave his work to his sitters or to their institution. (Popular tradition holds that he received a portrait fee from Garvey, but this is questionable, since Garvey was never known to make such gestures and Eakins did not take payment from his other clerical subjects.) "Mr. Eakins painted such portraits . . . simply out of love of his art, and not because his sitters requested him to paint the portraits," Reverend Hugh Henry later wrote.

Eakins' painting of Mary Patricia Waldron, mother superior of the Convents of the Sisters of Mercy in Philadelphia and Merion, presented an unusual situation: his subject presumably liked her Eakins portrait, but her sister nuns did not. Mother Waldron, in her late sixties when Eakins painted her, was a much loved and admired figure at the Sisters of Mercy and a frequent visitor to St. Charles. Eakins painted a half-length portrait of her garbed in the black and white robes of her order, her hands clasped before her. After Eakins presented her with the painting, she sent him a small check to cover his expenses, along with a note of thanks. Regardless of her gratitude, the community of nuns apparently did not feel the painting fit with their image of Mother Waldron. After her death, in 1916, her portrait was removed from the convent and a second, "more pleasing portrait"—likely to have been painted

from Eakins' original—took its place. His *Portrait of Mary Patricia Waldron* was either destroyed or lost.

Another of the artist's Catholic portraits, one of Bishop Edmond Prendergast, also vanished. All that attests to the painting is a small sketch indicating it was a half-length figure that showed Prendergast seated in violet vestments with his hands in front of him. Murray told the Eakins biographer Lloyd Goodrich that he had it "from a reliable source" that the painting, which Murray considered "superb," was somehow disposed of.

For three of the Catholic clergy portraits Eakins had to travel a considerable distance. *Portrait of Sebastiano Cardinal Martinelli* (The Armand Hammer Collection) and *Archbishop Diomede Falconio* (National Gallery of Art) were painted in Washington, D.C., in 1902 and 1905. *Portrait of Archbishop William Henry Elder* (Cincinnati Art Museum) was made in Cincinnati in 1903. These paintings were likely inspired by Dr. Henry Turner. To explain Henry Elder's portrait, it helps to consider that Turner worked with Coadjutor Archbishop Henry Moeller of Cincinnati; Moeller in turn helped Eakins with travel arrangements and presumably covered the artist's expenses.

Eakins painted Sebastiano Martinelli in February 1902 in the nation's capital. Cardinal Martinelli achieved prominence as the second apostolic delegate to the United States. A small man, just under five feet, in his mid-fifties, with a thick mane of dark hair, Martinelli was posed in profile seated in a wood-paneled room of the cardinal's residence. He wears the black robes of the Order of Hermits of Saint Augustine. Eakins included an Augustinian shield in the upper left corner of the painting. The cardinal cradles in his lap his crimson red biretta, designating his high rank in the Catholic Church. Several other splendid touches add color to the painting: the red skullcap, the crimson sash around his waist, and red at his collar. Like Eakins' painting of Turner, however, his skill in capturing Martinelli's expression invigorates the portrait. Martinelli displays the cool, self-possessed look of a visionary, a leader among men. His gaze is intense, focused, and yet abstract. A viewer senses Martinelli is lost in thought, no doubt the case after long hours of sitting for the portrait.

Martinelli soon would be returning to Rome. Rather than present him with the portrait, Eakins gave it to Catholic University, close to where the portrait had been painted. This painting was one of the first of Eakins' clerical

portraits to be warmly received by the non-Catholic public. In 1903, when it was shown at the Pennsylvania Academy, a critic praised its "quiet poise," and judged it as "one of the commanding features of the exhibition." Another said: "There is no trickery about this portrait, nor has the artist paid much attention to composition, but painted his subject in the most direct manner possible. . . . [The Cardinal's] sharp, intelligent face is painted with force and directness and the whole canvas is an artistic document of great value."

Eakins arrived at a more frontal approach for Archbishop William Elder, who posed in his residence in Cincinnati in 1903. Elder, like Martinelli, was seated in a wood-paneled room, clad in a black house cassock with violet sash and buttons and a violet biretta (plate 39). Eakins had his sitter face straight ahead; in this pose the viewer can appreciate the subject's age and rugged facial characteristics. At eighty-four when his portrait was painted, Elder was the oldest of the clergymen Eakins portrayed. Like Melville the sea captain, Elder had overcome great obstacles. Two episodes from his earlier years are particularly notable. In 1864 he refused to follow the command, issued by the federal post commandant in Mississippi, to use specific language in public prayers for the president of the United States. Elder, who considered the military edict an infringement on his religious freedom, was convicted for his stand (a higher military court eventually overturned the decision). Bishop Elder demonstrated a different kind of courage during a yellow fever epidemic in 1878. In 1883 the church rewarded his bravery by naming him archbishop of the Cincinnati diocese, whose congregation flourished under his tenure.

No coat of arms appears in Elder's portrait. His garb, although decorative, is not distracting. His face, lean and wrinkled with age—along with his sinewy, knobby, nearly misshapen hands—provides the greater story. Eakins' accomplishment in gathering on canvas the essence of his subject is especially remarkable in that he painted this magnificent, emotionally captivating portrait in such a short time. He left Philadelphia by train on November 25, 1903, and wrote to a friend in New York on December 15: "I have just finished in Cincinnati a full-length, life sized portrait of the venerable Archbishop Elder which I did in one week." Two weeks later Eakins admitted how proud he was of the painting: "I think it one of my best," he wrote.

Harrison Morris, an Eakins admirer who was in charge of the academy's

exhibits, was determined to show the Elder portrait in the 1904 annual. There it garnered even higher acclaim than his portrait of Martinelli the previous year. Critics praised its "true tonature," finding it "quite extraordinary in its cold, deliberate analysis of a human personality," and as an "exceedingly forceful piece of work [that] shows Eakins at his best." This time the academy jury could only express its homage by awarding Eakins the exhibition's highest honor, the Temple Gold Medal. It was Eakins' first award from his alma mater. "This medal stands for a long and brilliant series of paintings shown at the Academy," the awards committee wrote, "but it may be doubted if it has ever been given for a more solid and substantial piece of painting."

After so many years of neglect, the awards committee heaped on their accolades: "Artists differ in the emotions which they excite. . . . His high qualities are those of balance, solid drawing, indefatigable attention to the precise quality of the subject before him and amazing capacity for handling his entire problem without losing sight of any of the component factors."

Eakins, once due attention was given, did not feel honored; he was indignant. In one of the most discussed and written about moments of his career, as it turned out, he arrived for the awards ceremony on his bicycle wearing his cycling outfit: short trousers tucked into his boots, tattered sweater, and red cap. "I think you've got a heap of impudence to give me a medal," he reportedly remarked to Edward Coates. Eakins then cycled off to the United States Mint to redeem the gold medal for its value in cash. (Eakins allegedly looked so "disreputable" when he arrived at the mint that an academy official was contacted to make certain that Thomas Eakins was the man he claimed to be.)

Despite Eakins' reaction to the academy, a deep tide had shifted and honors steadily accrued. Thanks to the encouragement of Harrison Morris, who had assumed charge of the academy after Coates retired, Eakins began serving on the annual exhibition jury, an honor that had been withheld from him for more than a decade. It was in March 1902, while he painted Cardinal Martinelli, that the National Academy of Design elected Eakins an associate, and two months later bestowed on him the rank of academician, making him the only artist to receive both honors in the same year. In 1903 the Carnegie Institution asked Eakins to serve on its annual exhibition jury. That same year Eakins' *The Gross Clinic* was awarded a gold medal at an exhibition in St. Louis.

Eakins had not suddenly learned to behave himself. Rather, Philadel-phians gradually were coming to the conclusion that they needed him more than he needed them. Though rarely seen in Philadelphia galleries, his art was found throughout the city where professionals of all kinds could view it: Eakins' paintings hung at Jefferson Medical College, at the University of Pennsylvania, at a rowing club on the Schuylkill River, at Charlie McKeever's boxing club, in the corporate offices of the Fidelity Trust Company, and in the form of biblical prophets looking down on the city from above. In the years to come, after Eakins' death, it would be difficult to understand Philadelphia or Philadelphians without embracing, or at least acknowledging, the man who had lived and labored among them.

fifty
Return to Rush

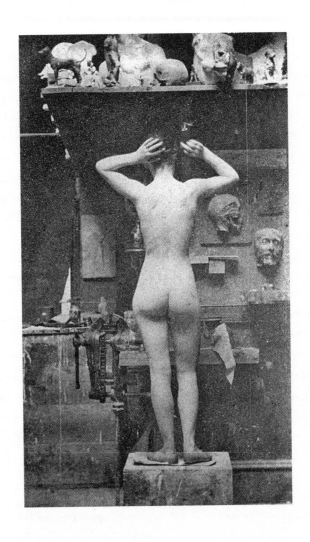

Of Eakins' continued fascination with nude modeling, both before and after his formal portraits of Catholic clergymen, there is no doubt. Sam Murray told of a Miss Belmont, a friend of Admiral Melville, who had a particularly handsome body and lustrous red hair. Belmont had modeled for a head and bust portrait by Murray, and he was so taken by her appearance that he recommended she model for Eakins. According to Murray, Eakins soon had her posing for eight or nine hours a day, at a dollar an hour. A painting must have emerged, one would think, from the sessions, though no one, including Charles Bregler, recollected ever seeing it. It is possible Eakins just liked looking at her and may not have finished an artwork.

Josephine Kern Dodge told biographer Lloyd Goodrich that the artist once invited her and her husband to visit Mount Vernon Street to see a model; she may have been the red-haired woman recommended by Murray. After being admitted to his studio, the Dodges found themselves face to face with an undressed young woman—the first time, Mrs. Dodge claimed, she had ever seen a woman or a man completely nude before. Eakins insisted on taking them over to examine the model, ran his hands down her side, and said how fine a form it was. He had them walk around to view the model from behind. "He didn't need to do that," Mrs. Dodge said. She sensed no untoward or sinister motive, let alone depravity, in what Eakins had done, though she did understand that many people who visited the artist's studio might have reacted more narrowly.

Alice Kurtz, a prominent banker's daughter whom Eakins painted clothed in 1903, was one of the female subjects he asked to pose nude. Many years after their modeling session, after Kurtz had become a grandmother, she recalled the "amusing incident," as she termed it. In the midst of posing, her collar button slid down inside the back of her dress. "I wore high starched collars over shirt-waists in those days," she wrote. "I sat as long as possible with the wretched button pressing into my spinal column & then during a rest I screwed up my courage to ask Mr. Eakins if he could reach down my back & get it out. After doing so, he remarked, 'You have a nice back—much like a boy. I would like to paint you nude.' His manner was so simple, so honest, I said, 'Well I will ask

Overleaf: Female nude in Eakins' Chestnut Street studio, early 1890s; photograph by Thomas Eakins (Courtesy of The Pennsylvania Academy of the Fine Arts, Charles Bregler's Thomas Eakins Collection; purchased with the partial support of the Pew Memorial Trust)

my Mother and see.' My mother did not forbid it, but said perhaps it would be better not on the whole. . . . My personal reaction would have been that I'd have quite liked to do it, for I felt he was quite pure-minded in the matter. I was rather a simple minded young thing of twenty or there about when he painted me and the idea of being a nude model quite appealed to me."

Mary Hallock Greenwalt, a strikingly attractive thirty-two-year-old professional pianist who had posed for Eakins in 1903, told Goodrich that she too was asked to pose nude—but would not consent. Even though she is clothed, Eakins' portrait of Greenwalt (Wichita Art Museum), showing her dressed in a sleeveless low-necked, rose-violet silk gown, captures the superb lines of her torso with unerring detail. The same attention was not paid to representing her head, which, however honestly depicted, looks as though it belongs on a different painting. Like Elizabeth Dunbar and Alice Kurtz, she too, in later years, regretted her decision not to bare herself.

Mrs. James Carville, the thirty-year-old niece of photographer Louis Husson, a friend of Eakins, was painted in 1904. Her portrait, a commission, shows the dignified Carville in a white blouse and pale lilac collar. In a lovely portrayal, her soft, dark brown hair is lifted in a bun. Carville's daughter, who inherited her mother's portrait, described what her mother said about her sessions with Eakins. "I remember Momma telling me that Mr. Eakins asked her to pose for him in the nude—and even though this was over thirty years later, she blushed when telling me about it, and was still indignant and outraged as she was the day she refused—muttering to herself, 'I just let him know I wasn't that kind of a woman!' Isn't it a pity? I'm sure it would have been a beautiful portrait because my mother was a beautiful and gracious woman, shy-quiet [and] completely honest."

Mrs. Farnum Lavell, described as pleasant, witty, and rather conventional by Goodrich, posed for Eakins in 1907. People had let her know he had a bad reputation and might say something "disgusting" to her; but she found he never did. He told her a few "broad stories" of his student years in Paris, but "he made no advances." She described the artist as possessing a sensual face and the build of bear. In the painting, she wears a low-necked dress, and during the session Eakins complimented the bones of her shoulders and chest and would poke at them with the handle of his brush and say "beautiful bones!"

Eakins repeatedly asked her to pose nude, until she finally went to her mother and asked permission, which was not forthcoming. "He seemed to feel that there was something disgusting in my not being willing to." Eakins' niece Rebecca Macdowell, whose portrait he painted in 1908, told author Gordon Hendricks that when she was young she often visited the Eakins family and that her uncle asked her and her sisters to undress for him too. "He always wanted us to pose in the nude," she recalled.

Helen Parker (later Evans), who posed when she was twenty-three for Eakins' 1908 painting titled *The Old-Fashioned Dress* (Philadelphia Museum of Art), recounted her experience in ambiguously bittersweet terms. Like Eakins' niece, she was practically part of the Eakins family. She and Susan Macdowell, along with Mary Adeline Williams, spent time together visiting and working at needlepoint. Parker was not put off by Eakins asking her to disrobe; her concern was the prominence the artist gave to his depiction of her nose (plate 40). Parker pleaded with him to make her "just a little pretty." Eakins invariably came back by saying, "You're very beautiful. You're very beautiful . . ." The more she complained the larger and more bulbous he made her nose. After having posed for thirty-five sessions, at two and three hours at a time, she finally gave up complaining, and eventually declared the canvas her "Ugly Duckling" portrait. "Thomas Eakins was not interested in my face," she later said. "I . . . felt a sense of being decapitated."

Mrs. Nicholas Douty, who had lent Eakins the book of bawdy stories, told Goodrich that when Eakins painted her in 1910, he repeatedly asked that she, too, pose nude for him. Douty declined—not out of modesty, but because she was not proud of her figure. Eakins told her the specific contours of her body didn't matter: "every figure was beautiful." To her, Eakins seemed "starved for the nude."

How many other women Eakins asked to pose undraped one can only guess. Modesty would have prevented a certain number from sharing what they viewed as an affront to their virtue. Five out of eight women Goodrich interviewed or with whom he corresponded told the same story. The other three were unlikely candidates due to advanced age. (Eakins had to carry one sitter into his studio because she was too infirm to walk up the four flights.)

Eakins' frank approach to nudity, and his unrelenting efforts to have

friends and family members remove their clothes for him, suggests two strong forces tugging within his personality: one was an innate, curious innocence, the other a socially fraught, nearly pathological desire to come to terms with the impulse that drove him, forty-two years earlier, from the Jefferson Medical College to the Pennsylvania Academy of the Fine Arts.

For all Eakins' fixation on the nude, and his unique qualifications to capture the human body, it must be noted that before 1908 he had painted only two significant portraits of nude women. One of them was Anna Williams, later the goddess of Liberty depicted beneath "E Pluribus Unum" on silver dollars. She modeled for him as the historic Louisa Vanuxem in his William Rush portrait. The second was Susan Macdowell; she posed for one of Eakins' unfinished Arcadia series.

Like Eakins' many trips to the seminary, times when he must have wrestled with the articles of his own faith, the artist's attention to the nude during his later career may have been driven by an overwhelming desire to come to terms, finally, with his obsession: to make real his muse. His many attempts to find the right nude model could well have been a preparation for his painting a portrait he knew, in advance, would not likely be exhibited in his lifetime.

At age sixty-four, in 1908, Eakins returned to the theme that had haunted him three decades earlier: Rush sculpting the figure of Vanuxem. Eakins gave the first of two paintings in that year the same title as the earlier work, *William Rush Carving His Allegorical Figure of the Schuylkill River* (Brooklyn Museum of Art). As in his 1877 painting, the Vanuxem figure is not a nymph but a faithfully portrayed flesh-and-blood human model (plate 41). Rush is a hardworking craftsman dedicated to capturing his model's essential, luminous beauty for the sculpture that would form the heart of the city's Center Square fountain.

Eakins was returning, metaphorically, to the river of his childhood. "The elderly artist took stock of his career," Eakins scholar Elizabeth Milroy has written. "He turned not just to the memory of an admired predecessor but also to the embodiment of the place that was dear to his heart—the river along which he lived a long and productive life."

As in his earlier depiction of the scene, Eakins placed Vanuxem, posing for Rush, standing on a wooden block with her back to the viewer and a dictionary held on her shoulder. A chaperone sits quietly to the side with her knitting.

Similarly, the artist's color range and technique are not substantially different from his 1877 depiction. The same golden tones of the model's body are set against the warm browns of Rush's studio, with its many props and examples of the sculptor's previous work. The features that demark the two paintings are in the portrayal of Rush and the pose and presentation of the nude model.

Instead of a slender and graceful Vanuxem, Eakins this time pictures an older, more robust woman. In the earlier painting the model's left leg is slightly bent, which drops her hip, and makes her pose more suggestive, even alluring. In the later painting the model stands bolt upright, confronting the sculptor head-on. The straight groove of her backbone is pronounced, as are her shoulder blades and rounded buttocks. She does not stand as one would expect an artist to pose a paid model, or as Vanuxem stands in the Center Square sculpture; the reinvented river spirit is depicted as an ordinary woman or amateur model—suggesting that eternal or miraculous qualities exist, always before us in this world—posed as she might stand in front of a dressing-room mirror.

Several other important differences arise in the paintings. In the earlier view Eakins seated a formally dressed chaperone in a Chippendale chair, in partial profile. She has been replaced by an African-American woman who sits in a green, less formal chair facing the viewer. The sculptor is also changed, reflecting what seems a desire to portray him more straightforwardly, without pretension. Rush still wears short pants and buckled shoes, but his long-sleeved coat and brass buttons have been exchanged for a sleeveless workman's jersey. He is shorter and stockier, looking, as it happens, remarkably like Eakins himself in his favorite bicycling outfit.

The resemblance between the sculptor and Eakins grows more pronounced in Eakins' second version of his reinvented Rush painting, *William Rush and His Model* (Honolulu Academy of Arts). Here the correspondence is unmistakable. Rush's head is rounder and his body bulkier. The sculptor Rush has been transformed into Thomas Eakins. The artist has moved from historical re-creation to thinly veiled autobiography.

In *William Rush and His Model,* a three-by-four-foot canvas, the sculpting session has presumably ended (plate 42). Rush, who appears in partial profile, holds his model's hand as he leads her in stepping down from her wooden block pedestal. Eakins has portrayed this Vanuxem in full frontal

nudity, including pubic hair. As in the first of the later Rush paintings, she is a mature woman with a generous figure. Full light falls directly on her breasts, belly, and upper thighs. Her body is roundly and solidly formed. Her clothes, which previously were draped on a chair, and the knitting chaperone, are gone altogether. Gone also is the detailed inventory of Rush's studio. All that can clearly be delineated is Rush, a partially obscured carved wooden scroll, and the nude Vanuxem stepping from the uncarved block.

In this last of Eakins' Rush paintings—a view that may be the first un-adulterated realist depiction of frontally facing nudity in mainstream art pro-duced in America—the artist and the model are joined hand in hand. Rush has become Eakins. The face of Vanuxem, now evident to the viewer, bears an uncanny resemblance both to Eakins' wife, Susan Macdowell, and their live-in houseguest and her very close friend, Mary Adeline Williams. Her expression and posture are of a woman totally at ease with herself and her undraped form. The slight smile on her face as she takes her sculptor's hand most directly communicates the painting's message. The full measure of his model's feminine appeal rests in the splendor of her being a unique flesh-and-blood human being. Eakins, the artist, captured her image. Nature provided the template.

fifty-one

Artist in Residence

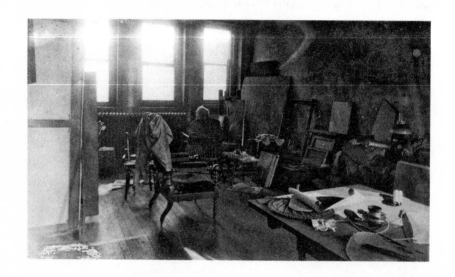

Eakins never tired of hiking the New Jersey shores. In the summer and early fall he strolled the beach at Manasquan, where tides seeped into the footprints he left in the sand, the sun darkened his face and bare shoulders, and salt dried on his ankles. On a walk he took in 1907, he happened upon a dead eagle. In the decaying, delicately ribbed plumage of the once proud creature, Eakins' keen eye would have recognized his own mortality. Four years later, on a trip to Fairton, he had a more concrete reminder.

He and Murray spent the day swimming and sunning themselves at the Eakins boathouse. Invariably they shared a plate of oysters or another of the local delicacies then in season, topped off with a pitcher of milk. On this day Murray felt some effects from their meal, and grew nauseated. As they discovered, the milk they drank was laced with formaldehyde, commonly used then as a preservative. Without proper care, in large quantities, the result is toxic; today the practice is outlawed. Eakins at first did not feel overwhelmed. Murray, however, feared for his life. He claimed to have overcome the poisoning by cycling at high speed back to Philadelphia and stopping along the way for shots of whiskey. Eakins, who remained at the boathouse, was possibly nursed by the family of Charlie Boyer, his friend the gunsmith and piano teacher.

Friends claimed that Eakins never fully recovered. After the tainted dose, he started losing his eyesight. Formaldehyde poisoning from the large amounts of milk he drank regularly may not have been the source of his deteriorating condition. Four decades of accumulated exposure to the components in oil paints and their chemical solvents may well have created a toxic condition in his body. Heavy metals such as cadmium, which produced the brilliant reds, oranges, and yellows in Eakins' paintings—and lead, the primary component of white—are now known to seriously damage the nervous system, kidneys, and bone marrow. Murray and other friends of Eakins spoke of the artist suffering from kidney problems. His wife noticed jaundice. The many years of working long hours without adequate ventilation in his home studio, inhaling the fumes from solvents and absorbing the toxins in paints through his skin, was likely what caused his demise.

Soon after the milk poisoning, by the time the century's second decade began, Eakins' vigor had left him. His close-cropped, disorderly dark hair

Opposite: Eakins in his Mount Vernon Street studio, 1912–13 (Courtesy of The Bryn Mawr College Library, Seymour Adelman Collection)

had gone iron gray, and his sparse mustache and beard were grizzled. His face became heavier and deeply lined. His artist's intense eagle eyes were dulled. A journalist from the *Philadelphia Press,* interviewing Eakins for an article, described him as an "old, old man looking out upon a passing world." Eakins was "enfeebled and yellowed by age and illness till his face is like a mask from which two dark eyes burn somberly—till his limbs will hardly bear him longer."

Friends witnessed Eakins dropping off to sleep at social gatherings. Paintings that had previously taken him a week to create now sat on his easel for months. Macdowell helped him complete several of his last portraits, though the arrangement was not to his liking. Eakins' vision had become so blurred that he could not clearly see the work she was doing.

The last painting Eakins worked on was *Portrait of Dr. Edward Anthony Spitzka* (Hirshhorn Museum and Sculpture Garden, Smithsonian Institution), which he began in 1913. Spitzka, a professor of general anatomy at Jefferson Medical College, esteemed for his research on brain tissue, was portrayed full length, holding a plaster cast of a human brain. Eakins depicted him wearing black, with a low priestlike collar. Had Spitzka been holding not a plaster cast but a Bible, a viewer would take the distinguished scientist for a clergyman.

Eakins had the most trouble in this work accurately depicting the cast brain. He told Macdowell he "couldn't get it right" and asked her to try. His idea was to contrast the living, thinking man with the artifact he held in his hands. Macdowell worked exclusively on the hand and plaster-cast section of the painting. Eakins assessed that she did a good job; but of the whole canvas hers was the only finished part. An art dealer purchased the painting years later and cut it down to a head and bust portrait, removing the element that had inspired the artist for his last portrayal of an accomplished Philadelphia physician.

In the planning stages was a portrait of John Brashear, director of fine arts at the Carnegie Institute. Brashear was an engineer and a colleague of Dr. Henry Rowland, Eakins' physicist friend and portrait subject. "Although I have never met you, you still seem like an old friend to me," Eakins wrote to Brashear, enclosing a photograph of his Rowland painting to tempt Brashear to pose. In the letter, the artist's once impeccable penmanship appears unsteady; the lines slope downward and the letters are spaced unevenly.

Eakins gave up painting altogether that same year, in 1913. Left unfinished on his easel was a full-length portrait of Emily Sartain (present location unknown). Circumstantial evidence suggests that Eakins had begun her portrait a decade or more earlier. He depicted her standing confidently in a golden evening gown with her right arm extended, beckoning to the viewer. Her formal dress indicates that Eakins had no intention of painting her in her role of artist or educator. She is an elegant and beautiful Junoesque woman in midlife in a surrealistic space that gives no hint of a setting. Emily's face is the only part of the painting that has neared completion. Letters and witnesses do not reveal why Eakins never finished Emily's portrait over so long a time, how many times she posed for him, or whether he intended to give the painting to her. Emily had never married. She saved the letters he had written to her over the years; her writings to him were not preserved.

Eakins' reluctance to put the finishing touches on the painting may simply have followed from a desire to leave Emily's portrait in his studio where he could see and think about her. From time to time he likely thought as well about Elizabeth Crowell, the comely and vivacious younger sister of Kathrin, to whom he had once been engaged. Elizabeth had learned to play the piano in the Eakins family parlor, and there Tom had painted her teaching Lizard— his dog with "house privileges"—to do tricks. At one point the Eakins family piano was shipped to her in San Diego, California; Susan Macdowell, possibly as a birthday present, was to receive a new upright piano. After Eakins died, Elizabeth Crowell received another gesture of Tom's affection for her by mail. Macdowell sent her the engagement ring—dated 1874—that Tom had purchased for Kathrin.

Samuel Murray in Eakins' later years remained an important presence in the artist's life. Now that Eakins no longer used his own studio, he visited Murray in his West Philadelphia home and work space, where they could talk while Murray sculpted. Murray's home, purchased with help from Eakins, was on lovely, tree-shaded Lancaster Avenue, opening to a view of the countryside. Eakins enjoyed the hours he spent visiting Murray while the sculptor—now in much demand—created some of the best art of his career. Among the finest of his sculptures was a statue of the elderly Thomas Eakins. Into the work he poured all his compassion and respect for his once vital mentor. Just before

Murray's death in 1941, he presented the earliest sculpture he had made of Eakins—showing him cross-legged on the floor painting Dr. Hayes Agnew—to the Pennsylvania Academy. Murray's later statue reveals the artist—who had been such a restless and indomitable presence as the nation and its art came of age—now as an old man. The later work went to the Philadelphia Museum of Art.

Accompanied by Murray, Eakins traveled to Germantown to visit James Dodge's family, who frequently gave lavish luncheons and dinner parties. Though the report is unconfirmed, a story has Eakins meeting Samuel Clemens at a dinner there. In the winter, James Dodge flooded a ravine behind the house, where his children and grandchildren demonstrated their skating prowess. Too old and infirm to take to the ice, Eakins was content to watch the children cut circles as he had once done with Master Benjamin, trailed by his sisters. One day Eakins showed up at the Dodge's door with a paper bag, carrying three box turtles; that night, after Eakins left, Will Sartain arrived with a birdcage containing a kitten. To Mrs. Dodge, it was the kind of day and evening "you don't forget."

On Saturday afternoons, accompanied by Susan, Eakins visited former league student Frank Linton, who, with Samuel Myers, put on musical performances in their home. Helen Parker described Eakins as so moved by a performance there that he sat in a corner and, unabashedly, sobbed.

Lucy Wilson was another family friend Eakins liked to visit in his later years. Her adolescent son David later became a professor at Harvard University; he recalled Eakins' practice when he joined the family in their swimming pool: afterward, when everyone else had gone inside the house, Eakins sneaked out for another dip, this time without his swim trunks. Later, in the evenings, after festivities were over, he taught David geometry. Murray remembered Tom saying, no doubt thinking of Lucy's son, that young people were coming along "all right."

The last known cycling trips Eakins made were to Schrack's painting supply store on Fourth Street. In earlier years Christian Schrack, the proprietor, had waited on him. Later it was the son of the owner, Joseph Stulb, who received Eakins and never tired of recounting how the "Professor," as Eakins was known at the shop, walked in looking like a "badly baled load of straw

more or less held together by his blue flannel shirt." Stulb and Eakins traded opinions about fighters and wrestlers and exchanged off-color stories. Stulb once warned Eakins that he was using a pigment that would over time turn black. Eakins did not believe him, but apparently he kept turning what Stulb had said in his mind. One day the artist came in and laid a bill on Stulb's desk, remarking, "You will live longest. I'll bet you a dollar. When we meet in the Great Beyond you tell me if my pictures have turned black." (Many of his paintings did indeed darken.)

Eakins in this period gave occasional lectures, though not at the Pennsylvania Academy or Drexel; he reportedly spoke at Fairmount Park's public meeting hall. Of exciting forays, Eakins made a trip to New York City accompanied by Murray, where they went touring in a "dare devil mood." Following their custom, they likely visited New York's Metropolitan Museum of Art (Eakins always insisted on seeing the museum's collection of Greek casts), then dined in Little Italy and visited a nickelodeon. Eakins' trips from home, however, soon proved too taxing. On the rare occasion he did leave, such as to a portrait and sculpture exhibition in 1912 for local artists in Lancaster, Pennsylvania, he took them against his physician's orders.

Although Eakins technically had no direct connection that would permit his work to be shown at the Lancaster exhibit, Dr. Hayes Agnew had grown up there, and the exhibition committee, headed by a former academy pupil, asked for the surgeon's portrait to be included. Eakins gratefully accepted the invitation and arranged *The Agnew Clinic*'s shipment to Lancaster, where it occupied a full eleven feet of wall space. Murray escorted him to the opening-night ceremonies.

The evening was a reunion of friends and former students of Eakins. In caliber the portraits on display were a mixed lot—one contributor, Miss Nevins, was best known for her sculptures in butter. Eakins, as the event's star attraction, was met at the train station by Pennsylvania's attorney general. Church bells resounded; an orchestra played. *The Agnew Clinic* was featured on the front cover of the exhibition catalogue. The publication listed Eakins' painting as "one of his masterpieces and a remarkable example of a distinctly American Art." Susan Macdowell Eakins later told the *New York Sun* critic Henry McBride that she thought the Lancaster reception was the "most comforting

experience" of her husband's entire career. Eakins had, it has been said, "a grand good time."

Two years later, in 1914, the Pennsylvania Academy's annual exhibit showed Eakins' large three-quarter-length study of Agnew. Helen Henderson, art critic of the *Philadelphia Inquirer,* called the portrayal "certainly the most important canvas in the exhibition." A few weeks later she declared that "[the painting] will stand always with the great things of the world."

Fueled by laudatory reviews, rumors circulated that the painting was valued at $25,000, although the more modest price listed in the catalogue was $4,000. Dr. Albert Barnes, in the midst of building one of the world's premier collections of American and European art, stepped forward and paid the asking price. (Many years later his opinion of Eakins' work changed, and he sold the painting; today it resides in the collection at Yale University.)

The publicity generated by the Barnes purchase brought Eakins once again to the attention of the city's art community. Among several interviews Eakins gave was one with the *Philadelphia Press,* whose reporter asked the artist to comment on the present and future of American art. In the spirit of the great bard of Camden, Eakins championed a quintessentially American character, one he believed would become the driving artistic inspiration for the next generation of American urban realists. "If America is to produce great painters and if young art students wish to assume a place in the history of the art of their country, their first desire should be to remain in America to peer deeper into the heart of American life, rather than spend their time abroad obtaining a superficial view of the art of the Old World. . . . Americans must branch out into their own fields. . . . They must strike out of themselves and only by doing this will we create a great and distinctly American art."

Impressive as the purchase price Eakins received for the Agnew study was, other paintings by him did not sell. *Hauling the Net,* from his Gloucester paintings, was appraised after Eakins' death by bank officers at a mere $10, his second Rush painting at $25, and *Between Rounds* at $50. His *Portrait of Mrs. Frishmuth* and *The Crucifixion* were given the highest values, at $400 each. Nearly a century later, in 2003, *Cowboys in the Bad Lands,* the last major Eakins painting remaining in a private collection, sold at auction at Christie's for $5,383,500.

Murray helped look after Eakins until the end. He visited him daily, and was touched by how Susan patiently and tenderly nursed her husband. Billy Smith, retired from the boxing ring and now a "Fighting Evangelist" for the Salvation Army, also came frequently to the artist's side. He would stretch Eakins out in his bed and give him a rubdown, the way he would a fighter preparing for a bout. Nicholas Douty visited and sang for him.

Eakins' legs eventually gave out in 1916, and he was confined to the house. Murray would carry him piggyback downstairs and deposit him on the parlor sofa after the evening meal. Eakins welcomed his companionship. "Murray, come again tomorrow," he always said when it was time for his friend to leave. "I'm kind of lonesome."

Among several friends from the distant past who were presences in the household was Harry Moore, Eakins' deaf-mute art school companion at the academy and the école; Moore came to see him in January 1916. He had sailed from Paris to avoid the growing hostilities that soon engulfed Europe and much of the world in war. His Spanish wife was no longer living; Moore had remarried and brought his new wife to Philadelphia. (During World War II, she courageously saved her husband's extensive art collection from being seized by the Nazis. For this act she was locked in and put on display in the monkey house at the Paris Zoo.)

The moment Harry Moore came into the room Tom wrapped his arms around him. Five months later, in June, Eakins became confined to his bedroom, where he spent his last ten days. By this time, fearing that Susan Macdowell and Addie Williams were trying to prolong his life by mixing medications with his food, he let only Murray feed him. Eakins asked his friend to hold his hand. Murray did most of the talking, at times telling jokes, until Eakins fell asleep.

The end came just before one o'clock in the afternoon on June 25. The artist's breathing grew labored, and he no longer responded to questions. The Philadelphia press soon after reported that Eakins had died from heart failure. Since no medical records have been found, it is impossible to know for certain. He was one month short of his seventy-second birthday. "Tom is dead," Susan Macdowell entered in her diary. "My poor Tom away forever from the house this day," she wrote a day later, when Eakins' friends, among

them Harry Moore and Tommy Eagan, gathered in the family parlor to bid him farewell.

A posthumous celebration of the artist and his career came to life the following year when the artist Robert Henri wrote a eulogy: it was in the form of a letter urging his pupils at the Art Students League of New York to see Eakins' paintings. "Thomas Eakins was a man of great character," Henri wrote. "He was a man of iron will and his will was to paint and to carry out his life as he thought it should go. This he did. It cost him heavily, but in his works we have the precious result of his independence, his generous heart and big mind."

Bryson Burroughs, the curator of American art at New York's Metropolitan Museum, organized the first memorial showing of Eakins' art in November 1917. He initially thought to mount a small show. After visiting Macdowell and seeing the size of the collection of works in Eakins' home, he staged a more ambitious exhibition featuring sixty paintings. Burroughs, who praised Eakins as "the most consistent of American realists," wrote at length about the artist. "Much of his work is indeed somewhat stern at first sight and his pictures demand an effort that all are not willing to give, but to those who take the trouble to enter into the artist's ideal, a wealth of rare observation and enthusiastic workmanship will be revealed."

Many visitors to the exhibition were apparently unwilling to take the trouble. (Attendance fell well below what Burroughs anticipated.) But others, among them the realist painters Robert Henri, George Bellows, and Edward Hopper, found in Eakins' work essential qualities that became the foundation for their own. They saw in Eakins an artist who illuminated ancient and medieval practices while simultaneously looking ahead to the twentieth century with uncanny insight. They perceived in him an artist whose dedication to principle and achievement lifted him well above passing attentions and into a more timeless, revered status, reserved for the most masterful figures. The Pennsylvania Academy, responding to considerable local pressure, staged its own memorial exhibit for their native son in December of the same year.

Eakins' final request was for no religious service, funeral, or flowers; contrary to accepted practice at the time, he asked that his body be cremated at the Chelton Hills Cemetery, as had Dr. Gross. Susan Macdowell kept his ashes in a safe in Benjamin's former bedroom, and there they remained for twenty-two

years—until she herself died, and Addie Williams, her companion until the end, moved to Washington, D.C., to live with her niece.

Susan and Addie gave Eakins' large personal collection of paintings primarily to the Philadelphia Museum of Art; furniture and other belongings, including the family armchair, were sold at auction following Susan's death. Charles Bregler took the rest. In the late 1940s or early 1950s, Bregler met Mary Picozzi, a worker at the counter in a dry-cleaning shop where he took his laundry. He was in his eighties and she in her late thirties. Only from Charlie did Mary Picozzi know of Tom Eakins, whose drawings, sketches, and works of art he had gathered from the empty house after Susan died and were displayed in every room of Charlie's home. Mary married him, and they stayed together until his death in 1958. She then moved into her mother's home in South Philadelphia, keeping her late husband's collection stored there in boxes and trunks under beds and in the attic. It was Mary Bregler who, in 1985, sold the collection to the Pennsylvania Academy of the Fine Arts, within whose halls it can be found today, along with the famous Eakins armchair.

No one, except perhaps Charles Bregler, imagined the city that had turned a cold shoulder to Eakins' art would, one day, be revising the municipal map to accommodate a park and traffic circle named in the artist's honor. Eakins Oval, now firmly established in the city's ever-expanding chessboard grid, in the shadow of the Philadelphia Museum of Art, adjacent to the Schuylkill River, opens onto expansive Fairmount Park (and is where the fictional boxer Rocky Balboa in the Hollywood movie trained for going the distance with imaginary champion Apollo Creed).

Nearly three decades passed before a headstone marked the burial spot of Thomas Eakins' ashes in Philadelphia's Woodlands Cemetery. An anonymous donor paid tribute by placing a simple marker for him beside the headstones of his mother, father, sisters, and infant brother. The same donor purchased the Mount Vernon Street house once owned by Benjamin Eakins and gave it to the city of Philadelphia; today it is home to the Philadelphia Mural Arts Program. Eakins' restless spirit, if it still visits the house from time to time, is surely drawn most to the studio upstairs, where, like an aging Phidias sculpting an image of himself on Athena's shield, the artist confronted his muse, and found her much to his liking.

Notes

Abbreviations

AAA	The Archives of American Art, Smithsonian Institution
AGAA	Addison Gallery of American Art, Andover, Mass.
BE	Benjamin Eakins (father)
BRM	Brandywine River Museum, Chadds Ford, Pa.
CB	Charles Bregler
CBC	Charles Bregler Collection
CCE	Caroline Cowperthwait Eakins (mother)
CE	Caroline Eakins (sister)
Dietrich	Collection of Mr. Daniel W. Dietrich, Phoenixville, Pa.
ES	Emily Sartain
FE	Frances Eakins (sister)
FEC	Frances Eakins Crowell (after 1872)
FHL	Friends Historical Library of Swarthmore College
HMSG	Hirshhorn Museum and Sculpture Gardens, Smithsonian Institution
HSP	Historical Society of Pennsylvania, Philadelphia
JS	John Sartain (senior)
KC	Kathrin Crowell
LG	Lloyd Goodrich
ME	Margaret Eakins (sister)
MMA	Metropolitan Museum of Art, New York
PAFA	Pennsylvania Academy of the Fine Arts, Philadelphia
PMA	Philadelphia Museum of Art
PSC	Philadelphia Sketch Club
SAM	Samuel Aloysius Murray
SDMA	San Diego Museum of Art
SM	Susan Macdowell
SME	Susan Macdowell Eakins (after 1883)
TE	Thomas Eakins
UPA	University of Pennsylvania Archives, Philadelphia
WC	William Crowell
WS	William Sartain

Overleaf: Thomas Eakins Memorial Exhibition at the Metropolitan Museum of Art, New York, November 5–December 3, 1917 (Courtesy of The Metropolitan Museum of Art, New York)

Front matter

The title of the book is the same as that used for chapter 7 in Cohen-Solal (2001).
The epigraph is from TE to Edward Coates, September 11, 1886, CBC at PAFA.

Introduction

Changing perceptions of TE and his work: Lubin (2002), pp. 1–10, online version; Darrel
 Sewell, "Thomas Eakins and American Art," in Sewell (2001), pp. xi–xxii; Ellwood
 Parry, "The Exact, Uncompromising Eye of Thomas Eakins," *Art News* (October
 1982), pp. 80–83.
"Men with their beautifully-ugly muscles": "Fine Arts, The Water Color Exhibition," *New
 York Tribune* (February 14, 1874), p. 7.
"A shock to artistic conventionalities": "The Fine Arts: The Spring Exhibition at the Academy—
 Second Notice," *Philadelphia Evening Telegraph* (April 6, 1881), p. 5.
"Peculiar": "The Fine Arts: The Third Art Reception at the Union League," *Philadelphia
 Evening Bulletin* (April 28, 1871), p. 1.
"scientific statement": S. R. Koehler, "The Exhibitions: Pennsylvania Academy of the Fine
 Arts, Fifty-second Annual Exhibition," *American Art Review,* vol. 2, pt. 2 (188), p. 122.
"photographic proofs": for this and other references to the French reception of TE's art,
 Cohen-Solal (2001), pp. 115–18.
"I love sunlight and children": TE to BE, March 6, 1868, CBC at PAFA.
Eakins' art was judged provincial: Walter Pach, "A Grand Provincial," *The Freeman,* vol. 17
 (April 11, 1923).
"If he had been a French painter": "Thomas Eakins and the Heart of American Life,"
 Economist, vol. 329 (October 16, 1993), p. 106.
"horrible and disgusting detail" and Philadelphia reaction: Brownell (1880), p. 13.
"Powerful, horrible, and yet fascinating": "The Society of American Artists. Second Annual
 Exhibition—Varnishing-Day," *New York Daily Tribune* (March 8, 1879), p. 6.
"His gift": quoted in *American Artist,* vol. 65 (November 2001), p. 44.
Destruction of TE's paintings: "Eakins Outrages a Convent," *Connoisseur* (July 1989), pp.
 75–76; see also Elizabeth Milroy's "Transcript of interview with Lloyd Goodrich of
 March 23, 1983," pp. 7–8, LG Research Files at PMA.
"Mother was sick": Goodrich (1982), vol. 2, p. 78.
"Feeling for bones": ibid., p. 72.
"How beautiful an old woman's skin": Mary Hallock Greenwalt to LG (1930 or 1931), LG
 Research Files at PMA.
"A man could easily be accused of lewdness": TE to Edward Horner Coates, September 11,
 1886, CBC at PAFA.
"Talent seldom expresses": quoted in Schendler (1967), p. 56.
"No one collected Eakins but Eakins" and "Few could paint like Eakins [and] even
 fewer seemed to want to": Hendricks (1974), p. xxx. Such statements are, of course,

exaggerations. Albert Barnes's purchase of a study by Eakins for $4,000 in 1914 (described in Chapter 51) shows that there did indeed exist a market for TE's work.

"My honors are misunderstanding": TE to Harrison Morris, April 23, 1894, PAFA.

Settling of accounts in Eakins' favor: Carol Troyen, "Eakins in the Twentieth Century," in Sewell (2001), pp. 367-76.

"I appreciate very much your desire": Goodrich (1982), vol. 1, pp. vii-viii.

"hearty contempt": Lubin (2002), p. 513 (Info-track online version).

Eakins and Whitman: F. O. Matthiessen, quoted in Bolger and Cash (1996), p. 5.

"Only his greatest virtue": Eliot (1957), p. 139.

"twice the rebel": Lubin (2002), p. 513.

"Eakins, the opera": quoted by W. Douglass Paschall, in Glassman and Lemoine (2003), p. 12.

Contents and acquisition of the CB papers: Foster and Leibold (1989), pp. 1-28.

"They are to be burned" and "Do not read, just destroy": ibid., p. 11.

"I never in my life seduced": TE to Edward Coates, February 15, 1886, CBC at PAFA.

"Each of [Eakins'] paintings represents": Henry Adams, "Thomas Eakins: The Troubled Life of an Artist Who Became an Outcast," Smithsonian, vol. 22, no. 8 (November 1991).

TE and photography: Kimmelman (2002).

"[Eakins' painting] furnishes a melodrama": Lubin (2002), p. 8 (online version).

Chapter 1. The Eakins Family of Philadelphia

Eakins and Cowperthwait lineage: Goodrich (1982), vol. 1, pp. 1-4; Hendricks (1974), p. 4. I have used the spelling for Cowperthwait (without the final "e") that Goodrich (1933) uses, which is also how it appears in the Eakins family account books.

BE's teaching career: Haines (1938), pp. 39, 55-56.

BE's investments: Milroy (1986), p. 37; Amy B. Werbel, "Eakins's Early Years," in Sewell (2001), p. 1.

"If you knew old Benjamin Eakins": Samuel Murray to LG, July 8, [1931], LG Research Files at PMA.

Wages and income in Philadelphia at the time: Walter (1995), p. 207.

"I would have them taught facts": quoted in Michael Lewis, "The Realism of Thomas Eakins," New Criterion, vol. 20 (December 2001), p. 27.

Development and use of Fairmount Park: Elizabeth Milroy, "Images of Fairmount Park in Philadelphia," in Sewell (2001), pp. 79-80.

CCE and religion: McHenry (1945), pp. 4, 129.

TE's relationship with CCE: Foster (1997), p. 14.

"A staunch Democrat": Stanley S. Wohl, interviewed by Seymour Adelman and others, April 11, 1973, PMA.

"lit into Tom": McHenry (1946), p. 29.

Street gangs and need to carry a pistol: Lane (1979), pp. 1-10, 61-62.

Purchase of 1729 Mount Vernon Street: Goodrich (1982), vol. 1, p. 312.

Details of Mount Vernon Street neighborhood: Walter (1995), pp. 157–64.

Description of Mount Vernon Street home: McHenry (1946), p. 124; Goodrich (1982), vol. 1, p. 4.

Mary Tracy: McHenry (1946), p. 125.

Description of furniture: from TE's paintings *The Chess Players* and *Home Scene.*

BE's lingering legacy in the Mount Vernon house: Pach (1938), p. 64.

The Eakins armchair: Seymour Adelman rescued the chair from the Eakins house and gave it to the city of Philadelphia.

Chapter 2. Master Benjamin

BE as mentor: Goodrich (1982), vol. 1, p. 8.

Attractions in Fairmount Park: Shinn (1875), pp. 41–48.

Eakins family activities: There are numerous references in TE's correspondence from Europe; see TE to CCE, October 1, 1866, CBC at PAFA; TE to CE, October 6, 1866, CBC at PAFA; and TE to CE, October 8, 1866, CBC at PAFA; also see TE to ES, November 16, 1866, PAFA.

Tom learned carpentry and other skills: Foster and Leibold (1989), p. 186.

Herbert Spencer: TE refers to Spencer in TE to BE, March 6, 1868, CBC at PAFA; see also Milroy (1986), pp. 228–35.

"The habit of drawing conclusions" and Spencerian philosophy: Milroy (1986), pp. 229–32.

Platt Rogers Spencer: Master Penman Archives, Zanerian College, Columbus, Ohio, courtesy of the International Association of Master Penmen, Engrossers and Teachers of Handwriting, Webster, N.Y.

TE's early training and the relation between process, product, and payment: Amy B. Werbel, "Eakins's Early Years," in Sewell (2001), pp. 1–2; see also Milroy (1986), pp. 35–50.

Chapter 3. The Art of the Penman

TE's early training: Milroy (1986), pp. 35–50; Amy B. Werbel, "Eakins's Early Years," in Sewell (2001), pp. 1–6.

"quite a dabster": FE to TE, February 25, 1868, PMA.

John Jenkins manual: *The Art of Writing,* Book 1 (Cambridge, Mass., 1813).

Peale texts: Chamberlin-Hellman (1981), p. 52.

Peale and Spencer: Werbel, "Eakins's Early Years," pp. 3–5.

"The vast, firm chess-board": quoted in Elizabeth Milroy, "Images of Fairmount Park in Philadelphia," in Sewell (2001), p. 78.

George Holmes: Goodrich (1982), vol. 1, p. 8.

Bertrand Gardel: ibid., p. 17; Foster (1997), pp. 14–15.

John Sartain and family: Darrel Sewell, "Thomas Eakins and American Art," in Sewell (2001), p. xv; see also Martinez and Talbott (2000), pp. 1–25.

Sartain background and Masonic connections: "A Noted Philadelphian," *Philadelphia Press* (February 22, 1886).

Will Sartain and pocket knife: McHenry (1946), p. 116.

Charles Coleman Sellers and connection to TE: W. Douglass Paschall, "The Camera Artist," in Sewell (2001), p. 240.

Sellers and photography innovations: U.S. Patent 31,357, issued February 5, 1861.

Zane Street School: "Thirty-Ninth Annual Report of the Controllers of the Public Schools, of the First School District of Pennsylvania, Comprising the City of Philadelphia, for the Year Ending July 16, 1857," Philadelphia: Board of Controllers (1858), p. 140.

Education at Central High: analyzed by Johns (1980); also Werbel (1996), pp. 33–76, and Goodrich (1982), vol. 1, pp. 5–6.

"the chief goal": Werbel (1998), p. 36.

TE's graduation from Central High and his being asked to speak: "Local Intelligence. High School Commencement. Scenes at the Academy of Music," *Philadelphia Inquirer* (July 12, 1861), p. 8.

"[Eakins was] unwilling to do clever": SME to Henry McBride, September 25, 1917, McBride Papers, AAA.

"flowers, axe handles, [and] the tools of workmen": TE to Henry Rowland, September 2, 1897, AGAA.

Chapter 4. An Uncertain Future

Philadelphia before and during the Civil War: Gallman (1990), pp. 4–29.

TE and Civil War: Goodrich (1982), vol. 1, p. 2; Hendricks (1974), p. 14.

BE purchasing draft deferment: Foster and Leibold (1989), p. 129.

"sweet reminder": WS to ES, September 12, 1862, HSP.

"The rebels are . . . [tearing] up the railroad": WS to ES, September 27, 1862, HSP; see also Martinez and Talbott (2000), pp. 122–23.

Art scene in Philadelphia: "Philadelphia Sketch Club, Notes from the Minute Books (to early 1885)," PSC.

Joseph Boggs Beale: Wainwright (1973), pp. 485–510.

Chapter 5. The Medical Arts and the Fine Arts

TE considering a career as a surgeon: Berkowitz (1999), pp. 123–28.

TE's relations with physicians: Nuland (2003), p. 121.

General background on Philadelphia medical community during Civil War: Gallman (1990), pp. 117–51; see also Bell (1987), pp. 159–69.

Jefferson Medical College: Scharf and Westcott (1884), vol. 3, pp. 1643–50.

TE's cards of admission to Jefferson: CBC at PAFA.

TE and surgery: There is a tantalizing reference in LG's papers at PMA suggesting that a particular incident caused TE to want to become a surgeon, but no such story is recorded.

Lucy Langdon: Lucy Langdon to Lloyd Goodrich, LG Research Files at PMA.

John Deaver: Saint-Gaudens (1941), pp. 178–79.

Eakins "was well delighted to wield the scalpel as the brush": Poore (1931), p. 199.

PAFA background: Werbel (1996), pp. 53–74.

"fusty, fugdy place" and "Over it all": Goodrich (1982), vol. 1, p. 9.

Earl Shinn's recollections: Shinn (1884), p. 32; also see Sartain (1899), pp. 144, 145.

Chapter 6. The Pennsylvania Academy

Background on the state of art education in Philadelphia and at the academy: Milroy (1986), Onorato (1977), Foster (1997), and Chamberlin-Hellman (1981).

TE enrolling at PAFA: "Student Register for the Antique Class, 1862–63," AAA.

TE graduating to life studies: ibid.

TE's lessons learned: Foster (1997), pp. 26–28.

Earl Shinn's recollections: Shinn (1884), p. 32.

Women and the academy: Chamberlin-Hellman (1981), pp. 29–48.

"the first pose": ibid., pp. 7–9; Sellin (1977), pp. 4–6.

Nude modeling: Chamberlin-Hellman (1981), p. 58.

TE modeling: The Fussell painting of Eakins was given to the PMA by Seymour Adelman in 1946; see also Rosenzweig (1977), pp. 38–41.

Schussele and Rothermel: Chamberlin-Hellman (1981), pp. 67–75; Foster (1997), pp. 28–31.

References to TE's long fascination with Phidias: Brownell (1879).

Chapter 7. A Dangerous Young Adonis

TE's flirtations: TE to FE, March 11, 1868, BRM.

"Do come to see me": TE to WS, October 15, 1863, CBC at PAFA.

"noticing young man": TE to KC, July 22, 1874, CBC at PAFA.

"Who that has ever looked": TE to FE, referenced as "April Fool's Day," 1869, AAA.

"He . . . converses in Italian, French and German" and "dangerous young Adonis": Earl Shinn, January 3, 1867, FHL.

"French as an Irishman": TE to CE, October 1, 1866, CBC at PAFA.

"contemptible little pimp": TE to FEC [probably summer 1867], AAA.

"cultivated, taciturn, and rather aloof": Shinn (1869), pp. 292–94.

Lizard and TE's pets: unpublished oral history interview conducted with Crowell family members by Marlene Will, November 1993, SDMA.

Sallie Shaw: McHenry (1946), p. 29.

"I do not believe that great painting or sculpture": TE to Edward Coates, September 11, 1886, CBC at PAFA.

Margaret and Caroline attending secondary school and TE's support of women: Foster
(1997), p. 234.

Emily Sartain: Martinez and Talbott (2000), pp. 120–38.

"Love had racked me & was tearing my heart": TE to WC, September 21, 1868, BRM.

"You call my attention to the childish word": TE to ES, June 12, 1866, PAFA.

"No artist lives and loves": "One Word More," by Robert Browning.

Further TE to ES correspondence: Foster and Leibold (1989), pp. 52–54.

"Bella, care Emilia, Addio": TE to ES, undated, PAFA.

Reasons for leaving for Europe: Chamberlin-Hellman (1981), pp. 73–76.

BE's financial support: Goodrich (1982), p. 15.

"I received your second letter in Italian": TE to ES, September 18, 1866, PAFA, translated by
Patricia Ricci in Martinez and Talbott (2000).

Departure from New York and arrival in Philadelphia: TE to CE on October 6, 1866, CBC at
PAFA; also TE to ES, September 17, 1866, PAFA.

Chapter 8. From Temple to Palace

TE and the Paris experience: I have relied on Ackerman (1969), Foster (1972), Young (1960),
and Shinn (1888).

TE's correspondence chronicling difficulties gaining entrance to the école: TE to BE and
CE, October 13, 1866, CBC at PAFA, and October 26–27, 1866, CBC at PAFA.

Gérôme's home studio: McHenry (1946), pp. 15–16.

Harry Moore: ibid., pp. 1–2; TE to BE, November 1, 1866, CBC at PAFA; and TE to FE,
June 12, 1867, AAA.

"The Minister had yielded": Shinn (1869), pp. 292–94.

Chapter 9. Heads and Hands

Jean-Léon Gérôme: Barbara Weinberg, "Studies in Paris and Spain," in Sewell (2001),
pp. 13–15; Hering (1892), pp. 482–99.

TE and Gérôme: Shinn (1888), pp. 308–19.

"The oftener I see him the more I like him": Goodrich (1982), vol. 1, p. 14.

"No one else could have done it": TE to FE, "April Fool's Day," 1869, AAA.

"Some painters paint beautiful skin": TE to FE, ibid.

"Americans are looked on in Europe": TE to ME and Max Schmitt, April 12, 1867, CBC at
PAFA.

"Oh the pretty child!": TE to [BE?], November 26, 1866, LG Research Files at PMA.

TE sliding down staircase with pistols: Albright (1953), p. 65.

"My good man, let me give you a piece of counsel": TE to [BE?], November 26, 1866, LG
Research Files at PMA.

"Gérôme comes to each one": TE to BE, November 11, 1866, LG Research Files at PMA.

"The big artist does not sit down": TE to BE, March 6, 1868, CBC at PAFA.

"Once an artist was given sufficient practice": TE to BE, ibid.

"Whether or not I will . . . find": TE to BE, October 29, 1868, CBC at PAFA.

"I love sunlight and children": TE to BE, March 6, 1868, CBC at PAFA.

"either become a great painter or would never be able to paint at all": SME to Henry
 McBride, September 28, 1917, McBride papers, AAA.

"middling good parts": TE to BE on March 12, 1867, LG Research Files at PMA.

Chapter 10. Letters Home

TE's correspondence home, not referenced below or in the text: Foster and Leibold (1989),
 pp. 142–54; see also "Thomas Eakins' Letters: Master List," PMA.

Aunt Tinnie: Goodrich (1982), vol. 1, p. 36.

"It must be very beautiful": McHenry (1946), p. 3.

"Then shall we again have belly smashers": Schmitt to TE, May 1, 1866, copy in the Thomas
 Eakins Research Collection at PMA.

"It is not probable I can ever hear such singing again": TE to BE, March 17, 1868, CBC at
 PAFA.

Example of expenditures: TE to [CE?], late January 1867, LG Research Files at PMA.

"It was a nice large studio": McHenry (1946), pp. 6–8.

removing "souvenirs" from historic monuments: TE to CE, November 8, 1866, CBC at
 PAFA.

"Men & horses in motion" and "If Paradise": Goodrich (1982), vol. 1, p. 33.

"The whole afternoon that I spent": TE to BE, January 16, 1867, CBC at PAFA.

"The French are strange": TE to CE, October 8, 1866, CBC at PAFA.

"In place of the sixth she has a chair": TE [addressed to Eliza Cowperthwait and FE],
 January 31, 1868, CBC at PAFA.

On French pets: TE to CE and FE, June 18, 1869, CBC at PAFA.

"Even the cats here are strange": TE to CE, October 8, 1866, CBC at PAFA.

Killing fleas: TE to CE, August 24, 1868, CBC at PAFA.

"French dandies": TE to FE, January 24, 1867, CBC at PAFA.

"English snobs": TE to BE, August 10, 1867, CBC at PAFA.

"The ladies of the court are said to dress": TE to Eliza Cowperthwait, July 17, 1867, CBC at
 PAFA.

Political situation: TE to Max Schmitt, April 25, 1867, CBC at PAFA.

TE visiting the Louvre: TE to FE and ME, October 30, 1866, CBC at PAFA.

TE visiting the Salon: TE to BE and CE, May 9, 1868, Dietrich.

Follow-up letter: TE to BE, no date (presumed to be May 1868), LG Research Files at PMA.

"I was on the spot with Billy Crowell": Goodrich (1982), vol. 1, p. 48.

"The most God forsaken place": TE to BE, August 15, 1867, CBC at PAFA.

"I love my home as much as anybody": Goodrich (1982), vol. 1, p. 21.

"For a long time I did not hardly sleep": TE to BE, November 29, 1869, LG Research Files
 at PMA.

"How I suffered in my doubtings": ibid.

"The studio will enable me": TE to BE, September 20, 1867, CBC at PAFA.

"The studio is not so large": TE to BE, November 1867, CBC at PAFA.

"You make a thing mighty bad": TE to BE, January 17, 1868, LG Research Files at PMA.

"Let not the long time that will elapse": TE to ES and WS, October 30, 1866, PAFA.

"looking for agreeable and decent companions": TE to ES, October 30, 1866, PAFA.

"I envy your drives": TE to ES, November 16, 1866, PAFA.

"There was love between Emily and me": TE to FE, March 11, 1868, BRM.

"There are some women": TE to FE and BE, October 29, 1868, CBC at PAFA.

"I will be glad to see you soon": TE to ES, June 11, 1868, PAFA.

Chapter 11. Rough Around the Edges

"He is much thinner than when he left home": Goodrich (1982), vol. 1, p. 24.

"He is, however, a laconic companion": Shinn (1869), pp. 292–94.

TE and ES: the best summary of their relationship appears in Foster and Leibold (1989), pp. 52–53.

Background on William Dean Howells: Alkana (1996); Anesko (1997).

"There is a common mistake": TE to BE, October 29, 1868, CBC at PAFA.

"I have never judged a man by his clothes": TE to ES, [c. July 1868], CBC at PAFA.

"People talked of the temptation": ES to TE, ibid.

"I can't help thinking that Emily": TE to BE, October 29, 1868, CBC at PAFA.

"It taught me what I never even dreamed of" and "All I want to say": TE to WC, September 21, 1868, BRM.

"I am working as hard": TE to BE, October 29, 1868, CBC at PAFA.

Chapter 12. The Artist and His Muse

"He loved and admired his master": SME, "Notes on Thomas Eakins," CBC at PAFA, quoted in Foster (1997), p. 32.

"runs his boat, a mean old tub": TE to BE, March 6, 1868, CBC at PAFA.

"My hard work is telling on me and my studies are good": TE to BE, September 8, 1868, LG Research Files at PMA.

On Dumont: TE to BE on March 6, 1868, CBC at PAFA.

"Everything is in a muddle": TE to BE on September 8, 1869, LG Research Files at PMA.

"He saw better than his teacher": ibid.

"I am less worried": TE to BE, March 17, 1868, CBC at PAFA.

"I am getting on as fast": TE to BE on June 24, 1869, CBC at PAFA.

"There are advantages here": TE to BE on March 17, 1868, CBC at PAFA.

"I feel now that my school days": TE to BE in autumn 1869, LG Research Files at PMA.

Chapter 13. Picture Making

"as well as any of Gérôme's boys": TE to BE, November 5, 1869, CBC at PAFA.

"I suppose you would laugh": TE to BE, November 29, 1869, LG Research Files at PMA.

"The sun got up in a clear sky": ibid.

"better than any people I ever saw": TE to BE, December 2, 1869, CBC at PAFA.

"Now I have seen": TE to BE on December 2, 1869, CBC at PFA.

TE's Spanish notebooks: PAFA.

A general survey of Spanish trip: Foster and Leibold (1989), pp. 60–61.

"Rubens is the nastiest most vulgar noisy painter": TE to BE, December 2, 1869, CBC at PAFA.

Contributions of the Spanish: TE to BE, December 12, 1869, LG Research Files at PMA.

Arrival of Moore and Sartain in Spain: McHenry (1946), pp. 18–19.

"I am painting all the morning till three": TE to BE, January 6, 1870, LG Research Files at PMA.

Trip to Ronda, Spain: WS Diary, AAA.

"She is only 7 years old": TE to CE, [around December 25] 1869, LG Research Files at PMA.

"The trouble of making a picture": TE to BE, March 14, 1870, LG Research Files at PMA.

"Picture making is new to me": TE to BE, March 29, 1870, LG Research Files at PMA.

"I am not in the least disheartened": TE to BE, April 28, 1870, LG Research Files at PMA.

Chapter 14. The Road Less Traveled

TE in the 1870s: I have relied on Marc Simpson, "The 1870s," in Sewell (2001), pp. 27–40.

Philadelphia landmarks and building projects: Scharf and Westcott (1884), McCabe (1876), and Morrone (1999).

the Gilded Age: Trachtenberg (1982).

"that perfected miracle of ugliness": Morrone (1999), p. 9.

TE's studio: Goodrich (1982), vol. 1, p. 66.

His mother's mental illness: Osler (1892), pp. 377–78.

"an image of candor and virtue": Esquirol (1845), pp. 377–78.

"write . . . to tell me about Mommy": TE to FE, March 26, 1869, AAA.

"Tom Eakins has been at home since July": Rebecca Fussell to her daughter, April 2, 1871, PAFA collection.

TE's sketch presumed to be mother and daughter: Foster (1997), pp. 296, 298.

"I never met such a devoted family": Stanley S. Wohl, interviewed by LG, October 9, 1961, LG Research Files at PMA.

"like an animal": Goodrich (1982), vol. 1, p. 220.

Elizabeth Crowell with a Dog: unpublished oral history interview conducted with Crowell family members by Marlene Will, SDMA, November 1993.

Description of KC: McHenry (1946), p. 29.

"It got so poetic": TE to Earl Shinn, January 30, 1875, Cadbury Papers at FHL.

"He who would succeed must": "Eakins Chats on Art of America. Veteran Painter Vigorous and Enthusiastic as in Days of Past," *Philadelphia Press* (February 22, 1914), p. 8.

Chapter 15. Champion Oarsman

Background and conservators' observations and insights on the rowing paintings: I have relied on Cooper (1996).

Background on rowing and Fairmount Park: Elizabeth Milroy, "Images of Fairmount Park in Philadelphia," in Sewell (2001), pp. 77–87; Johns (1983), pp. 19–45.

TE's relationship with Max Schmitt: TE to FE, July 8, 1869, AAA.

TE urged to compete: Adelman (1977), p. 176.

TE following news of Schmitt's victory: TE to CE, June 28, 1867, CBC at PAFA; TE to FE, July 2, 1869, CBC at PAFA.

On the Schmitt race: Johns (1983), p. 37.

TE producing boat miniatures: TE's "Notebook VI, Talks to Class," undated notes in SME's hand, CBC at PAFA.

Technical studies of the canvas and methods TE used: Christina Currie, "Thomas Eakins Under the Microscope: A Technical Study of the Rowing Paintings," in Cooper (1996), pp. 90–101.

"marked ability": *Philadelphia Inquirer* (April 27, 1871).

"peculiar" and "more than ordinary interest": "The Fine Arts: The Third Art Reception at the Union League," *Philadelphia Evening Bulletin* (April 28, 1871).

Chapter 16. The Biglin Brothers Racing

"exhaustion from mania": Goodrich (1982), vol. 1, pp. 76, 79.

"If I ever marry it will likely be with a girl": TE to FE, March 11, 1868, BRM.

Background on Biglin brothers and conservators' observations of style and technique: Cooper (1996), pp. 36–39.

The Biglin race as described: *Turf, Field, and Farm* (May 24, 1872), p. 335; see also *New York Times* (May 21, 1872), p. 1; *Philadelphia Evening Telegraph* (April 6, 1881), p. 1; *New York Herald* (April 28, 1879), p. 5.

Chapter 17. Hikers and Hunters

TE's depictions of sailboats on the Delaware: I have relied on Foster (1997), pp. 131–44.

"A vessel sailing": Eakins (2005), pp. 74–76.

"I have chosen to show my old codgers": McHenry (1946), pp. 39–40.

"As soon as the water is high enough": Foster and Leibold (1989), p. 154.

History of baseball: "Baseball's Origins: They Ain't Found Till They're Found," *New York Times* (September 12, 2004).

"The moment is just after the batter": TE to Earl Shinn, January 30, 1875, Cadbury Papers at FHL.

Chapter 18. Uncompromising Realism

TE's work with photographs and the paintings of the mid-1870s: I have relied on Mark Tucker and Nica Gutman, "Photographs and the Making of Paintings," and W. Douglass Paschall, "The Camera Artist," both in Sewell (2001), pp. 225–38 and 239–55.

"The best modern painters among the Italians": Joshua Reynolds, *Essays on Painting* (1764), quoted in "Camera Obscura," by Robert Leggat (unpublished essay, 2001).

"The photograph . . . has compelled": translated and cited in Paschall, "The Camera Artist," p. 255.

Treatment for malaria: Osler (1892), pp. 202–13.

"I would have made the details": TE to Gérôme, c. March 1874, CBC at PAFA.

"I will not conceal from you": May 10, 1873, quoted in Hendricks (1974), p. 80.

"I give you my compliments": Gérôme to TE, September 18, 1874, quoted in Goodrich (1982), vol. 1, p. 116.

Negotiations to sell his art in Paris: William Sartain, "Thomas Eakins," *Art World* (January 1918), pp. 291–93.

"Mr. Eakins, a disciple of Mr. Gérôme's": *L'Art,* vol. 2, p. 276, as translated in Hendricks (1974), p. 81.

"These two canvases": Goodrich (1982), vol. 1, p. 119.

"The reason my . . . [painting] was not exhibited": TE to Earl Shinn, undated, quoted in ibid., pp. 121–22.

"fine muscular studies": New York *Daily Graphic* (February 7, 1874), quoted in Marc Simpson, "The 1870s," in Sewell (2001), p. 29.

"not only utterly without color": S. R. Koehler, "The Exhibitions: III—Second Annual Exhibition of the Philadelphia Society of Artists," *American Art Review,* vol. 2, pt. 1, no. 3 (January 1881).

"[Eakins'] portraits of rowing and sculling celebrities in their boats": *New York Daily Tribune* (February 14, 1874), p. 7.

"miraculous" and "brutal exactitude": Earl Shinn, "The Pennsylvania Academy Exhibition," *Art Amateur* (May 1881), p. 115.

"remarkable for good drawing": "Budding Academicians. American Genre Pictures . . . 'The Oarsmen' of Thomas Eakins," *New York Times* (April 20, 1879), p. 10.

"excellent in drawing": *New York Times* (February 14, 1875), p. 5.

"It is a very simple truth": Henry James, "John S. Sargent," *Harper's Magazine* (October 1887).

"My works are already": TE to Earl Shinn, undated (1875), Cadbury Papers at FHL.

Chapter 19. A Good and Decent Girl

"He is all right": BE to Henry Huttner, July 29, 1874, PAFA.

"I feel my love days long over": TE to William Crowell, September 21, 1868, BRM.

KC and BE's influence on TE: McHenry (1946), p. 29.

A review of TE and KC correspondence: Foster and Leibold (1989), pp. 64–68.

TE and the Philadelphia Sketch Club and his transition to the academy: Kathleen A. Foster, "Eakins and the Academy," in Sewell (2001), pp. 98–106.

Details of the Philadelphia Sketch Club: "Philadelphia Sketch Club, Notes from the Minute Books" (to early 1885), PSC; also see Chamberlin-Hellman (1981), pp. 126–29.

"If your friends of the Sketch club": TE to Earl Shinn, April 2, 1874, Cadbury Papers at FHL.

"If the rooms were four times as capacious": *Philadelphia Evening Telegraph* (February 21, 1876).

Students' appreciation for TE: Shinn (1884), p. 32.

TE's appreciation of students: TE to Earl Shinn, April 13, 1875, Cadbury Papers at FHL.

"I have just got a new picture blocked in": ibid.

"I never dealt with hypothesis": Gross (1887), p. 160.

Chapter 20. The Blood-Covered Scalpel

Background on Dr. Gross: Johns (1983), pp. 46–81; see also *The Art of Philadelphia Medicine* (1965), pp. 64–68.

The operation depicted was described in the catalogue of the Centennial exhibition: "Report on the Participation of the War Department in the International Exhibition," *Report of the U.S. Board on Behalf of U.S. Executive Department at the International Exhibition* (Washington, D.C.: 1884), vol. 1, p. 137.

Further background on the Centennial Exhibition: Elizabeth Milroy, "Images of Fairmount Park in Philadelphia," in Sewell (2001), pp. 86–88; McCabe (1876).

"Eakins, I wish you were dead!": Goodrich (1982), vol. 1, p. 128.

"a picture for modern times": Henry McBride, "Modern Art," *The Dial,* vol. 80 (January 1926), pp. 77–79.

"[*The Gross Clinic*] still stands": Sellin (1976), p. 14.

"Tom Eakins is making excellent progress": JS to ES, August 1875, HSP.

TE's competition: "Philadelphia Sculpture," *Philadelphia Evening Bulletin,* undated clipping from Roberts scrapbook, Redclyffe Roberts Collection, cited in Sellin (1976), pp. 38–39.

Transportation of Howard Roberts work: Sellin (1976), pp. 45–47.

Chapter 21. A Degradation of Art

TE exchanging photographic images with ES: Hendricks (1974), p. 91.

"The public of Philadelphia now have": "The Fine Arts: Eakins' Portrait of Dr. Gross," *Philadelphia Evening Telegraph* (April 28, 1876), p. 4.

"Pictures like yours need no passing on by the Committee": undated letter in the Sartain Family Collection of the HSP, cited in Hendricks (1972), p. 95.

Background on the Centennial Exhibition: Elizabeth Milroy, "Images of Fairmount Park in Philadelphia," in Sewell (2001), pp. 86–88; McCabe (1876).

TE visiting the Centennial Exhibition: his exhibitor's pass is part of the AAA collection.

Awards presented at Centennial: Sellin (1976), p. 52.

Critics' reception of *La Première Pose:* ibid., pp. 41–48.

TE in near tears: Jordan as recalled by Robert Henri in his diary for January 14, 1927, cited in Homer (1992), p. 80.

"It is a great pity": *Philadelphia Evening Telegraph* (June 16, 1876), p. 2.

"large and pretentious": *Philadelphia North American* (April 29, 1879).

"one of the most powerful, horrible": "The Society of American Artists. Second Annual Exhibition—Varnishing-Day," *New York Daily Tribune* (March 8, 1979), p. 5.

"ladies, young and old, young girls and boys": "The Society of American Artists. Second Annual Exhibition," *New York Daily Tribune* (March 22, 1879), p. 5.

"A degradation of Art": *Art Journal* (May 1879), p. 156.

"Nothing could be more untrue": *Autobiography of Samuel D. Gross, M.D., Reminiscences of His Times and Contemporaries* (Philadelphia: W. B. Saunders, 1893), p. 175.

Chapter 22. Painting Heads

The new academy building and practices: Chamberlin-Hellman (1981).

Description of academy layout: "Board Minutes," December 7, 1872, PAFA.

Condition of Christian Schussele and PAFA's need for TE: "Board Minutes," February 5, 1877, PAFA; "Committee on Instruction Minutes," January 9, 1877, PAFA.

Fairman Rogers taking over responsibilities from JS: "Board Minutes," June 8, 1874, PAFA.

Efforts made to install TE at the academy: Philadelphia Sketch Club Minute Books, PSC; Seventy-Five Years of the Philadelphia Sketch Club, PSC.

Sketch Club petition: Clark to Board of Directors, PAFA, January 22, 1876, PAFA.

"inexpedient to grant the use of the room": "Board Minutes," February 14, 1876, PAFA.

"Matters are to go on in the same old-fashioned style": *Philadelphia Evening Telegraph,* undated clipping, PMA.

"I love sunlight and children": TE to BE, March 6, 1868, CBC at PAFA.

FEC and WC and Avondale: Homer (1980), p. 9.

"Here he forgot his quarrels": James W. Crowell, "Recollections of the Life on the Crowell Farm," c. 1975, as quoted in Homer (1980), p. 10.

Chapter 23. The Unflinching Eye

Background on Archbishop Wood: O'Donnell (1964), pp. 44–65.

Details of sale of the alleged Rubens painting: WS Diary, AAA.

Current status of the painting: Cait Kokolus, letter to the author, November 2004.

"little parade" with "gildings & tinsel": TE to FE, April 1, 1869, AAA.

"All this springs from such a fact": TE to FE, June 19, 1867, AAA.

"the most learned man I ever saw": TE to CE, October 1, 1866, CBC at PAFA.

"Fleshy" and "In some important respects": *Art Journal,* vol. 3 (June 1877), pp. 189–90.

Efforts to restore Wood portrait: Goodrich (1982), vol. 2, p. 196.

"If . . . [the president] is disposed": TE to George McCreary, June 13, 1877, CBC at PAFA.

"It is with pleasure that I introduce": Goodrich (1982), vol. 1, p. 142.

"The portrait was far from conventional": ibid., p. 143.

"The president gave me two sessions": TE to KC, August 29, 1877, CBC at PAFA.

"conducive to portraiture": Foster (1997), p. 202.

"This portrait gives a very different idea": *Evening Telegraph* (December 10, 1877), p. 4.

"the picture almost needs a label": *Philadelphia Press* (February 7, 1878), p. 5.

"I had to handle the matter delicately": Goodrich (1982), vol. 1, p. 144.

removal of the portrait: ibid.

Chapter 24. Talk of the Town

Christian Schussele's condition: George Corliss to Christian Schussele, May 15, 1877, PAFA.

TE assuming responsibilities at PAFA: "Report to the Committee on Instruction," June 1877, PAFA.

"more like an inventor": Mariana Griswold Van Rensselaer, quoted in Goodrich (1982), vol. 2, p. 198.

"In those days it was an excitement to hear his pupils": Henri (1923), p. 87.

"That was it": SME to LG (1930), LG Research Files at PMA.

Sums spent on models: expense report for the 1877–78 term presented to the board on January 23, 1879, PAFA.

"This course was degrading": TE to the Committee on Instruction [John Sartain], January 8, 1876 [1877], PAFA.

"To show how very much in earnest": "Philadelphia as a Center of Art Culture," *Sunday Mercury* (October 21, 1877), clippings scrapbook, PAFA.

"Our desire in having this class is to offer": SM to Fairman Rogers, November 2, 1877, PAFA.

Background on Rush: Johns (1983), pp. 82–115.

Chapter 25. Nymph in the Fountain

"My God! She's alive!": Morris (1930), pp. 36–37.

TE's account of painting the Rush portrait: quoted in Goodrich (1982), vol. 1, p. 146.

General background on TE researching and painting Rush: Marc Simpson, "Eakins's Vision of the Past and the Building of a Reputation," in Sewell (2001), pp. 213–15; Johns (1983), pp. 82–115.

Anna Williams: Goodrich (1982), vol. 1, p. 148.

"If belles have such faults": "A New Art Departure. Association of American Artists. First Annual Exhibition—Art for Its Own Sake," *New York Daily Tribune* (March 9, 1878), p. 6.

"What ruins the picture": "The American Artist: New Paintings in the Exhibition," *New York Times* (March 28, 1878), p. 4.

"would be improved": "Secession in Art. The First Exhibition of the New Society of American Artists," *New York Evening Post* (March 19, 1878), p. 1.

"The comments made on the picture are curious and amusing": William Clark, "American Art. A New Departure—The Exhibition of the Society of American Artists in New York," *Philadelphia Daily Evening Telegraph* (March 13, 1878), p. 7.

"The painter of the fountain": "Fine Arts: The Lessons of a Late Exhibition," *The Nation*, vol. 26, no. 667 (April 11, 1878), p. 251.

"unpleasant business squarely in the face": Fairman Rogers to George Corliss, October 7, 1878, PAFA.

Hiring of Eakins: PAFA "Circular of the Committee on Instruction, 1878–79," PAFA.

contradicting JS: "Sartain Diaries," AAA.

Chapter 26. The Open Door

TE's teaching career: I have relied heavily on Chamberlin-Hellman (1981), pp. 139–67.

Instituting reforms: Kathleen A. Foster, "Eakins and the Academy," in Sewell (2001), pp. 100–101.

Depictions of curriculum under TE: PAFA "Circular of the Committee on Instruction, 1882–1883," PAFA.

Brownell article: Brownell (1879), pp. 737–50. Other journalists also praised TE's methods, such as in Waller (1879), pp. 20–22.

Statements made by TE while an instructor at PAFA: Bregler (1931).

"Strain your brain more than your eyes": Bregler (1931), pp. 30–50.

His silence was "sufficient criticism": ibid.

"It meant he could see some improvement": Albright (1947), p. 138.

Chapter 27. A May Morning in the Park

Discussion on how painting was created: Foster (1997), pp. 151–63, 321–30, 398–401, 438–39; see also Rogers (1879), p. 2, and Fairman Rogers, "The Schools of the Pennsylvania Academy of the Fine Arts," *Penn Monthly* (June 1881).

"I whirled the cylinder": Albright (1947).

"There is a feeling of awe": "Man of Action," *Smithsonian Magazine* (September 2004).

Muybridge combined horse photographs to make the sequence convincing: W. Douglass
 Paschall, "The Camera Artist," in Sewell (2001), p. 243.
"The horse enters so largely": Fairman Rogers, "The Schools of the Pennsylvania Academy
 of the Fine Arts," *Penn Monthly* (June 1881), reprinted as a brochure by PAFA (1881),
 pp. 7-8.
Death of KC: McHenry (1946), p. 29.
Foster's study of *A May Morning in the Park:* Foster (1997), pp. 151-62.
"Mr. Eakins is a builder on the bed-rock of sincerity": *Philadelphia Press* (November 25,
 1880).
"scientifically true": Mariana Griswold Van Rensselaer: "The Philadelphia Exhibition,—II,"
 American Architect and Building News, vol. 8, no. 261 (December 25, 1880), p. 303.
"I fear his rage may bring on a fit": TE to SM, September 9, 1879, HMSG.

Chapter 28. Jerusalem in New Jersey

Overview of TE painting *The Crucifixion:* Marc Simpson, "The 1880s," in Sewell (2001),
 pp. 108-9.
TE and Wallace's expedition to New Jersey: Goodrich (1982), vol. 1, pp. 190-91; McHenry
 (1946), pp. 53-54.
Issues of divinity: TE to BE, January 21, 1867, CBC at PAFA.
"pure landscape" and "silent prayer": TE to FE, April 1, 1869, AAA.
General survey of the painting's creation: Milroy (1989), pp. 269-84.
"the lean, white, bent-at-the-knee flank of the youth": Lubin (2002), p. 511.
"Mr. Eakins' 'Crucifixion' is of course": *Art Amateur* (June 1882), p. 2.
"revolting beyond expression": "Fine Arts. Exhibition Notes," Philadelphia *Independent*
 (May 11, 1882), p. 99.
"The artist who undertakes anything": "Art Notes: The Society of American Artists," *Art
 Journal,* vol. 8 (June 1882), p. 190, quoted in Marc Simpson, "Eakins's Vision of the
 Past and the Building of a Reputation," in Sewell (2001), p. 222.
"What he has done": William Clark, Jr., "The Fine Arts: The Academy Exhibition—Third
 Notice," *Philadelphia Daily Evening Telegraph* (November 1, 1882), p. 4.
"the canvas was something more": Mariana Griswold Van Rensselaer, "Art Matters. The
 Fifth Annual Exhibition of the Society of American Artists, New York," *Lippincott's
 Magazine,* vol. 4 (July 1882), pp. 106-7. This is a condensed version of an earlier essay
 by Van Rensselaer (cited in the next note).
"It is extremely difficult to put into words": Mariana Griswold Van Rensselaer, "Society of
 American Artists, New York II," *American Architect and Building News,* vol. 2, no. 334
 (May 20, 1882), p. 231.
William Merritt Chase: Darrel Sewell, "Thomas Eakins and American Art," in Sewell (2001),
 p. xiii.
"He is most modest and unassuming" and "I do not believe he knows": Mariana Griswold
 Van Rensselaer to S. R. Koehler, June 12, 1881, S. R. Koehler Papers, AAA.

"Of all American artists": Mariana Griswold Van Rensselaer, "The New York Art Season," *Atlantic Monthly,* vol. 48, no. 286 (August 1881), pp. 198–99.

Chapter 29. Tripod and Easel

TE's work with photographs and the paintings of the early 1880s: I have relied on Mark Tucker and Nica Gutman, "Photographs and the Making of Paintings," and W. Douglass Paschall, "The Camera Artist," both in Sewell (2001), pp. 225–38 and 239–55.

Gérôme and photography: Chamberlin-Hellman (1981), pp. 103–4.

For general background on history of photography and art: Hockney (2001), Kosinski (1999), and Liedtke, Plomp, and Rüger (2001).

Singing A Pathetic Song: Marc Simpson, "The 1880s," in Sewell (2001), p. 110.

Judging from the comments later made by an Eakins family friend: [William Clark,] "The Fine Arts: Artists and Art Doings," *Philadelphia Daily Evening Telegraph* (October 17, 1881), p. 4.

"great calmness, breadth of treatment, and harmony": Edward Strahan [pseud. of Earl Shinn], "The Art Gallery: The Philadelphia Society of Artists. Third Annual Exhibition," *Art Amateur,* vol. 6, no. 2 (January 1882), p. 26.

"The mere back views": Shinn (1881), p. 6.

"one of the best in the collection": "Art Notes. New York.—American Art Gallery," *Art Journal,* vol. 7 (May 1881), pp. 157–58.

"admirably painted and . . . absolutely true to nature": Mariana Griswold Van Rensselaer, "The New York Art Season," *Atlantic Monthly,* vol. 48, no. 286 (August 1881), pp. 198–99.

"There is almost an utter absence of accessories": Leslie Miller, "Water-Colors in New York," *American Architect and Building News* (April 22, 1882), p. 185.

"His old vigor and point are gone": "The Academy of Design," *New York Times* (April 30, 1882), p. 3.

"some exquisitely drawn": Harold [special correspondent], "Art at the Metropolis," *Philadelphia Press* (March 28, 1882), p. 5.

"In their labored feebleness of execution": Leslie Miller, "Water-Color Exhibition at Philadelphia," *American Architect and Building News,* vol. 11, no. 330 (April 22, 1882), p. 185.

Chapter 30. Nudes and Prudes

TE's personal and professional photographs and trips to Manasquan: Hendricks (1972).

Treatment of typhoid fever: Osler (1892), section 1, p. 1.

"The heartbreak was manifest": Stanley S. Wohl, interviewed by LG, October 9, 1961, LG Research Files at PMA.

"It required many days": Seymour Adelman (1977), p. 169.

Muybridge's coming to Philadelphia: "The Attitude of Animals in Motion," *Journal of the Franklin Institute,* vol. 115, no. 4 (April 1883), pp. 260–74.

Background on the naked series: Ellwood Parry III, "Thomas Eakins's 'Naked Series' Reconsidered: Another Look at the Standing Nude Photographs Made for the Use of Eakins's Students," *American Art Journal,* vol. 20, no. 2 (Spring 1988); also see Foster and Leibold (1989), pp. 22–63.

"A number of photographs of models used in the Life Classes": "Report of the Committee on Instruction," PAFA *Circular of the Committee on Instruction,* 1883–84, PAFA, p. 13.

"Tommy Anshutz, Wallace & myself": C. Seiss to Horatio W. Shaw, April 8, 1883, Shaw Family Papers, Bently Historical Library, University of Michigan, Ann Arbor, referenced in W. Douglas Paschall, "The Camera Artist," in Sewell (2001), p. 249.

"Get life into the middle line": Bregler (1931), p. 383.

Anthony Comstock: Danly and Leibold (1994), pp. 52–57; see also Beisel (1997), pp. 128–58.

TE and the New York customs office: Elizabeth Milroy's "Transcript of interview with Lloyd Goodrich of March 23, 1983," p. 14, LG Research Files at PMA.

Defining "true art": "R.S." to James Claghorn, April 11, 1882, PAFA.

Charges for extracurricular activities: TE's 1883 ledger, CBC at PAFA.

"the right to bring to his studio his models": agreement between TE and BE, "use of 4th story studio," HMSG.

"She possessed a positively rollicking": Goodrich (1982), vol. 2, p. 3.

Fairman Rogers' resignation: Fairman Rogers to TE: November 9, 1883, PAFA.

"My own little home": TE to FEC, June 4, 1886, CBC at PAFA.

"My notion of marriage is the joining of two hearts": SME to Lillian Hammitt, undated [1887], CBC at PAFA.

James Scott reliefs: Amy B. Werbel, "Art and Science in the Work of Thomas Eakins, The Case of Spinning and Knitting," *American Art* (Fall 1998); see also Goodrich (1982), vol. 1, pp. 213–19.

Scott letter: TE is quoting Scott's letter in his own response; TE to James P. Scott, June 18, 1883, LG Research Files at PMA.

Saint-Gaudens letters: Augustus Saint-Gaudens to TE, c. May 27, 1884, and June 2, 1884, transcripts in LG Research Files at PMA.

TE and Saint-Gaudens: Saint-Gaudens had resigned from the committee prior to the deciding vote and was thus unable to sway members of the jury.

Chapter 31. The Lovely Young Men of Dove Lake

Swimming and TE's Dove Lake expedition: For a general survey of relevant material and conservators' insights I have relied on Bolger and Cash (1996). A noteworthy review of the sexually charged nature of *Swimming* is Hatt (1993), pp. 8–21. The painting *Swimming* is reproduced courtesy of The Amon Carter Museum, Fort Worth, Texas; purchased by the Friends of Art, Fort Worth Art Association, 1925; acquired by the Amon Carter Museum, 1990, from the Modern Art Museum of Fort Worth through grants and donations from the Amon G. Carter Foundation, the Sid W. Richardson Foundation, The Anne Burnett and Charles Tandy Foundation, Capital Cities/ABC

Foundation, Fort Worth Star-Telegram, The R. D. and Joan Dale Hubbard Foundation, and the people of Fort Worth.

Biographical information on Coates: *Biographical Catalog of the Matriculates of Haverford College Together with Lists of the Members of the College Faculty and the Managers, Officers, and Recipients of Honorary Degrees* (Philadelphia: printed for the Alumni Association, 1922), p. 115.

On Coates, Florence Nicholson, and the academy: Bolger and Cash (1996), pp. 36–39.

Dove Lake location: Eakins' account book for expenses through July 31, 1884, PAFA.

Preparatory sketches: SME to Mrs. Lewis R. Dick, c. 1930, CBC at PAFA.

Foster's comparative study of the sketches and the completed painting: Kathleen Foster, "The Making and Meaning of Swimming," in Bolger and Cash (1996), p. 19.

Claire Barry's study of *Swimming:* Claire M. Barry, "Swimming by Thomas Eakins: Its Construction, Condition, and Restoration," in Bolger and Cash (1996), pp. 98–106.

Choosing the models and background on the models chosen: Sarah Cash, "Friendly and Unfriendly: The Swimmers of Dove Lake," in Bolger and Cash (1996), pp. 49–60.

Modeling George Reynolds: Albright (1947).

Difficulties rendering Reynolds: deduced from Eakins' account book for expenses through July 31, 1884, PAFA.

"In a big picture": TE to BE on March 6, 1868, CBC at PAFA.

Homosexuality and *Swimming:* Davis (1994), pp. 301–41; see also Hart (1993), pp. 8–12.

"an important work": "Academy Exhibition Fifty-sixth Annual Display," *Philadelphia Inquirer* (October 29, 1885), from TE clipping scrapbook, AAA.

"the best" in the show: "The Academy Pictures. How the Exhibition at the Academy Compares with Those Elsewhere," *Philadelphia Press* (October 29, 1885), from TE clipping scrapbook, PAFA.

"interesting [subject] matter": "The Fine Arts," *Philadelphia Evening Telegraph* (October 31, 1885), p. 4.

"not agreeable": "At the Private View. First Impressions of the Autumn Exhibition at the Academy of the Fine Arts," *Philadelphia Times* (October 29, 1885), p. 2.

"Mr. Eakins has done some very strange things": Leslie Miller, "Art. The Award of Prizes at the Academy," *The American*, vol. 11, no. 274 (November 7, 1885), p. 45.

"My reasons for this": Edward Coates to TE, November 27, 1885, CBC at PAFA.

TE requesting raise: TE to PAFA Board of Directors, April 8, 1885, PAFA.

Chapter 32. Philanthropists and Philistines

Costs of operating the PAFA: Chamberlin-Hellman (1981), pp. 314–17.

Comstock's anti-vice campaign: Beisel (1997), pp. 128–58.

"It will I think be best not to issue any tickets": Coates to PAFA board, "Minutes of the Committee on Instruction," May 1885, PAFA.

"that it might give rise to unfavorable criticism": PAFA's "Annual Report to the Board of Directors," May 9, 1881, PAFA.

TE's core beliefs regarding the nude: Kathleen A. Foster, "Eakins and the Academy," in Sewell (2001), p. 104.

Construct, model, and paint: this point was made by Albright (1947), p. 138.

"Be sure you have a human": quoted in Chamberlin-Hellman (1981), p. 207.

"[Eakins] loved the beauty of living things": Albright (1947), p. 139.

"I felt a very hard-boiled and heroic person" and TE chatting with students near academy elevator: Calder (1947), pp. 3–4.

"That's how you'll end up": Saint-Gaudens (1941), p. 179.

"I can remember the flutter": Albright (1947), p. 139.

"Thomas Eakins' formidable personality": Beaux (1930), p. 96.

Chapter 33. The Hanging Committee

Muybridge and Eakins: For general survey of relevant material I have relied on W. Douglass Paschall, "The Camera Artist," in Sewell (2001), pp. 239–55, and Muybridge (1957).

Eakins and the motion picture camera: Bregler (1943), pp. 28–29.

Eakins and photography: Foster (1997), pp. 106–20.

"cameras . . . were clocks for seeing": Roland Barthes, *Camera Lucida*, trans. Richard Howard (New York: Hill and Wang, 1981), p. 15.

Camera equipment: Rogers (1879), pp. 2–3.

Muybridge and Eakins experiments: a first-person survey of relevant materials on the differences between their methods is found in Albright (1947).

Details of the University of Pennsylvania experiments: "Minutes of the Board of Trustees," August 7, 1883, UPA.

TE's appointment to commission: William Pepper, "Note" in *The Muybridge Work at the University of Pennsylvania—The Methods and the Results* (New York: Arno, [reprint] 1973), p. 6.

"They would like to fire": Thomas Anshutz to John Wallace, August 1884, PMA.

Chapter 34. Point of No Return

TE as a liability at the academy: Foster and Leibold (1989), pp. 69–78.

The sequence of events: TE and Edward Coates correspondence published in ibid., pp. 214–18.

Horse down the stairwell: McHenry (1946), p. 67.

"Eakins found a great deal of fault": Horatio Shaw to Susan Shaw, December 26, 1880, as quoted in Chamberlin-Hellman (1981), p. 208.

"Our crowd didn't have much interest": quoted in Chamberlin-Hellman (1981), p. 247.

"succumbing to [the] obsession of his personality": Beaux (1930), p. 98.

Loincloth incident and scandal: Foster and Leibold (1989), pp. 69–90, 109; also see Chamberlin-Hellman (1981), pp. 312–56.

Coates asks for resignation: Edward Coates to TE, February 8, 1886, CBC at PAFA; see also

"Professor Eakins Resigns. He Withdraws from the Life Class of the Academy of the Fine Arts," *Philadelphia Evening Bulletin* (February 15, 1886), p. 6.

"The class as a whole is perfectly satisfied with Mr. Eakins": "Professor Eakins Resigns," *Philadelphia Press* (February 15, 1886), p. 1.

Details of students marching in protest: "Indignant Art Students. They Demand the Return of Mr. Thomas Eakins to the Academy of the Fine Arts," *Philadelphia Evening Bulletin* (February 16, 1886), p. 2.

"Each man wore a large E": ibid.

"We will not ask Mr. Eakins to come back": "The Fiery Art Students," *Philadelphia North American* (February 18, 1886), p. 1.

The student petition: "Petition from Fifty-five Academy Students to the Board of Directors," February 15, 1886, PAFA.

Details of the academy rebellion: "For and Against Eakins, The Directors Stand Firm and the Students Strike an Attitude," *Philadelphia Evening Item* (February 19, 1886), p. 1; see also "The Fiery Art Students," *Philadelphia North American* (February 18, 1886), p. 1.

"I could not give ... [my students]": "The Fiery Art Students," p. 1.

"Mr. Eakins' resignation and the foolish proposition": "The Academy Life School," *Philadelphia Evening Bulletin* (February 19, 1886), p. 17.

"If Mr. Eakins offended the modesty of the women": *Art Interchange* (February 27, 1886), p. 69.

"The whole thing, in my opinion": "Professor Eakins Resigns," *Philadelphia Press* (February 15, 1886), p. 1.

"Professor Eakins' resignation was the result": ibid., p. 6.

Chapter 35. Demons and Demigods

The events of 1886 at the PAFA: I have relied on Chamberlin-Hellman (1981), pp. 350–74, and Foster and Leibold (1989), pp. 69–78.

Lecture notes and meetings of the Sketch Club: "Philadelphia Sketch Club, Notes from the Minute Books" (to early 1885), PSC.

Whistler and Wilde: Eliot (1957), p. 116.

"If you paint a young girl": ibid., p. 117.

"I think [Whistler's work]": Goodrich (1982), vol. 2, p. 15.

"It has always appeared to me that the art education": quoted in Chamberlin-Hellman (1981), p. 355.

"gave her the explanation": TE to Edward Coates, September 12, 1886, CBC at PAFA.

Van Buren staying at Mount Vernon Street: McHenry (1946), p. 126.

Elizabeth Macdowell comes to support TE: Elizabeth Macdowell to TE and SME, November 8, 1888, CBC at PAFA.

TE's letters looking for support: Foster and Leibold (1989), pp. 156–59, 165–67, 172–79, and 214–39.

"I myself see many things clearer": TE to Edward Coates, March 10, 1886, CBC at PAFA.

"I see no impropriety": TE to Edward Coates, September 11, 1886, CBC at PAFA.

"I send you a statement": TE to ES, March 25, 1886, PAFA.

Chapter 36. The Family Skeleton

Sketch Club scandals: I have relied on Sellin (1977), pp. 37-41, and Foster and Leibold
(1989), pp. 79-89.

"conduct unworthy": TE's Sketch Club dossier #4, CBC at PAFA.

TE's wondering what the public will think: TE to FEC, June 4, 1886, CBC at PAFA.

TE's discovery of allegations: TE to Edward Coates, draft, c. March 10, 1886, CBC at PAFA.

"It would be folly for me to appear": TE to John Sears, March 26, 1886, PSC.

Sketch Club investigation: John Sears to TE, March 11, 1886, CBC at PAFA.

letters about Stephens' allegations: ibid.; TE to John Sears, March 13, 1886, CBC at PAFA.

TE not cooperating until he knows charges: TE to John Sears, March 13, 1886, PSC.

"The Committee have a very delicate and uncongenial duty": Walter Dunk to TE, April 7,
1886, CBC at PAFA.

"I could come to no conclusion": TE to John Sears, April 7, 1886, CBC at PAFA.

TE asks for specifics: ibid.

TE demands that all correspondence be presented: TE to Sketch Club, April 17, 1886, PSC.

"[They] feel that they have made a mistake" and "Frank Stephens insisted in pushing":
Dunk to Sears, quoted in Sellin (1977), pp. 39-40.

Crowell's discussion of charges: WC to TE, April 26, 1886, CBC at PAFA.

Crowell's affidavit and report on interview with Stephens: WC to John Sears, June 5, 1886,
CBC at PAFA.

FEC affidavit: June 5, 1887, CBC at PAFA.

The growing scandal from TE's point of view: TE to Arthur Frost, June 8, 1887, CBC at
PAFA.

"Your own worn appearance": William Macdowell to SME, October 15, 1886, CBC at PAFA.

"No amount of good painting": TE to FEC, June 4, 1886, CBC at PAFA.

Reorganization of living arrangements on Mount Vernon Street: TE to FEC, June 4, 1886,
CBC at PAFA.

"I never in my life seduced": TE to Edward Coates, February 15, 1886, CBC at PAFA.

Whitman at Eakins home: unpublished oral history interview conducted with Crowell family
members by Marlene Will, November 1993, SDMA.

Talcott Williams introducing TE to Whitman: this is derived from the announcement which
ran in *North's Philadelphia Musical Journal*, vol. 2, no. 9 (September 1887), p. 7.

"sick," "rundown," and "out of sorts": Traubel (1953), p. 135.

Drip mark in *Swimming*: Bolger and Cash (1996), p. 107.

Changes to *The Crucifixion*: Goodrich (1982), vol. 1, p. 193.

TE reworking painting of SME: Homer (1992), p. 127; Foster and Leibold (1989), p. 88;
and Goodrich (1982), p. 224.

Chapter 37. Black Care

"the mischief . . . might never": TE to FEC, June 4, 1886, CBC at PAFA.

TE in the Dakotas: Foster and Leibold (1989), pp. 90–93, 189–97.

TE's correspondence from Dakotas: quotations not referenced in the text (along with an inventory of all of TE's Dakota correspondence) can be found in ibid., pp. 159–61.

Wood's camp cure: Wood (1880), p. 90; see also Liften (1989), vol. 2, pp. 247–74; Johns (1983), pp. 160–61.

TE's letter of introduction from Wood for Dakota trip: Horatio Wood to [Albert] Tripp, undated, CBC at PAFA.

Wood's acquisition of a share in the Dakota ranch: Homer (1980), p. 21.

Last herds of buffalo, cattle raising, and Dakota terrain: Trefethen (1975), pp. 5–19.

Theodore Roosevelt's movements in Dakota Territory: Dr. John Gable, Theodore Roosevelt Association, Oyster Bay, N.Y., telephone conversation with author, 2004.

TE describes roundup: TE to SME, August 1887, CBC at PAFA.

TE and Tripp: TE to SME, September 7, 1887, CBC at PAFA.

TE and horse thief: TE to SME, September 26 and October 9, 1887, CBC at PAFA.

TE to start east: TE to John Wallace, October 14, 1887, CBC at PAFA.

Additional Wallace correspondence, Wallace Collection, Joslyn Art Museum, Omaha, Nebr., see June 23, 1887.

Description of cowboy activities in Avondale: Morris (1930), p. 33.

Chapter 38. The Bard of Camden

Survey of the relationship between TE and Walt Whitman: Goodrich (1982), vol. 2, pp. 28–38; see also Johns (1983), pp. 144–69, and Rule (1974), pp. 7–57.

TE meeting and getting to know Whitman: Carr (1989), pp. 3–10.

Quotations by Whitman as reported by Traubel: those not referenced below or otherwise identified in the text can be found in Goodrich (1982), vol. 2, pp. 31–38. Most of LG's sources are from Traubel (1889) and Traubel (1953).

"[Eakins] seemed careless": Traubel (1953), p. 155.

"Mr. Eakins, the portrait painter, of Philad": Whitman to Leonard M. Brown, November 19, 1887, referenced in Wilmerding (1993), p. 109.

Whitman at Eakins home: unpublished oral history interview conducted with Crowell family members by Marlene Will in November 1993 for SDMA.

Talcott Williams introducing TE to Whitman: this is derived from the announcement which ran in *North's Philadelphia Musical Journal*, vol. 2, no. 9 (September 1887), p. 7.

Chapter 39. A League of His Own

Predictions for the league's failure: "The End of Eakins. The Eccentric Director of the Academy Life Class Retires," *Philadelphia Evening Item* (February 15, 1886), p. 1; see also Editorial, *Philadelphia Evening Bulletin* (February 24, 1886), p. 4.

History of league and background of students: McHenry (1946), pp. 102–8; Goodrich
 (1982), vol. 1, pp. 295–302.
Movements of the school and numbers of students: Chamberlin-Hellman (1981), pp. 377, 412.
"I remained at the Academy": Calder (1947), p. 3.
"It was with great regret": Albright (1947), p. 184.
"collecting" trip: McHenry (1946), p. 104.
"If you boys knew how good": ibid., p. 68.
Franklin Schenck: Goodrich (1982), vol. 1, pp. 299–300.
Schenck and the bathtub: McHenry (1946), p. 103.
Schenck and the ashes story: Goodrich (1982), vol. 1, p. 300; see also McHenry (1946),
 pp. 103–14.
Schenck ice skating: McHenry (1946), p. 93.
"an illustration of the broad mindedness": Goodrich (1982), vol. 1, p. 300.
"Lustily carolling": "Pennsylvania Art Exhibit to Be Sent to the Columbian Exhibition,"
 Philadelphia Public Ledger (January 16, 1893), p. 6.
Eagan and the egg: McHenry (1946), p. 68.
"He skated as he painted": ibid., p. 70.
Eagan with the cat: ibid., p. 69.
SAM coming to the league: ibid., p. 71.
SAM visiting Harleigh Cemetery: ibid., p. 87.
SAM telling anti-academy stories: Goodrich (1982), vol. 1, pp. 300–301.
background of CB: Foster and Leibold (1989), pp. 317–25.
CB making record of TE's class comments: "Thomas Eakins as a Teacher," *The Arts,* vol. 17,
 no. 6 (March 1931), p. 383.
CB walking with SME: McHenry (1946), p. 58.
"Please don't come tomorrow": TE to CB, May 15, 1888, CBC at PAFA.
"keeper of the gate": George Barker to CB, July 30, 1944, CBC at PAFA.
CB helped himself to the "debris": Foster and Leibold (1989), p. 14.
"These things are all for future students": CB to SAM, July 23, [1939], CBC at PAFA.

Chapter 40. Dressed and Undressed

Teaching at other schools: Goodrich (1982), vol. 1, pp. 303–4, and vol. 2, p. 188.
league social events: McHenry (1946), pp. 104–5; see also Goodrich (1982), p. 298.
Eakins' picture was "all wrong": McHenry (1946), p. 91.
"poor, unhappy [and] demented": SME to LG, LG Research Files at PMA.
Hammitt case and Ella Crowell: Foster and Leibold (1989), pp. 93–122.
"infamous rumors industriously spread": TE to Charlotte Connard, March 2, 1887, CBC at
 PAFA.
SME's counseling Hammitt: SME to Hammitt, undated draft, CBC at PAFA.
"That you should have consulted": TE to Lillian Hammitt, March 2, 1888, CBC at PAFA.
"You are laboring under false notions": ibid.

TE's knowledge of mental illness and Eliza Cowperthwait's condition: Goodrich (1982), vol. 2, p. 1.

"my dear friend Mr. Eakins would I know be very glad to help": quoted in Foster and Leibold (1989), p. 99.

"The condition of your sister Lillian": TE to Charles Hammitt, June 5, 1890, CBC at PAFA; see also Charles Hammitt to Lillian Hammitt, June 23, 1890.

"criminal" intent: L. B. Nelson to Charles Hammitt, June 15, 1890, CBC at PAFA.

"I have from you a letter": TE to L. B. Nelson, June 19, 1890, CBC at PAFA.

"My love is always welcome": Lillian Hammitt to TE, July 3, 1890, CBC at PAFA.

personalities of Crowell children: McHenry (1946), p. 100.

"anxious heart": FEC to TE, April 4, 1890, CBC at PAFA.

"That you should feel so anxious": TE to FEC, April 1890, CBC at PAFA.

"trouble, estrangement, distress of mind": FEC to TE, April 7, 1890, CBC at PAFA.

"I thought you had given up girl students posing": ibid.

"when every one known to me": WC to TE, April 10, 1890, CBC at PAFA.

Chapter 41. Portraits by a Modern Master

Lillian Hammitt in Norristown: Maggie Unkle to TE, December 7, 1892, CBC at PAFA.

TE meeting Letitia Wilson Jordan: Goodrich (1982), vol. 2, p. 67.

"painted, apparently, with that unsparing realism": "The Academy Exhibition," *Art Amateur*, vol. 24, no. 6 (May 1891), p. 145.

"To end a lie of nearly half a century": Dunbar (1936), pp. 215–16.

"He would bring out all those traits": Goodrich (1982), vol. 2, p. 77.

"Why, what's the matter with that?": ibid., p. 84.

TE capturing Cook's form singing: Siegl (1978), p. 128.

"I got to loathe [singing the aria]": Weda Cook [Addicks] to LG, May 20, 1931, LG Research Files at PMA.

TE's attempts to have Cook pose nude: ibid.

Cook on refusing to pose: McHenry (1946), p. 121.

"He fell in love with me": Weda Cook [Addicks] to LG, May 20, 1931, LG Research Files at PMA.

TE on building the frame: TE to Henry Rowland, October 4, 1897, AGAA.

"It is, I believe, to your interest": TE to Da Costa, January 9, 1893, LG Research Files at PMA.

Fetter, Harry, and the crackers: McHenry (1946), pp. 109–10.

Cushing background and posing for TE: TE to W. J. McGee, April 17, 1900, National Anthropological Archives, Bureau of American Ethnology, 1899–1906, Smithsonian Institution, Washington, D.C. (copy at PMA); see also William Truettner, "Dressing the Part: Thomas Eakins's Portrait of Frank Hamilton Cushing," *American Art Journal* (Spring 1985), pp. 49–72.

Gertrude Murray standing in for Cushing: McHenry (1946), p. 112.

Cushing and Bobby the monkey: Goodrich (1982), vol. 2, p. 12.

"peach" and "baby doll" and "cantankerous": SAM to LG, LG Research Files at PMA.

Chapter 42. Horrors of the Dissecting Table

The history of medical portraiture in Philadelphia: *The Art of Philadelphia Medicine* (1965). The number of physicians Eakins actually painted is not known because not all of his work has been found. Those that I have identified are Hayes Agnew, Mathew Cryer, Henry Beates, John Brinton, Hugh Clarke, Jacob Da Costa, Thomas Fenton, William Smith Forbes, Albert Getchell, Frank Greenwalt, Samuel Gross, James W. Holland, Joseph Leidy, Charles Lester Leonard, Edward Nolan, Gilbert Lafayette Parker, Howard Rand, Benjamin Sharp, Edward Spitzka, Alfred Watch, optician William Thomson, William White, William Wilson, George Wood, and Horatio Wood.

Agnew portrait commission offered to TE and his response: SME to Horatio Wood, April 4, 1917, CBC at PAFA; see also SME to Edgar F. Smith, July 13, 1919 at PMA.

Diverging interpretations of *The Agnew Clinic:* Lubin (1985), pp. 27–82; Bridget Goodbody, "The Present Opprobrium of Surgery: The Agnew Clinic and Nineteenth-Century Representations of Cancerous Female Breasts," *American Art,* vol. 8, no. 1 (Winter 1994), pp. 32–51; Whitney Davis, "Erotic Revision in Thomas Eakins's Narratives of Male Nudity," *Art History* (September 1994), pp. 301–41; Judith Fryer, "The Body in Pain in Thomas Eakins's Agnew Clinic," in *The Female Body: Figures, Styles, Speculations,* ed. Laurence Goldstein (Ann Arbor: University of Michigan Press, 1991), pp. 235–54; Marcia Pointon, *Naked Authority: The Body in Western Painting, 1830–1908* (Cambridge: Cambridge University Press, 1990), pp. 35–58.

Agnew's character and attitudes toward women: Adams (1892), pp. 300–350.

Agnew resigning from U of Penn and his return: Bell (1987), p. 145.

History of breast surgery: Keen (1912–13), vol. 3, pp. 570–79, and vol. 6, pp. 404–10.

"I can give you just one hour": McHenry (1946), p. 144.

Agnew treating SAM's infected finger: ibid., p. 105.

Presentation and initial reception of *The Agnew Clinic:* ibid., pp. 143–46.

"other reasons for not wishing": Goodrich (1982), vol. 2, pp. 48–49.

"For the last three years my paintings": TE to the Society of American Artists, quoted in ibid., pp. 50–51.

"the advisability of including his portraits": "Pennsylvania Art Exhibit. To Be Sent to the Columbian Exhibitions," *Philadelphia Public Ledger* (January 16, 1893), p. 6.

"It is impossible to escape from . . . ghastly symphonies": Montague Marks, "My Note Book," *Art Amateur,* vol. 29, no. 2 (July 1893), p. 30.

"Eakins is a butcher": Weda Cook Addicks to LG, May 20, 1931, LG Research Files at PMA.

Chapter 43. Casting for Commissions

"I am puzzled to understand": Henry Adams to Lucy Baxter, October 18, 1893, Massachusetts Historical Society, referenced in Adams Archive at University of Michigan, Ann Arbor.

TE and the sculpture commissions: Foster (1997), pp. 98–105.

"real men on real horses" along with following quote: Cleveland Moffett, "Grant and Lincoln in Bronze," *McClure's Magazine,* vol. 5, no. 5 (October 1895), pp. 420–21.

Shipping Clinker: TE to "Bunny" McCord, August 4, 1894, copy in the Thomas Eakins Research Collection at PMA.

Modeling at Avondale: McHenry (1946), p. 96.

"a direct catch—no middleman": Traubel diaries, cited in Homer (1992), p. 216.

"I am not a speaker": Goodrich (1982), vol. 2, p. 38.

"If this bit of 'realism' was intended to distract": "Public Sculptures in Brooklyn," *Art Amateur,* vol. 34, no. 3 (February 1896), p. 60.

Payment for sculptures: Goodrich (1982), vol. 2, p. 119.

"I personally selected Mr. Murray": ibid., p. 105.

References on who modeled for Witherspoon commission: Chamberlin-Hellman (1981), p. 477.

"fell prey to vandalism, weather, or neglect": Goodrich (1982), vol. 2, p. 106.

"Eakins was in exile": Morris (1930), pp. 30–31.

Chapter 44. The Pied Piper of Philadelphia

"Certain scholars have felt offended": Edwin Blashfield to TE, LG and Edith Havens Goodrich Collection at Whitney Museum of American Art, New York.

"I had no intention surely": TE to Edwin Blashfield, December 22, 1894, CBC at PAFA.

The Drexel firing: "Objected to the Nude," *New York Sun* (March 15, 1895), p. 1; see also "Thomas Eakins: The Drexel Institute and the Artist," *Philadelphia Evening Item* (March 17, 1895), p. 27.

Chronology of events and the relationship between Hammitt and TE: Foster and Leibold (1989), pp. 95–104.

"Never come here again": SME in undated draft, CBC at PAFA.

Chronology of events and the relationship between Ella Crowell and TE: Foster and Leibold (1989), pp. 105–22, 290–98.

"decided to work from one another" and Macdowell's own account of events: SME Memorandum on Ella [1897?], CBC at PAFA; also see SME to FEC, October 18, 1896, and SME to FEC, November 1, 1896, CBC at PAFA.

Claims concerning the "degraded" manner in which Ella was treated by TE: It has been widely reported that TE forced Ella to touch his "private parts." The source of this claim is rooted in statements made by Eakins biographer Gordon Hendricks, based on interviews he conducted with later-generation Crowell family members. Here is a case, I believe, of supposition evolving into "fact."

"That girl's sick": McHenry Papers, HSP.

Attitudes of Ella's siblings: Foster and Leibold (1989), pp. 114-18.

"a lightning rod": ibid., p. 119.

Account of Ella's suicide: ibid., p. 114.

"A broken-down old man": Stanley S. Wohl, interviewed by Seymour Adelman and others, April 11, 1973, PMA.

"My honors are misunderstanding": TE to Harrison Morris, April 23, 1894, PAFA.

Chapter 45. Portrait of a Physicist

Mount Desert Island and Craigmore: Charlotte Singleton, Mount Desert Island Historical Society, telephone interview with author, 2004.

"once an artist": TE to BE, March 6, 1868, CBC at PAFA.

"Dear Sir": TE to Henry Rowland, August 16, 1897, AGAA.

"My Dear Rowland": TE to Henry Rowland, July 17, 1897, AGAA.

"We get on famously together": TE to SME, July 1897, CBC at PAFA.

"I am very curious to watch": TE to SME, c. 1897, CBC at PAFA.

Diffraction gratings: A. D. Moore, "Henry Rowland," *Scientific American* (February 1982), pp. 150-61.

"[Rowland] wanted to go out": TE to SME, July 1897, CBC at PAFA.

"I hope that as soon as you find the time": TE to Henry Rowland, October 4, 1897, AGAA.

"I am going over the head again": TE to SME, summer 1897, CBC at PAFA.

"My exhibition frames": October 4, 1897, AGAA.

"I have concluded": TE to Harrison Morris, November 17, 1897, PAFA.

Chapter 46. Down for the Count

Boxing paintings: I am especially grateful in this chapter for the research found in Walter (1995), which includes a thorough study of these works and an indexing of boxing-related citations in the Philadelphia press from which I have drawn. For background material see also "Muscles, Morals, Mind: The Male Body in Thomas Eakins' Salutat," in *The Body Imaged: The Human Form and Visual Culture Since the Renaissance*, ed. Kathleen Adler and Marcia Pointon (Cambridge: Cambridge University Press, 1993), pp. 57-69. For background on the individual fighters' relationships with TE: Goodrich (1982), vol. 2, pp. 144-45.

Learning boxing from Max Schmitt: TE to [BE?], November 26, 1866, CBC at PAFA.

Attended nearly three hundred fights: Goodrich (1982), vol. 2, p. 144.

"The character of prize-fighters": E. L. Godkin, "A Point in Journalism," *The Nation* (March 23, 1893), p. 210.

Bill Vernon's death: *Philadelphia Weekly Item* (June 12, 1897), p. 2.

George Stout's death: *Philadelphia Record* (April 9, 1898), p. 13.

Cranmer and his assistance to TE: TE to Cranmer, May 19, 1899, Gordon Hendricks
 Papers, AAA.

Billy Smith: Goodrich (1982), vol. 2, pp. 144–45.

Background on McCloskey: "Brief Sketch of My Career," undated, CBC at PAFA.

"At the Arena tonight Charlie McKeever": *Philadelphia Inquirer* (April 29, 1898), p. 4.

"Charley McKeever easily bested": *Philadelphia Record* (April 30, 1898), p. 11.

"rattling fast mill from end": *Philadelphia Inquirer* (April 30, 1898), p. 4.

"It was the chef d'oeuvre": ibid.

"Billy was a favorite not only among fighters": SME to Charles Sawyer, January 24, 1934,
 AGAA.

Spectator identification: Walter (1995), pp. 174–78.

"snakes" and "geese": *Philadelphia Inquirer* (April 23, 1898), p. 4.

"Tim Callahan and Billy Smith, the very clever": *Philadelphia Press* (April 23, 1898).

"With His Right Hand": translation used in Walter (1995), p. 90.

"Stay a while and I'll put you in the picture": Goodrich (1982), vol. 2, p. 147.

Boxers identified in *Salutat*: SME to Charles Sawyer, January 23, 1934, AGAA.

" 'Salutat,' by Tom Eakins": *Art Collector* (February 1, 1899), p. 102.

"Feeding the new popular taste": W. P. Lockington, *Collector and Art Critic* (February 1,
 1900), p. 121.

"Mr. Eakins, to me was a Gentleman": Billy Smith to Walker Galleries, August 15, 1940,
 AAA.

Chapter 47. Outlaw in an Undershirt

"Outlaw in an Undershirt" is the title of an article about TE in *Newsweek,* vol. 23, no. 16
 (April 17, 1944), pp. 99–100.

Melville discovering TE carried a revolver: McHenry (1946), p. 119.

Carrying a revolver and willingness to use it: referenced by Gilbert Parker in his catalogue for
 the 1917–18 Eakins retrospective at PAFA, PAFA; see also Goodrich (1982), vol. 2, pp.
 6–7.

Smith and Wesson revolver: Goodrich (1982), vol. 1, p. 32.

"[I] could never get [it] away from him": Mrs. Nicholas Douty to LG, June 10, 1930 or 1931,
 LG Research Files at PMA.

"Feeling for bones": Goodrich (1982), vol. 2, p. 72.

Bobby and silver dollars: ibid., p. 12; see also McHenry (1946), p. 125.

"Here I come, Eakins": Goodrich (1982), vol. 2, p. 12.

to pay him "no mind": ibid., p. 69.

"Mr. Eakins, why do you look at me": ibid., p. 67.

"I remember his telling me": ibid., p. 59.

"his descendants to think of their grandfather": ibid., p. 234.

"You've never seen a naked man": quoted in Foster and Leibold (1989), p. 121.

"I try on rich stuffs to tempt": SME diary, February 16, 1899, CBC at PAFA.

"She shielded him from household chores": Goodrich (1982), vol. 2, p. 3.

"Mrs. Eakins was kinda killed": McHenry (1946), p. 59.

"Yoo-hoo," chortled Benjamin: ibid., p. 131.

BE remained vital: SME diary, June 4, 1899, CBC at PAFA.

"the grandest man": Adolphe Borie to LG, May 9, [1930 or 1931], LG Research Files at PMA.

"very kindly and humorous": Francis Petrus Paulus to Bryson Burroughs, October 25, 1929, PMA.

"his delightful friendly side": Catherine Janvier to SME, August 13, 1916, PMA.

"If anyone did him an unfair injury": Goodrich (1982), vol. 2, p. 6.

Addie Williams: McHenry (1946), pp. 131–34.

"She is a pretty little girl": TE to FE, May [1867?], CBC at PAFA.

BE and TE bicycle trip: SME diary, June 4, 1899, CBC at PAFA.

"Rather worried": Goodrich (1982), vol. 2, p. 174.

"more relaxed and more tender": ibid.

"You know, of course, that Uncle Tom": Hendricks (1974), p. 244.

Ménage-à-trois arrangement: Goodrich (1982), vol. 2, p. 174.

"Jamie Dodge is going to explain": McHenry (1946), p. 133.

"[I] was asked several times": ibid., pp. 128–29.

Reading the Bible: ibid., p. 129.

Chapter 48. Pictured Lives

"living thinking acting men": TE to FE, April 1, 1869, AAA.

"I have intended writing you": Goodrich (1982), vol. 2, p. 209.

"I should be delighted": quoted in Siegl (1978), p. 152.

"heavy-necked, square faced": Schendler (1967), p. 218.

"such homely women": Goodrich (1982), vol. 2, p. 69.

"I shall take pleasure in showing them": ibid., p. 175.

"You will receive the painting back": Asbury Lee to TE, September 19, 1905, LG Research Files at PMA.

"not only one of his finest": Goodrich (1982), vol. 2, p. 201.

"barely outlasted the honeymoon": Sellin (1977), p. 30.

"Louis strikes Lid in the face": SME, "Personal Papers, 1879–1938," CBC at PAFA.

"of unusual excellence": "Seventieth Annual Salon at the Academy of the Fine Arts. American Art Finely Displayed," *Philadelphia Press* (January 13, 1901), p. 3.

"the very crudity of the realism": Charles Caffin, "Some American Portrait Painters," *The Critic,* vol. 44, no. 1 (January 1904), p. 34.

"Mr. Eakins I have known": "A Revolt at Drexel Institute. Indignation Caused by a Nude Male Model Before a Mixed Class," *Philadelphia Times* (March 14, 1895), p. 1.

"One day a stocky little man": Rourke (1938), pp. 14–15.

"[Eakins] not only wanted me to wear": Leslie Miller to Arthur Bye, 1923, PMA.

"The likeness is excellent": "Art and Artists," *Philadelphia Press* (February 7, 1901), p. 1.

"Friends of Mr. Miller say": "Leslie Miller's Portrait Pronounced True to Life," *Philadelphia Press* (February 13, 1901), p. 4.

"I desire to remind the Art patrons": "Thomas Eakins. His Fine Portrait of Leslie W. Miller," *Philadelphia Evening Item* (February 16, 1902), p. 8.

Chapter 49. Pontiffs and Prelates

Portraits of James Flaherty, Hugh Thomas Henry, James Turner, Dr. Patrick Garvey: background and details are from the St. Charles Borromeo Seminary portrait files; also see Sullivan (1998), pp. 1–23.

TE reading the Bible: McHenry (1946), p. 129.

David Jordan's opinions on TE and religion: David Jordan to LG, May 5, 1930, LG Research Files at PMA.

Question of "divinity": TE to BE, January 31, 1867, CBC at PAFA.

TE and SAM bicycling to Overbrook: McHenry (1946), pp. 114–15.

Outfits worn: ibid., p. 114.

"Dr. Garvey was not": O'Donnell (1964), p. 75.

"I hope the painting has been found": Goodrich (1982), vol. 2, p. 196.

"Mr. Eakins painted such portraits": ibid., p. 188.

"quiet poise": "Notable Display of Art to Be Seen at the Academy To-Morrow. Brilliant Display of High-Class Art," *Philadelphia Inquirer* (January 18, 1903), p. 2.

"There is no trickery about this portrait": "The Academy Pictures. A Brilliant Exhibition Illustrative of American Art," *Philadelphia Record* (January 18, 1903), p. 9.

"I have just finished": TE to Frank W. Stokes, December 15, 1902, HMSG.

"I think it one of my best": TE to Frank W. Stokes, January 3, 1904, HMSG.

"true to nature": Francis Ziegler, "A Fine Lot of Pictures," *Philadelphia Record* (January 24, 1904), p. 24.

"This medal stands for a long and brilliant series": "Art and Artist," *Philadelphia Press* (February 14, 1904), p. 6.

"I think you've got a heap of impudence": Goodrich (1982), vol. 2, p. 201.

Eakins' looking "disreputable" at the mint: McHenry (1946), p. 51.

Chapter 50. Return to Rush

TE using Murray's model: McHenry (1946), p. 128.

"He didn't need to do that": Goodrich (1982), vol. 2, p. 96.

"I wore high starched collars": Mrs. John B. Whiteman to LG, May 1930, LG Research Files at PMA.

"I remember Momma telling me": Goodrich (1982), vol. 2, p. 94.

"broad stories" and "beautiful bones": ibid.

"He always wanted us to pose in the nude": Hendricks (1974), p. 263.

"just a little pretty": McHenry (1946), p. 130.

"Thomas Eakins was not interested in my face": Helen Parker Evans to Sylvan Schendler, September 29, 1969, referenced in Goodrich (1982), vol. 2, p. 242.

"starved for the nude": ibid., p. 94.

"The elderly artist took stock": Elizabeth Milroy, "Images of Fairmount Park in Philadelphia," in Sewell (2001), p. 94.

Chapter 51. Artist in Residence

Dead eagle: TE donated the bald eagle to the Academy of Natural Sciences in 1907; Kathleen Brown, "Chronology," in Sewell (2001), p. xxxix.

Eating oysters and other delicacies in Fairton: TE to FE, November 12, 1868, AAA.

Formaldehyde poisoning: McHenry (1946), p. 141.

Paint as poison: Walter (1995), p. 101.

"old, old man looking out upon a passing world": "Eakins Chats on Art of America," *Philadelphia Press* (February 22, 1914), p. 8.

"Although I have never met you": TE to John Brashear, c. 1912, CBC at PAFA.

Meeting Samuel Clemens: McHenry (1946), p. 115.

"you don't forget": ibid., p. 116.

TE crying while listening to music: ibid., p. 121.

"badly baled load of straw": Saint-Gaudens (1941), pp. 178–79.

TE giving lectures in Fairmount Park: Stanley S. Wohl, interviewed by Seymour Adelman and others, April 11, 1973, PMA.

"dare-devil" mood: McHenry (1946), pp. 141–42.

Lancaster exhibition: ibid., pp. 136–37, 142–43, 146–47.

"a grand good time": ibid., p. 148.

"certainly the most important canvas": *Philadelphia Inquirer* (February 8, 1914), p. 14.

"[the painting] will stand": *Philadelphia Inquirer* (February 22, 1914), p. 8.

Barnes sale: Homer (1992), p. 249.

Valuations for TE's paintings: Hendricks (1974), pp. 275–76; Goodrich (1982), vol. 2, p. 273.

"If America is to produce": "Eakins Chats on Art of America," *Philadelphia Press* (February 22, 1914), p. 8.

"Murray, come again tomorrow": McHenry (1946), p. 135.

"Tom is dead" and "My poor Tom away": SME, "Personal Papers, 1879–1938," CBC at PAFA.

"Thomas Eakins was a man of great character": Henri (1923), p. 86.

"the most consistent of American realists": Burroughs (1917), p. vi.

CB's relationship with Mary Picozzi: Foster and Leibold (1989), pp. 18–20.

Fictional boxer Rocky Balboa: see humorous footnote in Walter (1995), p. 197.

Bibliography

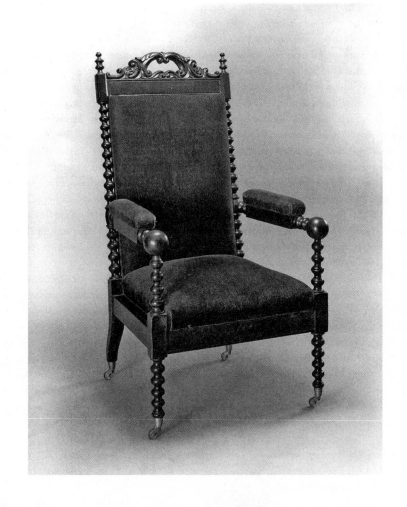

Research Archives

Most of the documents cited in the notes can be found in the Thomas Eakins Research Collection at the Philadelphia Museum of Art. This collection, the single largest repository of Eakins research material in existence, consists of photocopies or transcripts of most of the surviving primary documents relating to Eakins, with the notable exception of the material in the Charles Bregler Collection at the Pennsylvania Academy of the Fine Arts. In addition to these primary documents, the Philadelphia Museum collection contains copies of reviews of exhibitions or other published material from Eakins' lifetime, copies of Eakins-related publications, correspondence with researchers and collectors, subject files on individuals, art organizations, or general historical topics, and object files containing background information on works by Eakins. An important new addition to the Thomas Eakins Research Collection is the recently acquired research files of Lloyd Goodrich, which he compiled while writing his two biographies of Eakins and an unfinished catalogue of the artist's work.

Other significant collections include the archive of the Pennsylvania Academy of the Fine Arts, where much of the material collected by Charles Bregler resides. In addition to this rich trove of Eakins and Macdowell family research materials, the academy archive contains historical records of minutes of the board and its committees, faculty, stockholders, and academicians, annual reports, financial records, clippings files, scrapbooks, press releases, and exhibition records. Included in this archive are letters and documents pertaining to Eakins' tenure as a faculty member and director of the school, correspondence between Eakins and Emily and William Sartain, and documents relating to various members of the Eakins and Crowell families which were acquired from the estate of Eakins biographer Gordon Hendricks.

Much of the Bregler material not belonging to the Pennsylvania Academy of the Fine Arts resides with the Smithsonian Institution's Hirshhorn Museum and Sculpture Garden, in Washington, D.C. The Archives of American Art, another division of the Smithsonian Institution, houses other original documents as well as photocopies of numerous Eakins and Macdowell manuscripts, and hundreds of pages of the Pennsylvania Academy's older historical records, publications, and clippings.

The largest private collection of Eakins research material belongs to Mr. Daniel W. Dietrich II, of Phoenixville, Pennsylvania. Numbering over eighty objects, the contents of this collection range from a delicate drawing of a camel and rider (which Eakins made when he was sixteen) to rare photographs of artists Eakins knew and admired (while he was a Paris art student). A substantial portion of the Dietrich collection was acquired from Seymour Adelman, a Philadelphia bibliophile and close friend of Susan Macdowell Eakins. Adelman used the proceeds from the Dietrich sale to purchase the Eakins home at 1729 Mount Vernon Street, which was then given to the Philadelphia Museum of Art. Remaining items from the Adelman collection now reside at Bryn Mawr College, where can be found five paintings by Susan Macdowell Eakins and a voluminous collection of correspondence between Macdowell and Adelman.

Overleaf: The Thomas Eakins armchair (Courtesy of The Pennsylvania Academy of the Fine Arts, Charles Bregler's Thomas Eakins Collection; purchased with the partial support of the Pew Memorial Trust)

Articles, Books, and Manuscripts

Ackerman, Gerald M. 1969. "Thomas Eakins and His Parisian Masters Gérôme and Bonnat." *Gazette des Beaux-Arts,* series 6, vol. 73 (April).

Adams, Henry. 2005. *Eakins Revealed: The Secret Life of an American Artist.* New York: Oxford University Press.

Adams, J. Howe. 1892. *History of the Life of D. Hayes Agnew, M.D.* Philadelphia: F. A. Davis.

Adelman, Seymour. 1977. *The Moving Pageant.* Lititz, Pa.: Sutter House.

Albright, Adam Emory. 1947. "Memories of Thomas Eakins." *Harper's Bazaar* (August).

———. 1953. *For Art's Sake.* Philadelphia: privately printed.

Alkana, Joseph. 1996. *The Social Self: Hawthorn, Howells, William James, and Nineteenth-Century Psychology.* Lexington: University Press of Kentucky.

Anesko, Michael, ed. 1997. *Letters, Fictions, Lives: Henry James and William Dean Howells.* New York: Oxford University Press.

The Art of Philadelphia Medicine. 1965. Philadelphia: Philadelphia Museum of Art.

Beaux, Cecilia. 1930. *Background with Figures.* New York: Houghton Mifflin.

Beisel, Nicola. 1997. *Imperiled Innocents: Anthony Comstock and Family Reproduction in Victorian America.* Princeton: Princeton University Press.

Bell, Whitfield J. 1987. *The College of Physicians of Philadelphia: A Bicentennial History.* Canton, Mass.: Science History Publications.

Berger, Martin A. 2000. *Man Made: Thomas Eakins and the Construction of Gilded-Age Manhood.* Berkeley: University of California Press.

Berkowitz, Julie. 1999. "Thomas Eakins as a Scientist and His Relationship with Jefferson Medical College." In *Adorn the Halls: The History of the Art Collection at Thomas Jefferson University.* Philadelphia: Thomas Jefferson University.

Blanchard, Mary W. 1998. *Oscar Wilde's America: Counterculture in the Gilded Age.* New Haven: Yale University Press.

Bolger, Doreen, and Sarah Cash, eds. 1996. *Thomas Eakins and the Swimming Picture.* Fort Worth: Amon Carter Museum.

Bregler, Charles. 1931. "Thomas Eakins as a Teacher." 2 parts. *Arts,* vol. 7 (March and October).

———. 1943. "Photos by Thomas Eakins: How the Famous Painter Anticipated the Modern Movie Camera." *American Magazine of Art* (January).

Brownell, William C. 1879. "The Art Schools of Philadelphia." *Scribner's Monthly,* vol. 18, no. 5 (September).

———. 1880. "The Younger Painters of America." *Scribner's Monthly,* no. 20 (May).

Burroughs, Bryson. 1917. *Loan Exhibition of the Work of Thomas Eakins.* New York: Metropolitan Museum of Art.

Calder, Stirling. 1947. *Thoughts of A. Stirling Calder on Art and Life.* New York: privately printed.

Carr, Carolyn Kinder. 1989. "A Friendship and a Photograph: Sophia Williams, Talcott Williams, and Walt Whitman." *American Art Journal,* vol. 21.

Chamberlin-Hellman, Maria. 1981. "Thomas Eakins as a Teacher." Ph.D. diss., Columbia University.

Cohen-Solal, Annie. 2001. *Painting American: The Rise of American Artists, Paris 1867–New York 1948*. New York: Alfred A. Knopf.

Comstock, Anthony. 1887. *Morals Versus Art*. New York: J. S. Ogilvie.

Cooper, Helen A. 1996. *Thomas Eakins: The Rowing Pictures*. With contributions by Martin A. Berger, Christina Currie, and Amy B. Werbel. New Haven: Yale University Press.

Danly, Susan, and Cheryl Leibold. 1994. *Eakins and the Photograph: Works by Thomas Eakins and His Circle in the Collection of the Pennsylvania Academy of the Fine Arts*. Washington, D.C.: Smithsonian Institution Press.

Davis, Whitney. 1994. "Erotic Revision in Thomas Eakins's Narratives of Male Nudity." *Art History*, vol. 17, no. 3 (September).

Domit, Moussa M. 1969. *The Sculpture of Thomas Eakins*. Washington, D.C.: Corcoran Gallery of Art.

Dunbar, Elizabeth. 1936. *Talcott Williams, Gentleman of the Fourth Estate*. Privately printed.

Eakins, Thomas. 2005. *A Drawing Manual*. New Haven: Philadelphia Museum of Art in association with Yale University Press.

Eliot, Alexander. 1957. *Three Hundred Years of American Painting*. New York: Time.

Esquirol, E. 1845. *Mental Maladies: A Treatise on Insanity*. Philadelphia: Lea and Blanchard.

Foster, Kathleen A. 1972. "Philadelphia and Paris: Thomas Eakins and the Beaux-Arts." Master's thesis, Yale University.

———. 1997. *Thomas Eakins Rediscovered*. With contributions by Mark Bockrath, Catherine Kimock, Cheryl Leibold, and Jeanette Toohey. New Haven: Yale University Press.

Foster, Kathleen A., and Cheryl Leibold. 1989. *Writing About Eakins: The Manuscripts in Charles Bregler's Thomas Eakins Collection*. Philadelphia: University of Pennsylvania Press.

Fried, Michael. 1985. "Realism, Writing, and Disfiguration in Thomas Eakins's Gross Clinic." *Representations* (Winter).

———. 1987. *Realism, Writing, Disfiguration: On Thomas Eakins and Stephen Crane*. Chicago: University of Chicago Press.

Gallman, Matthew J. 1990. *Mastering Wartime: A Social History of Philadelphia During the Civil War*. Cambridge: Cambridge University Press.

Gayley, Fames. 1858. *A History of the Jefferson Medical College of Philadelphia, with Biographical Sketches of the Early Professors*. Philadelphia: J. M. Wilson.

Glassman, Elizabeth, and Serge Lemoine, eds. 2003. *Painting and Masculinity*. Giverny, France: Terra Foundation for the Arts and Musée d'Orsay.

Goodrich, Lloyd. 1933. *Thomas Eakins: His Life and Works*. New York: Whitney Museum of American Art.

———. 1982. *Thomas Eakins*. 2 vols. Cambridge, Mass.: Published for the National Gallery of Art by Harvard University Press.

Gross, Samuel. 1887. *Autobiography of Samuel D. Gross, M.D.* Philadelphia: George Barrie.

Haines, Joseph E. 1938. *A History of Friends' Central School.* Philadelphia: Friends Central School.

Hatt, Michael. 1993. "The Male Body in Another Frame: Thomas Eakins' The Swimming Hole as Homoerotic Image." *Journal of Philosophy and the Visual Arts.*

Hendricks, Gordon. 1972. *The Photographs of Thomas Eakins.* New York: Grossman.

———. 1974. *The Life and Work of Thomas Eakins.* New York: Grossman.

Henri, Robert. 1923. *The Art Spirit.* Philadelphia: J. B. Lippincott.

Hering, Fanny Field. 1892. *The Life and Works of Jean-Léon Gérôme.* New York: Cassell.

Hershberg, Theodore, ed. 1981. *Philadelphia, Work, Space, Family, and Group Experience in the Nineteenth Century.* New York: Oxford University Press.

Hockney, David. 2001. *Secret Knowledge: Rediscovering the Lost Techniques of the Old Masters.* London: Thames and Hudson.

Homer, William Innes. 1980. *Eakins at Avondale and Thomas Eakins: A Personal Collection.* Chadds Ford, Pa.: Brandywine River Museum.

———. 1992. *Thomas Eakins: His Life and Art.* New York: Abbeville.

Homer, William Innes, and John Talbot. 1963. "Eakins, Muybridge and the Motion Picture Process." *Art Quarterly,* vol. 26, no. 2 (Summer).

Johns, Elizabeth. 1980. "Drawing Education at Central High School and Its Impact on Thomas Eakins." *Winterthur Portfolio* (Summer).

———. 1983. *Thomas Eakins: The Heroism of Modern Life.* Princeton: Princeton University Press.

Keen, James, ed. 2002. *Keen of Philadelphia.* Dublin, N.H.: William Bauhan.

Keen, William, ed. 1912–13. *Surgery, Its Principles and Practice.* Philadelphia: W. B. Saunders.

Kimmelman, Michael. 2002. "A Fire Stoking Realism." *New York Times* (June 21), sec. E, p. 31.

Kosinski, Dorothy M. 1999. *The Artist and the Camera: Degas to Picasso.* Exh. cat., Dallas: Dallas Museum of Art.

Lane, Roger. 1979. *Violent Death in the City: Suicide, Accident, and Murder in Nineteenth-Century Philadelphia.* Cambridge: Harvard University Press.

Leibold, Cheryl. 1988. "Thomas Eakins in the Badlands." *Archives of American Art Journal,* vol. 28, no. 2.

Leja, Michael. 2001. "Eakins and Icons." *Art Bulletin* (September 1).

Liedtke, Walter, with Michiel C. Plomp and Axel Rüger. 2001. *Vermeer and the Delft School.* Exh. cat., New York: Metropolitan Museum of Art.

Liften, Norma. 1987. "Thomas Eakins and S. Weir Mitchell: Images and Cures in Nineteenth-Century Philadelphia." In *Psychoanalytic Perspectives in Art.* Hillsdale, N.J.: Analytic Press.

Lubin, David. 1985. *Act of Portrayal: Eakins, Sargent, James.* New Haven: Yale University Press.

————. 1997. "Modern Psychological Selfhood in the Art of Thomas Eakins," in *Inventing the Psychological: Toward a Cultural History of Emotional Life in America*, ed. Joel Pfister and Nancy Schnog. New Haven: Yale University Press.

————. 2002. "Projecting an Image: The Contested Cultural Identity of Thomas Eakins." Exhibition review, *Art Bulletin*, vol. 84 (September).

McCabe, James D. 1876. *The Illustrated History of the Centennial Exhibition, Held in Commemoration of the One Hundredth Anniversary of American Independence.* Philadelphia: National Publishing.

McHenry, Margaret. 1946. *Thomas Eakins, Who Painted.* Oreland, Pa.: privately printed.

Martinez, Katharine, and Page Talbott, eds. 2000. *Philadelphia's Cultural Landscape: The Sartain Family Legacy.* Philadelphia: Temple University Press.

Memorial Exhibition of the Works of the Late Thomas Eakins. Philadelphia: J. B. Lippincott, 1918.

Milroy, Elizabeth. 1986. "Thomas Eakins' Artistic Training, 1860–1870." Ph.D. diss., University of Pennsylvania.

————. 1989. "Consummatum est . . . : A Reassessment of Thomas Eakins's Crucifixion of 1880." *Art Bulletin*, vol. 71, no. 2 (June).

————. 1996. *Guide to the Thomas Eakins Research Collection, with a Lifetime Exhibition Record and Bibliography.* Philadelphia: Philadelphia Museum of Art.

Morris, Harrison. 1930. *Confessions in Art.* New York: Sears.

Morrone, Francis. 1999. *An Architectural Guidebook to Philadelphia.* Layton, Utah: Gibbs Smith.

Muybridge, Eadweard. 1957. *Animals in Motion.* New York: Dover.

Nuland, Sherwin. 2003. "The Artist and the Doctor." *American Scholar,* vol. 72 (Winter).

O'Donnell, Rev. George E. 1964. *St. Charles Seminary, Philadelphia.* Philadelphia: American Catholic Historical Society, St. Charles Seminary.

Onorato, Ronald. 1977. "The Pennsylvania Academy of the Fine Arts and the Development of an Academic Curriculum in the Nineteenth Century." Ph.D. diss., Brown University.

Osler, William. 1892. *The Principles and Practice of Medicine, Designed for the Use of Practitioners and Students of Medicine.* New York: D. Appleton.

"Outlaw in an Undershirt." *Newsweek* (April 17, 1944).

Pach, Walter. 1938. *Queer Things, Painting: Forty Years in the World of Art.* New York: Harper Brothers.

Philadelphia Board of Controllers. 1858. "Thirty-Ninth Annual Report of the Controllers of the Public Schools, of the First School District of Pennsylvania, Comprising the City of Philadelphia, for the Year Ending July 16, 1857." Philadelphia: Board of Controllers.

Poore, Henry Ranklin. 1931. *Modern Art: Why What and How?* New York: G. P. Putnam's Sons.

Rogers, Fairman. 1879. "The Zoötrope. Action of Animals in Motion—The Muybridge Photographs of Horses—The Instrument as a Factor in Art Studies." *Art Interchange,* vol. 3 (July 9).

Rosenzweig, Phyllis D. 1977. *The Thomas Eakins Collection of the Hirshhorn Museum and Sculpture Garden.* Washington, D.C.: Smithsonian Institution Press.

Rourke, Constance. 1938. *Charles Sheeler, Artist in the American Tradition.* New York: Harcourt, Brace.

Rule, Henry. 1974. "Walt Whitman and Thomas Eakins: Variations on Some Common Themes." *Texas Quarterly* (Winter).

Saint-Gaudens, Homer. 1941. *The American Artist and His Times.* New York: Dodd, Mead.

Sartain, John. 1899. *The Reminiscences of a Very Old Man, 1808–1897.* New York: D. Appleton.

Saslow, James M. 1999. *Pictures and Passions: A History of Homosexuality in the Visual Arts.* New York: Viking.

Scharf, Thomas, and Thompson Westcott. 1884. *History of Philadelphia, 1609–1884.* Philadelphia: L. H. Everts.

Schendler, Sylvan. 1967. *Eakins.* Boston: Little Brown.

Sellin, David. 1976. *The First Pose: 1876, Turning Point in American Art; Howard Roberts, Thomas Eakins, and a Century of Philadelphia Nudes.* New York: W. W. Norton.

———. 1977. *Thomas Eakins, Susan Macdowell Eakins, and Elizabeth Macdowell Kenton.* Roanoke, Va.: North Cross School.

Sewell, Darrel. 1982. *Thomas Eakins: Artist of Philadelphia.* Philadelphia: Philadelphia Museum of Art.

———, ed. 2001. *Thomas Eakins.* With essays by Kathleen A. Foster, Nica Gutman, William Innes Homer, Elizabeth Milroy, W. Douglass Paschall, Darrel Sewell, Marc Simpson, Carol Troyen, Mark Tucker, H. Barbara Weinberg, Amy B. Werbel, and chronology by Kathleen Brown. New Haven: Yale University Press.

Shinn, Earl. 1866. [pseud. E.S.] "Art-Study Abroad." *The Nation*, vol. 3, no. 62 (September 6).

———. 1869. [pseud. E.S.] "Art Study at the Imperial School in Paris." Parts 1–5, *The Nation*, vol. 8, no. 198 (April 15), pp. 292–94; no. 201 (May 6), pp. 351–52; no. 205 (June 3), pp. 433–34; no. 208 (June 24), pp. 492–93; vol. 9, no. 212 (July 22), pp. 67–69.

———. 1872. [pseud. S.E.] "The First American Art Academy." 2 parts, *Lippincott's Magazine* (February and March).

———, ed. 1875. [pseud. Edward Strahan.] *A Century After: Picturesque Glimpses of Philadelphia and Pennsylvania.* Philadelphia: Allen, Lane & Scott and J. W. Lauderbach.

———. 1881. [pseud. Edward Strahan.] "The Art Gallery: Works of American Artists Abroad. The Second Philadelphia Exhibition." *The Art Amateur*, vol. 6, no. 1 (December).

———. 1884. [pseud. Sigma.] "A Philadelphia Art School." *The Art Amateur*, vol. 10, no. 2 (January).

———. 1888. [pseud. C. H. Stranahan.] *A History of French Painting.* New York: Charles Scribner's Sons.

Siegl, Theodor. 1978. *The Thomas Eakins Collection.* Philadelphia: Philadelphia Museum of Art.

Sullivan, Mark. 1998. "Thomas Eakins and His Portrait of Father Fedigan," *Records of the American Catholic Historical Society of Philadelphia* (Fall–Winter).

Thomas Eakins: Image of the Surgeon. Baltimore: Walters Art Gallery, The Johns Hopkins Medical Institutions, 1989.

"Thomas Eakins: Philadelphians Who Snubbed Him Now Honor Him as an American Old Master." *Life* (May 15, 1944).

"Thomas Eakins and His Portrait of Father Fedigan." *Records of the American Catholic Historical Society,* vol. 109, nos. 3–4 (Fall–Winter 1998).

Trachtenberg, Alan. 1982. *The Incorporation of America: Culture and Society in the Gilded Age.* New York: Hill and Wang.

Traubel, Horace L. 1889. *Camden's Compliments to Walt Whitman, May 31, 1889.* Philadelphia: David McKay.

———. 1953. *With Walt Whitman in Camden.* Philadelphia: University of Pennsylvania Press.

Trefethen, James B. 1975. *An American Crusade for Wildlife.* Alexandria, Va.: Boone and Crockett Club.

Wainwright, Nicholas D. 1973. "Education of an Artist: The Diary of Boggs Beale, 1856–1862." *Pennsylvania Magazine of History and Biography* (October).

Waller, Frank. 1879. *Report on Art Schools.* New York: Art Students' League.

Walter, Marjorie Alison. 1995. "Fine Art and the Sweet Science: On Thomas Eakins, His Boxing Paintings, and Turn-of-the-Century Philadelphia." Ph.D. diss., University of California, Berkeley.

Werbel, Amy. 1996. "Perspective in the Life of and Art of Thomas Eakins." Ph.D. diss., Yale University.

———. 1998. "Art and Science in the Work of Thomas Eakins." *American Art* (Fall).

Whitman, Walt. 1889. *Notes, Addresses, Letters, Telegrams,* ed. Horace L. Traubel. Philadelphia.

Wilmerding, John, ed. 1993. *Thomas Eakins and the Heart of American Life.* London: National Portrait Gallery.

Wood, Horatio. 1880. *Brain-Work and Overwork.* Philadelphia: Presley Blakiston.

———. 1887. *Nervous Diseases and Their Diagnosis: A Treatise upon the Phenomena Produced by Diseases of the Nervous System.* Philadelphia: Lippincott.

Young, Dorothy Weir. 1960. *The Life and Letters of J. Alden Weir.* New Haven: Yale University Press.

Acknowledgments

Eakins scholarship owes a profound debt of gratitude to Lloyd Goodrich. The hundreds of interviews he conducted with the artist's family, friends, and students are the bulwark on which later generations of art historians, curators, and conservators have relied. Among the many dedicated scholars who have followed in Goodrich's footsteps to make their own significant contributions are Martin Berger, Maria Chamberlin-Hellman, Helen Cooper, Christina Currie, Kathleen Foster, Michael Fried, Nica Gutman, Gordon Hendricks, William Innes Homer, Elizabeth Johns, Cheryl Leibold, David Lubin, Elizabeth Milroy, Ellwood Parry, Douglass Paschall, Phyllis Rosenzweig, David Sellin, Theodor Siegl, Darrel Sewell, Marc Simpson, Carol Troyen, Mark Tucker, H. Barbara Weinberg, and Amy Werbel. Rather than try to build on the work of these pathfinders I have instead endeavored to put the fruit of their labor into the broader context of the historical panorama which would shape Eakins, and which he in turn would modify; without their invaluable contributions my own work would have been infinitely more difficult.

Kathleen Foster, a devoted guardian of the Eakins legacy, deserves special mention for carrying the mantle of Eakins scholarship forward through her own writing and by preserving and expanding the greater body of Eakins research materials under her care, first at the Pennsylvania Academy of the Fine Arts, and now at the Philadelphia Museum of Art. I am indebted to Foster for permitting me to roam freely through the Philadelphia Museum archive and for helping me to untangle the many tightly woven strands of Eakins' artistry.

Audrey Lewis has been my indispensable guide to the Philadelphia Museum archive; she patiently answered my innumerable questions and helped me to chart my course through the museum's massive Eakins collection. Cheryl Leibold, archivist at the Pennsylvania Academy of the Fine Arts, has similarly fielded my questions and generously provided access to the extensive collection there.

My special thanks for help with research goes to Charlene Adlinger and Ron Chapman of the Honolulu Academy of the Arts; D. Scott Atkinson,

Curator of American Art at the San Diego Museum of Art; Whitfield Bell, Jr., Philadelphia medical historian; Dana Bottomley, Registrar for Collections at the San Diego Museum of Art; Sheree Cooper at Woodlands Cemetery; Kylee Denning, Curator of Collections at the Haggin Museum; Sister Joan Freney of the Sisters of Mercy; Derek Gillman, President of the Pennsylvania Academy of the Fine Arts; Laura Griffith of the Fairmount Park Art Association; Marianne Henein, the Assistant Registrar for Rights and Reproductions at The Corcoran Museum of Art; Cait Kokolus, head of the library at the Saint Charles Borromeo Seminary in Overbrook; Marian Kovinick at the West Coast Research Center of the Smithsonian Institution's Archives of American Art; Lora Martinolich, reference services manager for the City of Glendale, California, library; Nancy Miller of the University of Pennsylvania Archives; Lisa Picana of the Jefferson Medical College; Eric L. Pumroy, Associate Director for Collection Development and Seymour Adelman Head of Special Collection Development at the Mariam Coffin Canaday Library of Bryn Mawr College; Charlotte Singleton of the Mount Desert Island Historical Society; Jessica Smith, the Curator of American Art at the Henry E. Huntington Library in San Marino, California; Samir Zeind of the Health Sciences Library at the Huntington Memorial Hospital; and Linda Kay Zoeckler, head of the Art Reference Library at the Henry E. Huntington Library in San Marino, California.

For reading my manuscript and her many editorial suggestions thanks goes to Akela Reason of the High Museum in Atlanta. Douglass Paschall, Curator of Collections at the Woodmere Art Museum, shared with me his many invaluable insights into Eakins and his circle of friends and associates. David Sellin, author and former head of the schools at the Pennsylvania Academy of the Fine Arts, was instrumental in helping me keep the Eakins story in perspective. I am also grateful for close readings and commentary from Phillip King, at Yale University Press. Credit for what I got right belongs to these four.

My heartfelt thanks to all those whose hospitality lightened my labors, most especially to Derek Dickinson, Michael and Digby Diehl, Dan and De-Launé Fried, Louis Malaer, Jackie Oakley, Stella Olive, Cheryl and Chuck Scott, and Jennifer and Eric Zicht. Hart Perry, formerly of the Kent School in Kent, Connecticut, and currently the executive director of the National Rowing Foundation, kindly arranged for me to spend a morning on the Schuylkill

River with oarsman Chuck Alexander (of the Masters Rowing Association), who personifies the indomitable spirit of Philadelphia's Schuylkill Navy. Thanks also to the Phillyringers for a most memorable evening at Saint Mark's Church.

Richard Morris, my agent at Janklow and Nesbitt and a dedicated Philadelphian, conceived and inspired the writing of this book. I am deeply grateful for his guidance and presence in my life. Jonathan Brent, of Yale University Press, shepherded the project from proposal into print. Like Richard, he believed that Eakins' story was both a compelling personal tale and a glimpse into American life at a pivotal moment in our nation's history.

Love and gratitude, always, to Nancy Webster, my partner and muse, and to her daughter, Mercedes Thurlbeck, whose art career led to her appreciation of human anatomy and finally to medical science.

Lastly, my profound thanks goes to Peter Nelson, of the Art Center College of Design in Pasadena, California, who pulled me through many a crisis and who selflessly shared with me his imaginative advice, astute criticism, and myriad editorial suggestions. Every writer needs such a friend.

Index

Eakins family, 11–12, 20–29, 220; activities of, 31–35, 370; boathouse of, 158; death in, 172; incest allegations and, 328; Mount Vernon Street house, *19*, 25, 26–29, 39, 366, 495; nude photography and, 276; piano of, 489; as portrait subjects, 131–32, 133–35, 204–5; TE's correspondence from Paris and, 96–97
Eakins Revealed (Adams), 9, 133
Earle, Harrison, 73
Earles Galleries (Philadelphia), 397, 412
École des Beaux-Arts (Paris), 72, 75, 87–92, 448; TE's arrival at, 76–83; hazing rituals in, 87–88; student life at, 88–90
École Gratuite de Dessin (Paris), 77
Edison, Thomas A., 243, 309
Egypt, 86
Egyptian Recruits Crossing the Desert (Gérôme), 73
Eichholz, Jacob, 71
Elder, Archbishop William, 476
Elgin marbles, 65, 470
Eliot, Alexander, 8
Elizabeth Crowell with a Dog (Eakins), 135–36, 137, 140, 161, 261, plate 3
Elizabeth at the Piano (Eakins), 193
Eugénie, Empress, 86, 98, 115
Evans, Helen Parker, 450, 451, 482, 490
Exposition Universelle (Paris), 3, 98, 99
Eyck, Jan van, 165

factories, 21, 26
Fairmount Park (Philadelphia), 31, 48, 96, 123, 470; Centennial Exposition in, 183, 194; Civil War preparations in, 48; Eakins family trips to, 133; horses and coachmen in, 245, 246, 247, 248, 249; Pennsylvania Museum in, 364; Philadelphia Zoo, 450; public meeting hall, 491; statue of George Washington in, 224
Falconio, Archbishop Diomede, 474
feminism, 61–62
Fidelity Trust Company, 462, 478
Fifty Years Ago (Eakins), 220
Fisler, Wes, 161
Fitzgerald, Riter, 467–68
Flaherty, James A., 474
Flayers (street gang), 26
Flexner, James Thomas, 5
Flore family, 122
Foster, Kathleen, 10, 133, 364; on *Baseball Players Practicing*, 162; on Eakins as "lightning rod," 422; and Eakins papers, 9, 318, 321, 323–24, 416; on Hammitt, 370, 371; on *A May Morning*, 246, 248; on President Hayes portrait, 212; on *Swimming*, 288–89; on *William Rush*, 225
Fox, Benjamin, 287
France, 15, 97; academic tradition in, 63; art critics, 2, 3; art patronage in, 115; impressionists, 4; popularity of American inventions in, 98
Franco-Prussian War, 126
Frank Hamilton Cushing (Eakins), 386–87
Franklin, Benjamin, 2, 42
French language, 68, 79, 80, 81; TE's fluency in, 55, 89; studies in, 43, 45
Friends Central School, 20, 22, 27, 208, 287
Frishmuth, Sarah Sagehorn, 460–62
Frost, Arthur, 279, 399
Furness, Frank, 57, 199
Fussell, Charles, 63, 180

García, Cencion, 122
Gardel, Bertrand, 40, 203
Gardiner, Oscar "Omaha Kid," 440

The Henry McBride Series in Modernism and Modernity

The artistic movement known as modernism, which includes the historical avant-garde, produced the most radical and comprehensive change in Western culture since Romanticism.

Henry McBride (1867–1962) wrote weekly reviews of contemporary art for the New York *Sun* (1913–50) and monthly essays for the *Dial* (1920–29) and was one of the most perceptive and engaging of modern critics. He discussed difficult artistic issues in a relaxed yet informed style, one that is still a model of clarity, grace, and critical responsiveness. The Henry McBride Series in Modernism and Modernity, which focuses on modernism and the arts in all their many contexts, is respectfully dedicated to his memory.